Objects/Histories

Critical Perspectives on Art, Material Culture, and Representation

A SERIES EDITED BY NICHOLAS THOMAS

Published with the assistance of the Getty Foundation.

Bailkin, Jordanna. "Indian Yellow: Making and Breaking the Imperial Palette." *Journal of Material Culture* 10(2) (2005): 197–214, reprinted by permission of Sage Publications.

Benjamin, Roger. "Colonial Panaromania," excerpts from *Orientalist Aesthetics: Art, Colonialism, and French North Africa, 1880–1930*, 105–27, 296–99. © 2003 by the Regents of the University of California. Published by the University of California Press.

Bleichmar, Daniela. "Painting as Exploration: Visualizing Nature in Eighteenth-Century Colonial Science." *Colonial Latin American Review* 15(1) (2006): 81–104, reprinted by permission of the publisher (Taylor & Francis Ltd., www.tandfonline.com).

Çelik, Zeynep. "Speaking Back to Orientalist Discourse," in *Orientalism's Interlocutors: Painting, Architecture, Photography*, ed. J. Beaulieu and M. Roberts, 19–42. Durham: Duke University Press, 2002.

Ciarlo, David. "Advertising and the Optics of Colonial Power at the Fin de Siècle," in *German Colonialism, Visual Culture and Modern Memory*, ed. Volker M. Langbehn, 37–54. London: Routledge, 2010. © 2010 Routledge. Reproduced by permission of Taylor & Francis Books UK.

Eaton, Natasha. "Excess in the City? The Consumption of Imported Prints in Colonial Calcutta." *Journal of Material Culture* 8(1) (2003): 45–74, reprinted by permission of Sage Publications.

Gikandi, Simon. "Picasso, Africa, and the Schemata of Difference," *Modernism/modernity* 10(3) (2003): 455–80. © 2003 The Johns Hopkins University Press. Reprinted with permission of The Johns Hopkins University Press.

Gruzinski, Serge. "The Walls of Images," extract from *Images at War: Mexico from Columbus to Blade Runner, 1492–2019*; 69–86, 244–47. Durham: Duke University Press, 2001.

Hevia, James L. "The Photography Complex: Exposing Boxer-Era China (1900–1901), Making Civilization," in *Photographies East: The Camera and Its Histories in East and Southeast Asia*, ed. R. C. Morris, 79–119. Durham: Duke University Press, 2009.

Larkin, Brian. "Colonialism and the Built Space of Cinema," in *Signal and Noise: Media, Infrastructure, and Urban Culture in Nigeria*; 123–45, 266–69. Durham: Duke University Press, 2008.

Oguibe, Olu. "*Double Dutch* and the Culture Game," in *The Culture Game*, 33–44. Minneapolis: University of Minnesota Press, 2004. © 2004 by the Regents of the University of Minnesota.

Padrón, Ricardo. "Mapping Plus Ultra: Cartography, Space, and Hispanic Modernity," in *Representations* 79(1) (2002): 28–60. © 2002 by the Regents of the University of California.

Pinney, Christopher. "Creole Europe: The Reflection of a Reflection." *Journal of New Zealand Literature* 20 (2003): 125–61.

Pinney, Christopher. "Notes from the Surface of the Image: Photography, Post-Colonialism, and Vernacular Modernism," in *Photography's Other Histories*, ed. C. Pinney and N. Peterson, 202–20. Durham: Duke University Press, 2003.

Ramaswamy, Sumathi. "Maps, Mother/Goddesses, and Martyrdom in Modern India." *Journal of Asian Studies* 67(3) (2008): 819–53.

Schmidt, Benjamin. "Mapping an Exotic World: The Global Project of Dutch Geography, circa 1700," in *The Global Eighteenth Century*, ed. Felicity A. Nussbaum, 21–37, 327–30. Baltimore: Johns Hopkins University Press, 2003. Reprinted with permission of The Johns Hopkins University Press.

Smith, Terry. "Visual Regimes of Colonisation: European and Aboriginal Seeing in Australia," in *Paysage et Art*, ed. Ulpiano Toledo Bezeera de Meneses, 91–100. São Paulo: Comité Brasileiro de Historia da Arte, 2000.

Stam, Robert. "Fanon, Algeria, and the Cinema: The Politics of Identification," in *Multiculturalism, Postcoloniality, and Transnational Media*, ed. E. Shohat and R. Stam, 18–43. New Brunswick, NJ: Rutgers University Press, 2003.

Stein, Eric A. "Colonial Theatres of Proof: Representation and Laughter in the 1930s Rockefeller Foundation Hygiene Cinema in Java." *Health and History* 8(2), Health, Medicine and the Media (2006), 14–44. Permission to republish granted by Hans Pols, editor of *Health and History* and representative of the Australian and New Zealand Society of the History of Medicine.

Thomas, Nicholas. "Objects of Knowledge: Oceanic Artifacts in European Engravings," in *In Oceania: Visions, Artifacts, Histories*; 93–109. Durham: Duke University Press, 1997.

Thompson, Krista A. "'I am rendered speechless by your idea of beauty': The Picturesque in History and Art in the Postcolony," in *An Eye for the Tropics: Tourism, Photography, and Framing the Caribbean Picturesque*; 252–75, 326–28. Durham: Duke University Press, 2006.

From the very beginning, this volume has been a collaborative enterprise. Its origins lie in a Dissertation Proposal Development Seminar sponsored by the Social Science Research Council, which we were privileged to teach in May 2009 in New Orleans and September 2009 in Philadelphia. Funded by the Andrew W. Mellon Foundation, these seminars bring together graduate students from disparate fields at the moment when they are first formulating their dissertation topics. Our theme was "Empires of Vision," and from a very competitive field of applicants, we chose a dozen participants. They exceeded our most exorbitant expectations, and our marathon sessions were wonderfully productive exercises in collaborative intellectual stimulation. Our first expression of gratitude goes to the members of the seminar: Mustafa Avci, an ethnomusicologist from New York University; Jill Campaiola, a media studies student from Rutgers; Josefina de la Maza Chevesich, an art historian from the State University of New York at Stony Brook; Christine DeLucia, an American studies student from Yale; Melissa Heer, an art historian from the University of Minnesota, Twin Cities; Jessica Horton, an art historian from the University of Rochester; Saydia Kamal, an anthropologist from the University of North Carolina, Chapel Hill; Andrea Korta, an art historian from the University of California, Santa Barbara; Daegan Miller, a historian from Cornell University; Deniz Turker, an art historian from the Massachusetts Institute of Technology; Katherine Wiley, an anthropologist from Indiana University, Bloomington; and Marieke Wilson, an anthropologist from the Johns Hopkins University. Keep your eyes out for them; they are all future leaders in their fields. We would also like to thank the SSRC staff, Josh DeWind, Camille Peretz, Emily Burns,

and Lauren Shields, for the gracious exercise of their formidable organizational talents.

Our next expression of gratitude goes to David Moshfegh, who took time away from completing his dissertation in the UC Berkeley History Department to do Herculean combat with the multi-headed Hydra who grants permissions for previously published essays and images. Rather than violence, he used tenacity, wit, and charm to obtain what made this collection possible. Also crucial in that endeavor was the generous support of the Duke University Center for International Studies and its executive director Robert Sikorski, and the Sidney Hellman Ehrman Chair at UC Berkeley. We are grateful as well to the staff at the Duke University Press, in particular Ken Wissoker, Jade Brooks, and our copyeditors Laura Poole and Danielle Szulczewski, for all their help over the long gestation of this project. Additional thanks to the two anonymous readers who made helpful suggestions, and to Diana Witt for preparing the index. But perhaps our deepest gratitude goes to the authors of the essays included in this volume. The opportunity to bring their remarkable work to a new and larger audience has been enormously gratifying.

Martin Jay
Sumathi Ramaswamy

The Work of Vision in the Age of European Empires

Sumathi Ramaswamy

The conquest of the earth, which mostly means taking it away from those who have a different complexion or slightly flatter noses than ourselves, is not a pretty thing when you look into it too much. What redeems it is the idea only. An idea at the back of it; not a sentimental pretence but an idea; and an unselfish belief in the idea—something that you can set up, and bow down before, and offer a sacrifice to.

—Joseph Conrad, *Heart of Darkness*

Seeing is an art . . . which must be learnt.

—William Herschel

Empires of Vision assembles recent scholarship that draws our attention to the mutual implication of the global overseas empires of Europe and modern regimes of visuality and their reciprocal constitution. The past few centuries have witnessed not only the sweeping expansion of Europe beyond its putative borders and subsequent contraction but also an exponential escalation in the global flows of peoples, objects, ideas, technologies, and images. This volume explores the range of pictorial practices, image-making technologies, and vision-oriented subjectivities that have been cultivated, desired, and dispersed within the contexts of modern empire formation and decolonization. The essays collected here consider the transformations undergone by these technologies, practices, and subjectivities as they get entangled in empire-building, nationalist reactions, postcolonial contestations, and transnational globalization. In addition to tracking the intertwined histories of "empire" and "vision" in modernity, the selections elucidate what might be specifically colonial about the image-making technologies, practices, and subjectivities encountered in these pages. The goal is also to understand

the "(post)colonial" as among many competing ocular fields in the scopic regimes of modernity.[1] In considering these themes, *Empires of Vision* also opens up for scrutiny what "Europe" looks like when seen with (post)colonial eyes.

As such, this volume is located at the intersection of two vibrant cross-disciplinary fields in contemporary humanist and social scientific scholarship—colonial and postcolonial studies and visual culture—and invites the reader to consider the new configurations and reordering of received knowledge enabled by this nexus. Adapting from Ann Laura Stoler, the question is *the force of the image* in empire-building and self-making.[2] Section I, "The Imperial Optic," is concerned substantively with modern European empires as image-making, image-consuming, and image-collecting regimes and with sketching the lineaments of an optical theory of colonial power.[3] Theoretically and conceptually, the essays in this section illuminate the place of visuality—of seeing and being seen—in what Gayatri Chakravorty Spivak called "the planned epistemic violence of the imperialist project."[4] Primarily (but not exclusively) focused on empire formation and consolidation in the age following the Industrial Revolution, they explore the global dispersal of five image-making technologies that fundamentally reconstituted the visual regimes of both Europe and its colonies: oil and easel painting, mechanically reproduced print (in its many forms), maps and landscape imagery, photography, and film.[5] Rather than presume these image-makers as uniquely "Western" technologies whose development was exclusively molded by isolated (and heroic) individuals located in the metropole, we learn from these works that they are imperially dispersed but locally appropriated in creative and unexpected ways. We are also interested in understanding why Europe's industrial empires cultivated these particular visual technologies and the image practices and protocols of seeing associated with them, and how in turn these were transformed through their entanglement in colonial and imperial projects. In making the case for the constitutive role of vision in the age of global overseas empires and imperialism's role in shaping modern visuality, this section examines the various means by which the naked eye came to be vastly enhanced and extended through the technological innovations of industrial modernity even while skepticism and suspicion accumulates about and around the colonizing power of "the gaze" and "the look."

Furthermore, *Empires of Vision* suggests that the influential postcolonial argument "Can the subaltern speak?" has to be necessarily supplemented—

and here I use the term in the complex Derridean sense—with questions of seeing and looking. Does the empire not only speak and write back but also look back in unexpected ways, and at whom and with what effect? Does subaltern seeing extend imperial ways of looking even in the course of countering it, does it produce an alternative emancipatory vision, or is it a haphazard mix of both? Section II, "Postcolonial Looking," shifts the focus from image-making technologies to the subaltern image-worker, both resident in Europe's overseas colonies and increasingly in the metropole (such as Yinka Shonibare, one of whose works serves as the cover illustration for this volume).[6] In the decades accompanying and following formal decolonization, many artists immigrated to the metropole, demographically transforming the very heart of whiteness in the process. In such "voyages in," to borrow Edward Said's felicitous formulation, what happens to Europe itself as an object of regard—and reference?[7] This is an important question to ask if we want to understand how Europe as sovereign subject changes when viewed from the perspective of the global flow of images and visual apparatuses and from imperially transformed habits of seeing and being seen.[8]

The essays collected in this volume draw in various ways on postcolonial theory in all its myriad dimensions. At the same time, they manifest the limits of that theory whose own theoretical and conceptual roots largely draw on the world of words.[9] But images are not mere illustrations or passive reflections of something already established elsewhere through the vast verbal archives of these modern industrial empires; instead, imperial and postcolonial history, culture, and politics are at least partly constituted by "struggles occurring at the level of the image."[10] This volume demonstrates that the image is a site where new accounts of empire, the (post)colony, and Europe itself emerge that depart from—even challenge—the more familiar narrative line(s) of nonvisual histories. This is fundamentally what is at stake in this project. We are interested not so much in making a case for the sovereignty of the image—that would be a futile, even undesirable exercise—as in arguing against treating it as merely an eye-catching accessory. At the very least, by placing the "colonizing" image (and its linked technologies and subjectivities) at the center of our thinking, theorizing, and writing, we aim to expand and complicate the archive on the basis of which both imperial histories and the histories of modern vision in the industrial age have been written so far. We seek to write against the disciplinary confinement and containment of images to the academic field of art history, where they

have been understood until recently with a lamentable lack of attention to the colonial and the postcolonial; this, too, is at stake.

Empires of vision becomes a productive concept with which to work *only* when the boundaries of both constitutive terms of our title—*empire* and *vision*—are tested by asking which aspects of empire did not leave their trace in the image or the figural, and correspondingly, which modalities of the visual have been unconcerned or indifferent to the impress of imperialism.[11] Our selections teach us that it is not a matter of whether "art follows empire" (as Sir Joshua Reynolds claimed circa 1790) or whether "empire follows art" (as contrarily amended by William Blake circa 1810–20),[12] but that empire and art—or more broadly, power/knowledge and visual subjectivities—are mutually constituted and entwined, both in the colonies and in the metropole. Furthermore, the extraordinary movements of images across neatly laid borders and geopolitical boundaries, as well as the heterogeneous uses to which visual technologies have been put, challenge theories that conceive of the West and the East, the colonizer and colonized, the center and the periphery, as Manichean oppositions locked in perpetual struggles of domination on the one hand and subordination or resistance on the other. What we are instead learning from the work of the image in colonial and postcolonial settings is to consider empire formation as a messy business of mutual entanglements and imbrications, of collisions and compromises, and of desiring-while-disavowing and disavowing-while-desiring. Europe or its technologies no longer appear as the sole motor of modern visual culture; by the same token, the colonies can no longer be cast as either passive recipients of the white man's magic or massive resistors of formations and influences fanning out from Europe. Faced with such enmeshments, ideological undertakings such as visual decolonization, motivated by nativism and nationalism, seem inadequate (and even, possibly, undesirable), as do studies based on an insulated and fenced-off Europe—pure, white, untouched, and untropicalized. Indeed, as Christopher Pinney writes, "Europe was always a reflection of other times and places, never a self-present unity awaiting its replicatory colonial enunciation."[13] Nowhere is this arguably more apparent than in the realm of the visual, and demonstrating this is also one of the briefs of this collection being assembled at a time when the very concept of Europe—a "Europe in black and white"—is generating new scholarly and media discussion.[14]

The Panic of the Visual in (Post)Colonial Studies

This collection is consciously poised against what Barbara Stafford has identified as "the entrenched antivisualism pervading western neo-Platonizing discourse from the Enlightenment forward." Commenting on the totemization of language in the putative West where writing is identified with intellectual potency, Stafford observes that the passionate visualist "is haunted by the paradoxical ubiquity and degradation of images: everywhere transmitted, universally viewed, but as a category generally despised." More so than verbal genres, images have historically been perceived as more treacherous and lacking in integrity, in the face of which she calls for making public "the affirmative actions of images throughout time and across civilizations." This entails recognizing their "marvelous capacity to make abstractions concrete, their ability to provide both meaningful direction and delight to the individual thrashing her way through the maze of experience."[15] The need to make public "the affirmative" work of images is even more urgent in colonial and postcolonial contexts weighed down by the additional burden of the European denigration and delegitimization of preexisting and "native" visual cultures on one hand, and their exoticization and sensationalization on the other hand. At the same time, all such affirmative attempts rub up against the undeniable fact that visual technologies and practices frequently underwrote colonial governance and power. Steering a path between affirming "the virtue" of images and charting their participation (vicariously or conscientiously) in new regimes of imperial mastery over the Other is a challenge faced by all those who work at the nexus of empire and vision.[16]

In going against the grain of the entrenched antivisualism of much social scientific thought and practice, the image interrupts and intervenes, disturbing the discursive field of colonial and postcolonial studies that has for long been dominated by the hegemony of the word and the tyranny of the textual archive.[17] A few years ago, in a conversation with W. J. T. Mitchell, Edward Said revealed that he got "tongue-tied" when asked about pictures, admitting that "just to think about the visual arts generally sends me into a panic."[18] This is an ironic confession from a scholar whose work has exerted enormous influence on those who think and write at the intersection of imperialism, postcolonialism, and visuality. I seize on the word *panic* in Said's disclosure, however, and use it to argue that the value of the sometimes disorderly, frequently unpredictable, and occasionally incoherent world of

images lies precisely in its capacity to disrupt the flow of history-as-usual based on the certitudes of the written word; to take us down routes not readily available in the official archives of the state with their privileging of the document; and to bring to the center of our analyses that which is unsayable and ineffable—that which words have failed.[19] Almost a century ago, Walter Benjamin, in his aphoristic "Theses on the Philosophy of History," proposed that to articulate the past historically does not mean to recognize it "the way it really was." Instead, "it means to seize hold of a memory as it flashes up at a moment of danger . . . to retain that image of the past which unexpectedly appears to man singled out by history at a moment of danger." As others have noted, the historical materialist actively and creatively shuttles between the present and the past, between the living and the dead, with the all-too-keen awareness that "every image of the past that is not recognized by the present as one of its own concerns threatens to disappear irretrievably."[20] This urgent need to retrieve and redeem images and visual technologies that have all too quickly been dismissed as inconsequential or marginal to the serious business of empire-building or anticolonial politics underlies the work of the scholars collected in this volume.

In visually "panicking" the field of colonial and postcolonial studies, Edward Said's presence looms large, all the more noteworthy because neither his *Orientalism* (1978) nor his *Culture and Imperialism* (1993) critically engaged with the graphic image or pictorial practice.[21] All the same, as Saloni Mathur has eloquently argued, Said's early critique refutes any approach that views "the realm of art and aesthetics as relatively autonomous, or existing in a 'super-structural' relation to the economic, social and political spheres."[22] In his later work, Said directed our attention to "the massively knotted and complex histories" of colonizer and colonized that are perforce the product of the dynamically interconnected field occupied by both Europe and its colonies since at least the age of industrial capitalism.[23] This led him to suggest that the seemingly discrepant experiences of colony and metropole, hitherto radically separated, be read "contrapuntally, as making up a set of what I call intertwined and overlapping histories." Such contrapuntal readings would serve as "an alternative both to a politics of blame and to the even more destructive politics of confrontation and hostility."[24]

In the wake of the publication of *Orientalism* in 1978, art historian Linda Nochlin was among the first to extend its insights to the field of visual studies in her reflections on nineteenth-century French Orientalist painting

and its relationship to colonial ideology.[25] Nochlin wrote her essay explicitly in response to an exhibition in 1982 called "Orientalism: The Near East in French Painting 1800–1880," whose catalog invoked Said only to distance itself from any examination of the political scaffolding that enabled such works to emerge in the first place.[26] Categorically rejecting the insulation of the realm of aesthetics from colonial ideology and also calling into question her own discipline's canon, which had marginalized such artworks, Nochlin identified the absences and excesses that enabled the European white male artist to paint and frame the Orient for Western contemplation and consumption. So Orientalist painting is marked by an absence of history or change, industrious work by natives, and the looming colonial presence in the Orient, especially the violence visited on the conquered (land). On the other hand, the fleshly native body is displayed in excessive plenitude, typically in settings and postures of lassitude and indulgence, especially as the nude female and the cruel despotic male. Gratuitous attention to redundant architectural details (which added to the "reality effect" of these works) and ethnographic exactitude are other hallmarks of this prolific genre that dominated European attempts pictorially to enframe the Orient.[27]

Nochlin's astute observations today are vulnerable to some of the same criticisms leveled against Said, including the neglect of participation by "Orientals" themselves in Orientalist art-making or of native resistance to such caricatures.[28] As Roger Benjamin persuasively shows in a revealing catalog essay published in 1997, Europe's Orientalist art is very much in demand among collectors of Arab and Turkish origin, who seem to value it because it appears to them to restore a lost past: "The fact that it was Western artists who had the means to record such images is almost incidental from this perspective."[29] Faced with the paradox of the so-called Orientals as assiduous collectors of Orientalist art that apparently demeaned and denigrated them, Benjamin invites us to consider how such acts of repossession of European cultural documents may instead be read as "an assertion of selfhood, and as redressing historical imbalances."[30] Although the Saidian framework adapted by Nochlin does not readily explain such paradoxes, her essay nevertheless inserted the critical new problematic of "visual orientalism" into art historical and colonial studies by inexorably linking art, aesthetics, and colonial power/knowledge, a problematic that has been enormously enabling for those who have written in her wake.[31] Indeed, so enduring is this paradigm shift that a critic of the Saidian approach like John Mackenzie who seeks to undo the connection and return

the art of the imperial age to a realm untouched by colonial politics, ideology, and operations of power seems unconvincing, although his cautionary comments against homogenizing all experiences under the single umbrella of "Orientalism" is important.[32]

The nexus between power, visuality, and the global spread of European empires is also at the heart of Mary Louise Pratt's *Imperial Eyes: Travel Writing and Transculturation* (1992), another work that, although based largely on analyses of the written word, has left its mark on those who write on colonial visual cultures and economies.[33] Like the later Said, whom interestingly she does not invoke, Pratt is concerned with the constitution of "the domestic subject of Euroimperialism"[34] through practices of travel, acts of discovery, and masterful writing. In contrast to *Orientalism*, *Imperial Eyes* includes (brief) analyses of close to forty images drawn from eighteenth- and nineteenth-century travel writings that are a product of the age of mechanical reproduction discussed at greater length in part 2 of section I, "The Mass-Printed Imperium." Such mass-produced prints—and the narratives in which they were embedded—emerge in the "contact zone," social spaces in distant lands away from the metropole where subjects previously separated by geographic and historical disjunctures meet, clash, and grapple with each other, often in highly asymmetrical relations of domination and subordination. Prints like these were the work of a wide-ranging male "imperial eye" that perforce adopted a "monarch-of-all-I survey" stance that anchored nineteenth-century travel narratives. Such "promontory" images of subordinated lands and the peoples who inhabited them—viewed by the imperial eye from a distance or from a safe spot above them—masterfully reordered them as would a painting, appropriating them into European schemes of possession, enjoyment, and desire. In Pratt's analysis, domination and control emerge from such imperial protocols of seeing and gazing (upon). Sight, therefore, is critical to the imperial enterprise that, in her understanding, is a "relation of *mastery* predicated between the seer and the seen."[35]

Although she does not invoke him, Pratt's argument regarding the constitutive capacity of sight and vision in the politics of imperialism recalls the powerfully evocative discussion, indebted to Jean-Paul Sartre, of "the look" and modern subject-formation in Frantz Fanon's *Black Skin, White Masks*.[36] As Robert Stam writes in his essay included in this collection, there has been a tremendous resurgence of scholarly interest in the past few decades in the works of this West Indies–born, French-educated writer who practiced psychotherapy in North Africa in the 1940s and 1950s, and who with

extraordinary prescience anticipated much that is central to cultural studies and postcolonial theory as we know and practice them today. Even Michael Taussig's recent call to pay attention to color as the motor of world and colonial history had already been signaled in Fanon's much-invoked discussion of "the fact of blackness" as the sine qua non of empire.[37] The image-saturated and visually charged vocabulary of his writings makes Fanon a "disturbing" figure for a colonial and postcolonial studies steeped in the world of words and texts. Consider statements such as "All around me the white man . . . All this whiteness that burns me"; or, the black woman "asks for nothing, demands for nothing, except for a little whiteness in her life"; and most iconically, the opening assertion of chapter 5 in *Black Skin, White Masks*, "Look, a Negro."[38] Such inexorable connections that Fanon makes on subject formation triggered by "the look from the place of the Other"[39] in the cauldron of color ("The glances of the other fixed me there, in the sense in which a chemical solution is fixed by a dye . . . Look at the nigger! . . . Mama, a Negro!") enables his writings to "panic" the field of textually driven colonial scholarship, which otherwise takes for granted the power of color and the color of power.

Colonizing Visual Studies

In one of the founding moments of postcolonial critique in 1985, Gayatri Chakravorty Spivak observed: "If . . . we concentrated on documenting and theorizing the itinerary of the consolidation of Europe as sovereign subject, indeed sovereign and subject, then we would produce an alternative historical narrative of the 'worlding' of what is today called 'the Third World.' To think of the Third World as distant cultures, exploited but with rich heritages waiting to be recovered, interpreted and curricularized in English translation helps the emergence of the 'Third World' as a signifier that allows us to forget that 'worlding.'"[40]

Through such a worlding, hitherto uninscribed and uncolonized space is forcefully brought into a world (via activities such as cartographic mapping) that has been essentially constituted around and by the idea of Europe. Spivak's arguments regarding worlding compel us to move even beyond the important conjuncture between operations of colonial power/knowledge and the production of artworks toward which Said and Nochlin take us, by suggesting that colonial violence was not so much the precondition of or pretext for modern visual culture but critically integral to its very making,

for, as Deborah Cherry reminds us, "it was in 'the planned epistemic violence of the imperialist project' that earth was transformed into world, land into landscape."[41] To forget the worlding of the world through the project of imperialism has consequences not just for the way we think about lands and lives outside Europe but for Europe itself and its particularistic experiences writ large as History and Theory.

Fanon, Said, Pratt: we encounter their names and works, although rarely constitutively, in the numerous visual culture anthologies and readers that have proliferated in the academic marketplace since the onset of the so-called visual turn in the human sciences. Despite the massive presence of Europe's imperial project and its aftermath in the very centuries in which metropolitan theorists of the visual and the image issued their authoritative statements, empire is not an organizing idea or argument for most existing published collections or surveys on modernity's visual culture.[42] In 1996, the influential journal *October* published a widely read and much-quoted "Visual Culture Questionnaire." Responses to four questions on the then-emergent cross-disciplinary field of visual culture were invited from a range of art and architecture historians, film theorists, historians, literary critics, and artists, nineteen of which were published. It is telling that not one respondent was a dedicated specialist on the worlds outside Euro-America, even though the questionnaire sought a response to the claim that the new visual studies prepared "subjects for the next stage of globalized capital."[43] With one exception—the historian of art Keith Moxey rightly observed in passing that the assumed universality of European art and aesthetics was critical to the exercise of colonial power—no respondent even commented on the presence of large global empires as one of the constitutive matrixes within which modern visual culture was forged between the sixteenth and twentieth centuries.[44]

This questionnaire is not alone in this regard. Critical theorist W. J. T. Mitchell's 1995 model syllabus on the new visual studies, organized around the rubrics of "signs," "bodies," and "worlds," largely ignores European empire-building as a constitutive phenomenon.[45] The nineteenth century was fundamentally reconstituted by European imperialism at home and abroad and famously inaugurated a global "scramble" for colonies whose consequences we are still living with multiple decades later. Yet the otherwise exemplary *Nineteenth-Century Visual Culture Reader* merely gestures toward the reordering force of this global project.[46] A recent anthology called *Images: A Reader* does not even do this.[47] Two other recent works

that bring together the reflections of key thinkers in this vibrant field of visual studies do not heed scholars whose work has been informed by their engagement with the colonial and the postcolonial.[48] *Critical Terms for Art History*, edited by Robert S. Nelson and Richard Shiff (University of Chicago Press, 1996; 2003) does not include *empire* as one of the critical terms necessary for us to understand "art history." *Art since 1900: Modernism, Antimodernism, and Postmodernism* (Thames & Hudson, 2004) edited by Hal Foster and his colleagues at *October*, has only passing references to Europe's colonial projects and their undoing in the twentieth century and a mere nod toward postcolonial theory. As I hope that the reader will (re)learn from Simon Gikandi's essay on Pablo Picasso's foundational encounter with African art reproduced in this volume, it is impossible to think of modernism, antimodernism, and postmodernism without thinking of Europe's aesthetic confrontation with the Other.[49]

The result of such erasures and silences is that there is now a new visual studies canon in which the historical experience of European visuality is unproblematically taken as universally true and valid, or just as perniciously, it is assumed that there is a distinctive "non-Western" aesthetic that should be a matter of concern for only those who study parts of the world outside of Euro-America. The fundamental reshaping of modern and global visual culture by Europe's encounter with and control over the Other remains massively occluded.[50] Certain themes have become de rigueur—the mechanical reproduction of the image, the society of the spectacle, scopic regimes, the simulacrum, the fetish, and the gaze most notably—yet the colonial roots of such concepts or their postcolonial trajectories have been barely interrogated. In her response to the "Visual Culture Questionnaire" in 1996, Susan Buck-Morss quipped (from a position very much within the U.S. academy), "Visual culture, once a foreigner to the academy, has gotten its green card and is here to stay."[51] *Empires of Vision* is a (gentle) reminder that large numbers of green card holders today hail from former colonies of European empires, and their visual experiences—and theories based on them—are here to stay as well and even to demand equal rights.

Hating Empire's Images Properly

The twin assertion of this volume is therefore that no history of imperialism is complete without heeding the constitutive capacity of visuality, and correspondingly, no history of modern visuality can ignore the constitutive

fact of empire. Images interrupt and realign the flows of a textually driven colonial and postcolonial scholarship; correspondingly, facts of empire and the postcolony disrupt the claims of metropolitan visual culture and image studies: these are the reordering forces at work in this volume.

In making these assertions, this volume benefits hugely from what Mitchell has identified acutely as the "pictorial turn" in the human sciences:

> Whatever the pictorial turn is, then, it should be clear that it is not a return to naive mimesis, copy or correspondence theories of representation, or a renewed metaphysics of pictorial "presence"; it is a rather a post-linguistic, post-semiotic rediscovery of the picture as a complex interplay between visuality, apparatus, institutions, discourses, bodies and figurality. It is the realization that *spectatorship* (the look, the gaze, the glance, the practices of observation, surveillance, and visual pleasure) may be as deep a problem as various forms of *reading* (decipherment, decoding, interpreting, etc.) and that visual experience or "visual literacy" might not be fully explicable on the model of textuality. Most important, it is the realization that while the problem of pictorial representation has always been with us, it presses inescapably now, and with unprecedented force, on every level of culture, from the most refined philosophical speculations to the most vulgar productions of the mass media. Traditional strategies of containment no longer seem inadequate, and the need for a global critique of visual culture seems inescapable.[52]

Yet Mitchell's call for a global critique of visual culture is possible *only* if we think Europe and its (former) colonies together within the same field of inquiry. This is a fact that is especially important to underscore in our "globally post-imperial, endlessly neo-imperial moment."[53] In scrutinizing the work of vision in the age of European empires, which necessarily includes an analysis of the postcolonial aftermath, we ought to be concerned with what a particular art object or visual document might mean in its own times, and as importantly with tracking how it does its work, producing effects in the world that range from power and mastery to desire, ambivalence, and anxiety. Even more insistently, instead of considering a visual practice or an image-maker as merely a means to know something else, be it "empire" or "modernity," "race," or "difference," we ought to be committed to these as objects of knowledge in and of themselves, as world-making and world-disclosing, rather than merely world-mirroring. The essays reproduced here neither naively celebrate empire's visual work nor innocently go about the

task of recuperating it. Instead, they document the contradictions and ambivalences in the very processes by which territorial conquest, settlement, and mastery went hand in hand with ocular possession and ordering.

As Joseph Conrad observed, empire indeed is not a pretty thing when one looks into it too much. Nevertheless, it is important to look deeply and systematically because imperial acts of looking (and being looked at), the technologies for looking and for documenting the observed, and the ever proliferating archives and sites for (re)presenting that-which-has-been-looked-at have continued to endure long after the empires of the industrial age and as formal structures of mastery and control have given way to other (postcolonial) formations. This recognition also drives this volume, underscoring the stakes of what we look at and how we look.[54]

As such, as we look deeply, systematically, and expansively in our postcolonial times, we ought to cultivate an ethic of hating empire's images *properly*.[55] Sunil Agnani from whom I adapt this idea rethinks Theodor Adorno's enigmatic aphorism, "One must have tradition in oneself, to hate it properly," to propose "One must have empire in oneself to hate it properly." For Agnani, hating empire properly entails "entering into its terms and allowing the internal contradictions to be heightened rather than covered over by a political veil." To paraphrase him, hating empire properly is a peculiar combination of an antagonistic relationship to empire, alongside a (tragic?) immersion in it, "a subtle form of inhabitation."[56] This form of subtle inhabitation of antagonism and immersion, of hating and (tragic) loving at the same time, is especially true for our postcolonial encounter with empire's images, many of which remain objects of great beauty and value, much sought after and collected, even (and possibly especially) in the postcolonial world, if we recall Roger Benjamin's work discussed earlier in this essay.[57] Anthropologist Liam Buckley perceptively observes as he reflects on the challenges of working with colonial photographs in the Gambian National Archives today, "If projects of visual design were central to the regulation and presentation of the imperial world, then our encounter with that world was and remains via the medium of visual record. *It was and remains love at first sight*."[58] Paradoxically therefore, although as good postcolonial scholars we may hate empire and with a passion, we fall in love with its images, which we come to study with care and thought, indeed, as Buckley insists, with love. These images undoubtedly "depict times that we no longer love," but nevertheless they "remain loved objects themselves."[59] I may "try to wrest myself from the amorous Image-repertoire: but the

Image-repertoire burns underneath, like an incompletely extinguished peat fire; it catches again; what was renounced reappears; out of the hasty grave suddenly breaks a long cry."[60] This condition of desiring-while-disavowing and disavowing-while-desiring *obliges* us to hate empire's images properly. As Neil Lazarus reminds us in his reading of Adorno's aphorism, "'Properly' . . . does not mark a plea for conformity, orderliness, civility, or good manners. Adorno calls for something far more profoundly ruptural, far less contained, or indeed, containable, than this . . . Adorno wishes us to learn to hate in the right way, rigorously and thoroughly."[61] Agnani pushes this further to suggest that an "improper hating would seem to be an example of that which is purely oppositional, a rejection from an external position." Instead, following Adorno, he calls for a disposition that requires "experience, a historical memory, a fastidious intellect and above all an ample measure of satiety."[62] Following Adorno and Agnani, then, *Empires of Vision*, too, asks for a rigorous and thorough engagement with empire's images with an "ample measure of satiety" and a "loving" immersion in them, so that we may learn to hate them properly.

Notes

1 For the influential concept of scopic regimes, see Martin Jay, "Scopic Regimes of Modernity," in *Force Fields: Between Intellectual History and Cultural Critique* (New York: Routledge, 1992), 114–33; and his concluding essay in this volume. Given the complexity of colonial formations over time and across cultures and spaces, it would be naive to speak of a singular "imperial" or "postcolonial" scopic regime. Nonetheless, it is worth exploring constituent elements and features of such a regime and identify what it might share with the other dominant formations identified by Jay (Cartesian perspectivalism, the art of describing, and the baroque) and what was indeed specific to the colonial condition. Like many of the authors collected in this volume, I share with Nicholas Thomas the foundational understanding that "the dynamics of colonialism cannot be understood if it is assumed that some unitary representation is extended from the metropole and cast across passive spaces, unmediated by perceptions or encounters. Colonial projects are construed, misconstrued, adapted and enacted by actors whose subjectivities are fractured—half here, half there, sometimes disloyal, sometimes almost 'on the side' of the people they patronize and dominate, and against the interests of some metropolitan office" (see Nicholas Thomas, *Colonialism's Culture: Anthropology, Travel and Government*. [Princeton: Princeton University Press, 1994], 60). In spite of its recent appearance (or perhaps because of it), the term *postcolonial* has a more complex (even vexed)

history. Though I use it here in the temporal sense of the aftermath of colonialism following formal decolonization, conceptually it covers projects dedicated to interrogating empire eccentrically, from its margins, and as Edward Said might put it, from the perspective of its victims.

2 Ann Laura Stoler, *Along the Archival Grain: Epistemic Anxieties and Colonial Common Sense* (Princeton: Princeton University Press, 2009), 1. Replete with fascinating images and discursive imagery (in her discussion, for example, of the "watermark" and "the historical negative") this work, however, only addresses the written and textual archive of empire.

3 In this regard, consider Michael Taussig's statement, "Colonial history too must be understood as a spiritual politics in which image-power is an exceedingly valuable resource." Michael Taussig, *Mimesis and Alterity: A Particular History of the Senses* (New York: Routledge, 1993), 177.

4 Gayatri Chakravorty Spivak, "Rani of Sirmur: An Essay in the Reading of the Archives," *History and Theory* 24(3) (1985): 247–72, see p. 253. Although I invoke Spivak, I do so with the recognition that her essay is based on the reading of a verbal archive.

5 Daniel Headrick's much-cited book *Tools of Empire: Technology and European Imperialism in the Nineteenth Century* (New York: Oxford University Press, 1981) ignores the constitutive role of image-making technologies in empire formation, as also noted by Paul Landau ("Empires of the Visual: Photography and Colonial Administration in Africa," in *Images and Empires: Visuality in Colonial and Postcolonial Africa*, ed. Paul S. Landau and Deborah Kaspin [Berkeley: University of California Press, 2002], 141–71). The scholars whose works are reproduced in this volume have played a critical role in correcting this important oversight, as has Duke University Press's important series Object/Histories in which this reader appears.

6 I use the term "subaltern" in its extended sense of the disenfranchised, marginalized, and neglected. Even as I do so, I draw attention to the fact that the Subaltern Studies collective whose scholarship has done so much to transform our understanding of the colonial and postcolonial world has largely ignored images and the visual domain.

7 Edward Said, *Culture and Imperialism* (New York: Vintage Books, 1994), 239–61. See also Rasheed Araeen, "When the Naughty Children of Empire Come Home to Roost," *Third Text* 20(2) (2006): 233–39; and Ian Baucom and Sonya Boyce, *Shades of Black: Assembling Black Arts in 1980s Britain* (Durham: Duke University Press, 2005).

8 I borrow this idea from Gayatri Spivak, who writes that Europe had consolidated itself as "sovereign subject by defining its colonies as 'Others,' even as it constituted them, for purposes of administration and the expansion of markets, into near-images of that very sovereign self" (Spivak, "Rani of Sirmur," 247).

9 Homi Bhabha's formulations regarding hybridity and mimicry and Gayatri Spivak's on worlding have had considerable influence on those who work at

the intersection of visuality and imperialism. Nevertheless, in their theorizing, "'the visual' remains a concept that is actualized in the domain of writing" (Geoff Quilley and Kay Dian Kriz, "Introduction: Visual Culture and the Atlantic World, 1660–1830," in *An Economy of Colour: Visual Culture and the Atlantic World, 1660–1830*, ed. Geoff Quilley and Kay Dian Kriz [Manchester: Manchester University Press, 2003], 1–12, quotation p. 2). For Bhabha's more recent writings on the postcolonial art world and diasporic image practices, see especially Homi Bhabha, "Postmodernism/Postcolonialism," in *Critical Terms for Art History*, ed. Robert Nelson and Richard S. Schiff (Chicago: University of Chicago Press, 2003), 435–51; and "India's Dialogical Modernism: Homi K. Bhabha in Conversation with Susan S. Bean," in *Midnight to the Boom: Painting in India After Independence*, ed. Susan S. Bean (New York: Peabody Essex Museum in Association with Thames & Hudson, 2013), 23–35.

10 Christopher Pinney, *Photos of the Gods: The Printed Image and Political Struggle in India* (New Delhi: Oxford University Press, 2004), 8.

11 I am adapting here from W. J. T. Mitchell, "What Is Visual Culture?," in *Meaning in the Visual Arts: Views from the Outside (A Centennial Commemoration of Erwin Panofsky)*, ed. I. Lavin (Princeton: Institute for Advanced Study, 1995), 207–17, see especially p. 208.

12 Hermione de Alemeida and George H. Gilpin, *Indian Renaissance: British Romantic Art and the Prospect of India* (Aldershot, U.K.: Ashgate Publishing, 2005), 271; W. J. T. Mitchell, *What Do Pictures Want? The Lives and Loves of Images* (Chicago: University of Chicago Press, 2005), 145.

13 Christopher Pinney, "Creole Europe: The Reflection of a Reflection," *Journal of New Zealand Literature* 20 (2003): 125–61; quotation on pp. 127–28. The demonstration of the constitution of modern Europe through its colonial adventures is of course a foundational goal of the postcolonial project. Writing in 1992, Mary Louise Pratt observed, "Borders and all, the entity called Europe was constructed from the outside in as much as from the inside out. . . . While the imperial metropolis tends to understand itself as determining the periphery . . . it habitually blinds itself to the ways in which the periphery determines the metropolis" (Mary Louise Pratt, *Imperial Eyes: Travel Writing and Transculturation* [London: Routledge, 1992], 6). Dipesh Chakrabarty's "provincializing" Europe project has as its agenda the task of displacing "a hyperreal Europe from the center toward which all historical imagination currently gravitates" (Dipesh Chakrabarty, *Provincializing Europe: Postcolonial Thought and Historical Difference* [Princeton: Princeton University Press, 2000], 45). See also Ella Shohat and Robert Stam, "Narrativizing Visual Culture," in *The Visual Culture Reader*, ed. N. Mirzoeff (London: Routledge, 1998), 27–49, esp. pp. 29–30.

14 Rodolphe Gasché, *Europe, or The Infinite Task: A Study of a Philosophical Concept* (Stanford, CA: Stanford University Press, 2009), and Manuela Ribeiro Sanches, Fernando Clara, João Ferreira Duarte, and Leonor Pires Martins, eds., *Europe in Black and White: Immigration, Race and Identity in the "Old Continent"*

(Chicago: University of Chicago Press, 2011). See also Martin Jay's concluding essay in this volume.

15 Barbara Maria Stafford, *Good Looking: Essays on the Virtue of Images* (Cambridge, MA: MIT Press, 1995), 5, 11–12. See also Martin Jay, *Downcast Eyes: The Denigration of Vision in Twentieth-Century French Thought* (Berkeley: University of California Press, 1994).

16 On "the virtue" of images, see Stafford, *Good Looking*.

17 I borrow and adapt this argument from Roland Barthes via Christopher Pinney. See Christopher Pinney, *The Coming of Photography in India* (London: British Library, 2008), 5. Among pioneering scholars who early on "interrupted" via the image the textualist preoccupations of colonial studies, Bernard Smith, especially his *European Vision and the South Pacific* must be singled out (1960; New Haven, CT: Yale University Press, 1985). In this and other works, Smith demonstrated how since the eighteenth century, the Pacific Ocean and its various landmasses came to be visually constituted through the image work of explorers, scientists, and artists (both metropolitan and native) across a range of visual media, including scientific illustration and the travel narratives. Several early volumes in John Mackenzie's *Studies in Imperialism* series (published by Manchester Press) should also be mentioned in this regard. Over the past decade, the number of monographs, edited volumes, and journal articles on this subject have dramatically increased. I especially draw the reader's attention to the following collections that serve as good introductions to the key debates: Catherine B. Asher and Thomas R. Metcalf, eds., *Perceptions of South Asia's Visual Past* (New Delhi: American Institute of Indian Studies, 1994); Paul S. Landau and Deborah Kaspin, eds., *Images and Empires: Visuality in Colonial and Postcolonial Africa* (Berkeley: University of California Press, 2002); T. J. Barringer, Geoff Quilley, and Douglas Fordham, eds., *Art and the British Empire* (Manchester: Manchester University Press, 2007); Quilley and Kriz, *An Economy of Colour*; and Volker M. Langbehn, ed., *German Colonialism, Visual Culture and Modern Memory* (London: Routledge, 2010). For an introduction to the visual culture of "the end of empire," see especially Simon Faulkner and Anandi Ramamurthy, *Visual Culture and Decolonisation in Britain* (London: Ashgate, 2006).

18 W. J. T. Mitchell, "The Panic of the Visual: A Conversation with Edward W. Said," in *Edward Said and the Work of the Critic: Speaking Truth to Power*, ed. Paul A. Bové (Durham: Duke University Press, 2000), 31–50, see esp. pp. 31–32.

19 James Elkins, *On Pictures and the Words That Fail Them* (Cambridge: Cambridge University Press, 1998). See especially pp. 241–66 for a discussion of "the unrepresentable," "the unpicturable," "the inconceivable," and "the unseeable."

20 Walter Benjamin, "Theses on the Philosophy of History," [1940] in *Illuminations: Essays and Reflections*, ed. Hannah Arendt (New York: Schocken, 1985), 253–64; quotations on p. 255.

21 Many critics have puzzled over the absence of attention to images in the work

of a scholar who has written so much on the connection between power, visu-ality, and spatiality. For example, Derek Gregory, "Orientalism Re-Viewed," *History Workshop Journal* 44 (Autumn 1997): 269–78, 273; and Edmund Burke and David Prochaska, "Introduction: Orientalism from Postcolonial Theory to World Theory," in *Genealogies of Orientalism: History, Theory, Politics*, ed. E. Burke and D. Prochaska (Lincoln: University of Nebraska Press, 2008), 1–74, 33. The cover illustration for the paperback version of *Orientalism* (1979) is a detail from Jean-Léon Gérôme's *Les charmeurs des serpents* (circa 1880), a classic example of French Orientalism. Neither the artist nor the painting is ana-lyzed by Said, leading the reader to wonder "whether this seductively symbolic packaging is of the author's or publisher's choosing" (Daniel Martin Varisco, *Reading Orientalism: Said and the Unsaid* [Seattle: University of Washington Press, 2007], 24–25). This is also the case with the striking image that adorns the Random House paperback version of *Culture and Imperialism* (1994), Henri Rousseau's *The Representatives of the Foreign Powers, Coming to Hail the Republic as a Token of Peace* (1907). Reprints of both *Orientalism* and *Culture and Imperi-alism* feature other striking cover images. At the very least, such book covers, when left unaccompanied by explanations or justifications for their choice, raise the issue of images being taken out of context and mobilized in new circuits of consumption that range from voyeurism to bafflement.

22 Saloni Mathur, *India by Design: Colonial History and Cultural Display* (Berkeley: University of California Press, 2007), 7.

23 Said, *Culture and Imperialism*, 32.

24 Said, *Culture and Imperialism*, 18; see also pp. 31–43.

25 Linda Nochlin, "The Imaginary Orient," *Art in America* 71 (1983): 118–31, 186–89; subsequently, the essay was reprinted in Linda Nochlin, *The Politics of Vision: Essays on Nineteenth-Century Art and Society* (New York: Harper and Row, 1989), 33–60. Nochlin notes that although the insights offered by Said's *Orientalism* are central to her arguments, "Said's book does not deal with the visual arts at all" ("Imaginary Orient," n. 3). For some other reevaluations of colonial art and aesthetics, published soon after in response to *Orientalism*, see Olivier Richon, "Representation, the Despot, and the Harem: Some Ques-tions around an Academic Orientalist Painting by Lecomte-de-Nouy (1885)," in *Europe and its Other*, ed. F. Barker (Colchester: University of Sussex Press, 1985), 1:1–13; James Thompson, *The East: Imagined, Experienced, Remembered: Orientalist Nineteenth Century Painting* (Dublin: National Gallery of Ireland, 1988); Asher and Metcalf, *Perceptions of South Asia's Visual Past*; and *The Lure of the East: British Orientalist Painting*, ed. Nicholas Tromans (New Haven: Yale University Press, 2008).

26 Nochlin, "Imaginary Orient," 119. The exhibition was on display in museums at the University of Rochester and State University of New York in late 1982.

27 I borrow the notion of enframing from Martin Heidegger, "The Age of the World Picture," in *The Question Concerning Technology and Other Essays* (New

York: Garland 1977), 115–54. For a pioneering use of this concept in a colonial context, see Timothy Mitchell, *Colonising Egypt* (Berkeley: University of California Press, 1988). Building on Nochlin, Olivier Richon characterizes French Orientalist art as fundamentally a creation of nineteenth-century imperialism ("Representation, the Despot, and the Harem," 2). See also Darcy Grimaldo Grigsby, *Extremities: Painting Empire in Post-Revolutionary France* (London: Yale University Press, 2002); and Roger Benjamin, *Orientalist Aesthetics: Art, Colonialism, and French North Africa, 1880–1930* (Berkeley: University of California Press, 2003).

28 For a sustained criticism of Nochlin's approach, see especially John MacKenzie, *Orientalism: History, Theory and the Arts* (Manchester: Manchester University Press, 1995), 45 ff. For post-Saidian attempts to "disturb" the neat divisions of Orientalism's "imaginative geography," see especially Jill Beaulieu and Mary Roberts, eds., *Orientalism's Interlocutors: Painting, Architecture, Photography* (Durham: Duke University Press, 2002).

29 Roger Benjamin, "Post-Colonial Taste: Non-Western Markets for Orientalist Art," in *Orientalism: From Delacroix to Klee (Exhibition Catalogue)* (Sydney: Art Gallery of New South Wales, 1997), 32–40; quotation on p. 33. See also Krista Thompson's essay in this volume.

30 Benjamin, "Post-Colonial Taste."

31 Burke and Prochaska, "Introduction," 34.

32 Insisting that European creative arts acted "in counterpoint rather then conformity" to imperial ideologies, Mackenzie writes, "there is little evidence of a necessary coherence between the imposition of direct imperial rule and the visual arts" (Mackenzie, *Orientalism*, 14–15). Statements like these are unfortunate, because studies published in Mackenzie's pioneering series *Studies in Imperialism* from Manchester University Press, have helped lay the groundwork for the burgeoning scholarship on empire and visual culture. For a useful discussion that compares Said's and Mackenzie's approaches, see Gregory, "Orientalism Re-viewed."

33 A second edition with a new preface was published by Routledge in 2008.

34 This is a term that she borrowed from Spivak (Pratt, *Imperial Eyes*, 4).

35 Pratt, *Imperial Eyes*, 204, emphasis in original. For a recent fascinating analysis of how such visual "mastery" over and surveillance of native terrains was further consolidated with the spread of colonial aviation, see Federico Caprotti, "Visuality, Hybridity, and Colonialism: Imagining Ethiopia through Colonial Aviation, 1935–1940," *Annals of the Association of American Geographers* 101(2) (2011): 380–403.

36 Originally published in French as *Peau Noire, Masques Blancs* (1952), this pioneering work was translated into English in 1967.

37 Arguing that the Western experience of colonization is the experience of "colored Otherness," Taussig evocatively characterizes the past four centuries as "the layered history of Western expansion into the lands of colored people,

home to all manner of bright colors and wondrous varnishes" (Michael Taussig, *What Color Is the Sacred?* [Chicago: University of Chicago Press, 2009], 160). This expansion (and the fantasies that nurtured it) "effectively divided the world into chromophobes and chromophiliacs" (16).

38 Frantz Fanon, *Black Skin, White Masks* (New York: Grove Press, 1967), 114, 42, 109. I have benefited here especially from the analysis of Fanon's phenomenology of the racial look in Bill Schwarz, "Afterword: 'Ways of Seeing,'" in *Visual Culture and Decolonisation in Britain*, ed. Simon Faulkner and Anandi Ramamurthy (London: Ashgate, 2006), 263–70.

39 Stuart Hall, "The After-life of Frantz Fanon," in *The Fact of Blackness: Frantz Fanon and Visual Representation*, ed. Alan Read (London: Institute of Contemporary Arts, 1996), 13–37.

40 Spivak, "Rani of Simur," 247. In formulating this argument, Spivak built on Martin Heidegger's essay on the origins of the work of art.

41 Deborah Cherry, "Earth into World, Land into Landscape: The 'Worlding' of Algeria in Nineteenth-Century British Feminism," in *Orientalism's Interlocutors: Painting, Architecture, Photography*, ed. J. Beaulieu and M. Roberts (Durham: Duke University Press, 2002), 103–30, quotation from pp. 106–7.

42 An exception here are the two editions of Nicholas Mirzoeff's *The Visual Culture Reader* (Routledge, 1998, 2002), which excerpted landmark essays by such leading figures as Malek Alloula, Anne McClintock, and Timothy Mitchell, who wrote at the intersection of visuality and colonialism, even while noting (in 1998) that the field was still very emergent (a third edition was released in 2012). Soon after the publication of the first edition of Mirzoeff's volume, Sage published *Visual Culture: A Reader*, edited by Jessica Evans and Stuart Hall (1999; subsequently reprinted). Although this volume incorporates valuable pieces by Fanon, Pratt, and Bhabha, clearly colonialism or empire formation is not an organizing concern.

43 "Visual Culture Questionnaire," *October* 77 (Summer 1996): 25–70; quotation on p. 25.

44 "Visual Culture Questionnaire," 58.

45 Mitchell, "What Is Visual Culture?," 210–14. The occlusion of the colonial question in this syllabus is especially noteworthy given Mitchell's important reflections on the relationship between landscape painting and European imperialism (W. J. T. Mitchell, "Imperial Landscape," in *Landscape and Power*, ed. W. J. T. Mitchell [Chicago: University of Chicago Press, 1994], 5–34). See also his argument that "art" and "aesthetics" emerged as critical categories in the age of colonial encounters in W. J. T. Mitchell, "Empire and Objecthood," in *What Do Pictures Want?*, 145–68.

46 Vanessa R. Schwartz and Jeannene M. Przyblyski, ed., *The Nineteenth-Century Visual Culture Reader* (New York: Routledge, 2004).

47 Sunil Manghani, Arthur Piper, and Jon Simons, ed., *Images: A Reader* (London: Sage, 2006).

48 Margarita Dikovitskaya, *Visual Culture: The Study of the Visual after the Cultural Turn* (Cambridge, MA: MIT Press, 2005); Marquard Smith, *Visual Culture Studies: Interviews with Key Thinkers* (Los Angeles: Sage, 2008).

49 Stuart Hall observes as well, "The world is . . . littered by modernities and by practicing artists, who never regarded modernism as the secure possession of the West, but perceived it as a language which was both open to them but which they would have to transform" (Stuart Hall, "Museums of Modern Art and the End of History," in *Modernity and Difference*, ed. S. Hall and S. Maharaj [London: Institute of International Visual Arts, 2001], 19). See also in this regard Said, *Culture and Imperialism*, 242–43, and Sieglinde Lemke, "Picasso's 'Dusty Manikins,'" in *Primitivist Modernism: Black Culture and the Origins of Transatlantic Modernism* (Oxford: Oxford University Press, 1998), 31–58.

50 Ella Shohat and Robert Stam make this point even more trenchantly: "Europe thus appropriated the material and cultural production of non-Europeans while denying both their achievements and its own appropriation, thus consolidating its sense of self and glorifying its own cultural anthropophagy" ("Narrativizing Visual Culture," 28).

51 "Visual Culture Questionnaire," 29–30.

52 W. J. T. Mitchell, *Picture Theory: Essays on Visual and Verbal Representation* (Chicago: University of Chicago Press, 1994), 16 (emphases in original).

53. I am grateful to an anonymous reviewer of an earlier draft of this introduction, who I quote.

54 For an eloquent defense of "looking at" rather than "looking through" images, see Michael Gaudio, *Engraving the Savage: The New World and Techniques of Civilization* (Minneapolis: University of Minnesota Press, 2008).

55 Sunil Agnani, *Hating Empire Properly: The Two Indies and the Limits of Enlightenment Anticolonialism* (New York: Fordham University Press, 2013).

56 Agnani, *Hating Empire Properly*, 186–87. Agnani also refers to Neil Lazarus's critique of Adorno's aphorism in which he clarifies, "to hate tradition properly is rather to mobilize its own protocols, procedures, and interior logic against it—to demonstrate that it is only on the basis of a project that exceeds its own horizons or self-consciousness that tradition can possibly be imagined redeeming its own pledges" (Neil Lazarus, "Hating Tradition Properly," *New Formations* 38 [1999]: 9–30; quotation on p. 13).

57 See also Krista Thompson in this volume.

58 Liam Buckley, "Objects of Love and Decay: Colonial Photographs in a Postcolonial Archive," *Cultural Anthropology* 20(2) (2005): 249–70; quotation on p. 265, emphasis added.

59 Buckley, "Objects of Love and Decay," 265. Correspondingly, our discourse about them, "a lover's discourse," betrays "our feelings for, and intimacy with, colonial culture" (250). See also British filmmaker Isaac Julien's observation, "I also wonder about the kind of murky question of our attraction to these images—this question of having perhaps a critical nostalgia, the fact that some

of these images are in fact quite beautiful, some of them are very disturbing, and this kind of surplus identification that comes about when looking at these images" (Isaac Julien, "Undoing the Colonial Archive," in *Film and the End of Empire*, ed. Lee Grieveson and Colin MacCabe (London: Palgrave Macmillan, 2011), 273–75, quotation on p. 274.

60 Roland Barthes, quoted in Buckley, "Objects of Love and Decay," 249.

61 Lazarus, "Hating Tradition Properly," 12, 13.

62 Agnani, "Hating Empire Properly," 183–84.

The Imperial Optic

Martin Jay and Sumathi Ramaswamy

Easel painting, mechanically reproduced and printed illustrations, maps of territory underwritten by the evolving protocols of "scientific" cartography, the camera and still photography, and the moving picture. These are among the many new image-making technologies whose arrival and careers in the colony are charted by the essays reproduced in this section, as they explore whether such technologies and their associated practices inaugurated and consolidated a fundamental reorganization of vision in areas outside Europe, as they did arguably in the metropole. Collectively and individually, these essays move us beyond reductionist and instrumentalist understandings of images as tools of control and assertions of dominance to suggest a more complex terrain of desire, ambivalence, anxiety, self-doubt, and pleasure in which master and native found themselves mutually entangled.

These selections address many other aspects of the mutually constitutive relationship between empire and image-work. First, they help us understand the nature of the colonial visual economy that emerged around such technologies and within which they functioned, even as they transformed its terms and conditions. We borrow the concept of visual economy from anthropologist Deborah Poole's valuable ethnography of postcolonial Andean photography. Though not dispensing with the concept of "visual culture," which she concedes serves well in conveying a sense of "the shared meanings and symbolic codes that can create communities of people," Poole argues that the analytic of visual economy more productively enables us to show that "the field of vision is organized in some systematic way. It also clearly suggests that this organization has as much to do with social relationships,

inequality, and power as with shared meanings and community."[1] Indeed, as many of the essays in this section reveal, meanings accrue as well as mutate when art objects and images (were) moved across imperial boundaries, came to inhabit varied spaces, and often were put to unintended uses. As such, we are more interested in tracking routes of travel than searching for roots of origin, as we follow the itineraries and peregrinations of specific works, practices, and technologies. The concept of visual economy also enables us to place at the forefront of our discussion issues of production, circulation, and consumption, which imbue the image with a more dynamic history and with sheer material presence in the world, as well as compelling us to follow such movements on a global scale.

Not least, the concept of visual economy allows us to highlight another key heuristic concept that has received much recent attention, variously referred to as *inter-ocularity*, *inter-visuality*, and *inter-iconicity*. As Jonathan Crary documents in his *Techniques of the Observer*, a distinguishing feature of visual modernity or modern visuality as it came to be consolidated in the nineteenth century is "a proliferating range of optical and sensory experiences," enabled by the numerous technological innovations of the industrial age. A modern viewer of any image—be it an oil painting, a black-and-white photograph, or in today's digital age, a computer-generated graphic—looks on it "not in some impossible kind of aesthetic isolation . . . but as one of many consumable and fleeting elements within an expanding chaos of images, commodities, and stimulation." As a result, no visual form—or image-world—has a singular autonomous identity to which a potential viewer brings to bear a singular eye or perceptual memory. Instead, "the meanings and effects of any single image are always adjacent to this overloaded and plural sensory environment and to the observer who inhabit[s] it."[2] In making this argument, Crary built on Walter Benjamin's discussion in his Arcades project of the new dream-spaces of industrial age Paris through which the viewer-as-*flâneur* saunters, peppered with department stores, botanical gardens, museums, railway stations, and panoramas, not to mention the new forms of lighting and technologies of illumination following the introduction of electricity.[3]

Writing around the same time as Crary and on the basis of an argument derived from observing the work of vision in the new public culture constituted by and around museums, television, cinema, sports, and tourism in postcolonial South Asia, the anthropologist Arjun Appadurai and the historian Carol Breckenridge observed in 1992 that:

Each of these sites and modes offers new settings for the development of a contemporary public gaze in Indian life. The gaze of Indian viewers in museums is certainly caught up in what we would call this inter-ocular field (the allusion here, of course, is to inter-textuality, as the concept is used by the Russian literary theorist Mikhail Bakhtin). This inter-ocular field is structured so that each site or setting for the disciplining of the public gaze is to some degree affected by the viewer's experiences of the other sites. This interweaving of ocular experiences, which also subsumes the substantive transfer of meanings, scripts, and symbols from one site to another in surprising ways, is the critical feature of the cultural field within which museum viewing in contemporary India needs to be located.[4]

Historicizing this insight about inter-ocularity, Christopher Pinney subsequently pointed to the distinctive aesthetic that emerged in late colonial India in the first few years of the twentieth century when "many different media—photography, theatre, chromolithography, and film—were all working together, and cross-referencing each other."[5] Concurrently, writing about diasporic visual culture, Nicholas Mirzoeff proposed the related concept of inter-visuality to refer to "interacting and inter-dependent modes of visuality."[6] In imperial contexts, where rival aesthetic regimes as well as new technologies for producing images and for seeing jostle for prominence at a time when European power and privilege operated to dismiss or appropriate older or alternate image practices, the concept of inter-ocularity/visuality is particularly useful in tracking how incoming "colonial" practices ally with or disrupt more established ones, trigger prior associations, catalyze submerged memories, render the unfamiliar recognizable, and frequently reconfigure the recognizable.

The concept of inter-ocularity also allows us to place the humblest postcard or the ubiquitous product advertisement within the same analytic field as the grand history painting, because it enables us to show how "earlier images . . . are forever waiting to erupt in the present as they continually migrate, moving in and out of new times and changing political contexts."[7] Indeed, the very persistence of older (and in some cases, more familiar) modes of viewing alongside new ones being ushered in with new image-making technologies makes colonial and postcolonial visual regimes such fecund sites for the emergence of hybrid image-formations and protocols of seeing. Despite the many statements in the official archives of the colonial state sys-

tems about the native's utter fascination-to-the-point-of-adulation with the new technologies of painting, printing, mapping, photographing, or filming that arrived in the colonies, there is considerable evidence that none of these forms were taken on board simply through straightforward copying and passive reproduction of the European norm.[8] In any case, after Homi Bhabha and Michael Taussig, we have learned to think of mimicry in the colonies as being anything but acquiescent and harmless, free of menace or mockery.[9] At the same time, such new technologies did bring in novel practices—such as perspective and realist illusion, or canvas-and-easel painting with oils—that facilitated what Serge Gruzinksi has characterized as "conquest via the image."[10] These pictorial or visual conquests inaugurated novel protocols of seeing illuminated by the chapters in this section—such as the illusionist, the picturesque, the cartographic, the panoramic, and the exhibitionary—even as they examine the modes of resisting these dominant modalities through a resort to the corpothetic,[11] the idolatrous, and the antirealist.

Empires of the Palette

It is clear from numerous studies that the progressive European conquest of Earth provided crucial employment for an army of painters, portraitists, and other visual artists from the metropole, who descended on the colony to peddle their new and prestigious representational practices, especially oil portraiture. We begin this section with essays that urge us to consider the part played by practices associated with paint and pigment—in their sheer materiality—in the new visual order that emerged around empire-building, although there was no straightforward reproduction of these practices in the periphery and, indeed, some serious (and some comic) cases of undoing. The colonies, as we learn from the essays in part 1 of this section, provided not only visual inspiration and motifs but all too often the very stuff—such as Indian yellow—that was used in metropolitan high art.[12]

In historian Serge Gruzinski's discussion, abstracted from his important monograph *Images at War: Mexico from Columbus to Blade Runner, 1492–2019*, in which he argues provocatively that "the war over images is as important as ones over oil,"[13] the Spanish territorial conquest of Mexico in the sixteenth century proceeded apace with "the conquering grasp of the Western image," as this grasp took the form of northern European painted

canvases, and especially illustrated books and Christian engravings (which transformed the singular into the multiple) that invaded the Indian *imaginaire*.[14] Territorial and spiritual conquest went hand in hand with a painterly assault that confronted the Indian with "walls of images." Although the new visual order might have been backed by the Renaissance "discovery" of perspective and command of realist illusion, these wondrous European norms were frequently undone in the New World so that even a century later they were "poorly mastered," sacred meanings remained elusive, and the Christian image risked becoming native idol. All the same, the invaders' images "only foreshadowed other invasions that would perturb the visual habits of these peoples over and again."

If the ships of Hernán Cortés's successors came over loaded with paintings, engravings, and images, the vessels returning home also were similarly burdened. Pictures often received the most attention when the crates were unpacked in historian Daniela Bleichmar's account of the Spanish physician José Celestino Mutis (1732–1809) and his Royal Botanical Expedition to the New Kingdom of Granada (1783–1810). In the evolving science of natural history that she documents for the eighteenth-century Spanish empire in the New World, Bleichmar argues that seeing and painting, art and science were intimately connected to knowing, possessing, and owning. Painted images at the nexus of this connection were "instruments of persuasion" that lubricated the machinery of metropolitan science. "Images preserved and transported the distant." They came to stand (in) for the actual American plants, flowers, and leaves that European scientists could not hold in their own hands, thus promoting "long-distance knowing by seeing." Bleichmar's essay (like several others in this volume) also reminds us that the so-called imperial optic is not solely the product of the European eye and hand, but that native artists, craftsmen, and assistants also actively shaped its contours and terms.[15] Mutis's workshop, mostly constituted by native-born artists, produced a distinct "American" style for botanical illustrations that exceeded in critical regards the European models on which they were based, as he himself was quick to declare proudly.

If Bleichmar's account leads us into the hybrid representational practices put in place in the eighteenth-century New Granada ateliers where Mutis trained "American" artists in the novel science of botanical illustration, the historian of modern Britain Jordana Bailkin asks us to consider the sheer materiality of the matter out of which such visions are conjured up in her

intriguing account of one particular pigment, Indian yellow, whose addition to the European color palette she traces to the new metropolitan taste for painting brown flesh. As she follows the itinerary of this pigment from its manufacture out of the urine of cows raised on mango leaves in colonial India to the palette of British artists over the course of the later eighteenth and nineteenth centuries, Bailkin also reflects on the visual culture of race, wondering "was it possible for race to exist in *paint* in a different way than it did in colonial law or science?"[16] As European empires expanded overseas from the eighteenth century on, the artist's palette expanded as well, as exotic colors such as gamboge, ultramarine, celadon green, and indigo, flowed into the metropole.[17] "The centrality of art in colonial encounters," she argues, "is evident not only on finished canvases, but in the negotiations that preceded them in order to acquire *the stuff of art* itself. Some of the most basic elements of artistic production were themselves products of colonial engagement." In so arguing, Bailkin, as others in this volume do, moves beyond a focus on representation and production of meaning to study the work of an image or a pictorial practice in its gross materiality and ontological autonomy, some even asking, inspired by W. J. T. Mitchell, what the image or picture wants.[18]

The role of easel and topographic painting in pictorially delivering the colonies to the metropole on a spectacular scale is the subject of Australia-based French art historian Roger Benjamin's nuanced analysis of colonial "panoramania," which we have extracted from his monograph *Orientalist Aesthetics: Art, Colonialism, and French North Africa, 1880–1930*. Benjamin's neologism *panoramania* seeks to capture the huge enthusiasm for the vast circular paintings and murals that adorned the inside walls of colonial pavilions in the numerous universal expositions of the later nineteenth and early twentieth centuries that are symptomatic of modernity's exhibitionary complex.[19] These gigantic works took easel painting outside the limited sphere of the urban salon to vast expositions in which millions of French viewers were provided with "all-embracing views" of their far-away possessions, albeit only temporarily. With such material demonstration on walls and built surfaces, the empire of the palette reached a spectacular new scale, with spectators transported through the power of panoramic illusionism and simulacra to colonial situations "with an unrivaled sensory intensity" that necessarily needed new modalities of seeing. Benjamin argues that in the decades when panoramas and dioramas thrived as a visual form before

the industrialization of photography and the arrival of cinema, painting's capacity to reproduce the world mimetically was harnessed in such mass spectacles that enabled the generation of popular enthusiasm in the metropole for the project of overseas empire.

The Mass-Printed Imperium

Such arguments connecting paint to empire-building notwithstanding, the average native in lands far away from the metropole was more likely to encounter the European image and visions of self and the world through printed proxies and surrogates rather than the painted canvas.[20] Indeed, the historical conjuncture between what Elizabeth Eisenstein has identified as the printing revolution in early modern Europe and the inauguration of that continent's overseas adventures is hard to overlook, although her pioneering work did not explore this connection.[21] The obverse, even dark, side of Benedict Anderson's argument regarding print capitalism is print colonialism, "whereby the diverse colonial territories become abridged and contiguous at the turn of a page."[22] The mass-produced printed image that disseminated across the far reaches of these global empires range from monochromatic engravings of the early modern period that Serge Gruzinski flags for our attention in the excerpt included in this volume to lithographs and chromolithographs, the illustrated book and magazine, cartoons and caricatures, and (not least) the printed advertisement visually lubricating the engines of colonial commerce after the onset of industrialization of print, on which others in this volume focus.

As anthropologist Nicholas Thomas observes in a discussion that takes us into the "mass-printed imperium" (part 2 of this section), the humble but ubiquitous printed image—dismissed until recently as derivative and inconsequential, thus confined to a scholarly "wilderness beyond critical vision"—needs to be taken seriously as a cultural product that had a consequential career as both a visual and a material presence in (post)colonial life-worlds. Extracted from a longer essay in which he goes on to explore the cultural politics of risk, Thomas's selection here offers a historical analysis of eighteenth-century European prints of exotic ethnographic implements, ornaments, and weapons from Oceania, which he reads as "somewhat opaque images that attest more to insecurity than to mastery, and to a disputed knowledge of the exotic." In particular, his work persuades us to

attend to pictorial strategies of decontextualization, through which such objects are abstracted from human use and purposes as they are transferred and translated to print. Discursively evacuated of meaning, the stage is prepared for the subsequent transformation of such objects into dehumanized "curiosities" to be collected, commoditized, and displayed in museums, exhibitions, and other metropolitan sites far away from their former life-worlds of use and affect in distant reaches of empire.

From historian of art Natasha Eaton's essay on the fate of European prints as they travel in the reverse direction (from the metropole to the colony), we learn that such objects can also become "colonial companions, while simultaneously exacerbating nostalgia" for home among British residents in late eighteenth-century Calcutta. As such, colonial emporia are stocked with these newly auraticized things that are signs of "uncertain, extravagant, desperate living" in what we might call, following Joseph Conrad, Europe's outposts of progress. Discarded by the European as he or she departs for home and relegated to the rubbish heap of colonial history, such prints found unusual new "tropicalized" lives on the walls and in the living rooms of new Indian patrons, at whose hands their meanings and uses are "de-formed." As with many others in this volume, Eaton invites us to consider the very thingness of these prints as they assume a quasi-fetishistic stature, regardless of the representational work they do as "English" art in the colony.

Another manifestation of what Eaton characterizes as "the aesthetic of the ephemeral" is the ubiquitous commodity advertisement featuring colonial products that was the subject of a landmark essay by Anne McClintock in 1995.[23] In a response to that essay, historian David Ciarlo, whose analysis of German advertisements from the late nineteenth and early twentieth centuries is included in this section, observes that "visual provocations" such as advertisements do not merely reflect colonial ideology but in fact opportunistically created racialized visions of empire.[24] The circulation of such ads generated a "new visual field" that also entailed "a new way of seeing and behaving," although this "empire of fantasy" far exceeded the German colonial enterprise on the ground that was in fact largely circumscribed. Ciarlo asks us to consider advertising as a generative force in its own right, a pictorial provocation that might have aided the German state and public toward imperial aspirations, short-lived and truncated though these were in reality (although not for want of trying).

Mapping, Claiming, Reclaiming

Nicholas Thomas urges us to take printed images seriously not only because their mass production allowed them to saturate the world materially and visually but also because "some kinds of prints were taken as peculiarly objective representational truths." Paradigmatic of such prints are maps of territory that begin to proliferate from the early modern period, backed by the new and increasingly influential practices of cartography, which progressively mutated from art to science as the world came to be subjected to what Terry Smith (in his essay in this volume) has referred to as "the measuring eye." At the height of the scramble for colonies in the late nineteenth century, Lord Salisbury, prime minister of the tiny island nation in the northern Atlantic that led the pack, observed (possibly in a rare moment of anxious reflection on this matter), "We have been engaged in drawing lines on maps where no white man's foot ever trod; we have been giving away mountains and lakes and rivers to each other, only hindered by the small impediment that we never knew exactly where the rivers, mountains, and lakes were."[25] Indeed, the "worlding" of Earth into a geocoded realm of dots and dashes, lines and contours is one of the most consequential outcomes of the unholy alliance between science and empire that the essays in part 3, titled "Mapping, Claiming, Reclaiming," detail for us.[26] Paraphrasing Martin Heidegger, we might argue that the fundamental event of the modern age is the conquest of the world as map, resulting in the staging of Earth on a piece of paper before one's eye as an enframed whole that can be ordered, secured, rendered knowable, and ultimately masterable.[27] Notwithstanding the intriguing reflections of the likes of Jorge Luis Borges and Umberto Eco on the absurdity that propels the hubris of drawing the perfect map of the empire, every fraction of which is rendered visible to the Master's Eye,[28] the scientific map form is exemplary of what Donna Haraway has called "the god-trick of seeing everything from nowhere."[29] In Benedict Anderson's memorable words from *Imagined Communities*, as Europe fanned out from the confines of its own continent, "triangulation by triangulation, war by war, treaty by treaty, the alignment of map and power proceeded."[30] As historians of cartography who write under the influence of J. B. Harley's pioneering scholarship have documented, this god-trick frequently preceded the messy fact of empire, as maps were first used to claim lands and resources on parchment and paper for European powers well before they were effectively occupied by colonizing bodies and presences.[31]

The selections we have chosen to advance our understanding of this nexus between the emergent science of cartography and the bloody business of empire are drawn from the early Spanish, Dutch, and British empire-building projects. Literary critic Ricardo Padrón takes us back to a time before a unified science of cartography had emerged in Western Europe to standardize representations of space and considers "way-finding" artifacts such as Spanish itinerary maps, nautical charts, and finding guides, which privileged linear distance over abstract space. He thus complicates "the story of territorialization so central to the 1492 Encounter" by demonstrating that sixteenth-century Spanish maps were themselves in the process of transiting from a spatial imaginary rooted in embodied travel to one that came to be governed by the geometric rationalizations of scientific cartography, even as they confronted the contrary Amerindian conceptions of territory that Walter Mignolo, Barbara Mundy, and others have brought to our attention.[32] An important reminder we receive from Padrón's essay is that heterogeneous ways of drawing and representing space and place were overwhelmed—alongside the consolidation of nation-states in Europe and their colonies elsewhere—by the more or less homogeneous gridded abstractions of scientific cartography.

In Padrón's account, early modern Spain had a good amount of catching up to do in the world of early modern cartographic science, the masters of which were clearly the Dutch, the preeminent mapmakers of Europe. Historian Benjamin Schmidt tracks "the explosion" of geographical objects from the Dutch Republic in the later seventeenth and early eighteenth centuries as witnessed in an array of lavish maps, dazzling globes, and sumptuous atlases that were much sought after in and of themselves, if not for the territories they mapped so beautifully. Rather than the straightforward collusion between cartography and empire we have learned to expect, Schmidt paradoxically suggests that even and especially as Dutch imperial adventures begin to peter out, their geographical production and cartographic reproduction of the world moved ahead in leaps and bounds. "The Republic was becoming less and less engaged in conquering the world as it became more and more vested in describing it," he argues, almost as if the conquest of the world on paper was much more rewarding than "real" empire for the Dutch. In this account, the Dutch views of the world came to prevail despite no longer participating in world conquest, as they became the principal vendors of cartographic products in Europe.

In contrast, in art historian and art critic Terry Smith's account of the

British "settling" of Australia, the violent conquest of land—and the "obliteration" of earlier inhabitants—was all too real in the closing years of the eighteenth century and for much of the nineteenth century. The visual regime of colonization, he proposes, is the triangulation of three processes he names "calibration," "obliteration," and "symbolization" or "aestheticization." Through such processes, land was measured, mapped, and "ordered"; the natives rendered invisible; and the whole then incorporated into the very English idiom of "the picturesque," which was then deployed back in the metropole in pretty pictures used to persuade white settlers to move out to distant places.[33] In contrast to such metropolitan practices that the English settler-artist imposed on the land, Australian Aboriginal imagination about that very land is neither measured nor calibrated. Instead, it is "a visual provocation" to ceremonial song and the telling of elaborate narratives that demonstrate an affective bond with land, rather than an imperializing command over it. Anticipating some of the arguments of the next section, Smith's essay alerts us to how postcolonial Aboriginal "murmuring" and "mark-making" as it finds artistic expression in artworks such as *Warlugulong* (1976, figure 10.3) by brothers Clifford Possum and Tim Leura Tjapaltjarri, "look back" at the imperial penchant for measurement and mapping. Indeed, as some new work that explores the complex relation between "cartography" and "art" in our times is beginning to show us, visual artists of many stripes have come to favor fuzzy contours and blurred boundaries over the unyielding lines of state and scientific cartography.[34] Smith's work—as does Sumathi Ramaswamy's essay in the next section—takes some measure of alternate ways in which some have continued affectively and intimately to inhabit a world made over by the "measured eye" of scientific cartography.

The Imperial Lens?

We close this first section with essays that complicate our understanding of the part played by the camera and the practices of viewing associated with it in furthering what Gruzinski has characterized as "the conquering grasp of the Western image."[35] Susan Sontag, among others, has noted the congruence between the vocabularies associated with hunting and photography. In colonial contexts, this congruence took an extra charge because of overt affinities proclaimed between the gun and the camera in the arsenal of empire, as in this telling assertion by Samuel Bourne from 1863:

As there is now scarcely a nook or corner, a glen, a valley, or mountain, much less a country, on the face of the globe which the penetrating eye of the camera has not searched, or where the perfumes of poor Archer's collodion has not risen through the hot or freezing atmosphere, photography in India is, least of all, a new thing. From the earliest days of the calotype, the curious tripod, with its mysterious chamber and mouth of brass, taught the natives of this country that their conquerors were the inventors of other instruments besides the formidable guns of their artillery, which, though as suspicious perhaps in appearance, attained their object with less noise and smoke.[36]

While not ignoring the part played by the camera as a proxy weapon and as a not-so-covert instrument of surveillance, the scholarship on the "colonizing" camera—as producer of both still and moving picture—has come a considerable distance from crudely casting it as a tool of the colonial powers to which the hapless native became optical victim. Instead, we are learning of/from much more nuanced ways in which acts of photographing and filming are dynamic performative encounters where there is room for resistance, subversion, and derision to surface and for participation by native bodies and gazes, indeed, for the production of unexpected intimacies in indexical encounters.[37] The colonial photograph or film certainly can reveal the power and reach of the imperial look, but it also may and does disclose moments of uncertainty and anxiety, of the blurring of mastery, of undoing by laughter. Metropolitan theories that privilege the indexical power of the photograph are leavened by arguments that instead stress the "substance" of the image as holding more value for the native.[38] An alternate aesthetics has been located in photographic and filmic practice that undercuts the detached version of Cartesian perspectivalism of an Enlightenment-style modernity imported from Europe and that instead privileges a "corpothetic" encounter premised on "getting hold" of the image rather than distancing oneself from it, as will see from Christopher Pinney's essay in the following section. Cinema in the colonies was tied more closely to the imperatives of the colonizing state, so we are perforce compelled to write a different history for this global form when we relocate ourselves outside the metropole. Indeed, as recent postcolonial theorizing about both photography and cinema shows us, the conception and ontology of these media are reworked in the colonial trajectories of these image-making technologies, making their first appearance though they might have in the metropolitan West.

Many of these issues come to the fore in historian James Hevia's essay, which takes us to Qing China circa 1900 at a critical moment when the camera became an image-making partner in a multinational effort to bring to heel the so-called rebellious Boxers who had dared to challenge the increasing presence of the West and Christian missionaries in the Middle Kingdom. Like others in this volume, Hevia persuades us to go beyond the representational work of the image to what he calls, following Bruno Latour's actor-network theory, "the photography complex," an assemblage of actants made up of numerous parts human and nonhuman and a range of agencies visible and nonvisible (the camera itself, but also chemicals and film, optics theory, the photographer, the networks through which the photograph travels, archives where the photograph is stored, and so on). It is such a complex entity that accompanied the multinational armies that marched into Beijing in 1900 and forced the Forbidden City to its knees, the photography complex functioning as an apparatus of surveillance and documentation, as an instrument with which the humiliation of the rebels was recorded and circulated to an eager viewing public back home, and as a pedagogical system through which valuable civilizational lessons were taught in China. Nonetheless, even such an "imperial" photography complex with its shock-and-awe tactics leaves behind "ghosts in the archive." Our ethical obligation then is to "disturb the regularities" of this complex, hence his focus on a photograph that continues to bear traces of its subjects mocking both the imperial/invading photographer and his apparatus.

Mocking and laughing back at Euro-America's fascination with its new image-making technologies is also the subject of cultural anthropologist Eric Stein's ethnographic study of attempts in Dutch Java in the 1930s to use hygiene cinema to discipline and manage the (diseased) native body and incorporate it into a new sanitary order. Hygiene cinema in the tropics functioned as a "colonial theater of proof" in which magnifying lenses, microscopy, and film technology were deployed to make visible and identify the invisible pathogens lurking within the afflicted native body as the true cause of disease, seemingly displacing the spirits, winds, and other notions of pathogenicity of the Javanese life-world. Stein shows how the makers of these hygiene films drew on Javanese shadow puppet (*wayang kulit*) theater to make the foreign technology and its important message "entertaining" and also to mask the inherently coercive thrust of the colonial health project. Yet the visual forms that were used opened up the state's efforts to mockery and outright laughter. Thus, the serious hygiene *mantri*, whose job it

was to educate the ignorant native about contagion and disease, came to be mocked as an "outhouse technician," and images of the ravaged body of the hookworm victim as they flashed across the screen elicited collective laughter reserved for the comic figure of the Wayang pantheon's Gareng, which it resembled. How does one interpret such instances of inappropriate laughter at "the wrong" time, Stein asks, and did they necessarily put an end to the violent pedagogy of hygiene cinema? The mockery and laughter, he proposes, served as incitement to discourse, producing evaluative claims about bodies and hygiene. Contrary to colonial claims though, few latrines came to be built then or since.

In the last essay in this section, abstracted from a longer ethnography on the arrival and dispersal of diverse media ranging from radio to video in Kano, anthropologist Brian Larkin considers the built environment of the commercial cinema (*sinima*) theater that appeared in Nigeria in the 1930s as a new kind of public space that seemingly challenged existing hierarchies of gender, class, and race among the Hausa. By their very location on the margins of an evolving colonial metropolis, the sinima theaters of Kano were threshold places from where Hausa audiences otherwise confined to Nigeria could certainly travel to an "elsewhere." All the same, the experience of going to the movies in places like colonial Kano was tainted by their location. "As illicit moral spaces, commercial cinemas repelled respectable people, attracting only the marginal, the young, or the rebellious." Such origins have cast a long shadow over cinema's career in places like Kano. Larkin's ethnography thus calls into question the assumption that "cinema is a universal technology," promoting similar viewing practices and modes of experiencing leisure and entertainment. As do many others in this volume, Larkin underscores the importance of considering the way certain standardizing forces that we might associate with a particular image-making technology are hybridized by the singularities of the colonial and postcolonial context(s) to which it travels, creating plural forms that are frequently at odds with what one might encounter in the (imperial) metropole.

The imperial optic, then, these selections suggest to us, has been complexly coconstituted, Europe and (post)colony, master and native, mutually entangled in image-making and image consuming, to a point that it is difficult to tell what is specifically "European" at all, hence our choice of the word *imperial*. The technologies considered in this section might have had their origins in the metropole, but what we are learning is that this does not necessarily mean they have had a career in the (post)colony that repli-

cates the experience in the West, diverse enough as that was in that locale as well. To quote Gruzinski, with whom we began this section, colonization ensnared the world "in an ever-growing net of images that was cast out over and over again, and that shaped itself according to the rhythm of the styles, politics, reactions, and the oppositions it met."[39] The problem of the twenty-first century that has inherited such a world is in many ways "the problem of the image."[40] *Empires of Vision* and the cross-disciplinary body of scholarship on which it builds compels us to seek the history of this "problem" in five centuries of European empire formation when images—and the technologies and practices that produced and delivered them—became a conquering force through which the world came to be grasped and turned into picture.

Notes

1 Deborah Poole, *Vision, Race and Modernity: A Visual Economy of the Andean Image-World* (Princeton: Princeton University Press, 1997), 8.
2 Jonathan Crary, *Techniques of the Observer: On Vision and Modernity in the Nineteenth Century* (Cambridge, MA: MIT Press, 1992), 20, 23.
3 Susan Buck-Morss, *The Dialectics of Seeing: Walter Benjamin and the Arcades Project* (Cambridge, MA: MIT Press, 1989). See also Chris Otter, *The Victorian Eye: A Political History of Light and Vision in Britain, 1800–1910* (Chicago: University of Chicago Press).
4 Arjun Appadurai and Carol Breckenridge, "Museums Are Good to Think: Heritage on View in India," in *Museums and Communities*, ed. I. Karp, S. Levine, and C. M. Kraemer (Washington: Smithsonian Institution Press, 1992), 34–55; quotation on pp. 51–52.
5 Christopher Pinney, *Camera Indica: The Social Life of Indian Photographs* (Chicago: University of Chicago Press, 1997), 93. For Poole, such "referrals and exchanges among images themselves, and the social and discursive relations connecting image-makers and consumers" constitute an "image world." "The metaphor of an image world through which representations flow from place to place, person to person, culture to culture, and class to class also helps us to think more critically about the politics of representation" (*Vision, Race and Modernity*, 7).
6 Nicholas Mirzoeff, "The Multiple Viewpoint: Disaporic Visual Cultures," in *Diaspora and Visual Culture: Representing Africans and Jews*, ed. N. Mirzoeff (London: Routledge, 2000), 1–18; quotation on p. 7.
7 Christopher Pinney, "The Nation (Un)Pictured: Chromolithography and 'Popular' Politics in India," *Critical Inquiry* 23(4) (1997): 834–67; quotation on p. 867.

8 At the same time, we are mindful of Brian Larkin's cautionary insistence that we should pay attention to "the destabilizing, terrifying effects of technology. Not because this is evidence of cognitive difference but because it is a feature of the introduction of technologies across all cultures. We must beware of an agentive theory of history that insists on the autonomy of human subjects who 'indigenize' and 'rework' technologies at will, as this denies the autonomous properties of technologies—the way technologies fashion subjects rather than the other way around." Brian Larkin, *Signal and Noise: Media, Infrastructure, and Urban Culture in Nigeria* (Durham: Duke University Press, 2008), 116. See also in this regard Jill H. Casid, "'His Master's Obi': Machine Magic, Colonial Violence and Transculturation," in *The Visual Culture Reader*, ed. N. Mirzoeff (London: Routledge, 2002), 533–45.

9 Homi Bhabha, "Of Mimicry and Man: The Ambivalence of Colonial Discourse," in *The Location of Culture* (1987; London: Routledge, 2004); Michael Taussig, *Mimesis and Alterity: A Particular History of the Senses* (New York: Routledge, 1993). For a fascinating discussion of mimetic encounters in Portuguese Guinea that are expressive of "the right to copy" and domesticate the European through appropriations, see Eric Gable, "Bad Copies: The Colonial Aesthetic and the Manjaco-Portuguese Encounter," in *Images and Empires: Visuality in Colonial and Postcolonial Africa*, ed. P. S. Landau and D. Kaspin (Berkeley: University of California Press, 2002), 294–319.

10 Serge Gruzinski, *Images at War: Mexico from Columbus to Blade Runner, 1492–2019* (Durham: Duke University Press, 2001), 72. For some recent thoughtful reflections on "the colonizer's medium of oil," see Saloni Mathur, *India by Design: Colonial History and Cultural Display* (Berkeley: University of California Press, 2007), chap. 3; on perspective and the European civilizing mission, see especially Michael Gaudio, *Engraving the Savage: The New World and Techniques of Civilization* (Minneapolis: University of Minnesota Press, 2008).

11 For an understanding of the corpothetic, see the work of Pinney, who uses it to mean the sensory embrace of and bodily engagement with images that is characteristic of the modern visual regimes in places like South Asia, especially at the popular and devotional level across numerous religious, regional, and ethnic divides.

12 See also in this regard Michael Taussig, *What Color Is the Sacred?* (Chicago: University of Chicago Press, 2009), 146.

13 Gruzinski, *Images at War*, 3.

14 Gruzinski, *Images at War*, 3.

15 For a comparable discussion from the seventeenth century and French India, see Kapil Raj, "Surgeons, Fakirs, Merchants and Craftsmen," in *Relocating Modern Science: Circulation and the Construction of Scientific Knowledge in South Asia, 17th–19th Centuries* (New Delhi: Permanent Black, 2006), 27–59.

16 For other takes on this critical question for the early modern world, see Geoff

Quilley and Kay Dian Kriz, eds., *An Economy of Colour: Visual Culture and the Atlantic World, 1660–1830* (Manchester: Manchester University Press, 2003).

17 "The old masters of Europe such as Jan Van Eyck or Jan Vermeer applied their pigments in layer after layer of color mixed with glazes and varnishes, many coming from colonial outposts of Europe" (Taussig, *What Color Is the Sacred?*, 110).

18 W. J. T. Mitchell, *What Do Pictures Want? The Lives and Loves of Images* (Chicago: University of Chicago Press, 2005).

19 Tony Bennett, "The Exhibitionary Complex," *New Formations* (1988): 73–102. There is a growing literature on the role of the exhibitionary complex in the many different European empires, on which see especially Timothy Mitchell, "The World as Exhibition," *Comparative Studies in Society and History* 31(2) (1989): 217–36; Peter H. Hoffenberg, *An Empire on Display: English, Indian, and Australian Exhibitions from the Crystal Palace to the Great War* (Berkeley: University of California Press, 2001); Marieke Bloembergen, *Colonial Spectacles: The Netherlands and the Dutch East Indies at the World Exhibitions, 1880–1931* (Singapore: Singapore University Press, 2006); and Zeynep Çelik and Leila Kinney, "Ethnography and Exhibitionism at the Expositions Universelles," in *Genealogies of Orientalism: History, Theory, Politics*, ed. E. Burke III and D. Prochaska (Lincoln: University of Nebraska Press, 2008).

20 In this regard, see Gruzinski's comment that the native in sixteenth- and seventeenth-century colonial Mexico largely encountered a "Europe in black and white," a product of the monochromatic engraving and print (*Images at War*, 73).

21 Elizabeth Eisenstein, *The Printing Revolution in Early Modern Europe* (Cambridge: Cambridge University Press, 1983).

22 Nuno Porto, "Picturing the Museum: Photography and the Work of Mediation in the Third Portuguese Empire," in *Academic Anthropology and the Museum: Back to the Future*, ed. M. Bouquet (New York: Berghahn Books, 2001), 36–54; quotation on p. 52.

23 Anne McClintock, "Soft-Soaping Empire," in *Imperial Leather: Race, Gender and Sexuality in the Colonial Context* (London: Routledge, 1995).

24 Ciarlo's essay appears in an edited volume that explores other aspects of German colonial visual culture, a topic on which there is very little scholarship to date. See also in this regard, George Steinmetz and Julia Hell, "The Visual Archive of Colonialism: Germany and Namibia," *Public Culture* 18(1) (2006): 147–83.

25 J. D. Hargreaves, "West African Boundary Making," in *Borders and Border Politics in a Globalizing World*, ed. Paul Ganster and David E. Lorey (Lanham, MD: SR Books, 2001), 97–106; quotation on p. 100.

26 For the geocoded world, see John Pickles, *A History of Spaces: Cartographic Reason, Mapping, and the Geo-Coded World* (London: Routledge, 2004).

27 Martin Heidegger, "The Age of the World Picture," in *The Question Concerning Technology and Other Essays* (New York: Garland, 1977), 115–54, esp. pp. 134–35. We also draw on Bruno Latour's insight, "There is nothing you can *dominate* as easily as a flat surface of a few square meters; there is nothing hidden or convoluted, no shadows, no 'double entendre.' In politics as in science, when someone is said to 'master' a question or to 'dominate' a subject, you should normally look for the flat surface that enables mastery (a map, a list, a file, a census, the wall of a gallery, a card-index, a repertory) and you will find it. . . . The 'great man' is a little man looking at a good map" (Bruno Latour, "Drawing Things Together," in *Representation in Scientific Practice*, ed. Michael Lynch and Steve Woolgar (Cambridge, MA: MIT Press), 19–68; quotations p. 45, 56.

28 Jorge Luis Borges, "Of Exactitude in Science," in *A Universal History of Infamy* (New York: Dutton, 1972); Umberto Eco, "On the Impossibility of Drawing a Map of the Empire on a Scale of 1 to 1," in *How to Travel with a Salmon and Other Essays* (New York: Harcourt, Brace, 1982).

29 Quoted in Derek Gregory, *Geographical Imaginations* (Cambridge, MA: Blackwell, 1994), 65–66.

30 Benedict Anderson, *Imagined Communities: Reflections on the Origin and Spread of Nationalism*, 2nd ed. (London: Verso, 1991), 173.

31 J. Brian Harley, *The New Nature of Maps: Essays in the History of Cartography* (Baltimore: Johns Hopkins University Press, 2001), 57. See also Jean Baudrillard's much-invoked statement, "the map precedes the territory. . . . It is the map that engenders the territory" (Jean Baudrillard, *Simulations*, trans. Paul Foss, Paul Paxton, and Philip Beitchman [New York: Semiotext, 1983], 2).

32 Walter D. Mignolo, *The Darker Side of the Renaissance: Literacy, Territoriality and Colonization* (Ann Arbor: University of Michigan Press, 1995); Barbara E. Mundy, *The Mapping of New Spain: Indigenous Cartography and the Maps of the Relaciones Geograficas* (Chicago: University of Chicago Press, 1996). See also in this regard Benjamin Orlove, "The Ethnography of Maps: The Cultural and Social Contexts of Cartographic Representation in Peru," in *Introducing Cultural and Social Cartography*, ed. R. A. Rundstrom (Toronto: University of Toronto Press, 1993), 29–46.

33 See also in this regard Simon Ryan, *The Cartographic Eye: How Explorers Saw Australia* (Cambridge: Cambridge University Press, 1996). For a suggestive argument connecting sowing, planting, and other landscaping technologies to the "cultivation" of the French and British empires in the eighteenth century, see Jill H. Casid, *Sowing Empire: Landscape and Colonization* (Minneapolis: University of Minnesota Press, 2005).

34 See, for example, Katharine Harmon, *The Map as Art: Contemporary Artists Explore Cartography* (New York: Princeton Architectural Press, 2009).

35 The photographic and film camera, in turn, were among many optical devices that made use of the lens and mirrors, such as the Claude glass so necessary for the British picturesque tradition; telescopes, binoculars, photospheres for

scientific observation; and the magic lantern that became essential in imperial pedagogy as well as for early mass entertainment. For a fascinating recent study of many such devices (although without attending to their imperial reach), see Otter, *The Victorian Eye*.

36 Quoted in John Falconer, "Photography in Nineteenth-Century India," in *The Raj: India and the British, 1600–1947*, ed. C. A. Bayly (London: National Portrait Gallery Publications, 1990), 264–77; quotation on p. 264. For an elaboration of the link between photography and hunting as colonial technologies, see especially Paul Landau, "Empires of the Visual: Photography and Colonial Administration in Africa," in *Images and Empires: Visuality in Colonial and Postcolonial Africa*, ed. P. S. Landau and D. Kaspin (Berkeley: University of California Press, 2002), 141–71.

37 Jane Lydon, *Eye Contact: Photographing Indigenous Australians* (Durham: Duke University Press, 2005). See also Priya Jaikumar, *Cinema at the End of Empire: A Politics of Transition in Britain and India* (Durham: Duke University Press, 2006); David Prochaska, "Telling Photos," in *Genealogies of Orientalism: History, Theory, Politics*, ed. E. Burke and D. Prochaska (Lincoln: University of Nebraska Press, 2008), 245–85; Christopher Pinney, *The Coming of Photography in India* (London: British Library, 2008); Lee Grieveson and Colin MacCabe, *Empire and Film* (London: Palgrave Macmillan, 2011); and Lee Grieveson and Colin MacCabe, *Film and the End of Empire* (London: Palgrave Macmillan, 2011).

38 Olu Oguibe, "Photography and the Substance of the Image," in *The Culture Game* (Minneapolis: University of Minnesota Press, 2004), 73–90. For a reconsideration of the yearning for indexicality central to photographic practice until recently, see Pinney, *The Coming of Photography in India*.

39 Gruzinski, *Images at War*, 3.

40 W. J. T. Mitchell, *Picture Theory: Essays on Visual and Verbal Representation* (Chicago: University of Chicago Press, 1994), 2.

Empires of the Palette

The Walls of Images

Serge Gruzinski

The Image from Flanders

What was the first visual imprinting the Indians received? The earliest images to land on Mexican soil were canvases and—more influential—sculptures; one can get an idea of them by looking at fifteenth-century Castilian, Aragonian, and Andalusian works and the few examples preserved in Mexico. For example, there was the Virgin of the Antigua, deposited in the Cathedral of Mexico City.[1] It was the Flemish experience of the image as much as Iberian art—and very little that of the Italian quattrocento—that surfaced at the beginning of this adventure: Ghent as much as Seville, and much more so than Florence or Venice. Flemish influences crossed through the Spanish Gothic during the entire fifteenth century, and with them the idea that the figurative and empirical orders ran closely together and were governed by the same laws.[2] Most of the first printers established on the Iberian peninsula were of Germanic or Flemish origins, and many engravings spread throughout Spain were copied from Nordic originals.[3] Northern styles thus influenced sculpture,[4] painting, illustrated books, and engraving. The saturation was such that in order to magnify the talent of the Mexican Indians, the Dominican Bartolomé de Las Casas quite naturally invoked the example of the Northern painters: "They began to paint our images; they did it with as much perfection and grace as the very first masters of Flanders."[5] Elsewhere, it was Flemish tapestry that served him as a basis for his comparison.[6] To this artistic prestige one can add the special links that tied Castile to Aragon in the Netherlands and to Germanic Europe, since Charles V, heir to the Catholic kings, was also heir to the Habsburgs and the Dukes of Burgundy. Let us not forget that it was in the name of a ruler born in Ghent and who was the Count of Flanders that Cortés conquered faraway Mexico, just as it

was through the lessons of a Fleming, Peter Crockaert, that the theologian Francisco de Vitoria assimilated Thomistic thought, and gave the School of Salamanca an unequaled glamour.[7]

Flanders was present in Mexico in yet an even more immediate fashion. Thanks to the "favor of the Flanders greats [who] at this time led throughout the Spains"[8]—let us understand by this the Burgundy counselors of the young emperor—Franciscans from the Ghent convent went over to America and settled in Mexico after 1523.[9] One of them, a lay brother by the name of Peter of Ghent, was a pioneering figure of this history. He abandoned the Netherlands even as they continued to flourish. Painting prospered there under the influence of Memling, Gérard David, Hugo Van der Goes, and the epigones of the Van Eycks. The archaistic masters worked side by side with artists who were more sensitive to the Italian quattrocento experience. Bosch had been dead for seven years, and Brueghel was yet to be born when Peter left Flanders. Once arrived in Mexico, the Ghent painter opened a school in an annex of the San José de los Indios chapel, to teach arts and Western techniques. In a town only just reborn from the cinders of the Conquest, he undertook to show the natives writing, drawing, painting, and sculpture based on European models, and therefore primarily Flemish ones. Tradition says that Peter of Ghent had enough talent himself to be the author of an image of the Virgin de los Remedios kept today in the Tepepan church, southwest of Mexico City.[10]

The missionary was accompanied by two other Flemish Franciscans: Johann Van den Auwera (Juan de Aora); and Johann Dekkers (Juan de Tecto), from Ghent himself as well, confessor of Charles V and theologian from the University of Paris.[11] Both had apparently packed books printed in the Netherlands and in the north of Europe. Without waiting for the arrival of the Twelve in 1524—the first Franciscan contingent sent to America—this little Flemish band laid the bases for the gigantic "spiritual conquest" that the evangelization of Mexico and Central America was to become.[12] Dekkers and Van den Auwera disappeared fairly early, but Peter of Ghent held an incomparable and magisterial sway until his death in 1572; in a half-century of uninterrupted activities his popularity and his prestige made him a rival of even the archbishop of Mexico.[13] Despite the distance, these Flemings kept ties with their native land, and not only through letters,[14] since it is possible that Peter the Ghent's Nahuatl Catechism may have been sent to the Netherlands to be printed in Antwerp around 1528.[15] Later, painters from the North settled in New Spain, and it is not surprising, in 1585, that

the Third Mexican Provincial Council recommended to painters the use of the treatise on sacred images by Juan de Molano, a Fleming who was born in Lille and died in Louvain.[16]

The Bull and the Indian

For the Indians, the teaching of images immediately turned into an apprenticeship. The first native work inspired by the West is thought to have appeared in 1525: it was the copy of a vignette engraved on a papal bull representing the Virgin and Jesus. The work was so perfect that a Spaniard took it with him to Castile "in order to show it off and draw attention to it."[17] It is remarkable that this American "premiere" had the 1525 launching of idoloclastic campaigns as a background, and that the destruction of the idols of Texcoco was contemporaneous with the unfolding, by a native hand, of the Christian image in Mexico. The simultaneity and the parallelism of these events might astonish us less if we remember the active part Peter of Ghent took in tearing down temples and idols while he was spreading the image and writing. The entire ambivalence of Westernization, its alibis, its lack of remorse, and its efficiency were incarnated through this character. The Christian image was thus literally born on the debris and ashes of the idol in Mexico.

It is equally revealing that the first image produced by a native immediately became an object of curiosity, exportation, and exposition ("*cosa notable y primera*"). What is more, it was followed by other works—feather mosaics, most notably—that went to richen European collections, as the zemis had thirty years earlier. From the beginning the role of the native artist was circumscribed: it consisted in reproducing a European original in the most faithful manner possible. From the outset confined to copying, Indian creativity was to restrict itself to displaying a technical ability or virtuosity that would be awarded only if it abstained from changing either form or content, that is to say, if it knew how to stay invisible: "It seemed there was no difference from the original to the copy he had made of it."[18] The ideal conditions for native copying were thus set in 1525: they stipulated a passive reproduction and reined in Indian intervention to the utmost. On the lookout for reproducers, and not conceptualists, the conquering West rarely ever abandoned that attitude thereafter.

The natives would from then on busy themselves with scrupulously reproducing "the materials given to them,"[19] *materias* that were primarily en-

gravings, for they could reach Mexico more easily than canvases or sculptures and could circulate among the Indians. The late fifteenth century was not only the age of the diffusion of printing in all of Europe, but also the rise of engraving.[20] Mechanical reproduction opened horizons that constituted an unprecedented media revolution, comparable in scope to the spread of printed matter. It also corresponded to the discovery and colonization of the American continent, to which it offered quite opportunely the means for a conquest via the image. Even in Spain alone, almost one quarter of the incunabula Lyell counted contained wood engravings, and it was in 1480 in Seville—door to the Americas—that the first book to be illustrated in Spain was printed.[21] The image that the Western world could reproduce massively for the first time was thus reducible to a generally monochrome expression, within which the line furnished a selective reading of reality, and space divided two principal planes with a quite rudimentary form of perspective. A Europe in black and white.

One can envision this by leafing through Peter of Ghent's catechism. The *Doctrina* was published in Mexico in 1553. Right from the beginning the eye is drawn to the astonishing diversity of quality and technique. Very rudimentary, even crude drawings of local provenance alternate with extremely elaborate compositions of northern (Flemish and German) inspiration: Christ's entrance into Jerusalem on Palm Sunday or the Deposition are of an astonishingly more sophisticated rendering than the Ascension of Christ, or the Crucified Christ that looks like a hieratic icon.[22] A Northern influence, rather than Italian or Iberian, seems to predominate throughout the illustrations. The same tonality existed in the inventory of the library of Santa Cruz de Tlatelolco, where the Franciscans provided a superior education to the children of the native aristocracy. The printed books before 1530 originated primarily in Paris, Lyon, and Venice. But along with Basel, Strasbourg, Rouen, Nuremberg, and Cologne, the contingent that carried the day was that of the Northern lands, and with it, probably, the engraving from these countries. An examination of the library of the first bishop and archbishop of Mexico, the Franciscan Juan de Zumárraga, corroborates this tally: one finds books from Paris, Cologne, Basel, Antwerp, then a strong Venetian contingent, and a handful of works printed in Lyon.[23] In any case Spain is in the minority, a Spain that was more often in the hands of German printers anyway, whose ranks featured the illustrious Crombergers of Seville.

The Northern image was thus particularly present in America, as it was

in a great part of Europe. To measure its richness one has but to glance at a work belonging to the evangelizer Juan de Gaona: the second volume of the *Opera minora* by Denys the Carthusian. On the first page, printed in Cologne in 1532, a complex set of juxtaposed compositions are spread out in eight vignettes concerning the Church doctors; on the lower register one can see the ecclesiastical hierarchy and the kings present at the ecstasy of a saint contemplating, in his vision, God the father surrounded by the Virgin and Christ.[24] This may constitute a Northern predominance, but it is also an extraordinarily composite range of forms where the strokes vary from the most simple to the most complex, where the depth oscillates between perspective and a rudimentary juxtaposition of planes, where the legibility of the motifs and ornaments is far from being uniform: this is what the native eye discovered and copied in the 1520s, '30s, and '40s. Europe's image was monochrome and multiform, let us not forget, even if an analysis cannot always take this into account.

No matter the style of the copied model, the link between books and engraving and that between images and writing stood out from the beginning, since Peter of Ghent's young native students learned how to read, write, trace gothic letters, draw illuminations and engravings (*imágenes de plancha*) all at the same time. By simultaneously discovering the graphic reproduction of language and the engraved reproduction of reality (the first image copied by an Indian accompanied the printed [?] text of a bull), Peter of Ghent's Indians were, from the outset, able to familiarize themselves with what the evangelizers meant by "image": the tracing of a *molde*, a copy but never—such as the *ixiptla*—the irresistible manifestation of a presence. Despite the hugeness of the project, Peter of Ghent's undertaking was crowned with success: the native workshops of the Fleming produced "the images and retables for all the country's temples."[25]

The Walls of Images

The painted and sculpted image, in Mexico as elsewhere, was indissociable from the framework in which it was exposed to the gaze of the faithful. One cannot, therefore, abstract it from the religious architecture of the sixteenth century, that of the great Franciscan, Dominican, and Augustine monasteries lining the roads of Mexico and filling one of the most fascinating chapters of the history of Western art. It is an oft-neglected chapter, for the interest focused on the pre-Hispanic remains and the seduction created

by the Mexican baroque contribute to leaving in the shadows the hundreds of buildings that the Indians erected under the direction of the mendicant monks.[26] Captivated by the spectacular exoticism of the pyramids, blinded by the retables' delirium of gold and silver, our gaze balks at the familiar strangeness of these buildings . . . and avoids it. We are confused to discover a medieval or Renaissance déjà vu, an awkward, deforming, and shattered mirror devoid, in any case, of the attraction of distance.

It was in the immense parvis in front of the cathedrals being built that the open "chapels" rose up. In front of their altars, sheltered under stone archways, the neophytes followed the celebration of the mass under open skies. Then, after the late sixteenth century, the tall naves—seemingly defying the laws of gravity so much that they were said to have scared the natives, since the Indians did not know of the art of the archway—sprang up next to the cloisters. These were the places in the countryside and the native towns where the Christian image appeared. Mexico City and a few Spanish colonies scattered throughout the country gave the Indians, to begin with, their only opportunities to perceive other types of representation, this time of a profane, but equally disconcerting nature. This was notably the case of the playing cards the invaders always had with them. Images in general thus blended strongly with the Christian image in particular.

The Indians discovered the painted and sculpted image on the walls and the archways of churches, in the interior of open chapels, all along hallways and stairs, in the rooms and refectories of the convents, and more rarely, through an open door, on the cell walls of the monks. Frescos usually alternated with canvases and unfolded drapes—"*muy amplios tapices*"—along the walls of the churches.[27] Walls of images, at times gigantic screens displayed over tens of square meters, the Christian frescos were not plunged into the penumbra of sanctuaries as had been the pre-Cortesian panels only the priests could visit. These frescos were part of a new organization of space, shapes, and architectural volumes that the monks progressively introduced and transformed. How could one imagine the frescos of Actopan without the great stairway they decorate, and with which they form a whole built like the Benozzo Gozzoli chapel in the Ricardi palace in Florence?[28] The students of the Augustines, the servants, the sacristans, the cantors who took the stairs daily, all these Indians circulated amidst an overabundance of porticos, columns, and friezes. The great figures of the order were also represented there, enthroned on their sumptuously decorated cathedras, surrounded by a profusion of ornaments, fully comparable to the most exuber-

ant pre-Hispanic works. The religious scenes of Epazoyucan, the paintings of Acolman, and even the pieces of frescos that remain in many places still reveal a recurrent trait of this decor: a saturation of images. The frescos followed each other seamlessly across the walls, as if the monks had wished to re-create surroundings that had been left back in Europe, and thus preserve at all moments a visual link with this distant heritage: were they not the first consumers of these images? One must add, on a minor note but with a quite different impact, the illustrated books and engravings that the native nobility, instructed in the convents, were invited to leaf through and read.

Exposure to the image thus usually took place in a liturgical or catechistic framework. One followed the images the priest was interpreting, or one prayed in front of them. The image served as a base for oral teaching, or even stood in for it at times: since he did not speak Nahuatl, Jacobo de Testera used a painting featuring "all the mysteries of our Holy Catholic faith," and an Indian interpreted it into the language of the faithful.[29] The clandestine access provided by theft or a discreet intrusion into a library was less common, even if it was attested to.[30] This framework was indeed both that of an apprenticeship and of a conversion, a doubly personal investment centered on the founding of a process of communication with new forces, the Christian God and the supernatural associated with it. The education of the native eye—as the monks practiced it—went through instilling the rudiments of the catechism and stimulating an attitude of waiting and adhesion that the liturgical celebrations maintained. The explanation of forms and procedures was reserved for the artisans who collaborated with the monks, unless they were invited to copy what they saw mechanically. And even so, this explanation limited itself to what the monks deemed essential to transmit. The apprenticeship appears even more complex when one considers that the set of these artistic manifestations also put less explicit—and in a certain sense more fundamental—values and principles into play than those of the catechism, which were of a visual order and of an *imaginaire* whose internalization could only deeply upset the autochthonous imaginaire.

It is particularly delicate to re-create the neophyte gaze and the manner in which a native receptivity to the Christian image was developed. Let us offer a few hypotheses nonetheless. By discovering the painted or graven image the Indians were bound to stumble against an exotic and hermetic set of iconographic conventions. One would have trouble enumerating them in their entirety, but at the forefront one must incontestably place anthropomorphism, or the preponderance of the human figure, which since Giotto

has become, in Western art, the instrument of figurative thought. Anthropomorphism postulated a representation invaded by the notions of incarnation and individuality.

One has only to glance over the engravings of Peter of Ghent's *Doctrina* again to immediately understand the emphasis invariably placed on the human being, whether a saint, the Virgin, or Christ. All these beings were inscribed in history, or more exactly, in a particular relationship to the past that was maintained by faith and clarified by the ecclesiastical tradition. The frescos of the Actopan stairway displayed a gallery of portraits gathering the great figures of the order of Augustines; these "historical" figures were individualized by gestures, backgrounds, and attributes. These figures were neither abstract types, nor *ixiptla*, but beings of flesh that one could theoretically identify and distinguish from one another. One could say the same of the Christian "gods" displaying distinctly human traits, who were supposed to have lived a historic existence. Incarnation and historicity governed the Christian image and disallowed any confusion. But the two postulates were implicit: beyond conventions and attributes, nothing very essential distinguished an Augustine archbishop from a saint, from Christ, or even God to the native eye, no more so than a woman saint or the Virgin was fundamentally different from a pagan sibyl. The Indians' response, at first mistaking the image of the Virgin for that of God and applying the name of Santa María to all Christian effigies alike, allows us to measure the magnitude of the obstacle. As much as it manifested a very natural ignorance of Christian figures, of connotations and contexts, their reaction supposed a polymorphous conceptualization of divinity that was very far from Christianity.

After the beings, the things. The Indians had to become familiar with a large quantity of figurative objects: with the cross, of course, but also with costumes, drapes and hangings, elements of architecture such as columns, chapiters, and arches. Under the iconographic convention was often lodged a European object completely devoid of concrete existence for the Indians. The representation of clouds, grottoes, trees, and rocks depended on a mode of stylization and an idea of nature that were not obvious to the natives either. The fantastic, decorative, or demoniac bestiary that the monks liked to reproduce did not refer to any local or even Iberian reality, and only acquired meaning when referenced to the Western imaginaire. The allegorical groupings—Justice and her sword and scales,[31] the chariot of Time or of Death[32]—belonged to a figurative procedure meant to help visualize a cate-

gory or an idea, as Torquemada reminds us in his *Monarquía indiana*.[33] On the other hand, this was not the case for St. Francis's chariot of fire,[34] an image drawn this time from a supernatural whose "reality" was not even in question for an educated Catholic. Beyond the obstacle of recognition, the native spectators still had to get their bearings within this maze by assigning what they saw either to the reality of the senses, the supernatural, the fantastic, the category of ornament or stylized figure. This was to suppose that they implicitly possessed the "moral eye" the religious painting of the West privileged, an aptitude for identifying, under a concrete and trivial exterior, the spiritual meaning of the symbol.[35] One can see that traps accumulated around the Indian, whose imaginaire was suddenly confronted with the conquering grasp of the Western image.

On the walls of the Mexican convents, Western beings and things were ordered and took their meaning according to groupings and layouts that were not self-evident. The image of the frescos was, in many respects, a mise-en-scène close to that of the theater of evangelization the natives were discovering during these same years. The distribution of the characters in paintings of the Last Supper, the Crucifixion, or the Last Judgment expressed an economy, a traveling of scenic space, and a theatricality that could only have disoriented the native spectator. The actions, the mimicry, the attitudes came from a repertoire unknown to the Americas; it needed to be explained, and it remains as hermetic to us sometimes as it was for the Indians. One cannot forget, after Baxandall's work, that the genuflections, St. John's open hand over Acolman's suffering of Jesus on the Cross, or Duns Scotus's pointed index finger were in no way arbitrary, but were equivalent to precise contributions by the European designers and artists.[36] The sequences and the succession of situations unveiled a sense of causality and human liberty proper to Christianity that was clearly far from the complex mechanics that tended to make the native submit to games of divine forces and to the absolute control of the community.[37]

Visible and Invisible Spaces

These scenes unfolded within a space whose geometric construction is also worthy of study. The Italian image of the quattrocento was often symbolized by Alberti's Window, a cut-out portion of space analogous to that which one might see out of a window, and in principle following the same rules as the empirical universe.[38] It was this type of spatial perception that the open-

ings of Actopan's stairway reflected back to the onlooker seeing the trompe l'oeil walls through them. Truth be told, *perspectiva artificialis* and *perspectiva naturalis*—geometrically elaborate or not—were far from being present in all the images the Indians discovered. But when these techniques did appear, in very different forms indeed, they created new obstacles to the understanding of the image. The space of the native codices and frescos was bidimensional; the differences in scale did not translate an application of linear perspective, but very distinct modes of information hierarchization. It is true that perspective remained an empirical or poorly mastered practice long after the Conquest, and that at the beginning of the seventeenth century, in his musings on the image, the Franciscan Juan de Torquemada did not treat it as anything particularly special. On the pages of Peter of Ghent's *Doctrina* (1553), buildings were drawn from perspectives that defied the laws of the quattrocento; Christ's resurrection took place against a blank background, while other engravings obeyed the principles of linear perspective.[39]

But realist illusion showed other aspects as well. Some frescos excelled at creating the impression of depth and relief: the cups, dishes, knife, and table top in the *Last Supper* of Epazoyucan were treated in a manner which, it seemed, hardly baffled the natives.[40] Trompe l'oeil was commonly used, and even deliberately promoted in Mexico, for it enabled one to obtain the equivalent of decorative sculpture at little cost. But ultimately its usefulness was restrained, or annulled: not only was the Indian not accustomed to "reading" these projections, but also, because he had no knowledge of Europe, he could hardly conceive of the shapes, motifs, architectonic effects—the caisson ceiling, for example—to which the procedure alluded and sought to suggest. Far from proposing substitutes to the eye, the trompe l'oeil risked being reduced, in the native gaze, to an additional decorative variation.

The European image was also a landscape. The rocky backgrounds or the forested heights onto which the false windows at Actopan opened illustrated the successful application of pictorial technique, as well as the rendition of a landscape captured by a recipe of Italo-Flemish heritage. The more or less finished sketch of a perspective, the art of the trompe l'oeil, the wall absorbed into the background all exposed the image's powers of illusion by distilling the magic of a "realism" in which the copy continuously competed with the model. Though the anachronistic term of *"realism"* might perhaps be doubly misleading: the West only captured the reality of the senses through codes and conventions as artificial as those of Mesoamerican painting, and for religious painting, this process remained constantly

subordinated to the representation of the invisible and the divine, to the teaching of a superreality.

If an image devoted to reproducing the visible is to be capable of rendering the invisible, it must have recourse to conventions and markers that identify the nature of the painted space according to whether it is profane, terrestrial, celestial, or supernatural. This was quite enough to disconcert more than one native onlooker. And yet the Christian image constantly played within these registers, as the filmic and televised image today juxtaposes or mixes the live document with the reconstruction of events or fiction; even the modern spectator is sometimes incapable of identifying the origin of the visuals he receives. On one of the frescos of the stairs of Actopan, two kneeling Indians and an Augustine monk are worshipping a Crucifixion.[41] If the Christ represented on the cross was at first only a representation within a representation, an image within an image (the fresco), it was also an icon by its celestial referent, as opposed to the three characters venerating it.

Was it easier to make out the pure and simple figuration of the crucifixion, or the hierophany of Christ on a cross? Let us take the example of *St. Gregory's Mass*: the episode links the apparition of Christ with the stigmata, and instruments of the Passion with Pope Gregory the Great, who is portrayed leading the ceremony. On Dürer's engraving the position of the officiants, the presence of two angels surrounded by clouds, and the unusual posture of the Christ reveal that the participants are perceiving an apparition. One group of characters absorbed in their task marks a third space outside of the event and the miracle; it is out of the picture, as it were. On the native version at Cholula (figure 1.1), it is very difficult to separate the world of men and that of the hierophany:[42] are we meant to see two levels, an inferior one for men, and a superior one for Christ? Or else must we contrast a first plane, that obeys natural laws, with a second supernatural one peopled with objects floating in the air, the instruments of the Passion? The Indians certainly had trouble distinguishing what was historical and event-related (the officiants) from what was epiphanic representation on this fresco; they had trouble differentiating the figuration of a materially present object (the chalice on the altar) from that of a "hierophanic" object (the nails of the Passion).

It was normal, however, for many levels of reality—one of which corresponded to the divine and to mystery—to coexist and interpenetrate within the same image. Of course there existed iconographic markers capable of

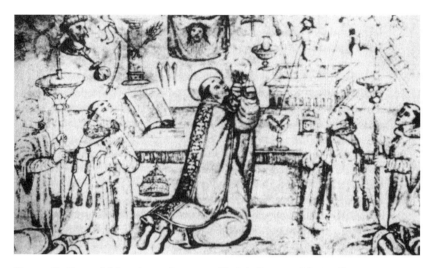

Fig. 1.1. *St. Gregory's Mass*, sixteenth century. Cholula Convent, Mexico City.

separating hierophanic "reality" from the represented event: they were the same in sixteenth-century Flanders and Italy as in New Spain. The clouds surrounding the Virgin of Tlayacapan, in the middle of which God the Father appears on the engravings of the *Doctrina* in 1553,[43] the nimbus and crowns of stars; the thick clouds separating St. Cecilia's chambers from the celestial world of the musical angels; the angels defying gravity pirouetting above Simon Pereyns's Virgin of Forgiveness: these merely reworked constantly refined medieval recipes.[44] The irruption of the invaders' image thus challenged many things. By upsetting traditional space-time it foreshadowed other invasions that would perturb the visual habits of these peoples over and over again. From Cortés's and Peter of Ghent's images to today's, Western techniques would continue to influence the natives' imaginaire.

One might suppose that under these conditions the Indians' access to the image remained quite limited. No doubt the times and social milieu should be taken into account, since former generations had not reacted as did the adolescents who had been raised in the convents amidst Christian images. But it was the native artists working under the monks' orders, and who were sometimes the overseers for the frescos, who first had to conquer or overcome the obstacles that Western representation put in their way. Certain factors played in their favor by easing the passage from one universe to another. The European chromatic palette—and therefore Western

color symbolism—was more often and easily neglected since the models the monks and the Indians used were engraved monochrome works. The proliferation of decorative motifs framing the convent frescos lent itself to repetitive copying and to mechanical tracing without much prior interpretation.

But it is mostly in the variety and extreme disparity of the European models where one must look for the breaches enabling the native artists to penetrate this new visual order. The absence of background in certain engravings of European origin[45] might have built a bridge between the two visual universes. The juxtaposition of elements, scenes, and characters in Acolman's *Thebaid* hardly takes the laws of perspective into account, even if they are spread over a mountainous landscape clearly defined by a distinct crest line.[46] The plurality of representations of a same space, and their synoptic accounts—so characteristic of the ancient codices—are also present in the Huejotzingo frescos that depict St. Francis receiving the stigmata, and further on, preaching to the animals.[47] The range of Christian symbols could thus easily be decrypted and reused, since the principle did contain pre-Hispanic echoes: the Huejotzingo Virgin appears surrounded by emblematic objects proclaiming her virtues—the tower, the fountain, the town, the star (*Stella Maris*)[48]—which act like ideograms; it is the same in the case of the symbols of the Passion on the Cholula *St. Gregory's Mass*[49] or with animals representing the three evangelists. Pre-Hispanic glyphs exploited a stereotyping reminiscent of decorative elements that, on Christian frescos, metonymically designate landscape components: a tree trunk, a hill (the Sinai mountain). The play of scale, measuring the height of figures by their hierarchical importance and not their position in space, has native equivalents: Joan Ortiz's Virgin, a giant at whose feet are gathered the praying faithful, gives us a European example.[50] The bridges were thus diverse enough to permit a partial reception of the image, even if it was riddled with misunderstandings or did block out the essential.

If the image faced so many pitfalls, it was because it was the manifestation of a structure that was larger than it in every way: it was the expression of a visual order, and even more of an *imaginaire* whose conscious and unconscious assimilation was synonymous with Westernization. One can understand the importance of what was at stake, and constantly went further than the lessons of catachesis and the consciousness of the protagonists. This was not only about the discovery of a completely new iconographic repertoire but about the imposition of what the West meant by person, divine, nature, causality, space, and history.[51] In fact, other grids operate under stylistic

and perceptual grids, thus composing a conceptual and emotional framework that unconsciously organizes all the categories of our relationship to the real. The monks' diffusion of the image fit perfectly into their project of making the Indian into a new man, even if the mendicant orders had not fully discovered every use of the instrument they wielded. It goes without saying under these conditions that the monks' commentary could not use up the substance of the image, and that the abundance of cultural and theological references, the depth of the memory the image brought into play and required made it into a fount of information, an instrument of apprenticeship and secondarily a source of illusion and fascination. The image of the frescos was an image under control, exacting and difficult. But it was not the only one that the monks placed before the eyes of their neophytes.

The Spectacle-Image

Very early on, the animated image extended and developed the potential of the fixed image, thus completing the implementation of the Western plan. After having participated in the first Christian processions organized on the continent, the Indians discovered the spectacle-image during the 1530s, and with it, what the evangelizers had judged important to keep (or were able to keep) from Iberian dramaturgy of the Middle Ages, whether texts, "scenarios," or theatrical techniques.[52]

It was probably toward 1533 that the *Last Judgment*[53] was played in Tlatelolco, at the gates of Mexico. After this "premiere" there was a rash of new plays presented in the capital and the center of the country, in Cuernavaca, Cholula, and mostly in Tlaxcala, before enthusiastic local crowds. With *The Conquest of Rhodes* performed in Mexico, with *The Drama of Adam and Eve*, *The Conquest of Jerusalem*, *The Temptation of the Lord*, *The Preaching of St. Francis*, and *Abraham's Sacrifice* played in Tlaxcala, the year 1539 seems to have marked the pinnacle of this astounding, mostly Franciscan enterprise[54] explicitly meant to put down Christian roots and to weed out local beliefs and practices. It is thus that while offering an extraordinary illustration of the itinerary of the sinner and of Christian eschatology, the Tlatelolco *Last Judgment* engaged in an official attack on native polygamy, which the Church was having great difficulties eradicating. In the same vein but on a more modest scale, far from the grand showy imagery of the country's cities, the Franciscan Juan de Ribas played on memory and the visual: "He made the Indians enact the mysteries of our holy faith and the lives of the

saints on their own feast-days, so that they could better understand them and put them in memory, because they are people whose capacity and talents are so limited."[55]

These works exploited the Western image as did frescos, painting, and engraving. They developed a visual translation of the sermons, thus making them more accessible. The image and theatrical representation were nonetheless still temporary auxiliaries, tightly subordinated to the teaching of the catechism to the Indians. This was, certainly, what all those who were bent on ending this experiment and forbidding native theater in all its forms fought to point out at the end of the seventeenth century.

Notes

Serge Gruzinski, "The Walls of Images," extract from *Images at War: Mexico from Columbus to Blade Runner, 1492–2019*; 69–86, 244–47. Durham: Duke University Press, 2001.

1 Manuel Toussaint, *Pintura colonial en México*, 2nd ed. (Mexico City: UNAM, 1982), 14. After 1519 the Casa de Contratación of Seville acquired works to be sent to America, and Flemish painters worked in the port of Guadalquivir for the Western Indies.

2 Hubert Damisch, *Théorie du nuage: Pour une histoire de la peinture* (Paris: Seuill, 1972), 118–19.

3 James P. R. Lyell, *Early Book Illustration in Spain* (1926; New York: Hacker Art Books, 1976), 3, 31.

4 Fabienne Emilie Hellendoorn, *Influencia del manierismo-nórdico en la arquitectura virreinal religiosa de México* (Mexico City: UNAM, 1980), 165.

5 Bartolomé de Las Casas, *Apologética historia sumaria*, ed. E. O'Gorman, 3rd ed., 2 vols. (Mexico City: UNAM, 1967), 1:322.

6 Las Casas, *Apologética*, 1:340.

7 Anthony Robin Pagden, *The Fall of Natural Man: The American Indian and the Origins of Comparative Ethnology* (New York: Cambridge University Press, 1982), 60.

8 Juan de Torquemada, *Monarquía indiana*, ed. Miguel Leon-Portilla, 3rd ed., 7 vols. (Mexico City: UNAM, 1981), 5:21.

9 Torquemada, *Monarquía*, 5:51.

10 Toussaint, *Pintura*, 21.

11 Toribio de Motolinía, *Memoriales; o, Libro de las cosas de la Neuva España y de los naturales de ella*, ed. E. O'Gorman, 2nd ed. (Mexico City: UNAM, 1971), 123.

12 Georges Baudot, *Utopia and History in Mexico: The First Chroniclers of Mexican Civilization (1520–1569)*, trans. Bernard R. Ortiz de Montellano and Thelma Ortiz de Montellano (Boulder: University Press of Colorado, 1995 [1977]),

254–55. On the evangelization, see Robert Ricard, *The "Spiritual Conquest" of Mexico: An Essay on the Apostolate and the Evangelizing Methods of the Mendicant Orders in New Spain, 1523–1572*, trans. Lesley Byrd Simpson (Berkeley: University of California Press, 1966 [1933]); and Serge Gruzinski, *The Conquest of Mexico: The Incorporation of Indian Societies into the Western World, 16th–18th Centuries* (Cambridge: Polity Press, 1993), 184–91 and throughout.

13 Torquemada, *Monarquía*, 6:184–88.

14 Torquemada, *Monarquía*, 6:187–88.

15 Pedro de Gante, "Introduction of Ernest de la Torre Villar to Fray Pedro de Gante," *Doctrina Cristiana en lengua mexicana*, facsimile reproduction of the 1553 edition (Mexico City: Centro de Estudios Históricos Fray Bernardino de Sahagún, 1981), 80.

16 José Guadalupe Victoria, *Pintura y sociedad en Nueva España: Siglo XVI* (Mexico City: UNAM, 1986), 108.

17 Geronimo de Mendieta, *Historia eclesiàstica indiana*, 4 vols. (Mexico City: Salvador Chàvez Hayhoe, 1945), 3:62.

18 Mendieta, *Historia*, 3:62.

19 Mendieta, *Historia*, 3:62.

20 William Mills Ivins, *Prints and Visual Communication* (Cambridge: Harvard University Press, 1953).

21 Lyell, *Early Book Illustration in Spain*, 3. On the use of colors at the end of the Middle Ages, see Michel Pastoureau, "Du bleu au noir: Ethique et pratique de la couleur à fin du Moyen Age," *Médiévales* 14 (1988): 9–21.

22 Gante, "Introduction," fol. 109, 100, 139v.

23 Miguel Mathés, *Santa Cruz de Tlatelolco: La primera biblioteca académica de las Américas* (Mexico City: Secretaria de Relaciones Exteriores, 1982), 93–96 [*The America's First Academic Library: Santa Cruz de Tlatelolco* (Sacramento: California State Library Foundation, 1985)].

24 Mathés, *Santa Cruz de Tlatelolco*, 30; Hellendoorn, *Influencia*, 191.

25 Torquemada, *Monarquía*, 6:184. On the teaching of alphabetic writing and its cultural and social consequences, see Gruzinski, *Conquest*, 6–69.

26 See the unsurpassed work by George Kubler, *Mexican Architecture of the Sixteenth Century*, 2 vols. (New Haven: Yale University Press, 1948).

27 Valadés, in Esteban J. Palomera, *Fray Diego Valadés O.F.M., evangelizador humanista de la Neuva España*, 2 vols. (Mexico City: Jun, 1962), 139.

28 Toussaint, *Pintura*, 40.

29 Torquemada, *Monarquía*, 6:268.

30 Fernández del Castillo, "Proceso seguido contra Antón, sacristán," in *Libros y libreros*, 38–45.

31 In the paintings of the Casa del Deán in Puebla (see Francisco de la Maza, "Las pinturas de la Casa del Deán" *Artes de Mexico* 2 [1954]: 17–24).

32 Maza, "Las pinturas."

33 Torquemada, *Monarquía*, 3:104.

34 "San Francisco," Huejotzingo convent in the state of Puebla.

35 Daniel Arasse, *L'homme en perspective: Les primitifs d'ltalie*, 2nd ed. (Geneva: Famot, 1986), 269, 207.

36 Michael Baxandall, *Painting and Experience in Fifteenth-Century Italy: A Primer in the Social History of Pictorial Style*, 2nd ed. (Oxford: Oxford University Press, 1988 [1972]), 60–70.

37 Arasse, *L'homme*, 259.

38 Damisch, *Théorie du nuage*, 156.

39 Gante, "Introduction," fol. 14v.

40 Epazoyucan is an Augustine convent in the state of Hidalgo; see Toussaint, *Pintura*, 39.

41 Toussaint, *Pintura*, 40.

42 Gante, "Introduction," fol. 129v; Toussaint, *Pintura*, 26.

43 Toussaint, *Pintura*, 46; Gante, "Introduction," fol. 37.

44 Toussaint, *Pintura*, 43, 61.

45 Gante, "Introduction," fol. 14v.

46 Toussaint, *Pintura*, 40.

47 Toussaint, *Pintura*, 43.

48 Toussaint, *Pintura*, 43. This Virgin is surrounded by St. Thomas and Duns Scotus. This is an Immaculate, painted toward the middle of the sixteenth century.

49 Toussaint, *Pintura*, 26. The reuse of Christian symbolism is patently obvious in the process of the creation of "neoglyphs" of Western inspiration enriching the native pictographic repertoire after the Conquest; see Gruzinski, *Conquest*, 33–34.

50 Gante, "Introduction," fol. 37, 17.

51 It is obvious that in the space given by perspective, one can visualize narrative and logical relationships as well as a grasp of past time—that we call history— that are proper to the European world and its lettered milieus, and thus completely new to the native spectators.

52 Motolinía, *Memoriales*, 119; Othón Arróniz, *Teatro de evangelizatión en Nueva España* (Mexico City: UNAM, 1979), 48–50; and Fernando Horcasitas, *El teatro náhuatl: Epocas novohispana y moderna* (Mexico City: UNAM, 1974), 107–8 and throughout.

53 Horcasitas, *El teatro náhuatl*, 77.

54 Horcasitas, *El teatro náhuatl*, 78–79.

55 Mendieta, cited in Arróniz, *Teatro de evangelización*, 55.

Painting as Exploration:

Visualizing Nature in Eighteenth-

Century Colonial Science

Daniela Bleichmar

This essay discusses the production of botanical illustrations by Spain's Royal Botanical Expedition to the New Kingdom of Granada (1783–1810), directed by the Spanish physician José Celestino Mutis (1732–1809).[1] Over the years, the expedition's more than forty artists created a staggering total of approximately 6,700 illustrations—far more than any other European expedition at the time, to the best of my knowledge. Although existing studies have carefully reconstructed the workshop practices that produced these images,[2] neither the reasons for Mutis's extreme dedication to visual material nor the ways in which these illustrations functioned vis-à-vis contemporary natural history iconography have been fully examined. This essay seeks to answer two questions: how does one understand this apparent oddity, the botanical expedition as a painting workshop? And, what can one make of the noticeable differences between the expedition's American-painted images and those produced by contemporary European botanical illustrators?

In the first section of the essay I present the manufacture and use of images as a technique for investigating, explaining, and possessing nature. Eighteenth-century natural history expeditions, I argue, acted as visualization projects that enabled Europeans to see the nature of the Spanish Americas. This is not a mere figure of speech. Expeditions always employed draughtsmen, regularly traveling with as many artists as naturalists, if not more. Whether they focused on natural history, astronomy, geography, navigation, exploration, or cartography, and whether they originated in Spain, Britain, France, or other European territories, all expeditions produced numerous images as part of their stated goals. At home or abroad, European naturalists used images in their daily work, and wrote abundantly

about them in their journals and correspondence. Pictures deserved special mention in the inventories of collections shipped back to Europe, and frequently received the most attention as crates were unpacked. For example, when reviewing a shipment sent by naturalists Hipólito Ruiz and José Pavón to Madrid from South America, Spanish botanist Casimiro Gómez Ortega pronounced the drawings the most precious materials received and suggested to Minister José de Gálvez that they be presented to the king at court.[3] If traveling naturalists sought to honor a patron—scientific or administrative—or needed to ask a favor, images constituted the preferred instrument of persuasion. At a time when European powers undertook the exploration of distant territories as a matter of key economic, political, and scientific importance, the production of images represented a central practice for investigating colonial nature and incorporating it into European science. In the eighteenth-century study of nature, seeing was intimately connected to both knowing and owning. Images of plants and animals were more than pleasant, secondary by-products of exploration: they were instruments of possession.[4]

In the second section of the essay I conduct a detailed analysis of the illustrations produced by the New Granada Botanical Expedition's workshop based on both iconographic choices and projected scientific usage. I argue that their significant stylistic departures from contemporary European images—a trait that remains unexplored in the literature—was not due to the American artists' failure to reproduce a foreign model but, on the contrary, to the conscious decision to present a pictorial alternative based on both scientific and artistic criteria. Rather than deficient examples of a European model, these illustrations represent the willful creation of an innovative mode of botanical representation articulated specifically as a response to the perceived shortcomings of European natural history imagery as viewed from the Americas.

Natural History Expeditions: Seeing, Knowing, Owning

In the eighteenth century, Spain actively invested in the exploration of its colonial territories, funding fifty-seven scientific voyages between 1760 and 1808 (Lafuente and Valverde 2005, 136).[5] Although the Spanish-language scholarship on these expeditions is extensive, they remain grossly understudied by anglophone scholarship.[6] This is somewhat surprising given the enormous scholarly interest over the past few decades in investigating

the connections between science and empire. With rare exceptions, however, discussions of science and colonialism—as well as those of science and enlightenment—have focused almost exclusively on English and French projects.[7]

Table 2.1 provides a comparative overview of the eight natural history expeditions funded by the Spanish Crown in the second half of the eighteenth century.[8] A detailed analysis of all these expeditions exceeds the purpose of this chapter, but they shared two important traits that are central to my argument. The first is a consensus in privileging botany as a focus of investigation. As Paula De Vos explains,[9] during the eighteenth century the Spanish Crown attempted to renew the kingdom economically and politically by implementing a thorough transformation of its colonial policies. Natural history was crucial to these reforms. A better known and efficiently administered empire, it was hoped, would furnish rich revenues by providing new natural products that Spain could sell within Europe or use to compete with trade monopolies maintained by other countries. Rather than purchasing natural commodities such as coffee, tea, cinnamon, pepper, nutmeg, or *materia medica* (natural specimens with medical uses) from European competitors, Spain hoped to locate profitable substances in its own colonial territories. This climate of international economic and political competition created opportunities for naturalists to sell their services to interested patrons. Botanical expertise became a highly valuable form of practical knowledge.[10]

The second trait that these expeditions had in common was that, without exception, they all employed artists and produced numerous images. Indeed, illustrations represented the bulk of their work: many more images were painted than descriptions written or objects collected.[11] The most extreme case by far was Mutis's expedition, which privileged images to the point that it became a painting workshop beyond anything else. While only about 500 plant descriptions were written, the number of pictures is overwhelmingly greater: almost 6,700 finished folio images of plants and over 700 floral anatomies.[12] Over the years, the expedition employed over forty artists, almost all of them Americans from Santa Fe, Quito, and Popayan.

Having trained as a surgeon in his native Cadiz and as a physician in Seville, Mutis arrived in New Granada in 1761 as the personal physician of the newly appointed viceroy Pedro Mesía de la Cerda. Between then and 1783, when he finally received official authorization and funding to conduct an expedition he had been proposing since 1763, Mutis worked in Santa Fe

Table 2.1 Spanish natural history expeditions to the American colonies in the second half of the eighteenth century

EXPEDITION	DATES	AREAS	NATURALISTS	ARTISTS	IMAGES
Limits expedition to Orinoco	1754–56	Orinoco (Venezuela)	Pehr Löfling	Juan de Dios Castel	115 botanical, 81 zoological, 2 ethnological, 2 maps
Botanical expedition to Chile and Peru	1777–88	Peru and Chile	Hipólito Ruiz, José Pavón, Joseph Dombey	José Brunete, Isidro Gálvez	2,224 botanical, 24 zoological
Botanical expedition to New Kingdom of Granada	1783–1810	New Granada (Colombia, Venezuela, Ecuador)	José Celestino Mutis + associates	Salvador Rizo, Francisco Matis, >40 others	6,618 botanical, >700 anatomies
Expedition to the Philippines	1786–94	The Philippines	Juan de Cuéllar	Anonymous local artist(s)	80 botanical
Circum-navigation (Alejandro Malaspina)	1789–94	South, Central, North America, Australia, the Philippines	Tadeus Haenke, Luis Née, Antonio Pineda	José Guío, José del Pozo, Francisco Pulgar, José Cardero, Tomás de Suría, Fernando Brambila, Francisco Lindo, Juan Ravenet, José Gutiérrez	286 botanical, zoological, ethnological, charts and maps
Botanical expedition to New Spain	1786–1803	Mexico and Guatemala	José Mociño, Martín de Sessé, Vicente Cervantes	Atanasio Echeverría, Vicente de la Cerda	119 botanical
Expedition to Cuba	1796–1802	Cuba	Baltasar Manuel Boldó, José Estévez	José Guío	66 botanical
Expedition to Ecuador	1799–1808	Ecuador	Juan Tafalla	Francisco Pulgar, Francisco Xavier Cortés	216 botanical

Source: Real Jardín Botánico, Madrid.

as a physician, taught mathematics and physics at the Colegio Mayor de Nuestra Señora del Rosario (participating in its curricular reform after the Jesuit expulsion in 1767), and served as a mine administrator for nine years. In his observation journals, which he began during his Atlantic crossing, he included descriptions of local customs, reflections on the native knowledge (for the most part disapproving), lists of Latin names, observations of ants and other insects, and domestic details.[13] Thus, by the time the expedition received royal authorization, Mutis had gained significant experience with local nature and established himself as an authority to whom people often wrote asking for advice on botanical remedies and other natural subjects.[14] He had also assembled a team, which constituted the initial personnel of the expedition: Eloy Valenzuela as second botanist; Roque Gutiérrez as plant collector or *herbolario*; and Pablo Antonio García, a celebrated local painter, as botanical illustrator.[15]

When the expedition officially began in 1783, Mutis traveled with this team to the town of Mariquita. They remained there for seven years, until in 1790 growing peninsular impatience—as the useful and profitable natural commodities he had promised to the Crown failed to materialize—forced Mutis to move back to Santa Fe, where his sedentary expedition settled for the rest of its duration. The expedition's headquarters, the Casa Botánica, consisted of the painters' workshop, a library, an astronomical laboratory, and several rooms dedicated to storing the herbaria, illustrations, stuffed animals, fossils, and minerals.

In the early days of the expedition, Mutis went to the fields with his collectors to point out the plants that interested him and guide them through the process of gathering samples without damaging any important parts. Once the herbolarios knew what was expected of them, however, Mutis's field days were over. The herbolarios worked as field naturalists, searching for better specimens of plants they had already gathered and scouting for plants that had not been collected previously. Their expertise in the local flora and the informal training obtained from their work allowed them to collect independently and to make suggestions. Mutis became an armchair naturalist, an administrator of science. He not only occupied the highest rank within the expedition's hierarchy but also served as its centripetal nucleus. Most of the work was conducted in the house. The herbolarios continued their daily collecting excursions, but rushed their specimens back to the expedition's headquarters to be examined, described, and drawn. Mutis's fieldwork was for the most part reduced to growing plants in the acclimatization garden

he formed in the grounds bordering the house—he never mentions, however, using the garden for observations or experiments, nor as a source of plants to ship to Europe. More than a venture outside, the garden seems to have been a domestication of the outdoors through which nature became an annex of the library. European scientific expeditions were understood as ventures into the world that would isolate and extract natural specimens to send back to Europe, where they could be studied indoors, in libraries and cabinets.[16] In this way, the study of nature was divided into two types of activity: one involving physical movement outdoors, another based on visual examination indoors, in specialized quarters.[17] Mutis's expedition, however, localized this model in the Americas: the herbolarios functioned as the travelers, Mutis as the cabinet botanist.

Mutis went further in his move to make the European model of natural exploration local by launching small-scale expeditions of his own. In addition to the plants gathered by the herbolarios, he obtained specimens through collaborators who sent samples from different parts of the kingdom: Diego García, traveling through the regions of Muzo, Tocaima, Ibagué, Neiva, la Plata, and Andaquíes, in New Granada; Francisco José de Caldas, collecting in Ecuador; Eloy Valenzuela, in Boyacá and Santander; and José Mejía.[18] Collaborators of the expedition were usually criollos or mestizos of higher social standing than the herbolarios; many of them had been educated in the Colegio Mayor where Mutis had taught before 1783. Through these collaborators, Mutis could expand the territory covered by his sedentary, centralized expedition. Through frequent and detailed correspondence, Mutis instructed his collaborators about the material they should collect and dispatch, detailing the procedure they were to follow. In each territory, collaborators were asked to make a list of all trees, study their resins, and collect their parts (branches, leafs); conduct mineralogical investigations; and collect precious stones, shells, and woods for the Madrid Royal Cabinet of Natural History. The collaborators' travels were aided by the viceroy, who provided them with special passports that allowed free movement through the kingdom and expedited their mail.

The object of all this collecting activity on the part of herbolarios and collaborators was to furnish material to produce an herbarium and a graphic record of American flora. Several specimens of each plant would be gathered and rushed back to the Casa, to be used for drawing the whole figure of the plant, to be "sacrificed" in order to observe and draw the floral anatomy in detail, to be described in writing according to the Linnaean system, or to

be pressed, dried, and added to the herbarium. Since drawings were made from fresh plants, it was crucial that herbolarios chose specimens in excellent condition and transported them with great care, wrapped in large sheets of paper to keep them from breaking. Mutis also received specimens from his correspondents, who had to make sure to send complete plants if they wanted them to be of use: when in 1784 Antonio de la Torre sent Mutis a sample of a rare cinchona that did not include the plant's flowers, Mutis decided to wait for a year until an intact sample could be secured.[19]

Specimens were drawn according to an established procedure. An artist would make an initial drawing of a plant using pencil on a large sheet of paper, carefully noting the colors of each part of the plant. Plants were kept in water so they would remain fresh, and the initial sketch was done as quickly as possible to attempt to capture this freshness. Over the course of a few days this sketch would be worked out in detail and colored with tempera paints (ground pigments added to a glutinous base) to produce a final image. While the plant's portrait was being created, another painter conducted floral dissections using magnifying glasses or a microscope, and then drew the floral anatomy (a key component of eighteenth-century botanical illustration, since it allowed the viewer to classify the plant according to the Linnaean system). The anatomical miniature would then be copied by one of the regular artists onto the plant's portrait, at the bottom of the page. The last step was to write the plant's name if it was known, and at times to trace a frame around the image. Two monochrome copies of this image would be made, in black and sepia ink, to be used later to produce engravings for publication. This work procedure was altered only on special occasions, when the number of plants gathered by the herbolarios was so large that it became necessary to work more hurriedly. In these situations, a plant would be sketched quickly in pencil, and only two leaves filled in with color: one showing the front and the other the back. If time was short, this last step would be skipped. After producing this incomplete image as rapidly as possible, the artists would take their time to draw the floral anatomy in detail, since this was considered the crucial part that could not be left until later.[20] Mutis planned to publish these images in a multivolume *Flora de Bogotá*, a sumptuous work which would appear in multiple large-format volumes, each with one hundred images and botanical descriptions, in Spanish, of American plants previously undescribed, not well determined, or not illustrated.[21]

Mutis's expedition was unique among European projects of this type

in establishing a fixed and large painting workshop that produced finished illustrations over an extended period of time. The great majority of eighteenth-century illustrations of non-European plants were drawn in Europe, often from sketches produced rapidly in the field, either by an artist traveling with a naturalist or by a naturalist himself, who would quickly sketch a plant before moving on to another one. The drawings would be finished later when there was time—that is, back in Europe. In the field it was necessary only to record the shape of the plant and the colors of its parts, for later reference. At times, illustrations represent the result of a long chain of intermediaries: European explorers in tropical colonies would commission drawings of native plants from local artists; these drawings would be then shipped to Europe; finally, a European painter would use these illustrations, together with dried herbarium specimens, to produce a composite portrait of a plant. In most cases, however, painters depicted the few specimens of tropical plants—usually ornate ones, with large colorful flowers—that managed to survive in European gardens. In contrast, the Royal Botanical Expedition assembled an artistic workshop with fixed personnel who worked closely together for a long period, and with repeated access to a much larger variety of American plants than would be possible for any artist in Europe. Over the years, the expedition employed almost fifty painters; about thirty of them worked at any one time.[22]

The first painter hired by Mutis was Pablo Antonio García, who collaborated with him for several years before the official start of the expedition in 1783 and then worked in this new capacity for a year and a half. Mutis sent illustrations by García to Spain in 1777, and also to Linnaeus as a gift.[23] The latter set of images was seen by the Swedish botanist Bergius, who enthusiastically expressed his surprise at the excellence of this American painter, pronouncing him superior to his European counterparts and saying he had not seen comparable images in Europe.[24] The next two painters hired by Mutis remained with the expedition throughout its duration, and became central to its operation. Salvador Rizo (employed 1784–1812) became its *mayordomo*, in charge of daily operations and all practical arrangements, from buying provisions to overseeing the functioning of a large team of artists, collectors, support staff, and long-distance contributors. When the expedition returned to Santa Fe in 1790, Rizo directed a free Escuela de dibujo to train young boys as botanical illustrators so that later they could join the expedition's workshop. Francisco Xavier Matis (employed 1783–1816) joined the expedition almost at its beginning and, although he

had no formal training in painting or natural history, worked his way up through the expedition's ranks from apprentice painter to principal painter to second naturalist, in charge of conducting and drawing the floral anatomies included in each illustration and used to classify plants according to the Linnaean system. He was also involved in plant collection from time to time.[25] Matis's talents impressed Humboldt, who described him in an 1803 letter to Willdenow as "the top flower painter in the world and an excellent botanist."[26]

In 1785 the expedition briefly employed Pablo Caballero, a renowned artist from Cartagena whose participation was secured through the intercession of viceroy Caballero y Góngora. Mutis, however, considered this "American Apelles" too finicky: he produced only four images in his first month in the expedition, and was promptly dismissed. Mutis had a similarly bad experience with two Spanish artists from the Madrid Academia de Bellas Artes de San Fernando, whom he agreed to employ in 1788 under pressure from the viceroy. After examining a sample of their work, an unconvinced Mutis grumbled to the viceroy that these artists might have been "schooled in artistic principles" but possessed no skills whatsoever as botanical painters, a genre that clearly was not properly taught in Spain. Their work, he claimed, lacked the "sublime degree of refinement" demonstrated by the expedition's artists, whose work could, unlike the Spaniards', compete with the most sumptuous botanical illustrations published in Paris and London. Nothing, however, that training could not remedy.[27] Matters did not prove that simple. One of the artists, José Calzado, died less than six months after arriving in New Granada. The other, Sebastián Méndez, quit the expedition after little more than two years and many arguments with its director. In a letter to Viceroy José de Ezpeleta, who had replaced Caballero y Góngora in 1789, Mutis complained that Méndez was unskilled, lazy, and slow, his work requiring constant emendation from the expedition's more experienced painters. He was also of dubious moral character and dissolute behavior, and claimed to have married a local woman although he already had a wife back in Spain. Mutis asked Viceroy Ezpeleta to force Méndez to leave not just the expedition but also the kingdom, since he was a danger to both.[28]

After such problems with academic painters, who had strong ideas concerning painting techniques, work schedules, and their own status, Mutis decided to change strategies. He wrote to Juan José de Villaluenga, president of the Real Audiencia of Quito, requesting young artists from the city's re-

nowned painting workshops. Any young painter would do, "as long as they are skilled in drawing and in handling the brush . . . especially if in them, although beginners, genius and application are to be found." Although strong skills in oil painting were appreciated, they were a bonus rather than a requirement since all painters would be trained to work with tempera paints. Overall, Mutis explained, artistic promise and malleability were the most important criteria: "It has been easier, and always will be, to manage people who are more docile, even if they are less skilled, because I provide through training the skills they lack at the beginning, and in this way I can compensate for the lack of docility of the Spanish artists, who always do poorly in America."[29] Announcing his request for Quito painters to Viceroy Caballero y Góngora, Mutis explained that it was far easier for him to work with painters "from here" than with Spanish academic painters, even if he had to train them to use tempera paints.[30] Mutis also found that the expedition's funds stretched much further if he hired local painters rather than Spanish ones, calculating that the salary paid to the two peninsular painters would be enough to hire five American artists. This estimate was based on a nine-hour workday and a year of 288 working days.[31]

The expedition hired five young artists from Quito in 1787, and five more in 1790 when it returned to Santa Fe.[32] These men had been apprenticed in the production of portraits and miniatures using oil paints, and were retrained by Rizo and Matis to produce botanical illustrations using tempera paints. During the 1790s, Mutis hired ten additional New Granada painters from workshops in Popayan and Santa Fe.[33] In the following decade, the expedition also had more than twenty *oficiales pintores principiantes*, young boys from New Granada taught in the expedition's free drawing school. During the years the expedition spent in Mariquita (1783–90), six hundred images were produced and a total of eleven painters hired, although only Rizo and Matis worked for the entire period and the workshop remained volatile until the arrival of the Quito painters in 1787. By comparison, during its Santa Fe period (1790–1816) the expedition hired forty artists, having about thirty at any one time, who produced about six thousand images.

The Development of an American Style

This team of American artists, the largest of any European expedition of the time, was trained locally to produce illustrations modeled on printed European images from Mutis's library. These pictures were meant to be incorpo-

rated easily into European botany. Although Mutis wished for a complete set of the expedition's images and a duplicate of its herbarium to stay in New Granada, the goal of the project was to have these images inserted within the European visual repository of nature.[34] For this reason, the images produced by the expedition participate in the conventions of botanical illustration of the time, and demonstrate the artists' fluency in this pictorial language. As was standard in Europe at that time, the illustrations present a nature that is always green, always in flower, static in its lushness, decontextualized geographically on the white page as well as temporally from life cycles. This decontextualization can be interpreted as more than a simple iconographic tradition: it represents the end point of the process through which nature was domesticated, rejecting the outdoors in favor of the indoors, the field in favor of the page.[35]

As was also standard, the images were not realistic depictions of any specific living specimen but rather idealized type representations, indicating what a certain kind of plant would look like in general.[36] The expedition's artists deployed standardized iconographic strategies that allowed them to compress space and time so that the images included the expected botanical information. An artist could, for instance, compress time by showing different stages in the life of a plant in a single imaginary specimen, presenting the viewer with little buds, mature flowers, and fruits in different stages of maturation, as well as green and yellowing leaves, to indicate all the possible states of that type of plant.[37] An artist could also compress space, bending a tall reedy plant into sinuous curves in order to fit it into the page, chopping another plant into pieces, or folding or cutting leaves in order to better display a plant on the page.[38] In other images, a leaf will appear to have been eaten away so that another leaf can fit in the page, or leaves will curl so that both their top and bottom can be clearly seen.[39] Some images present torn leaves almost realistically, while others highlight the artistic manipulation by pointedly snipping off every other leaf in a branch and leaving behind a little telltale fragment that functions like the ellipsis in a quote, indicating that something has been left out because it was not necessary in order to preserve the complete meaning of the statement, but signaling the omission to the reader as proof of trustworthiness.[40] This type of image demonstrates the artists' mastery of a standardized pictorial shorthand, and Mutis's intention of having these images participate in a community which carried out a standardized viewing that could decipher this shorthand. The reader of the image was expected to understand its iconographic vocabulary, to know

that the plants depicted did not exist as such in the field, and to carry out a participative, active viewing, recomposing the image mentally by turning leaves over, filling in gaps, expanding abbreviations, connecting torn stalks in order to assemble a plant.

European conventions of natural history illustration mandated not only what an image was meant to show but also the style in which it was produced: a flower depicted in a certain manner was appropriate for decorative or ornamental use in clothing or home furnishings; produced in another style it became a scientific object fit for inclusion in a botanical text. The prevailing style of European botanical illustration of the time insisted on naturalistic verisimilitude, not on realism, since illustrations did not reproduce specimens exactly, but offered an illusion of the lifelike.[41] One stylistic result of this aim was a preference for volume over flatness. Among the botanical images produced in Mutis's expedition, we can find some images that adhere to this convention. Most of the expedition's pictures, however, depart significantly from the contemporary European illustrations on which they were modeled. In general, the American images tend to be much flatter and show a stronger penchant for symmetry; colors are usually denser and more opaque as a result of the medium used (tempera instead of watercolor, which was more commonly used by European artists).

Until now, the compositional and stylistic differences between the expedition's images and European illustrations have remained unexplored in the existing literature, perhaps because it has been assumed that they can be attributed to the general traits exhibited by colonial Latin American art—which tended toward the use of flat simple shapes, dramatic delineation, sharp contours, and large blocks of color. I argue that the expedition's images represent the evolution of a strongly defined iconographic style developed in Mutis's workshop, different from that of other expeditions and going beyond imitation of European models. Flatness is indeed a trait that these images share with contemporary natural history illustrations produced by non-European artists from a range of colonial territories, such as the collection of 80 botanical images purchased by Spanish botanist Juan de Cuéllar in the Philippines between 1785 and 1794,[42] or the 722 pictures drawn by an Indian artist for the French doctor Nicolas L'Empereur ca. 1690–1725.[43] These and other similar natural history images were produced specifically for sale to foreigners by local artisans trained to depict flowers and plants within decorative traditions that differed significantly from the European conventions prevalent in natural history texts.

Some of the images painted for L'Empereur, for instance, were copied from Hendrik Adriaan van Rheede's *Hortus indicus malabaricus* (Amsterdam, 1678–93) by Indian artists who had until then worked in the local textile industry, painting flower patterns on cloth. A comparison of the European engravings with their Indian copies indicates quite clearly the presence of a different iconographic tradition at work. This is also the case with contemporary images painted by Chinese and Japanese artists following European models.[44] In Spanish America, comparable instances of syncretic art were produced during the sixteenth century by artists who combined pre-Hispanic and European artistic vocabularies into a hybrid patois in their depictions of human figures, plants, and animals in a variety of media and across a range of genres.[45] The situation had changed by the late eighteenth century. At this point, the Spanish expeditions were visiting colonies with a history going back over two hundred years, with strong identities and local interests to rival metropolitan ones. This is in marked contrast to their English and French contemporaries, or with European conquerors and explorers of the sixteenth century. The Royal Botanical Expedition's images were not produced by artists encountering a new pictorial regime but by painters who belonged to that tradition themselves, who had been trained in it and considered it their own. So although Asian and American images both transformed European models, they did so from quite different standpoints.

In the images produced by the artists employed by Mutis, flatness and symmetry were a conscious choice and, moreover, one guided not by artistic traditions or shortcomings but by botanical considerations. Symmetry was a key stylistic choice for the Mutis workshop, even when the plant was not shown flatly but was modeled with great volume and carefully detailed texture. Some pictures positioned the plant in the center of an image and carefully arranged its branches in nearly perfect symmetry, but provided a sense of volume and playfully arranged the leaves in a pleasant composition. As to flatness, the fact that it was a decision and not an impediment can be clearly demonstrated by a series of four images depicting the same plant (figure 2.1). The color tempera painting is a good example of the expedition's standard image, flat and symmetrical on the blank page (figure 2.1, top left).[46] A second image exists, a monochrome ink drawing that would be used to make an engraving for the planned publication, as was the norm for the expedition (figure 2.2, top right).[47] But a third and fourth image also exist, which is extremely unusual for the expedition. One is a drawing in ink and wash of the same plant (figure 2.3, bottom left).[48] This sketch is

much more naturalistic. It shows curling leaves, and the plant is modeled with more volume than usual and is more three-dimensional as a result. The composition is also a slight departure from the usual. This image clearly shows that the painters in Mutis's workshop were quite able to produce this "European" kind of image, and strongly suggests that a choice was made to represent plants in a different way. The fourth image in this series represents a middle point between the conventional European-style illustration represented by the previous image and the flat image normally produced by the Mutis workshop (figure 2.4, bottom right).[49] It is clearly a work in progress: the figure and the coloring are not completed, and it is a flattened version of the previous image, but still has more volume than the finished pictures in color and in monochrome ink that adhere to the conventions followed by most of the expedition's images.

The argument for the evolution of a particular style by the Mutis workshop is further supported by juxtaposing two series of images produced at different moments. In 1777, a year after the Royal Cabinet of Natural History was founded in Madrid, Mutis sent a series of forty-five botanical images as a gift to the new collection. These images, in black ink and wash, were produced by a single painter, Pablo Antonio García, working under Mutis's close guidance. They were meant to persuade the Crown of the great potential of the expedition (which Mutis had unsuccessfully proposed to the Crown in 1763 and 1764). Some of these forty-five images show plants that were drawn again by the expedition's painting workshop many years later. However, iconographically they are quite different from the bulk of the workshop's production—to the point that at the Archive of the Madrid Royal Botanical Garden, where the images, manuscripts, and herbaria produced by the different expeditions are held, they were classified for many years as belonging to the Malaspina expedition and not the Mutis expedition, and it was not until recently that this misattribution was resolved in publication.[50] To give but one example, one of García's images from 1777 depicts a flower curving gracefully across the page in a semicircle in a very decorative arrangement (figure 2.5, top left).[51] The modeling, the volume, and the vividness of the picture adhere to European conventions of botanical illustration. In contrast, a picture of the exact same plant produced years later by the workshop departs from European botanical preferences in favor of those which had by then been established by this expedition (figure 2.6, top right).[52] Another image from the 1777 shipment to the cabinet shows the same plant at a different stage, presenting considerable depth and shad-

Lobelia

Centrapogon caricus (L.) Decne

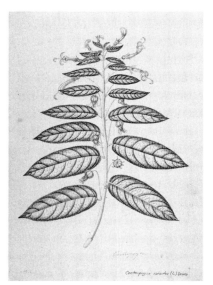

Centrapogon caricus (L.) Decne

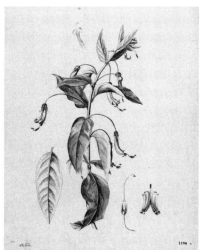

1196

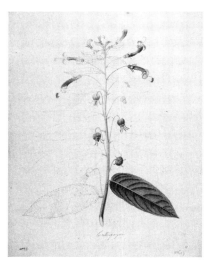

Centrapogon

ing, and portraying its tendrils in a naturalistic fashion quite uncombed and disorderly (figure 2.7, bottom left).[53] When the very same plant was drawn years later, the seed sacks were portrayed much more flatly, less shading was used, and the composition was much more symmetrical. Following another stylistic preference of the workshop, the tendrils were stylized, turned into neatly combed, curling strings (figure 2.8, bottom right).[54]

Although Mutis alluded frequently in his correspondence to his artists and the images they produced, he wrote much less regarding specific stylistic decisions—and the little he did mention has gone largely unnoticed in discussions of his work. However, the entry for January 21, 1785, in his observation journal indicates that at this point, two years after the beginning of the expedition, representation was not standardized but was still being explored and decided on a case-by-case basis. Faced with a specimen of a plant he calls *Besleria*, Mutis expressed doubt as to the relative merits of having the plant depicted in a frontal or dorsal view, and in the end had Rizo draw both views on a single page—a very unusual choice for both European iconography and the expedition's own later conventions.[55] Experiments were also being carried out at the time with the manufacture of tempera paints, exploring different compositions of the base.[56] An image from the period was produced by Matis using watercolors, which were the preferred European medium for natural history illustration but were almost never used by this expedition.[57] The image represents a significant departure not only from the expedition's usual medium but also from its later style: it is not flat and spread out, and the strong vertical pull is counterbalanced by a curling

Figs. 2.1–2.4 (opposite). *Centropogon cornutus* (Campanulaceae family).

Top left: Unsigned (New Granada expedition), *"Lobelia"* (*Centropogon cornutus*), undated, tempera on paper, 21.5 × 15 inches (54 × 37.5 cm). Archivo del Real Jardín Botánico (CSIC), Madrid, III, 1196. © RJB-CSIC.

Top right: Unsigned (New Granada expedition), untitled (*Centropogon cornutus*), undated, drawing in black ink, 21.5 × 15 inches (54 × 37.5 cm). Archivo del Real Jardín Botánico (CSIC), Madrid, III, 1196b. © RJB-CSIC.

Bottom left: Unsigned (New Granada expedition), untitled (*Centropogon cornutus*), undated, drawing in ink and wash with watercolor, 21.5 × 15 inches (54 × 37.5 cm). Archivo del Real Jardín Botánico (CSIC), Madrid, III, 1196a. © RJB-CSIC.

Bottom right: Unsigned (New Granada expedition), untitled (*Centropogon cornutus*), undated, drawing in watercolor and pencil, 21.5 × 15 inches (54 × 37.5 cm). Archivo del Real Jardín Botánico (CSIC), Madrid, III, 1196c. © RJB-CSIC.

Alstroemeria multiflora.

Alstroemeria multiflora fructificatio.

motion of the leaves toward and away from the center. It also proves that Matis was perfectly capable of producing "European"-style natural history illustrations, even if he did not do so subsequently.

The argument that the Mutis workshop developed its own style is supported by Mutis's writings, which demonstrate his proud awareness that the workshop's images constituted innovations on European models. He explained in 1785 that "perhaps the method we have created is new, since we have not imitated any [existing one] because it was necessary for us to break free and go down new roads," noting with satisfaction, "each day my plates achieve greater perfection."[58] This search for a new and distinctive style of botanical illustration is evidenced in a 1786 letter to Viceroy Caballero y Góngora in which Mutis described the state of the expedition's work. He noted that at that point two competing styles were being employed by the painters, indicating that "the delicate and fine nature of the two sublime styles in which my images are produced are a competition between its two inventors, since one belongs to Don Salvador Rizo, and the other was invented by me and executed by Don Francisco Matis." He went on to explain that, after comparing the images produced by his workshop with the printed illustrations in Jacquin's work, he concluded that the pictures "produced in America under my direction have pointed advantages compared to anything that has been published in Europe to this date." And this was not just his own personal opinion: the three small images he had sent to the Stockholm and Uppsala academies had "excited the impatient curiosity of those savants."[59]

Figs. 2.5–2.8 (opposite). *Bomarea frondea* (Amaryllidaceae family).

Top left: Pablo Antonio García (attr., New Granada expedition), untitled (*Bomarea frondea*), undated (1777?), pen and ink drawing with wash, 16.6 × 10.6 inches (42.2 × 26.8 cm). Archivo del Real Jardín Botánico (csic), Madrid, VI, 276. © rjb-csic.

Top right: [Francisco Javier] Matis (New Granada expedition), "*Alstroemeria multiflora*," undated, pen and ink drawing with wash, 21.5 × 15 inches (54 × 37.5 cm). Archivo del Real Jardín Botánico (csic), Madrid, III, 288. © rjb-csic.

Bottom left: Pablo Antonio García (attr., New Granada expedition), untitled (*Bomarea*), undated (1777?), pen and ink drawing with wash, 16.6 × 11.1 inches (42.2 × 28.3 cm). Archivo del Real Jardín Botánico (csic), Madrid, VI, 277. © rjb-csic.

Bottom right: [Lino José de] Azero (New Granada expedition), "*Alstroemeria multiflorae fructificatio*," undated, tempera on paper, 21.5 × 15 inches (54 × 37.5 cm). Archivo del Real Jardín Botánico (csic), Madrid, III, 288c. © rjb-csic.

Furthermore, the search for a new style seems to have arisen out of Mutis's poor opinion of most European images of foreign floras. He considered Pablo Antonio García's images superior to Catesby's, and bragged to his botanical affiliate Eloy Valenzuela that the images by García and Matis sent by him to Spain "will cause our Spanish draughtsmen (*dibujantes*) to faint, if they are mere draughtsmen and not [truly] painters."[60] He expressed his dissatisfaction with the images in an unnamed book by the French author Duhamel de Monceau, complaining that the great majority were "imperfect," and was similarly critical of the accuracy of Jacquin's image of a variety of *Passiflora*, which he found inaccurate in its details.[61] Although he considered Jacquin's work "without a doubt the best that has been published in Europe," he found his own images superior to any European work, and confessed to being vain about them.[62] Mutis explained that his painters had laughed at the images in Jacquin's *Hortus Vindobonensis*—with good reason, he thought, given that they themselves illuminated engravings in a far superior manner.[63]

In his final report to Caballero y Góngora, who was returning to Spain at the end of his term as viceroy, Mutis deplored European images of the Americas not only for their lack of accuracy but most important for their style:

> Without diminishing the glory owed to Hernández, Plumier, Sloan, Catesby, Barrier, Brown, Jacquin, and lately the tireless Aublet, all of their works need to be retouched (except, usually, those of the illustrious Jacquin). Their extremely imperfect plates do not satisfy today's sublime taste for *Iconism*. Its renowned promoters Oeder, Jacquin, and Miller encouraged it, and now they have been surpassed by Raignault, Curtis, Bulliar, L'Héritier, giving the immortal Linnaeus well founded reasons to regret and almost take back his old warning about the lack of usefulness of *Iconism*. In effect, if current botanical luxury proves amply the need for a certain degree of luxury, provided it does not degenerate to the extent of one [author] copying the other, and if plants from the Old World—which have been seen and examined for hundreds of years—are illustrated with increasing frequency, how much more important is it to work well out, once and for all, the never ending botany of the New World in all its parts? If I am not deceived by my own passion . . . I can promise myself that any image coming from my hands will not need any retouching by those who come after me, and any botanist in Europe will

find represented in it the finest characters of fructification, which are the a-b-c of science—of botany in the Linnaean sense—without the need to come see them in their native ground.[64]

Thus, Mutis believed, the images produced by his workshop would constitute the definitive embodiment of the plants they depicted, providing such accurate information that they would not require retouching or correcting years later (unlike existing European images). His illustrations would allow for long-distance knowing by seeing—and this is precisely the reason he considered the illustrations to be his expedition's most valuable work. "No plant," he explained in a letter written in July 1786, "from the loftiest tree to the humblest weed, will remain hidden to the investigation of true botanists if represented after nature for the instruction of those who, unable to travel throughout the world, without seeing plants in their native soil will be able to know them through their detailed explanation and living image."[65] Images preserved the impermanent and transported the distant. More than illustrations or representations, they came to stand for the objects they depicted, providing European naturalists with visual repertoires that allowed them to gather and compare natural specimens from around the world within the enclosed spaces of their studies.

Mutis's proud assertion of his workshop's excellence, and its implications regarding the self-perceived status of the expedition's naturalists and artists as local experts in comparison with their European counterparts, was articulated not only in writing but also visually. Figure 2.9 shows the work of the expedition's artists at its best.[66] The careful treatment of the flower, the depth provided to the leaves, the arrangement of leaves and flower to provide a powerful composition, all contribute to its visual impact. This picture demonstrates a confident mastery of the techniques and conventions of European botanical illustration, which it has appropriated to articulate its own kind of artistic and botanical statement. Captured by the power of the image, the viewer easily misses a most telling detail. In the bottom left corner, the painter has not only signed his name, Cortés, but also added something extremely unusual: a denomination of origin. The tag *Americ. Pinx.*, an abbreviation for *Americus pinxit*, declares "Cortés the American painted this." By not only signing his name but also pointing out his origin, and by extension the image's and the plant's, the painter shows how European botany and European illustration were appropriated and reinterpreted by the American artists who participated in Mutis's expedition.

Fig. 2.9. *Gustavia augusta* (Lecythidaceae family). Manuel Antonio Cortés Alcocer (New Granada Expedition), *"Gustavia augusta,"* undated, tempera on paper, 21.5 × 15 inches (54 × 37.5 cm). Archivo del Real Jardín Botánico (CSIC), Madrid, III, 2673. © RJB-CSIC.

Notes

Daniela Bleichmar, "Painting as Exploration: Visualizing Nature in Eighteenth-Century Colonial Science," *Colonial Latin American Review* 15(1) (2006): 81–104, reprinted by permission of the publisher (Taylor & Francis Ltd., www.tandfonline.com).

An earlier version of this essay was presented at the History of Science Society 2002 meeting. I am grateful to Antonio Barrera, Paula De Vos, and the audience for their comments. Susan Deans-Smith, the panel's chair, has provided many helpful suggestions and editorial comments and deserves special thanks.

1 J. A. Amaya, *Bibliografía de la Real Expedición Botánica del Nuevo Reino de Granada* (Bogotá: Instituto Colombiano de Cultura Hispánica, 1983); M. Frías Núñez, *Tras El Dorado vegetal: José Celestino Mutis y la Real Expedición Botánica del Nuevo Reino de Granada (1783–1808)* (Seville: Diputación Provincial de Sevilla, 1994); A. F. Gredilla, *Biografía de José Celestino Mutis* (Bogotá: Plaza & Janés, 1982); E. Pérez Arbeláez, *José Celestino Mutis y la Real Expedición Botánica del Nuevo Reino de Granada*, 2nd ed. (Bogotá: Instituto Colombiano de Cultura Hispánica, 1983); B. Villegas, ed., *Mutis y la Real Expedición Botánica del Nuevo Reyno de Granada* (Bogotá: Villegas Editores; Barcelona: Lunwerg, 1992).

2 A. E. de Pedro, "Imágenes de una expedición botánica," in *La expedición botánica al Virreinato del Perú (1777–1788)*, ed. A. Gónzalez Bueno (Madrid: Lunwerg, 1988); A. E. de Pedro, "Las expediciones científicas a América a la luz de

sus imágenes artístico-científicas," in *Ciencia, vida y espacio en Iberoamérica*, ed. J. L. Peset (Madrid: CSIC, 1989), 3:407–27; R. Rodríguez Nozal and A. Gónzalez Bueno, "La formación de grabadores para las 'Floras Americanas': Un proyecto frustrado," in *De la ciencia ilustrada a la ciencia romántica*, ed. A. R. Díez Torre et al. (Madrid: Doce Calles, 1995); C. Sotos Serrano, *Los pintores de la expedición de Alejandro Malaspina* (Madrid: Real Academia de la Historia, 1982); C. Sotos Serrano, *Flora y fauna cubanas del siglo XVIII: Los dibujos de la expedición del conde de Mopox, 1796–1802* (Madrid: Turner, 1984); J. Torre Revello, *Los artistas pintores de la expedición Malaspina*, Estudios y Documentos para la Historia del Arte Colonial, vol. 2 (Buenos Aires: Universidad de Buenos Aires, 1994); L. Uribe Uribe, "Los maestros pintores," in *Flora de la Real Expedición Botánica del Nuevo Reino de Granada (1783–1816)* (Madrid: Ediciones Cultura Hispánica, 1954), 1:102–6; and L. Uribe Uribe, *La Expedición Botánica del Nuevo Reino de Granada: Su obra y sus pintores* (Bogotá: Instituto Colombiano de Cultura Hispánica, 1958).

3 H. Ruiz, *Relación histórica del viage, que hizo a los reinos del Perú y Chile el botánico D. Hipólito Ruiz en el año 1777 hasta el de 1788, en cuya época regresó a Madrid*, ed. J. Jaramillo Arango, 2nd ed., 2 vols. (Madrid: Real Academia de Ciencias Exactas Físicas y Naturales, 1952), 445; M. A. Calatayud Arinero, *Catálogo de las expediciones y viajes científicos españoles a América y Filipinas (siglos XVIII y XIX)* (Madrid: CSIC, 1984), item 42.

4 D. Bleichmar, "Visual Culture in Eighteenth-Century Natural History. Botanical Illustrations and Expeditions in the Spanish Atlantic," Ph.D. diss., Princeton University, 2005; and B. M. Stafford, *Voyage into Substance: Art, Science, Nature and the Illustrated Travel Account, 1760–1830* (Cambridge, MA: MIT Press, 1984).

5 A. Lafuente and N. Valverde, "Linnaean Botany and Spanish Imperial Biopolitics," in *Colonial Botany: Science, Commerce, and Politics*, ed. L. Schiebinger and C. Swan (Philadelphia: University of Pennsylvania Press, 2005), 137–47.

6 Spanish-language studies include A. Díez Torre et al., eds., *La ciencia española en ultramar* (Madrid: Doce Calles, 1991); Frías Núñez, *Tras El Dorado vegetal*; A. González Bueno, ed., *La expedición botánica al Virreinato del Perú (1777–1788)* (Madrid: Lunwerg, 1988); Gredilla, *Biografía*; A. Lafuente and J. Sala Catalá, eds., *Ciencia colonial en América* (Madrid: Alianza, 1992); A. Lafuente, A. Elena, and M. L. Ortega, eds., *Mundialización de la ciencia y la cultura nacional* (Madrid: Doce Calles, 1993); J. Pimentel, *La física de la monarquía: Ciencia y política en el pensamiento colonial de Alejandro Malaspina (1754–1810)* (Madrid: Doce Calles, 1998); J. Pimentel, *Testigos del mundo: Ciencia, literatura y viajes en la Ilustración* (Madrid: Marcial Pons, 2003); F. Muñoz Garmendia, *La botánica al servicio de la Corona: La expedición de Ruiz, Pavón y Dombey al virreinato del Perú* (Madrid: Lunwerg, 2003); F. Muñoz Garmendia, *La botánica ilustrada, Antonio José Cavanilles (1745–1804) jardines botánicos y expediciones científicas* (Madrid: Caja Madrid Obra Social; Barcelona: Lun-

werg, 2004); M. Nieto Olarte, *Remedios para el imperio: historia natural y la apropiación del Nuevo Mundo* (Bogotá: Instituto Colombiano de Antropología e Historia, 2000); M. P. de San Pío Aladrén, *El águila y el nopal: La expedición de Sessé y Mociño a Nueva España (1787–1803)* (Madrid: Lunwerg, 2000); F. J. Puerto Sarmiento, *La ilusión quebrada. Botánica, sanidad y política científica en la España Ilustrada* (Madrid: CSIC, 1988); B. Sánchez, M. A. Puig-Samper, and J. de la Sota, eds., *La Real Expedición Botánica a Nueva España 1787–1803* (Madrid: Real Jardín Botánico, 1987); and Villegas, *Mutis y la Real Expedición*, among others. The only two English-language monographs are A. R. Steele, *Flowers for the King: The Expedition of Ruiz and Pavon and the Flora of Peru* (Durham: Duke University Press, 1964) and I. H. W. Engstrand, *Spanish Scientists in the New World: The Eighteenth-Century Expeditions* (Seattle: University of Washington Press, 1981); articles include J. Cañizares-Esguerra, "Spanish America: From Baroque to Modern Colonial Science," in *The Cambridge History of Science*, vol. 4, *Eighteenth-Century Science*, ed. R. Porter (Cambridge: Cambridge University Press, 2003), 718–38; J. Cañizares-Esguerra, "How Derivative Was Humboldt? Microcosmic Nature Narratives in Early Modern Spanish America and the (Other) Origins of Humboldt's Ecological Sensibilities," in *Colonial Botany: Science, Commerce, and Politics*, ed. L. Schiebinger and C. Swan (Philadelphia: University of Pennsylvania Press, 2005), 148–68; K. Gavroglu, ed., *The Sciences in the European Periphery during the Enlightenment* (Dordrecht: Kluwer, 1999); T. Glick, "Science and Independence in Latin America (With Special Reference to New Granada)," *Hispanic American Historical Review* 71 (1991): 307–34; R. Iliffe, "Science and Voyages of Discovery," in *The Cambridge History of Science*, vol. 4, *Eighteenth-Century Science*, ed. R. Porter (Cambridge: Cambridge University Press, 2003), 618–46; A. Lafuente and N. Valverde, "Linnaean Botany and Spanish Imperial Biopolitics," in *Colonial Botany: Science, Commerce, and Politics*, ed. L. Schiebinger and C. Swan (Philadelphia: University of Pennsylvania Press, 2005), 133–47; A. Lafuente, "Enlightenment in an Imperial Context: Local Science in the Late Eighteenth-Century Hispanic World," in *Nature and Empire: Science and the Colonial Enterprise*, ed. R. MacLeod, special issue of *Osiris* 15 (2000): 155–73; M. Nieto Olarte, "Remedies for the Empire: The Eighteenth-Century Spanish Botanical Expeditions to the New World," Ph.D. diss., Imperial College, London, 1993; and M. L. Pratt, *Imperial Eyes: Travel Writing and Transculturation* (London: Routledge, 1992). Some reasons for this neglect are discussed in J. Cañizares-Esguerra, "Iberian Science in the Renaissance: Ignored How Much Longer?" *Perspectives on Science* 12(1) (2004): 86–124, and A. Nieto-Galán, "The Images of Science in Modern Spain," in *The Sciences in the European Periphery during the Enlightenment*, ed. K. Gavroglu (Dordrecht: Kluwer, 1999).

7 See, for instance, L. H. Brockway, *Science and Colonial Expansion: The Role of the British Royal Botanical Gardens* (London: Academic Press, 1979); W. Clark, J. V. Golinski, and S. Schaffer, eds., *The Sciences in Enlightened Europe* (Chi-

cago: University of Chicago Press, 1999); R. Grove, *Green Imperialism: Colonial Expansion, Tropical Island Edens, and the Origins of Environmentalism, 1600–1860* (Cambridge: Cambridge University Press, 1995); T. L. Hankins, *Science and the Enlightenment* (Cambridge: Cambridge University Press, 1985); J. Kellman, "Discovery and Enlightenment at Sea: Maritime Exploration and Observation in the 18th-Century French Scientific Community," Ph.D. diss., Princeton University, 1998; Y. Laissus, ed., *Les Naturalists français en Amérique du Sud XVIe–XIXe siècles* (Paris: Editions du CTHS, 1995); R. MacLeod and M. Lewis, eds., *Disease, Medicine and Empire: Perspectives on Western Medicine and the Experience of European Expansion* (London: Routledge, 1988); J. E. McClellan, *Colonialism and Science: Saint Domingue in the Old Regime* (Baltimore: Johns Hopkins University Press, 1992); P. Petitjean et al., eds., *Science and Empire: Historical Studies about Scientific Development and European Expansion* (Boston: Kluwer, 1992); D. P. Miller and P. H. Reill, eds., *Visions of Empire: Voyages, Botany, and Representations of Nature* (Cambridge: Cambridge University Press, 1996); R. Porter and M. Teich, *The Enlightenment in National Context* (Cambridge: Cambridge University Press, 1981); and N. F. Safier, "Writing the Andes, Reading the Amazon: Voyages of Exploration and the Itineraries of Scientific Knowledge in the Eighteenth Century," Ph.D. diss., Johns Hopkins University, 2004.

8 The early modern term *natural history* encompasses a variety of studies corresponding to present-day disciplines including botany, zoology, entomology, mineralogy, climatology, geography, and physical and biological anthropology. See N. Jardine, J. A. Secord, and E. C. Spary, eds., *Cultures of Natural History* (Cambridge: Cambridge University Press, 1996).

9 P. De Vos, "Research, Development, and Empire: State Support of Science in the Later Spanish Empmire," *Colonial Latin American Review* 15(1) (2006): 55–79.

10 I discuss these matters in great detail in chapters 1 and 2 of my dissertation (Bleichmar, "Visual Culture in Eighteenth-Century Natural History"), where I examine not only Spanish policies and projects but also their enactment in the colonies. Concentrating exclusively on the movement of information and specimens from colonies to metropolis, I argue, would imply missing half the story. Trajectories were not only imperial but also colonial; initiatives originated not only in Madrid but also in places like Bogotá, Lima, and Mexico City. Colonial governors and administrators sponsored investigations of local nature with an enthusiasm that suggests that they had their own reasons to be interested in natural history, beyond their duty to ensure the prompt fulfillment of orders from Madrid. Throughout the colonies, local administrators actively encouraged the exploration of nature, hoping to identify products that would boost the regional economy by securing profitable trade with the metropolis. Distance from Madrid—in space, time, and experiences—granted naturalists considerable autonomy, and favored the development of an independent attitude. As Spanish and Spanish American naturalists became increasingly com-

mitted to local projects, the relationships they forged in the New World became stronger than those they maintained across the ocean. The relevance of Madrid to their daily work diminished, their priorities and allegiances shifted, and they subtly and gradually turned away from the distant metropolis to face much more immediate and present concerns. Naturalists working in the colonies became nodes of a truly global network in which center and periphery were far from clear or stable categories.

11 Ruiz and Pavón were the only travelers who published a *Flora*. Hipólito Ruiz López and José Pavón, *Flora Peruviana et Chilensis: Prodromus, descripciones y láminas de los nuevos géneros de plantas de la Flora del Perú y Chile* (Madrid, 1794); Hipólito Ruiz López and José Pavón, *Flora Peruviana et Chilensis*, 3 vols. (Madrid, 1798–1802), 4th vol. (Madrid: Instituto Botánico A. J. Cavanilles, 1957), 5th vol. in installments, *Anales del Instituto Botánico A. J. Cavanilles*, XVI (1958), 353–462; XVII (1959), 377–495; see Bleichmar, "Visual Culture in Eighteenth-Century Natural History," chap. 5, and A. González Bueno, "Un tesoro de las maravillas de la naturaleza: La *Flora peruviana et chilensis*," in *Flora peruviana et chilensis*, ed. H. Ruiz and J. Pavón, facsimile ed. (Madrid: CSIC, 1995), 1:cx–cxxv.

12 In addition to the finished anatomies included on plant portraits, there is a working notebook with 156 anatomies produced by Matis in 1809–10 (soon after Mutis's death). This *Cuaderno de florones* is kept at the Archivo del Real Jardín Botánico, Madrid (hereafter ARJBM), III, M-174 to M-200 and III, M-481. It is fully reproduced in *Flora de la Real Expedición Botánica del Nuevo Reino de Granada (1783–1816)* (Madrid: Ediciones Cultura Hispánica), vol. 50, plates 40–91. The archive also holds a notebook of corresponding botanical descriptions: ARJBM III, 4, 7, 1–36.

13 J. C. Mutis, *Diario de observaciones de José Celestino Mutis (1760–1790)*, ed. Guillermo Hernández de Alba, 2nd ed., 2 vols. (Bogotá: Instituto Colombiano de Cultura Hispánica, 1983), and *Viaje a Santa Fe*, ed. Marcelo Frías Nuñez (Madrid: Historia, 1991).

14 Mutis reviews his work in New Granada between 1760 and 1783 in a letter to Viceroy Antonio Caballero y Góngora, March 27, 1783, in J. C. Mutis, *Archivo epistolar del sabio naturalista Don José C. Mutis*, ed. Guillermo Hernández de Alba, 2nd ed., 4 vols. (Bogotá: Instituto Colombiano de Cultura Hispánica, 1983), 1:107–16.

15 Roque Gutiérrez had worked for Mutis since 1772, García at least since 1777.

16 B. Latour, *Science in Action* (Cambridge, MA: Harvard University Press, 1987).

17 D. Outram, "New Spaces in Natural History," in *Cultures of Natural History*, ed. N. Jardine, J. A. Secord, and E. C. Spary (Cambridge: Cambridge University Press, 1996), 249–65.

18 M. P. de San Pío Aladrén, ed., *Catálogo del Fondo Documental José Celestino Mutis del Real Jardín Botánico* (Bogotá: Instituto Colombiano de Cultura Hispánica, 1995), sees. 1, 2.

19 Frías Núñez, *Tras El Dorado vegetal*, 287.

20 Mutis, *Diario de observaciones*, 2:530–31.

21 Mutis, *Archivo epistolar*, 1:121–22, 166–68, 179–85, 300–304.

22 C. Sotos Serrano, "Aspectos artísticos de la Expedición Botánica de Nueva Granada," in *Mutis y la Real Expedición Botánica del Nuevo Reyno de Granada*, ed. B. Villegas (Bogotá: Villegas Editores; Barcelona: Lunwerg, 1992), 1:121–57; Uribe Uribe, "Los maestros pintores."

23 Anonymous artist, *Icones Ineditae*, thirty-two drawings in pen and ink, ca. 1773. Linnaean Society, Mss. BL 1178.

24 ARJBM III, 1, 2, 85, fol. 2r.

25 ARJBM III, 1, 3, 599 and III, 1, 3, 600.

26 Uribe Uribe, "Los maestros pintores," 103.

27 Mutis, *Archivo epistolar*, 1:416–17.

28 Mutis, *Archivo epistolar*, 2:34–38.

29 Mutis, *Archivo epistolar*, 1:313.

30 Mutis, *Archivo epistolar*, 1:330–31.

31 Mutis, *Archivo epistolar*, 1:442.

32 The first five were Antonio Cortés y Alcocer, Nicolás Cortés y Alcocer, Antonio Barrionuevo, Vicente Sánchez, and Antonio de Silva; the others were Francisco Xavier Cortés y Alcocer, Francisco Escobar y Villarroel, Manuel Roales, Mariano Hinojosa, and Manuel Martínez.

33 Félix Tello, Manuel José Xironza, Nicolás José Tolosa, José Antonio Zambrano, and Valencia (first name unknown) from Popayán; José Joaquín Pérez, Pedro Advíncula de Almansa, José Camilo Quezada, José Manuel Domínguez, and Francisco Manuel Dávila from Santa Fe.

34 Mutis, *Archivo epistolar*, 1:166–68.

35 D. Bleichmar, "Training the Naturalist's Eye in the Eighteenth Century: Perfect Global Visions and Local Blind Spots," in *Skilled Visions: Between Apprenticeship and Standards*, ed. C. Grasseni (London: Berghahn Books, 2006), 166–90.

36 L. Daston and P. Galison, "The Image of Objectivity," *Representations* 40 (1992): 81–128.

37 ARJBM III, 803.

38 ARJBM III, 596.

39 ARJBM III, 448.

40 ARJBM III, 1358.

41 B. Hall, "The Didactic and the Elegant: Some Thoughts on Scientific and Technological Illustrations in the Middle Ages and Renaissance," in *Picturing Knowledge: Historical and Philosophical Problems Concerning the Use of Art in Science*, ed. B. S. Baigrie (Toronto: University of Toronto Press, 1996), 3–39; P. Parshall, "*Imago Contrafacta*: Images and Facts in the Northern Renaissance," *Art History* 16 (1993): 554–79; C. Swan, "*Ad vivum, naer het leven*, From the Life: Defining a Mode of Representation," *Word and Image* 11(4) (1995): 353–72.

42 M. B. Bañas Llanos, *Una historia natural de Filipinas: Juan de Cuéllar, 1739?–1801*

(Barcelona: Ediciones del Serbal, 2000); M. P. de San Pío Aladrén, *La expedición de Juan de Cuéllar a Filipinas* (Madrid: Lunwerg, 1997).

43 K. Raj, "Surgeons, Fakirs, Merchants, and Craftspeople: Making L'Empereur's Jardin in Early Modern South Asia," in *Colonial Botany: Science, Commerce, and Politics*, ed. L. Schiebinger and C. Swan (Philadelphia: University of Pennsylvania Press, 2005), 252–69.

44 G. Saunders, *Picturing Plants: An Analytical History of Botanical Illustration* (London: Zwemmer, 1995), 73–81.

45 S. Gruzinski, *Painting the Conquest: The Mexican Indians and the European Renaissance* (Paris: Flammarion, 1992); J. F. Peterson, *The Paradise Garden murals of Malinalco: Utopia and Empire in Sixteenth-Century Mexico* (Austin: University of Texas Press, 1993).

46 ARJBM III, 1196.

47 ARJBM III, 1196b.

48 ARJBM III, 1196a.

49 ARJBM III, 1196c.

50 J. Fuertes, "La colección de láminas de Mutis localizadas en el fondo documental 'Expedición Malaspina' del Archivo del Real Jardín Botánico," in *La armonía natural: La naturaleza en la expedición marítima de Malaspina y Bustamante (1789–1794)*, ed. M. P. de San Pío Aladrén and M. D. Higueras Rodríguez (Madrid: Lunwerg, 2001), 85–92.

51 ARJBM VI, 276.

52 ARJBM III, 288a.

53 ARJBM VI, 277

54 ARJBM III, 288e.

55 Mutis, *Archivo epistolar*, 2:548–51, 553; ARJBM III, 1151a.

56 Mutis, *Diario de observaciones*, 2:584–85.

57 ARJBM III, 1156.

58 ARJBM III, 1, 2, 85, fol. 2r.

59 Mutis, *Archivo epistolar*, 1:300–304.

60 Mutis, *Archivo epistolar*, 1:167, 186.

61 Mutis, *Diario de observaciones*, 2:514.

62 ARJBM III, 1, 2, 85, fol. 3r.

63 ARJBM III, 1, 2, 85, fol. 2v.

64 Mutis, *Archivo epistolar*, 1:439–40.

65 Mutis, *Archivo epistolar*, 1:316.

66 ARJBM III, 2673.

Indian Yellow: Making and Breaking the Imperial Palette

Jordanna Bailkin

This article traces the life and death of a pigment called Indian yellow, a substance that was both unusually popular and unusually controversial during the age of empire. Indian yellow was also known as *purree* or *piuri*, and sometimes as *jaune indien*. Its use was reported in Dutch paintings in the seventeenth century, but its period of greatest popularity in Britain and Europe did not begin until the early nineteenth century.[1] Throughout the Victorian period, Indian yellow was prized in Britain for its value in depicting a wider range and brilliance of skin tones, especially in the darker shades of flesh. It was, therefore, a vital component of the imperial palette. But by the early twentieth century, the pigment had all but vanished—the conditions of its production in India denigrated by the same British lobbyists who had championed its beauty and utility just a few years before. Why did Indian yellow suddenly disappear from British palettes? I argue that if we track this particular pigment from Bengal to London and back again, we can see an atypically explicit conflict between the demands of imperial politics and those of visual culture. Simply put, the twists and turns of Indian yellow revealed the ways in which the desire to *paint* or visually represent colonized peoples came to clash directly with the mission to *rule* them. My hope is that this history of pigment and palette highlights some of the ways in which imperial experiences of race and governance could be deeply and literally material.

Recent studies of the social life of material objects in British India have helpfully sketched out historical shifts in the British "taste" for Indian goods,[2] whereas other scholars have examined the material culture produced by the Raj within India itself.[3] Evangelical missionary educators from England and Scotland, for example, strove to create an object-centered

pedagogy in Indian schools in order to wean Hindu children away from their indigenous "idolatry" and instruct them in the virtuous practices of empirical observation and, ultimately, abstract reasoning.[4] The rise and fall of purree offers a vivid example of the pleasures, perils, and traps of colonial economies: what Natasha Eaton has termed a distinctly Creole dialectic between needs and luxuries, the colonial cosmopolitanism that produced simultaneous attractions and repulsions of the British to "Indian things."[5] Of course, one of the more interesting elements in the history of purree is the question of whether it should properly be considered an "Indian thing" at all. What I have sketched out here is an admittedly quirky tale of the birth and decline of one colonial commodity, one with a special relationship to the related realms of art, religion, racial science, labor, and commerce.

There were particular conditions of life under the Raj that made both the production and the consumption of this pigment highly controversial by the early twentieth century. Before turning to these conditions, however, I wish to situate the debates about Indian yellow in a brief history of the politics of pigment in the eigteenth- and nineteenth-century Atlantic world. What were the mechanics of painting race? How did artists of this period structure their palettes to convey information about racial identity and indigeneity? Was it possible for race to exist in *paint* in a different way than it did in colonial law or colonial science?

Theories of Color, Theories of Race

In 1892, the artist and teacher Oliver Olds published a slim little manual with an uncomfortably lengthy title: *Trinity of Color, or the Law of Chromatics, or How to Paint*.[6] From Olds's point of view, the "trinity" of the title was a particularly holy one. Intended for British and American art students, Olds's book referred not to a trinity of spirits, but to the trinity of races: whites, mulattos, and a deliberately vague category of "darkies." What Olds stressed for his students was that just as national laws governed the intermarriage of the races in life, so too the principles of science governed their interaction on canvas. He determined which pigments artists should use in order to convey without confusion the racial identity of their subjects: for example, the pigment raw sienna should only be used for painting Negro skins.[7] There were pigments to be used for the skins of Caucasians, but Olds also prescribed related pigments for clothes, flowers, and even pets, all to avoid accidentally darkening a white skin through an unintended contrast.

Any violation of the laws of color—the laws that kept the races separate on canvas—would result in "miserable caricature" rather than true art.[8] "If you paint," Olds wrote,[9] "so one could not tell whether a Negro or white person were intended, then wherein lies the merit of your portrait?" The reason that students should learn the science of color and instruct themselves (or be instructed) in the "laws of the palette" was both moral and political: that they might use their pigments to make their racial categories readable and unmistakable.

Olds's text was unusually vivid both in its racism and in its application of pseudo-science to high art. But his connection of race and pigment in the art world was neither new nor unique. This discussion originated in the eighteenth century, most notably in the writings and paintings of William Hogarth. Based on his discussions with medical men, and his readings of the scientific writer Marcello Malpighi, Hogarth believed that skin derived its color from the fluid underneath it. Every human being possessed the same stuff of pigmentation, and differed only in degree. "The fair young girl, the brown old man, and the Negro all have the same appearance," he said, "when the upper skin is taken away."[10] For the most part, Hogarth's African figures were physiognomically similar to whites. They bore no frizzy hair, no thick lips or flat noses. For Hogarth, beauty and race were both skin deep. Skin color, and often skin color alone, was this particular artist's primary indicator of racial identity.[11]

Whereas Hogarth's contemporaries denigrated the "monotony" of black skin—in particular, its inability to blush—Hogarth claimed that darker skins varied as much as white in terms of texture, absorption of light, and reflection of other colors. But his reliance on color over physiognomy to indicate racial difference was atypical among his contemporaries. The famed Dutch naturalist Peter Camper noted that a pivotal moment in the development of his racial theories came from his artistic education. Camper's teacher had asked him to copy a North African Moor from an older painting, a project Camper found objectionable. In the original painting, although the Moor's skin color was black, his features were depicted as European, and for Camper, these two facts were clearly incompatible. The original artist had made a scientific error that Camper did not wish to repeat. Namely, Camper refused to paint a figure that possessed both black skin and European facial features. He claimed that the artist who executed such an image was perpetuating scientific misconceptions.[12] In Camper's racial science, an image in which the subjective category of color served as the sole source of

racial information was inferior to one grounded in an objective, mathematical system of facial angles, the system for which he would become famous.

Recently, scholars have begun to explore the various slippages and insecurities of eighteenth-century racial taxonomies, noting, for example, that British artists of this period often portrayed Native American and Caribbean figures as interchangeable in terms of their skin color. One current theory is that European painters in the eighteenth century approached the topic of skin color with a considerable degree of flexibility, and that even in the nineteenth century skin color and "savagery" did not correspond in any simple or straightforward way. Although nakedness was often a crucial component in the visual depiction of African slaves or Indian "savages," a dark skin was optional. British artists perceived complexion imprecisely and treated skin color as an unpredictable indicator of identity throughout the eighteenth century (Wheeler 2003: 44–45).[13] Part of my intention here is to take this story about paint and race into the nineteenth and twentieth centuries. Did the later period in fact witness a "hardening" of racial ideology in the realm of visual culture, as many historians of race have suggested happened in other spheres of knowledge? Or does the visual culture of race have its own chronology, which might disrupt the accepted dogma of the fluidity of racial identity in the eighteenth century inexorably giving way to the rigidity of the later period?

As this juxtaposition of Olds, Hogarth, and Camper would suggest, the politics of privileging skin color over physiognomy in art were not always obvious, nor were these politics static over the eighteenth and nineteenth centuries. The artistic community was never unified on the question of how to treat skin color with regard to race, and changes over time were accompanied by important national and individual variations. In Britain, eighteenth-century artists and critics may have initiated and promoted discussions of skin color in theories of race (Rosenthal 2004),[14] but it was nineteenth-century scholars who aimed to make these discussions "scientific."[15] Starting in the 1860s, art teachers began to offer skin color charts and proposals to standardize color terminology—especially terms like *dusky*, *swarthy*, and *pale* that might provide clues to racial identity.[16] The standardization of color vocabulary, particularly as it pertained to the human races, was one preoccupation of British art teachers during the age of empire.

But despite this growing interest in the regimentation of color vocabulary, the creation of a palette—even for painting the skin of South Asians or Africans—was never formulaic. It always involved an act of artistic agency

as well as a formal educational apparatus. Indeed, this was Olds's greatest concern: the fact that the individual artist might make decidedly unscientific choices when it came to depicting the skin colors of the different races. For Olds, the greatest disaster that could befall a portrait artist was for the race of his sitter to be misread. But other teachers, especially in Britain, suggested that paint might contribute to the study of race in more progressive ways. Robert Patterson, for example, reminded his art students that each painter must judge, individually, whether to "exalt, diminish, or neutralize the dominant tint" of a given complexion (Patterson 1862: 42).[17] Patterson stressed that the varieties of complexion were infinite; the decision to depict a given complexion as predominantly dark or predominantly fair was ultimately up to the artist, rather than a reflection of some absolute scientific truth as someone like Olds would suggest. When it came to the problem of skin, Patterson said, "no rules could be devised."[18]

In a number of different genres, British artists were continually reminded that the materials they used—the stuff of art—was part of a global economy and a global history of labor. This particular lesson was not confined to professional art schools, but extended into more popular discussions of amateur painting as well. For example, in Edith Nesbit's 1906 children's tale of time travel, *The Story of the Amulet*, British children playing with their shilling paint-boxes are transported to the ancient world to see the origins of their paints. The narrator didactically instructs her readers that anyone who wants to paint an Egyptian or Asiatic complexion should rely on the widely available colors of yellow ochre, red ochre, and sepia. But when the children want to know where these pigments in their paint-box come from, they find themselves amid slave workers in Tyre, miserably put to work extracting dyes from nasty cuttlefish.[19] They are relieved to travel back to their own modern Britain, slightly shaken when they contemplate the paintings they have made and the horrific toil that has facilitated their own pretty pictures. The paint-box becomes a mechanism for the children to understand the unbeautiful facts of empire. The message for young readers—not necessarily skilled artists, but any student or dilettante who picked up a box of paints—was that their renditions of nonwhite peoples were intrinsically and materially linked to the ways in which pigment was produced or extracted via the exploitation of nonwhite labor.

This range of opinion in the realm of art education, coupled with important nineteenth-century changes in the technology of paint and the introduction of a bewildering new range of pigments from the far reaches of the

empire, all raised important questions about how British painters under-stood the materiality of race. Historians and art historians have begun to pay careful attention to visual representations of race—focusing on the painted arrangement of colonized subjects as feminized, inactive, or bloodthirsty, or on British sitters engaged in poses of exotic "cross-dressing," or on the am-biguous status of colonial portraits as both "gifts" and "tributes" to British authorities.[20] With reference to South Asia, Sandria Freitag and others have stressed the ways in which the visual realm has operated as a critical compo-nent of the formation of civil society in modern India;[21] the "visual turn" in modern Indian studies has been increasingly preoccupied with the enor-mous power of images to transform and mobilize individuals and commu-nities in South Asia during precolonial, colonial, and postcolonial moments of history.[22] But what we still lack is a detailed historical sense of the eco-nomic, political, and technological conditions that motivated any given set of colonial depictions and made them possible. This account of the produc-tion, consumption, and death of one pigment—Indian yellow—is an at-tempt to begin to redress this lacuna.

The Production of Indian Yellow

Indian yellow was a brilliant orange-yellow pigment, tactfully described in the eighteenth century as "organic" in origin. Indeed, "organic" was quite an understatement. In fact, purree was produced in India from the urine of cows that had been fed exclusively on mango leaves. British writers seemed unaware or uncertain of the product's origin through the late nineteenth century, denying that any "animal matter" was used in making what ap-peared to be a "vegetable" pigment.[23] Purree was manufactured mainly in Bengal, where the annual yield was up to fifteen thousand pounds of pig-ment a year. But the primary market for the pigment was in Europe; British and German artists in particular had used Indian yellow since the beginning of the eighteenth century.[24] In Europe, Indian yellow was always used in paint (both water and oil), and it was praised for its fineness in conveying the subtleties of skin colors.[25] When mixed with vermilion or hematite, Indian yellow was said to be especially useful in creating a dark brown flesh tone.[26]

British painters already had a good supply of yellows; English ochre, for example, was dug out of the Shotover Hills near Oxford, and by the nine-teenth century much of this substance was known patriotically as Oxford ochre.[27] But while these "domestic" ochres were useful and reliable, they

lacked the radiance of purree. Cadmium yellow and cobalt yellow were both introduced to British consumers at the Great Exhibition of 1851, but these pigments were not recommended for painting flesh tones.[28] Yellow pigments had been imported from India to England before; gamboge, which was made from tree resin, was an exciting novelty when the East India Company introduced it in 1615.[29] Bengal quince was also used to make a vivid yellow dye, but several British observers complained that this color was "tinctorially unknown" in Europe despite their efforts to publicize it.[30] But the value of purree as a "pure, beautiful" color was uncontested,[31] at least until the end of the nineteenth century. In Fielding's *Index of Colours*, it was listed as one of the thirty most useful pigments for figure painting.[32] Indian yellow thus represented a breakthrough in the British palette, being of greater clarity, depth, and saturation of color than either ochre or gamboge and of greater utility in conveying a wider range of flesh tones, especially at the darker end of the spectrum.

In 1883, the British romance with purree came to an end. Two reports exposed the "real" origins—that is, the animal origins—of this prized colonial commodity: one report by Hugh M'Cann of the Bengal Education Department, and another by Trailokya Nath Mukharji, the highest-ranking South Asian in the Department of Revenue and Agriculture and an expert on India's material resources.[33] Both reports were spurred by an inquiry by Sir Joseph Hooker at the Royal Society of Arts. Hooker, ever the ardent taxonomist, wanted an accurate account of how to classify this mysterious and popular substance, and he deputed M'Cann and Mukharji to investigate. M'Cann's discussion of purree took place in a larger debate about the Indian dyeing industry and British improvements thereto. He noted that while a tiny amount of purree would dye one whole yard of cloth bright yellow, Indian consumers uniformly rejected the pigment because of its offensive smell. If Indian artisans used the pigment at all, it was to color doors and railings. The Indian market for this substance was exclusively geared toward craft, and not the fine arts.[34]

Mukharji's fieldwork was more damning.[35] In his report of 1883, Mukharji revealed that there were actually *two* pigments named Indian yellow: one was the more widely known substance from Bengal, and the other was a mineral pigment that was made in London and exported to Calcutta.[36] The mineral pigment from London was never mentioned in any of the British paint charts or color guides; Mukharji claimed that the pigment made in England was not as bright as that manufactured in India and the English

product was therefore less desirable for artists. In India, Mukharji tracked the production of purree to a village in northeastern Bihar. Here he interviewed a group of *gwalas* (milkmen) who were busy manufacturing the pigment. He described how they collected the urine in small earthen pots, and concentrated it by heating it over a fire. The liquid was strained through a cloth, and the gwalas then formed the sediment into balls, which they dried in the sun. The balls were sold to local merchants, who would occasionally advance money to the milkmen for its manufacture. Typically, merchants paid one rupee per pound of pigment; once they shipped the pigment to Calcutta, the price could go up to one or two hundred rupees. Indian observers reported that the pigment was never used locally, but was always sent to Calcutta for shipment to Europe (Banerjei, 1976: 19).[37]

Once in Europe, the balls of pigment were washed, purified, and formed into yellow tablets to be used as a base for oil paint or watercolor. The trade in purree was not necessarily profitable for the milkmen, but was quite lucrative for the merchants; dealers in Indian yellow could reach taxable income levels. Some European writers denounced the high cost of purree; Frederick Maire, for example, complained that the expense of Indian yellow made it difficult for "ordinary" modern artists to add it to their palettes and thus ensure a full range of flesh tones.[38] An advertisement from Reeves and Sons in 1891 put the price of a cake or tube of Indian yellow at one and sixpence,[39] a relatively high cost that British artists still seemed willing to pay.

The Ends of Purree

In 1908, exactly twenty-five years after Mukharji's report, the Government of India banned purree. Both the manufacture of purree and its export to foreign markets were to cease immediately. Why did the British intervene in such a profitable colonial venture, one apparently of great use to their own artists? The pigment had long been described as dirty, ill smelling, and possibly unhygienic;[40] modern chemists have raised the possibility that the pigment was in fact toxic.[41] But the primary concern in Britain—at least from 1883 to 1908—was not about toxicity or European health; rather, it was the perceived gap between colonial and metropolitan codes of production. The production of dye and pigment had become a focal point of indigenous political discontent in this region before, most famously during the famed Bengali indigo disturbances of the 1850s and 1860s.[42] But beyond this his-

torical precedent, the particular problem with purree was its imbrication in the realm of colonial labor and colonial religion: specifically, the threat this valuable commodity posed to the sacred cow of Hindu belief and practice.

Mukharji's report had noted a disturbing element of purree manufacture: namely, that the cows used for making purree were dying. The process of manufacturing purree (again, primarily for the British palette and more specifically for British representations of brown skin) depended on artificially stimulating the cows' urine, and limiting their diets to mango leaves, which led to severe malnutrition. The high price of purree in Europe was due in part to the fact that the gwalas had to replace the cows every two years; few cows survived longer than that.[43] Mukharji insisted that the manufacture of purree was not so deadly as its critics would suggest; he recorded earlier reports, mostly by regular dairy farmers in Monghyr, that said all cows used in this capacity died in two years, but he argued that he had seen much older cows put to this purpose. He admitted that the cows seemed "very ill and poorly nourished, though they were not being killed wholesale."[44] As Mukharji noted with sadness, the cow-keepers (the gwalas) were being stigmatized because of their role in producing this pigment as cow-destroyers, and dangerous social antagonisms were developing as a result.[45]

Art critics of the 1920s and 1930s referred to the ban of purree as a humane and merciful act of British government: the result of a movement that escalated in London in the 1890s and culminated in the 1908 law in Bengal.[46] The problem with this interpretation, which has long since passed into the realm of popular myth,[47] is that I can find no legislative record of a ban on purree by the Government of India, nor can I locate any record of a discussion about this pigment in *Hansard's Parliamentary Debates*. When I began to research Indian yellow, a chemist who had searched in vain for this legislation previously assured me that he must have been looking in the wrong place; a professionally trained historian would have better luck. Alas, a disciplinary divide was not the problem. If the British did ban the production of purree in India, this ban has left very little in the way of documentary trace.[48] What is clear is that production of purree continued through to 1910; the pigment then fell into disuse and was unavailable commercially after 1921.[49] Although there were manmade German substitutes for Indian yellow, Doerner noted in his *Materials of the Artist* that these substances such as German indanthrene yellow never managed to capture the "peculiar" and "beautiful" gold tones of purree;[50] the disappearance of Indian

yellow was at least somewhat of an artistic disappointment. Let me suggest some of the reasons why the British government might have instituted an informal ban on this pigment, discouraged its import into the United Kingdom, or encouraged at least the perception that it had outlawed this commodity's production outright.

Mukharji's report coincided with the rise of humanitarian and antivivisection movements in Britain,[51] which provided a new context for British interpretations of Indian yellow. In fact, an amendment to the Cruelty to Animals Act was discussed and passed in the same month that Hooker sent Mukharji off to Bihar.[52] The Royal Society for the Prevention of Cruelty to Animals had concerned itself before with improper treatment of animals in the colonies, legislating against cruelty to animals in Ceylon in 1862.[53] Furthermore, the British administration in India had brought in a series of protective laws relating to cattle prior to 1908: the Cattle Trespass Act in 1871 and the Prevention of Cruelty to Animals Act in 1890. But the prohibition of Indian yellow, whether it took place in legislative terms or simply through accelerated disuse and discouragement, was distinct from these humanitarian precedents. In Britain, cruelty to animals was thought to stem either from working-class brutishness or from the unfortunate by-products of medical progress. But the alleged cruelty to cows in India was engendered by British consumer demand, not by indigenous custom.[54] Whereas many British debates regarding foreign or colonial commodities—such as tea— stressed the dangers of Eastern manufacturers who required legal regulation and intervention to prevent them from adulterating their products and endangering British buyers,[55] the only dangers in the case of Indian yellow seemed to be to Indians themselves. For once, indigenous moral failure and inauthenticity were not the key issues.

Instead of signaling an indigenous process of adulteration, the existence of Indian yellow, especially as an export, pointed to a wide variety of British failures. Regulating the treatment of Indian cattle was vitally important to preserving the appearance of virtuous and effective British rule. Starting in the 1880s, the development of indigenous Cow Protection Societies in India became a focal point of British concern.[56] The first Cow Protection Society, or Guarakhshini Sabha, was established in 1882, just one year before Mukharji's investigation. According to colonial authorities, these societies created an active and powerful bloc of Indian leaders and encouraged the unification of Hindu interests across class and region; both developments were potentially destabilizing to the Raj. Such concerns about cow

protection heightened metropolitan fears that highly influential and well-organized indigenous protest groups could supersede the British apparatuses of local government. Indeed, Lord Lansdowne referred to the cow protection movement as the greatest threat to the British government in India since the "Mutiny."

The ostensible focus of these organizations was to protect Indian cattle from rampaging Muslims, not from British artists. Nevertheless, one salient point about the cow protection movement is that it labeled Muslims and the British equally impure. According to the movement's leaders, the regulation of purity and pollution in India was to be placed in Indian hands.[57] The fact that cow protection came primarily from an indigenous vigilante source of power led the British to reassert their dominance through their own forms of protection: that is, the disuse of Indian yellow. But in part, it was British legislative failure in the 1860s that necessitated new action in the early twentieth century. According to the Indian Penal Code of 1860, perhaps the most important legal legacy of the Raj, a cow was *not* a sacred object. Cows were therefore not covered by section 295 of the Code, the section against destroying places of worship or objects held sacred.[58] This interpretation of the Code was upheld in a High Court ruling of 1888; after this ruling, the indigenous cow protection movement swept India's urban and rural centers, destabilizing the British government's manipulation of Indian networks of social control. The "ban" on Indian yellow may have represented a British effort to regain that control, a British attempt to avoid the perception that the Raj allowed violations of indigenous religious practice and even instigated communal violence in order to feed its own consumer demands.

The "ban" followed closely on a general boycott of British goods in the same part of Bihar,[59] and although it is unlikely that the disuse of Indian yellow by British buyers had a sufficiently wide economic impact to constitute an effective response to *swadeshi* policies, the British rejection of this pigment in the early twentieth century reflects the highly charged politics of imported and exported commodities during this era of the Raj, as well as the British desire to find an alternative to the Brahmin nationalist politics of swadeshi that was structured around the rejection of British goods. If the British taste for painting brown flesh had produced new indigenous pathologies—that is, the destruction of the cow as material, spiritual, and social resource—then the British would now promote the perception that they had brought this traffic to an end.

The trajectory of Indian yellow shares certain key characteristics with the histories of other colonial commodities and their relationship to tales of economic, social, and cultural decline. For example, the production of leather goods in Bihar to outfit the British army engendered similar debates about the destructive demands of foreign markets on indigenous religious practices.[60] But regarding Indian yellow, the particular conjunction of the issue of "sacredness" with the realm of art and aesthetics made this pigment particularly intriguing within the world of colonial things. It does seem that any British "ban" operated informally rather than legislatively, but what is clear is that the agitated decades of the 1920s and 1930s saw a serious British effort to publicize this presumed humanitarian intervention, and also to denigrate the pigment of Indian yellow as impermanent and unstable—hopelessly out of fashion. Indeed, the claim that Indian yellow was impermanent first appeared shortly after Mukharji's report, which made clear that the production of Indian yellow was incompatible with good colonial governance.[61] The British palette had changed, and a particular mode of depicting colonized subjects had diminished aesthetic appeal precisely because the process of acquiring the raw materials to produce these depictions had itself become a threat to British rule. In short, the long-standing practice of *depicting* Indians on canvas had come into open conflict with the desire to *govern* them. By the 1920s, British artists were no longer painting flesh in the same range of colors.

The notion that the choice of pigment and palette was politically vested was more directly expressed as the age of empire drew to an end. As the chemist C. A. Klein reminded his students in 1924 in terms that put a considerably sunnier face on Nesbit's nightmarish vision of pigment and labor, a tin of paint represents the work of many workers and the produce of many lands: linseed oil and resin from India, white lead from Australia, and tin from Singapore. Taking this history of labor and export into account, he said, a "wonderful story of empire" could be written about the ordinary tin of paint.[62] But as Klein himself underscored, all pigments and paints seemed to involve the extraction of labor of some kind. Along the same lines, the art teacher Arthur B. Allen compared the origin of the painter's palette to the origin of the alphabet: a "communal contribution spread over a wide area, in a profuse manner." Furthermore, Allen argued that modern British conceptions of race and color originated in ancient artistic representations. When

an Egyptian painted an Asiatic, Allen said, he painted him in yellow, and that accounted for the erroneous modern casting of Asians as "yellow men." The division of races into color groups—that is, thinking of race as a visual phenomenon at all—was rooted for Allen in the history of paint itself.[63] Paint, he implied, was logically prior to the legal and scientific (or pseudo-scientific) systems of racial classification that held such powerful sway over the minds of his countrymen. The hyperbole of Allen's claims about racial identity being "created" through paint should not prevent us from seeing that a host of teachers and critics like him were busily instructing British art students both about techniques of color and about the political ramifications of their choices. The centrality of art in colonial encounters[64] is evident not only on finished canvases, but in the negotiations that preceded them in order to acquire the stuff of art itself. Some of the most basic elements of artistic production were themselves products of colonial engagement.

Methodologically speaking, the case of Indian yellow suggests that a history of empire narrated via the history of material culture is by no means a way of leaving the politics out, even if one employs a strictly "high" definition of the political. At first, the merit of the pigment seemed to lie in its capacity to convey essential truths about the visual appearance of the British Empire's "dark races." But ultimately, it may have accrued even more value beyond the canvas. To put it another way, did British authorities in London and Bengal have more to gain from encouraging the consumption of Indian yellow or from the abolition of it? The use of Indian yellow initially offered European artists greater effectiveness in painting darker skins, no insignificant asset in the imperial work of visual documentation and fantasy. But the *disuse* of the pigment—on the grounds of either promoting liberal humanitarian values in colonial locales or of preventing communal violence—afforded a far greater political opportunity to expand the field of the Raj's intervention in Indian affairs. Indian yellow had several different incarnations as a colonial commodity. The function of the pigment shifted over time from the enhancement of metropolitan artists' abilities to represent fully the diversity of colonized subjects to the enlargement of a new realm of imperial governance: namely, the regulation of indigenous marketplaces and religious practices.

The rise and fall of Indian yellow is explained in part by the pigment's relationship to the vagaries of imperial rule. As Britons cautiously calibrated their relationship to "Indian things," it became evident that the regulation and renunciation of the objects of empire offered its own unique set of plea-

sures and powers beyond the gratifications of consumption. The role of purree from a British perspective was at first limited to its capacity to capture the flesh, to represent something about dark skin that was previously believed to be elusive. What Mukharji's report revealed was the danger of representation, the fact that the very mechanics of creating purree could themselves pose a threat to effective foreign governance. Both because the process of making Indian yellow potentially destabilized the religious energies of the region and because the local responses to this destabilization prompted powerful new forms of indigenous organization, the consumption of purree soon proved to be against the interests of the colonial state. The banning of purree, or at least the promotion of the perception thereof, enabled the British to claim a more significant role in the peaceful government of India than painting its people could have done, and the dangers of purree were neutralized. This particular element of visual culture—the pigment called purree—had at different moments challenged and facilitated the development of British power in India. This brief history of pigment production in Britain and its empire, which seeks to reconstruct the politics of the palette at one key moment in time, also begins to suggest the ways in which the visual arts might best be understood as a powerful argument about—not merely a reflection of—the historical processes of racial formation and racial identity.

Notes

Jordanna Bailkin, "Indian Yellow: Making and Breaking the Imperial Palette," *Journal of Material Culture* 10(2) (2005): 197–214, reprinted by permission of Sage Publications.

This article was originally presented at the North American Conference on British Studies (Portland, Oregon, 2003) as part of a panel titled "Foreign Objects: Knowledge and the Material Culture of Empire." I thank our organizer, Erika Rappaport; our commentator, Doug Peers; and the audience for stimulating questions. Deborah Cohen, Michael Fisher, and Caroline Winterer made further insightful comments on a later version of the article. I gratefully acknowledge the assistance of the Yale Center for British Art, the Keller Fund at the University of Washington, and the National Humanities Center in funding the initial research for this project, and thank the editors and reviewers of the *Journal of Material Culture* for their helpful suggestions.

1 Philip Ball, *Bright Earth: Art and the Invention of Color* (Chicago: University of Chicago Press, 2001).

2 Nupur Chaudhuri, "Shawls, Jewelry, Curry, and Rice in Victorian Britain," in *Western Women and Imperialism: Complicity and Resistance*, ed. Nupur Chaudhuri and Margaret Strobel (Bloomington: Indianapolis University Press, 1992), 231–46; Tim Barringer and Tom Flynn, eds., *Colonialism and the Object: Empire, Material Culture and the Museum* (London: Routledge, 1998); Michelle Maskiell, "Consuming Kashmir: Shawls and Empires, 1500–2000," *Journal of World History* 13(1) (2002): 27–65.

3 Thomas Metcalf, *An Imperial Vision: Indian Architecture and Britain's Raj* (Berkeley: University of California Press, 1989); Swati Chattopadhyay, "'Goods, Chattels and Sundry Items': Constructing Nineteenth-Century Anglo-Indian Domestic Life," *Journal of Material Culture* 7(3) (2002): 243–71.

4 Parna Sengupta, "An Object Lesson in Colonial Pedagogy," *Comparative Studies in Society and History* 45(1) (2003): 96–121.

5 Natasha Eaton, "Excess in the City? The Consumption of Imported Prints in Colonial Calcutta, c.1780–c.1795," *Journal of Material Culture* 8(1) (2003): 45–74. The essay appears in this volume, chapter 6.

6 Oliver Olds, *Trinity of Color, or the Law of Chromatics, or How to Paint* (New York, 1892).

7 Olds's prescriptions are borne out by other artists, such as the genre painter William Sidney Mount, who made his living from highly stylized reproductions of black musicians. In producing the artificial, chocolaty brown for his "Negro" subjects, he drew on a mixture of Van Dyke brown, Indian red, burnt sienna, yellow ochre, and terre verte. See Albert Boime, *The Art of Exclusion: Representing Blacks in the Nineteenth Century* (Washington: Smithsonian Institution Press, 1990), 6.

8 Olds, *Trinity of Color*, 29.

9 Olds, *Trinity of Color*, 28.

10 William Hogarth, *An Analysis of Beauty* (New Haven, CT: Paul Mellon Centre for British Art by Yale University Press, 1997), 88.

11 David Dabydeen, *Hogarth's Blacks: Images of Blacks in Eighteenth-Century English Art* (Manchester: Manchester University Press, 1987); David Bindman, "'A Voluptuous Alliance between Africa and Europe': Hogarth's Africans," in *The Other Hogarth: Aesthetics of Difference*, ed. Bernardette Fort and Angela Rosenthal (Princeton: Princeton University Press, 2001), 260–69.

12 Roxann Wheeler, *The Complexion of Race: Categories of Difference in Eighteenth-Century British Culture* (Philadelphia: University of Pennsylvania Press, 2000); David Bindman, *Ape to Apollo: Aesthetics and the Idea of Race in the Eighteenth Century* (London: Reaktion, 2002).

13 Roxann Wheeler, "Colonial Exchanges: Visualizing Racial Ideology and Labour in Britain and the West Indies," in *An Economy of Colour: Visual Culture and the Atlantic World, 1660–1830*, ed. Geoff Quilley and Dian Kriz (Manchester: Manchester University Press, 2003), 36–59. Along similar lines, Rebecca Earle ("Luxury, Clothing and Race in Colonial Spanish America," in *Luxury in the*

Eighteenth Century: Debates, Desires and Delectable Goods, ed. Maxine Berg and Elizabeth Eger [Houndmills: Palgrave, 2003], 219–27) argues with reference to sumptuary legislation in the colonial Americas that eighteenth-century scientific opinion regarded clothing as a racial characteristic. Earle notes that because "race" was partly defined by a person's wealth, clothing could be a more important indicator of racial status than skin color. By the nineteenth century, discussions of dress had disappeared from most classificatory systems of race.

14 Angela Rosenthal, "*Visceral* Culture: Blushing and the Legibility of Whiteness in Eighteenth-Century British Portraiture," *Art History* 27(4) (2004): 563–92.

15 In the late nineteenth and early twentieth centuries, discussions of skin tone were increasingly linked to broader medical theories about the visual markers of health or disease. See William Henry Jonas Brown and A. Campbell, *The Complexion: How to Preserve and Improve It* (London: H. Renshaw, 1889); Herbert John Fleure, *The Characters of the Human Skin in Their Relations to Questions of Race and Health* (London: Chadwick Trust, 1927), 29–30.

16 Allan Cunningham, "On the Colour-Sense," *Nature* 32 (1885): 604; E. J. Taylor, "The Standardizing and Teaching of Colour," *Third International Art Congress* (1908): 221–25. The famed Cambridge anthropological experiments with skin, hair, and eye color charts in the late nineteenth century are discussed in Henrika Kuklick, *The Savage Within: The Social History of British Anthropology, 1885–1945* (Cambridge: Cambridge University Press, 1991).

17 Robert Hogarth Patterson, *Essays in History and Art* (Edinburgh, 1862), 42. For other useful sources on artistic renditions of flesh tones, see Thomas Page, *The Art of Painting* (Norwich: W. Page, 1720); William Enfield, *Artists' Assistant* (London: Simpkin and Marshall, 1822); R. H. Laurie, *The Art of Painting in Water-Colours* (London: R. H. Laurie, 1832); Henry Warren, *Hints upon Tints, with Strokes upon Copper and Canvas* (London, 1833); Theodore Henry Fielding, *On the Theory of Painting* (London, 1842); Thomas Miller, *A Treatise on Water Colour Painting as Applied to the Landscape and the Figure* (London, 1848); John Burnet, *Practical Hints on Portrait Painting* (London: David Bogue, 1850); Alice Baker, *How to Paint Photographs in Oils and Water-Colours* (Leeds: Chorley and Pickersgill, 1902).

18 Patterson, *Essays in History and Art*, 42.

19 Edith Nesbit, *The Story of the Amulet* (London: T. Fisher Unwin, 1906), 261, 315.

20 Julie Codell and Dianne Sachko Macleod, eds., *Orientalism Transposed: The Impact of the Colonies on British Culture* (Aldershot: Ashgate, 1998); Beth Fowkes Tobin, *Picturing Imperial Power: Colonial Subjects in Eighteenth-Century British Painting* (Durham: Duke University Press, 1999); Geoff Quilley and Dian Kriz, eds., *An Economy of Colour: Visual Culture and the Atlantic World, 1660–1830* (Manchester: Manchester University Press, 2003); Natasha Eaton, "Mimesis and Alterity: Art, Gift, and Diplomacy in Colonial India," *Comparative Studies in Society and History* 46(4) (2004): 816–44.

21 Sandria Freitag, "The Realm of the Visual: Agency and the Modern Civil Society," in *Beyond Appearances? Visual Practices and Ideologies in Modern India*, ed. Sumathi Ramaswamy (New Delhi: Sage, 2003), 365–97.

22 Sumathi Ramaswamy, ed., *Beyond Appearances? Visual Practices and Ideologies in Modern India* (New Delhi: Sage, 2003).

23 In 1844, John Stenhouse noted that some observers had claimed that Indian yellow was made of animal matter, either from the gallbladders of camels, elephants, and buffalo or from the deposit of their urine. But Stenhouse dismissed these reports as fantastic rumors and labeled the pigment vegetable in origin: "the juice of some tree or plant." John Stenhouse, "Examination of a Yellow Substance from India Called Purree, from which the Pigment Called Indian Yellow Is Manufactured," *Dublin Edinburgh London Philosophical Magazine* 25 (1844): 321–25. See also George H. Bachhoffner, *Chemistry as Applied to the Fine Arts* (London: J. Carpenter, 1837); Frederick Crace-Calvert, *Dyeing and Calico Printing* (Manchester, 1876); John William Mollett, *An Illustrated Dictionary of Words Used in Art and Archaeology* (London: Sampson and Low, 1883).

24 George Field, *The Rudiments of Colours and of Colouring* (London: Strahan, 1870).

25 Mary Philadelphia Merrifield, *Practical Directions for Portrait Painting in Water Colours* (London: Windsor and Newton, 1851), 16, 36–37.

26 H. C. Standage, *The Artists' Manual of Pigments* (London: Crosby Lockwood, 1886). On the use of Indian yellow in European watercolor painting, see Ernest Parry and John H. Coste, *The Chemistry of Pigments* (London: Scott, Greenwood, 1902), 273–75; on its use in oils, see Edward Fielding, *Mixed Tints, Their Composition and Their Use* (London, 1859), and M. M. Riffault, A. D. Vergnaud, and G. A. Toussaint, *A Practical Treatise on the Manufacture of Colours for Painting*, trans. A. A. Fesquet (Philadelphia: H. Baird, 1874).

27 R. D. Harley, *Artists' Pigments, c.1600–1835: A Study in English Documentary Sources* (London: Butterworth Scientific, 1970), 105.

28 J. Gauld Bearn, *The Chemistry of Paints, Pigments, and Varnishes* (London: Ernest Benn, 1923), 79.

29 Harley, *Artists' Pigments*, 105.

30 Thomas Wardle, *Monograph on the Wild Silks and Dye Stuffs of India* (London, 1878).

31 John P. Ridner, *The Artist's Chromatic Hand-book, Being a Practical Treatise on Pigments, Their Properties, and Uses in Painting* (New York: George P. Putnam, 1850), 42.

32 Theodore Henry Fielding, *Index of Colours and Mixed Tints* (London, 1830).

33 Hugh M'Cann, *Reports on the Dyes and Tans of Bengal* (Calcutta: Bengal Economic Museum, 1883); T. N. Mukharji, "Piuri, or Indian Yellow," *Journal of the Society of Arts* 32 (1883): 16–17; Peter Hoffenberg, *An Empire on Display: English, Indian, and Australian Exhibitions from the Crystal Palace to the Great*

War (Berkeley: University of California Press, 2001); Joseph Childers, "Outside Looking In: Colonials, Immigrants, and the Pleasure of the Archive," *Victorian Studies* 46(2) (2004): 297–307.

34 M'Cann, *Reports on the Dyes and Tans*, 92.

35 George Watt, *A Dictionary of the Economic Products of India* (Calcutta: Superintendent of Government Printing, 1892), 6(part 1):132.

36 "Indian" yellow was also produced synthetically in Germany starting in 1889. See A. Eibner, "Indian Yellow and Its Substitutes," *Tech. Mitt.* 22 (1905): 164–67.

37 N. N. Banerjei, *Monograph on Dyes and Dyeing in Bengal* (New Delhi: Navrang, 1976).

38 Frederick Maire, *Modern Pigments and Their Vehicles* (New York: John Wiley, 1908), 89.

39 Bachhoffner, *Chemistry as Applied to the Fine Arts*, 168; H. C. Standage, *A Handbook of the Chemical and Artistic Qualities of Water-Colour Pigments* (London: Reeves and Sons, 1891); N. S. Baer, A. E. Joel, R. L. Feller, and N. Indictor, "Indian Yellow," in *Artists' Pigments: A Handbook of their History and Characteristics*, ed. Robert Feller (Cambridge: Cambridge University Press, 1986), 1:17–36.

40 Eibner ("Indian Yellow and Its Substitutes") argued that "refined" Indian yellow had no odor, although he also noted that the odor served as a reliable sign of the true organic pigment (versus the synthetic). The mixture, he said, was "freed" from its odor when it was processed into an artist's color.

41 Baer et al., "Indian Yellow," 1:25.

42 Blair B. King, *The Blue Mutiny: The Indigo Disturbances in Bengal, 1859–1862* (Philadelphia: University of Pennsylvania Press, 1966).

43 Banerjei, *Monograph on Dyes and Dyeing*, 19.

44 Watt, *Dictionary of the Economic Products of India*, 6 (part 1):132.

45 Mukharji, "Piuri, or Indian Yellow," 16–17.

46 Rutherford J. Gettens and George L. Stout, *Painting Materials: A Short Encyclopedia* (New York: D. Van Nostrand, 1942), 119; Noel Heaton, *Outlines of Paint Technology* (London: Charles Griffin, 1947), 137.

47 Baer et al., "Indian Yellow"; Ball, *Bright Earth*.

48 On the politics of colonial archives (and their absences in particular), see Nicholas Dirks, "Colonial Histories and Native Informants: Biography of an Archive," in *Orientalism and the Postcolonial Predicament: Perspectives on South Asia*, ed. Carol Breckenridge and Peter van der Veer (Philadelphia: University of Pennsylvania Press, 1993), 279–313; Nicholas Dirks, "The Crimes of Colonialism: Anthropology and the Textualization of India," in *Colonial Subjects: Essays in the Practical History of Anthropology*, ed. Peter Pels and Oscar Salemink (Ann Arbor: University of Michigan Press, 1999), 153–79; Saloni Mathur, "History and Anthropology in South Asia: Rethinking the Archive," *Annual Review of Anthropology* 29 (2000): 89–106; Antoinette Burton, *Dwelling*

in the Archive: Women Writing House, Home, and History in Late Colonial India (Oxford: Oxford University Press, 2003).

49 D. F. Cary, *Colour Mixing and Paint Work* (London, 1925); A. P. Laurie, *The Painter's Methods and Materials* (London: Seely, 1926); Max Doerner, *The Materials of the Artist* (London: G. G. Harrap, 1935).

50 Doerner, *Materials of the Artist.*

51 Brian Harrison, "Animals and the State in Nineteenth-Century England," *English Historical Review* 88 (1973): 786–820; Coral Lansbury, *This Old Brown Dog: Women, Workers and Vivisection in Edwardian England* (Madison: University of Wisconsin Press, 1985); Harriet Ritvo, *The Animal Estate: The English and Other Creatures in the Victorian Age* (Cambridge, MA: Harvard University Press, 1987); Dan Weinbren, "Against All Cruelty: The Humanitarian League, 1891–1919," *History Workshop Journal* 38 (1994): 86–105; Hilda Kean, "'The Smooth Cool Men of Science': The Feminist and Socialist Response to Vivisection," *History Workshop Journal* 40 (1995): 16–38.

52 *Hansard's Parliamentary Debates* 276 (February 16, 1883).

53 Harrison, "Animals the State," 806.

54 There is a parallel of sorts between the "ban" on Indian yellow and the British movement against the feather trade (Weinbren, "Against All Cruelty"). In the latter case, fashionable women were encouraged to boycott feathers because of the cruelty to birds engendered by the trade. But the purchase of the feather did not represent an abandonment of a global "civilizing" mission for the British in the same way as the purchase of Indian yellow.

55 Erika Rappaport, "The Public's Health and the Dangers of Chinese Tea in Mid-Victorian Britain," paper presented at the North American Conference on British Studies, Portland, Oregon (2003).

56 Anthony Parel, "The Political Symbolism of the Cow in India," *Journal of Commonwealth Political Studies* 7(3) (1969): 179–203; Sandria Freitag, "'Natural Leaders,' Administrators and Social Control: Communal Riots in the United Provinces, 1870–1925," *South Asia* 1(2) (1978): 27–41; Sandria Freitag, "Sacred Symbol as Mobilizing Ideology: The North Indian Search for a 'Hindu' Community," *Comparative Studies in Society and History* 22(4) (1980): 597–625; Anand Yang, "Sacred Symbol and Sacred Space in Rural India: Community Mobilization in the 'Anti-Cow Killing' Riot of 1893," *Comparative Studies in Society and History* 22(4) (1980): 576–96; Peter Robb, "The Challenge of Gau Mata: British Policy and Religious Change in India, 1880–1916," *Modern Asian Studies* 20(2) (1986): 285–319; Harjot Oberoi, "Brotherhood of the Pure: The Poetics and Politics of Cultural Transgression," *Modern Asian Studies* 26(1) (1992): 157–97.

57 Oberoi, "Brotherhood of the Pure."

58 Freitag, "Sacred Symbol as Mobilizing Ideology."

59 Sumit Sarkar, *The Swadeshi Movement in Bengal, 1903–1908* (New Delhi: People's Publishing House, 1973).

60 Tirthankar Roy, "Foreign Trade and the Artisans in Colonial India: A Study in Leather," *Indian Economic and Social History Review* 31(4) (1994): 461–90.

61 Standage, *Handbook of the Chemical and Artistic Qualities*, 30.

62 C. A. Klein, *Chemistry in the Manufacture of Paints, Pigments, and Varnishes* (London: Ernest Benn, 1924), 24.

63 Arthur B. Allen, *Imagination and Reality in Colour: An Art Manual for Teachers* (London: F. Warne, 1939), 55–59.

64 Eaton, "Mimesis and Alterity."

Colonial Panoramania

Roger Benjamin

———————————

The universal expositions brought metropolitan and regional publics (as well as many foreign visitors) face to face with the French colonies through a complex array of representations. The best known are the colonial pavilions, elaborate temporary structures, each a pastiche of traditional building styles in the colony. Nearly as familiar (touching as they do the history of anthropology as well as popular culture) are the native villages, where traditional temporary dwellings—huts, tents, tepees—were staffed by indigenous peoples brought from far-off colonies.[1]

The *insides* of the colonial pavilions, however, are a little-examined sphere of visual art and spectacle: the use of panoramas and dioramas, and collections of easel paintings to represent distant colonial sites.[2] The word *panoramania* in this chapter's title was coined to describe the fashion for the vast circular paintings that gave unprecedentedly accurate "all-embracing views" of places.[3] Such gigantic paintings, along with dioramas and *tableaux vivants*, proved among the most popular attractions of the universal and colonial expositions. Orientalists harnessed all these forms of image making, and the phrase "colonial panoramania" suggests the enthusiasm for such visual technologies, as pressed into service by colonial interests in fin-de-siècle France.

In propagating panoramania in the colonial sphere, the Society of French Orientalist Painters once again proved a driving force, at least in the three expositions treated in this chapter: the 1900 Paris Universal Exposition, the 1906 National Colonial Exposition of Marseille, and the 1907 National Colonial Exposition at Nogent-sur-Marne. The society realized that its annual salons were minor events compared with the expositions—thirty-nine million people visited the 1900 Paris exposition over its seven-month duration, for example.[4] Anticipiating such success, the Orientalist Painters orga-

nized two separate exhibitions for 1900, and its members worked on murals for colonial pavilions and on panoramas, dioramas, and other spectacular projects scattered about the colonial precinct.[5]

It is not surprising that the Society of French Orientalist Painters, formed as it was in the aftermath of the Fine Arts Room at the 1889 Algerian pavil-ion, came to specialize in assembling exhibitions on request, providing a thematically appropriate veneer of colonial high art for expositions and other displays. Léonce Bénédite, at the invitation of the premier cultural institute in French Tunisia, the Institut de Carthage, in 1897, had taken an exhibition of one hundred pictures to that protectorate.[6] The Orientalist Painters made painting as a means of cultural transfer their special province, exploring the potential of murals, panoramas, and *salonnets* (or little salons) of portable easel pictures to communicate between nation and colonies.

Colonial Spectacle: Murals, Panoramas, Dioramas

In considering how the Ministry of the Colonies regulated the vast colonial precinct of the Trocadéro Gardens in 1900, it is useful to draw upon the cul-tural theorist Tony Bennett's idea of the "exhibitionary complex." Bennett distinguishes between official government displays at the expositions and popular attractions and assesses the interplay between those zones in a dis-cursive as well as material sense. "Initially," Bennett writes, "these fair zones established themselves independently of the official expositions and their organizing committees. The product of the initiative of popular showmen and private traders, . . . they consisted largely of an ad hoc melange of both new (mechanical rides) and traditional popular entertainments (freak shows etc)."[7] As expositions came increasingly under the control of the central government, the fairgrounds more closely complemented the themes pre-sented in the official zones.

Such a relationship is evident in the displays devoted to Algeria, promi-nent among the pavilions of the Trocadéro Gardens (on the Right Bank of the Seine across the river from the Eiffel Tower) that housed the French colonies, foreign colonies, sovereign Oriental powers, and attractions like the Trans-Siberian Panorama.[8] Algeria, as the richest French colony, had pride of place on the main axis between the Trocadéro and the Eiffel Tower. Its official and commercial sections were housed in two separate buildings on either side of the great thoroughfare. Both were designed in the "Moor-ish" style by the French architect Albert Ballu.[9] The Palace of Algerian At-

tractions, a conglomerate of "picturesque, familial, and mercantile Algeria,"[10] was a major site of colonial panoramania: it housed two commercial installations, the Moving Stereorama, and the Algerian Diorama (to which I will turn shortly). Below them was the much photographed Algerian Quarter, a corner of a generic casbah reconstructed on the banks of the Seine. The idea was derived from the famous Cairo Street of the 1889 exposition, with a similar emphasis on the realism of the facsimile architecture.

Indeed, simulacra played a crucial role in the exhibitionary complex. The streets and villages of 1900, with their staff of transported indigenes, claimed to remove observers to the other world. They were a confluence of dreams and real-life encounters: indigenous displays were often the site of ludic exchanges, ennui, even sexual engagements that shattered the illusion of a pristine world of visual alterity. As early as the 1867 exposition commentators sensed the now familiar idea of the exposition as microcosm: "This immense exposition recapitulates the entire world. . . . Dreamers of travel, those who are attached by the short chain of their jobs and who dream of excursions to the banks of the Nile or the Bosphorus . . . have no reason to complain. If they cannot go to the Orient, the Orient has come to them."[11]

Opposite the jumbled Palace of Algerian Attractions was the spatially more coherent Official Palace of Algeria, a government installation in composite Moorish style, with horseshoe arches and a long colonnade. The central court, with its ceremonial staircase addressing the Pont d'Iéna, was based on one in the Bardo Palace, and the dome and minaret, on Algerian models like the Mosque of Bou Medine near Tlemcen. On the Official Palace's basement floor a set of casts of classical antiquities from the ruins of Timgad and Tebessa established a museological tone, simultaneously claiming, that is, to educate and delight. Those purposes were somewhat opportunistically spliced, as Zeynep Çelik points out, with a wine bar for tasting the "delights" of colonial viticulture.[12]

Up on the airy first floor of the Moorish courtyard, after the displays of the Algerian press, the education authority, and the Winter Tourism Committee of Algiers, came the stand-alone Fine Arts Room mounted by the Orientalist Painters. It was decorated with a frieze of stenciled cactus designed by Chudant, incorporating the initials of the Society of French Orientalist Painters.[13] Here the society had been asked to provide (as Bénédite wrote) "an exhibition of more particularly ethnographic character." According to the Hachette guide there was "nothing so gay and bright as this hall inundated with light, where all these canvases representing scenes of Alge-

rian life are shown to the best advantage." Hachette also commends a "large chart of the French domination in Africa, as well as the relief map, 6 by 4 meters, that occupies the center of the room."[14]

Such didactic displays alter the symbolic tone of the Fine Arts Room considerably. Facts and figures, hortatory phrases, combinations of images and words were variants on the standard exposition installation that Philippe Hamon, in his book on the nineteenth-century exposition as a formation of literature as well as architecture, has characterized as "exemplary objects." "Scale models, blueprints and cut-aways of machines . . . [were] all accompanied by descriptions. . . . Similarly, on the boulevard, items bearing names and labels were exposed behind shop windows accompanied by a laudatory epideictic discourse—the advertisement."[15] Such visual and textual installations in the colonial pavilions were designed to convince spectators of the particular colony's economic worth and potential and of the good sense of the colonial enterprise in general.

The emphasis on this "epideictic discourse" increasingly weighed against the aesthetic claims of the fine arts at the expositions. In 1900 two permanent buildings, the Grand Palais and the Petit Palais, housed the main national fine arts displays: in the Grand Palais, contemporary works selected by the guest nations, and in the Petit Palais the prestigious Centennial and Decennial of French Art. Artworks not selected for display in either building were in a sense tainted by their attachment to the didactic and peripheral context of the national and colonial pavilions, which were classified hierarchically, according to "nations and the supra-national constructs of empires and races."[16] Thus one commentator, lauding the art on view in the French colonial pavilions, could lament that the official jury of 1900 would not consider for awards any work by artists in the Trocadéro precinct.[17] That is not to say the Orientalists showing at the Algerian pavilion lacked the status as artists to be represented in the Grand Palais: works by the society stalwarts Cottet, Dinet, Leroy, and Lunois were indeed on exhibit there.[18] But much of their work at the Grand Palais was non-Orientalist; at the Algerian pavilion, in contrast, most of the 135 easel paintings were of Algerian subjects. The exceptions were works exhibited by amateur artists resident in Algeria. Their flower pieces and portrait subjects were displayed to show that the civilized arts flourished among émigrés to Algeria.[19]

Although such an exhibit assimilates art to the didactic project, the didactic genre was best visible in the Official Palace's domed hall, which contained material samples of the country's agricultural produce: wheat, sorghum,

corn, cork, and so on. The cycle of decorative paintings on its walls related to this produce: *Sowing in the Arab and the French Way* (*Les Sémailles à la mode arabe et à la mode française*) and *The Harvest of Dates, Alfa, and Oranges* (*Le Récolte des dattes, de l'alfa, des oranges*).[20] (Alfa is a desert grass.) Illustrative and literal, they put the technology of painterly representation to work in a way that may today seem labor-intensive but was guaranteed to have an impact in the age before the color photo enlargement.

These wall paintings introduce the greatly expanded context in which the technology of painting was used at the universal expositions. Easel painting worked as a token of cultural value, the "high" creative arts. In the environment of international competition that characterized the universal expositions, it came to stand for the prestige of French culture and the preeminence of France in the arena of nations. The role of specifically colonial easel painting was to disseminate into the representations of the colonies the capital generated by metropolitan high culture. Easel painting could be used to claim the colonies as a vehicle for the arts and, when those colonies themselves begot such painting, as proof of the project's instigating "culture," as the French conceived it, in the local situation.

In some ways the true usefulness of colonial painting was realized only on the expanded scale of decoration and beyond.[21] Decorative painting had a key role in the Palace of the Ministry of Colonies, a neobaroque building designed by Scellier de Gisors. So did large bronze sculptural groups: in front of the building was the *Monument to Madagascar* (*Monument de Madagascar*) by Louis Ernest Barrias, dedicated to "the memory of the officers, soldiers, and sailors who died for our country, Madagascar 1895."[22] Inside, the distinguished official painter Fernand Cormon provided two large ceiling pieces, *France and Her Colonies* (*La France et ses colonies*) and *Fauna and Flora of the Colonies* (*Faune et flore des colonies*). The first shows the apotheosis of a female incarnation of France, standing in the clouds with a ring of muses behind her, welcoming a motley crew of the colonized, seen from below: an Arab on a rearing horse, a Senegalese rifleman, and an Ouled-Naïl woman are all identifiable.[23]

It was the illusionistic technologies of the panoramas, dioramas, and their variants, however, that transported the spectator to colonial situations with an unrivaled sensory intensity. The circular canvases of the panoramas proper were numerous at the 1900 exposition, especially in the colonial precinct. The original panorama was set up in 1788 by Robert Barker in Edinburgh, and the genre was popularized on both sides of the Channel by

the great events of the Napoleonic wars. Panoramas, as Stephan Oetterman remarks in his fundamental study, were the most distinctively nineteenth-century mass medium, in that the year 1900, which marked the birth of commercial cinema, also signaled the demise of the panorama.[24]

Some introduction to this visual technology is in order. The principle of the panorama is to presuppose an observer "who in turning round looks successively to all points of the horizon." Such a view is constructed in a large cylindrical room, whose inside

> is covered with an accurate representation in colors of a landscape, so that an observer standing in the centre sees the picture like an actual landscape in nature completely surround him. . . . The observer stands on a platform . . . and the space between this platform and the picture is covered with real objects [the *false terrain*] which gradually blend into the picture itself. The picture is lighted from above . . . so that no light but that reflected from the picture reaches the eye . . . the staircase [and] the platform [for the spectators] are kept nearly dark.[25]

Panoramas generally required the construction of a housing or rotunda building, and their fabrication posed specific problems, not least of which were the immense area of canvas to be covered, the calculations of perspective required to make the view appear "natural" from the central platform, and the difficulty of achieving the illusion of uniform illumination in a work produced by many hands. Constructing a false terrain to mediate the space between the foot of the viewing platform and the edge of the circular canvas wall was another challenge. It was met by dispersing actual objects (carts or cannon, bushes, and plaster boulders) among illusionistically painted flats; cutout upright figures could be painted to merge visually with the picture space itself.

At the Trocadéro two important but conventional panorama installations were run as private enterprises. Both were thoroughly colonial in theme, celebrating the best-known French military and expeditionary exploits of the 1890s: the annexation of Madagascar and Colonel Marchand's expedition across East Africa in competition with the British in the "scramble for Africa."[26] I mentioned before that battle scenes, contemporary and commemorative, were one of the two great subjects of the panorama (the other was the view, from a central spire or peak, of famous cities or landscapes). Several panoramas exhibited over the century in Paris had been Oriental in theme, from the 1799 Battle of the Pyramids (reconstituted in the 1850s by

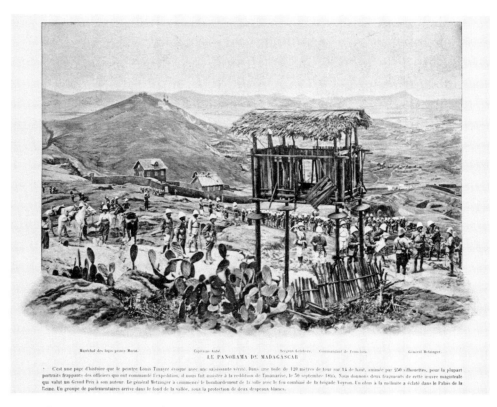

Fig. 4.1. Louis Tinayre, *The Panorama of Madagascar* (*Panorama de Madagascar*), Paris, 1900; oil on canvas, timber, and plaster. From *Le Panorama*, 1900. Courtesy of Bibliothèque Forney, Paris.

Colonel Jean-Charles Langlois in homage to Napoleon) to scenes from the Crimean War in the 1860s.

Continuing this tradition, the painter Louis Tinayre devoted the *Panorama de Madagascar* in 1900 to the military events by which General Joseph Gallieni achieved the surrender of the Malagasy forces (figure 4.1). Tinayre had been present at the scene he painted. His panorama was on the upper floor of the enormous circular Madagascar pavilion, just north of the Trocadéro Palace. The scene was introduced by eight small "dioramas"—curved canvases enclosing a three-dimensional foreground on which scale models of soldiers and armaments were set on a false terrain.[27] These dioramas documented the early stages of the campaign, from the disembarkation at Majunga on. The panorama painting itself showed "the exact position of

French troops at Tananarive on 30 September 1895, with the bombardment of the capital and the act of surrender to General Duchesne."[28] The military action could be studied in all its detail from the central viewing platform, for which Tinayre used a specially imported Malagasy timber hut. The final display of four dioramas showed the aftermath, "the pacification and the development of the colony by General Gallieni."[29]

Such a colonial panorama performed in various ways for the observer. It served as an object of what Bennett calls "stupefaction" in the face of its technological virtuosity, compounded no doubt by the message of European technical superiority and efficacy in the art of war. At the same time it provided an imaginary transport to Madagascar, even though panoramas, because of their very meticulousness (as Oettermann remarks), typically leave little to the imagination. I am not arguing that the panorama exhibits any more specific cross-cultural modality than standard Orientalist easel paintings; with equal ease, however, it was enlisted into the political, historical, and experiential project of colonialism.

Many of the official colonial pavilions in 1900 featured smaller panoramas and dioramas; the series of Indochinese pavilions, for example, contained panoramas of the principal cities Hue, Saigon, Phnom Penh, Mytho, and Hanoi.[30] Several images of smaller Caribbean and African colonies and protectorates that lacked their own pavilions were gathered in the Pavilion of the Dioramas. Various artists associated with the Orientalist Painters were active at this pavilion. The Somali Coast boasted an *Environs de Djibouti*, prepared by Henry d'Estienne for the Ministry of the Colonies after the maquette of Marius Perret.[31] Paul Buffet went on a demanding mission to paint in Abyssinia with government funding and presented a suite of six scenes of the colony of Djibouti and of Abyssinia. Paul Merwaert would no doubt have been sent to French Oceania to prepare his officially sponsored diorama *Pearl Fishers on the Touamotou Islands* (*Les Pêcheurs de perles sur les îles Touamotou*).[32] In 1900 members of the Society of French Orientalist Painters acted as experts available for hire to visualize everything in the global French overseas empire.

Displays at the Palace of Algerian Attractions (a commercial, as opposed to an official, space) offered novel physical sensations, a less earnest didacticism aligned with the pleasures of modern tourism. In the commercial zones technical experimentation was put to work. Vying for attention among the exhibits was "a new mechanism that has been very warmly received by the

Fig. 4.2. *Moving Stereorama*, or *Poème de la Mer*, Palais des Attractions algériennes, Paris, 1900. From De Natuur, 1900 (ANU Photography).

public: the Moving Stereorama, or Poème de la Mer" (figure 4.2).[33] An initiative of the entrepreneurs Francovich and Gadan, it was described enthusiastically in the Hachette guide as "enabling us to accomplish, without the least fatigue and sheltered from the cares of seasickness, a voyage along the Algerian coast. With the help of an ingenious gadget—an assemblage of canvases and planes in relief that turn before our eyes—we rapidly forget our presence on the banks of the Seine and believe ourselves transported over the Mediterranean to within sight of the enchanting coasts of Algeria."[34] The Dutch popular science journal *De Natuur*, more precise about the technology, explained that the sightseeing voyage began with the morning light on the fishing boats in the port of Bône (now Annaba). Then followed a scene of Bougie (now Bejaïa), with a calm sea and blue sky, converted to choppy sea as the viewers' putative steamship approached Algiers (with its famous panorama of white houses and minarets); the Poème closed within sight of the port of Oran at evening. Along the way the spectator encountered boats of all kinds, even "an imposing squadron of warships, including ironclads, battle-cruisers and torpedo-boats"[35]—a militaristic image that announced the French possession of Algeria and advertised French sea power to all foreign visitors to the exposition. A second geographical rep-

resentation of the premier colony, a transect of the nation from the desert at Biskra to the port of Algiers (Maxime Noiré's painted Diorama de l'Algérie), asserted possession just as clearly.[36]

Across the Seine on the Champ-de-Mars, in the continuation of the exposition behind the Eiffel Tower, were star commercial attractions featuring the painted canvas. Like the Moving Stereorama, these offered more than a central viewing platform and static encircling panorama. The Maréorama, Hugo d'Alési's installation, gave the illusion of a maritime voyage from Marseille to Constantinople (with landings at Nice, Sousa, Naples, and Venice), as experienced from the bridge of a facsimile steamer that rolled and pitched because of a set of enormous hydraulic pistons. The scrolling topographical canvas required for this multisensory experience was one and a half kilometers long. Nearby was the immensely popular Cinéorama, "a new application of the cinematograph to the panorama."[37]

Most pertinent to the colonial context, however, was the Panorama du Tour du Monde, by the architect Alexandre Marcel and the painter Louis Dumoulin. Together they designed a magnificent display on the Champ-de-Mars that today looks as if it had strayed from Euro Disney. Conceptually the Tour du Monde was a compressed version of Jules Verne's famous novel *Around the World in Eighty Days* (1873) that led the visitor "from one end of the world to the other end" in just over an hour.[38] The exterior of Marcel and Dumoulin's multistory building was a polyglot of architectures: a Cambodian temple, or wat; a seven-story Chinese pagoda; an entrance based on a Japanese ceremonial gateway; and an apparently North Indian balconied main structure. It was vaunted as one of the most original creations of the exposition: "No expense has been spared in making this spectacle as exact and as seductive as possible. The gate alone, executed by Japanese carpenters using materials from Japan, cost one hundred thousand francs."[39] Visitors descended the interior in a slow spiral, walking past large-scale dioramas with topographical backdrops painted by Dumoulin and his team. In these dioramas "M. Dumoulin had ingeniously organized in the foreground little scenes containing indigenous persons from the countries represented: this was the *animated panorama.*"[40]

It is not surprising that Dumoulin ventured an innovation in panorama scenography. Early in his career he had executed the vast panorama of the Battle of Waterloo, one of the few panoramas still on view today.[41] In 1900 Dumoulin's scenes combined the familiar ideas of the indigenous village and the theatrical performance—what Sylviane Leprun calls "plastic ethnol-

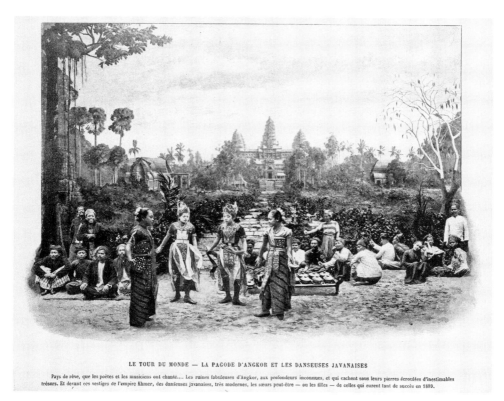

LE TOUR DU MONDE — LA PAGODE D'ANGKOR ET LES DANSEUSES JAVANAISES

Pays de rêve, que les poètes et les musiciens ont chanté.... Les ruines fabuleuses d'Angkor, aux profondeurs inconnues, et qui cachent sous leurs pierres écroulées d'inestimables trésors. Et devant ces vestiges de l'empire Khmer, des danseuses javanaises, très modernes, les sœurs peut-être — ou les filles — de celles qui eurent tant de succès en 1889.

Fig. 4.3. Javanese Dancers with Louis Dumoulin's Painted View of Angkor Wat, in Le Tour du Monde Paris Exposition, 1900. From *Le Panorama, 1900.* Courtesy of Bibliothèque Forney, Paris.

ogy"—with large-scale topographical painting.[42] As surviving photographs indicate, however, claims to scientific accuracy should not be exaggerated: in the Tour du Monde Dumoulin played fast and loose with ethnic and national identity, particularly that of peoples colonized by European powers. In one photograph (perhaps a montage) Javanese dancers and a gamelan orchestra from the Dutch East Indies perform before a painted view of Angkor Wat, emerging from its jungle fastness in French Cambodia (figure 4.3). Thousands of kilometers are compressed into this collage of exotic icons.

Dumoulin was more respectful in his diorama of Japan, a sovereign nation that, after all, had its own pavilion at the exposition. Twelve professional geishas brought over from Tokyo figure in a formal garden at cherry-blossom time at Nikko, "the holy mountain, covered with thousand-

year-old temples and admirable gardens."[43] From such Far Eastern dioramas as this and the Chinese Village at Shanghai, Dumoulin moved westward, to a scene of Port Said on the Suez Canal and a cemetery in Constantinople. This last ensemble was transparently inspired by Pierre Loti's most famous novel, *Aziyadé* (1879).[44]

A commercial attraction like the Tour du Monde stood outside the normal taxonomy of exhibiting nation-states that Tony Bennett elucidates. It included scenes from subject states, colonies both French and otherwise, and nations that were sovereign (albeit under pressure from European powers), like China, Japan, and Turkey. The physical situation of the Tour du Monde gives the clue to its interpretation: located well away from the official colonial precinct, near the northeast pier of the Eiffel Tower, it was adjacent to the pavilions of the Alpine and Automobile Clubs—travel and sporting bodies with strong links to the tourist industry. More significant, its position in the overall layout matched that of the Maréorama, the Cinéorama, and a ride named the Great Celestial Globe: like them, it was an attraction of the new technologies of vision. Trading on the empirical, mimetic, and ethnographic languages of the official colonial pavilions, but not limited by the actualities of colonial control, the Tour du Monde took the entire world of mankind, in one imperializing sweep, as its field of representation.

In constructing it, Louis Dumoulin had unequaled authority. As a longtime official painter to the French navy, he indeed became a kind of Pierre Loti of the painted view. (Loti's source material for his exotic romances was his lifelong career as a naval officer.) As for Dumoulin, travels around the world afforded this former student of Henri Gervex who had once sought and received the advice of Edouard Manet an unending series of landscapes and *scènes de moeurs* (human studies).[45] Dumoulin worked in a bright-toned, quasi-Impressionist technique, displaying an eye for vivid detail and a sometimes daring sense of composition. His curiosity about the Far East piqued during the 1880s by the *japonisme* craze, Dumoulin obtained from Director of Fine Arts Castagnary a diplomatic passport and free passage with the French navy on sea lanes heading east. In 1889 he exhibited one hundred paintings he had made in Japan, China, and Indochina. (The great supporter of japonisme Philippe Burty wrote the preface to the catalog.) The exhibition successfully presented some of the early painted images of sites of a kind made popular by novels like Loti's *Mme Chrysanthème* (which inspired Van Gogh's Japanophilia).[46]

Prior to 1900 Dumoulin was no stranger to the great expositions: the

Indochinese part of his Far Eastern suite had been put on view in the International and Colonial Exposition of Lyon in 1894.[47] The idea for the Tour du Monde possibly arose at that time, with Dumoulin surrounded by small-scale colonial pavilions. In any event, it became one of the most popular attractions at the 1900 Paris Universal Exposition. Curiously, Léonce Bénédite did not coopt the talents of Dumoulin, who never exhibited at the Orientalist Painters. On the contrary, Dumoulin, who after his success in 1900 was appointed commissioner of fine arts for the 1906 National Colonial Exposition of Marseille, went on to found the only exhibiting society that rivaled the Orientalist Painters, the Colonial Society of French Artists.

Modalities of the Salonnet

The second strategy for disseminating Orientalist art into the broad public domain of the expositions grew out of the society's primeval function: that of mounting exhibitions of easel painting. Hardly a radical cultural practice, it did less to cross the hierarchies of the visual than the Orientalist Painters' participation in panorama painting and its mechanized variants. Yet in manipulating what I call the salonnet, the proponents of Orientalist art siphoned off the high art of painting from respectable exhibitions and moved it into the carnavalesque world of temporary colonial representations.

Thus in 1900 the Orientalist Painters engaged in a third, most unexpected, participation, in a largely forgotten zone of spectacle: Andalusia in the Time of the Moors. This "immense village" covered five thousand square meters of the Trocadéro Gardens,[48] presenting "all that is picturesque from ancient and modern Spain. It is the 'Rue du Caire' of 1900, better run."[49] Its organizer is described as a M. Roseyro, apparently a publisher with links to *L'Illustration* and the *Revue des deux mondes*. It has been suggested that Roseyro was of Sephardic Jewish background, which might explain the drive to re-create a time when Jewish as well as Islamic high culture flourished on the Iberian Peninsula.[50]

The writer Armand Silvestre, who himself had established a popular theater at the 1900 exposition, set the scene in his guidebook: "With this magnificent reconstitution, one can relive the Arab civilization of the fifteenth century, which shone with such brightness in the South of Spain. For this the promoters of the enterprise have had only to draw upon the marvelous treasures of Moorish architecture that the monuments of Cordoba, Seville,

and Granada have preserved for us."[51] The two major architectural works were the Lion Court, based on the Patio of the Lions at the Alhambra Palace in Granada, and the tower of the Giralda at Seville, seventy meters high, like the original, and topped with its gyrating golden Genius. The Giralda encapsulates the theme of cultural hybridity and accretion that animates Andalusia in the Time of the Moors, being "Moorish in its base, Renaissance in its bell tower."[52] The Alhambra, as an architectural marvel, had been a place of pilgrimage for Orientalist artists and writers since the early nineteenth century.[53] The challenge for the organizers of Andalusia in 1900 was to reconstitute the historical environment of the Alhambra. This they did (at least in the official exposition photograph) with a montage of Maghrebian men and women inserted into the colonnades of the Lion Court, with not a European visitor to be seen—visually reinstalling the exiled Moors of historical memory.

The question of ethnic identity in the Andalusia display was cut through with a historical awareness not apparent in the Tour du Monde. The *Livre d'or* of the exposition deprecated the culture of Catholic Spain: "The domination of the Moors is incontestably the most brilliant epoch in the history of Spain. These alleged barbarians in effect brought with them—together with perfect manners and a high degree of civilization—the arts and sciences that the Germanic invasions have erased from memory."[54] This theme of cultural admiration and historical regret casts an interesting light on contemporary attitudes toward the talents of the Muslims, whose descendants in the Maghreb were now colonial subjects of the French. At the Andalusia display a small hippodrome in the shadow of the Giralda gave a spectacular physical expression to historical conflicts between the Moors and Christians. Recalling the mortal entertainments of the Roman circus, its track of sixty meters was intended for "fantasias, for tournaments between Moors and Christian knights, for gazelle hunts with *sloughis* (Arab greyhounds), for the attack on a caravan by Touareg, for the ceremonies of a Gypsy marriage."[55]

Christian knights jousting with Moors would activate memories of the Crusades, and of Emperor Charlemagne, who had halted the Saracen armies at Roncesvalles in the Pyrénées in 778. That was the central action of the medieval French literary classic the *Chanson de Roland*. Yet in 1900 from the French perspective, the camel-mounted Touareg (the Berber nomads always clad in blue who dominated the Sahara) were a real threat to Saharan trade routes and to France's attempts to extend its military rule into the

far south of Algeria, where the French were also pressuring the sultan of Morocco for territorial concessions. The Touareg had almost nothing to do with medieval Andalusia, but everything to do with the French experience of resistant Islam.

Such feigned martial conflicts may have had less allure than the varieties of dance performed at ethnically coded sites across the Andalusian precinct. Dance has been identified as one of the great signifiers of cultural identity as well as sexuality in the romance of the universal expositions.[56] Given the absence of living Moorish culture in present-day Andalusia, Maghrebian dancers were called to duty. Thus dancers of the sect of Aïssaouas performed adjacent to a copy of the facade of the Mosque of the Aïssaouas from Tétouan in Morocco. Elsewhere, Jewish women from Tangier, Kabyles, and Ouled-Naïl women were figures of the past, standing in for exiles from Andalusia, relics of a culture lost to Europe. But they were also figures of contemporary currency, exponents of an allure familiar to colonial tourists and soldiers in present-day Algeria. In contrast, the dance troupes brought up from Spain—the "Sévillanaises" with their bolero or the Gypsy flamenco dancers from present-day Granada—presented a less conflicted view of the balletic arts and could still in some sense be claimed as European.

Against this background of bodies and beasts in conflict, and of passionate dance, the logic of the Orientalist Painters' presence is that of quietude and the museum. "Museum" is indeed the name given to the space where "the Society of Orientalist Painters . . . has organized an exhibition of the finest works by its members. Next to these canvases so full of sun and light we find a complete retrospective exhibition of Muslim art."[57] No doubt the Orientalists offered characteristic scenes of Maghrebian life in which no European presence was felt, symbolizing the life of old Moorish Andalusia. A later photograph shows a typical society installation, with paintings of the Maghreb, Oriental carpets, clay sculpture on pedestals, a leatherwork saddle, and even arrays of Moorish weapons. There would certainly have been Spanish scenes—previous Orientalists' salons had regularly included works painted in Spain, a country that (as the colonial novelists the Leblond brothers expressed it) was the very "liege land of Orientalism."[58]

This salonnet functioned, then, not like a panorama, which presented a view of a singular location, but like a multifarious collective view of lands settled, either currently or in the past, by the Moors. As a scattered collectivity it nuanced a straightforward trompe l'oeil landscape painted on a high brick wall opposite the Spanish Village: a giant view of the Alhambra and

Monte Sacro. The museum even contained a metonym for Spain itself: an exhibition dedicated to the bullfight. One imagines its appeal to the young Andalusian Pablo Picasso, had he strayed over to Andalusia in the Time of the Moors during his visit to the Paris exposition. At the Grand Palais, his bedside melodrama *Dying Moments* (*Derniers moments*) was an official Spanish entry, even if his bread-and-butter paintings in 1900 were scenes of the bullfight and the *café-concert*.

The main surviving record of the Orientalist Painters' contribution is the poster *Andalusia in the Time of the Moors* (*L'Andalousie aux temps des Maures*), by Etienne Dinet. Featuring a life-size figure of a female dancer, this enormous chromolithograph, framed by panels of hand-painted tiles, is full of verve despite its somewhat garish colors. In it Dinet imagines an Andalusia straight from his studies of the Ouled-Naïl in Bou-Saâda and Laghouat: a tattooed young Berber woman in rich flowing robes of green and yellow and heavy silver amulets dances in a narrow horseshoe archway. Behind her, smiling Arab men smoke and wait in the purplish evening air. This poster, too, has its epideictic function: the dancer exhorts passersby to enter her *gourbi*, or Moorish village—which after all allegorizes the Andalusian exhibit itself. Dinet's Andalusia stresses the Islamic element at the expense of the Spanish, rereading the historical other in a contradictory colonial present.

The multiple involvements of the Society of French Orientalist Painters at the 1900 Paris exposition opened the path for further exploits. The society had impressed the commissioner of the colonial section, Jules Charles-Roux, a wealthy industrialist, writer, and politician from Marseille.[59] When in 1906 he was head of Marseille's own great exposition, he gave extraordinary prominence to the visual arts. Marseille's mounting of the first-ever national colonial exposition needs explaining. As the great colonial port of France, Marseille served North Africa and all the Eastern shipping routes. A large and wealthy city, it was a commercial rival of Paris. In an era when great exhibitions were a mark of the ambition and prestige of emerging capitals—Philadelphia, Melbourne, Chicago, Lyon, Hanoi, Liège—Marseille was eager to seize such an opportunity for itself. At the close of the 1900 exposition the interest in the colonial domain was such that a further exposition was planned, in which the colonies would be the exclusive subject of study. The exposition, backed by the powerful Chamber of Commerce of Marseille, opened there in April 1906 on a campus of thirty-six hectares at Longchamp. Before closing in November, its total of 7,960 exhibitors drew

some 1.8 million visitors.[60] The exposition had two principal parts: a Grand Palais, showing the metropole's offerings to the colonies, and a series of colonial pavilions containing products destined for continental Europe. The two other key sections were oceanography and the fine arts.

One result of the Marseille exposition was a lesson in decentralization. Germany, Britain, Belgium, Russia, Spain, and even Mexico sent official visitors delegated to study French colonialism. Charles-Roux's opening speeches favorably documented the weight of Marseille and the colonial sector in the overall French economy.[61] The success of the 1906 and 1922 Marseille expositions was recognized in 1983, when the city commemorated the two events with a series of retrospectives. Mayor Gaston Deferre (the husband of the writer Edmonde Charles-Roux, who was the granddaughter of Jules Charles-Roux and the biographer of Isabelle Eberhardt) evoked the refusal of the people of Marseille "to bow to the excesses of an aggressive centralism, imposing their initiatives, defending them when Paris sought to thwart them."[62]

For Commissioner Charles-Roux, the abundance of fine arts exhibitions was deliberate policy. In his preface to the luxurious illustrated catalog Charles-Roux laments the indifference of the French public to "the lessons of the official displays—statistics, graphics, the rather arid documentation." He perceived that more spectacular attractions, including the ever-popular exhibitions of painting, might redress the problem.[63] At Marseille the fine arts were installed as an "attraction" in the pavilion of the Ministry of the Colonies. Over half of its eleven rooms were given to painting and sculpture, but to reach them the visitor had to run the gauntlet of rooms devoted to the Geographical Service, colonial health, and so on.[64]

The nature of the fine arts displays was determined by Louis Dumoulin, by then the artistic advisor and commissioner of fine arts at Marseille. Dumoulin had collaborated closely with Charles-Roux in 1900 in designing the Grotte Khmer for the Indochinese section (as well as mounting the Tour du Monde), and Charles-Roux had formed a high opinion of his "talent as an artist and as *metteur en scène*." By appointing Dumoulin, Charles-Roux wished to avoid the "chaos and the errors of taste that often exist in these colossal agglomerations of monuments, of palaces and kiosks, of towers and campaniles, of grottos . . . bridges, and walkways." Dumoulin's role was to coordinate and harmonize the "plantation du décor" for the whole exposition, as well as oversee the fine arts.[65]

In keeping with the vigorous regionalism of the Marseille effort, a major

retrospective of Provençal art was installed in the metropolitan pavilion, the Grand Palais. It included works from the Avignon Primitives to artist heroes like Pierre Puget and Jean-Honoré Fragonard to the nineteenth-century Provençaux François Granet and Adolphe Monticelli.[66] Contemporary Provençal art was represented in surprisingly advanced form by Matisse's friend from Marseille, Charles Camoin, and the young expressionist Auguste Chabaud. Paul Cézanne, however, the most patriotic of all Provencal avant-gardists, was not included. Even in 1906 (the last year of his life) Cézanne was very likely too controversial. Yet his spirit hovers over the strange exotic scene at Longchamp, where pagodas and the tower of Angkor Wat were profiled against what Charles-Roux called the "marvelous decor of mountains"—the rocky mountains of L'Estaque where Cézanne had recently made some of his greatest landscapes.

The contemporary vigor of the Orientalist movement was well established in the pavilion of the Ministry of the Colonies. The largest room was given to the "living Orientalist and colonial artists," including members of the Society of French Orientalist Painters.[67] Dumoulin, however, enlisted another group of colonial painters, by and large artists working for the various ministries or colonial governments. Several of them were familiar from Paris in 1900: Georges Rochegrosse from Algiers, Charles Duvent and Joseph de la Nézière with their Far Eastern views, Paul Merwaert (who had died in 1902) with his West African sites, and José Silbert, the president of the Marseille painters' group. Silbert exhibited figure paintings studied from life in Tangier and Algiers, like his *Cockatoo Trainer* (*Montreur de cacatoès*), its technique realist but its colors almost psychedelic, like the rainbow-hued cockatoos themselves.[68] Silbert would play a major role in organizing the fine arts at the next National Colonial Exposition of Marseille, in 1922.

An additional salonnet that sprang from Dumoulin's initiative comprised the works of young French painters competing for new traveling scholarships instituted for the Marseille colonial exposition. After that competition Dumoulin and Gaston Bernheim (of the Bernheim-Jeune Gallery) went on to form the Colonial Society of French Artists (Coloniale for short), modeled on Bénédite's Orientalist Painters, to encourage such grants.[69]

Charles-Roux saw the value of mounting a historical exhibition of the colonial visual arts "to establish the balance sheet of our colonial riches, our wealth of memories." The display had two sections, a historical colonial exhibition and a retrospective of Orientalism. The first sought to evoke "the

glorious epochs when France was the sovereign mistress of India, Louisiana, and Canada," as well as to follow the more familiar campaigns of expansion in Indochina, Madagascar, and West Africa. Paintings, engravings, lithographs, and curios would "reawaken the dormant specters of men and the failing memories of things."[70] This exhibition of colonial history was small, but as Charles-Roux predicted, it became a standard feature of subsequent colonial expositions—that of Vincennes in 1931, for example, with its theme of celebrating the centenary of Algeria as a French possession, was a major undertaking, researched over several years and provided with a significant scholarly catalog.

The *Retrospective Exhibition of French Orientalists* consolidates a familiar idea, first broached in the early 1890s by Bénédite. To curate this Marseille retrospective, however, Charles-Roux called on the talents of Gaston Bernheim. His enlistment in the colonial cause at first seems surprising: with his brother, Josse, Bernheim was the director of one of the most distinguished art dealerships in Paris, bidding fair to supplant Durand-Ruel's hold on the market for nineteenth-century progressive artists, established contemporaries like Edouard Vuillard and Pierre Bonnard, and, after 1909, new talents like Matisse. As is so often the case, Gaston Bernheim had a colonial background, having spent his youth in the French Antilles. He was also an amateur painter, who exhibited female nudes from time to time under the name Gaston de Villers. His experience at Marseille had a lasting impact on the colonial art scene in that he became one of its major promoters in the 1920s, as treasurer of the Coloniale.

Bernheim's retrospective of sixty canvases drew largely from private collections, including the families of artists like Belly, Guillaumet, and Chassériau, and from major collectors like Prince Alexandre de Wagram and the specialist collector of Orientalism from Angers, an M. Bessonneau (who lent ten major pieces). Bernheim's retrospective was peculiar in unexpectedly including the modernists Edouard Manet and Paul Gauguin with the Orientalists recognized as canonical. Manet was represented by a portrait bust titled *Negro Woman* (*Négresse*), whose inclusion seems primarily a way of annexing the great modernist, somewhat unconvincingly, to the exoticist tradition.[71] To claim Renoir and Gauguin seems more legitimate. The Algerian phase of Renoir (with Besnard, the only living artist in this retrospective) had already been accredited by the Society of French Orientalist Painters. At Marseille Renoir was represented by three canvases: the *Arab*

Festival, Algiers: The Casbah (lent by Claude Monet), *Madame Stora in Algerian Costume*, and an unidentified *Head of an Algerian Woman* (*Tête d'Algérienne*).[72]

Paul Gauguin had heretofore been rigorously excluded from all exhibitions of Orientalist art, despite critical acclaim and the abundance of his Tahitian paintings on the Parisian art market after 1893 (he died in 1903). Bénédite would have none of him, either at the Orientalist Painters or in collecting for the Luxembourg. Roger Marx, however, had included Gauguin in the Centennial of French Art at the 1900 Paris Universal Exposition, and at Marseille his *Tahitian Landscape* (*Paysage à Tahiti*) was legitimized in the catalog with the phrase "Centennale 1900." Gauguin's *Martinique* (*La Martinique*) was lent by Prince de Wagram, probably a major Bernheim client.[73] Some months before the massive Gauguin retrospective at the 1906 Salon d'Automne in Paris, the injection of the still controversial Gauguin into this construct of a colonial canon was certainly daring. Bernheim apparently sought to raise the prestige of Orientalist art by affiliating the work of the avant-gardist with it. Yet it is a historically accurate connection that few twentieth-century scholars saw fit to make.

The final Orientalist salonnet to be considered here, as bizarrely unexpected as that at Andalusia in the Time of the Moors, occurred in 1907 at the Jardin d'Acclimatation in Nogent-sur-Marne. After 1900 this botanical garden was well known for its small colonial expositions focusing on agriculture and accompanying tribal encampments. The origins of the colonial garden at Nogent went back to 1897, when a Tunisian bureaucrat proposed a botanical garden for Paris where new plants could be grown under agronomical conditions and experiments made to save new colonists time and uncertainty. In 1898 an officer was sent to study Kew Gardens outside London, and a tract of state land near Vincennes, at Nogent-sur-Marne, was ceded to the Ministry of the Colonies for the creation of a "Jardin d'Essai colonial."[74]

Expositions began to be organized at Nogent under ministerial patronage. As early as 1905 one of the nine categories (tropical agriculture, husbandry of exotic animals, colonial engineering, and so forth) of the National Exposition of Colonial Agriculture included the surprising class of fine arts.[75] Once again painting and the graphic arts appeared, to document the colonial effort visually. At the same time the contexts in which such art appeared tell us something about the mechanics of "colonisation intellectuelle" and the colonial process itself. When the National Colonial Exposi-

tion was organized at Nogent for the summer of 1907, the Society of French Orientalist Painters, no doubt spurred by the success of its Marseille venture, was called in. It seemed almost too easy to arrange, "in the middle of the reconstituted or lived scenes of colonial life, . . . the pavilion of fine arts organized by the Society of French Orientalists . . . [containing] souvenirs of local customs, of distant voyages, and of picturesque interiors."[76]

Here was more proof that a colonial exposition, however unlikely in theme, could hardly be conceived without two-dimensional representations. Once again the high art of painting was expected to inhabit a world of the exotic recognized as a theater of representations. A particular effort was made to maximize the presence of indigenous peoples at the Colonial Garden at Nogent. The French colonies were represented there by now familiar installations, for example, the Annamite Fort and the Kanaka and Congolese Villages. Pride of place was reserved for the display titled Touareg of the Sahara, an attraction organized by the popular magazine *Journal de Voyages*.[77]

The relevance of such displays to the advanced visual arts in the summer of 1907—the high summer of the Parisian avant-garde's Africanism, that of Picasso's *Demoiselles d'Avignon* and Matisse's *Blue Nude (Souvenir of Biskra) (Nu bleu [Souvenir de Biskra])*—is something that has yet to be investigated. The presence of such displays is certainly suggestive, strengthening the argument that opportunities for an avant-garde awareness of African and Oceanic peoples and arts amounted to more than masks that could be bought at bric-a-brac shops or visits to the Trocadéro Museum.[78] Proof that progressive commentators knew of the ethnographic presence at the Colonial Garden comes at least as early as 1912, in an article by the prominent young critic Léon Werth, published in the *Grande Revue* (where Matisse's "Notes of a Painter" had been published four years before). In it Werth manifests his sympathy for the persons and culture of displaced Africans, effectively themselves an exhibit at the Colonial Garden.[79] When French colonial troops from North and West Africa fought in France during World War I, such sympathy flowered, contributing in the 1920s to the taste for *l'art nègre* and American jazz music.

In these pages, I have moved the debate on the Society of French Orientalist Painters from the specialist written discourse of Orientalist aesthetics to the broadest sphere of interaction with the public. There is some value in seeing the Orientalist painting movement as the visual "research and development" wing of the whole colonial movement. The universal expositions,

with their commercial and quasi-industrial aspects—the gigantism of the displays, their technocratic bias, the vast numbers and diversity of the spectators—provided an ideal forum for the various interests involved.

Those interests were as varied as a powerful Chamber of Commerce wishing to promote colonial trade (led by Charles-Roux at Marseille in 1906); a possibly Sephardic Jewish entrepreneur wishing to glorify a pre-Catholic, tolerant Islamic world (Roseyro's Andalusia in the Time of the Moors); an entrepreneurial artist capitalizing on long years of overseas travel and research by harnessing the taste for exoticism (Dumoulin's Tour du Monde); and a colonial government working in tandem with the Ministry of the Colonies to expose and popularize its achievements in the cultural and touristic precincts of the Algerian pavilions of 1900. At that historical moment, the Society of French Orientalist Painters (and its cohorts like Dumoulin and his Coloniale) provided a highly flexible mechanism of image making. It infiltrated the field of public vision, much like the cinema and color photography at expositions later in the century, but with a whiff of the ineffable that "art" provides.

Notes

Roger Benjamin, "Colonial Panaromania," excerpts from *Orientalist Aesthetics: Art, Colonialism, and French North Africa, 1880–1930*, 105–27, 296–99. © 2003 by the Regents of the University of California. Published by the University of California Press. Reprinted with permission of the publisher.

1 The literature on the universal exposition is vast; books on colonial precincts prior to World War I include Philippe Jullian, *The Triumph of Art Nouveau: Paris Exhibition, 1900* (Oxford: Oxford University Press, 1974); *L'Orient des provençaux: Les expositions coloniales*, exh. cat. (Marseille: Vieille Charité, 1982); Sylviane Leprun, *Le théâtre des colonies: Scénographie, acteurs, et discours de l'imaginaire dans les expositions, 1855–1937* (Paris: L'Harmattan, 1986); Paul Greenhalgh, *Ephemeral Vistas: The Expositions Universelles, Great Exhibitions, and World's Fairs, 1851–1939* (Manchester: Manchester University Press, 1988); Zeynep Çelik, *Displaying the Orient: Architecture of Islam at Nineteenth-Century World's Fairs* (Berkeley: University of California Press, 1992); Tony Bennett, *The Birth of the Museum: History, Theory, Politics* (London: Routledge, 1995); and Annie Coombes, *Reinventing Africa: Museums, Material Culture and Popular Imagination in Late Victorian and Edwardian England* (New Haven, CT: Yale University Press, 1997).

2 Patricia A. Morton, *Hybrid Modernities: Architecture and Representation at the 1931 Colonial Exposition, Paris* (Cambridge, MA: MIT Press, 2000), treats the re-

lated issue of interior architectural decor in chapter 6, on the 1931 Musée des Colonies.

3 The term is taken from Ralph Hyde, *Panoramania! The Art and Entertainment of the "All-Embracing" View*, exh. cat. (London: Trefoil, in association with the Barbican Art Gallery, 1988).

4 *Encyclopaedia Britannica*, 11th edition, s.v. "exhibition."

5 See Léonce Bénédite, "Avertissement," in *Société des Peintres Orientalistes Français* (Paris: Galeries Durand-Ruel, February 15–March 3. 1900), 4.

6 See Narriman El-Kateb-Ben Romdhane, "La Peinture de chevalet en Tunisie de 1894 à 1950," in *Lumiéres tunisiennes* (Paris: Paris-Musées and Association française d'action artistique, 1995), 14; the pamphlet "Exposition artistique de 1897, Institut de Carthage," Arch. Nat. F^{17} 13064; and Léonce Bénédite, "Une tentative de rénovation artistique: Les 'peintres orientalistes' et les industries coloniales," *Revue des arts décoratifs* no. 4 (April 1899): 101–2.

7 Bennett, *The Birth of the Museum*, 86.

8 Herbert E. Butler, "The Colonial and Foreign Buildings," in *The Paris Exhibition, 1900*, ed. D. Croal Thomson (London: Art Journal, 1901), 22.

9 See Çelik, *Displaying the Orient*, 129.

10 *Paris Exposition, 1900* (Paris: Librairie Hachette, 1900), 339.

11 *L'Illustration* (July 20, 1867), quoted in Çelik, *Displaying the Orient*, xvi.

12 Çelik, *Displaying the Orient*, 130, 215n. 80.

13 See T. Lambert, ed., *L'Art décoratif moderne: Exposition universelle de 1900* (Paris, 1900), plate 35, fig. 4.

14 *Paris Exposition, 1900* (Hachette), 340.

15 Philippe Hamon, *Expositions: Literature and Architecture in Nineteenth-Century France* (1989), trans. Katia Sainson-Frank and Lisa Maguie (Berkeley: University of California Press, 1992), 67.

16 Bennett observes that this hierarchy established "a progressivist taxonomy . . . laminated on to a crudely racist teleological conception of the relations between peoples and races which culminated in the achievements of the metropolitan powers, invariably most impressively displayed in the pavilions of the host country" (Bennett, *The Birth of the Museum*, 95).

17 B. de L., "Le Jury des Beaux-Arts," *La Dépêche coloniale*, July 27, 1900.

18 See *Catalogue général officiel, Exposition Internationale Universelle de 1900*, vol. 2, *Oeuvres d'art* (Paris: Lemercier, 1900), 249–56.

19 The Salle des Beaux-Arts also featured sculpture, architecture, renderings of Islamic monuments, and plans for new buildings, such as the "Project for an Algerian Eden" by a designer with the fitting name of Contestable; see *Catalogue général officiel . . . 1900*, 2:256.

20 *Paris Exposition, 1900* (Hachette), 340.

21 On this issue (in the context of Algerian public buildings, not expositions), see François Pouillon, "La peinture monumentale en Algérie: Un art pédagogique," *Cahiers d'études africaines* 141–42(36) (1996): 183–213.

22 The monument, later transferred to the Malagasy capital of Tananarive, is illustrated in Jules Charles-Roux and Scellier de Gisors, *Exposition universelle de 1900, section des colonies et pays de protectorat: Album Commemoratif* (Paris, 1900), plate 31.

23 Charles-Roux and Gisors, *Exposition universelle de 1900*, 263.

24 Stephan Oettermann, *The Panorama: History of a Mass Medium* (1980), trans. Deborah Lucas Schneider (New York: Zone Books, 1997), 5.

25 *Encyclopaedia Britannica*, 11th ed., s.v. "panorama"; see further Oetterman, *The Panorama*, 5–97; and Jonathan Crary, *Techniques of the Observer: On Vision and Modernity in the Nineteenth Century* (Cambridge, MA: MIT Press, 1990), 112–14.

26 In the *Panorama Marchand* the painter Charles Castellani, a member of the expedition, devised an installation of twelve small dioramas stressing both exotic and political aspects of events: an elephant hunt, the burning of a "rebel" village, impassable rapids and threatening hippopotami on the Oubanghi River, the interview with the Ethiopian negus Ménélik at the journey's end. The vast ring painting of the panorama itself showed optimistic beginnings: the *Embarcation of the Mission on the Oubanghi*. See *Paris Exposition, 1900* (Hachette), 320.

27 Dioramas in this twentieth-century sense differed from the installations originally bearing that name, the first of which, constructed by Daguerre, seated an audience in front of large diaphanous screens that could be moved to establish different scenes; see Oetterman, *The Panorama*, 69–83.

28 *Paris Exposition, 1900* (Hachette), 320.

29 *Paris Exposition, 1900* (Hachette), 317.

30 Charles Lemire, "L'Exposition Coloniale du Trocadéro," *L'Exposition des colonies et la France coloniale*, May 5, 1900, 4.

31 *Catalogue général official . . . 1900*, 257. For an illustrated obituary, see Léonce Bénédite, "Figures d'Extrême-Orient: A propos de l'Exposition posthume des oeuvres de Marius Perret," *Art et décoration* 11 (January–June 1902): 69–74.

32 See *Catalogue général officiel . . . 1900*, 257–58.

33 Alfred Picard, *Le bilan d'un siècle (1801–1906): Exposition universelle internationale de 1900 à Paris* 1 (Paris: Imprimerie Nationale, 1906), 433–34. For another view of the stereorama, see Rhonda Garelick "*Bayadères, Stéréoramas*, and *Vahat-Loukoum*: Technological Realism in the Age of Empire," in *Spectacles of Realism: Gender, Body, Genre*, ed. Margaret Cohen and Christopher Prendergast (Minneapolis: University of Minnesota Press, 1995), 294–319.

34 *Paris Exposition, 1900* (Hachette), 340.

35 *De Natuur* (1900), 257, quoted in Leonard de Vries, ed., *Victorian Inventions*, trans. Barthold Suermondt (London: John Murray, 1971), 123–24.

36 The Diorama de l'Algérie by Charles Galand and Maxime Noiré had seven compartments, including "the Hill of Sfa, with Biskra in the distance and the immensity of the desert, . . . a view of the famous *Ravine of Constantine*, . . . [and finally] the panorama of Algiers seen from Upper Mustapha" (*Paris Exposition,*

1900 [Hachette], 340). Noiré was the best-known French painter permanently resident in Algeria. He exhibited from time to time with the Orientalists in Paris and was a stalwart of the Algiers-based Société des Artistes algériens et orientalistes. A friend of Isabelle Eberhardt's (he illustrated the Fasquelle edition of her *Notes de Route*), Noiré has a reputation that seems hard to credit now in view of his treacly vistas in which human figures are absent; see Marius-Ary Leblond, "Maxime Noiré," in *Peintres de races* (Brussels: G. Van Oest, 1909), 185–96.

37 On the Maréorama, see *De Natuur*, in de Vries, *Victorian Inventions*, 125–26; and Picard, *Le bilan d'un siècle*, 434; on the Cinéorama, see "Les Attractions: Trocadéro," *Revue universelle* 10 (1900): 298–99; and de Vries, *Victorian Inventions*, 126–27.

38 For reflections on the global collecting of sites and peoples in the most extensive colonial exposition, that of 1931, see the chapter "Le tour du monde en un jour," in Morton, *Hybrid Modernities*, 16–69.

39 *Le Panorama, 1900: Exposition universelle* (Paris: Ludovic Baschet, 1900), 163.

40 "Panoramas et dioramas: Décoration théâtrale," in Picard, *Le bilan d'un siècle*, 434.

41 This work, conserved at Waterloo, Belgium, is illustrated in the multipage frontispiece to Oettermann, *The Panorama*.

42 See Leprun, *Le théâtre des colonies*, 17.

43 The caption continued: "To people this decor, charming creatures have come. They are twelve Geishas, singers and instrumentalists. They have left Tokyo and will return there as soon as the Parisian festival is finished" (*Le Panorama, 1900*, 172–73).

44 "M. Louis Dumoulin introduces us to a sacred place, to the cemetery where Aziyadé was entombed, and of which M. Pierre Loti has traced such ravishing descriptions" (*Le Panorama, 1900*, 167).

45 See Philippe Burty, preface to *Exposition Louis Dumoulin: Tableaux et études de l'Extrême-Orient, Japon, Chine, Cochinchine, Malaisie* (Paris: Galerie Georges Petit, December 20, 1889), 3.

46 See Jules Antoine, "Exposition Louis Dumoulin," *Art et Critique*, December 28, 1889, 497–98; my thanks to Karen Esielonis for this reference.

47 See Fernand Blum, "Tableaux et études de Louis Dumoulin, peintre du Ministère de la marine rapportés d'une mission en Extrême-Orient en 1888," in *Notices coloniales, publiées . . . à l'occasion de l'Exposition universelle internationale et coloniale de Lyon* (Lyon, 1894), xli–xlii.

48 Joseph Dancourt, "L'Andalousie au temps des Maures," in *Le livre d' or de l'Exposition de 1900* (Paris: Edouard Cornély, 1900), 2:239. I treat this subject at greater length in "Andalusia in the Time of the Moors: Regret and Colonial Presence in Paris, 1900," in *Edges of Empire: Orientalism and Visual Culture*, ed. Jocelyn Hackforth-Jones and Mary Roberts (Oxford: Blackwell, 2008), 181–206.

49 "Les Attractions: Trocadéro," *Revue universelle* 10 (1900): 298.

50 I owe this suggestion to Adrian Rifkin.

51 *Guide Armand Silvestre de Paris et de ses environs et de l'Exposition de 1900* (Paris: Silvestre, 1900), 140.

52 *Le Panorama, 1900*, 207.

53 John Frederick Lewis, *Sketches and Drawings of the Alhambra* (London, 1835); and Owen Jones and Jules Gourey, *Plans, Elevations, and Sections of the Alhambra* (London, 1836–45), are discussed in Michael Danby, *The Islamic Perspective* (London: World of Islam Festival Trust, 1983), 27, 43.

54 Dancourt, "L'Andalousie," 239.

55 *Guide Armand Silvestre*, 141.

56 See Zeynep Çelik and Leila Kinney, "Ethnography and Exhibitionism at the Expositions Universelles," *Assemblage* 17 (December 1990): 35–59.

57 Dancourt, "L'Andalousie," 240.

58 Marius-Ary Leblond, "Les expositions: L'Exposition des orientalistes," *La Grande revue* 47 (March 1908): 381.

59 See Jules Charles-Roux, *Souvenirs du passé: Le cercle artistique de Marseille* (Paris: Lemerre, 1906).

60 Pamphlet titled "No. 1037, Chambre des Députés . . . Projet de Loi relatif à la concession de décorations . . . de l'Exposition coloniale nationale de Marseille" (July 10, 1907), Arch. Nat. F¹² 7577. For a brief discussion of the Marseille expositions, see Morton, *Hybrid Modernities*, 71–72, 286–87.

61 See Henri Malo, "L'Exposition coloniale nationale de Marseille," *La Nouvelle revue* n.s. 43 (1906): 43, 53–54, 56–57.

62 Gaston Deferre, preface to *Les orientalistes provençaux: L'Orient des provençaux* (Marseille: Musée des Beaux-Arts de Marseille, 1982), viii.

63 Jules Charles-Roux, "Nos expositions des Beaux-Arts," in Charles-Roux et al., *Notice officielle et catalogue illustré des expositions des Beaux-Arts, Exposition coloniale nationale de Marseille* (Paris: Moderne imprimerie, 1906), xix.

64 See the floor plan in *Album commemoratif, Exposition coloniale nationale de Marseille, 1906* (Marseille, 1906), n.p.

65 See Charles-Roux, in Charles-Roux et al., *Notice officielle*, xx–xxi.

66 Malo, "L'Exposition . . . de Marseille," 48.

67 Léonce Bénédite, "L'Exposition de la Société des Peintres Orientalistes Français," in Charles-Roux et al., *Notice officielle*, li–liv, lv–lix.

68 Exhibited as *Charmeur de perroquets*; see Charles-Roux et al., *Notice officielle*, lviii. Today it is in the Musée des Beaux-Arts de Marseille, at Longchamp.

69 This society merits a study in its own right: it was forming by the time the seventeen Marseille scholarship holders returned to Paris to exhibit in February 1908 at the Galeries Bernheim-Jeune, which hosted a series of salons up to 1914. The travel scholarships the Coloniale attracted (allied as it was to the Société des Artistes Français) exceeded those managed by the Orientalists. Its heyday was the 1920s, when Bernheim, as treasurer, documented its activities in his *Bulletin de la vie moderne*. Highly visible at both the 1922 and 1931 exhibitions, where its

members' works were shown alongside those of the Society of Orientalists, the Coloniale in 1931 had some three hundred members. It continued to exhibit up to World War II.

70 Charles-Roux et al., *Notice officielle*, xxii, xxvi.

71 "Exposition rétrospective des orientalistes français," in Charles-Roux et al., *Notice officielle*, xlii, cat. no. 45, *Négresse*, property of Prince Alexandre de Wagram.

72 "Exposition rétrospective des orientalistes français," in Charles-Roux et al., *Notice officielle*, xlii, cat. nos. 52, *Tête d' Algérienne*; 53, *Fête au camp* (property of Claude Monet); 54, *Tête d' Algérienne* (property of Jules Strauss).

73 "Exposition rétrospective des orientalistes français," in Charles-Roux et al., *Notice officielle*, cat. nos. 31 and 32.

74 Eugène Charabot and Georges Collot, "Organisation et description de l'Exposition coloniale nationale de 1907: Rapport générale," *Revue coloniale* n.s. 8 (1908): 705–7.

75 See the pamphlet "Exposition nationale d'agriculture coloniale, ouverte du 20 juin au 20 juillet 1905 au Jardin Colonial à Nogent-sur-Marne" (Paris: Société française de colonisation et d'agriculture, 1905); Arch. Nat. F^{12} 7576.

76 Charabot and Collot, "Organisation et description de l'Exposition coloniale nationale de 1907 . . . Suite," *Revue coloniale* n.s. 9 (January 1909): 49.

77 Charabot and Collot, "Organisation et description de l'Exposition coloniale nationale de 1907," 719.

78 See in particular the argument of Patricia Leighten in her "White Peril and *L'Art nègre*: Picasso, Primitivism, and Anticolonialism," *Art Bulletin* 72(4) (1990): 609–30.

79 Léon Werth, "Les Nègres au Jardin d'acclimatation," *La Grande revue* 74 (August 1912): 609–12.

The Mass-Printed Imperium

Objects of Knowledge: Oceanic
Artifacts in European Engravings

Nicholas Thomas

"The real voyeur is engraving."
—Pablo Picasso

In *Modern Painters*, John Ruskin suggested that it was especially charac-
teristic of modern engraving that everything was "sacrificed to illegitimate
and contemptible sources of pleasure," which were "vice throughout," pos-
sessing "no redeeming quality nor excusing aim."[1] However idiosyncratic
this peculiarly forceful condemnation may be, Ruskin's more specific refer-
ences to the inadequacy of the media—for instance, for conveying J. M. W.
Turner's atmospheres—resonate with art history's enduring attachment to
what is original rather than derivative, to higher genres and proper forms of
art. If prints were ever only cheap or not-so-cheap reproductions of paint-
ings that were themselves available for inspection, this consignment of poor
copies to a wilderness beyond critical vision might be justifiable; but from
a historical perspective concerned with the circulation and effect of repre-
sentations, it would seem desirable to put together some sort of critical and
interpretive technology that takes the various forms of prints seriously as
singular cultural products.

As with video, there are obvious sociological propositions—for instance,
that the technology permits the "copies" to be circulated far more exten-
sively than the original or prior media such as paint or film—in differing
class contexts and in a fashion less accessible to policing. Observations of
this kind may do something to account for persisting aesthetic hierarchies,
but they don't take us far toward a positive account of what exactly prints
are. Just as video is something other than film on tape (especially when a
movie has been shot on video, rather than transferred, as Wim Wenders

demonstrates in his *Notebook on Cities and Clothes*),[2] engravings have effects that are specific to their techniques and materiality.

Benedict Anderson has drawn attention to the crucial significance of what he has called "print capitalism," and especially newspaper publication, for creole nationalism.[3] Linda Colley has similarly suggested that newspapers "made it easier to imagine Great Britain as a whole" even in the early eighteenth century;[4] they later created a more intense and general awareness of events in the life of the monarchy, in parliamentary business, and in other political processes. While these arguments concerned printed *texts*, it is obvious that the reproduction of visual material, and especially of political cartoons and satires through mass-circulation engravings, was equally crucial to the articulation and shaping of public political sentiments. The power of such images derives from their condensed character, from the use of icons such as John Bull, and often from simple and direct appeals to moral responses—for example, toward the barbarous treatment of women[5] or toward behavior that may not be savage but is manifestly ridiculous or effeminate. Of course, the truth in such images does not arise from any literally accurate representation of circumstances but from their capacity to anticipate and immediately resonate with truths perceived by a viewing public, an audience that has prior interests and preoccupations yet may be refashioned as it consumes visual representations and self-representations.

The particular power of engravings may also be derived from the long-prevalent notion that visual images have a special capacity to convey truth that words do not. It is, of course, a fact that certain kinds of information— concerning botany and architecture, for instance—may be far more readily conveyed graphically than verbally, but I am less concerned to extend fairly tired arguments on this point than to note that one of the specific correlates—the idea that a text is less sufficient than art engraving—is attested to for the period I focus on in this chapter, implicitly by the singular importance of prints in travel books, and more explicitly by the common reference to an illustration that gives "the best idea" of an object, building, or scene. In the radical novel *Hermsprong*, Robert Bage heightens his readers' anticipation and makes his account of a near fatal riding accident more compelling through appeal to the graphic texture of an absent print, while ironically parading the modest status of his own book: "Without an engraving, I despair of making my readers understand the ensuing description; and the patrons of this humble sort of book-making are not sufficiently liberal to enable a poor author to gratify his readers and himself in this particular.

However, when the public ask a fourth edition, I will certainly give it, with a map, at my own expense."[6]

I am suggesting that what made prints important was not merely the technological and social facts of their mass distribution, which enabled the anticipation of certain public audiences, but also the notion that some kinds of prints were taken as vehicles for peculiarly objective representational truths, such as those evoked through charts, diagrams, and anatomical profiles (while others, if possessing truth of any kind, might be allegorical or exemplary). This could not have been asserted in any vehement way for the prints associated with travel books in the sixteenth and seventeenth centuries, which were usually produced without reference to primary sketches and often on the basis of images borrowed from other travel books or from biblical iconography, of peoples or places remote from the region notionally depicted.[7] For these imaginings, which were in significant senses preracist, the differences between African and native American bodies, even European and Native American ones, were not of such importance that they needed to be accurately conveyed through visual representations. In the eighteenth century however, and particularly after 1750, it became more common for engravings to be based directly on the traveler-author's sketches or those of an accompanying artist; a degree of ethnographic specificity emerged, and glaring contradictions between texts and images (the one denigrating, the other idealizing native peoples) became less common. By the early nineteenth century, when techniques were considerably diversified and improved, it was claimed that engravings were not merely accurate but possessed an indexical relation to what was depicted: "The pencil is narrative to the eye . . . its representations are not liable to the omissions of memory, or the misconceptions of fancy; whatever it communicates is a transcript from nature."[8] This rhetoric, which was subsequently appropriated by the advocates of photography, had its technical correlate in the use of devices such as the camera obscura, which artists such as Thomas and William Daniell, James Baillie Fraser, Henry Salt, and others employed in India and elsewhere. The tone and light of their aquatints were remarkable; the use of color conveyed the distinct exoticism of plants, landforms, buildings, costumes, and bodies as never before.

At the same time as prints were being authorized or championed with the aid of this prephotographic rhetoric, the adequacy of their representations was constantly questioned. Lord Valentia, traveling through north India, found fault with a number of the plates in William Hodges's *Select Views in*

India:[9] one of a gateway "had no resemblance to it," while it was sardonically presumed at Juanpore Bridge that "Mr. Hodges's view seems to have been drawn from memory."[10] These statements were no doubt motivated by the fact that Valentia was accompanied by his own secretary and artist, Henry Salt, whose rival works illustrated the publication quoted. It may similarly be noted that a good deal of the acrimonious debate surrounding the publication of the findings from James Cook's second voyage — between the naturalists Johann Reinhold Forster and George Forster, the astronomer William Wales, and in the background, the Admiralty and Cook himself — turned upon the accuracy or otherwise of engravings published in the official account of the voyage. The costume of the Malekulan man, the dress and physique of the Tongans, the form of indigenous artifacts and ornaments — the published representations of all of these were challenged and debated.[11]

In the context of the travel publishing business, the idea that a print is above all a derivative image is inappropriate. Portraits and even landscape views were often based not on oil paintings that would have been exhibited as works of art in their own right but on watercolors or sketches prepared specifically for reproduction. In the case of natural history illustrations and a closely affiliated genre that I consider here, which consists of representations of exotic ethnographic implements, ornaments, and weapons, it was still less the case that the "original" drawings or paintings had any status as artworks in themselves; like a typescript, they amounted merely to a stage in the preparation of a printed work.

In the case of eighteenth- and nineteenth-century political prints, the most obvious matters to be analyzed are their content, stance, and ambiguities; however, one of the questions that may be of greater interest to the historian concerns the kind of public or audience the images sought to address and what wider assumptions about political opinion and active citizenship they therefore registered. Similarly, an analysis of travel prints can address the issue of how distant peoples and colonized or prospectively colonized places were represented (were they feminized? bountiful? neglected? archaic?). Though such studies certainly contribute to the rapidly accumulating corpus in colonial cultural studies that is concerned with European representations of non-European "others," we may discover more that we do not already know if we ask about producers and audiences rather than about what is depicted. In the case of travel, as distinct from that of the political caricatures, there might be less of interest to say about the public

projected by the images and more value in attempting to establish what the visual representations implied about travelers and the work of travel itself. It is something of a cliché to say that the traveler uses the experience of the foreign to fashion himself or herself; familiar as the proposition may be, it is relevant for the grand tour, because that was understood specifically as a methodical and pedagogical exercise,[12] and in a different way for scientific travel, which was not unambiguously celebrated or approved of. Though many critics have argued that science legitimated imperialism, natural history and antiquarianism were not themselves definitely legitimate: scientific travel, like collecting, was often considered trivial or promiscuous, a mask for espionage, commerce, or licentiousness. How, I ask in this chapter, does a rather odd class of visual representations relate to the effort of self-definition, which I take not as an interior psychological process but as a public project of intellectual and moral authorization, not strictly of the self but also of the endeavor of natural history and scientific travel?

Artifacts

The kinds of prints that I deal with here have been ignored not only by art historians but also by the wide range of scholars dealing with European representations of non-Western peoples. While anthropologists, for instance, have been increasingly concerned with the ways in which European uses of artifacts have encoded interests in the exotic and the primitive, discussion thus far has mainly been oriented to institutions such as museums and international expositions.[13] There has been less work on the agendas of particular collectors and on the representation, as opposed to the arrangement and display, of objects.[14] Of course, plates such as those from the publications of Cook's famous voyages of the 1770s (see figure 5.1) might seem merely an esoteric or very minor class of images undeserving of critical attention, but it is important to note that these books and similar voyage works were extremely popular and were frequently reprinted; the pictures, which included landscape views and portraits of islanders but often also numerous arrays of artifacts of this kind, were considered particularly attractive. Fashionable interest in the ethnographic specimens known as curiosities was moreover unprecedented, such that common sailors could augment their incomes considerably by selling collections on returning from voyages; some of the material ended up in major private collections such as the Leverian Mu-

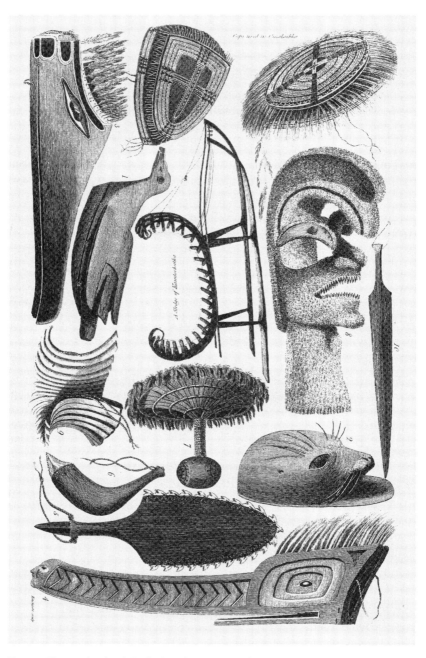

Fig. 5.1. *Various Articles of Nootka Sound, Various Articles of the Sandwich Islands*, engraving from George William Anderson, *A New, Authentic, and Complete History of Voyages round the World* (London, 1784–86). National Library of Australia, Canberra.

seum. Although museums existed earlier in Germany, Italy, and France,[15] the period was one in which the interest in both European and colonial antiquities was expanding and becoming a matter for larger public institutions and societies as well as notoriously fetishistic private collectors: the British Museum, seemingly the paradigmatic repository of imperial loot, was established in 1753; the Royal Asiatic Society, which collected material and published information concerning antiquities and anthropology exhaustively in India, was founded in 1784; early in the nineteenth century, organized excavations were proceeding under British sponsorship in Egypt and material flowed steadily to London. In retrospect, these institutions and projects epitomize colonial collecting, which seems rapacious, extraordinarily self-confident, and absolutely indissociable from military, political, and economic dominance. Leaving aside the question of whether this is adequate even for interests in specimens, artifacts, and collections during the Victorian period, this perception would radically overstate the degree of authority and coherence that collecting—and the scientific travel that facilitated it—possessed earlier. The ways in which artifacts were depicted in the late eighteenth century are thus of some salience for the longer history of Western interests in exotic material things and peoples. They are not self-evidently part of an imperial, totalized knowledge "of the other"; rather, they are somewhat opaque images that attest more to insecurity than to mastery, and to a disputed knowledge of the exotic.

I have argued elsewhere that there was a good deal of enthusiasm about Pacific curiosities in the late eighteenth century, but the attitude is marked by a puzzling lack of content and specificity; exotic objects commanded attention but were not subject to articulated aesthetic assessment, classification, or enframing in any comparative discourse concerning peoples or technologies.[16] This is manifest in the kind of text that accompanied figures of "weapons and implements": "20. Is a kind of Battle-axe, used either as a lance or as a patta-pattoo. The length of these is from five to six feet. The middle part of them is very ingeniously carved . . . 24. A Whistle, made of wood, having the out-side curiously carved. Besides the mouth-hole they have several for the fingers to play upon. These, which are worn about the neck, are three inches and a half in length, and yield a shrill sound."[17] Both textually and visually, things are represented in a rigorously objective fashion, yet also in the most radically uninformative way; their uses may be obvious or may be referred to in captions of the kind quoted, but relevant comment is almost always rigidly neutral. While remarks are occasionally made

on the dexterity or ingenuity of carving, especially in New Zealand material, inflected moral or aesthetic adjudications, or narrative associations, are hesitant or absent from descriptions of the baldest sort.

The absence of any twentieth-century interpretive discourse concerning plates depicting ethnographic specimens is thus matched by an absence in eighteenth-century commentary; the very lack may itself be an index of the objects' identities as appropriated European exotica and of the cultural and political interests inscribed in the images' production. If scholars who have otherwise found Enlightenment workings of the exotic a remarkably complex and rich field have apparently had nothing to say about these illustrations, this lack may manifest not just a simple absence of interest but also perhaps a fact—that in a sense there is nothing that can be said about them. A marked degree of illegibility might, of course, merely reflect our own lack of awareness of the ways in which these engravings were responded to at the time of publication, but in this case there is arguably a singular kind of discursive vacuity that can be seen to positively express the conflicted interests in the things represented and in the broader work of representing the exotic in the late eighteenth century.

This vacuity of meaning emerges, I suggest, from the extreme decontextualization of the pieces depicted, from the kind of space that they occupy, and from the absence of clear adjudications or narrative positioning in the texts within which these plates were physically bound. The extent of discursive deprivation can be signaled crudely by the contrast with another set of engravings in the same publications (figure 5.2), which depicted Cook's landings on various islands and meetings with indigenous peoples after the paintings of William Hodges and John Webber. Some of these showed peaceful encounters; others violent ones. All embodied the sense of historical significance that the voyage of exploration possessed, which was manifested not only in the expansion of strictly geographical knowledge, but also in the commerce and intercourse that ensued between European civilization and islanders; commerce, which was considered fateful and morally ambiguous, would induce progress through trade and the introduction of manufactured articles as it would also corrupt the characters and bodies of natives, emblematically through prostitution and the introduction of venereal disease in the fashion discussed elsewhere.[18] The topographic sites of these encounters on the edges of land and sea, civility and barbarity; the inclusion of the ship, expressive of the voyage and British naval power; and the juxtaposition between the dignity of the classicized islanders and the grandeur of

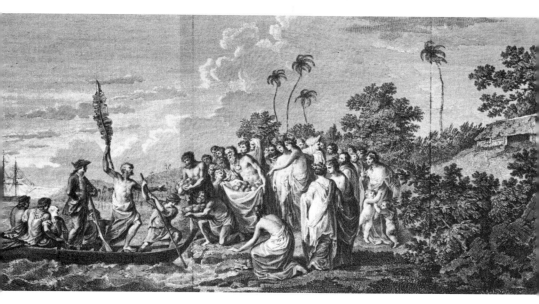

Fig. 5.2. *The Landing at Middleburgh, One of the Friendly Isles*, engraving by J. K. Sherwin after William Hodges, from James Cook, *A Voyage towards the South Pole and round the World* (London, 1777), I, plate 54.

Cook's arrival are immediately reminiscent of established traditions of history painting—which found subject matter still more appropriate in Cook's death on the beach in Hawaii during the third voyage.[19] The landing and meeting pictures are, in other words, saturated with human purpose, with human difference, with an encounter that was (and was at the time understood to be) historically constitutive.

It is precisely this contextualization in human action—action that is accorded some moral or historical significance—that is at the greatest remove in the images of curiosities. Though the objects are of course the products of human work and craft, they are abstracted from human uses and purposes; the very possibility of displaying "weapons and ornaments" in a single assemblage indicates the extent to which the things imaged are decontextualized and their uses become irrelevant. While the meanings of objects normally subsist in their functions and in their perceived and encoded significance, and they are hence clubs and headdresses rather than merely pieces of wood or shell, such differentiations seem subordinated or forgotten here in the perception of forms; it would no doubt be going too far to suggest that the associations with particular practices are entirely erased, but we

are, I think, at a severe remove both from any sort of narrative and from the ordinary flow of experience, when fighting, fishing, and self-decoration can be equated in this fashion.

While these images are essentially variants of natural history illustrations, there is also a kind of painting that they remind us of. The genre of still life, Norman Bryson suggests, offers several insults to the kind of "human-centered dignity" we are used to in other genres of painting and of course in narrative and representation more generally: "In history painting we see the human form more or less idealized, and in portraiture we see the human form more or less as it is, but in still life we never see the human form at all." The viewer is, moreover, "made to feel no bond of continuous life with the objects which fill the scene"; the objects depicted "lack syntax: no coherent purpose brings them together in the place where we find them."[20] Bryson argues that some still life, and particularly that of Jean-Baptiste-Siméon Chardin, humanizes and refamiliarizes its objects through a casualness of vision that implies households and domesticities rather than showcases, and hence, that there is scope for a counterbalancing contextualization that mutes the genre's objectifying fetishism. I will suggest that in just a few of the images of artifacts, there is a comparable amelioration. These, however, are exceptional, and Bryson's proposition that the genre displaces or excludes humanity is true in a more extreme way of the engravings; this is perhaps not surprising, since a variety of parallels and continuities might be noted between Dutch still life, the business of collecting, and eighteenth-century scientific illustrations, with respect not only to the decontextualizing mode but what was decontextualized. The still life paintings frequently included rare or Oriental commodities and natural curiosities such as shells (which, like flowers, are identifiable as species or varieties); the realism of their precise vision was also combined with bizarre and unreal juxtapositions and combinations that emphasized the material character of objects and neutralized their diverse uses. The minute descriptive vision of the Dutch painters—"the little style, where petty effects are the sole end"—was censured by Joshua Reynolds; in much the same language, he criticized the unaesthetic visual empiricism that some landscape painters were beginning to adopt and which was present to some degree in paintings from the Cook voyages, caught as they were between neoclassical aesthetics and scientific interests in novel atmospheres, plants, and bodies.[21] This attitude has no particular bearing on the representations of artifacts, which were simply subaesthetic rather than inadequate or imperfect forms

of something else; but if "minute particularities" led the artist not simply to produce inadequate work but to "pollute his canvas with deformity," as Reynolds suggested, it is possible that the engravings express more substantial transgressions of value, which arise from the wider moral status of particularity and novelty.

The disconnection between human viewer and an array of things has more particular determinations than those in still life painting (a defamiliarizing treatment of otherwise familiar bread, fruit, and vessels); dissociation is magnified not only by the peculiar conjuncture of objects belonging to quite different domestic and nondomestic domains of human activity—tattooing and warfare—which has already been mentioned, but also by a simple fact that can only be considerably less arresting for the museumgoing, late twentieth-century viewer, namely, that in the 1770s, Maori carving was indeed radically novel and strange and, to a greater or lesser degree, so were many of the other artifacts and designs brought back from the Pacific on Cook's voyages. Of course, some things were readily recognizable as spears, bows, or bowls; but others, such as a Marquesan headdress of feathers, shells, and tortoiseshell fretwork and the garment of the chief mourner in Tahitian funeral processions, were considered extremely curious and perplexing.

Let me return briefly to the space that the imaged things occupy, which I suggest is what makes their exclusion of humanity still more radical than that typical of still life painting. In the second half of the nineteenth century, artifacts were sometimes arranged on walls in a fashion reminiscent of the printed images of that period, which gave much greater emphasis to symmetrical appropriations of form, but there is no sense for the earlier period that what confronts us is a representation of a wall or of any other natural space on which or within which we see things that are set out. Rather, the absence of shadow, the deemphasis of tone associated with any particular light source, the frequent lack of any framing or border on the page, and the inclusion of a variety of implements of quite distinct sizes presupposes an abstract, nonspatial field in which weightless things might equally be standing vertically or laid out on a surface. The strange counterpoint to the uninflected realism of the objects' treatment is the wholly imaginary field that they occupy, which could be seen as no less abstract and unnatural than the painted surfaces of Jackson Pollock or Mark Rothko. If the latter immediately strike us as paintings rather than paintings *of* anything, the former is just an area of blank paper upon which things have been printed, rather than

an area that imitates a real space of any other kind. The suppression of scale and the fact that one piece can appear twice within an image—from different angles or in its entirety and in a detail—not only suggests a comprehensive abstraction from any normal physical domain but raises a question about the position and the character of the viewers: is there some correspondence between the unworldliness of the specimens' nonspace and their own vision and interest in the objects? That is, can that interest be positively constructed as an engagement that is correspondingly dehumanized and objective, free of inflected motivation, or is it intelligible only as a kind of alienation, a failure that is ensured by the severity of the images' decontextualization?

Curiosities

This is the point at which it becomes important to ask what it meant to call artifacts *curiosities*. Of course, this term had been employed earlier, as it was subsequently and is sometimes still (though after the mid-nineteenth century *curio* was more widely used); given this diversity of context it cannot be suggested in some transhistorical way that this labeling is especially revealing. For the second half of the eighteenth century, however, it is notable that travel writing (concerning Europe as well as more distant regions) is pervaded by the idea of curiosity, that the nature of curiosity is not fixed but morally slippery, that its associations with legitimate authority and inquiry are disputed and ambivalent, and that this area of semantic conflict is directly associated with responses to ethnographic specimens, since "curiosities" were frequently characterized as being "curious" and as arousing the "curiosity" of people for whom they were exotic. In Cook's own journals, and in the voyage accounts of the naturalists and officers, there are a plethora of references to "curious" garments, ornaments, adzes, caps, and the like, as well as to "curious" carving, staining, tattooing, and so forth.[22]

 Given that the artifacts were found to excite a passionate acquisitiveness among sailors (who, it was said, preferred to barter for them rather than for fresh fish and fruit) and that the Cook voyages in general were said to excite an eager curiosity for geographical knowledge among the British public, what seems specific to the moment is a field of meaning within which subjective response, adjectival characterization, and naming would seem intimately if not harmoniously connected. In the late nineteenth century, in contrast, a "curio" was more immediately legible as a sign of idolatry or

cannibalism, which would provoke quite specific moral responses rather than the form of desire that I will suggest was marked by its ambivalence and vacuity. To put this another way, and in quite anachronistic theoretical terms, the eighteenth-century associations implied a relationship between exotic object and knowing subject that was profoundly hermeneutic—a thing could not be considered a curiosity without reference to the knower's intellectual and experiential desire; discourses, inquiries, and relations, not just their objects, were curious—while subsequent attitudes tended to objectify the tribal specimens as expressions of a savage condition, a barbaric stage founded in the order of social development rather than in the responses and pleasure or displeasure of a particular civilized person. There is an implication of risk for the eighteenth-century engagement with an exotic object that appears not to arise in other contexts.

This implication may be read as positively hazardous if the wider associations of curiosity are taken into account. Though the idea of legitimate inquisitiveness is often encountered, there are many forceful expressions, in a variety of genres, of the notion that curiosity is infantile, feminine, somehow tarnished, and licenced in the sense of licentiousness rather than authorization. In fiction, curiosity is often explicitly promiscuous. It might be suggested that its dependence on external things, and its arousal and risk, in the context of a masquerade in Fanny Burney's *Cecilia*, is paradigmatic: "In her curiosity to watch others, she ceased to observe how much she was watched herself."[23] The peculiar blending of illegitimate and laudable aspects is captured by the paradoxical gloss in Johnson's dictionary: to be curious is to be "addicted to enquiry." While enquiry would usually seem a proper and essentially masculine activity, addiction, entailing abandonment or at least a partial surrender of self-government before an external agent or object, is certainly illegitimate and excessive.

What is infantile, insecure, and morally problematic in society at home nevertheless figures as an appropriate disposition abroad: Edward Gibbon expressed the commonplace with respect to his own grand tour that "in a foreign country, curiosity is our business and our pleasure,"[24] and it seems entirely natural for Samuel Johnson to note censoriously that a writer who failed to ascertain the correct breadth of Loch Ness was "very incurious."[25] The apparently logical character of this shift, which arises from the different status that a preoccupation with the novel has in familiar circumstances and in foreign parts, does not, however, render curiosity unproblematic in the

context of travel; it is not as if the external situation of the objects of inquisitiveness insulates knowledge from the implication of impropriety. For John Barrow, in 1801, discursive authorization was evoked through the curiosity's exclusion: "To those whom mere curiosity, or the more laudable desire of acquiring information, may tempt to make a visit to Table Mountain [above Cape Town], the best and readiest access will be found directly up the face next to the town."[26] But what was the difference between being curious and desiring information? Barrow wrote that the mountain's summit was "a dreary waste and an insipid tameness" that prompted the adventurer to ask whether "such be all the gratification" to be gotten after the fatigue of the ascent: "The mind, however, will soon be relieved at the recollection of the great command given by the elevation; and the eye, leaving the immediate scenery, will wander with delight round the whole circumference of the horizon. . . . All the objects on the plain below are, in fact, dwindled away to the eye of the spectator into littleness and insignificance. . . . The shrubbery on the sandy isthmus looks like dots, and the farms and their enclosures as so many lines, and the more-finished parts of a plan drawn on paper."[27]

In Barrow's account, the exhausted body doubts the worth of a short excursion because of the dullness of the immediate surroundings; on the other hand, for the mind, the value of the ascent is established by the panorama that it affords, which is marked by the fact that the traveler can experience the surrounding world as a picture. The association of the mind, the larger view, and information prompts an opposed series of implications—of curiosity and a kind of vision that responds to proximate surroundings and is overwhelmed by the condition of the body rather than delighted by the larger scene. This overdetermination of intellect by corporeality is of course expressed in the vocabulary of curiosity, which, like hunger and lust, is not governed by the mind but is "aroused," "gratified," and so on. This is hardly specific to the period, but it is notable that the aim of a desire "more laudable" than curiosity is the subsumption of other lands to the form of representation over which one possesses a "great command." It is as if picturing, understood immediately and explicitly as an operation of power, somehow establishes the legitimacy of a kind of knowledge or interest that is otherwise problematic, otherwise anxious and giddy. This is highly suggestive insofar as the imaging of the objectifications of curiosity, of ethnographic specimens, is concerned, and this is a point I'll return to.

Enduring proverbs (e.g., "curiosity killed the cat") and more recent texts

such as the Curious George children's stories and *I Am Curious (Yellow)* tell us that curiosity's connotations of risk and licence were not specific to the eighteenth century.[28] The question therefore arises as to precisely why they should have been discursively conspicuous in that period, rather than merely semantically present. I suggest that curiosity was a problem because it shadowed another term that had the same attributes—one that was also a matter of passion and particularity, of the attraction of what was novel. Unlike curiosity, commerce was central to eighteenth-century British political debate, and attitudes toward it were similarly profoundly ambiguous. Even in a relatively neutral account such as David Hume's, it was as directly associated with novelty and passion as we have already seen curiosity to be:

> In most nations, foreign trade has preceded any refinement in home manufactures, and given birth to domestic luxury. The temptation is stronger to make use of foreign commodities, which are ready for use, and which are entirely new to us, than to make improvements on any domestic commodity, which always advance by slow degrees, and never affect us by their novelty. The profit is also very great, in exporting what is superfluous at home, and what bears no price, to foreign nations, whose soil or climate is not favourable to that commodity. Thus men become acquainted with the *pleasures* of luxury and the *profits* of commerce; and their *delicacy* and *industry*, being once awakened, carry them on to farther improvements, in every branch of domestic as well as foreign trade.[29]

As I noted earlier, Hume sees an appetite for the novel as improving, but his own observations on the "uncertain signification" of luxury adumbrate the negative dimension of the process, which receives a good deal of attention also in the works of Lord Kames, John Millar, and Adam Smith.[30] One argument was that luxury was feminizing and corrupting; Britain could be identified with earlier empires or societies that had declined as opulence sapped their martial vigor and public spirit. Another was that the particularization of labor removed one of the bases of active citizenship; not only were men therefore cheapened, the state of the body politic as a whole was prejudiced by the scope for despotism. These debates, which of course have a complex relationship with class instability and social rivalries between trade and landed property, need not be discussed further here. My point is simply that curiosity, in its canonically impassioned and infantile form, was both metonymically situated within the process of trade—as the form that desire

for novel foreign commodities took—and metaphorically associated with the whole. A vocabulary of corporeal desire governed both; the fetishism of the bauble, the particularism of the flycatcher, had as problematic a relation to public virtue as the "petty effects" of the empirical painter had for Reynolds's aesthetic universalism. One's interest in a specimen or object might indeed be definitely scientific; but the fact that this interest could not be apprehended as the appreciation of some general truth, but took the form of a desire for particular things, meant that one's project could only be polluted and deformed, if the implications of the neoclassical dicta were taken to their limits. This characterization is not as extravagant as it may seem. I discuss elsewhere that some forms of collecting and antiquarianism really were licentious, and sometimes preoccupied by literal deformity, or imagined deformity, that certainly deformed the business of inquiry. This is all too well attested to by the shocking case of the "Hottentot Venus";[31] let that stand for the plethora of expressions of colonial prurience that are too sad and objectionable to be rehearsed.

Notes

Nicholas Thomas, "Objects of Knowledge: Oceanic Artifacts in European Engravings," in *In Oceania: Visions, Artifacts, Histories*; 93–109. Durham: Duke University Press, 1997.

1 John Ruskin, *Modern Painters*, 5 vols. (London: George Allen and Unwin, 1898), 1:43n.
2 Wim Wenders, dir., *Notebook on Cities and Clothes* [*Aufzeichnungen zu Kleidern und Staedten*] (West Germany: Cenre national d'art et de culture/Road movies filmproduktion, 1989).
3 Benedict Anderson, *Imagined Communities: Reflections on the Origins and Spread of Nationalism*, 2nd ed. (London: Verso, 1992).
4 Linda Colley, *Britons: Forging the Nation, 1707–1837* (New Haven, CT: Yale University Press, 1992), 41, 220–21.
5 Colley, *Britons*, 264.
6 Robert Bage, *Hermsprong; or, Man as He Is Not* (Oxford: Oxford University Press, 1985), 17.
7 Bernard Smith, *Imagining the Pacific: In the Wake of the Cook Voyages* (New Haven, CT: Yale University Press, 1985), 173–74; M. van Wyk Smith, "'The Most Wretched of the Human Race': The Iconography of the Khoikhoin (Hottentots) 1500–1800," *History and Anthropology* 5 (1992): 285–330.
8 Thomas Daniell and William Daniell, *A Picturesque Voyage to India, by Way of China* (London: Longman, 1810), ii.

9 William Hodges, *Select Views in India* (London: W. Hodges, 1785–88).

10 Viscount George Annesley Valentia, *Voyages and Travels in India, Ceylon, the Red Sea, and Egypt, in the years 1802 . . . 1806*, 3 vols. (London: William Miller, 1809), 1:82, 1:89, see also 1:125.

11 Rudiger Joppien and Bernard Smith, *The Art of Captain Cook's Voyages*, 3 vols. (New Haven, CT: Yale University Press, 1985–87), 2:72–73, 2:87–92.

12 See Justin Stagl, *A History of Curiosity: The Theory of Travel, 1550–1800* (Chur, Switzerland: Harwood Academic Publishers, 1995).

13 George W. Stocking, *Objects and Others: Essays on Museums and Material Culture* (Madison: University of Wisconsin Press, 1984); James Clifford, *The Predicament of Culture: Twentieth-Century Ethnography, Literature, and Art* (Cambridge, MA: Harvard University Press, 1988); Sally Price, *Primitive Art in Civilized Spaces* (Chicago: University of Chicago Press, 1989).

14 But see Roger Cardinal and John Elsner, *The Cultures of Collecting* (London: Reaktion Books, 1994); Stephen Bann, *Under the Sign: John Bargrave as a Collector, Traveller, and Witness* (Ann Arbor: University of Michigan Press, 1995).

15 Oliver Impey and Arthur MacGregor, *The Origins of Museums: The Cabinet of Curiosities in Sixteenth and Seventeenth-Century Europe* (Oxford: Clarendon Press, 1985); Kryzstof Pomian, *Collectors and Curiosities* (Princeton: Princeton University Press, 1990).

16 Nicholas Thomas, *Entangled Objects: Exchange, Material Culture, and Colonialism in the Pacific* (Cambridge, MA: Harvard University Press, 1991) and *Colonialism's Culture* (Princeton: Princeton University Press, 1994).

17 Sydney Parkinson, *Journal of a Voyage in the South Seas in H.M.S. Endeavour* (London: C. Dilly, 1784), 130–31.

18 Nicholas Thomas, "Liberty and Licence: New Zealand Societies in Cook Voyage Anthropology," in *In Oceania: Visions, Artifacts, Histories* (Durham: Duke University Press, 1997), 71–92.

19 Joppien and Smith, *Art of Captain Cook's Voyages*, 2:71–73.

20 Norman Bryson, "Chardin and the Text of Still Life," *Critical Inquiry* 15 (1989): 228–34. See also Norman Bryson, *Looking at the Overlooked: Four Essays on Still Life Painting* (Cambridge, MA: Harvard University Press, 1990).

21 Joshua Reynolds, *The Literary Works of Joshua Reynolds* (London: George Bell, 1878), 1:359; Smith, *European Vision and the South Pacific*, 111; see also Svetlana Alpers, *The Art of Describing: Dutch Art in the Seventeenth Century* (Chicago: University of Chicago Press, 1983).

22 Smith, *European Vision and the South Pacific*, 123–25; Thomas, *Entangled Objects*, 129–32.

23 Fanny Burney, *Cecilia, or Memories of an Heiress*, ed. Peter Sabor and Margaret Anne Doody (Oxford: Oxford University Press, 1988), 106.

24 Edward Gibbon, *Memoirs of My Life*, ed. Betty Radice (Harmondsworth: Penguin, 1984), 134. In Copenhagen, N. Wraxall found that he was suspected of being a spy "because I come from England, and have no avowed motive, ex-

cept curiosity and knowledge" (N. Wraxall, *Cursory Remarks Made in a Tour through Some of the Northern Parts of Europe* [London: T. Cadell, 1775], 38–39). The premise of this text is that the remarks are "on the chief objects of curiosity here" (27) and much of the business of travel involves inspecting cabinets of curiosities, rarities, antiquities, and artworks.

25 Samuel Johnson, *Selected Writings*, ed. Patrick Cruttwell (Harmondsworth: Penguin, 1968), 307.

26 John Barrow, *An Account of Travels in to the Interior of Southern Africa, in the Years 1795, 1796, and 1797* (London: T. Cadell, 1801).

27 Barrow, *An Account of Travels*, 37–38.

28 H. A. Rey, *Curious George Takes a Job* (Boston: Houghton Mifflin, 1954); Vilgot Sjoman, *I Am Curious (Yellow)* (New York: Grove Press, 1968).

29 D. Hume, *Essays, Moral Political, and Literary*, 2 vols., ed. T. H. Green and T. H. Grose (London, 1882), 1:295–96.

30 G. A. Pocock, *The Machiavellian Moment: Florentine Political Thought and the Atlantic Republican Tradition* (Princeton: Princeton University Press, 1975), 430–31; Stephen Copley, *Literature and the Social Order in Eighteenth-Century England* (London: Croom Helm, 1984); James Raven, *Judging New Wealth: Popular Publishing and Responses to Commerce in England, 1750–1800* (Oxford: Clarendon Press, 1992).

31 Stephen Jay Gould, "The Hottentot Venus," in *The Flamingo's Smile: Reflections in Natural History* (New York: W. W. Norton, 1985), 291–305.

CHAPTER 6

Excess in the City? The Consumption
of Imported Prints in Colonial
Calcutta, c. 1780–c. 1795

Natasha Eaton

Chance volumes are constantly in danger of changing into others and affirm, negate and confuse everything like a delirious divinity. . . . I know of districts in which the young men prostrate themselves before books and kiss their pages in a barbarous manner, but they do not know how to decipher a single letter.
—Jorge Luis Borges, "The Library of Babel," *Labyrinths*

As regards the sounding out of idols, this time they are . . . here touched with the hammer as with a tuning fork—there are no more ancient idols in existence. . . . That does not prevent their being the most believed in and they are not (usually) . . . called idols.
—Friedrich Nietzsche, *Twilight of the Idols or How to Philosophize with a Hammer*

Were chance volumes of prints constantly in danger of becoming something other? Dampened by the tropics, passing in and out of the lives of dying Britons, such images performed a crucial role as believed-in-idols in Calcutta's public life. Engaging with current concerns with cultural thingness, networks, and the proliferation of hybrids, this chapter underscores the importance of prints in the symbolic-economic space of British colonial diaspora. It examines the nature of colonial consumption in the context of recent ethnography and postcolonial studies. These will provide the framework to plunge into the consuming patterns of Calcutta's British diaspora in order to analyze its attitudes toward prints as luxury goods of conspicuous consumption and markers of racial segregation. The final section argues for the centrality of prints through the lens of the "emporium effect." It also exposes the tensions in fashioning a discursive forum informed by both politics and art, at a time when Calcutta was catapulted from spectacular boom into darkest recession.

Celebrated in contemporary newspapers and traceable in those mercantile records that constitute the imperial archive, paradoxically this most ubiquitous of art forms has hardly left its mark on extant colonial collections. As East India Company "archive fever" burned with imperialist nostalgia— to preserve what was perishing under colonial rule (the rare or curious)— English prints played no part.[1] Instead, they were classified by the pragmatics of everyday life, as familiar and disposable, possessing an ambivalent relationship with difference. Being the art of mechanical reproduction, they had no entry into the "archive as fetish," which performed as the "stand-in for the past that brings the mystified experience of the thing itself."[2] Yet distinct rituals surrounded prints in India; they possessed their own aura that was only heightened by their status as reproductions cast into exotic new contexts. They may have allowed consumers to stake a claim in global networks but they were deeply inflected by the local. They constituted a "parallel" as much as a "derivative" modernity that was generated by innovation, imagination, pleasure, nostalgia, melancholy, and the unlived.[3] Circulating in international networks, prints entailed a mode of linkage between forms of micro-political agency and wider cultural processes that valorized something more than patriotic celebration or mourning over the rupture of exile and loss. Instead, they highlighted more indeterminate emotions about the contingent nature of national and colonial existence.[4]

Along with other imported commodities such as cheese and champagne, prints were preferred to local art and luxuries. Who cared about an overpriced, cumbersome Zoffany portrait, a badly scraped local engraving or the "flawed, curious" realism of Company painting, when you could have a cabinet of English prints! Like their human cohabitants, these pictures lived brief lives, succumbing to the heat and the dust, monsoons, ants, and the damp. Glittering, nationalistic, novel, and expendable, prints signified as conspicuous waste rather than as inalienable possessions.[5] Yet they contained an "animism" capable of molding the appearance, even the very being of the city. For instance, prints not only decorated Calcutta's public buildings but these very structures were devised by Company engineers reliant on imported editions of *Vitruvius Britannicus*. In turn these buildings were recorded by amateur engravers such as Captain William Baillie who combined his military topography with flourishes gleaned from Boydell's views of London, Edinburgh, and Ireland, declaring, "I lay my hands on all books of views that come within my reach."[6]

Provincial Mughal artists forced to migrate from the former capital of

Bengal, Murshidabad, were commissioned by colonial officials to trace, copy, and reverse prints such as William Hodges's *Choix des Vues de l'Inde*.[7] As patrons Britons and Indians could choose from (and discriminate against) an enormous range of art.[8] For instance, the estate of Henry Maschmann included a print of Gainsborough's *Watering Place* sold to Mr. Needham for 24 rupees (hereafter Rs), two prints of Queen Mary and King Charles sold to Govind Pyker for 31 Rs, and four square Hindustani pictures sold to Pharsee Johame for 38 Rs.[9] A distinct Indian patronage structure flourished among north Calcutta's mercantile community, which created its own taste agenda. Partners in colonial commission houses, these merchants became shrewd observers of British social mores for the accretion of their own cultural identities—practices mediated by prints.

In these complex networks, prints' display and their subject matter formulated technologies for fashionable, nostalgic colonial selves, as well as influenced the consuming patterns of indigenous artists and elites. They instigated and became entangled within debates over luxury, climate, and race. They had access to Indian spaces interdict to the British; they signified English authenticity while becoming utterly hybridized by the tropics.

Animism in the Labyrinth: Rethinking Things in Colonial Consumption

Objects are naturally shifty.
—John Frow, "A Pebble, a Camera and a Man Who Turned into a Telegraph Pole"

Why should these torn bits of paper (that died before colonial archives could enshrine or reject them) be allowed to share their tales of the city? Monographs on objects have become increasingly numerous—from lives of the biro to the tampon—as part of a growing preoccupation with histories of consumption. The "consumption of culture" dominates debates on eighteenth-century life, yet what does it actually mean to consume, what did these diasporic pictures want?

In Western democracies consumption has become one of the principal means for participating in the polity. Yet, it is also dubbed destructive of the worldly durability of things embedded in the culture of premodern use. So what of eighteenth-century colonial consumption? To a large extent the idea of a celebratory, Whiggish "consumer revolution" still lurks beneath debates concerning the "discovery of the economy" and the dissemination of luxury goods.[10] Such interpretations define consumption as a symbolic trace

of social status which elevates prestige through distinction and emulation.[11] Yet where is the agency, the alterity of things? Pierre Bourdieu asserts that human agency is unaltered by passive objects, while Jean Baudrillard suggests that objects are charismatic, even person-forming. Although his definition takes men and things to signify arbitrarily through linguistic simulacra (hence neglecting issues of being and illegibility), he does acknowledge some (albeit human-oriented) agency for objects.

It is largely through the work of Bruno Latour that things are at last being given equal borrowing rights and entry into a network of reciprocation with humans. Deconstructing the Cartesian *res* and the Kantian "thing" to be perceived by the transcendental subject, Latour shows that things and humans are coproduced. Using the concepts of quasi object and quasi subject, he argues that modernity portrays society as "either too weak or too powerful vis-à-vis objects which are alternately too powerful or too arbitrary."[12] Instead quasi objects and quasi subjects are discursive, generated in and articulated by networks rather than removed into a realm of "sleek nature," autonomous discourse, false consciousness, and simulacra. "Real objects are always part of institutions, trembling in their mixed status as mediators, mobilizing faraway lands and peoples, ready to become people or things, not knowing if they are composed of one or of many, of a black box counting for one or of a labyrinth concealing multitudes."[13] Things are the age-old and the new Others of discourse that refuse to return the human-(ist) gaze. This is not to "re-enchant things" which would merely be to turn human agency on its head, but rather it manifests an entanglement of men and things where the world is many, not double.

While this has made us rethink the whole problematic of European modernity understood as disenchantment, it is yet to be used in colonial contexts—in sites of staging *other* modernities. Arjun Appadurai and Nicholas Thomas have traced the social lives of entangled objects (specifically concerning commodities and exotic private property) but in the end they also reduce the agency of things to culturally configured tropes ("methodological fetishism"), merely extending the humanist root metaphor of culture as the production of humans alone.[14] Postcolonial studies it seems, is not yet ready to throw out the modernist-colonialist paradigm and to shift its agenda from a theory of agency still afflicted and inflected by colonial legacies. While Latour was penning *We Have Never Been Modern*, Homi Bhabha was rethinking hybridity through the lens of ambivalence as axiomatic to colonialism. This critical linkage of ambivalence to hybridity re-

inscribes colonial encounters with a productive tension—a sense of differ-ence that is not about pure otherness. Bhabha uses things to symbolize the slippage between British culture's incomplete translation to the colonies which becomes both a source of increased, despotic control and of anxiety—of the incomplete, the uncanny, as these cracks in colonial discourse create a space for resistance. He mobilizes chapattis and Bibles as signs and symbols in imperial encounters. Like the peoples they encounter, these things pos-sess ambivalent status—not quite objects, belonging to the colonized who are never accorded full subjecthood. Although these things are ultimately reduced to a linguistic, if highly problematic signification, their role within colonial struggles opens new horizons for their alterity and agency.[15]

Sometimes chapattis and Bibles assume a quasi-fetish status in Bhabha's India and it is discussions of fetish that convey the animism, allure, and re-pulsion of things in the colonies. Deriving from the Portuguese for witch-craft, *fetish* became enmeshed with the personification of material objects and belief in objects' supernatural powers arising from chance or arbitrary conjunctions. "This alleged aleatory procedure for the external determina-tion of a subject's will by the contingent association of a singular material object with an individual purpose, constituted the fundamental intellectual perversion of fetish worship."[16] Fetish was transformed into the Modern Other not only to a Christian or commercial European imperialism, but also as a form of devil worship integral to all exotic, primitive, barbaric places. Yet *fetish* bears the same root as *fact*—it is the religion of Europe always in denial, convincing itself it is rational, that the world is painted in black and white, that things, ideas, and people do not seep, feed, bleed into one an-other. By making these human–nonhuman, nature–culture, subject–object, fact–fetish (factish) connections, Latour suggests that we should think side-ways—that such networks operate on the horizontal not the vertical hier-archy that has divided races, that has severed men from things.[17] This is not merely to free things from the "Panopticon" of racial and cultural confine-ments, but to recognize that things are messy, that these cyborgs, these hybrids pertain to the labyrinthine, to the Creole, and that this has always been so.

Facts and fetishism were integral to colonial Calcutta. Information gathering dominated early Orientalist activity, but so did the less explored realm of fetish. Compartmentalizing Hindus as iconophiles and Muslims as iconophobic, Britons were poised in an in-between space of their own making. Unlike the Catholic Portuguese who employed European and

Indian painters to adorn their churches and government buildings, Britons eyed all painters with suspicion. The East India Company refused direct patronage to British artists. Although the Court of Directors granted permission to sixty professional painters to travel to its presidencies (rebuffing several others, including leading artist Francis Wheatley), it remained reluctant to fund print schemes, to accept work dedicated to the Company, and ignored pictures sent as gifts by such talents as William Hodges.[18] Former Mughal court artists known as "Company School" painters were commissioned by Britons to produce cheap watercolors of trades and castes or else to partake in the information-gathering projects of the colonial state—for which professional British artists were considered unsuited. Denigrated for a dearth of genius and yet praised for copying, these Indian artists as "mimic men" played a crucial if liminal role within the Company state.[19] Given these oblique and highly mediated relationships between the Company authorities and artists, why did English prints more than any other art form (and seemingly so marginal to these encounters) assume a "quasi-fetish" stature?

White Sepulchral City: Imprinting Death and Luxury in Calcutta

The city of Calcutta is such a place that even birds may tear out their feathers . . . if any animal grazes here it will lose its life . . . the trees are bereft of fruits, streams are filled with rubbish, the city is charmless. . . . The hearts of the people are always devoid of truth, righteousness and morality. They keep their doors shut all day and night out of fear of their own kind.
—Karam Ali, *The Muzzafarnama*

Calcutta: city of palaces, city of death, articulated by a rhetoric of whiteness yet dirty, labyrinthine—an Oriental city with a sickly, colonial heart. Established as a factory in 1690, this small fort-based enclave was razed to the ground in conflicts with the nawab of Bengal Siraj ud-daula in 1756. With victory machinated at Plassey the following year and the right to stand forth as *diwan* of Bengal, Calcutta usurped Murshidabad as the new capital. Huge houses coated in seashell lime and ornamented with classical facades were raised amid warrens of lanes and stinking tanks. Villages were destroyed by its Leviathan expansion, forcing rural image-makers to migrate to the bazaars. To the north, the Black Town, pivoting on the fiefdoms of a few wealthy indigenous (merchant-secretaries to the British), also distended to gigantic proportions, so that by 1790 the city harbored a population of over 200,000.

Poorly constructed on a mosquito-infested swamp, the majority of the city remained impenetrable to British painters and surveyors and was strongly criticized by the Indo-Muslim elites—hardly the ideal harbinger for the fine arts. Although as many as twenty-seven British painters and print makers used Calcutta as their base, the colonial community was never more than tepid in its artistic support. This became glaringly obvious in the sudden recession from 1785, forcing painters either to explore India in search of ethnographic subjects and landscapes (which they hoped to translate into successful metropolitan print schemes), or to relinquish their artistic practice—a strategy officially outlawed by the Company. Portraiture was dying; nabobs became debtors; Cornwallis's strict reforms along with war in Mysore effectively ended Hastings's glittering era of money and corruption. Despite attempts to enforce apartheid between the Black and White Towns, Calcutta became a dense heterotopia, its art market a tournament economy driven by the tensions of a proto-cosmopolitanism. Given this intense competition, shoddy, pricy, colonial print-making suffered most. William Baillie in correspondence with his former colleague—the now London-based miniaturist Ozias Humphry, apologized for the poor quality of the etching of his *Twelve Views of Calcutta*: "it will appear a very poor performance in your land I fear. You must look upon it as a Bengali work."[20] A familiar criticism, colonial print-making was repeatedly marginalized by the nationalistic, patriotic agenda of Britain's print capitalism.[21]

In the London press Calcutta was stereotyped as a hyper-realm of sickly, effete, vicious, and decadent nabobs, all in search of Oriental wealth. As early as the 1750s the city was represented as a den of iniquity, indolence, and decadence; Lord Clive declared it be "one of the most wicked places in the universe . . . rapacious and luxurious beyond conception."[22] Calcutta resembled a "brilliant if slightly tawdry imitation of Europe"—its mimicry associated with the menacing, farcical "tropical gothic" of a "middle-class aristocracy."[23] One reason for disdain was the slippage between definitions of needs and luxuries in the metropolis and the colony. In Britain, the dangers of Oriental goods (such as tea and opium) were hotly debated by moralists; they condemned these irresistible, addictive things for ruining individuals and for corrupting the body politic. Here was a discourse of Orientalism articulated by things too powerful for their own good, exaggerated in the colonies through the trope of the decadent, carnivalesque English "nabob." "Assimilation of the Orient might slip into infatuation; a dose of the exotic might become an infection rather than an inoculation. . . . Medical environ-

mentalism reinforced the idea of an Indianized European body as diseased. The nabob as a hybrid of East and West was primarily the product of cultural miscegenation."[24] Calcutta's British diaspora was not only exposed to these Oriental temptations but simultaneously chastised for its extravagant consumption of English things. Medical treatises prescribed against the use of tight corsets; rich, meaty dishes; Madeira; and too much dancing to London tunes, all of which led to humeral imbalance, fever, liver disease, and painful death. The concoction of climatic determinism and overconsumption placed corporeal strain on the nervous system—whose proper functioning was crucial to the physiological processes of *aesthetic* perception.

Such medical prescription colors the few polite portraits of colonial residents where luxury signified through self-representation and aesthetic display. In Zoffany's painting of the *Auriol and Dashwood Families*, the subjects stage themselves under a jackfruit tree, attended by Indian servants, displaying their imported china, Chippendale chairs, and decked in the latest European fashions (made from Oriental silk). The picture demonstrates how a repertoire of complex objects can create artifact-centered selves and how self-centered artifacts can become the new artistic subjects for an exotic British portraiture. Oriental action articulates the scene—chess, tea, and hookah smoking connote a heightened sense of colonial cosmopolitanism that elicited a distinctly creole dialectic between needs and luxuries: "*Living* is very expensive on account of the great rent of houses, the number of servants, the excessive price of all European commodities such as wine and clothes. The perspiration requires perpetual changes of clothes and linen; not to mention the expenses of palanquins, carriages and horses. Many of these things which perhaps luxuries *are* in this climate, real necessaries of life."[25] In Britain, needs and desires were closely entangled; Adam Smith cautioned that luxuries could not keep off "the winter storm, but leave (their possessor) always as much and sometimes more exposed . . . to anxiety . . . to disease and to death."[26] Yet in the colonies luxuries became integral to the survival of these hybridized and diasporic selves.

Not all luxuries were defended as needs. Although in the boom, Calcutta's inhabitants lavished coins on jeweled gowns, expensive victuals, and riotous ritual, they considered painting an unstable commodity, as exotic excess. Art was marginal to both colonial habitus and to public potlatch. Only for a wealthy few did pictures (usually British oil portraits and sometimes rare Mughal manuscripts) perform as "symbolic capital." To demonstrate this distinction, they paid astronomical prices to British artists who

were prohibited from trespassing in other professions.[27] This market for British painters was severely constrained, not only by a lack of local enthusiasm but also by its exclusion from global networks; as heavy customs duties in Britain deterred colonial painters from sending their works from India, inferring that this should be a one-way artistic dissemination.[28] Instead, several insured themselves as print dealers—which was viewed by the Company as a legitimate form of private trade—a practice that proved vital to their survival.[29] While the colonial press exposed artists' squabbles, oscillating portrait prices, and print scheme delays, in contrast advertisements for imported art (couched in polite idioms, defined by efficiency, regularity, and universal taste) promoted a visual economy, as opposed to graphic anarchy.[30]

This press puffing reflected metropolitan celebration: "the calculation in all understandings is on the foreign sale being thrice above our own."[31] Although an expanding international trade, print commerce depended on an intimate kinship network of ambassadors and artists for high-quality prints to make the passage to India, while middling stock circulated through established routes for luxury goods, as celebrated in the metropolitan press: "The print sellers have at present an amazing run for exportation; the engravers and colourers are fully employed, so great is the demand for presents as well as trade in our East India settlements. The Indians in our interest are enraptured with views of our public buildings in the concave mirror."[32]

Yet in these early accounts it is Indian wonder that justifies print consumption, as such images began to infiltrate diplomatic gifting thus affecting indigenous elite notions of art, self, space, and taste.[33] Simultaneously, colonial documents disclose colonial contempt for Indian taste. They frequently mock a range of indigenous elites for their choice and display of English prints—integral to a xenophobic discourse that accelerated from the mid-1780s and against which *colonial* print consumption must be situated.[34]

In the 1760s, leading London print dealers Ryland and Bryer devised an ambitious scheme to distribute paintings and prints in Calcutta and Madras—but being too inflexible in their economic demands, the pictures returned to Britain unsold, bankrupting the firm.[35] Their cargo was too highly priced and they lacked a network of contacts to negotiate with local needs (the prints not even making it off Indian quaysides into colonial enclaves), yet already sophisticated commodity networks were evolving in which prints would become powerful "attractors" in global networks.[36] By the 1780s, leading print dealers Macklin and Boydell were inundating Cal-

cutta's market with lavish schemes such as *Shakespeare's Gallery* and *English Poets* by mobilizing trusted agents—including relatives, artists, and captains to distribute high-quality images.[37] When in the tropics, prints demanded to be used in other ways to the metropolis. The miniaturist/print dealer Ozias Humphry described such practices to his then-fiancée, Boydell's niece: "What I formerly suggested of furnishing my apartments with prints pasted to the wall cannot possibly prevail . . . in any degree in Calcutta as people are forever unfix'd here. It being customary to let houses from month to month only, no person finds himself sufficiently interested in a house to decorate it in so costly a market. Framed prints which are movable and transferable are in great fashion in India."[38] White ants and the damp precluded prints from being pasted to walls or to dressing- or firescreens as was the fashion in Europe. Instead, fewer images were acquired already framed and glazed—strategies which partially protected them from the tropical climate. Being relatively cheap and often won through lotteries, they transgressed the imperatives of tasteful decoration in Britain, as well as epitomizing the "chronopolitics" of a hybrid public culture in a state of constant flux.[39] The normal lifetime of a Briton in Calcutta averaged just two monsoons; as part of this putrefying ethos, this short-term clique settled for what was ultimately short-term art, ciphered by an "aesthetics of ephemerality" crucial to the civilizing rhythms of accumulation and divestiture.[40]

Time became Messianic in the colonies. The climate assaulted not only the corporeal constitution but also the familiarizing symbols of the English constitution. So for artistic consumption to be validated, it had to signify as a transitory instance of individual wealth which should be allowed to decay; at best in this dialectic of men and things, there was a race to the death. The tropics eroded markers of civilization such as architecture far faster than in Britain. Although landscape painters such as William Hodges portrayed Calcutta as the epicentre of modernity (in contrast to his exaggeration of the atrophy of the Mughal cities such as Murshidabad and Agra), cheaply built in brick and *chunam*, this decaying colonial city could never resemble the marble marvels of its chosen precedents—imperial Rome and Mughal India. Likewise its public art collection consisted in a few motley "scraps, patches and rags," including grand canvases of the king and queen of France snatched from the French settlement of Pondicherry, Lord Clive's and George III's imported portraits, and the likenesses of the nawabs of Arcot and Awadh (privately owned and later removed by Governor-General

Warren Hastings).[41] Patching up these totemic traces became imperative to imperialism's illusion of permanence.

While public buildings provided at least semi-permanent, partially inalienable art display, the rented homes of temporary residents signified as "space without places, time without duration," subject to structural disintegration.[42] Although a few residents exclaimed "what would you say of an apartment forty feet high and one hundred and twenty feet square, lighted by five or six crystal lustres?," only a few Europeans could afford a large house; most lived in apartments or single-room dwellings that were defined by short rents and located on the margins of the White Town.[43] These were fluid spaces. The nonspecificity of their rooms was a method of responding to a changing market, in which there was no assurance that the building would continue in its present use. This "open-plan central room design" made Calcutta houses like "a theatre in the round . . . [pivoting on] a concentric arrangement which allowed multiple points of entrance and dispersal where there was little privacy and even less display of conspicuous consumption."[44]

Although grand in size, let unfurnished, and lacking the moral cachet of property, few of these apartments housed anything akin to an art collection, but rather a bricolage of *objets trouvés*. This was taste based on cultural difference more than on social distinction—the majority of Calcutta's colonial residents wanted to be with prints, in fact with anything European however deficient or absurd, instead of being labeled with the taboo of Indian things.[45] "Paper and wainscot are improper both on account of the heat, the vermin, the difficulty of getting it done, the rooms are all white walls but plastered in panels which has a very pretty effect and are generally ornamented with prints, looking glasses or whatever else may be procured from Europe."[46] Apartments in Calcutta were constantly limed down for medical purposes after the death of tenants or following the monsoon, which produced a distinct "aesthetic of whiteness" defined by functionality, health, and economy: "the walls are painted white, paper or tapestry are never used; they are sometimes hung with pictures or prints, but these are destroyed in a short time."[47] In Britain whitewashed walls were low in the hierarchy of polite decoration but in Calcutta they were puffed as "marble-like," bestowing "a freshness" in the midst of the miasmic humidity.[48]

Returning to the miniaturist Ozias Humphrey's remark that "no one finds himself sufficiently interested to decorate a house in so costly a market"— "sufficiently interested" evokes a host of meanings. Struggling artists criti-

cized local taste as being debased and basic, where likeness (given the often dramatic physiological changes in sitters and the need to maintain long-distance kinship networks) assumed primacy.[49] Both portraits and sitters decayed in the tropics, putting "resemblance" strangely out of sync in these presentations of the self. "Lack of interest" also referred to print acquisition. Calcutta survived on credit, thus constraining art, property, and taste, which transformed it into a commercial society in extremis. It fetishized appearances and promises over substance and consumption over accumulation. While these prints-as-credit-objects were being paid for they were simultaneously wearing out, which for an image-conscious, young, and fashionable community, careless of an uncertain future, was the only solution. Always owing money to agency houses (from whence credit derived), objects were never fully removed into the private, inalienable realm of the family (itself destabilized in the colonies), but remained obliged by the demands of commerce.

In the severe recession from 1785, this network collapsed.[50] The small coterie of art patrons left for London.[51] However, the rake William Hickey did boast his art collection in terms of property, ostentation, and envy, capital distinguishing his superior taste. His conspicuous consumption acted as potlatch—as glittering, desiccating pictures enabled waste to become the ultimate object for acquisition:

> In March 1790, my new mansion being furnished and very handsome I removed into it. I furnished it in such a style as gained universal approbation and acquired me the reputation of possessing great taste. The principle apartments were ornamented with immense looking-glasses, also a number of beautiful pictures and prints, forming altogether a choice and valuable collection. The expense was altogether enormous, but as I looked only to pleasant times, having no idea I should ever be able to lay up a fortune, I was indifferent about the price of things, purchasing every article I felt any inclination for. When completed my house was pronounced to be the most elegantly fitted up of any in Calcutta and in fact there was none like it. Some of my facetious acquaintances christened it *Hickey's Picture and Print Warehouse*.[52]

As opposed to Humphry's remark that no one was sufficiently interested in a costly market, Hickey is "indifferent about the price of things, purchasing every article" as conspicuous consumption overrides economy. Prints as

quasi objects both formulate and are articulated by Hickey's judgment to the extent that their appropriation by the taxonomic momentum of the "collection" is incomplete. Instead, they retain their alterity—each picture vying for attention, as if still displayed in the "anonymity" of a warehouse. Thus pictures move in and out of colonial self-fashioning—their ambivalence not allowing for their total appropriation by buyers such as Hickey. His neighbors' allusion to an auction house articulated the obvious insult to lob at his excess—antithetical to "conspicuous parsimony." This commercial analogy also conjures up one of the few heterotopias where art could be viewed in late eighteenth-century Calcutta. By 1790 at least 75 percent—that is, ten auction houses were dealing in prints and paintings; they provided the colonial diaspora with a medium for constituting the world as a specific type of picture—a process that can be termed "the emporium effect."[53]

"The Emporium Effect": Lotteries and Aesthetic Monopolies in Calcutta

I come from a dizzy land where the lottery is the basis of reality. . . . The Babylonians threw themselves into the game . . . those who did not play were scorned, but also the losers who paid the fine were scorned. . . . The bravado of a few is the source of the omnipotence of the Company . . . [which] made the lottery secret, free and general.
—Jorge Luis Borges, "The Lottery in Babylon," *Labyrinths*

Borgesian Babylon provides a "parallel modernity" to eighteenth-century Calcutta. Both cities were portrayed as viciously luxurious, decadent, and wicked. For both, Chance is fetishized to excess, as the cosmology for uncertain, extravagant, desperate living. The tale of these two cities traces the chameleon transformations of lotteries from small enterprises into the ontology of public life.

While the "museum effect" articulated the nineteenth-century European archipelago of arcades, prisons, schools, world fairs, and museums, whose visual discipline operated through "object lessons," how did the "emporium effect" articulate colonial life?[54] The early Company state, littered with prisons and asylums, lacked museums, exhibitions, and arcades. Instead, imperial emporia occupied a central role in both politics and commerce. The men who ran these businesses were immensely powerful; they were frequently ambassadors, Orientalist scholars, and had access to monopolies in coveted commodities such as opium and indigo. Showcased in glitter-

ing lotteries, things fetishized the "commercial meanwhile" rather than imperialist nostalgia, becoming the metonyms for the Company state and its claustrophobic voyeurism.

Unlike Britain the economy in colonial India had no "autonomy." Based not only on social control, metropolitan governmentality contained within itself a space for dialogue, self-critique even for resistance.[55] In Calcutta, the East India Company regulated, even created the public by effecting the channels through which expression could be heard and entrenched itself as the sole arbiter of what discourse was legitimate. "Public amusements are perhaps fewer in Calcutta than in any other city in the world of equal elegance in buildings, extent and in the taste of its European inhabitants" as the dearth of leisure diversity exposed a severely impoverished civic forum.[56] Thus "the institutions of civil society in the forms which they had arisen in Europe always made their appearance in the colonies precisely to create a public domain for the legitimization of colonial rule."[57] Although no government press regulations were enforced until 1797, state coercion ensured that anti-Company opinions were publicly censored—in effect there was no free press, no print capitalism, and no graphic satire.[58] Hence things that had assisted in the creation and proliferation of opinion in England, such as highly politicized pamphlets, newspapers, and graphic satire, in Calcutta were conspicuously absent.

The only local visual satire was the Scottish engraver James Moffat's crudely etched Indian stereotypes and colonial types, which condemned parasitical economic mores and quotidian habits—subjects that were both trivial and grossly racial and which appealed to the familiar and to difference, the comic, and the uncanny. In *Hard Times* poor whites bemoan the effects of recession on Calcutta's luxury consumption, as its division of labor collapses; the undertaker complains, "I have only had 39 jobs yet the rains are almost over," indicative of a once decadent colonial community chastened by poverty. While the construction of difference increasingly "distracted" Britons from the limitations in their own public sphere (as poor whites and Indians became subaltern *others*), imperial emporia invited inhabitants to assert limited "citizen" rights through consumption. This was a type of citizenship that operated through both distance and difference. Newspapers and satires (albeit months out of date) were imported from Britain and circulated in imperial emporia, which acted as both the technological channels and dialogic spaces for local debate.

Although driven by an imperial "emporium effect," these businesses were

always transcultural heterotopias. They were frequently funded by indigenous merchants who bought British pictures to adorn the public apartments of their grand north Calcutta estates which easily surpassed colonial houses in their scale and decoration.[59] Traffic in foreign commodities in this colonial tournament economy gave these merchants power, even if it meant excessive sacrifices to the gods in order to remove the contamination of English things. Many despised colonial commodities (such as meat, alcohol, and the realism of English prints) as polluting, even as taboo, integral to their condemnation of the absurd British love of luxuries.[60] According to Abu Talib's analysis of English character, things "pamper their appetites, which from long indulgence, have gained such absolute sway over them, that a diminution of these luxuries would be considered by many a serious misfortune. . . . It is certain that luxurious living generates many disorders and is productive of various bad consequences."[61] With regard to British art as luxury, to these writers the London scene is even worse than Calcutta. The Indo-Muslim traveler Itesamuddin was astonished that paintings fetched as much as £2,000 and Abu Talib noted that "Mr Christie the auctioneer also paid me much attention and gratified me highly by showing me the articles he had for sale. He once exhibited to me a number of pictures which he valued at £60,000 and when I called there a few days afterwards, they were all disposed of."[62] According to Abu Talib broken statues are worshiped by Britons to the point of fetishization: "Statues of stone . . . are held in high estimation, approaching to idolatry. Once . . . a figure [in] which nothing but the trunk remained . . . sold for 5000 pounds. It is really astonishing that people possessed of so much knowledge and good sense who reproach the nobility of Hindustan with wearing gold and silver ornaments . . . should be tempted by Satan to throw away their money."[63] In this view, Britons are mindless dupes taken in by fetishism and by "false idols"—which become enmeshed within the urban phantasmagoria of the emporium effect. These imperial emporia were axiomatic to both colonial rituals and the practices of everyday life: "Balls, card parties and what are called 'Europe shops'— which are literally magazines of every European article whether luxury or convenience. These early in the morning are the public site of the idle and gay who there propagate the scandal of the day and purchase at an immoderate price the toys of Mr Pinchback and the frippery of Tavistock Street."[64] Lacking museums and galleries, and generally disenchanted by artists' private studios, for colonial consumer-citizens "Europe shops" became proto-arcades. Dazzling and novel they furnished a glamorous way of seeing the

world through glass, prints, and all the luxuries of metropolitan life. There is no didactic drive for "object lessons"—here sensual things want intercourse with humans:

> Here you may for hours lounge up and down and feast your eyes with the contemplation of the best prints and paintings, or turn to another part of the room and examine whole folios of caricature. You may take a chair and dip into the most recent publications. You may taste a cheese or read the history of the country where it was made; you may contemplate painted beauties on canvas or fall in love with painted beauties who are gazing at them . . . you may buy 10,000 Rs worth of articles or walk away without anything and give equal satisfaction. In short it is the most agreeable lounge in the world, but at the same time the most tempting one.[65]

Europe shops are defined by a mixture of corporeal and ephemeral pleasures rather than by Kantian aesthetic experience as the colonial body literally collapses into these things—feasting, tasting, dipping into, and falling in love. Here is the porous, amorphous colonial self whose embodiment relies on imported luxuries. This is not the manifestation of a strict "civilizing process" that represses corporeal aspects of the self, but the carnivalesque desires of early colonial lifestyle. Things create the division of space in these showrooms and their ensuing rituals. One lounges in these lounges which proffer the fragments of metropolitan living, moving through a jungle, a symphony of pictures, chairs, books, and painted beauties—ornamented with white lead and vermilion—both pictorial and as flesh in the world. These imported things linked the colonial body indexically to Britain. Imported foods were the fruit of the land; even topographical aquatints were based on drawings using the camera obscura whose black-boxing techniques created links between image and reality. Here was a corporeal patriotism enmeshed with the demands of colonial desire.

In these glittering emporia, possession was usurped by display, especially in the time of severe economic recession. By the late 1780s these credit-weary Europe shops collapsed: "About ten years ago there were no more than three or four Europe shops in Calcutta at which time they continued to increase till within the last twelve months; in this period most of the debts now due to individuals were contracted and in consequence . . . they began to decrease until the present day when strange it is that there should not be a single European shop in all Calcutta; they are converted to com-

mission warehouses . . . ready money only is the universal condition."[66] During recession, when engravers complained that they did "not believe that even Woollett [London's most renowned engraver] himself . . . would make both ends meet," this import market grew ever more sophisticated.[67] The market became saturated with images: "Pictures are in abundance of one sort or another . . . as to prints, the commonest bazaar is full of them. Hodges' Indian views are selling off at the out-cry by cartloads and although framed and glazed, are bought for less money than the glaze alone could be purchased in the bazaar."[68] To survive, Europe shops became attached to houses of agency—banking businesses that invested in real estate and up-country commerce, forming a powerful monopoly across northern and eastern India. In the purchase of imagery these agencies created their own monopolies; only they could withstand credit and only they could take risks in art sales. Things slowly atrophying, these showrooms grew more and more distended in their attempts to woo viewers:

> The competition among the 3 rival houses has excited emulation in tasty decoration, as well as in the active part of the business. The novelty of the new house attracted a great body on its opening and the crowd has been there ever since, the purchasers not proportionally plenteous. Dring and Rothman have been the statuary as usual. Both in numbers present and quantities sold the Europe goods of today's sale are of the best quality. King and Johnson's rooms present pillars and pictures of piety in the background the nearer the church the farther from music: a speaking trumpet would be a useful appendage to the crier there, for the lungs of Stentor could not convey "going a going" through half the lofty roof. Some of those who love to turn a penny bought some cheap bargains yesterday at these rooms and sojourning to the opposites, seeing what the effect of an unlocked jaw has over the imagination are led to exclaim after crossing the street—a "plague of both your houses."[69]

These houses blew sense and taste out of all proportions, so that not even the herald from the Trojan wars could make himself heard and the allusion to the bitter factions of Shakespearean Verona reveals that rivalry transgressed all boundaries.

Such reportage clashed with the self-imaging of these businesses as overseers of the White Town. The house of Paxton, Cockerell & Co. occupied a prime site in the commercial quarter (close to the river, to Tank Square, Writers Building, and St. John's Church where most agency headquarters

were located), paid tribute by the Daniells in the first print of their *Twelve-View Series of Calcutta*. The auction house performs as the centripetal point for a commercial narrative that reads left to right from imported goods being off-loaded from the River Hugli at the old fort (converted into the customs depot)—and then conveyed to Paxton's. The Daniells have ironed out the tight conjunction of two streets in order to give the city an illusory public piazza where Indians in the civic humanist pose of *Castor and Pollux* are engaged in civilized conversation.

Agency houses dispatched agents to London to establish links with publishers and artists; Baillie begged Ozias Humphry to assist one of Dring's partners who was "no judge of these articles I suppose and may be taken in unless recommended to a tradesman of eminence and character," inferring that the metropolis duped its colonies with shoddy, pricey goods.[70] Yet London connoisseurship became a vital component in the selection of prints: "a small but capital collection of paintings selected by a gentleman of taste in London."[71] "Novelty" acted as a cogent factor, as caricatures, the latest print schemes and patented reproduction processes, polygraphic paintings, even a panorama of London, inundated Calcutta.[72]

In contrast, oil paintings—rotting and economic, were usually disseminated through dice games, tombolas, raffles, and lotteries, many of which had to be canceled due to lack of public interest.[73] The process of the auction in recession had become so unpredictable that it created an ever-present potential for alienation, slippage, or loss of economic consensus within the public interaction of persons and things.[74] Art sales (Calcutta's public showily dressed, objects dusted in waiting), acted as complicated, spectacular, ocular tournaments—artifacts as the enactment of events where performances were the artifacts of people. In all this: "The object is the strand that holds the disparate components of the market together. This object, of paradoxical and ironic authenticity, its identity vacillating between that of frequently produced commodity and unique traditional artefact, is both exhibited in the market and sits at the head of a cult, its material form worshipped."[75] Bidding auctions had been popular in the early 1780s when the authentication of value reached an economic zenith, yet with recession, lotteries, dicing tournaments, and raffles intriguingly played on the collective and unique glamour of things—to be attained not by monetary fortunes but by good fortune—supposedly more egalitarian by being arbitrary. Through a species of "aleatory contract" the *determinism of things*—tickets, ivory dice, and slips of paper, forming their own collectives in the pots and jugs

into which the human hand of fate was dipped, linked themselves to fellow things—pictures—with human players as mere mediators. The lack of a visible, a priori human control people termed chance.[76] This practice deconstructed the distributive value of each image—as picture and winner were cast into unpredictable encounters. Pictures could retain and attain agency despite the arbitrary identity of their "owners." Company officials stationed for a couple of seasons in Calcutta could reminisce that they once "rented" the most magnificent chandeliers and the finest prints—a twilight of secular idols which shaped their personhood.

Conclusion

DIASPORIC DISPOSSESSION AND SECULAR FETISHISM

Q: What is commerce?
A: Gambling.
Q: What is the most cardinal virtue?
A: Riches.[77]

In Calcutta of the 1770s and 1780s, gambling fashioned techniques for scripting imperial selves and for presenting personhood, as well as organizing the ontology for colonial existence. All three of these metaphysical and practical mnemonics involved the conspicuous mobilization of symbolic capital in the desire to take risks, displaying the ability to lose even more than the need to win. Not confined to the whist, piquet, and dicing soirees of Calcutta's mansions and taverns, borrowing, promising, and indebtedness structured this society as an ostentatious but poorly constructed house of cards ready to collapse. "Trade in Bengal seemed to Europeans to be a lottery in which the prizes were high but in which there were many blanks."[78] Calcutta's journalists prophesied the implosion, "lotteries crowd on lotteries . . . but the proprietors do not seem to consider where the money to support them is to come."[79]

With such an unstable art market, how could Calcutta's print economy participate within nascent notions of the British Empire? Both "Britishness" and "Empire" were still contingent, amorphous, and reliant as much on colonial practices as on the metropolis for their articulations. Although agency house advertisements frequently deployed London practices to dignify imported things, this was a highly mediated sense of social emulation and national belonging. After all, diasporic Britons could imagine but not

inhabit empty homogeneous time, as the real space of modern life consisted in the density of heterotopias. The variety of metropolitan prints (of London, Scotland, India, and the Pacific, portrait mezzotints and etched political satire) elicited a peculiar dialectic between fashion and an imagined nostalgia for places unvisited, even for things that never were. "This imagined nostalgia thus inverts the temporal logic of fantasy (which tutors the subject to imagine what could or might happen) and creates much deeper wants than simply envy, imitation or greed could by themselves invite."[80] In this colonial context, the "nostalgia for the present" demonstrated the slippage involved in the nationalistic meanwhile. Prints became colonial companions, while simultaneously exacerbating nostalgia—an acute physical homesickness which was a well-charted, often fatal medical condition. Eliciting a complex range of emotions, prints were disaporic in their very being. They were primarily designed for overseas markets which grossed over three times British sales; their "scattering processes" relied on images being rhizomorphous—able to graft, to grasp a constellation of contexts.

Calcutta had no free press, no sites for intense public debate; its print making was crude and expensive; it lacked graphic satire and local art academies—the fundamental ingredients of metropolitan and aesthetic spheres. Capping it all, Calcutta lacked economic capital. The majority of Calcutta's public did not rent or win more than a handful of prints; instead pleasure of the spectacle gave "equal satisfaction" to possession. So things are not to be unpacked. Except for those prints sent as gifts, traded up country, or bought by north Calcuttan parvenus, the majority of images in the colonial community circulated in the ether of agency houses.[81]

Desires and needs slip sideways in the proliferation of colonial hybridities—these things are familiar-exotic, not quite collectibles, not quite souvenirs, perhaps closest to fetishes. Britons believed that fetish possessed certain coordinates: fear of death, the active role played by Chance—as arbitrary objects become animated by superhuman forces whose origins are often obscured. All of these aspects were present in print consumption. The fear of death was a constant apparition. Maybe Britons could protect themselves with an army of things as "charmed ornaments," but then maybe not. In lotteries Chance decided whose pledge would be rewarded with pictures—its nebulous power cast over the arbitrary. People wanted to be in the presence of prints. Simultaneously they didn't mind too much if these images passed away—these objets trouvés could be replaced—similar sentiments forced to course through others' etched veins. Pictures then were suspended between

the melodramatic polarities of iconophilia and iconoclasm. They pertained to the everyday, to the petty magic of quotidian living. Lurking beneath the "drab region of objects," all things, not just the dangerous few, possess uncertain glamour and animism.[82] As Latour asserts, modernity's fetishization of its own genealogy of iconoclasm (from the golden calf to Nietzsche) is always incomplete. The knife has no cutting edge, the hammer is too heavy; the physicality of idols may be smashed, but they are always hit sideways — their potency enhanced by these frail, failed acts of iconoclasm.[83]

In the light of trade meeting the ambivalent demands of an accelerating population, prints would seem to have done well for themselves; to have participated successfully in actor-network theory. Here also was a colonial "consumer revolution." But was this really the case? Calcutta may have expanded rapidly, but this did not produce a burgeoning art market. In terms of the colonial artistic community, the efflorescence of the early 1780s was never recuperated, as the amount of painters plummeted.[84] Likewise for prints, the number of auction houses did not increase dramatically in this final era before the atrophy of their stronghold in the 1820s. Already by the mid-1780s Calcutta was saturated by pictures. The market for images was always a complex web articulated both by xenophobia and by violent unpredictability. Bengali parvenus, Eurasian women, Company School painters, and nawabs all had access to English prints which were treated as trading artifacts, as pattern books, as curios, as signs taken for wonders, as inalienable possessions, as gifts, or as furniture. Despite government policies of increased racial bias from the 1790s, prints as objects and technologies negotiated and instigated channels and spaces that complicate their identification with British print capitalism.

Actor-network theory, while so illuminating in its redress of binary oppositions between subject and object, has perhaps gone too far toward reciprocation, efficiency, and productivity involving men and things. Yet conflict was everywhere. Being in the labyrinth of colonial existence meant competition and conflict, as much as collaboration. The British inclination for European over Indian goods and Shi'ite condemnation of British luxuries-as-taboo fetishes, demonstrate the potency and uncertainty that were in things. They resist total translation; they possess a partial intransigence that defies absolute mutability in recontextualization. Objects rarely reveal their thingness to humans; they are dividuated, sophisticated, and ambivalent. This is not to recuperate things as subalterns with partial voices that must be represented, but infers that they transform networks into laby-

rinths; they confuse, they enchant, they keep humans at arm's length and at hand, ultimately slipping sideways beyond their grasp.

At the level of community belonging and things as belongings, prints signified ambivalently as quasi objects grappling with the cosmopolitics of colonialism. These were prints capable of creating or withholding their own context. "For it is in-between the edict of Englishness that the assault of the dark, unruly spaces of the earth through an act of repetition" that this elusive, obdurate imagery emerges uncertainly.[85]

Notes

Natasha Eaton, "Excess in the City? The Consumption of Imported Prints in Colonial Calcutta," *Journal of Material Culture* 8(1) (2003): 45–74, reprinted by permission of Sage Publications.

Research for this chapter was funded by the British Academy, Yale University, the Leverhulme Trust, and a Simon Fellowship. For assistance in locating materials back in the last century, I am grateful to Timothy Clayton, and for comments at its various life stages I am indebted to P. J. Marshall, C. A. Bayly, Brian Allen, Michael Rosenthal, Dongho Chun, Urmila De, Bhaskar Mukhopadhyay, and the readers and editors of the *Journal of Material Culture*.

1 Renato Rosaldo, "Imperialist Nostalgia," *Representations* 26 (1989): 107–22; Jacques Derrida, *Archive Fever: A Freudian Impression*, trans. Eric Prenowitz (Chicago: Chicago University Press, 1995).

2 Dominick LaCapra, *History and Criticism* (Ithaca, NY: Cornell University Press, 1985), 92.

3 Arjun Appadurai, *Modernity at Large: Cultural Dimensions of Globalization* (Minneapolis: University of Minnesota Press, 1996); Brian Larkin, "Indian Films and Nigerian Lovers: Media and the Creation of Parallel Modernities," in *The Anthropology of Globalization*, ed. Jonathan Xavier Inda and Renato Rosaldo (London: Blackwell, 2002), 350–69.

4 Paul Gilroy, "Diaspora and the Detours of Identity," in *Identity and Difference*, ed. K. Woodward (London: Sage, 1997), 334–35.

5 The term *inalienable possession* is here used with reference to the work of anthropologist Annette Weiner. It is used to describe an artifact infused with the charisma of the giver which makes it difficult to give away and is more valued when kept (Annette Weiner, *Inalienable Possessions: The Paradox of Keep Whilst Giving* [Chicago: Chicago University Press, 1991]).

6 Ozias Humphry, *Correspondence of Ozias Humphry*, vols. 3–8 (London: Royal Academy Library, 1785–92). Captain Baillie's letters to miniaturist Ozias Humphry reveal his borrowings from Boydell's and Farington's prints—this also involved his evolution of a critical connoisseurship. St. John's-in-the-

Swamps in Calcutta built by James Agg drew closely on prints of St. Martin's-in-the-Fields. Along with Government House, this was the only architecture built in Calcutta as a planned public building. The rest were all private houses.

7 For the direct influence of Hodges's *Select Views of India* (London, 1785–88) see a series of sixteen watercolors by a Bengal artist Add Or 1131–46 (Oriental and India Office Collections [OIOC], London).

8 See the Bengal Inventory Series L/AG/34/27/vol. 1–20. I am grateful to Lizzie Collingham for alerting me to the importance of this public records series.

9 Bengal Inventory Series: L/AG/34/27/18 (OIOC). The sale of Hastings's effects in 1785 reveals a mixture of British and Indian buyers vying for red prints, oval pictures, and glass paintings—including Moddrun Dutt and Boydeneath Pundit. See also the estate of Thomas Harding L/AG/34/27/19: 1796 when pictures including oval prints and *The Death of Captain Cook* were sold to Gopi Mohun Baboo; also the sale of the goods of William Spink L/AG/34/27/1 1788 when five prints in gold frames were sold to Eduljee Darabjee. From James Lindsay's estate L/AG/34/27/3 1790, *Views of Europe* were sold to Sudersan Jain and Sadah Scin. While these names have been Anglicized, they disclose a range of Bengali, Eurasian, Parsi, Jain, and Muslim buyers. However there were many other estates which featured only British art, such as that of Justice Hyde L/AG/34/27/19, January 12, 1797, which included portraits of his family, three volumes of Boydell's collection of prints, Thomas Hickey's *History of Painting*, and a print of Dr. Johnson. Overall, these inventories disclose a mixture of Indian and British things—revealing a complex, multilayered notion of the self.

10 Neil McKendrick, John Brewer, and J. H. Plumb, *The Birth of a Consumer Society: The Commercialization of 18th-Century England* (London: Europa, 1982); Ann Bermingham and John Brewer, *The Consumption of Culture: Image, Object, Text* (London: Routledge, 1995); Maxine Berg and Helen Clifford, *Consumers and Luxury: Consumer Culture in Europe 1650–1850* (Manchester: Manchester University Press, 1999).

11 Jean Baudrillard, *The System of Objects*, trans. J. Benedict (London: Verso, 1968); Pierre Bourdieu, *Distinction: A Social Critique of the Judgement of Taste*, trans. R. Nice (London: Routledge, 1979; Thorstein Veblen, *Theory of the Leisure Class* (New York: Macmillan, 1899).

12 Bruno Latour, *We Have Never Been Modern*, trans. C. Porter (London: Harvester Wheatsheaf, 1993), 53.

13 Bruno Latour, *Aramis or the Love of Technology*, trans. C. Porter (Cambridge, MA: Harvard University Press, 1996), 61.

14 Arjun Appadurai, "Introduction," in *The Social Life of Things: Commodities in Cultural Perspective*, ed. Arjun Appadurai (Cambridge: Cambridge University Press, 1986); Nicholas Thomas, *Entangled Objects: Exchange, Material Culture and Cook in the Pacific* (Cambridge, MA: Harvard University Press, 1991).

15 Homi Bhabha, *The Location of Culture* (London: Routledge, 1994).

16 William Pietz, "The Problem of Fetish IIIa," *Res: Journal of Anthropology and Aesthetics* 16 (Autumn 1988): 110–22, 112.

17 Bruno Latour, *Pandora's Hope: Essays on the Reality of Social Studies*, trans. C. Porter (Cambridge, MA: Harvard University Press, 1998).

18 M. Archer, "The East India Company and British Art," *Apollo* 92 (1965).

19 M. Archer and W. G. Archer, *Indian Painting for the British* (London: Oxford University Press, 1955); Tapati Guha-Thakurta, *The Making of a New Indian Art: Artists, Aesthetics and Nationalism in Bengal, c. 1850–1920* (Cambridge: Cambridge University Press, 1992).

20 William Baillie to Ozias Humphry, Humphry Papers Royal Academy Library HU/4/118.

21 Graham Shaw, *Printing in Calcutta to 1800* (London: Bibliographical Society, 1981).

22 Christie's, *Visions of India* (London: Christie's St. James's, 1998), 73.

23 Benedict Anderson, *Imagined Communities: Reflections on the Origin and Spread of Nationalism* (London: Verso, 1991), 137; Percival Spear, *The Nabobs: A Study of the Social Life of the English in 18th-century India* (London: Oxford University Press, 1963), 34.

24 E. M. Collingham, *Imperial Bodies: The Physical Experience of the Raj, c. 1800–1947* (London: Polity, 2001), 34.

25 Jemima Kindersley, *Letters from India* (London, 1777), 292; emphasis added.

26 Smith's *Essay on Jurisprudence*, cited in Nicholas Xenos, *Scarcity and Modernity* (London: Routledge, 1989), 12.

27 Willison, Zoffany, Seaton, Home, and Kettle all made fortunes in India based on higher prices charged to Britons and Indians at a variety of rates. The *Sitters Book of Robert Home* (Heinz Archive, National Portrait Gallery) reveals that he could charge 600 Rs (£60) for a likeness—matching the top prices of London painters (although lacking some of their talent!). As the rent for a reasonable-sized house in Calcutta in the 1780s was 100 Rs per month, oil portraits could be commissioned only by the wealthy few. Ozias Humphry Papers, British Library: Add. Ms 22,951, ff. 1–4 for the conditions for traveling to India. This was the rule for all British artists in India as seen in the Court of Directors' letter for Tilly Kettle, who "has obtained our license to proceed to Bengal on condition that he does not act in any other capacity or engage in any commerce whatever . . . in failure there of, he is to be sent to Europe." N. K. Sinha, *Fort William East India House Correspondence and Other Contemporary Papers* (Delhi: Civil Lines Publications, 1949), 5:151, London, entry for November 11. By not allowing them to trade, the Company attempted to confine artists within a "disinterested" ideology.

28 M. Archer, *India and British Portraiture, 1770–1825* (London: Sotheby Parke Barnet, 1979), 440n46 observes that although some painters did send their work to exhibitions at the Society of Artists and Royal Academy, they were not encouraged to finish these pictures in India—as heavy customs duties were levied on all finished pictures entering Britain until 1793.

29 For instance, Ozias Humphry, portrait painter and print dealer; Guildhall Policy 111,936 policy number 45,5348.

30 For instance, the artist Swain Ward and engraver Richard Brittridge squabbled over the production of Swain Ward's proposed *Six Views of Calcutta* (*Calcutta Gazette*, September 15, 1785).

31 *The World*, February 3, 1787, cited in Timothy Clayton, *The English Print, 1688–1802* (New Haven, CT: Yale University Press, 1997), 262.

32 *London Evening Post*, January 22–24, 1767, cited in Clayton, *The English Print*, 262.

33 An early print commission to the court of Arcot can be found in the Robert Palk Papers, British Library (BL): Add Ms 34,686 f.14. See also the *Durbar Accounts of Warren Hastings, 1780–5*, Hastings Papers, BL: Add Ms 29,092 which included over 100 prints such as views of London and mezzotints of George III gifted to "the prince" in December 1784.

34 There are numerous eighteenth- and nineteenth-century colonial accounts of Indian interiors hung with prints which infer the colonial belief that these images had been inappropriately appropriated. For instance, Marchioness Bute, *The Private Journal of the Marquess of Hastings* (London: Saunders and Otley, 1858), 1:81–82, notes that the nawab's palace at Murshidabad was decorated with "a few English fox hunting prints of the secondary quality." Archer and Archer, *Indian Painting for the British*, 88, and Archer, *India and British Portraiture*, 288, note that prints were frequently hung upside down or filled every inch of palace walls — practices that subverted the imperative of colonial print decoration.

35 I am very grateful to Timothy Clayton for this case study. Ryland borrowed £5,000 in order to fund this scheme which included rare proofs by Thomas Watson and Valentine Green as well as old masters and the oils of George Stubbs. See Anonymous, *The Case of William Ryland* Bankruptcy Cases, Public Record Office, Kew PRO/B1/77 303–23 and PRO/C107/69. Ryland later tried to send them to Russia — again many were returned soiled. In 1784 Ryland was hanged for forging two East India Company bills of exchange — his life and engraving skills inextricably linked to India. See *Memoirs of William Wynne Ryland* (London, 1784), the *Whitehall Evening Post*, April 19–22, 1783, and Minutes of the Court of East India Directors, B/99 (1784) (OIOC), 99.

36 Print sellers may have been encouraged by the success of figures such as Josiah Wedgwood who was expanding his trade to the east. His wares appeared regularly in wills and inventories as well as in the press. For instance black and painted teapots, *Calcutta Gazette*, January 12, 1786; Queensware, *Calcutta Gazette*, August 8, 1793. He even planned to travel to India; see Abu Talib, *Travels of Abu Talib*, trans. C. Stewart (Calcutta, 1814), 96: "Wedgwood paid me much attention and at one period was very curious to accompany me by the route of Persia to India" in search of new markets and designs. He also experimented with samples of Bengali earth. J. Holzman, *The Nabobs in England: A Study of the Returned Anglo-Indian, 1760–1785* (New York, 1926), 91.

37 The case of John Boydell demonstrates this tight-knit network. His nephew was stationed in eastern India so could provide trusted information. The durbar accounts of Warren Hastings from 1780 indicate that Boydell's prints were already reaching India. Boydell also used Ozias Humphry who traveled over to India with Captain James Brabazon Urmston—a well-respected figure in both colonial and metropolitan society. In spite of recession Urmston managed to strike a deal for Boydell with Pope and Fairlie in 1785 (see *Calcutta Gazette*, August 11, 1785). From 1788 to 1792 Boydell used Calcutta merchants Colvin and Bazett to advertise subscription of his prints direct to either India or Britain (appealing to a short-term community). These mercantile contracts were renewed every season given the precarious status of ships and colonial trade (see Anonymous, *History of the Colvin Family*, vol. 1, Eur Ms Photo 145 [London: OIOC, n.d.]). Colvin and Bazett advertised the *Shakespeare Gallery* from September 18, 1788, onward and his *History of the Thames* was advertised in a similar manner. By 1795 Boydell was using other leading auction houses—those of William Dring and King and Johnson (see also Anonymous, *Reminiscences of the Urmston Family*, Eur Ms Photo 370 [London: OIOC, n.d.]). Naval captains were allotted 30 percent of their ships' cargo space in order to carry out their own private trade in luxuries to supplement their small incomes, so many would be only too happy to carry out prints which after all were small and could hence even dodge Calcutta's customs duties. Many painters on their return to Britain continued to work as private agents to patrons in India—for instance, Renaldi, Zoffany, and Hodges all acted as agents for the up-country patron Colonel Martin who wrote to Humphry in Calcutta in 1786, "I will receive your [Boydell's] catalogue with pleasure. I received a letter from my friend Hodges who purchased a parcel of prints at your Boydell and I am in expectation to see them" (Humphry, *Correspondence of Ozias Humphry*, HU/3/184).

38 Humphry, *Correspondence of Ozias Humphry*.

39 Prints were often marketed as prizes in lotteries—being preselected by artists or men of taste. For instance, the newly arrived painter John Brown planned a raffle of ten prizes "each containing a sufficient number of prints for a room at 32 Rs per chance" (*Calcutta Gazette*, October 2, 1794).

40 For modernity's obsession with waste see Georges Bataille, *The Accursed Share*, trans. R. Hurley, 2 vols. (New York: Zone, 1996). See also Appadurai, *Modernity at Large*, 83–84: "The pleasure of ephemerality is at the heart of the disciplining of the modern consumer. The valorization of ephemerality expresses itself at a variety of social and cultural levels: the short shelf life of products and lifestyles, the speed of fashion changes, the velocity of expenditure, the poly-rhythms of credit, acquisition. . . . The much-vaunted feature of modern consumption—namely, the search for novelty, is only a symptom of a deeper discipline of consumption in which desire is organized around the aesthetics of ephemerality."

41 Bhabha, *The Location of Culture*, 45.

42 Louis Althusser, *Politics and History: Montesquieu, Rousseau, Hegel and Marx* (London: NLB, 1972), 78.

43 John Le Couteur, *Letters from India* (London, 1790), 199–200.

44 Swati Chattopadhyay, "Depicting Calcutta," PhD thesis, University of California, Berkeley (1997), 150.

45 This is borne out by the Bengal Inventory Series L/AG/34/37, 1–20 (London: OIOC)—where prints outnumber references to "Hindustani" pictures by about five times. Both were cheap, usually ready-made images, and both can be said in very different ways to stretch the category of "souvenir."

46 Kindersley, *Letters from India*, 278–79.

47 Balthazar Solvyns, *Les Hindous*, 4 vols. (Paris, 1810), 1:123.

48 William Hodges, *Travels in India during the Years 1780, 1781, 1782 and 1783* (London, 1793), 12.

49 "The people here are ignorant of everything but likeness and smooth finishing . . . they see here daily the best and most finished pictures of Smart, Meyers and Cosway and all the best (London) miniature painters, whereas they never see one oil picture and Mr Hickey a very weak painter is their best," Humphry to Mary Boydell, 1785 HU/3/49. "There are but very few judges of a good picture; a likeness is what most people want," William Baillie to Humphry HU/4/113, Humphry, *Correspondence of Ozias Humphry*.

50 See for instance, Humphry, *Correspondence of Ozias Humphry*, on his arrival in Calcutta in 1785 wrote to Mary Boydell: "There was never known in Calcutta so much poverty or so great scarcity of money as there is at this time, all the first families are withdrawn from it and I have been confidently assured that there are scarcely twenty person left in Indostan whose fortune amounts to 20,000 pounds . . . your invaluable cabinet of prints has no chance now . . . of meeting an adequate purchaser in India," HU/3/123.

51 "The return of Mr Hastings who was a munificent patron . . . and the resolution that every person of property has taken to return immediately to avoid the obligations of Pitt's bill . . . added to the actual distress which prevails in Bengal . . . leaves one not a very flattering prospect," Humphry, *Correspondence of Ozias Humphry*, Humphry to Mary Boydell HU/3/36, August 1785. Also, Gavin Hamilton to Ozias Humphry, "painting is quite neglected here . . . there is really little encouragement in any branch," Humphry, *Correspondence of Ozias Humphry*, HU/4/18. He also noted "you would hardly know Calcutta again it is so much increased . . . in point of extent and number of houses and likewise in the bulk of inhabitants . . . manners are much the same. The arts are quite at a stand—no encouragement." Baillie acting as Humphry's agent warned, "the prints you left with me are now not worth a fifteenth of their value," Humphry, *Correspondence of Ozias Humphry*, HU/4/130.

52 William Hickey, *Memoirs*, 4 vols. (London, 1913–25), 3:159; emphasis added.

53 S. B. Singh, *European Agency Houses in Bengal* (Calcutta: Firma K. L. Mukhopadhyay, 1966), 1–15. Each year these agency houses tried to outdo each other

in quality and quantity of prints. For instance, *Calcutta Gazette*, September 9, 1784, "prints: the greatest variety ever exposed for sale in this settlement among which are many very scarce and valuable." *Calcutta Gazette*, March 9, 1786, Mr. Ord will "exhibit at his new warehouse a collection of upwards of 1000 capital prints by the first masters of Europe and engraved by the most celebrated artists"—to be divided into sixty prizes to be sold as a raffle at 64 Rs per ticket. From the finest oils of Stubbs (sold in a dice game) and Reynolds (belonging to his nephew) one could purchase Boydell's elaborate print schemes down to auctions for secondhand prints and cheap images distributed by agents of firms such as Carrington Bowles. For instance, sold "at the Cheap Shop next to Marvin and Forrest's a great variety of European articles at a lower price than any other shop in town for ready money only . . . prints in burnished frames . . . Captain Stewart's investment for the Atlas," *Calcutta Chronicle*, July 19, 1787. See also *The World*, January 4, 1794, for sale by commission at the European, Chinese, and Indian Warehouse at 46 Rada Bazaar, "Venus—a capital painting by Sir Joshua Reynolds at 1000 Rs," as well as maps and pictures at 32 Rs. These few examples demonstrate the variety of art on sale throughout Calcutta stretching into the bazaars on its margins. Each year tens of thousands of images were imported by captains to Calcutta, Madras, and Bombay (these two cities possessed similar means of marketing and distribution through their own newspapers and auction businesses—many of which were linked both to Calcutta and to Canton).

54 Svetlana Alpers, "The Museum Effect," in *Exhibiting Cultures: The Poetics and Politics of Museum Display*, ed. I. Karp and S. D. Lavine (Washington, DC: Smithsonian Institute Press, 1991); Tony Bennett, *The Birth of the Museum: History, Theory and Politics* (London: Routledge, 1995).

55 Michel Foucault, "Governmentality," in *The Foucault Effect: Essays in Governmentality: With Two Lectures by and an Interview with Michel Foucault*, ed. Graham Burchill, Colin Gordon, and Peter Miller (London: Harvester Wheatsheaf, 1991).

56 *Calcutta Chronicle*, January 18, 1787.

57 Partha Chatterjee, *The Nation and Its Fragments: Colonial and Postcolonial Histories* (Princeton: Princeton University Press, 1993), 237.

58 The first newspaper, *Hickey's Gazette*, established in 1780, attacked Hastings's corrupt government—but the editor James Hickey was soon arrested and his paper disbanded. Later papers moaned that "in this part of the world the channels of intelligence are few—the novelty of character trifling—the follies and vices of the people from a confined sphere of action not strikingly conspicuous. The subjects of merriment and laughter but thinly scattered. The vicissitudes of fortune though often times extraordinary, seldom worth relation." *India Gazette*, February 14, 1785. See also the *Calcutta Chronicle*, October 2, 1791: "The bounds of society are here very much circumscribed, authentic information on great subjects is necessarily held in profound secrecy and prudentially

limited to a few; except by those few, public opinions are not to be formed with ease and certainty."

59 These powerful urban zemindars counted for about 25 percent of the buyers of prints. It is not clear how far these prints were used to decorate the outer apartments (*bahir mahal*) of their homes or were resold as trade. As for markers of prestige, they preferred rare icons won from older rural rajas or Mughal manuscripts.

60 Abu Talib, *Travels*; Gulfishan Khan, *Indo-Muslim Travellers to the West in the 18th Century* (Karachi: Oxford University Press, 1998).

61 Abu Talib, *Travels*, 95.

62 Itesamuddin, *Shigurf-namah-i-velaet or Excellent Intelligence Concerning Europe Being the Travels of Mirza Itesamuddin in Great Britain and France*, trans. J. E. Alexander (London, 1827), 42; Abu Talib, *Travels*, 121.

63 Abu Talib, *Travels*, 143–44.

64 Asiaticus, *Memoirs of Asiaticus*, ed. W. K. Firminger (Calcutta, 1909), 33.

65 I. H. T. Roberdeau, "A Young Civilian in Bengal in 1805," in *Calcutta in the 19th Century*, ed. P. T. Nair (Calcutta, 1805), 34.

66 *Calcutta Chronicle*, October 30, 1788.

67 Baillie to Humphry HU/4/114, Humphry, *Correspondence*.

68 Baillie to Humphry HU/4/130, Humphry, *Correspondence*.

69 *The World*, June 9, 1792.

70 Humphry, *Correspondence*.

71 *Calcutta Chronicle*, July 26, 1787.

72 For instance, "a very capital and elegant collection of prints with gold burnished frames upon an entire new principle, the patent of which was granted February last and are the only ones that have yet been brought to this country," at Mouart and Faria's rooms, *Calcutta Gazette*, September 26, 1793, and *Asiatic Mirror*, October 9, 1793. For the latest caricatures including Hastings, *Calcutta Gazette*, June 28, 1787. For polygraphic paintings from 1789 onward, *Calcutta Gazette*, October 18, 1789, at Edward Gardner's rooms to be sold by auction — indicating wide appeal of these mass-reproduced oil painting simulations. See also *Calcutta Gazette*, November 31, 1791, Burrell, Dring & Co. advertised for sale the effects of Francis Rundell who had run the Old Theatre. These included "some very beautiful polygraphic copies of the following celebrated paintings: *Landscape of Morning* by Barrett, *View of Glaciers, of the Icy Cavern* by Webber, *Conjugal Peace* by Kauffmann . . . *Santa Teresa* from Correggio." The panorama of London was opened in Tank Square (where these agency houses were located) from January 1, 1798, tickets available from Colvin and Bazett; *Calcutta Gazette*, December 28, 1797.

73 There are several instances of the sales of oil paintings through raffles, lotteries, and dice games, traceable from the appearance of the first issues of the *Calcutta Gazette* in spring 1784. Most do seem to have gone ahead such as Urmston's investment of unsold oils by George Stubbs, divided into six prizes, to be won

in a raffle of forty subscribers, ticket at 150 Rs each. These included such well-known works as *Reapers and Haymakers* as well as *Lions and Tigers* (*Calcutta Gazette*, September 1, 1785, "raffle at Pope and Fairlie's"). An instance of a sale advertised then canceled was that of Europe shop proprietor Joseph Queiros, who proposed a raffle of old masters in 1784—first prize being nineteen pictures worth £500 (*Calcutta Gazette*, December 9, 1784). The subscription was not filled so he advertised them to be sold for ready cash (*Calcutta Gazette*, May 12, 1785).

74 H. Geismar, "What's in a Price?," *Journal of Material Culture* 6(1) (2001): 25–47.

75 Geismar, "What's in a Price?"

76 Chance had become a feature of Western metaphysics since Aristotle; by the 1720s it had become linked to the "aleatory contract"—which could be a legal agreement, the exchange of the present for an uncertain future, gambling, annuities and insurance policies, or loans. Hazard was outweighed by the hopes of future "expectation." It was largely because of the rise in risks and insurance policies that merchants began to collect detailed demographic data—the first step toward governmentality.

77 James Hickey, *Hickey's Gazette*, March 1781.

78 P. J. Marshall, *East Indian Fortunes: The British in Bengal in the 18th Century* (Oxford: Oxford University Press, 1976), 49.

79 *Calcutta Chronicle*, January 1, 1793.

80 Appadurai, *Modernity at Large*, 77.

81 This attachment of prints to agency houses is substantiated by comparison between the place of art in the Bengal Wills Series (L/AG/34/29, London, OIOC) and the Bengal Inventory Series (L/AG/34/27, OIOC). The wills of European residents rarely mention art (there is only the occasional reference to portraits to be sent to family members). Yet art appears regularly in about 30 percent of the inventories. These inventories consisted in the resale of departed or deceased inhabitants' things—which were usually commandeered by the agency houses from whence they were derived and then resold, the credit canceled. By this stage, such goods were often frayed, but this was a cheap way of picking up or renting things—for instance, Hodges's aquatint *Views of India* (London, 1785–88) forming lot 253 of the estate of John Roach were sold to Mr. Hawkins for 5 Rs (Bengal Wills Series, L/AG/34/27/9, 1788).

82 Latour, *Pandora's Hope*, 266.

83 Latour, *Pandora's Hope*.

84 From 1772 to 1786 as many as twenty professional painters traveled to India (eleven working in oil); from 1787 to 1802 only seven made the voyage (only one was an oil painter—George Chinnery arriving in 1802), this was despite a rise in population from 200,000 in 1780 to 350,000 by 1820.

85 Bhabha, *The Location of Culture*, 107.

Advertising and the Optics of
Colonial Power at the Fin de Siècle

David Ciarlo

In the last few decades of the nineteenth century, advertisements that
based their message entirely around imagery began to appear and circulate
en masse among all the industrialized nations of Europe. Great Britain, a
leader both in industrialized production and in the display of commodities
through exhibitions, also pioneered this visual advertising. Manufacturers
of the newest commodities, such as brand-name packaged soap, were among
the first to turn to this new promotional technique.[1] Yet, while the makers of
soap and cigarettes promoted new products with novel methods, the picto-
rial themes they chose—their visual motifs—remained quite traditional, at
least initially. In 1886, for instance, the Pears Soap Company purchased the
rights to a painting by a renowned pre-Raphaelite (Sir John Everett Millais)
of a pale child gazing wistfully at a bubble. The company then engraved a bar
of Pears soap into the scene, and thereby transformed high art into a univer-
sally recognized advertising logo: "Bubbles."[2] In a similar vein, the earliest
commercial images of the multinational Liebig Company, a beef bullion
manufacturer that pioneered illustrated trade cards, initially used classical
motifs of cherubic children in the late 1870s and early 1880s.[3] Around the
mid-1880s, however, British advertisers began to turn to different motifs
that were less traditional and more spectacular. For products ranging from
soap to tea to cocoa, British advertisers turned to the empire for inspiration,
presenting illustrations of savage dervishes in the Sudan genuflecting in awe
at British soap slogans, or depicting half-naked primitives puzzling over the
latest modern manufactures.

 In recent years, scholars such as John MacKenzie and Anne McClintock
have used these advertising images to illustrate the importance of the im-
perial ethos in forging British national identity and in recasting gender roles.

Others, such as Anandi Ramamurthy, have tied this imagery of empire more directly to colonial economy itself; representations of black workers in soap and cocoa advertising, she argues, trace back to manufacturers' need for vegetable oils from West Africa, and the actual exploitation of labor there under the colonial regime.[4] Collectively, these scholars' works advance our understanding of the broader significance of the colonial project to European society enormously. Yet all of these approaches see advertisements as somehow reflective of some facet of Britain's larger colonial project. In them, advertisements mirror larger, overarching structures of imperialism: they reflect the centrality of colonial ideology to nation-building; they reveal the degree to which racial thinking saturated popular culture and social identity; or they illustrate the economics of colonial extraction.

This chapter offers a challenge to the view of advertising as "reflective." Advertising does not merely replay preexisting ideologies or replicate cultural perspectives. It has its own agenda—namely, a commercial imperative to seize attention and impel purchase. And the manifestation of imperialism or the appearance of "the colonies" in advertising across Europe around the turn of the century owed more to advertising's own internal evolution than to the actual economic connections of nation to colony or to the prominence of empire in their self-conception. Images of subordinate colonial subjects or of half-naked "savages" materialized not because viewers found them important, but because advertisers found them useful. In Germany, for instance, advertisers turned to their new colonial empire not because of the significance of Germany's colonial economy (which remained minimal) but because colonial imagery offered opportunities—and resolved potential pitfalls—that other imagery with *non*colonial themes did not. In this sense, we should recognize that advertising *created* visions of empire; it was an originating font for colonial culture quite different from the collection plates of missionary societies, the publications of explorers and colonial scientists, the heated nationalistic rhetoric of colonialist pressure groups, or the investments of would-be entrepreneurs in extractive overseas enterprise.

Germany came late not only to colonial rule, but also to consumer-oriented imagery. Given the omnipresence of advertising today, we all too easily overlook how contingent and controversial this practice was at the fin de siècle.[5] In Germany, advertising emerged as a legitimate profession only in the last decade of the nineteenth century. Certain forms of textual advertising, such as newspaper classifieds, had been around for a century or longer, of course. The professionally crafted advertisement that framed

its primary appeal around imagery (*Bildreklame*) was new, however.[6] Technological innovations in the 1880s and 1890s, from the twin rotation press and the offset lithograph press to tin or paperboard chromolithography, made imagery cheap. Commercial images now appeared everywhere, on every conceivable surface: posters plastered city walls; ad inserts circulated in the new mass media; and packaging literally wrapped goods in imagery that people then carried back into their homes. In short, between 1880 and 1900 a new visual field emerged in Germany. Images circulated everywhere. They were seen as a new communicative form: commercial culture quickly changed from a verbal conversation with the neighborhood merchant to a swirl of images circulating among passing and distracted spectators. Visual advertising en masse presented not just a new tool, but entailed a new way of seeing and behaving: it represented not merely visual culture but visuality.[7] A great many factors fed into this emergence of commercial visuality, quite apart from just the technological innovations in printing. Businesses were increasingly willing to redirect capital investment toward professional ad men—ad men who claimed to be experts, but as yet had no method to evaluate their prowess. The public was increasingly willing to see their traditional reading material and their very urban landscape fundamentally transformed. Most importantly, however, the very meaning of consumption changed. The goods that one purchased, ate, or wore had connoted status and fashioned identity for centuries, of course.[8] Yet advertising and illustrated packaging pictorially delineated these social constructions. The mundane consumption of products was not only laced with fantasy, but that fantasy was literally illustrated. A professor of art wrote in an advertising journal in 1894: "He who furnishes local tables with the products of far away regions once used to exhibit his wares in their original casings. . . . [O]ut of manila sacks, and out of palm leaf baskets wafted the aroma of distant places, which could easily captivate an impressionable imagination." Yet "today . . . a new school leads us down a path allowing us a pictorial view *directly into* those distant lands."[9] Eventually, these consumer fantasies—now concretely drawn—were mass reproduced, and thereby reified. Cocoa tins featuring cute, happy children, beer bottles featuring busty serving women, or cigarette tins picturing a desert caravan were seen over and over and over again. This created an empire of fantasy, one connected only tenuously (if at all) to the actual everyday practices of child rearing, romance, or overseas travel.

In the 1890s, however, this commercial visuality was still in its infancy, with advertisers and graphic designers as its oblivious architects. Adver-

tising was powerful; advertisers were not. Collectively, their efforts con-
structed powerful visual fantasies, but the profession of advertising was not
yet socially legitimate, and its work scattered among countless small studios,
businesses, and small print shops.[10] There is no evidence these advertisers
and businesses ever shared any grand political vision; their daily work in-
volved tactical responses to pressing demands and immediate problems.
Pursuing their commercial raison d'être, one difficult problem emerged im-
mediately—and its resolution would have a great deal to do with the popu-
larity of colonial imagery. The qualities and superlatives of commercial dis-
course—the verbal guarantee of the shopkeeper, the textual exhortation of
the classified—are extraordinarily difficult to replicate in the visual field. It
is one thing to say, in millennia-old mercantile habit, that your particular
sort of coffee is "outstanding" or "unsurpassed," or to write that your cigars
are "of the highest quality" or "known to be the best."[11] But how do you
draw this?

At first, German advertisers used traditional approaches as they charted
out their new visual approach. The first wave of commercialized, mass-
produced imagery across the urban landscape in the 1880s and 1890s tended
to re-create familiar themes of social status or contentment to make familiar
connections and associations. An idealized, gesturing bourgeois housewife
points at a product encouragingly, or a cherubic child clutches a cup of hot
cocoa in pudgy hands, his happy grin offering the very picture of the posi-
tive effects of the cocoa. These two sorts of motifs—using women to direct
attention, using children to demonstrate good effects—continued to domi-
nate German advertising and packaging well into the twentieth century.[12]

The new practice of advertising, however, was not only about direction
and demonstration. It was also about enticement. As advertisers searched
for ways to entice the public, they often turned to visions of the exotic—and
particularly to the exotic realm of the Orient. Cigarette tins chromolitho-
graphed romanticized Egyptian landscapes, while tea tins painted scenes
from distant China. These chromolithographed scenes appeared as early as
the 1870s, counting among the very first commercial images to be mass pro-
duced in Germany.[13] Around 1900, however, exotic scenes of the Orient or
of the Caribbean gave way to a new style of motif across a broad range of
product categories from cocoa to soap to shoe polish. These new motifs
were not only exotic but also explicitly colonial, and remained prevalent up
until the start of the First World War.

What do we mean by the word *colonial* when we talk of advertising

imagery? The word *colonial* is among the most oft-used adjectives in scholarly writing over the last decade, and its meaning become almost limitlessly expansive. I will highlight three very specific categories of colonial motifs that appeared in German advertising. The first involves ads that use text or other connections outside of the frame of the image itself to make an association to colonial politics or to colonial trade or to some other aspect of official colonialism of the state. A second type of colonial motif illustrates some element of colonial ideology—such as staging a scene based on oft-repeated claims to Europe's special role in the "civilizing mission," or delineating the value of a colonial science like ethnography or geography. A third type works largely in the visual plane, presenting an optics of colonial rule that does not require the same political connections or ideological framework of the first two categories. This third category is particularly interesting, in that it reveals that "the colonial" can be detached almost entirely from actual colonialism, and emerge instead from a dynamic internal to the practice of advertising itself.

Delineations of the Colonial

The first significant wave of advertisements with colonial themes to appear in Germany came just before the turn of the century; they emerged hand in glove with a swell of public interest that attended German territorial acquisitions in the Far East.[14] An illustration trademarked by Hromadka and Jäger, a small bakery just outside of Dresden, offers one example. It was registered with the Imperial Patent Office in 1898 for use as product packaging. Hromadka and Jäger's packaging offers a glance into that most distant and exotic land, China: within the image, a reclining mandarin in hat and brocaded robes sits on an ornately carved chair next to his wife (or, perhaps, his concubine; see figure 7.1). The male figure holds a long opium pipe, while the woman in robes holds a fan. A porcelain vase, teapot, and teacup sit atop the table, while an approximation of Chinese characters appears on the vase and on the wall behind them. The scene, in short, offers a potpourri of objects and impressions from the Orient. This is a familiar "exotic" to Germans; however, it does not convey any "new" information. The depicted items—ornately carved furniture, silk, porcelain vases, tea, and even opium—are all Chinese-produced commodities circulating in the West for well over a century. Even the gently arcing tree in the background of the drawing, for instance, evokes a style of Chinese inkwash art exported to

Europe, and the letters of Jäger's brand name are similarly in a script meant to imitate Chinese brushwork used to decorate exported products. Collectively, these visual references do not offer a glimpse into China per se, but instead into a constellation of perceptions based on several centuries of the China trade.

There is a "colonial" element here, however. Textually and contextually, we see it in the product name (Kiaotschau Cookies) and in the date of its appearance (1898). Earlier that same year, Germany had used the murder of two missionaries as a pretext to demand compensation from the Chinese emperor. The treaty port of Qingdao (Tsing Tao) and its environs in Jiaozhou Bay thereafter became the German colony of "Kiautschou" on the northern Chinese coast. These "Kiaotschau Cookies," baked in Dresden, had no physical connection to the colony, of course. Instead, the packaging was part of an outpouring of commercialized imagery after 1898 that feted Germany's new colonial acquisition (and more aggressive stance on the international stage). Postcards both cute and belligerent, of Chinese children waving German flags or of German marines using prostrate Chinese men as footstools, circulated through the post. Manufacturing giants like Maggi (soup powder), Liebig (bullion), and Jürgen and Prinzen (margarine) issued collectable trading cards to commemorate the imperial occasion that featured warships steaming to China and maps of the new colony. Smaller busi-

Fig. 7.1. Trademark registration for Kiautschau Cookies, W. Hromaka and Jäger Nachfolger, Plauen-Dresden, 1898.

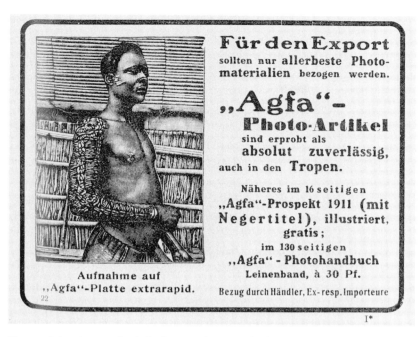

Fig. 7.2. Advertisement for Agfa photography materials, from Süsserott's Illustrated Colonial Calendar, 1912.

nesses came out with celebratory commodities like Prince Heinrich Kiao-Tchau Tea, Chinese Liquor Kiautschou, and German-Chinese Friendship Liquor. (Their peaceful-sounding brand names only thinly veiled the belligerence and even violence seen in their illustrations; not much "friendship" is in evidence on the liquor label, for instance.)[15] The scene depicted on Hromadka and Jäger's cookie packaging, to the contrary, appears serene, offering nothing violent or offensive—only a hodgepodge of illustrated exotic minutiae. The "colonial" element in this packaging lies outside of the image itself, in the way that the name alone embedded the product—including its illustration—in a web of jingo-nationalism and politicized colonialist posturing, both of which manifested in commercial culture around 1900.

Not all colonial contexts for illustrations tied into the politics or geopolitics of colonialism. An advertisement for Agfa photographic material from 1912 taps into more cerebral facets of the German colonial project (see figure 7.2). The ad promises "Agfa photo products are tested as absolutely dependable in the tropics." The implication, of course, is that the products will be used there. Agfa's illustration features an African man with prominent cheek

and arm scarification. The image is a photoengraving—a practice whereby a skilled engraver carves a photographic image onto a printing plate. (It remained the primary means of photo reproduction up through 1910, until halftone reproduction became more widely available.) The photoengraving presents the man ethnographically, as an ideal type of African. Note, for instance, the way the figure is in profile, not making eye contact (permitting us to stare at him more comfortably), and that his most bizarre feature—his scars—are the focal centerpiece of the illustration.[16] The scarring is also visually exaggerated by the deep cuts made by the engraver. This ethnographic pictorial style, interestingly enough, long predated photography. Engravers produced this type of delineation of natives and primitive peoples (*Naturvölker*) to illustrate books and magazines in the 1860s and even earlier. Early ethnographic photographers often sought to duplicate this older style of presentation, cajoling would-be photographic subjects to assume specific poses.[17] This Agfa ad illustration is therefore more complicated than it might seem at first glance: it is an engraving imitating a photograph imitating an engraving.

This illustration plays a similarly complex role as an advertisement. First, the illustration must grab attention; the scarification of the body is intended to capture our eye. Our attention ensnared, we are now meant to be equally impressed by the technology promised by the text: the modern camera, suitably durable for the rugged tropics, can now capture such ethnographic types easily, without the need for an intermediary such as an illustrator. (Of course, since the representative image is actually an engraving, the claim to be a snapshot [*Aufnahme*] on an Agfa plate is spurious.) The composition implies that if the viewer purchases such a camera and film, he will become an ethnographer himself. The illustration thereby legitimates the product; the camera is no consumer plaything, it is a serious scientific instrument, able to transform anyone into an amateur ethnographer.

This advertisement appeared in Süsserott's Colonial Calendar in 1912, which was a relatively new publication aimed at the cadre of colonial enthusiasts, most of whom were members of the German Colonial Society or its affiliates.[18] Among these more conservative colonialists, the practice of advertising could still be suspect. However, claiming a scientific role for the product could soothe irritation at the very presence of the ad in the first place. Ultimately, this ad was only one of many visual elements of Süsserott's calendar, all of which collectively constructed a virtual colonial project for the publication's readers. The vast majority of its readers would never

journey to the colonies. The ad itself hints at this armchair colonialism. While the text promises durability for tropical use, it also includes an offer for a free sixteen-page illustrated prospectus—"mit Negertitel." The reader can thereby receive more exotic, bizarre primitives in the mail. In this way, a simple ad for camera equipment in a colonialist journal has become part of a larger colonial fantasy, one that fuses virtual ethnography to the domestic consumption of technology.

Illustrations of Ideology

Advertising images could also illustrate a colonial relationship directly within the borders of the picture itself. An early advertising image trade-marked in 1902 by a Swiss firm for use in Germany offers a case in point. Similar to a number of images produced by German firms in the 1890s, it draws two figures, an "African" and a "European," arm in arm. The image illustrates a particularly venerable tendril of colonialist ideology, extolled by the famous explorer David Livingstone in the late 1850s: "the two pioneers of civilization—Christianity and commerce—should ever be inseparable."[19] The white figure has his arm placed protectively and paternalistically around the shoulders of the African figure, and the two figures are joined by the cocoa plant front above them (with cocoa pods). To make the "commerce" component even more explicit, a sailing ship and crated cargo appear in the scene as well. This is an allegory of colonial commerce as a civilizing mission, one that peacefully brings Europe's protective arm around Africa. The details are revealing. The mountain off to the right may (or may not) be Mount Cameroon, for instance, while the African figure holds a harvesting bowl, a subtle hint at the uneven distribution of labor. The dress of each figure deserves particular attention. The white figure appears in alpinist shorts, with cap and boots. He is derivative of the Rüger cocoa firm's 1895 logo of a pudgy boy in hiking boots.[20] The African figure, on the other hand, wears only a waist-wrap, adorned with some sort of shell necklace. His feet are bare.

The juxtaposition of the difference in clothing between the two figures gives the viewer a visual shorthand to Livingstone's civilizing mission of commerce. It also implicitly ranks the two figures, showing their different levels of civilization and wealth. Imagine, for instance, how dramatically different the scene would read if a poor white child laborer in a German chocolate factory were arm in arm with a wealthy prince of Zanzibar in a luxuri-

ous caftan, or a West African Duala trader in a formal Western suit. Yet, as more and more advertisements deployed markers like bare feet when drawing African natives, such markers become more omnipresent, more visible—and eventually, indispensable in identifying the figure itself. The growing scope and ubiquity of mass-produced advertising collectively formed a self-reifying vista, and thereby forged types into stereotypes.

Optical Power

A commercial image can "work" in ways beyond the interpretation of its symbolism or the belief in its stereotypical representations. Representations of colonial power could also work optically, relying on direct aspects of eyesight that involve scale, position, posture, and color contrast. Optical power positions a figure in a subordinate relationship to a depicted commodity; but by transporting the "tableau" to colonial terrain, the subordination becomes more palatable and more believable.

In the decade that followed the turn of the twentieth century, black figures in German advertising increasingly shoulder heavy burdens. This burden is most often the commodity itself, the firm's logo, or the raw material (such as a sack of coffee beans). In Reinhard Tetzer's ink advertisement from 1912, for instance, a black figure bends over under the burden of an ink jar (see figure 7.3). The brand name is Tinten-Sklave ("Ink-Slave"), deriving, perhaps, from a colloquial term for an ink jar.[21] When first glancing at this advertisement, the viewer might attribute the ad's theme to an association of "color": ink is black, just as Africans are "black," and this correlation accounts for the designer's thematic choices.[22]

I suggest a different driving force—one that unfolds from a more complex constellation of commercial concerns. Consider what I call the optics of the image. First, the stark contrast between the figure and the circle draws the eye; on a page of linear newspaper text, a solid black shape pressed into a white circle would draw your eye like an arrow to a target. (The heavy, solid shapes and lines also reproduce well in cheap newsprint.) The commodity itself—the ink—is in the upper third of the target circle, elevated above the figure, indeed, breaking out of the top of the circle, and the four fingers of the figure point directly to the brand name.

The figure, placed within the targeting circle, serves three distinct visual functions. First, it provides scale. The enormity of the commodity is immediately shown by contrasting it against another object of a size that is im-

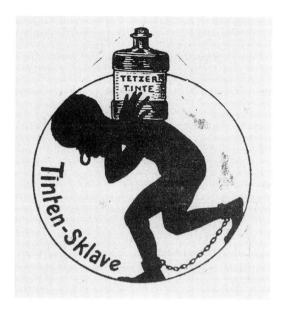

Fig. 7.3. 1912 trademark registration by Reinhold Tetzer (Berlin) for ink.

mediately, intuitively grasped—a human figure. (There is no more familiar object than the human body against which to estimate size instantly.) The inclusion of the figure thereby unequivocally magnifies the commodity. Second, the figure is drawn bent under a heavy burden—doubled over under the sheer magnitude of the product. The commodity thereby gains a sense of heft, as any viewer would inherently *feel*, at the level of bodily knowledge, this object's weight, based on the optical cues. (Imagine, for instance, that the jar were instead drawn on top of a scale reading "35 kilograms." How heavy would that be?) Third, the commodity on the back of the figure elevates the packaging not only up and out of the target circle—breaking through the top—but also above the level of the figure. The positioning literally raises the Tetzer brand name above the realm of the human.

This, then, is one way to illustrate abstract attributions like "valuable," "significant," "outstanding," or "known to be the best" without words. Tetzer's graphic tactics, moreover, convey information about the supremacy of their ink optically rather than allegorically or symbolically. Optical tactics such as these gradually constructed a new visual syntax that became extremely useful to the advertiser, for this syntax was oriented around capturing attention and conveying information instantaneously and unambiguously. These tactics could also be problematic, for they involve demeaning a

human figure in order to elevate the product. Imagine that this was a white German child, bent over in chains, or that a German worker performed the backbreaking labor of bringing the commodity to the viewer. (Such scenes did occasionally appear in adverting; they were attempted.) In the public sphere, however, such stark depictions of visual power might very well provoke an undesired association, or even a negative reaction.[23]

Here the "colonial" location of the scene enters into the equation. The designer can tamp down or evade negative associations by adding a simple symbol: a nose ring. The nose ring symbolically maps the figure as an "African native"—and thereby as "outside" of the viewer's familiar community. The subordination of the figure, achieved through bent posture and drawn chains, is made less startling to German viewers by the drawing in of markers such as primitive native jewelry and bare feet. The viewer thus cannot help but read the nose-pierced figure as "different." The rounded skull, bulging forehead, and apparent immaturity are similarly intended to differentiate the figure by evoking a tradition of racial physiognomy.[24] Silhouettes, as profiles, are particularly good at capturing facial (and supposedly racial) features.

The "colonial optic," then, is a two-step process. First, the design objectively magnifies the commodity, exalting it by juxtaposing it against a smaller (laboring and subservient) human being. Second and simultaneously, the design effaces the potentially uncomfortable implications of that optical assertion, by deploying symbolic elements or, later on, racialized facial features to differentiate the figure from the viewer and make the denigration of the human in the face of the commodity more palatable and seemingly more "natural." In terms of visual semiotics, the iconic elements of the Ink-Slave image magnify the commodity. Its indexical elements suggest the commodity's gravity; its symbolic elements—reified into transparency or even iconic "truth" by standardized mass reproduction—efface the power relationship by displacing it. The advertising image assures the supremacy of the commodity ad oculos, but minimizes the unpleasant implications of this visual power by moving it into the colonial realm.

The image reveals much more. The figure itself is a solid silhouette, without any detail, which evokes a characteristic of the product itself (inkiness). Moreover, the Sisyphean "work" done by the enchained slave figure in the Ink-Slave ad, and the absence of a white "master" figure, raises the logical possibility that you, the viewer, are the recipient of the labor. The supposi-

Fig. 7.4. 1914 trademark
registration by Fa. L Wolff
(Hamburg) for cigars.

tion flatters a low-status office clerk; the clerk becomes important enough
to warrant his "own" slave—or rather, with a virtual slave, brought through
the fantasy realm of commodity advertising. The virtual slave was a particu-
larly popular theme in American advertising of the 1890s, when famous
icons like Aunt Jemima, Rastus, and Uncle Ben emerged.[25] The enormous,
ceaseless labor—an increasingly popular theme of ads—could also be dis-
placed onto different types of "others," such as a homunculus like the Miche-
lin Man.[26] But in Europe, the colonized African remained a favorite subject.

In the colonial images discussed, the race of the figures emerges in a fairly
subtle fashion. The blackness of the Ink-Slave figure, for instance, adds one
more differentiating marker. (Just as the ethnicity of the African man in
the Agfa photoengraving also justifies his presence as an object of ethno-
photography.) Yet advertising—increasingly prone to overstatement—
developed "race" into a far less subtle pattern of depiction (see figure 7.4).
The practice of pictorial "racialization"—drawing great attention to sup-
posed racial features of Africans and African Americans, such as large lips,
wooly hair, flat noses, and so on—emerged at different times with different
themes in commercial imagery.[27] Around 1905, however, the pictorial prac-

tice of racialization became increasingly applied to black figures in a colonial setting; by 1910, the vast majority of black figures in German advertising were depicted in ways that emphasized enormous lips. It became a definitive marker. In the Wolff firm's "Georgsburg" cigar ad from 1914, for instance, inconsistencies of depiction hint at this overwhelming need—or perceived need—for racial demarcation. The roll of stomach fat, the slightly humped backbone, the strategically placed white dots around the waist to subtly suggest a bead loincloth, the accurate flattening of the arch of the foot—these are all subtle touches of realism, the mark of a skilled artist. Yet the figure's lips—the focal center of the tableau—are preposterous. Stark white, reminiscent of the makeup of a minstrel show performer, we cannot help but be struck by them.[28]

This pattern of racialization seems both offensive and ridiculous by contemporary standards. Yet it was not just a reflection of popular prejudice. It served a useful function for advertisers, by ensuring that the figure could not be mistaken for anything other than an African. Even after the turn of the century, the quality of cheap print reproduction was low. Distractions tugged at inattentive viewers—this cigar trademark could be seen from a distance as a poster, or only glimpsed while flipping through a tabloid in a streetcar. With many types of figures drawn as silhouettes (especially intaglio printing[29]) a black figure could be misperceived as a monochrome *European* figure. In the case of the Georgsburg cigar ad, such a mistake would totally disrupt the intended effect. Why would a German be kneeling, lower than the enormous cigar? Why would he be touching it so gingerly? Germans smoke cigars all the time. Why is he almost naked? Is he so poor that he sold his shirt? Is he drunk? Perhaps only naked drunks desire Georgsburg cigars? These questions disrupt the impact of the ad by challenging its premises. The enormous white lips on the figure, however, unequivocally prevent the figure from being mistaken for a German. In the final consideration, advertisers needed human figures that could be demeaned, because they were useful, and they adopted "race" in order to more efficiently accomplish this.

Colonialism is fundamentally about power. What is less often realized is that advertising is fundamentally about power as well. With a new arsenal of printing technologies at their disposal, the new professional advertisers stood ready to deploy a growing array of tactics to convey commercial messages efficiently and forcefully, and in ways that engendered the least resistance. Images of subordinate Africans, in particular, offered advertisers and designers an opportunity to present graphic configurations of

power to German viewers—but then to simultaneously mask those operations of power by displacing them into the "colonial" realm. Indeed, advertising's particular vision of colonial rule proved adept at wrapping a stark optical command in a warm coat of symbolic flattery. Moreover, it proved unmatched at disseminating this specific vision of colonial rule to a German public of unprecedented size and social scope, with profound implications for German national, cultural, and racial identity. Advertising is also, quite literally, a visual provocation. Far more than any other category of visuality, advertisers designed their products to elicit a specific real-world response.[30] Regardless of whether its commercial instigations were successful, the advertising industry disseminated colonial and racial visions to a viewing audience of unprecedented breadth and social scope. Advertising was therefore a generative force in its own right. The most widely disseminated visions of German power thus emerged not from the machinations of politicians or as a by-product of geopolitical economy, but as a constituent element of the new practice of consumer-oriented advertising.

Notes

David Ciarlo, "Advertising and the Optics of Colonial Power at the Fin de Siècle," in *German Colonialism, Visual Culture and Modern Memory*, ed. Volker M. Langbehn, 37–54. London: Routledge, 2010. © 2010 Routledge. Reproduced by permission of Taylor & Francis Books UK.

1 Thomas Richards, *The Commodity Culture of Victorian England: Advertising and Spectacle 1851–1914* (London: Verso, 1990); Clemens Wischermann and Eliot Shore, *Advertising and the European City: Historical Perspectives* (Aldershot, UK: Ashgate, 2000); Lori Anne Loeb, *Consuming Angels: Advertising and Victorian Women* (Oxford: Oxford University Press, 1994).

2 Adam MacQueen, *The King of Sunlight: How William Lever Cleaned Up the World* (New York: Bantam, 2004), 42–48. Sir John Everett Millais's original painting *A Child's World* was a meditation on the fragility of life. In 1889, William Lever and his Sunlight Company followed Pears's lead, purchasing William Power Frith's painting *The New Frock* around which to build their own advertising icon.

3 Especially series 2 through 8 from the late 1870s, printed in Paris. See Bernhard Jussen, *Liebig's Sammelbilder* (DVD-ROM) (Berlin: Yorck Project, 2002); Joachim Zeller, "Harmless '*Kolonialbiedermeier*'? Colonial and Exotic Trading Cards," in *German Colonialism, Visual Culture, and Modern Memory*, ed. Volker M. Langbehn (New York: Routledge, 2010), 71–86; and also Detlef Lorenz, *Reklamekunst um 1900: Künstlerlexikon für Sammelbilder* (Berlin: Reimer, 2000).

4 John M. MacKenzie, *Propaganda and Empire: The Manipulation of British Public Opinion, 1880–1960* (Manchester: Manchester University Press, 1984); Anne McClintock, *Imperial Leather: Race, Gender, and Sexuality in the Colonial Contest* (New York: Routledge, 1995); Anandi Ramamurthy, *Imperial Persuaders* (Manchester: Manchester University Press, 2003). On advertising in the West more broadly, see Jan P. Nederveen Pieterse, *White on Black: Images of Africa and Blacks in Western Popular Culture* (New Haven, CT: Yale University Press, 1992).

5 On the advent of advertising in Germany, see especially Christiane Lamberty, *Reklame in Deutschland 1890–1914: Wahrnehmung, Professionalisierung und Kritik der Wirtschaftswerbung* (Berlin: Duncker & Humblot, 2000).

6 On visuality and German advertising, see particularly Peter Borscheid and Clemens Wischermann, eds., *Bilderwelt des Alltags: Werbung in der Konsumgesellschaft des 19. und 20. Jahrhunderts* (Stuttgart: Franz Steiner, 1995); and Janet Ward, *Weimar Surfaces: Urban Visual Culture in 1920s Germany* (Berkeley: University of California Press, 2001).

7 Dirk Reinhardt, *Von der Reklame zum Marketing: Geschichte der Wirtschaftswerbung in Deutschland* (Berlin: Akademie, 1993). See also Stefan Haas, "Die neue Welt der Bilder," in *Bilderwelt des Alltags: Werbung in der Konsumgesellschaft des 19. und 20. Jahrhunderts*, ed. Peter Borscheid and Clemens Wischermann (Stuttgart: Franz Steiner, 1995), 78–90.

8 Woodruff D. Smith, *Consumption and the Making of Respectability: 1600–1800* (New York: Routledge, 2002).

9 *Die Reklame* 4(2) (February 20, 1894): 31. From the essay "Reklame und Plakat-Kunst" by Professor F. Luthmer (Frankfurt). This is certainly Ferdinand Luthmer (1842–1921), the director of Frankfurt's Kunstgewerbeschule after 1879.

10 German advertisers not only complained about their lower status vis-à-vis their American counterparts, but resented German businessmen who all too often insisted on being in charge of their campaigns. See Paul Ruben, *Die Reklame* (Berlin: Verlag für Sozialpolitik, 1914).

11 The most common phrases of German textual classified ads were *anerkannt das Beste* and *höchste Qualitat*. See Peter Borscheid, "Am Anfang war das Wort," in *Bilderwelt des Alltags: Werbung in der Konsumgesellschaft des 19. und 20. Jahrhunderts*, ed. Peter Borscheid and Clemens Wischermann (Stuttgart: Franz Steiner, 1995), 20–43.

12 Overviews include Reinhardt, *Reklame zum Marketing*; Deutsches Historisches Museum, *Reklame: Produktwerbung im Plakat 1890 bis 1918* (DVD-ROM) (Berlin: Directmedia, 2005); Deutsches Historisches Museum, Hellmut Rademacher, and René Grohnert, *Kunst! Kommerz! Visionen!: Deutsche Plakate 1888–1933* (Heidelberg: Edition Braus, 1992); and Jörg Meißner, ed., *Strategien der Werbekunst von 1850–1933* (Berlin: Deutsches Historisches Museum, 2004).

13 Tino Jacobs and Sandra Schürmann, "Rauchsignale: Struktureller Wandel und Visuelle Strategien auf dem deutschen Zigarettenmarkt im 20. Jahrhundert,"

Werkstatt Geschichte 16(45) (2007): 33–52; Sander Gilman and Zhou Xun, eds., *Smoke: A Global History of Smoking* (London: Reaktion, 2004).

14 Arguments about the relative prevalence of advertising in the German pub-
lic sphere come from intensive research into the trademark registration rolls
(Warenzeichenblatt des Kaiserlichen Patentamts), the results of which appear
in David Ciarlo, *Advertising Empire: Race and Visual Culture in Germany* (Cam-
bridge, MA: Harvard University Press, 2011).

15 On German colonialism in China, see Heiko Herold, *Deutsche Kolonial- und
Wirtschaftspolitik in China 1840 bis 1914: unter besonderer Berücksichtigung der
Marinekolonie Kiautschou* (Cologne: Ozeanverlag, 2004); George Steinmetz,
*The Devil's Handwriting: Precoloniality and the German Colonial State in Qing-
dao, Samoa, and Southwest Africa* (Chicago: University of Chicago Press, 2007);
and Paul M. Kennedy and John Anthony Moses, eds., *Germany in the Pacific
and Far East, 1870–1914* (St. Lucia: University of Queensland Press, 1977). On
the acquisition of Kiautschou in German commercial culture, see the postcard
collections of the Deutsches Historisches Museum (German Historical Mu-
seum); Hans-Martin Hinz and Christopher Lind, *Tsingtao: Ein Kapitel deutscher
Kolonialgeschichte in China 1897–1914* (Berlin: Deutsches Historisches Museum,
1998).

16 On popular anthropology, see Andrew Zimmerman, *Anthropology and Anti-
humanism in Imperial Germany* (Chicago: University of Chicago Press, 2001);
Alison Griffiths, *Wondrous Difference: Cinema, Anthropology, and Turn-of-the-
Century Visual Culture* (New York: Columbia University Press, 2002); Assenka
Oksiloff, *Picturing the Primitive: Visual Culture, Ethnography, and Early Ger-
man Cinema* (New York: Palgrave, 2001); Michael Wiener, *Ikonographie des
Wilden: Menschen-Bilder in Ethnographie und Photographie zwischen 1850 und
1918* (Munich: Trickster, 1990). On European fascination with scarification, see
Eric Gable, "Bad Copies," in *Images and Empires: Visuality in Colonial and Post-
Colonial Africa*, ed. Paul S. Landau and Deborah Kaspin (Berkeley: University
of California Press, 2002), 294–319. On photoengraving, see Gerry Beegan, *The
Mass Image: A Social History of Photomechanical Reproduction in Victorian London*
(New York: Palgrave Macmillan, 2008).

17 See especially Elazar Barkan and Ronald Bush, eds., *Prehistories of the Future:
The Primitivist Project and the Culture of Modernism* (Palo Alto, CA: Stanford
University Press, 1995); and Jürg Schneider, Ute Röschenthaler, and Bernhard
Gardi, eds., *Fotofieber: Bilder aus West- und Zentralafrika; Die Reisen von Carl
Passavant 1883–1885* (Basel: Christoph Merian, 2005).

18 The German Colonial Society was part political pressure group and part colo-
nialist clubhouse. See especially John Phillip Short, "Colonialism and Society:
Class and Region in the Popularization of Overseas Empire in Germany,
1890–1914," PhD diss., Columbia University, 2004; Ulrich S. Soenius, *Kolo-
niale Begeisterung im Rheinland während des Kaiserreichs* (Cologne: Rheinisch-
Westfälisches Wirtschaftsarchiv zu Köln, 1992).

19 David Livingstone's lecture, delivered before the University of Cambridge on December 4, 1857. Rev. J. E. Chambliss, *The Lives and Travels of Livingstone and Stanley* (Boston: De Wolfe, Fiske, 1881), 258.

20 The Rüger firm was established near Dresden in 1885. Its logo of a pudgy boy in hiking boots, cap, striped shirt, and with a walking stick emerged in 1895 and was trademarked in 1904.

21 *Kuli* (German slang for "pen") is not an abbreviation of *Kugelschreiber*, but rather, for *Tinten-Kuli* (Ink-Coolie) a specific brand of pen sold in 1928. The 1928 brand name, however, suggests that the notion of a pen as a "slave" or a "coolie" is older, as this ad would seem to indicate.

22 Indeed, a number of books on graphic design, and even some on racial imagery, go no further than such claims of color correlation when discussing ads for cocoa, coffee, ink, or shoe polish. See Michael Scholz-Hänsel, *Das Exotische Plakat* (Stuttgart: Institut für Auslandsbeziehungen, 1987).

23 There were many foes of advertising in its early years. They were not just landscape and *Heimat* preservationists, but also crusaders against public immorality, socialist collectivists, and even alarmist academics critiquing the corruption of culture itself. See Lamberty, *Reklame*.

24 Richard T. Gray, *About Face: German Physiognomic Thought from Lavater to Auschwitz* (Detroit: Wayne State University Press, 2004).

25 See M. M. Manring, *Slave in a Box: The Strange Career of Aunt Jemima* (Charlottesville: University Press of Virginia, 1998); Jo-Ann Morgan, "Mammy the Huckster: Selling the Old South for the New Century," *American Art* 9(1) (1995): 87–116; Rosemary J. Coombe, "Embodied Trademarks: Mimesis and Alterity on American Commercial Frontiers," *Cultural Anthropology* 11(2) (1996): 202–24.

26 Virginia Smith, *The Funny Little Man: The Biography of a Graphic Image* (New York: Van Nostrand Reinhold, 1993). See also Karen Pinkus, *Bodily Regimes: Italian Advertising under Fascism* (Minneapolis: University of Minnesota Press, 1995).

27 Ciarlo, *Advertising Empire*, chaps. 5 and 6. See also Jan P. Nederveen Pieterse, *White on Black: Images of Africa and Blacks in Western Popular Culture* (New Haven, CT: Yale University Press, 1992); Michael D. Harris, *Colored Pictures: Race and Visual Representation* (Chapel Hill: University of North Carolina Press, 2003); and Dana Hale, *Races on Display: French Representations of Colonized Peoples, 1886–1940* (Bloomington: Indiana University Press, 2008).

28 Minstrel show promotional posters, in fact, were one avenue by which racialized patterns of depiction came into German commercial culture. See Ciarlo, *Advertising Empire*, chap. 5.

29 Most famously, Hans Schwarzkopf's trademark of his "Shampoon mit dem schwarzen Kopf," advertised heavily after 1910, featured monochrome silhouettes of Germans. Such monochrome silhouettes were easily mistaken for figures of an African, particularly at a distance or with low-quality printing.

30 Advertising is not always successful in provoking this real-world response, of course. Indeed, in the era under discussion, any sort of evaluation of advertising's effectiveness was impossible: opinion polling and other forms of evaluation only emerged first in the 1930s, and did not become widespread until well into the 1950s. The effectiveness of advertising remained with the judgment of the advertising "expert"—whose expertise was usually self-proclaimed.

PART 3

Mapping, Claiming, Reclaiming

Mapping Plus Ultra: Cartography,
Space, and Hispanic Modernity
Ricardo Padrón

In his seminal work, *The Production of Space*, Henri Lefebvre describes a period spanning from the sixteenth to the nineteenth centuries in which a common spatial code served to organize Western European culture. As his title implies, "space," for Lefebvre, is not a natural given, but something "produced" in and through the conceptual, perceptual, and practical activity of human beings. In its own production of space, the modern West has given determinative power over many aspects of life to space as it is conceived geometrically, and has done so at the expense of space as it is perceived or lived. Modernity naturalizes geometric, optical, isotropic space as a fundamental epistemological category, and thereby gives undue authority to the abstractions of the mapmaker, the surveyor, the planner, the architect, and the like. Traditional "representational spaces"—spaces as they are perceived—such as the hearth or the geography of the sacred, are correspondingly stripped of their authority. In this order of abstraction, everything comes to be understood as either a location or an object within this space, and thereby becomes amenable to systematic understanding, commodification, appropriation, or subordination by a viewing subject.

The cartography that emerged from the so-called cartographic revolution of the fifteenth through eighteenth centuries makes a powerful contribution to this central characteristic of modernity.[1] Its importance can be understood through a brief comparison between two maps, one medieval and the other early modern.[2] Medieval mapmaking is perhaps best known for its *mappaemundi*, the traditional depictions of the known world that graced the walls of cathedrals and the pages of illuminated manuscripts. This is the cartography of ecclesiastical mapmakers more interested in orienting the soul toward heaven than in directing the body through the physical world.[3]

As such, it is predicated on a spatial armature that is best understood as a strategy for symbolizing the world rather than for representing it. That armature is best glimpsed in an incunabular printing of one of the earliest known examples from this tradition, the *mappaemundi* that accompanies a 1472 edition of the *Etymologia* of Saint Isidore of Seville (figure 8.1). It depicts the known world, or *orbis terrarum*, as a tripartite disk surrounded by a circumnavigant ocean. Its two basic graphic components—the "O" of the ocean and the "T" of the bodies of water that separate the world's parts—form a monogram of the thing it figures, the orbis terrarum. This symbol, furthermore, associates each of the three parts of the world—Europe, Asia, and Africa—with the son of Noah responsible for repopulating it after the biblical flood. Other maps in this tradition place Jerusalem at the center of the world, or transform the central cruciform shape into the body of Christ. In all of these ways, these maps reveal the shared characteristic most important to us here: they rationalize space according to cultural priorities unique to medieval Christendom, priorities that emphasize the historicotheological meaning of the world at the expense of its physical appearance.[4]

By 1500, the old mappaemundi had come to be replaced, among the learned at least, by a new type of map derived from Ptolemy's *Geographia*, which had been reintroduced to Western Europe early in the fifteenth century. The map of the known world from a 1513 edition of Ptolemy can serve to summarize some of the changes introduced by this new cartography (figure 8.2). For our purposes, the map's grid of latitude and longitude constitutes its most significant characteristic. Here, geometry, not a pseudo-symbolic form, provides the map with its basic spatial armature. That geometry allows the mapmaker to do something that his or her medieval counterpart could not readily do. That is, he or she can model, with an accuracy that would only grow between 1500 and 1800, the relationships of objects and locations on the surface of the Earth, conceived as a geometric grid. That geometric armature, moreover, in itself inscribes something that we cannot readily identify on the medieval mappaemundi, an empty space that is entirely distinct from a "blank spot." That space is not merely the blankness produced by ignorance of an undiscovered geographical or hydrographical feature—a "negative emptiness"—but the abstract space into which geographies and hydrographies are plotted—a "positive" emptiness. It subtends the entire surface of the map, but its "positive emptiness"—its substantial independence from the objects and locations it serves to plot—only becomes visible when we realize that it logically extends far beyond the borders of the image.

Sia ex noie cuiusdā mu/
lieris est ap/
pellata· que apud anti/
quos imperiū orientis
tenuit. Hec in tercia or
bis parte disposita· ab
oriente ortu solis·a me
ridie·oceāo· ab occiduo
nostro mari finitur· a
septentrione meothide
lacu & tanai fluuio ter
minatur. Habet autem
prouincias multas et re
giones·quarū breuiter nomina et situs expediam·sūpto initio
a paradiso Paradisus est locus in orientis partibus constitu/
tus·cuius vocabulum ex greco in latinum vertitur ortus. Porro
hebraice eden dicitur·quod in nostra lingua delicie interpretat·
quod verumq; iunctum facit ortum deliciarum·est enim omni
genere ligni & pomiferarum arborum consitus habens· etiam
lignum vite. Non ibi frigus· non estus· sed perpetua aeris tem/
peries·e cuius medio fons prorumpens·totum nemus irrigat· di
uiditurq; in quatuor nascentia flumina. Cuius loci post pecca/
tum hominis aditus interclusus est. Septus est eni vndiq; rom
phea flammea·id est muro igneo accinctus· ita ut eius cū caelo
pene iungatur incendium. Cherubin quoq; id est angelorum
presidium arcendis spiritibus malis super romphee flagrantia
ordinatum est·ut homines flamme·angelos vero malos angeli
boni submoueāt·ne cui carni vel spiritui transgressionis aditus
paradisi pateat. India vocata ab indo flumine· quo ex parte
occidentali clauditur. Haec a meridiano mari porrecta vsq; ad
ortum solis·& a septentrione vsq; ad montem caucasum perue/
nit·habens gentes multas & oppida· insulam quoq; taprobane
gemmis & elephantibus refertam. Crisam & argiram auro ar/
gentoq; fecundas·vtilem quoq; arboribus folis nunqm caren
tibus. Habet & flumina gangen & nidan & idaspen illustran/
tes in dos. Terra indie fauonio spiritu saluberrima. In anno bis

Fig. 8.1. *Mappaemundi* from *Etymologia* of Saint Isidore of Seville (Augsburg, 1472). This image from an incunabular edition of Isidore's seventh-century text constitutes the first printed European map. It figures the *orbis terrarum* as a tripartite disk surrounded by water. Courtesy of the Prints and Photographs Division, Library of Congress.

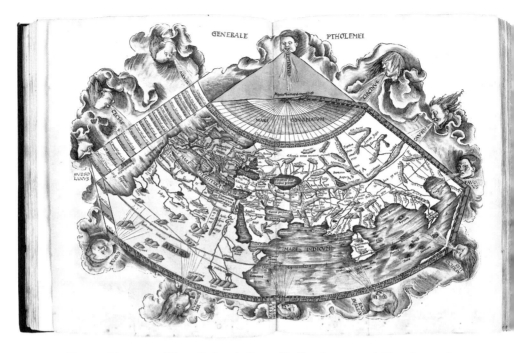

Fig. 8.2. *Mappaemundi* from Ptolemy's *Geographia* (Strasbourg, 1513). Coordinates of latitude and longitude frame the image of the known world. Courtesy of the Albert and Shirley Small Special Collections Library, University of Virginia Library.

It extends into that vast part of the spherical Earth that is not represented here, but whose existence is presupposed by the geometry of the grid.

With this new cartography, it has been argued, geometric space—abstract and homogeneous—came to be deployed for the first time in Western culture.[5] The consequences of this development were felt by Europeans and non-Europeans alike, especially as the universalist claims of the new, abstract spatiality empowered modern, Western European culture at the expense of premodern others. The cartographic rationalization of space, writes historian of cartography David Woodward, allowed for the idea of a world "over which systematic dominance was possible, and provided a powerful framework for political expansion and control."[6] That framework, Walter Mignolo has added, combined the appearance of ideological transparency with an unacknowledged political function. The gridded spaces of Renaissance maps established themselves, among Europeans of course, as the only true and accurate way of representing territory, thereby stripping Amer-

indian territorial imaginations of their authority to do likewise, and contributing powerfully to the deterritorialization of Amerindians.[7] A modernity at once scientific and imperialistic thus finds one of its origins in the twin phenomena of Renaissance cartography and the European invention of America.

This chapter responds to these and other similar accounts of the cartographic revolution and the history of Western spatiality by examining anew this transformation in European mapmaking, specifically as it intersects with the beginnings of European colonialism in the extra-European world. It argues that the order of abstraction ushered in by Renaissance humanism—however central it may have become for a modernity that can be said, in many ways, to begin in the fifteenth and sixteenth centuries—has relatively little to do with the spatial imagination of the earliest European colonial powers. Like the owl of Minerva, the abstractions of geometry fly, if not at dusk, then certainly at high noon, only after the Spaniards have established themselves in the West Indies and the Portuguese in the East. Their early efforts at discovering, conquering, and mapping a world beyond the Pillars of Hercules are informed by a very different spatial imagination. Here, I turn to some of the documents from the Spanish experience during this earlier colonial period, roughly 1492–1580, in order to outline the nature of this spatial imagination, and to specify how it supported a culture of expansion.

Emergent Space and Dominant Space

We are wrong to hastily assimilate Spanish cartography and its imperialistic commitments to the history of cartography and spatiality outlined above. Certainly, Iberia spearheaded certain developments in the European cartographic revolution, and pursued cartographic projects on a scale unimagined in the rest of Europe. As Portugal and Castile first expanded into the East and West Indies, they transformed late medieval maritime charts into precursors of the modern map, complete with scales of latitude and longitude. Their governments founded institutions that supervised this transformation, developing the most accurate and detailed maps of the world available to Europe during the first half of the sixteenth century. These developments reached their apogee in the reign of Philip II (1556–1598), a king passionately interested in geography and cartography as instruments of government. The old institution governing maritime cartography, Seville's

House of Trade, acquired new institutional cousins charged with geographical mapping in both Spain and America. A survey of the Iberian Peninsula was carried out, producing the most accurate atlas of Spain to date. Questionnaires were distributed to local governing officials in both Spain and the Indies, in an attempt to assemble geographical information of all kinds, as well as the data necessary to construct an accurate scale map of the Crown's possessions. An academy was founded in Madrid, meant to marshal the best of Iberia's technical expertise for the service of the Crown. Truly, this was an empire that, like the one in Jorge Luis Borges's parable "Del rigor en la ciencia," understood the cartographic rationalization of space to be a crucial component of the exercise of power.

But does this record of aggressive cartographic enterprise allow us to conclude that Spain must have fully participated in the cultural transformation described earlier? I argue that it does not. Despite the fervent efforts of the Spanish Hapsburgs to map their domains, it would be hasty to conclude that the cartographic revolution took root in Hispanic culture in such a way as to support the broad transformation of its "spatiality" in the manner described earlier. Some anecdotal evidence leads us to question the extent to which that transformation extended beyond the world of the technical practitioners at Philip's disposal. First, exceedingly few Spanish maps from this period seem to have made it into print. The reasons for this are unclear, but its consequences are easy to imagine. Maps must have continued to be relatively rare artifacts, found primarily in certain social and institutional circles—among navigators, for example—where their use was indispensable.[8] Without affordable, readily available printed maps to support the development of cartographic literacy, it is hard to imagine how a revolution in spatiality based on scientific mapping could be generalized. Second, whatever maps were produced in Spain did not keep apace with some of the most important cartographic innovations of the time. For example, cosmographers at Seville's Casa de la Contratación in charge of supervising maritime and overseas cartography were slow to adopt the crucial projection developed by Gerhard Mercator in the Protestant north. Finally, as Agustín Hernando points out, map production in Spain seems to have suffered a quantitative decline over the course of the seventeenth century. By century's end, Spanish intellectuals lamented that maps produced abroad were superior to Spanish maps in every way.[9] The geographer Sebastián Fernández de Medrano refers to geography as a science belonging not to Span-

iards, but to foreigners. "Tanto los Príncipes, como sus subditos, politicos, y militares," he writes, "estàn siempre sobre las Cartas" (Princes, just like their subjects, counselors, and military officers are always poring over their charts), by contrast with their counterparts in Spain, who rarely used maps. His book, he explains, is meant to advance the sort of cartographic literacy typical of these countries, but so lacking in his own.[10] Philip II seems to have planted seeds that did not take root, or that withered shortly after flowering.

The philological evidence tells a more striking tale about the extent of the spatial revolution in early modern Spain. It has been argued that the various Latin derivatives of the Latin *spatium* enter into general circulation only in the sixteenth and seventeenth centuries, and that this linguistic change is a measure of the increasing importance of abstract space in European culture.[11] In Spanish, the eighteenth-century *Diccionario de Autoridades* registers an entry for *espacio* that supports this contention. It defines *espacio* primarily as an abstract expanse, a definition consistent with the sort of space that structures the gridded maps of the Renaissance. That definition, moreover, specifically attaches the general notion of *espacio* to the two-dimensional space of modern cartography: "ESPACIO. f. m. Capacidad, anchura, longitúd ò latitúd de terréno, lugar, sitio, ù campo. Es tomado del Latino *Spatium*, que significa esto mismo" (ESPACIO . . . Capacity, breadth, longitude or latitude of a terrain, a place, or a field. It is taken from the Latin *spatium*, which signifies the same).[12] When we search for the word in sixteenth- and seventeenth-century Spanish texts, we find that *espacio* is used in this sense precisely where we would expect to find it, in the work of technically minded professionals actively involved in either theoretical or applied cosmography. For example, when such writers define such words as *zone* or *climate*, we find *espacio* used to refer to a two-dimensional expanse:

> Es de notar que las seys lineas o siete espacios, que imaginamos en esta quarta habitable, no son iguales en Latitud, ni en Longitud unos con otros. . . . Y contrariamente en la Region donde en mucho spacio de tierra se variare o hubiera poca diferencia en el tiempo, alii un clima comprehendera mayor spacio de tierra . . . (It should be noted that the six lines or seven spaces that we imagine in this habitable quarter are not equal either in latitude or in longitude with each other. . . . And, on the contrary, in a region where, in a large space of land one finds little difference or variation in the weather, there a climate would constitute a larger space of earth).[13]

Ansi que se define el Clima ser un espacio de la Tierra, puesto entre dos Paralelos. (And so a climate can be defined as a space of earth, placed between two parallels.)[14]

Estas Zonas por la misma orden que dividen y ciñen el cielo, dividen y ciñen tambien la tierra en otras cinco partes correspondentes derechamente a cada una de las divisiones que las dichas Zonas, o Parallelos estan situados en el cielo, asi como una figura que en si es grande, toda ella se representa en muy mas pequeño cerco de un espejo . . . desta manera e la tierra (muy mas pequeña que el cielo) se representan otros tantos espacios . . . (These zones, just as they divide and embrace the heavens, so too they divide and embrace the land in another five parts . . . in this way on the earth [many times smaller than the heavens] another set of spaces are represented).[15]

Clima es lo mismo que plaga, o region, y este es un espacio de tierra, la qual se incluye entre dos paralelos . . . (Climate is the same as sheet, or region, and this is space of land that is included between two parallels).[16]

Zona es todo el espacio que se comprehende entre dos paralelos, y de estas se haze mencion de solas cinco, que son las siguientes . . . (A zone is the whole space comprehended between two parallels, and of these only five are mentioned, and they are the following).[17]

Sixteenth- and seventeenth-century texts written by Spaniards who were not "cosmographers" of any kind, however, almost never exhibit this usage of the word *espacio*. Even in highly literate forms of early modern Spanish, *espacio* was much more likely to be used, as it had been for many years, to refer to time rather than space, in a manner similar to the modern *despacio*. The examples of this temporal definition in early modern Spanish usage are legion. It constitutes, for example, the most common sense of the word in Fernando de Rojas's classic, *La Celestina* (1499–1502):

¡Qué spacio lleva la barbuda; menos sosiego trayán sus pies a la venida! (What a long *space* [time, delay] the old bearded woman takes!)[18]
Da, señor, alivio al coraçón, que en poco spacio de tiempo no cabe gran bienaventurança. (Give, sir, relief to your heart for in so short a space of time such great good fortune does not fit.)[19]
O spacioso relox, aún te vea yo arder en bivo huego de amor. (O *spacious* [slowly moving] clock, how I would like to see you burn in the living fire of love.)[20]

A century later, Sebastián de Covarrubias's *Tesoro de la lengua castellana o española* (1611) registers only a vague spatial definition for *espacio*, one that simply reduces it to a synonym of *place*, and then quickly moves on to the temporal definition of the word: "ESPACIO. Del nombre latino SPATIUM, *capedo, intervallum*; vale lugar. Mucho espacio, poco espacio. 2. Tambien simplifica el intervalo de tiempo, y decimos por *espacio* de tiempo de tantas horas, etc." (ESPACIO. From the Latin word SPATIUM, *capedo, intervallum*; meaning place. Much space, little space. 2. It also signifies the interval of time, and so we say a "space" of time of so many hours, etc.)[21] Even later, the *Diccionario de Autoridades* continues to recognize this temporal usage. It cites St. Teresa of Avila's *Vida* (1565): "Bien la puede representar delante de su imaginación, y estarla mirando algún *espácio*" (One can very well represent it before one's imagination, and remain gazing upon it some *space*), as well as Juan de Mariana's *Historia de España* (1616): "Una sequedad de la tierra y del aire, que continuó por *espácio* de veinte y seis años" (A drought of land and air, which lasted for a *space* of twenty-six years [emphasis added]). We could also mention an example from Pedro Calderón's *El gran teatro del mundo* (ca. 1634), which is fascinating in the way it clings to the temporal definition of the word even as the speaker invokes an optical regime that should, it seems, involve the emergent usage of the term:

> Viendo estoy mis imperios dilatados
> mi majestad, mi gloria, mi grandeza,
> en cuya variada naturaleza
> perfeccionó de espacio sus cuidados.
> (I look upon my extended empires
> my majesty, my glory, my grandeur
> in whose variety nature
> *spaciously* [slowly] perfected its cares.)[22]

When *espacio* was used to refer to space, it most commonly clung to the one-dimensional, linear quality suggested by its temporal usage. This is true even in cosmographical texts. For Gerónimo de Girava, a Spanish resident of Milan and author of various, mostly derivative works on cosmography, *espacio* is more often synonymous with *distance* rather than *area*. He explains, for example, how the ancients traveled the distance between two places of known latitude and longitude and then "medieron el espacio de la Tierra que habian andado" (They measured the space of Earth that they had tra-

versed).[23] In literary texts as well, it is the one-dimensional, linear usage that appears rather than the two-dimensional, planar sense. The usage in the second passage from *La Celestina* cited above, "poco spacio de tiempo," treats a temporal extension as if it were a space in which things do or do not fit. Later, in the same text, we read: "No aprenden los cursos naturales a rodearse sin orden, que a todos es un ygual curso, a todos un mesmo espacio para muerte y vida, un limitado término a los secretos movimientos del alto firmamento celestial, de los planetas y norte, de los crecimientos y mengua de la menstrua luna" (The natural courses [of the celestial bodies through the sky] do not learn to turn without order, for to all the same path is given, the same *space* for death and life [emphasis added], a term limited to the movements of the high celestial firmament, of the planets and the north star, of the waxing and waning of the menstrual moon).[24] Here, the space through which bodies celestial and terrestrial move is a course, a linear progress from birth to death.

Other texts allow us to multiply the pertinent examples. In Francisco López de Gómara's *Historia general de las Indias* (1552) we read: "Del río de Palmas al río Pánuco hay más de treinta leguas. Queda en este espacio Almería" (From the Palmas River to the Panuco River there are more than thirty leagues. In this space lies Almería).[25] In Juan de Escalante's *Itinerario de navegación* (1575); it is asked, "¿Porque en tan poco espacio de camino como es éste, he visto discordar a muchas personas . . . ?" (Why, in so little *space of travel* as this, have I seen so many people disagree? [emphasis added]).[26] In Part II of Alonso de Ercilla's *La Araucana* (1578), the two senses of *espacio* as "a length of time" and "a distance in space" are made to coincide in a fascinating rhetorical figure: "Vuelto a la historia, digo que marchaba nuestro ordenado campo de manera que gran espacio en breve, se alejaba del Talcaguano término y ribera" (Returning to our story, I say that our ordered ranks marched *a great space in a brief one*, away from the border constituted by the Talcaguano riverbank [emphasis added]).[27] In *Don Quixote* (1605), we read how one character rides to meet his companion: "Que unbuen espacio de allí le estaba aguardando" (Who was waiting for him a good space away).[28] Curiously, even the examples that *Autoridades* uses to support its spatial definition of *espacio* refer to this linear imagination, rather than to the planar one that it pretends to identify in them. The dictionary cites Fernando de Herrera's *Anotaciones* (1580): "Dividen los Pyrenéos à Francia de España, cortándola por *espació* de casi ochenta leguas, del mar Mediterraneo al Océano Gálico" (The Pyrenees divide France from Spain,

cutting it for a *space* of almost eighty leagues, from the Mediterranean Sea to the Gallic Ocean [emphasis added]). It also cites Pedro de Espinel's *Vida del escudero Marcos de Obregón* (1618): "El *espació* era poco, y en un instante corriendo nos pusimos en sus casas" (The *space* was small, and in an instant of running we fell upon their houses [emphasis added]).

To recapitulate, only a small minority of early modern Spaniards seem to have used *espacio* to refer to a planar extension. For most Spaniards of this period, *espacio* continued to refer primarily to time, and secondarily to one-dimensional space, that is, distance. This brief philological discussion thus supports the conclusion suggested by the anecdotal evidence. The early modern revolution in mapping and spatiality should be treated as an emergent trend located in a particular sector of the culture—a class of technical specialists—rather than as a widespread phenomenon involving the culture as a whole.[29] If linguistic usage is any indicator of the way space was conceptualized, it was more common in early modern Spain to imagine space in linear, unidimensional terms rather than bidimensional, planar terms.[30] But how does this unidimensional spatiality manifest itself? What kind of text can be said to imagine space as a line, rather than a plane? To answer this question, we must turn to a variety of texts, both discursive and cartographic, typical of this spatiality that the cartographic revolution eventually consigned to the margins of the imagination of the West.

Beyond the Grid: Unidimensional Maps

The book written by Marco Polo in collaboration with the romance writer Rustichello da Pisa is usually thought of as a travel narrative. In fact, *The Travels* is the title given to at least one of its various English translations. Its original title, however, suggests that the book is something else. *Divissament du monde* suggests a descriptive, geographic piece, rather than a travel narrative. Why this change in title and, presumably, in genre? His book does indeed engage in a great deal of description, particularly of the cities and provinces of Asia, but it links these descriptions together by making reference to the routes one would travel to get from one to the other. Thus we read, "After leaving the Province of which I have been speaking you come to a great Desert. In fact you ride for two days and a half continually down hill. On all this descent there is nothing worthy of mention except only there is a large place there where occasionally a great market is held. . . . After you have ridden those two days and a half down hill, you find yourself in a

province towards the south which is pretty near to India, and this province is called Amien."[31] In this, Polo's book resembles other texts that circulated in late medieval and early modern Spain. They include the *Itinerario* of Ludovico Varthema (1510), the *Itinerarium* of John Mandeville (1496), the *Andanças e viajes* of Pero Tafur (c. 1436–1439), and the anonymous *Libro del conoscimiento* (c. 1450). It also resembles geographical descriptions that appeared in a number of conquest chronicles, including the *Suma de geografía* of Fernández de Enciso (1519); the *Historia general y natural de las Indias*, Parts II and III, of Gonzalo Fernández de Oviedo (c. 1544); and the *Historia general de las Indias* of Francisco López de Gómara (1552).

Marco Polo's book has a cartographic analog in the itinerary map. Cartographic representation, obviously, involves a number of choices on the part of the mapmaker. He or she must decide which aspects of the territory to include, which to exclude, and how to handle the selected material. The maker of an itinerary map selects, from the many and varied aspects of the territory he or she wants to figure, privileged destinations and the routes that connect them as his or her chosen objects of representation. All other aspects of the territory—its general topography, predominant kinds of vegetation, its aridity or humidity—are excluded. In making a map like the Peutinger Tabula, the mapmaker then decides to treat the network of routes in a schematic fashion that facilitates its use, at the expense of sacrificing geographical realism. The result is something like a modern subway map, which suits perfectly the purpose of getting around on the subway, even though it does not accurately map the territory as a whole. The spatial relationships among locations on the map are true only insofar as they reproduce the sequence of those locations along a route of travel, not their relative locations on a plane. One cannot use the itinerary map to bushwack across the territory, only to move along its routes.

Thus, although the itinerary map figures routes of travel and possible destinations as a two-dimensional network spread out over a cartographic surface, its two-dimensionality does not mean the same thing as that of the gridded map. The blank spaces of the itinerary map are empty in a way that the blank spaces of the gridded map are not. As we saw earlier, the blank spaces of the gridded map may be bereft of geographical objects, but they nonetheless speak of the plenitude of Euclidean space. They do not represent the parts of the map's surface that are left over once the territory has been drawn, but the portions of the cartographic grid that have yet to be filled. The empty spaces of the itinerary map, by contrast, represent nothing

as substantial as this. Like the spaces that separate one letter from another or one word from another in writing, they are simply the portions of the space of representation that are not inscribed upon. They provide the "spacing effects" that are necessary for the inscription to be legible, but lacking any geometric basis, they do not provide a spatial framework into which one can plot new locations. Certainly, one can add a road to the itinerary map, thereby cutting through this space and connecting locations that were not previously attached. In doing so, however, one is merely writing over one of the leftover bits of the original blankness, not plotting locations into a coordinate grid.

Such maps abounded in the early modern period. Some of them served as raw material for the fabrication of gridded maps. These will not concern us here. Others, including several examples from the history of the Encounter, seem to have been meant to serve as final products. Barbara E. Mundy discusses a number of such maps, drawn by Spanish colonial officials in New Spain in response to the questionnaires about the natural and moral history of the Indies distributed by Juan López de Velasco. Mundy has no interest in deprecating these mapmakers, but she clearly understands the frustrations that their maps must have caused for the cosmographer who requested them. In her words, the colonists' maps "lacked the rational, repeatable principles that López de Velasco felt should underlie their—and all—maps."[32] Rather than draw maps according to geometric principles, the colonists drew itinerary maps.[33] Among these are the maps that accompanied the *Relación Geográfica* of Tecuicuilco (1580) and the *Relación Geográfica* of Altatlauca-Malinaltepec (1580). In each, a route through the territory provides the basic spatial structure of the map. Places appear as stopping places along this route, rather than as locations in a Euclidean plane.

The itinerary maps that Mundy cites are by no means isolated examples. She herself indicates that the colonists may have found the inspiration for their own itinerary maps in printed itinerary maps with which they may have been familiar.[34] The corpus of colonial Spanish cartography, furthermore, provides other examples of itinerary maps from both before and after the period covered by the particular *Relaciones geográficas* that she examines. A 1550 map of New Spain drawn by a Pedro Cortés figures the colony's most important centers of population between Mexico City and New Galicia as stopping places on a route of travel extending northwest-ward from the city. A 1610 map of Chile replaces the road with a powerfully linear, schematic depiction of the Andes Mountains that ties the theater of war, at the ex-

treme right of the image, to the colonial administrative center of Santiago, at its extreme left. Of course, not all colonial maps take the form of itinerary maps. Some, for example, are the products of engineers and cosmographers working in the field, so to speak, and demonstrate the technical sophistication that one would expect from such professionals. Itinerary maps nonetheless form part of the corpus, and tell us something about the spatial and cartographic imagination of the field agents that produced them.

One might protest that travel narratives, itinerary maps, and nautical charts represent maps of a particular class—so-called way-finding maps—that primarily serve the purpose of "getting there," rather than of conceptualizing space or figuring geographical knowledge. Such maps are very important to anthropologists, particularly those interested in the spatial imagination of non-Western cultures in which way-finding maps may be the only kind of map in circulation. In the history of Western cartography, way-finding maps, particularly nautical charts, constitute an important object of study in their own right. Rarely, however, do they impinge on histories of Western spatiality, where the more theoretical cartography of the learned is left to glitter all on its own. Mignolo, for example, sets aside way-finding maps in his discussion of early modern European spatiality. As he explains, "These maps," referring to the nautical charts of the Casa de la Contratación, "do not conceptualize the Indies so much as the coastlines hitherto unknown to western Europe."[35] It seems that one would never confuse practical maps like these—be they sixteenth-century nautical charts, contemporary maps of subway systems, or the sketch maps that our friends provide us so that we can get to their homes—with maps of a more scientific nature. The scale map and its spatiality serve as synecdoches for the cartography and the spatiality of the culture as a whole, while the way-finding map can be consigned to the category of second-order cartographic products, and therefore left abandoned by any further discussion of spatiality.[36]

This kind of approach imposes on the past the cartographic culture of the present, the very cartographic culture, in fact, that was coming into being during the early modern period. Medieval mapmaking was a thoroughly heterogeneous enterprise. Different communities made different kinds of maps for different circumstances. Although these various strands of mapmaking could intersect and even blend at times, one cannot point to a shared idiom that united these various types of mapmaking into a unified cartographic science.[37] The cartographic revolution changed this, not just because it introduced geometrically rationalized maps where before there

had been none, but because it established one type of map as the hegemonic kind. It introduced something that the Middle Ages lacked, a cartographic idiom consciously asserted as a flexible means of mapping the surface of the Earth at any scale, from the largest to the smallest. It was an idiom that had at its disposal crucial technologies of reproduction and dissemination that were not available before, as well as increasing institutional support from governments, universities, and the like. These factors combined to guarantee that the cartography of the learned could extend out from its original social location among Renaissance humanists into other sectors of the culture in a way that no individual type of medieval map could.[38] The resultant hegemony of the gridded map came to be reflected by linguistic usage. During the sixteenth century derivatives of the Latin word *mappa* began to circulate widely for the first time, and they came to be associated specifically with the geometrical techniques of Renaissance cartography. Just as it defined *espacio* primarily as the two-dimensional space of modern cartography, the *Diccionario de Autoridades* defines *mapa* in terms that clearly associate it with the geometry of the gridded map:

> MAPA. f. amb. La descripción geográphica de la tierra, que regularmente se hace en papél ò lienzo, en que se ponen los lugares, mares, rios, montañas, otras cosas notables, con las distancias proporcionadas, segun el pitipiè que se elige, señalando los grados de longitúd y latitúd que ocupa el Pais que se describe, para conocimiento del parage ò lugár que cada cosa destas ocupa en la tierra. (MAPA . . . The geographical description of the earth, usually done on paper or canvas, and upon which one puts the places, seas, rivers, mountains, other notable things, with proportionate distances, according to the scale one chooses, marking the degrees of latitude and longitude of the country one describes, so that the location or place of these things on the earth can be known.)[39]

One of the examples cited in support of this definition, taken from Christoval de Fonseca's *Vida de Christo* (1601), specifically mentions a cosmographer as the maker of a map: "Quando un Cosmógrapho saca un *mapa* general de España, ò de todo el mundo, pone allí las principales cosas del" (When a Cosmographer makes a general map of Spain, or of the whole world, he places in it all its principal things). Here, then, we see institutionalized an association of mapping with geometry and the correct portrayal of the surface of the Earth that would remain all but unchallenged until recent years. It is an association that leads English users to refer to their own

itinerary maps—the sort of thing one draws so that a friend can find one's house—as a "sketch-map," and Spanish speakers to use the term *croquis*. Both usages acknowledge the hegemony of a scientific cartography as a type of mapmaking that lays sole claim to the production of "real" maps.

Lately, J. Brian Harley has proposed a new definition: "Maps are graphic representations that facilitate a spatial understanding of things, concepts, conditions, processes, or events in the human world."[40] Two things have disappeared from this definition: (1) specific mention of the particular cartographic idiom that has dominated Western cartography since the rediscovery of Ptolemy's *Geography*; and (2) specific mention of the surface of the Earth as the referent of the map. The word *map* has thus been cut free from its association with a particular type of mapmaking that has been hegemonic in a particular culture at a particular time, and has been opened up to include "maps" of many different kinds, from many different places and times. The new definition acknowledges that cartographic idioms, both in their referents and in their figurative strategies, are culturally and historically contingent, and that they share only two characteristics, that of being "graphic" and that of being "spatial." These terms, furthermore, are left unspecified, allowing us to include graphic representation of different kinds that embody different forms of "spatiality."

This new openness in the definition of the map has been crucial for those historians interested in the spatial and territorial elements of the history of the Encounter. Older definitions of the map tended to recognize only Western, scientific maps as "true" representations of territory, and consigned alternative cartographies—specifically non-Western ones—to an exotic fringe. Mignolo, in his own attempts to free historical discourse from the hegemony of the gridded map, tries to undermine this bias by proposing that we speak, not of "maps," but of "territorial representations." Like Harley's definition, this category is open to different determinations of what constitutes a "territory" and how it can be rendered in graphic form. It is meant to be inclusive, and to place such artifacts as Mexican *pinturas* on a level playing field with European maps. In this way, the story of territorialization so central to the history of the 1492 Encounter comes to be understood as a confrontation between different, incommensurable territorial imaginations, each one expressed in its own graphic idiom, rather than as the substitution of primitive mapping with scientific cartography.[41] I believe that we should now refine this argument by replacing its binary opposition of Amerindian and European territorial imaginations with a tertiary one that recognizes

change and diversity in the European side of the equation. The Encounter does not stage a clash between an Amerindian, ethnic rationalization of space and a European, geometric rationalization, but between an Amerindian imagination (I will leave it to others, better prepared to do so than I, to question the validity of the singular here) and a European imagination caught in a process of transformation from one stage to another.

In order to flesh out this tertiary opposition, we need to flesh out how the linear, unidimensional spatiality of early modern espacio, of travel narrative, of itinerary maps, and of nautical charts constitutes a "spatiality" comparable to the planar espacio of the gridded map. Let us return for a moment to Marco Polo. John Larner points out that "anyone who approaches the work [the book of Marco Polo] looking for a tale of heroic exploration is going to be badly disappointed. Nothing is more striking here than Marco's silence about the difficulties and dangers he must have faced or about the character of the journeys he made."[42] Later, he argues that "These supposed itineraries, alas, are fantasies . . . this is clearly not the route of the Polos through Asia; it is an organizational device, the route along which Marco and Rustichello lead their readers from west to east and back from east to west, the route through the Book."[43] Finally, Larner asserts that the text is not really travel narrative at all, but "simply and essentially a work of geography."[44] I agree that the purpose of Polo's book is primarily geographical exposition—not travel narrative in our sense—but I do not think that this interpretation requires us to reduce Polo's use of the itinerary to the status of a mere "organizational device." That skeletal travel narrative, like any skeleton, may be bare bones, but it is not superficial. Consider the following example:

> Now, we will quit this country. I shall not, however, now go on to tell you about India; but when time and place shall suit we shall come round from the north and tell you about it. For the present, let us return by another road to the aforesaid city of Kerman, for we cannot get at those countries that I wish to tell you about except through that city. . . . On the road by which we return from Hormos to Kerman you meet with some very fine plains, and you also find many natural hot baths. . . . Now, then, I am going to tell you about the countries towards the north, of which you shall hear in regular order.[45]

Why should the narrator need to backtrack to a city previously described in order to push his description forward? Why not simply describe the next

place, whether it be to the north or the south? While Marco Polo's text may not tell of the hazards and impressions of the journey, it does not entirely forget the limitations of the flesh-and-blood traveler. The result is something richer than what Larner identifies. This is not just geography organized as a textual itinerary, but geography organized as a journey, as a linear movement through space organized as a route of travel, albeit a fictive one. By reminding us, at this point, that we need to backtrack to a particular node in a network if we wish to move in a certain direction, the discourse invites us to relate to the territory from a particular point of view. It interpellates the reader, not as an onlooker looking down on the territory from a height, as in a map, but as a traveler, moving through that territory, place by place, along routes.

The difference between this point of view and that of the Renaissance map could not be more dramatic. It has been said that the change wrought in European cartography by the Renaissance cartographic revolution is best understood, not as an extension of European horizons, but as an elevation of the point of view from which an implied, European observer views the world. The modern map does not just grid the world, it puts it on display for consumption by an onlooker who has been abstracted from the world he or she inhabits, who has been raised to a commanding height.[46] Hence the tendency of many Renaissance mappaemundi to frame the world with clouds, or heads representing the various winds. Such devices have the effect of opposing the *terraqueous* globe and the map reader as an object in space, and a privileged onlooker gazing at it from above. They give explicit iconographic form to the optical regime implicit in any gridded map. Polo's insistence on the "reality" of his route of travel, inscribed in this reminder of the limitations felt by bodies moving across space, brings the reader down to Earth. It reminds him that the text he is reading constitutes a tour through a territory, not a figure of it to be perceived from a Mennipean height.

We are mistaken, furthermore, if we consign this way of rationalizing space to the margins of the culture, and save the center for "real" maps, of whatever kind, that do not depend on travel for their organizational strategy. Polo and the other "travel" writers I mentioned, the authors of our colonial itinerary maps, may in fact be heirs to a spatial imagination long established in the culture of the Mediterranean, and recently rediscovered by the Italian classicist Pietro Janni. In *La mappa e il periplo*, Janni has thought to contradict the established wisdom about cartography in the

ancient Mediterranean world. Very few ancient maps have survived to our day, requiring us to infer what they must have been like from texts of other kinds, such as discursive geographies and historiography. Janni argues that the inferences made from these texts by his fellow classicists have been fundamentally misguided. That scholarship tends, for example, to infer that lengthy geographical descriptions, like those of Strabo or Pomponius Mela, would have come accompanied by maps, or at least that they demonstrate a certain amount of cartographic literacy in the culture that produced and consumed them. It also tends to translate words that refer to different kinds of geographical descriptions as *map* or *chart*, and thereby reach generous conclusions about map use in antiquity. Janni argues that these inferences ignore the many crucial stumbling blocks presented by geographical language itself, and thereby mistakenly project onto antiquity a sort of cartographic culture that it did not have. Strabo, for example, uses a language of movement and orientation in his descriptions that do not easily translate into cartographic form. Janni thus advocates a more conservative treatment of classical geographical discourse, one that leads to a very different assessment of "ancient cartography." Map use, he argues, was not widespread in antiquity, and neither was the tendency to imagine the world through the two-dimensional spatiality of the map. The predominant spatial imagination of the Greco-Roman world was actually quite different from that of the modern West, in that it tended to imagine the world through the unidimensional spatiality of the itinerary or *periplus*, rather than the two-dimensional one of the map. The ancients, in this sense, can be considered a precartographic, or noncartographic culture.[47]

Whether or not Janni is right about the ancients, the sort of spatiality he is describing is clearly in evidence in early modern Spain, and well into the sixteenth century. Consider the following passage from Fernando Colón's *Descripción y cosmografía de España* (1517):

Toledo es cibdad de 18000 vecinos esta en unas cabezas de cerros e valles e entre unas syerras en hondo e tiene buenas alcazares cerca el rio dicho taxo . . . Toledo e fasta burguillos ay legua e media de cerros e cuestas arriba e en saliendo pasamos a taxo por puente que corre a la mano derecha e fasta xofira ay tres leguas e van por burguillos e fasta mazarambron ay tres leguas de cerros grandes e cuestas e en saliendo pasamos el dicho rio que corre a la mano derecha.

(Toledo is a city of 18,000 heads of household it is at the top of some

mountains and valleys . . . and has very good fortresses near the said Tagus river . . . on the way to Burguillos there are a league and a half of mountains and rising slopes, and in coming out of these we pass the Tagus by a bridge that runs along the righthand side and on the way to Xofira there are three leagues and they pass through Burguillos and on the way to Mazambron there are three leagues of large mountains and hills and when we come out of them we pass the said river which runs along the right-hand side.)[48]

His text refers to the "tablas" (tables) of Spanish geography that he plans to make. Note that he does not say "mapas" (maps), despite the fact that this is clearly what he is referring to, when he promises that this "tablas" will come complete with graduation "por grados de longitud y latitud" (by degrees of longitude and latitude).[49] But although his text is supposed to provide the raw material for such maps, it is difficult to imagine how one could convert the information provided in this typical passage into cartographic form. Like the passages from Strabo that Janni discusses, this passage from Colón clings to a language of movement and orientation that cannot easily be rendered on a map. It locates Burguillos by tracing a route of travel from the nearby city of Toledo. Although it provides the length of that route, it specifies its direction, not in the abstract, universal idiom of cardinal directions, but in the local, embodied idiom of physical orientation. The reader, interpellated as a fellow traveler, is told where the landmarks lie, either on his right or his left. While this information might be perfectly serviceable to the traveler, who could simply look for the mountains and head in their direction, it is not entirely useful to the mapmaker. In what direction do these mountains and this bridge lie? How can one translate this sort of local knowledge into the universal knowledge of a map? Territory here is conceptualized in and through travel, in ways that resist their representation in the new cartographic language of the gridded map. We can assume that Colón does this—and perhaps that the colonial mapmakers cited above do the same—not because their perception of territory is structured by travel as an individual experience, but because it is structured by travel as a universal idiom. This is the idiom that serves to figure territory *in the absence of a fully deployed cartographic and spatial alternative.*

That alternative, however, was in the making. Janni, like other historians, identifies the early modern period as a crucial nexus in the history of space in the West, but since his interpretation of what came before this period is

more radical than that of others, his brief mention of early modern mapping has deeper implications. For Janni, the early modern cartographic revolution does not just bring important changes in the way maps were made: it accomplishes a deeper transformation of the culture from a premodern, precartographic stage to a modern, cartographic one. With the map comes space itself. And, for him, the map in question is not primarily the gridded map, but another way-finding map, the nautical chart, especially as it was adapted to suit the needs of astronomical navigation.[50] This adaptation was originally the work of Portuguese mapmakers, but they were soon followed by their Spanish counterparts. The story of the nautical chart thus leads inevitably to Iberia, and, as we shall see, it complicates the simple opposition of linear versus planar, premodern versus modern that has governed the discussion so far.

The European nautical chart has its roots in the late medieval "portolan chart," a cartographic technology that came into use in the Mediterranean world along with the compass. The portolan chart, in turn, may have been a successor to an earlier, purely discursive rather than iconographic form, the *portolano*.[51] Portolanos are verbal descriptions of the prominent features of a coastline, meant to facilitate navigation that tended to move from one point to another generally without losing sight of the coast. The introduction of the compass led to the transformation of these portolanos into charts. The linear succession of toponymy in the portolanos seems to have left its mark on the portolan chart, which typically featured a closely packed series of place-names along the coastline, set at right angles to the outline of the coast itself. It also featured a web of "rhumb lines" that emanated out of compass roses. These devices were used in conjunction with the compass to set a course across open water. The portolan chart thus represents a significant moment in the development of a bidimensional, cartographic imagination, out of a strictly unidimensional one. As Europeans began to venture beyond the Mediterranean world, into the open ocean or along unfamiliar coastlines, they gradually abandoned the sort of sailing that these charts supported, based on compass bearings and dead reckoning, in favor of astronomical navigation. The charts then acquired scales of latitude, and eventually even full-blown grids.

For Janni, these technological changes required a cognitive leap on the part of the navigator that sealed the shift from a unidimensional to a two-dimensional spatiality that had begun with the portolan chart:

Navigazione d'altura significa un nuovo senso della bidimensionalità della superficie terrestre: essa sta alia carta come la navigazione costiera sta al periplo. Per navigare lungo costa bastava l'elenco dei porti, delle distanze, con qualche indicazione di direzione qua e là, come un di più; ora, por attraversare i mari e per arrivare non troppo lontano dal punto giusto, occorre una rotta, un azimuth, cose che si collocano non più lungo una *linea*, ma su una *superficie*.

(Navigation by the height of the pole star represents a new sense of the bidimensionality of the surface of the Earth; it is to the chart as coastal navigation is to the *periplus*. In order to navigate along the coast, one needs only a list of ports, with distances, and indications of the direction here and there, at the most; now, in order to traverse the sea and arrive not too far from the desired point, one needs a route, an *azimuth*, something that places one, not on a *line*, but on a *surface*.)[52]

Frank Lestringant concurs. He reminds us that the ocean is "an abstract place . . . without shape or points of reference."[53] More than any other part of the Earth's surface, it seems to resemble the trackless expanses of an empty cartographic grid, and thus lends itself well to geometric rationalization. There, in the ocean, "devoid of relief or definite colour and without any boundaries or routes . . . cosmographical theory and the concrete experience of the navigator coincided."[54] Lestringant cites Pedro de Medina, who wrote of the sea in precisely these terms. He calls it "una cosa tan larga y espaciosa como es la mar donde ni hay camino ni señal de él" (a thing so vague and spacious as the sea, where one leaves neither path nor trace).[55] In Medina's *espacioso*, Euclidean geometry comes down to Earth, so to speak, to coincide with its material cousin, the ocean. There, on a surface at once Euclidean and physical, the navigator could effect the leap from a unidimensional conceptualization of space to a two-dimensional one that was much more difficult for his landlubber counterparts.

Sadly, however, this happy tale of reconciliation between the abstract and the concrete on the high seas runs into the shoals of various historical particularities. Although Medina may wonder at the spaciousness of the sea, he does so only to praise the art of navigation, which makes it possible to domesticate this spaciousness, to find routes where there are apparently none. Here is his remark again, placed back into its context:

Quién basta a decir una sutileza tan grande que un hombre con un compás y unas rayas señaladas en una carta sepa rodear el Mundo, y sepa de

día y de noche a dónde se ha de allegar, y de dónde se ha de apartar y cuánto ha de andar a una parta o otra y que acierte a caminar por una cosa tan larga y espaciosa como es la mar, donde ni hay camino ni señal de él, por cierto cosa es muy sutil y dificultosa; y así considerada por Salomón, dice que una de las cosas más difíciles de hallar es el camino de la nave por la mar, porque ni sigue camino ni deja señal.

(Who is capable of putting words to so subtle a thing as the ability of a man with a compass and some lines marked on a chart to know how to round the World, and to know day and night where he is to head, and from where he is to depart, and how long he should travel from one place to another, and to know how to travel along a thing so vague and spacious as the sea, where there is neither path nor trace? Certainly this is a subtle and difficult thing, and it was so considered by Solomon, who said that one of the most difficult things to find is the way of a ship at sea, for it neither follows a marked track nor leaves a trace of its passing.)[56]

The reference to Solomon—the Book of Wisdom—leaves little doubt that the spaciousness and tracklessness of the sea is an object of dread. In the biblical text to which he alludes, the traceless passing of a ship at sea becomes a figure for the oblivion to which human vanity is destined.[57] Navigation, remarkably, conquers this powerful figure of oblivion by finding in it the routes that it does not seem to have. Those routes are in fact there, in the form of prevailing currents and winds that favor the passage of sailing vessels one way rather than another. It was Medina's job, as a cosmographer associated with the Casa de la Contratación, to maintain not only the *padron general*, but also *derroteros* of the maritime routes most important to Spanish commerce.[58] In short, it was his job to provide scientific and technical support to the massive task of taming the sea, of rendering it usable by finding routes through its spacious expanses. Medina's chart of the Atlantic world, included in his *Arte de navegar*, gives iconographic form to this task (figure 8.3). While its grid inscribes the spaciousness of the seas, the images of ships sailing the Atlantic along established routes of navigation mark its domestication. They mark a Hispanic *mare nostrum* by indicating how the seas have been converted into the sort of space (a repeatable route of travel) that one can use.[59]

The plane chart, like the navigation manuals that supported its use, also reveals this Janus-like attention to space as both plane and line. I will not deny that it, like its portolan predecessor, points in many ways toward

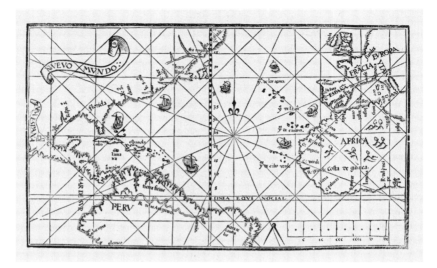

Fig. 8.3. The Indies, the North Atlantic, and Western Europe from Pedro de Medina's *Arte de navegar* (Seville, 1554). Images of sailing ships mark the commercial routes that tie the New World to Spain. Courtesy of the Rare Books Division, Library of Congress.

emerging developments, but I will also insist that, like any transitional product, it drags the past along with it as well. Specifically, it holds on to its roots in the unidimensional spatiality of the portolano. As we have seen, both portolan charts and plane charts were originally intended for navigation. But not only was their use intimately connected with finding one's way, so was their construction. In the absence of any method for measuring longitude at sea, newly discovered lands could only be plotted onto the chart by correlating their latitude with their distance and direction from a known location. Indeed, even the position of the ship itself, when a known coastline was not in sight, could only be determined using this method. The use of both portolan and plane charts was thus intimately connected with itineraries of travel, and depended on the skills of pilots with deep experience in the art of dead reckoning, the art of estimating speed and distance. This is the cartographic technology that voyages of exploration took with them, and that they used to chart the newly discovered coasts of the Indies.

Even those charts that were never destined to be taken aboard ships remain rooted in the space of the voyage. All of the extant planispheres believed to have been derived from the master map of the world maintained by the Casa de la Contratación, such as the 1529 chart of Diego Ribeiro

and the 1526 chart of Juan Vespucci, exhibit networks of rhumb lines and compass roses, as well as rows of coastal toponymy (figure 8.4). Whether or not they have their roots in the discursive portolanos of old, their dense rows of coastal toponymy invite the reader to trace itineraries across the surface of the chart. They thereby allow the spatiality of the voyage, as a unidimensional movement along a line of names, to subsist within the two-dimensional space encoded by the rhumb lines, or by the grid of the plane chart. The rhumb lines themselves, furthermore, extend a similar invitation. As a whole, they inscribe the two-dimensional space described above, but individually they invite the reader to relate to that space by tracing a voyage, real or imaginary, along one of the lines. The nautical chart, in both its late medieval and early modern forms, thus hangs suspended between the two spatial senses of espacio. Depending on the point of view taken by the chart's reader or user, the chart can be understood either as a graphic figure of an emergent sense of espacio as planar extension, or as a network of itineraries that reinforces the older, still dominant, sense of espacio as linear extension. At once, then, the chart figures the spaciousness of the sea as well as its reduction to a network of itineraries. Those itineraries, furthermore, invite the reader to activate their static arrangements of potential stopping places into narratives of travel.

————

With mention of these planispheres, we arrive at precisely those maps that Mignolo rejects in his analysis of the spatiality informing the European side of the Encounter. We arrive, in effect, at the prehistory of the geometric rationalization of space that was to be fully pursued, albeit unsuccessfully, by Philip II and others in the late sixteenth century and afterward. In that prehistory we find a spatial and cartographic hybrid, the nautical chart. In geographical mapping, the opposition between unidimensional and two-dimensional space is a matter of the relationship between two different cartographic forms—professional gridded maps and amateur itineraries—that can be located, more or less, in different social spaces. Its history suggests that, despite the continued presence of the itinerary on the cultural stage, the map must eventually triumph over it, consigning it to the diminished status of derivative, secondary, "merely" way-finding cartographic products. The maritime chart, by contrast, suggests a different approach. As a highly rationalized cartographic product that retains its connection with way-finding, as a map that figures space in and through the itineraries that serve to experi-

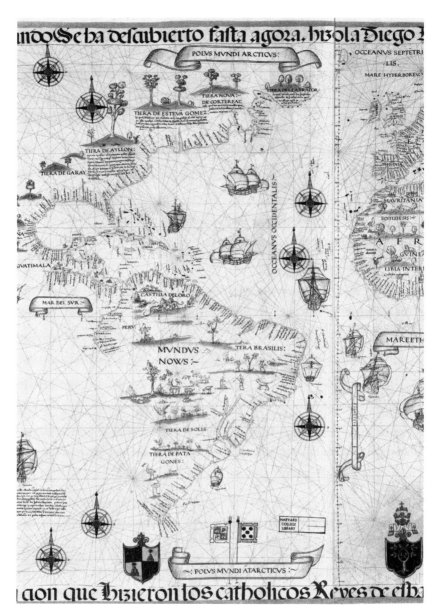

Fig. 8.4. Detail from planisphere, Diego Ribeiro (Seville, 1529). From a facsimile by W. Griggs, 1886. Original in the Museum of the "Propaganda" in Rome. A dotted line bisecting the image vertically provides the chart with its scale of latitude. Faint grid lines are also visible. Courtesy of the Geography and Map Division, Library of Congress.

ence and construct it, the chart seems to internalize that opposition between plane and line, and to place the two into a creative tension. In it, our two senses of space coexist on a single cartographic surface, a single chart, that comes to be produced and used by both highly literate mapmakers and the most illiterate mariners. As the hybrid product of a transitional historical moment, the nautical chart reminds us that the social groups and spatialities that we have traced so far were not always so neatly compartmentalized. It also suggests that the history of spatiality in this period must be understood in terms of the give-and-take between two tendencies, a give-and-take that can manifest itself even within the confines of a single text. The history of spatiality, and of its contributions to the origins of those empires that would only later be rationalized on the surfaces of gridded maps, is a story that has yet to be told.

That spatiality, it should be stressed, was not unique to Spanish culture. Most of the crucial cartographic innovations I have mentioned—the use of a scale of latitude on a maritime chart, for example—were borrowed from the Portuguese. These innovations were also adopted by other burgeoning maritime powers eager to rival the early achievements of the Iberians. Charts with rhumb lines, for example, were used in France, in England, and elsewhere throughout the sixteenth century. A quick glance at the *Oxford English Dictionary*, furthermore, suggests that the use of these charts may have been accompanied by an understanding of space similar to the one I have outlined: *space* in early modern English mirrors the meanings of *espacio* in the Spanish of the time. The Hispanic context, however, offers unique opportunities for studying alternative cartographic and spatial imaginations in the relatively large body of maps made by cartographic "amateurs," so to speak, drawn in response to the demands of imperial governance and preserved today in archives in Europe and the Americas. We have seen a few of these maps earlier. That context, moreover, becomes increasingly distinct from the rest of Europe as the sixteenth century yields to the seventeenth. As we have seen, Spanish cartography seems to have been left behind by the history of the map in northern Europe, where maps were more likely to reach print, and to be built on the latest cartographic projections. In this way, a spatiality that was once common to all of Western Europe gradually becomes uniquely Spanish, or uniquely Iberian or Mediterranean, as the map, abstract space, and modernity itself take root in northern Europe, leaving the south behind. It would not be until the eighteenth century, when a fully modern spatiality held sway in the north, and a French dynasty had come to

power in Madrid, that Spain would make a concerted effort to modernize its maps and its cartographic institutions.

The story of this spatiality may have few consequences for our understanding of the ways that non-Europeans suffered through the expansion of the West into the non-West. Colonization, deterritorialization, destructuration, transculturation—all of these things probably look the same to the colonized other, regardless of whether or not the colonizer has learned to think about space in terms of abstract spaces rather than linear distances. That is, of course, unless the order of abstraction empowers the colonizer in ways that enhance the effectiveness of colonial rule. The history of the map in the centuries following 1580 certainly suggests that it does. Those centuries witnessed the continued refinement of European mapping techniques and the ongoing development of state-sponsored cartographic institutions along with the growth of both the nation-state and the transnational empire. They also witnessed the ever-increasing dissemination of printed, scale maps throughout the world of the European powers. With the increasing availability and authority of the map, as we have come to know it, the territorial imaginations of colonial others increasingly began to experience the ideological colonization of the order of abstraction, and eventually fell out of public discourse almost entirely.

But this very hegemony of the map in our own times—its inextricable association with a highly naturalized notion of "space" as isotropic extension and its equally close affiliation with the spaces of the nation and the empire—makes it all the more urgent to rediscover the spatialities of the past. If nothing else, we find that the modernity from which we are just emerging, or at least one aspect of that modernity, was not produced by the abstract imagination of the mapmaker, the surveyor, the planner, the architect, and the like. Their representations of space, at their origins, begin to look like urgent attempts to apprehend and manage a wide world that had been brought into being by a very different culture of time and space. In so many ways the early maritime empires of Spain and Portugal were products of their medieval past. The rhetoric of crusading Reconquest, of chivalry, of universal Christian empire—all medieval inheritances—informed many of the ways Iberians imagined those empires. So, too, did a spatial imagination that clung to the itineraries of late medieval travel, turning to geometry as a way of compensating for the shortcomings of using an itinerant spatiality to apprehend unprecedented distances, unaware that the abstractions it thus invoked were the harbingers of the new.

Ricardo Padrón, "Mapping Plus Ultra: Cartography, Space, and Hispanic Modernity," in *Representations* 79(1) (2002): 28–60. © 2002 by the Regents of the University of California. Reprinted with permission of the publisher.

This chapter was written under the auspices of a Library of Congress Fellowship in International Studies sponsored by the American Council of Learned Societies. My thanks to both institutions for their support of my work. Thanks especially to John Hebert, director of the Geography and Map Division of the Library of Congress. While on the fellowship, I had the opportunity to present this project at the 2002 meeting of the Latin American Studies Association. My thanks, too, to all those who participated in the panel "Agonies of Historicity," especially my colleague, Ruth Hill.

1 Henri Lefebvre himself privileges the perspectival space of Renaissance painting and urban design. He dwells on cartography only long enough to consign it to the category of those representations of space that are to be held suspect for their complicity in abstraction; see Lefebvre, *The Production of Space*, trans. Donald Nicholson-Smith (Cambridge: Blackwell, 1991), 229–91. For an argument that builds on Lefebvre's work, but puts the story of Renaissance cartography front and center, see David Harvey, *The Condition of Postmodernity: An Enquiry into the Origins of Cultural Change* (Cambridge: Blackwell, 1990), 240–59. For the cartography of the Age of Exploration as a hinge between medieval speculations about space and the decisive triumph of space over place in seventeenth-century philosophy, see Edward S. Casey, *The Fate of Place: A Philosophical History* (Berkeley: University of California Press, 1997), 115.

2 This brief discussion of the cartographic revolution inevitably oversimplifies any number of matters. For a classic, and still very useful, introduction to the history of cartography, see Leo Bagrow, *History of Cartography*, 2nd ed., rev. and enl. R. A. Skelton (Chicago: Precedent Publications, 1985). For a highly readable, single-volume introduction to the history of cartography, see Lloyd A. Brown, *The Story of Maps* (New York: Dover, 1977). For an introductory text that associates changes in mapmaking with broader cultural transformations, see Norman J. W. Thrower, *Maps and Civilization: Cartography in Culture and Society*, revised edition of *Maps and Man* (1972; Chicago, 1996). The more recent, multivolume *History of Cartography*, from the History of Cartography Project at the University of Wisconsin, Madison, naturally provides a more up-to-date and extensive introduction to the subject than do any of these single-volume works; see J. Brian Harley and David Woodward, eds., *Cartography in Prehistoric, Ancient, and Medieval Europe and the Mediterranean*, vol. 1 of *The History of Cartography* (Chicago: University of Chicago Press, 1987). Although the first volume of this set bears on what follows here, the third volume, dedicated to Renaissance Europe, does not, since it had not yet appeared at the time of the writing.

3 There are important limitations to this assertion that I will not go into here. For further discussion, and for a lengthy bibliography see David Woodward, "Medieval *Mappaemundi*," in *The History of Cartography*, ed. Harley and Woodward, 1:286–370. See also Evelyn Edson, *Mapping Time and Space: How Medieval Mapmakers Viewed Their World*, vol. 1 of *The British Library Studies in Map History* (London: British Library, 1997).

4 The language is borrowed from Walter Mignolo, who writes of the "ethnic rationalization of space" on medieval *mappaemundi*. He compares this with the "geometric rationalization of space" on Renaissance maps; see Walter Mignolo, *The Darker Side of the Renaissance: Literacy, Territoriality, and Colonization* (Ann Arbor: University of Michigan Press, 1995), 219–58.

5 David Woodward, "Maps and the Rationalization of Geographic Space," in *Circa 1492: Art in the Age of Exploration*, ed. Jay A. Levenson (New Haven, CT: Yale University Press, 1991), 84–87. Woodward and the late Harley have been credited with championing a revolution in the study of the history of cartography. Together, their work has served to redefine what historians of cartography mean by a "map," to introduce the field to the interpretive possibilities offered by Marxist and poststructuralist literary and critical theory, and to insist on an understanding of the map as a "value-laden image" (J. Brian Harley, *The New Nature of Maps: Essays in the History of Cartography*, ed. Paul Laxton [Baltimore, MD: Johns Hopkins University Press, 2001], 53). Harley's most influential essays have been published in the posthumous collection *The New Nature of Maps*. See also Harley's introduction to *The History of Cartography*, "The Map and the Development of the History of Cartography" 1:1–6.

6 Woodward, "Maps and the Rationalization of Geographic Space," 87.

7 Mignolo, *Darker Side of the Renaissance*, 219–58.

8 Surprisingly, these circles do not seem to have included the Spanish military. In 1642, when the Crown had to defend Catalonia from an invasion by the French, its armies had only an outdated edition of a general atlas with which to organize its campaign, since nothing more current was available; see Geoffrey Parker, "Maps and Ministers: the Spanish Hapsburgs," in *Monarchs, Ministers, and Maps*, ed. David Buisseret (Chicago: University of Chicago Press, 1992), 145–46. The atlas of Spain that came out of Philip II's survey of the peninsula had never been printed, and lay unused and even unknown in the library at the Escorial.

9 Agustín Hernando, "The Spanish Contribution to the History of Cartography," *Cartographic Journal* 36(2) (1999): 113.

10 Sebastian Fernández de Medrano, *Breve descripción del mundo y sus partes ó guia geographica y hidrographica: dividida en tres libros* (Brussels, 1686), 4–5.

11 Paul Zumthor, *La mesure du monde: Représentation de l'espace au moyen âge* (Paris: Seuil, 1993), 51.

12 All references to the *Diccionario de Autoridades* are drawn from the original print edition, as it appears online in the *Nuevo tesoro lexicográfico de la lengua española*, Real Academia Española, April 26, 2002, http://www.rae.es.

13 Jerónimo de Chaves, *Tractado de la sphera que compuso el Doctor Ioannes de Sacro-busto con muchas additioes. Agora nuevamente traduzido de Latin en lengua Caste-llana por el Bachiller Hieronymo de Chaves: el qual añidio muchas figuras tablas, y claras demonstrationes: junctamente con unos breves Scholios, necessarios a mayor illu-cidation, ornato y perfection del dicho tractado* (Seville, 1545), 81v.

14 Gerónimo Girava, *Dos libros de cosmographia, compuestos nuevamente por Hiero-nymo Girava tarragones* (Milan, 1556), 35.

15 Juan Pérez de Moya, *Tratado de cosas de Astronomía y Cosmographia y Philosophia Natural ordenado por Iuan Perez de Moya* (Alcalá de Henares, 1573), 145.

16 Lorenzo Ferrer Maldonado, *Imagen del mundo sobre la esfera, cosmografía, y geo-grafía, teórica de planetas, y arte de navegar* (Alcalá de Henares, 1626), 198.

17 Fernández de Medrano, *Breve descripción del mundo*, 23.

18 Fernando de Rojas, *La Celestina*, ed. Dorothy Severin (Madrid: Cátedra, 1989), 292.

19 De Rojas, *La Celestina*, 292.

20 De Rojas, *La Celestina*, 292.

21 Sebastián de Covarrubias Horozco, *Tesoro de la lengua castellana o española*, ed. Felipe C. R. Maldonado (Madrid: Castalia, 1994), 503.

22 Pedro Calderón de la Barca, *El gran teatro del mundo*, ed. Eugenio Frutos Cortés (Madrid: Cátedra, 1987), lines 961–64.

23 Girava, *Dos libros de cosmographia*, 258.

24 Rojas, *La Celestina*, 138.

25 Francisco López de Gómara, *Historia general de las Indias y vida de Hernán Cor-tés*, ed. Jorge Gurria Lacroix (Caracas: Ayacucho, 1979), 23.

26 Juan de Escalante de Mendoza, *Itinerario de navegación de los mares y tierras occi-dentales 1575* (Madrid: Museo Naval, 1985), 26.

27 Alonso de Ercilla, *La Araucana*, ed. Isaías Lerner (Madrid: Cátedra, 1993), canto 22.6.

28 Miguel de Cervantes Saavedra, *El ingenioso hidalgo Don Quijote de la Mancha*, ed. Luis Andrés Murillo, 5th ed., 2 vols. (Madrid: Castalia, 1978), 1:135.

29 Richard Kagan has recently made a similar point in *Urban Images of the Hispanic World, 1493–1793* (New Haven, CT: Yale University Press, 2000), 55–62.

30 The philological evidence leads us in one direction, but it is not one that ex-hausts the alternatives to the grid that were available to early modern Euro-peans. For example, John Gillies writes of a "poetic geography" that subsists on the surface of Renaissance maps; see *Shakespeare and the Geography of Difference* (New York: Cambridge University Press, 1994), 4–12, while Kagan explores a "symbolic cartography" in urban images that we might not readily identify as "cartographic" in *Urban Images of the Hispanic World*, 59–62. Both alternatives fall outside of the opposition between line and plane that I examine here.

31 Marco Polo, *The Travels of Marco Polo: The Complete Yule-Cordier Edition*, 2 vols. (New York: Dover, 1993), 2:106–7.

32 Barbara E. Mundy, *The Mapping of New Spain: Indigenous Cartography and the Maps of the Relaciones Geográficas* (Chicago: University of Chicago, 1996), 34.

33 Mundy, *Mapping of New Spain*, 35.

34 Mundy, *Mapping of New Spain*, 36.

35 Mignolo, *Darker Side of the Renaissance*, 286. Later, in reference to the nautical charts of Alonso de Santa Cruz in particular, Mignolo argues, "The maps attached to his *Islario general*, together with the written discourse . . . focus on the coastline and wind directions rather than on the possessions of the Spanish empire, as is the case of . . . López de Velasco" (287).

36 Not everyone sets aside way-finding maps the way Mignolo does. Michel de Certeau provides a telling contrast, one that can help us discover how the circulation of way-finding maps signifies much more than the personal experiences of their makers. In *The Practice of Everyday Life*, de Certeau explores the ways in which space is figured by modernity and its institutions, as well as the ways these figures of space run into the resistance of individuals who use space otherwise. At one juncture, he assigns pride of place to precisely the sort of map that Mignolo ignores, the nautical chart, as a site of resistance to the modern. Unlike the map, which erases from its face the historical operations that brought it into being, the nautical chart acknowledges them. The images of ships that decorate so many of these charts serve to recall the journeys that first traced the geographies they figure; see Michel de Certeau, *The Practice of Everyday Life*, trans. Steven Rendall (Berkeley: University of California Press, 1984), 120–21. Charts thus become emblems of resistance to modernity and its power. While way-finding maps are disqualified, by the cartography of the Renaissance, as "real" maps, their commitment to the journey persists to our own day in the various ways we use space against the grain of modernity's spatial fix. Frank Lestringant follows in de Certeau's wake. He notes that the cartography of the humanists never established a complete monopoly over early modern mapmaking. Sailors continued to make and use the same sort of nautical charts that they had been using since the late Middle Ages, and thus mark a site of resistance to the increasing hegemony of the modern map; see Frank Lestringant, *Ecrire le monde à la Renaissance: Quinze études sur Rabelais, Postel, Bodin et la littérature géographique* (Caen: Paradigme, 1993), 326–27. He might have added that Spanish sailors were notorious for such resistance. Notice, however, that while both de Certeau and Lestringant authorize us to turn to nautical charts as a site where we might be able to explore this alternative spatiality of the early modern period, neither fully outlines the spatial imagination of the nautical chart itself. The chart is a site of resistance, it is "not that," rather than a figure of a spatiality in its own right.

37 P. D. A. Harvey recognizes four separate types of medieval maps: (1) mappaemundi produced in ecclesiastical and learned contexts; (2) portolan charts made and used by Mediterranean mariners; (3) itinerary maps used by travelers of different kinds; and (4) topographical maps used in a miscellaneous set of circumstances; see P. D. A. Harvey, "Medieval Maps: An Introduction," in *The History of Cartography*, ed. Harley and Woodward, 1:283–85.

38 Of course, I am referring here to the broad European picture. I have already expressed doubts that this transformation occurred as thoroughly in Spain as elsewhere.

39 Significantly, Covarrubias, whose *Tesoro de la lengua castellana* is closer to our period than is the *Diccionario de Autoridades*, is not as specific about the kind of map implied by the word "map" itself: "MAPA. Llamamos la tabla, lienzo o papel donde se describe la tierra universal o particularmente, y puede venir de MAPPA, que quiere decir lienzo o toalla." (MAP f. amb. The geographical description of the Earth, usually done on paper or linen, in which one puts places, seas, rivers, mountains, and other notable things, with the distances [among them] proportionate to the scale one chooses, indicating the degrees of longitude and latitude occupied by every Country that is described, for the knowledge of the situation or place that each of these things occupies on the Earth.) (735).

40 Harley and Woodward, *The History of Cartography*, 1:xvi.

41 Walter Mignolo, "Colonial Situations, Geographical Discourses and Territorial Representations: Toward a Diatopical Understanding of Colonial Semiosis," *Dispositio* 14 (36–38) (1991): 93–140.

42 John Larner, *Marco Polo and the Discovery of the World* (New Haven, CT: Yale University Press, 1999), 68.

43 Larner, *Marco Polo*, 69.

44 Larner, *Marco Polo*, 77. The problem for Larner is that, if this is true, Polo's book seems unlike any other work in the Western geographical tradition (77). I would point out that although Polo's work is exceptional in many regards, its use of the itinerary as an organizing device is not one of them. This is a characteristic that Polo's book shares with other medieval and early modern travel narratives, which, like Polo's book, should probably be categorized anew as a type of geographical writing. See the examples cited earlier.

45 Polo, *The Travels of Marco Polo*, 1:109–10.

46 Ken Hillis, "The Power of Disembodied Imagination: Perspective's Role in Cartography," *Cartographica* 31(3) (1994): 10; Frank Lestringant, *L'atelier du cosmographe ou l'image du monde à la Renaissance* (Paris: Albin Michel, 1991), 16.

47 Pietro Janni, *La mappa e il periplo: Cartografia antica e spazio odologico* (Rome: G. Bretschneider, 1984), 17–47. Alexander Podosinov has reached the same conclusion, independently of Janni. Readers of English can glimpse his argument through his review of the first volume of Harley and Woodward, *History of Cartography*; see Alexander V. and Leonid S. Checkin Podosinov, "Extended Review of *The History of Cartography*," *Imago Mundi* 43 (1991): 112–23. Their position is that of a small minority. For the majority view, see Oswald Ashton Wentworth Dilke, "Cartography in the Ancient World: An Introduction," in *The History of Cartography*, ed. Harley and Woodward, 105–6; see also his earlier monograph on Greek and Roman maps, *Greek and Roman Maps, Aspects of Greek and Roman Life* (Ithaca, NY: Cornell University Press, 1985).

48 Fernando Colón, Biblioteca Colombina, and Consejería de Cultura Junta de

Andalucía, *Descripción y cosmografía de España*, 2 vols. (Seville: Padilla Libros, 1988), 1:36.

49 Colón et al., *Descripción*, 1:24.

50 Janni, *La mappa e il periplo*, 59.

51 There is a great deal about the portolan chart that is still open to debate, including the story of its origins. My discussion inevitably simplifies many issues. For a fuller treatment, including an ample bibliography, see Tony Campbell, "Portolan Charts from the Late Thirteenth Century to 1500," in *The History of Cartography*, ed. Harley and Woodward, 1:371–463.

52 Janni, *La mappa e il periplo*, 59.

53 Frank Lestringant, *Mapping the Renaissance World: The Geographical Imagination in the Age of Discovery*, trans. David Fausett (Berkeley: University of California, 1994), 15.

54 Lestringant, *Mapping the Renaissance World*, 15.

55 Mariano Cuesta Domingo, *La obra cosmográfica y náutica de Pedro de Medina* (Madrid: BCH, 1998), 329, and Lestringant, *Mapping the Renaissance World*, 15.

56 Domingo, *La obra cosmográfica*, 329.

57 "All those things have vanished / like a shadow, / and like a rumor that passes by; / like a ship that sails through the water, / and when it has passed no trace can be found, / nor track of its keel in the waves" (Wisdom of Solomon 5:9–10).

58 Some of these derroteros find their way into writing through the curious *Itinerario de navegación* of Juan de Escalante de Mendoza (1575). There, a dialogue between a master pilot and a novice takes the reader down the Guadalquivir from Seville to Sanlucar, and then to the Canaries, to the Americas, and even around the Cape of Good Hope to the East Indies. Along the way, the novice learns not only the itineraries of travel, but also the science of cosmography and related disciplines. In the preface to this work, Escalante praises navigation as the art that saved humanity during the flood, and that has now brought Christianity to the New World and wealth to Spain. The Council of Indies refused to license the printing of the work, for fear that its detailed presentation of maritime itineraries would fall into the wrong hands.

59 Medina's counterpart Martín Cortés is more ironic—perhaps unwittingly— about the nature of the seas as both a blank space and a network of navigable routes. In his own navigation manual, Cortés acknowledges that the tracks of the sea are not visible, but only within the terms of a larger comparison that presumes that they are there, and are comparable to the routes we find on land: "Digo que navegar no es otra cosa sino caminar sobre las aguas de un lugar a otro; y es una de las cuatro cosas dificultosas que el sapientísimo rey escribió. Este camino difere de los de la tierra en tres cosas. El de la tierra es firme, éste flexible; el de la tierra quedo, éste mobible; el de la tierra señalado y el del mar ignoto" (I say that to navigate is but to walk on the waters from one place to another. It is one of the four difficult things of which the Wise King wrote.

This sojourn differs from those on land in three ways. On land, the way is firm, but this one is flexible. On land, it is still, but this one is unstable. On land, it is marked, but this one is unknown.); see Martín Cortés and Mariano Cuesta Domingo, *Breve compendio de la esfera y del arte de navegar* (Madrid: Editorial Naval, 1990), 214.

Mapping an Exotic World:

The Global Project of Dutch

Geography, circa 1700

Benjamin Schmidt

Geographic Maneuvers

For a brief moment in the spring of 1673—on or about the advent, one might retrospectively say, of the "long" eighteenth century—a small Moluccan island suddenly occupied the center of London's theatrical world. In that year, John Dryden's *Amboyna* "succeeded on the Stage" (as the playwright himself averred) by conveying English audiences to a steamy East Indian archipelago and thrusting before them, front and center, a "tragedy" of strikingly global dimensions.[1] Exotic drama, of course, was hardly new to Restoration London: Dryden's own *Indian Queen* (1664) and *Indian Emperour* (1665) had played to enthusiastic crowds only a few years earlier. Yet *Amboyna* brought the tropics to the Thames perhaps more sensationally and certainly more forcefully than its competitors. More so than other performances of its day, it embraced a plainly geographic orientation to go along with its pugnaciously political agenda—which speaks to both the image of the exotic world and the ironies of its representation at the dawn of the global eighteenth century.

Amboyna gets to geography in a curious if also confrontational way. Politics and place are brought sharply together in a drama forged in the heat of battle—composed, that is, against the backdrop of a veritable world war between the English Crown and the Dutch Republic, a conflict somewhat unassumingly known as the Third Anglo-Dutch War. For Dryden and his fellow Britons, the third war was the charm, in that England finally succeeded in cutting the upstart republic down to size: Charles II's Royal Navy at last overwhelmed the formidable fleet of the Netherlands; significant portions of the Dutch countryside, after enduring months of plunder, fell to the marauding troops of Charles's sometime ally Louis XIV. Yet

this war, like the previous two, also extended overseas: to America, where England claimed possession of the colony that would henceforth be called New York; to Africa, where Admiral Holmes assaulted Dutch forts along the Gold Coast; and to Asia, where British ships habitually harassed enemy trade. Dryden wished to make this internationalism central to his play, and he set his drama in Southeast Asia, on the spice island of Amboina, where a tropical tale with an unabashedly polemical twist unfolds. *Amboyna* presents a story of high intrigue and low villainy, in which the Dutch act the part of monstrous colonials, raping the island's natives and then blaming the English traders, who happen also to be stationed there, for their crimes. In the process, the play pushes every baroque button imaginable—sex, violence, torture, treachery—to persuade its audience that the Dutch, unlike the English, are despicable tyrants and unfit to govern abroad. To articulate this idea concretely and early in the action, the playwright adopts a conspicuously and *graphically* geographic metaphor: "No Map shews Holland truer than our Play," declares Dryden in his prologue, meaning thereby to introduce his audience to the character—the essence—of what the play will later term "the Dutch race."[2]

Why the geographic maneuver? In Dryden's mapping metaphor there are a number of ironies of which late seventeenth-century viewers and readers were sure to take note. First, it was precisely the Dutch—as Dryden well knew and elsewhere acknowledges—who were the preeminent mapmakers of Europe; Holland itself was the source of the sumptuous atlases of Joan Blaeu, Johannes Janssonius, and Frederick de Wit, which showed England, along with the rest of Europe, the shape of the late seventeenth-century world.[3] Blaeu's authoritative *Atlas maior* had debuted just a few years before Dryden's play; lavish, hand-colored, folio editions were by now available in London's finest shops. By the 1670s, moreover, the Dutch had emerged as the reigning geographers: of Europe in general and of England in particular, which imported Dutch maps, Dutch charts, and Dutch geographies in ever growing numbers. This goes for plainly "Dutch" products and for ostensibly English ones as well. Thus, the pride of British mapmaking, John Seller's *English Pilot*, was produced "from old worn Dutch plates," as Samuel Pepys reproachfully put it.[4] Meanwhile, the so-called royal geographer of the realm took the person of John Ogilby, a former dancer turned printer whose major contributions to geographic studies were nothing more than English translations of Dutch-composed texts—works printed with Ogilby's name on the cover—though under the direction of the entrepreneuring Amster-

dam publisher Jacob van Meurs. The Dutch, more generally, produced the leading accounts of Asia, Africa, and America, and made them widely available in English, French, and Latin. It was from these Dutch sources, in fact, that Dryden and his audience (and, for that matter, readers across Europe) derived much of their information about the world. The despised autocrats of Amboina, it turns out, happened also to be the reigning authorities on Amboinese geography.

A second irony has to do with the timing of this well-after-the-fact "Map" of Holland. Dryden's drama was based on an actual colonial event that had taken place much earlier in the century—in February 1623, precisely half a century prior to the play. Yet the Dutch by this time no longer constituted the rising, menacing, colonial power they once had been. The rapid expansion of the earlier half of the seventeenth century, when the original Amboina scandal had taken place, had lately given way to a recession of trade and a contraction of territory for the republic overseas, and the notion of the Dutch as lords of an expanding global empire made little sense by the 1670s. In Africa, what few possessions the Dutch West India Company might once have claimed were now regularly besieged by the English Royal African Company. In America, the short-lived colony of Dutch Brazil had returned to Portugal by 1654, and the ill-fated settlement of New Netherland had been forfeited to the Duke of York only ten years later. In the very year of *Amboyna*'s production, the Dutch West India Company was busy drawing up papers of bankruptcy. A once mighty colonial power, the Dutch Republic was now fading into the background of the European imperial world. Still active in parts of the East Indies, perhaps, elsewhere it was giving way in the great colonial contests of the later seventeenth and eighteenth centuries. Dryden, the audience could not help but note, had launched his polemical broadside against a ship already sinking.

The two ironies of Dryden's mapping metaphor are subtly related. By the later decades of the seventeenth century (and this goes for the early eighteenth century, as well), the Dutch were fast becoming the leading geographers of Europe—prolific authors of literary and cartographic texts, producers of tropical paintings and colorful prints, promoters of exotic rarities and imported *naturalia*—while at the same time assuming a less active role in the theater of European expansion. Or, put another way, the Republic was becoming less and less engaged in conquering the world as it became more and more vested in describing it. Two linked ironies make three central questions: Why would the Dutch role as geographers of Europe expand

at the very moment that their role in the expansion of Europe contracted? How, furthermore, did the Dutch describe a world that they had a diminished stake in possessing? And—to frame the issue in starkly Foucauldian terms—what shape did knowledge take as it became increasingly disengaged from power?[5]

This chapter explores the production of geography in the Netherlands and its impressive dissemination and consumption throughout Europe circa 1700. As the global eighteenth century got under way, a remarkable profusion of geographic materials issued from the Dutch Republic—an explosion of books, maps, prints, paintings, curiosities, and other objects pertaining to the representation of the non-European world—effectively mapping for the rest of Europe the shape of the expanding globe. Yet both the intense production and the avid consumption of Dutch geography should give pause to students of culture and empire. For geography in early modern (no less than late modern) Europe was a highly interested, generally contested, and idiosyncratically "national" endeavor not easily transplanted abroad. Dryden designed a most malevolent "Map" of Holland's character for propaganda purposes, plain and simple, and one hardly imagines the play performed outside of England. The Dutch, too, engaged in their share of cartographic conflict and geographic fashioning, originally at the expense of their longtime nemesis, Spain, and later taking aim at the English and French. Yet this habit of tactical—call it "local"—geography appears to change by the final decades of the seventeenth century, at which time the Dutch appear also to recede from the battleground of global empire. Indeed, what is most striking about this later corpus of Dutch geography is, first, how broadly accessible, attractive, and appealing it is (this, to be sure, from a European perspective); and second, how strikingly unpolemical, apolitical, and disinterested it seems—at least relative to earlier patterns of Dutch geography and, for that matter, competing European traditions of geography. By the later seventeenth century, the Dutch had learned to make "maps" that appealed to Dryden's audience—and far beyond.

This chapter probes the very foundations of the global eighteenth century by examining the production of European images of the world circa 1700 and by considering the forms and purposes of those images at this critical moment of history. After briefly reviewing the patterns and traditions of geography in the Netherlands, it outlines the extraordinary expansion of geography in the Dutch Republic in the decades surrounding 1700, and then explores some of the methods and meanings of these sources. By way of con-

clusion, I wish to propose a very specific Dutch strategy of representing the world at this time, a broadly appealing mode of mimetic engagement that may be termed—to pose the issue as provocatively as possible—*exoticism*.

Making Maps and Other Geographies

Some background: The miracle of Holland, as the phenomenal political, economic, and social expansion of the northern Netherlands was dubbed even by contemporaries, occurred largely over the first two-thirds of the seventeenth century. It is less essential to detail here the astonishing growth of Dutch resources and power—military and diplomatic, commercial and demographic, literary and artistic—than it is to emphasize the timing of the Dutch Republic's meteoric rise from the late sixteenth century and underscore its exceptionally wide-reaching economic and cultural attainments by the middle of the seventeenth century. More pertinent to the subject of geography is the Republic's expansion overseas, which likewise took off spectacularly in the earlier seventeenth century, only to level off or regress thereafter. Trade to Asia began around 1600, with significant conquests (largely at the expense of Portugal) through the middle of the century. After that, though, the Dutch East India Company (Verenigde Oostindische Compagnie, or VOC) gave ground to the English and French; if the VOC still turned a profit, it did so increasingly as middleman in inter-Asian trade rather than as master of pan-Asian domains. The story of the Dutch in America presents a still starker model of rise and fall, with conquests in Brazil (again at Portugal's expense) and settlement in New Netherland taking place in the 1620s through 1640s. These gains, however, were followed by the catastrophic loss of Brazil in 1654 and of New Netherland in 1664. The Dutch Atlantic slave trade may have followed a slightly different pattern than other American commerce, in that contracts for slaves increased in the second half of the seventeenth century when the Republic could deliver cargoes for their former Iberian enemies. Yet this traffic was relatively marginal compared to the slaving activities of the English, French, and Portuguese; in Africa more generally, Dutch colonial reversals date from the 1660s and 1670s, when Dutch trading forts fell to superior French and English forces. By the final third of the century, in all events, the Dutch filled the role, in the West no less than the East, of middlemen. Much as they moved colonial goods, they had a minimal stake in colonies per se.[6]

The world according to the Dutch had a lot to do with those events that

coincided with its articulation of geography, since the Dutch worldview took shape as the Dutch *became* Dutch—as the Netherlands waged its epic struggle against Habsburg Spain, the searing Eighty Years' War that culminated in the Republic's foundation in 1648. Geography played a crucial role in this campaign, though it played a very particular role—by which is meant a provincial and idiosyncratic role—in expressing a new Dutch identity to match the new Dutch state. Over the course of the revolt, that is, cultural geographers in the Netherlands fashioned a version of the globe that suited the struggles of the Republic. This applies less for Asia and Africa, in which the Dutch initially showed less interest, than for America, whose "discovery" and conquest coincided (more or less) with the Dutch revolt. America was the site of Spanish "tyrannies," which the Dutch pronounced to be parallel to tyrannies committed in the Netherlands. The Indians were construed as allies, fellow sufferers of colonial oppression and brothers-in-arms in the war against Habsburg universal monarchy. "Colonialism" itself took on an Old World no less than New World meaning: the Duke of Alba's subjection of Dutch rebels was habitually juxtaposed with the Habsburg subjection of Indian comrades. This comparison, of course, was an exaggeration, but it was an exaggeration that worked and one that encouraged copious descriptions of "cruelties" in America, the "destruction of the Indies," and the tragedy of the *Conquista*—all of which were related to events back in the Netherlands. (It was in this period—the 1570s through 1620s—that the Dutch produced scores of editions of Bartolomé de Las Casas's catalog of atrocities, *The Mirror of Spanish Tyrannies in the West Indies*, sometimes slyly published with a pendant volume, *The Mirror of Spanish Tyrannies in the Netherlands*.) Dutch geography, in this way, was every bit as polemical in the early seventeenth century as Dryden's play a half century later. Indeed, it is yet another of the cheeky ironies of the latter that Dryden dared to compare the Dutch behavior in Amboina to that of Spain in the Netherlands: "D'Alva, whom you / Condemn for cruelty did ne're the like; / He knew the original Villany was in your Blood," offers the poet, opportunistically, in 1673. By this time, though, the Dutch had long abandoned the rally cry of "Spanish tyranny in America," since they had long ended their war against Spain, both at home and abroad.[7]

Timing here is crucial. The project of geography for the Dutch in the earlier years of the century was implicated in the project of "nation-ness" (to adopt Benedict Anderson's term, more appropriate for the early modern period than "nationalism").[8] Once the precarious moment of founda-

tion had passed, however, such meaningful representations of the world lost their purpose. By the later decades of the century, the Dutch abandoned the topos of "Spanish tyranny in America," quit their publication of Las Casas and other polemical tracts, and generally reoriented their geography away from their distinctly provincial image of America. Yet they did not abandon the project of geography altogether. Quite the contrary, they began to produce in these years more works, in more forms, than ever before. The sparkling maps, dazzling globes, and exceptionally well-regarded atlases produced in the Netherlands were coveted across the continent. Dutch-made prints, tropical paintings, and rare curiosa were traded among European princes, merchants, and scholars; while Dutch natural histories, proto-ethnographies, and accomplished geographies, in multiple editions and translations, became the standards throughout Europe. In presenting these materials, moreover, the Dutch adopted a distinct strategy of exoticism in order to market a version of the world that, rather than remaining peculiarly Netherlandic, was rendered more widely attractive to the whole of Europe. No longer as invested in the race to colonialize, the Dutch could afford to step aside and operate the concession stand, as it were, of European expansion, offering images of the world to those fast entering the competition.

The materials produced by the Dutch are unusually bountiful and strikingly beautiful. They are notably broad-ranging as well, both in their impressive attention to the vast baroque world and in their remarkable span of genres, media, and objects enlisted to represent that world. They comprise, most basically, "traditional," printed geographies which, in the humanist mode, gave broad outline to the cosmos. These include such massive, learned compilations as Philipp Clüver's (Cluverius's) *Introductionis in universam geographiam*, which appeared in a staggering sixty-seven editions by 1725; Bernardus Varenius's authoritative *Geographia generalis*; and the omnibus works of Georg Horn (Hornius) — "social" studies on the empires of the world, the origins of the races, the nature of the polities, and so forth — forty editions of which were printed in the final third of the century. Slightly less global in their focus, regional geographies took the form of fabulous folio works, which were sometimes called "atlases" and were always chock-full of foldout maps, engravings, and the like: Johan Nieuhof on China (which Ogilby sold as the *Atlas Chinensis*, sometimes with a companion *Atlas Japonensis* that was likewise done from a Dutch original); Olfert Dapper's lavish volumes on Asia and Africa; Arnold Montanus's best-selling (and thrice translated) *America*; Nicholas Witsen on Muscovy and "Tartary"; Engel-

bert Kaempfer's nonpareil *Japan*; and the magnificent, five-volume *Oud en Nieuw Oost-Indiën* (Old and New East Indies) by the Dutch dominee François Valentijn. Exotic travel narratives, a more peripatetic genre, likewise streamed off Dutch presses at a torrential pace: over fifty editions of Willem Bontekoe's adventures in the Indian Ocean, Ogier Busbecq's much-cited account of life among the Ottomans, and Cornelis de Bruyn's journeys from the Near to Far East. There are also impressive travel anthologies: sprawling, multivolume collections, including Joost Hartgers's "Voyages" and Isaac Commelin's "Travels" (which formed the basis of Renneville's and Churchill's likewise gargantuan collections, in French and English, respectively); and the twenty-eight-volume geography series of Pieter van der Aa, which served as the standard reference work for half a century. A final category that falls under the rubric of literary text is the Dutch "books of wonders"—a genre approximating printed *Wunderkammer*—which jumbled together the multiple marvels, mores, and curiosities of the world; arranged these with happy disregard for context or place; and then packaged them with such come-on titles as "The Great Cabinet of Curiosities," "The Wonder-Filled World," or, more prosaically, "The Warehouse of Wonders."⁹

Most of these works included maps, an indication that the Republic by this time had become the unrivaled capital of cartography. To be sure, the Dutch had excelled in mapmaking for much of the seventeenth century. Yet it was only in the second half of the century, *after* the fall of the Republic's American colonies and setbacks in Asia and Africa, that the stupendous "grand" atlases of Blaeu, Janssonius, and de Wit appeared in deluxe editions and in most major languages. Add to this category the water-worlds produced by the ateliers of Colom, Donker, and van Keulen—stunning sea atlases that, if always fairly decorative, had lately become even more so by the inclusion of hand-colored cartouches, elaborate vignettes, and baroque marginalia brimming with "ethnographic" detail—and it becomes apparent how thoroughly the Dutch dominated the field. They were, in short, the mapmakers of Europe. This applies, moreover, to a remarkably wide range of products and consumers, for the Dutch cartographic industry served both ends of the market. It churned out cheap sheet maps, topical news reports, and copious city views for the less affluent buyer, while also manufacturing premiere globes, watercolor topographies, and opulent wall maps—such as Blaeu's stupendous, three-meter-wide *mappa mundi* (a copy of which reached the court of the shogun in Edo) and his brilliant map of Brazil, decorated with extensive "local" scenery engraved by the artist Frans Post.¹⁰

Post's name is associated chiefly with a whole other class of images—tropical landscapes—that rightfully belong to the field of geography. The Dutch invented and then abundantly produced the tropical landscape, a new genre that developed in the final half of the seventeenth century—not, that is, in the Golden Age of Dutch painting, when landscapes were dedicated almost exclusively to domestic, or perhaps Italian, scenes. Now, however, the expanding colonial world could be viewed on canvas in bright and vivid color. Post himself concentrated on Brazilian scenes and pastoral settings, his lush foregrounds overflowing with the rich naturalia of the tropics. Other regions attracted other painters. Dirk Valkenburg cornered the market on Suriname, Andries Beeckman covered the East Indies, Reinier "Seaman" Nooms portrayed northern Africa, and Gerard van Edema applied his brush to that urban jungle lately known as New York, which he painted almost exclusively for English patrons. Dutch artists also undertook various still lifes of foreign flora, fauna, and indigenous peoples. And the places, races, and products of the Indies, East and West, might be further collapsed into a single canvas—as in Jacob van Campen's *Triumph, with Treasures of the Indies* (figure 9.1), in which the central basket is Congolese, the vase is Ming (draped with tropical, mostly East Indian shells), and the scarlet macaw is Brazilian. All of these images, finally, could be recycled in tapestries—the Gobelins series for Louis XIV being among the most famous example—or in earthenware or other decorative arts, produced largely in Delft though sold throughout the continent.[11]

The objects shown in the paintings and decorative arts were sorted out more meticulously in natural histories, of which the Dutch produced, once again, the most impressive samples. European scholars turned to Willem Piso's *Historiae naturalis Brasiliae* for tropical crustaceans and edentates, they consulted twelve thick volumes by Hendrik van Reede tot Drakestein on the natural wonders of Malabar, and they relied on Jan Commelin for comprehensive data on Asian flora—perhaps even visiting the renowned *Amsterdam hortus*, where Commelin grew his plants. More specialized, though no less spectacular, works include Georg Rumpf's (Rumphius's) monumental meditation on Moluccan shells, *D'Amboinsche rariteitkamer* (The Amboinese Curiosity Cabinet), and the breathtaking *Metamorphosis insectorum Surinamensium* by Maria Sibylla Merian, which showed the insects of Suriname crawling among those plants they called home. (Both texts appeared during what David Freedberg has so felicitously called the Netherlands' "*decennium mirabilius*" of exotic natural history, 1695–1705.)[12]

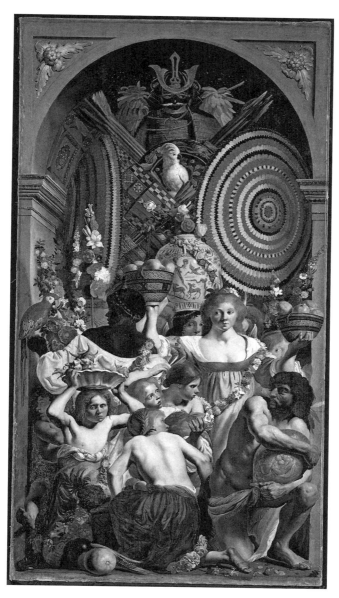

Fig. 9.1. Jacob van Campen, *Triumph, with Treasures of the Indies*.
380 × 205 cm, the Hall of Orange at the Royal Palace Huis ten Bosch,
The Hague.

Actual specimens could be handled or even purchased from Dutch *Kunst-* and *Wunderkammern*, which swelled in number during these years. Shells were the best preserved and therefore most popular items, though a wide variety of naturalia, *artificialia*, and hybrid items bridging the two categories—finely painted shells, artfully crafted fossils, ingeniously worked coral—could be had from Dutch dealers. Finally, paintings of collectibles also sold briskly: still lifes of rare flowers, exotic shells, or other imports from the Indies; or paintings of the very cabinets themselves—sometimes real though often imagined—like the fabulous renditions of connoisseurs' cabinets from the hand of Jan van Kessel (figure 9.2).[13]

The commerce in collectibles (and in geography more generally) highlights the impressive migration of these products, and it is important to stress just how far and wide Dutch geography dispersed and how influential the Dutch version of the world consequently became. Though not all of these sources can be readily traced, certain patterns of patronage can be reconstructed, especially as they pertain to Europe's most prominent consumers. German, French, and English aristocrats, among others, avidly collected Dutch tropical landscapes, for example. Louis XIV acquired a spectacular trove of Americana in 1679, including twenty-seven canvases by Frans Post. Maps and globes also circulated in the finest studies and drawing rooms of Europe. Queen Christina of Sweden assembled a collection of stunning cartographic watercolors, the so-called Vingboons atlas, illustrating nearly every port of interest in the non-European world. Peter the Great came to Amsterdam to buy, among other things, every Wunderkammer he could lay his hands on, following in the steps of Grand Duke Cosimo III de' Medici, who had raided Dutch collections only a few years earlier. Less is known about consumption at less elevated levels because fewer traces remain, though it is apparent that Dutch prints and sheet maps scattered widely and that their images were recycled aggressively across the continent. The circulation of published geographies makes a still deeper impression. Printers in Paris and London—Ogilby being a prime example—poached, pirated, and otherwise published Dutch texts, and sources originating in Holland spread from Stockholm to Naples and from Dublin to Dresden. Readers of German, Latin, English, French, Swedish, and Spanish all had access, in one form or another, to the bounty of Dutch geography. Consumers of books and prints, maps and paintings, rarities, and other mimetic forms of the world as imagined circa 1700—the dawn, that is, of the global

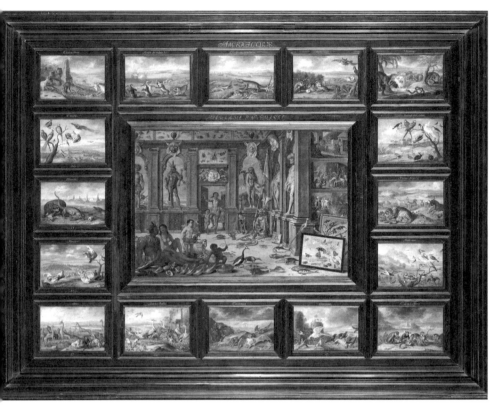

Fig. 9.2. Jan van Kessel (1626–79), *Americque*. 48.6 × 67.9 cm (center panel). Inv., 1913.
Alte Pinakothek, Bayerische Staatsgemäldesammlungen, Munich, Germany. Photo credit:
bpk, Berlin/Art Resource, New York.

eighteenth century—could avail themselves of the flood of products that streamed so impressively from the Dutch Republic.

Mapping an Exotic World

Why the universal attraction of Dutch geography? How (to frame the issue from the perspective of the producer) did these materials win such a wide following? Consider the fantasy cabinet of Jan van Kessel, which purports to portray a collector's ideal—and thus the allure of this brand of geography (see figure 9.2). Whatever the panel's many charms, one is hard pressed to identify a single theme, or a signal object, that draws the viewer into this undeniably compelling collection. On the contrary, one is struck by the abundance and variety of stuff and by the shapeless bric-a-brac quality of its arrangement. The painting is labeled *Americque*, though it would seem to lack a tightly focused American theme. One of a number of Indians sits in the foreground, though she is coupled with a dark-skinned African clad in feathers. To the woman's left stands a cherubic Indian boy, also decked in feathers and armed with an iconic bow and arrows; yet at her feet kneels another child—naked and less fair than the "Indian"—who plays with a set of Javanese gamelan gongs. The woman dancing through the door, meanwhile, wears *East* Indian costume, and to the right is a depiction of a Hindu suttee. Numerous other visual devices, in much the same manner, point to the subtle blending of races and the nonchalant bleeding of regions that occur throughout the panel. Next to the Javanese drummer boy struts an African crowned crane whose curving neck guides the viewer's eye toward a perched macaw and a toucan—two birds closely associated with Brazil. Between these glamorously tropical fowl, a whiskered opossum heads toward a sturdy anteater—we are, once again, in the landscape of America—yet the framed (and framing) insects and butterflies (top and bottom right) derive from both Old and New World habitats. The background statuary bracketing the open door features Tapuya Indians (modeled closely on drawings by the Dutch painter Albert Eckhout), while the niches on the right display a pair of Brahmins. Between these stone figures, in the corner, rests a suit of Japanese armor whose sword points plainly toward a Brazilian agouti and a centrally placed armadillo—the latter belonging to the standard allegorical representation of America, as codified earlier in the century in Cesare Ripa's *Iconologia*.[14] In place of specificity—the strategy that had characterized Dutch geography at the height of its struggle against Spain, when images

of America resolutely stressed the theme of Habsburg tyranny abroad—the panel conveys a remarkable sense of indeterminacy. Rather than the New World per se (let alone a Dutch New World), one gets an almost haphazard assembly of exotica from around the globe. Objects are in disarray and, in a crucial sense, decentered. Why title the work "America" at all, if it comprises so much more of the generically non-European world?

This sort of indeterminacy characterizes many of the sources emanating from the Republic circa 1700. There is a mix-and-match quality to Dutch geography of this period that stands in sharp contrast to the more sharply focused view propagated earlier in the century. When Johannes de Laet, a director of the Dutch West India Company, published Willem Piso's natural history of Brazil in 1648, he made clear in his prefatory materials the vital place of the Dutch in America—where they still retained, after all, important colonies. A number of years later (by which time those colonies had been lost), the work was reissued by an Amsterdam publisher with the patriotic preface excised, replaced by a poem in praise of wonders. A study of nature in the East Indies had also been added, along with a wholly new frontispiece that casually blends a heraldic Brazilian figure with a vaguely Persian one.[15] The same process also transformed a chronicle of the Brazilian travels of Johan Nieuhof, which originally lauded the Republic's rise in the West. When they later appeared in print in 1682, however, Western adventures merged with Eastern tales (Nieuhof's visit to China and Persia), the frontispiece once again inviting the reader to join in a more dizzying spin of the globe. The text itself does present two separate sets of travels in the order they took place, yet the illustration program is less fussy. Facing a description of Jewish merchants in Brazil is an otherwise incongruous engraving of a Malay couple, intoxicated with tobacco (a subtle allusion to international commerce?). An image of a Malabar snake charmer turns up in a section on indigenous Brazilians allied with the Dutch, leaving readers to ponder the relation between New World Indians and Old World enchanters, and the far-fetched correlation of the two.[16]

Relative to earlier models, then, the new geography promoted a freshly decontextualized, vertiginously decentered world. It offered sundry bric-a-brac—*admirabilia mundi*, as one writer put it—intended for a vast and cluttered mental cabinet of curiosities. Dutch sources of this period expressly do not develop the sort of polemical themes of the earlier literature, choosing instead to highlight the collectively admired, if indistinctly located, rarities of the world. One best-selling author states his strategy as purposeful discur-

siveness. He confesses to offering no more than quick "morsels" of exotica, since variety, surely, was the spice of geographic life. Spain's colonial record, so central for his predecessors, is briefly considered and mildly commended, even for the manner in which God had been delivered to the tropics. For another writer, Simon de Vries, Spain's greatest imperial sin was its lack of *curiosity* in its colonies—an appalling lapse for this author of tens of thousands of pages of "curious observations" of the Indies. Rarity is de rigueur in de Vries's *Great Cabinet of Curiosities*; the reader is invited to rummage through the strangeness, otherness, and oddities of the world. This volume amounts to a two-thousand-page descriptive tour de force that skims nimbly over events and habits, objects and creatures, scattered across the globe. Wampum in New York and wantonness in Brazil, dragons in India and drachmas in Attica, cabalism of the Jews and matrimony of the Lapps: all are deposited into a single "warehouse of wonders" (the title of another de Vries vehicle) from which readers could pick and choose the curiosa of their choice.[17]

These volumes' marvelous eclecticism, stunning breadth, and formidable vastness suggest a whole new order of geography. The Dutch had repackaged the world and transformed it into gargantuan, sprawling compendia of "curiosities." Like the exuberantly cluttered foregrounds of Frans Post's tropical landscapes, they teemed with lush description and dense detail of the late baroque world. Rather than restricting attention to Dutch deeds and Dutch settlements, they explored with encyclopedic interest *all* of the savage creatures, unusual inhabitants, and unknown landscapes of the globe. Rather than following the familiar tropes of earlier Dutch narratives, these works celebrated precisely the unfamiliar and indeterminate "strangeness" of the Indies. Dutch geography tolerated—encouraged even—variety. It cultivated chaos, and it reveled in randomness. Most importantly, it declined to play to a specific audience or perspective; it did not promote a particular place or purpose; it targeted no contested region or rival. It pursued, rather, what one magnificent tome of Asiana pronounced the "pleasures" of the exotic: *Amoenitates exoticae*.[18]

Along with the metaphor of the warehouse and commerce, the cabinet and collecting, Dutch geography also adopted the metaphor of the theater and stage—as in Petrus Nylandt's *Schouw-toneel der aertsche schepselen* (Theater of the World's Creatures, 1672), a printed performance of global marvels that spanned everything from the feathered American turkey to the turbaned Ottoman Turk—both shown on its splendidly jumbled title page (figure 9.3).[19] Nylandt's theatrical conceit allows this chapter to conclude

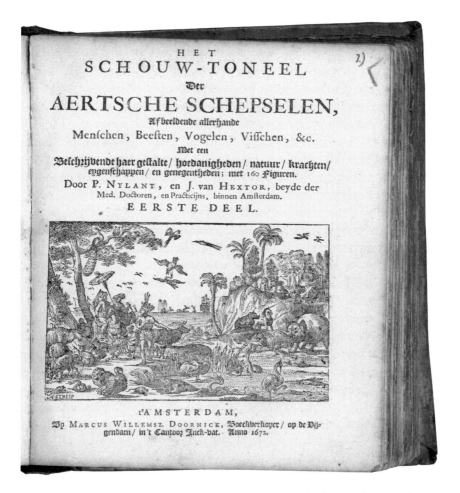

Fig. 9.3. Title page illustration (signed "A. Streip") in Petrus Nylandt, *Het schouw-toneel der aertsche schepselen* (Amsterdam, 1672). Courtesy of Special Collections, University of Amsterdam [OTM O 80-636 (2)].

where it began—with Dryden's *Amboyna*, a work that overlaps exactly, yet contrasts tellingly, with that of Nylandt. Both texts, in a sense, are works of geography; both offer a vision of the world and their audience's place within it. Yet in contrast to Dryden's "Map" of Dutch deceit and hotly drawn sketch of Amboina, Nylandt presents a more temperate view of the globe. He emphasizes the pleasure of wonder and the diversity of culture in a rich and plentiful world; his broad-ranging tour of the extra-European universe deliberately strips that world of all geopolitical specificity. Nylandt purges his "theater" of polemics; he makes no mention of colonial contests; he favors delight over didacticism. Or rather, Nylandt's message, like that of so many other practitioners of Dutch geography, eschews the pugnacious and political in favor of a generically appealing version of the globe that seemed to sell. Nylandt made the world palatable to all by offending none—in Europe, at least.

The global dramas staged by Nylandt and his contemporaries—the immense stock of geography, cartography, natural history, tropical painting, and travel literature produced in the Dutch Republic—was indeed an "embarrassment of riches." Yet they were riches meant to be moved from the shop, atelier, and merchant ship to the shelf, study, and Kunstkammer of consumers across Europe. To do so, the Dutch created an image—pursued a marketing strategy, as it were—that presented the increasingly contested globe as a decontextualized, decentered repository of bountiful curiosities and compelling collectibles. Less and less involved themselves in colonizing overseas, the Dutch could now afford to present a neutral, widely agreeable, perhaps even bland image of the world. Rather than the local and provincial, they now strove for the global and universal—at least, it merits reiterating, from the colonial European perspective—in projecting a world of alluring, enticing, spectacular richness. By the opening of the global eighteenth century, that world had become simply exotic.

Notes

Benjamin Schmidt, "Mapping an Exotic World: The Global Project of Dutch Geography, circa 1700," in *The Global Eighteenth Century*, ed. Felicity A. Nussbaum, 21–37, 327–30. Baltimore: Johns Hopkins University Press, 2003. Reprinted with permission of The Johns Hopkins University Press.

The research for this chapter began with the support of an Ahmanson-Getty Fellowship in 1999–2000. Many thanks to Peter Reill for making my stay in

Los Angeles so productive and pleasant. A version of this chapter was also presented at the Simpson Center for the Humanities (University of Washington), and I would like to acknowledge the helpful comments of my colleagues, especially those of Marshall Brown.

1 John Dryden, *Amboyna: A Tragedy* (London, 1673), for which see *The Works of John Dryden*, vol. 12, ed. Vinton A. Dearing (Berkeley: University of California Press, 1994). There is some debate on the precise dating of the play, though most evidence and scholarly consensus point to the spring of 1673, shortly after the Anglo-Dutch War broke out; see *Works of John Dryden*, 12:257–58. The play's successful performance is announced by the author in his dedication to Lord Clifford (*Works of John Dryden*, 12:5).

2 *Works of John Dryden*, 12:7. See also Robert Markley, "Violence and Profits on the Restoration Stage: Trade, Nationalism, and Insecurity in Dryden's *Amboyna*," *Eighteenth-Century Life* 22 (1998): 2–17, which also provides further bibliography. On Anglo-Dutch rivalries, see Charles Wilson, *Profit and Power: A Study of England and the Dutch Wars*, 2nd ed. (The Hague: M. Nijhoff, 1978).

3 Dryden notes in the prologue the formidable abilities of Dutch printers and publicists to propagate their views: "Their Pictures and Inscriptions well we know; / We may be bold one medal sure to show" (*Works of John Dryden*, 12:7). He later invokes specifically the Dutch commerce in geography—"you traffick for all the rarities of the World, and dare use none of 'em your selves" (*Works of John Dryden*, 12:31)—showing a keen understanding, too, of the Republic's role as merchant rather than consumer of exoticism.

4 Cited in John Seller, *The English Pilot, The Fourth Book*, ed. Coolie Verner (Amsterdam: Theatrum Orbis Terrarum, 1967), v.

5 See Michel Foucault, *The Order of Things: An Archeology of the Human Sciences* (New York: Pantheon, 1970), and *Power/Knowledge: Selected Interviews and Other Writings*, ed. Colin Gordon, trans. Colin Gordon et al. (New York: Pantheon, 1980). The project of Dutch geography c. 1700 also complicates the classic (and reflexively invoked) thesis of Edward Said's *Orientalism* (New York: Pantheon, 1978) by suggesting that the Dutch described the colonial world not so much to control it as to market it—albeit to others with a vested imperial interest. Said, it is worth adding, derives his source material mostly from the later eighteenth and nineteenth centuries—a period that follows, by half a century at least, the geographic moment described in this chapter. See further David N. Livingstone and Charles W. J. Withers, eds., *Geography and Enlightenment* (Chicago: University of Chicago Press, 1999); and G. S. Rousseau and Roy Porter, eds., *Exoticism in the Enlightenment* (Manchester: Manchester University Press, 1990).

6 On the East, see Femme S. Gaastra, *De geschiedenis van de VOC* (Zutphen: Walburg, 1991); and Jaap R. Bruijn and Femme S. Gaastra, "The Dutch East India Company's Shipping, 1602–1795, in a Comparative Perspective," in *Ships, Sailors and Spices: East India Companies and Their Shipping in the Sixteenth, Seven-*

teenth, and Eighteenth Century, ed. Jaap R. Bruijn and Femme S. Gaastra, NEHA Series III, no. 20 (Amsterdam: NEHA, 1993), 177–208, which makes a persuasive case for the relative decline, from the late seventeenth century, of the Dutch in Asia. On the West, see Henk den Heijer, *De geschiedenis van de WIC* (Zutphen: Walburg, 1994); and Pieter Emmer and Wim Klooster, "The Dutch Atlantic, 1600–1800: Expansion without Empire," *Itinerario* 23(2) (1999): 48–69, which dates the Republic's Atlantic decline quite precisely to the final decades of the seventeenth century. The Atlantic slave trade is surveyed in Johannes Menna Postma, *The Dutch in the Atlantic Slave Trade, 1600–1815* (Cambridge: Cambridge University Press, 1990); and see more generally Pieter Emmer, *The Dutch in the Atlantic Economy: Trade, Slavery and Emancipation* (Aldershot: Ashgate, 1998).

7 *Works of John Dryden*, 12:71. For Dutch geography and the New World, see Benjamin Schmidt, "Exotic Allies: The Dutch-Chilean Encounter and the (Failed) Conquest of America," *Renaissance Quarterly* 52 (1999): 440–73, and "Tyranny Abroad: The Dutch Revolt and the Invention of America," *De Zeventiende Eeuw* 11 (1995): 161–74, which also discusses the publication of Las Casas.

8 Benedict Anderson, *Imagined Communities: Reflections on the Origin and Spread of Nationalism*, rev. ed. (London: Verso, 1991), 4.

9 The classic bibliographies of Dutch geography—P. A. Tiele, *Nederlandsche bibliographic van land- en volkenkunde* (Amsterdam: Frederik Muller, 1884), and *Mémoire bibliographique sin les journaux des navigateurs Néerlandais réimprimés dans les collections de De Bry et de Hulsius, et dans les collections hollandaises du XVIIe siècle* (Amsterdam: Frederick Muller, 1867)—adopt a far less generous view of the range of "geography" than does this chapter and offer, accordingly, only moderate guidance. For printed work with any relevance to the Dutch experience in Asia, see John Landwehr, *VOC: A Bibliography of Publications Relating to the Dutch East India Company, 1602–1800* (Utrecht: HES, 1991); and, for books that make mention of the Americas—which applies to the geographies of Cluverius, Varenius, and Hornius, and to many of the Dutch "books of wonders"— see John Alden and Dennis Landis, eds., *European Americana: A Chronological Guide to Works Printed in Europe Relating to the Americas, 1493–1750*, 6 vols. (New York: Readex Books, 1980–97). Also useful is John Landwehr, *Studies in Dutch Books with Coloured Plates Published 1662–1875: Natural History, Topography and Travel Costumes and Uniforms* (The Hague: Junk, 1976).

10 Dutch-produced atlases are excellently cataloged in Cornelis Koeman, *Atlantes Neer landici: Bibliography of Terrestrial, Maritime and Celestial Atlases and Pilot Books, Published in the Netherlands up to 1880*, 6 vols. (Amsterdam: Theatrum Orvis Terrarum, 1967–85) (see also the revised edition of this work edited by P. C. J. van der Krogt ['t Goy-Houten: HES, 1997–]); for globes, see P. C. J. van der Krogt, *Globi Neerlandici: The Production of Globes in the Low Countries* (Utrecht: HES, 1993). On Dutch cartographic materials more generally, see Kees Zandvliet, *De groote waereld in't kleen geschildert: Nederlandse kartografie tussen de middeleeuwen en de industriële revolutie* (Alphen aan den Rijn: Cana-

letto, 1985); and, on the exotic world more particularly, his *Mapping for Money: Maps, Plans and Topographic Paintings and Their Role in Dutch Overseas Expansion during the Sixteenth and Seventeenth Centuries* (Amsterdam: Batavian Lion International, 1998).

The Brazil map, published in Blaeu's celebrated and widely circulated "major" atlas, derives from a still larger wall map that illustrated the entire extent of the former Dutch colony in Brazil. That original printed, and generally hand-colored map, of which two of the three extant copies come from the king of England's and the elector of Brandenburg's collections, is covered with scenes of Brazilian life and tropical nature and surrounded by columns of descriptive text, demonstrating inter alia how cartographic sources could effectively offer mini-geographies of a region.

11 The literature on painted exotica is uneven. For Post, see Joaquim de Sousa-Leão, *Frans Post, 1612–1680* (Amsterdam: A. L. van Gendt, 1973); P. J. P. Whitehead and M. Boeseman, *A Portrait of Dutch Seventeenth-Century Brazil: Animals, Plants and People by the Artists of John Maurits of Nassau*, Royal Dutch Academy of Sciences, Natural History Monograghs, 2nd ser., vol. 87 (Amsterdam: North-Holland, 1989), which thoroughly studies Brazilian iconography and details the oeuvre of Albert Eckhout, Post's South American colleague specializing in exotic still lifes and portraits. Valkenburg, Beeckman, Nooms, and van Edema still lack biographers and catalogers—though see the brief treatment of Valkenburg in C. P. van Eeghen, "Dirk Valkenburg: Boekhouder-schrijver-kunstschilder voor Jonas Witsen," *Oud Holland* 61 (1946): 58–69. On exotic themes in the visual arts more broadly, see Hugh Honour, *The European Vision of America* (Cleveland, OH: Cleveland Museum of Art, 1975).

12 David Freedberg, "Science, Commerce, and Art: Neglected Topics at the Junction of History and Art History," in *Art in History / History in Art: Studies in Seventeenth-Century Dutch Culture*, ed. David Freedberg and Jan de Vries (Santa Monica, CA: Getty Center, 1991), 376–428, which also discusses Dutch natural history more generally.

13 Patterns of Dutch collecting are surveyed in Ellinoor Bergvelt et al., *De wereld binnen handbereik: Nederlandse kunst- en rariteitenverzamelingen, 1585–1735*, 2 vols. (Zwolle: Waanders, 1992). On still lifes, see the exhibition catalog, Alan Chong and Wouter Kloek, eds., *Still-Life Painting from the Netherlands 1550–1720* (Zwolle: Waanders, 1999).

Van Kessel's *Americque* belonged to a series of Continents, which represented the four "parts" of the globe. The other paintings—of Asia, Africa, and Europe—might likewise be cited as prime examples of the exoticizing tendencies of Dutch geography. Note that each of the allegories was surrounded by sixteen smaller panels containing vignettes of "local" fauna—including, in the case of *Americque*, elephants, tigers, and unicorns.

14 See Whitehead and Boeseman, *Seventeenth-Century Brazil*, 90–94, which offers a superb reading of the paintings' naturalia; see the armadillo-riding "America"

in Cesare Ripa, *Iconologia* (p. 605 in the 1644 Amsterdam edition of this standard text, which first appeared with the American allegory in 1603 [Rome] and then in countless editions throughout the century). Note that while van Kessel, technically speaking, was not a "Dutch" painter—his workshop was based in Antwerp—the painting *Americque* very clearly derives from Dutch iconographic sources, as is meticulously detailed by Whitehead and Boeseman.

15 Willem Piso et al., *Historia naturalis Brasiliae* (Leiden and Amsterdam, 1648); see *De Indiae utriusque re naturali et medica libri quatuordecim* (Amsterdam, 1658).

16 Johan Nieuhof, *Gedenkweerdige Brasiliaense zee- en lantreize door de voornaemste land-schappen van West en OostIndien*, 2 parts (Amsterdam, 1682). Nieuhof's volume contained dozens of similarly engraved illustrations of exotic "races," which endeavored to show the reader not only the look of local inhabitants but also the "mores" and "habits" of the region. It was not uncommon for these plates to be confused in the process of printing—misnumbered, misplaced, mislabeled—especially in non–Dutch language editions of the book.

17 P. de Lange, *Wonderen des werelds* (Amsterdam, 1671), "Aen de Leser," sig. A2 (on exotic "morsels" and "admirabilia mundi"); Simon de Vries, *D'edelste tijd-kortingh der weet-geerige verstanden: of De groote historische rariteit-kamer*, 3 vols. (Amsterdam, 1682); *Wonderen soo aen als in, en wonder-gevallen soo op als ontrent de zeeën, rivieren, meiren, poelen en fonteynen* (Amsterdam, 1687), 266 (on lack of Spanish curiosity); see *Curieuse aenmerckingen der bysonderste Oosten West Indische verwonderens-waerdige dingen*, 4 parts (Utrecht, 1682); and *Historisch magazijn* (Amsterdam, 1686).

18 Engelbert Kaempfer, *Amoenitatum exoticarum politico-physico-medicarum fasciculi V. quibus continentur variae relationes, observationes & descriptiones rerum Persicarum & Ulterioris Asiae* (Lemgo, 1712).

19 Petrus Nylandt, *Het schouw-toneel der aertsche schepselen, afbeeldende allerhande menschen, beesten, vogelen, visschen, &c.* (Amsterdam, 1672).

Visual Regimes of Colonization:
European and Aboriginal
Seeing in Australia

Terry Smith

What were the visual regimes of colonization practiced in settler colonies such as those on the Australian and North and South American continents from the mid-sixteenth century to the mid-nineteenth century? I propose that a structure consisting of three major components—practices of calibration, obliteration, and symbolization (specifically, aestheticization)—underlay the vagaries of style and circumstance. These components could be hidden by their apparent naturalness, or laid bare in their brash instrumentalism, while at other times they seemed so distinct as to constitute a prevailing visual order. I will explore the case of the British colonies of Terra Australis, but the interpretation may have validity for other settlements during this period.

Mapping of the oceans and landmasses, measurement of distances and of governmental and property boundaries, surveillance of peoples—all of these are practices of *calibration*. They are more than acts of noticing and naming, of fixing position and describing characteristics, after which the job of the observer is done, and he and his machinery of observation move on. Rather, they initiate processes of continuous refinement, of exacting control, of maintaining order. They create the self-replicating conditions of a steady state, European-style. They are the bastions of a social structure which exists always on the cusp of collapse into disorder, even barbarism. Imperial expansion, economic necessity, and the exigencies of practical settlement require nothing less than this constantly reflexive watchfulness.

Erasing the habitus, the imagery, the viewpoints, and, eventually, the physical existence of indigenous peoples—these are practices of *obliteration*. This may take the form of violent extinguishment, or violation of ceremonial sites; of creating an environment in which the indigene can no longer

live, leading to lassitude, a "dying out" which puzzles its ignorant author; of unauthorized reproduction of Aboriginal designs to a literal scrawling of graffiti over sacred signs; of assimilating the indigene to the supposedly universal frameworks of Western rationality or setting him and her at an unbridgeable distance—as a "Noble Savage," for example. These practices range from actual, brutal murder to an equally potent imaginary othering. Art tends to serve the latter: it others the real other by abstracting the indigene, by figuring "the native" in kinds of representation at once comfortably familiar and wildly exotic. The actual otherness of the indigene is thereby screened from view.

Transforming the world of experience by treating selected parts of it, or certain relationships in it, as representative of an abstract idea (such as beauty) or of an ideological tendency (such as the rule of bourgeois law) is to practice symbolization. To subject the world to processes of representation which have been trialed in painting, sculpture, print-making, and, eventually, photography is to apply to the world practices of *aestheticization*. This was done to an unprecedented degree, during the eighteenth and nineteenth centuries, by the visual regime known as the Picturesque. It was more than an artistic style, more even than an affection of English gentlemen wishing to swan about the countryside and the Continent looking for aspects which reminded them of famous paintings. It was an open form of visual journeying, a technique for stringing otherwise incompatible sights and sites together. It became indispensable to colonization, the "human face" of imperialism. It spun charming appearances as garlands over the instrumental actualities of establishing colonies in foreign climates, of creating systems of control, of building ordered socialities.

The visual regimes of colonization, then, always involved a triangulation, a simultaneous crossing of the three perspectives: calibration, obliteration, and symbolization. And each of these was itself a hardening against its own, always threatening double: against disorder, othering, and the instrumental.

The Pictures at Sydney Cove

The first two known delineations of the British settlement which led to the foundation of the city of Sydney prefigure key elements of the contradictory perspectives which have shaped visual cultures in Australia ever since. On March 1, 1788, Captain John Hunter carefully rendered the shoreline, the depths of water, and the positions of both the rudimentary buildings and

the boats at harbor. His chart can be fitted exactly into the world map centered on Greenwich. In his journal he records, with the same linear instrumentalism, his first impressions of the harbour (figure 10.1).[1]

During April, the following month, the convict Francis Fowkes sketched the same place (figure 10.2). Despite the detailing, coloring, and coding added by engravers in London, it is obvious that Fowkes sees the place quite differently, that his priorities are sites of work, living, and control, as well as food sources. His sketch evokes no larger vision, implies nothing beyond its vague borders. No written record of Fowkes's views survives.

Both Hunter and Fowkes made instrumental images, aides to survival. They converge stylistically, but only because they were both re-presented in the same, other place, that is, London. Beneath these changes aimed at making them similar, we can discern the traces of original lines made by people in possession of quite different degrees, and kinds, of power.[2] The perspectives of people like Fowkes rarely appear in colonial representations of any kind—indeed, images of them, and of convicts as a class, are rare to the point not just of oversight but of repression. The practices of calibration, so clearly exemplified by Hunter's mapping, lead to their own kind of obliteration: they erase the perspectives of the victims and the slaves of imperialism.

Yet there is, already, another significant absence. Nowhere in the drawings of either man is there any sign that prior to their mapping of this place there had been others who, for many thousands of years, had lived in it, and represented their relationships to it. The approximately three thousand Dharug (Dharruk), Dharawal, and Kuring-gai peoples of the region had developed systems of marking their bodies, implements, and shields with traditional designs, and of representing animals and spirit figures by charcoal drawings inside caves and by elaborate engravings into open rock. But disease, murder, and dispossession devastated their society. As the convict period drew to a close around 1850, fewer than three hundred remained in the region. While the large number of images of Aborigines by white settlers enable us to trace their perception of the original inhabitants, it is impossible to trace to the period an Aboriginal visualization of convictism, nor even of the territory of its occurrence.[3]

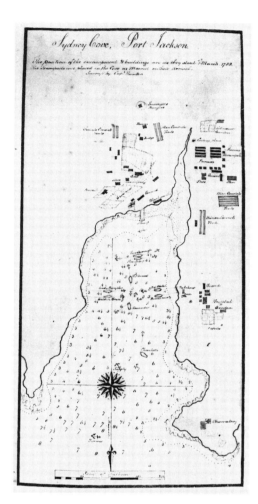

Fig. 10.1. John Hunter and William Bradley, *Sketch of Sydney Cove*, in John Hunter, *An Historical Journal of Events at Sydney and at Sea 1787–1792* (London, 1793), 29. Courtesy of the Mitchell Library, State Library of New South Wales [Safe 1/14].

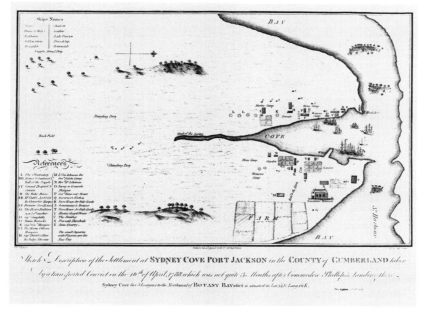

Fig. 10.2. Francis Fowkes (attributed), *Sketch and Description of the Settlement at Sydney Cove taken by a transported convict on 16th April 1788*, published R. Cribb, London, July 24, 1789, hand-colored engraving, 31 × 19 cm. Courtesy of the National Library of Australia, Canberra.

Aboriginal "Mapping"

It is possible, however, to extrapolate backward from practices of mapping in recent and contemporary Aboriginal representation. Given that every aspect of Aboriginal identity originates in the earth, takes form as a figuring of an aspect of a wide variety of relationships to the land, and constantly refers back to one's place as the foundation of being, then it is scarcely surprising that representations of territory constitute the most significant frameworks for sacred ceremony and are a frequently occurring subject in the many kinds of sacred/secular art forms which circulate beyond tribal communities to serve the burgeoning interest in contemporary Aboriginal art.[4] Nothing survives from the Sydney Cove region, but "mappings" of those areas throughout the Australian continent in which Aboriginal communities remain active are commonplace.

They occur in all forms of Aboriginal art: in body marking for ceremony,

as symbols on sacred message boards and burial poles, in sand paintings and in paintings using natural ochres on rock walls and on bark. There is rich evidence that these practices are many thousands of years old, the earliest forms dating to perhaps 40,000 year BP. They remain the primary content of art made by current Aboriginal artists who live and work in tribal settings. For those artists who live away from their communities, or who are the children of those separated from their families during the assimilationist period of the 1940s and 1950s, actual or psychic journeying is a frequent subject. In the work of Aboriginal artists living in the predominantly white cities and country towns the effects of dispossession are often registered as a traumatic yearning, in the art of Judy Watson, Tracey Moffatt, Gordon Bennett, and Fiona Foley, for example.[5]

Australian Aboriginal picturing of the land is, then, not a precise cartography, oriented north–south, east–west, nor set out in measured distances, with objects drawn to scale and events located exactly in time. It is a visual provocation to ceremonial song, to the telling of elaborate narratives of how and why the Originary Beings created Earth and everything in it, how the Ancestor Figures lived and where they went, their journeying, their acts, their example. These movements generated and differentiated the land; every land form, every element of the flora and fauna is evidence of their passage—and of their continuing presence, especially as their descendants reenact their creativity in sacred ceremony and in sacred/secular art.[6]

In this context, meaning is conveyed on four different levels. Each of these has two aspects, and all operate simultaneously, reinforcing each other. The paintings work as a depiction through inherited forms and techniques of stories, events, and figures of sacred significance, as both the broad narrative involving many related people, and as a specific moment or moral particular to the ancestors of the artist; as a visual writing of a place owned by the dreamer-painter, including journeys across it, both by the sacred originators and by the artist as a hunter or gatherer; as a witness that the duty of representing or singing the dreaming has been done, thus constituting a restatement of title or deed to the land indicated; and finally as an individual interpretation of these duties and practices, varying somewhat, and thus keeping alive, the obligations and pleasures of painting. Self-expression is important; but less so than all the other reasons for painting.[7]

While not all examples of Aboriginal art display this degree of complexity and subtlety, many do so. A striking example is the painting *War-lugulong*, made in 1976 by brothers Clifford Possum and Tim Leura Tjapal-

Fig. 10.3. Clifford Possum Tjapaltjarri and Tim Leura Tjapaltjarri, *Warlugulong*, 1976.
Synthetic polymer paint on canvas, 168.5 × 170.5 cm. Art Gallery of New South Wales.
Copyright Aboriginal Artists Agency Limited. Photo: Christopher Snee for AGNSW.

tjarri (figure 10.3). Both are from the Anmatyerre/Aranda language group,
whose lands are vast tracts of the Central Desert, largely to the north and
east of the town of Alice Springs. It is one of the first major statements to
be made by artists working within the painting movement which began at
Papunya, a settlement west of Alice, in 1971.[8] Within that tendency, artists
use sticks or reeds to juxtapose dots of acrylic on canvas surfaces, in a man-
ner which echoes the practice used in making ceremonial sand paintings, of
depositing small mounds of differently colored sands or crushed vegetative
matter such that the overall configuration sets out a sacred ground. Sand
paintings of these sacred subjects have been made for many thousands of
years. The normal practice is for them to be used as the central physical and

spiritual focus of the ceremony, which can last for some hours or for many days, and then for them to be swept up or left to the elements.

Warlugulong is the name for fire, particularly a series of Ancestor Figure stories associated with fire in an area near the present-day town of Yuen-dumu, about three hundred kilometers northwest of Alice Springs. War-lugulong is an actual site near Yuendumu where the Ancestor man Lung-kata, whose original form was the blue-tongue lizard, punished his two sons for killing and eating a sacred kangaroo by setting the bush alight. Its ex-plosive flames may be seen in the center of the canvas, the tracks of human footprints above being left by the fleeing sons. The waving lines between concentric circles indicate another major narrative of origination: at the top of the image, the Great Snake Yarapiri is shown traveling from Winparku, two hundred kilometers west of Alice, through limestone country. Other, lesser connected lines and circles relate to other snakes and snake men whose journeys through these regions were devoted to instructing locals in cere-monial matters.

The white emu tracks moving from the upper left to the lower center of the painting indicate the path of an Emu Ancestor from near what is now Napperby Station (fifty kilometers east of Yuendumu). He met with emu men from Walpiri regions nearby, and shared food with them, establish-ing the possibility of harmonious relationships between the Walpiri and the Anmateyrre. The brown human footprints through the lower right area re-call happy exchanges of the prolific supplies of food in the region between women from the two tribes. The possum tracks along the bottom edge of the painting are traces of a less happy story: one of warring between pos-sum men and hare wallaby men. The unlinked circles on the right relate to the killing of an euro (a hill kangaroo) by a wedge-tailed eagle. There are also a number of other narratives, ranging all the way back to the Origi-nary Beings who created this area, through the ancient Ancestor Figures to not-so-distant relatives of the present-day artists. The variegated patches of dots throughout the work evoke the kinds of country in which these events occurred: white areas indicate water, orange the color of sand, black the burned-out areas, and so on.

These various stories are set out as inscribing an area of country, as liter-ally making it what it is, as being alive within it. This means that the paint-ing *Warlugulong* is a conceptual field of these occurrences, these memo-ries, these continuing actualities. While all of the narratives depicted can be traced on actual ground—indeed, this is what much sacred ceremony

consists of, it is an actual going over the same ground and then a convening in one place, around a sand painting of the whole ground, to ritualize the knowing of it—this painting does not set them out in the same spatial relationships one would expect to find in a European map. The artists changed the north–south axis in the case of each of the main stories shown: the two sons fled south but are shown as going upward (north on a European map), Yarapiri traveled south to north but is shown moving left to right (east to west on a European map). Taking just these two together requires a "spinning in space above the landscape" on the part of a spectator who wishes to remain anchored, or better, a letting go of Western spectatorship.[9]

Aestheticization: Land into Landscape

Why were panoramic views of the newly settled colonies so popular during the late eighteenth and early nineteenth centuries? The many long, horizontal views of Sydney Cove, each one securely knowing that it would be succeeded by another, seem to be staging the processes of colonization, as if the emergent social order could be measured as it grows against an increasingly clearly understood natural topology. This is a technique of reportage, an extension of the necessary business of mapping the coastline. An aesthetic with great appeal to a maritime people, a social order whose empire depended on control of the seas.

Many areas of Terra Australis were depicted as if they were recognizably like, or approximate to, specific English landscapes. This not only reinforces a sense of familiarity, it does so with a purpose: to promote free emigration to the colonies, an outcome greatly desired from the 1820s, becoming a necessity with the cessation of transportation in the 1840s. Joseph Lycett's *Views* are an early instance, and were continued in many publications and presentations, such as the London exhibitions of John Glover and John Skinner Prout. Related to this is the enthusiasm for literally transforming suitable areas of land into approximations of environments in England or Scotland, by imposing similar modes of cultivation in farming lands and laying out huge public garden spaces in the main cities (returning them to walk-through pasture, as it were, but in picturesque modes). Both of these processes shape *The Town of Sydney in New South Wales*, a set of watercolors made by Major James Taylor, probably in 1821, which trace a 360-degree panorama around Sydney Cove from what is now Observatory Hill. In London two years later three of them were printed as hand-colored aqua-

tints by Robert Havell & Sons and published by Colnaghi & Co. The set was intended as a gift to key government officials, to be purchased by the small group of gentlemen who collected books and prints of the colonies, and to be of interest to those concerned with the current controversy about the political direction of the colony. At the same time, Taylor's "designs" formed the basis of a full-scale display at Barker & Burford's Panorama in Leicester Square. The message is clear: Georgian order can bring English civilization to the wildest, and most distant, places on the Earth. It is a utopia specific to Sydney Town: each figure encapsulates a particular dream of social mobility, of rising above the realities of harsh circumstances, exclusive class divisions, brutal systems of punishment, and the ghostly presence of strange, dark otherness. This was possible, in fact, for some. In Major Taylor's vision it was happening to all, right before their eyes.[10]

By the 1850s an instrumental imagery returned, briefly, to prominence, especially with the pragmatics demanded by picturing of the goldfields of Victoria—a site which captured world attention, and attracted the adventurous from everywhere. During the 1860s, however, with the return of the pastoral industries to economic, social, and political preeminence, the evidently aesthetic category of the landscape became the preferred vehicle to release a set of symbolic purposes. This occurred most clearly in a genre of paintings which can only be called "portraits of property."

The master of this genre was the Swiss-born immigrant Eugene Von Guérard. His Western District propertyscapes celebrate not just the results and rewards of decades of development, but something of the transformatory power of pastoralism as a set of practices for controlling natural forces so subtlety successful that they become themselves an ordering principle—of people, animals, places, and things. His 1864 image, *Yalla-y-Poora*, is outstanding among these. There is, certainly, a careful record of the signs of recent success: the Italianate style house, the imported trees, and sulky. These are the superfice; the real question is: what is the setting which von Guérard has activated? The work of the farm is conveyed not through the static overall gestalt but through the visual journeying within it: in looking, we rehearse the processes of working over the land. We do so through the geometry underlining the narrative passages. Split into halves by an emphatic horizon line, the upper half of Grampians and sky shows the natural world changing slowly, majestically, relentlessly, according to a geologic, while the human industrial transformations below hang from the horizon in ways which could be agitated, even discordant, but are absorbed into a matching

harmony by the figure-of-eight (a virtual Möbius strip) of the ornamental lake and the passages around and across it. This subdued but nevertheless vital drama unfolds before us, as we "walk" across the few rocks in the foreground to join the traveler at the fence marveling at the power—and the equivalence—of these two "natural," transcendent orders. Von Guérard shows this not only by picturing it, but also by subjecting the compositional potentialities of illusionistic naturalism to its limits. He creates here something close to the heart of painting's own paradoxical freezing of time, a nearly still geometry of implacable change. This is a visual metaphor of pastoralism's processing of the land which will echo for nearly a century.[11]

Aestheticism reaches its most precise, calibrated form in works such as this. Everything which the natural world does, everything which human beings strive to do to it, is subject to the measuring eye. But what an eye! There is no indigenous person to be seen, nor any traces of an indigenous presence on the surface or structure of this scene—the processes of obliteration have done their work. This scene was brought into this being by the labor of the colonizer, but this human effort has become something larger, more implacable. It has become a virtual civilization, a calibrating machine, a world imposed on the rawness of Nature by perfect measurement itself. For a moment, we look at the world as presented by this picture, and see the world through the superhuman eye of this picture. Our merely human seeing disappears, and for a moment, virtually, we see with, and are ourselves, the Eye of Seeing itself—what von Guérard (fantasizing back to late medieval holy innocence, and in parallel with William Blake's joy to the world) would imagine to be the Eye of God.

Triangulations—Coincidences

The coincidence on the Australian continent since the late eighteenth century of its first people's creation of a rich culture in conditions of scarcity and the expansive, transformative marauding of European imperialism threw into sharp relief several divergent practices of seeing. I will conclude by highlighting the three which have occupied us here.

Colonists such as Hunter applied to this strange place a supra-human regime of measurement, one which was capable of fitting any phenomena that came before it into a frame. Each frame was a separate section of a larger whole, itself made up of a huge but finite number of similar sets: latitude, and soon longitude, calibrated from Greenwich. That which did not

fit the frame, which was not measurable by such framing, was simply not seen, was effectively obliterated. As settlement progressed to a point when it needed to introduce its own practices of selective forgetting, landscape became more and more prominent, both in actual journeying and in the distilled visitation of the painted image. Artistic landscapes "improve" human observation, idealize it, aestheticize it. Sometimes, *aestheticization* induces such passages of reflexive engagement that it transcends itself to being, almost, a "pure" kind of vision—seeing as if done by a disembodied eye. In contrast, Aboriginal representation of territory—as far as one can generalize from such a variety of practices among what were over nine hundred language groups (now ninety) throughout the continent—does not calibrate in the sense of measuring distance or plotting exact locations on Earth's surface. Nor does it use the landscape forms of either Western or Eastern traditions, except by occasional adoption and adaptation. It is the product of a group of people standing together, leaning over a piece of ground or bark or the prone body of a ritual relation, and, taking this surface as a field for evocation, making the marks—the signifying "designs"—which trace how the larger surround—one's "country"—came into being. Painting and singing continue this sacred ground into the present. Ceremony and art-making repeat the imbrication of the bodies and spirits of men and women into the actual, and the reimagined, ground. It is a representing which preceded the era of colonization, and will supersede it. It is a murmuring and a mark-making which is incessant.

Notes

Terry Smith, "Visual Regimes of Colonisation: European and Aboriginal Seeing in Australia," in *Paysage et Art*, ed. Ulpiano Toledo Bezeera de Meneses, 91–100. São Paulo: Comité Brasileiro de Historia da Arte, 2000. Reprinted with permission of the publisher.

1 "It had rather an unpromising appearance, on entering between the outer heads or capes that form its entrance, which are high, rugged, and perpendicular cliffs; but we had not gone far in, before we discovered a large branch extending to the southward; into this we went, and soon found ourselves perfectly land-locked, with a good depth of water." John Hunter, *An Historical Journal of Events at Sydney and at Sea 1787–1792*, ed. J. Bach (1793; Sydney, 1968), 29.

2 The *Sketch of Sydney Cove* by John Hunter and William Dawes was in Hunter's *Journal*, copy in the Mitchell Library, Sydney. Fowkes's *Sketch and Description of the Settlement at Sydney Cove* was published in London by R. Cribb on July 24,

1789; a copy is in the National Library of Australia, Canberra. Both are discussed in the relevant entries in Joan Kerr, ed., *The Dictionary of Australian Artists: Painters, Sketchers, Photographers and Engravers to 1870* (Melbourne: Oxford University Press, 1992).

3 F. D. McCarthy, *Catalogue of Rock Engravings in the Sydney-Hawkesbury District* (Sydney: New South Wales National Parks and Wildlife Service, 1983); Peter Stanbury and John Clegg, *A Field Guide to Aboriginal Rock Engravings, with Special Reference to Those Around Sydney* (Sydney: Sydney University Press, 1990); Peter Turbett, *The Aborigines of the Sydney District before 1788* (Kenthurst: Kangaroo Press, 1989).

4 See, for example, Fred R. Myers, *Pintupi Country, Pintupi Self: Sentiment, Place and Politics among Western Desert Aborigines* (Washington and Canberra: Smithsonian Institution and Aboriginal Studies Press, 1986).

5 For good general introductions to Australian Aboriginal art, see, for example, Robert Edwards, *Australian Aboriginal Art* (Canberra: Australian Institute of Aboriginal Studies, 1974, 1979); Peter Sutton, ed., *Dreaming: The Art of Aboriginal Australia* (Melbourne: Viking, 1988); Jennifer Isaacs, *Arts of the Dreaming, Australia's Living Heritage* (Sydney: Lansdowne, 1984); Jennifer Isaacs, *Australian Aboriginal Painting* (Sydney: Craftsman House, 1989); Wally Caruana, *Aboriginal Art* (London: Thames & Hudson, 1993); and Howard Morphy, *Aboriginal Art* (London: Phaidon, 1998).

6 On "mapping," see particularly Sutton, *Dreamings*, and Morphy, *Aboriginal Art*, chapter 4.

7 This is a reformulation of an account given in Terry Smith, "From the Desert," in Bernard Smith with Terry Smith, *Australian Painting 1788–1990* (Melbourne: Oxford University Press, 1991), chap. 15.

8 Geoffrey Bardon, *Papunya Tula: Art of the Western Desert* (Melbourne: McPhee Gribble, 1991).

9 Vivien Johnson, *The Art of Clifford Possum Tjalpaltjarri* (Sydney: Gordon and Breach International, 1994), 54.

10 For more detailed discussion of this work, see Robert Dixon, "Colonial Newsreel," in Daniel Thomas, *Creating Australia, 200 Years of Art 1788–1988* (Adelaide: Art Gallery of South Australia, 1988), 66–67; Elisabeth Imashev, "Taylor, James," in: *Dictionary of Australian Artists*, ed. Joan Kerr (Melbourne: Oxford University Press, 1992), 780; Tim McCormick, ed., *First Views of Australia. 1788–1825* (Sydney: David Ell Press, 1987); and Gordon Bull, "Taking Place: Panorama and Panopticon in the Colonization of New South Wales," *Australian Journal of Art* 12 (1995): 75–95.

11 For further discussion of this work, and of the themes of this essay, see Terry Smith, *Transformations in Australian Art*, vol. 1, *The Nineteenth Century: Landscape, Colony and Nation* (Sydney: Craftsman House, 2002), 44–65.

PART 4

The Imperial Lens

CHAPTER 11

The Photography Complex:
Exposing Boxer-Era China
(1900–1901), Making Civilization
James L. Hevia

Perhaps no technological innovation of the nineteenth century compressed time and space more effectively and efficiently than photography. Certainly none did it in quite the same way. Photography not only created a sense of simultaneous temporal presence between a viewer and the images in a photographic print, but was capable of bringing distant and remote places into the visible space of a viewing subject. It accomplished this spatiotemporal compression through a marvelous sleight of hand. Photographs were understood to be a perfect mimetic medium, one that delivered an unmediated and pure duplication of another reality. Moreover, it could mime itself in an eminently replicable form for wide dissemination and inclusion in other forms of media. Copies could be inserted into books, pamphlets, newspapers, magazines, posters, slides, and stereographic apparatuses (of which more will be said below). The photograph could also be rerendered using older technologies such as engraved etchings. In a concise blending of animate and inanimate materiality, Oliver Wendell Holmes, in an 1859 article, captured the mimetic reproductive potentials of photography when he referred to the photograph as a "mirror with a memory."[1]

Yet it was, of course, not so simple as that. Even Holmes, who was himself a superlative promoter of photography and stereography, knew as much. The more he was drawn to the new medium, as much as he fantasized about a photographic archive so vast and immense that it could store all of reality, he was also concerned with the illusory qualities of the photograph.[2] As he put it in a less sanguine moment, the photographic image did not so much mirror the real as create an "appearance of reality that cheats the senses with its seeming truth."[3] The tension evident here between "appearances" and the memory mirror points to a certain discomfort with the unmediated, a sense

that there was more to the event of producing a photograph than a simple reflection—that the purported mirror effect of the reproducible image was itself an ideological construct that hid as much as it exposed.

Such skepticism about the ontological and epistemological status of the photograph remains a significant point of departure for critical traditions that interrogate representations. This kind of critique has also been important for constructivist social history, for histories of reception, and for phenomenological approaches to perception and visuality. Although these critical engagements with photography have been theoretically and empirically productive, they have tended to keep critical attention focused on the printed image itself, whether it stood alone or was embedded in a sociopolitical context. To put this another way, Holmesian-style skepticism tended to focus attention on the effects of photography—the end product, the outcome—rather than on the technomaterial process of photographic production and reproduction.

In part, this fixation on the image, and the variety of fetishisms that have resulted from it, is due to the ubiquity of the photograph. While mechanically reproduced photographs suffuse the social world in which many of us live, the multifaceted phases of the photography complex (of which the printed image is merely a part of the production process) remain relatively obscure. As a result of this occlusion, the image has been given precedence and ontological priority over other elements which temporally precede or follow upon it. Regardless of whether the photograph is isolated through aesthetic analysis or its reception is seen as part of a social process, the elements of production are usually perceived in an instrumental relationship to their "output," the photograph. This is not an unusual situation in studies on the relationship between technology and cultural production. As Daniel Headrick has noted in his discussion of the relation between technology and imperialism, the technological object is often divorced from its social production and naturalized as a passive object.[4] Others, such as Bruno Latour and Donna Haraway, have drawn attention to the propensity to identify clear ontological demarcations between the "mechanical" and the "human." Latour in particular has suggested ways of thinking about more complex agents momentarily made up of different materialities (microbes, slides, chemical solutions, barnyard animals, an entity known as Pasteur, the microscope).[5]

In terms suggested by Latour, we might, therefore, see the photography complex as a network of actants made up of human and nonhuman parts,

such as the camera (including its container, lenses, treated plates, moving parts, and the many variations of its form), optics theory, negatives, and chemicals for the development of "positive" prints (the albumen process, the moist collodion process, gelatin emulsions, dry plates). There is also the staggering array of reproductive technologies through which images move and circulate, especially those for printing photographs in books and newspapers (e.g., photolithography, photography-on-the-[wood]-block, line engraving, photogravure, and process halftone engraving).[6] Then there is the photographer, that which is photographed, the transportation and communication networks along which all of these parts travel, and the production and distribution networks that link faraway places to end users. There is also the question of storage and preservation; the image cannot be redistributed unless it is saved, so there must be a photographic archive. Such an archive is itself a new reality, one that is embedded in a unique Euro-American cultural formation that emerged in the second half of the nineteenth century and continues to the present, and whose epistemological status requires attention. Last, it would probably be unfair not to include in the complex light itself (waves? pulses?) as an author or actant (photography = light writing). When put in these terms, photography seems to be more like a heading under which a range of agencies, animate and inanimate, visible and invisible, are clustered.

But this Latourian-inspired arrangement is only part of the issue. These elements of the photography complex not only posit a more intricate set of relationships than the usual tripartite division photographer/camera/photograph; they also suggest a novel form of agency, one understood in terms of the capacity to mobilize and deploy elements for generating new material realities. The photograph is thus neither reflection nor representation of the real, but a kind of metonymic sign of the photography complex in operation.

What I propose to do in this chapter is explore this complex and some of the novel realities it generated in the early decades of its global development. To do this, I intend to slice into the complex at a particular historical moment in which its outlines appear particularly susceptible to scrutiny, serving up a snapshot. My objective is to demonstrate not only how new realities are instantiated via the photography complex, but how older realties could be incorporated to create the illusion of an almost seamless fit between past and present. The spatiotemporal moment in question is China 1900–1901, the period of the Boxer Uprising and the multinational invasion and occu-

pation of north China that resulted. I have selected this moment not simply because I am familiar with much of its history. It is also the case that contemporary developments in camera and print technology made the photography complex ubiquitous in the events surrounding the uprising and the occupation. Equally important, there remains an enormous archive of the photographs produced at that time, an archive that continues to reproduce images of China in academic and commercial publications.

Within this cross-section I examine four aspects of the complex. The first of these involves what Daniel Headrick has termed the "tools of empire." Here I will deal with the complex as a kind of multiapplication apparatus (not unlike a Swiss army knife) that has the capacity not only to expose and copy things, but to pry them open. The process of opening, exposing, and replicating seems to have been understood by contemporaries as having effects that not only documented reality but fundamentally altered it. The second aspect to be explored involves the relationship between photographic images and different forms of representation that also circulate through the complex, such as written description and other visual media (e.g., etchings, drawing, maps). The third element involves an unusual and now almost forgotten aspect of the complex, stereography. Perhaps at the time the densest and most complicated of all the subsystems within the complex, the stereographic component will require not only a degree of explanation but a consideration of its rather unusual status within our present. The last element of this cross-section involves reproductive technologies used by the popular press, in particular those apparatuses that lend themselves to the easy appropriation of the image and the implications for their dissemination of the photographic print. I begin with the photography complex as a tool of empire.

Tool of Empire

European imperial powers entered China in force in 1900 to suppress the violent Chinese reaction to the European presence conventionally known as the Boxer Uprising or Rebellion. The Boxers had emerged as a loose-knit anti-Christian social movement in 1898 and began to attack Christian missionary stations and Chinese Christian converts the following year. In north China, in and around the capital of Beijing, the Boxers also destroyed railroad and telegraph lines and, eventually, in collusion with Qing Dynasty military forces, attacked the Western enclaves outside the city of Tianjin

and the legation quarter in Beijing, laying siege to the latter. The European powers—Great Britain, Germany, France, Austria, Italy, Russia—and the United States and Japan dispatched military contingents to relieve the besieged legations. Once this was accomplished, the powers were determined to punish and teach lessons to the Chinese government and people for their assault against "civilization." In this large-scale project, the photography complex functioned as an apparatus of surveillance documenting the "reality" of Boxer China and as an instrument of punishment and lesson teaching.[7]

DOCUMENTATION

The camera was present from the moment the allies disembarked on the China coast near Tianjin, and it recorded the campaign from there to the capital. Once in Beijing, each of the occupying countries was intent on creating, as the American commander General Adna Chaffee put it, "a record of our occupation of Peking."[8] The Forbidden City was an especially popular subject for photography, with the French even launching a balloon to capture the city from above, but there were quite literally thousands of photographs taken by military and civilian photographers in and outside Beijing. This hypersensitivity to the documentary power of photography was paralleled by the participation of the camera in performances of power. Photographers, often en masse, recorded spectacular staged events, such as a "triumphal march" through the Forbidden City and the executions of purported Boxers.[9]

A look at the photographic record of the U.S. Army helps illustrate this process. Early in the occupation, Capt. Cornelius Francis O'Keefe, the official army photographer, was ordered to photograph sites in Tianjin, Shanhaiguan, and Beijing and its environs where American forces were operating.[10] These efforts were understood to be an official documentary project; that is, it was to create a public record of the American presence in China and transfer that record to archival depositories in the United States.[11] Over the course of the fall and winter of 1900–1901, O'Keefe produced well over a hundred photographic plates, many printed versions of which are in the U.S. National Archives in College Park, Maryland. The subjects include the "principal throne room" and halls of the Qing imperial palaces (the Forbidden City); the water gate under the Tartar Wall, where allied forces entered the city, and the Tartar Wall itself; the Summer Palace; the Great Wall and Ming tombs; the fort at Shanhaiguan (on the coast a few hun-

dred miles northeast of Beijing); the Temple of Agriculture; and the Temple of Heaven. O'Keefe also photographed U.S. troops advancing on Beijing, General Chaffee receiving a Chinese delegation, group photographs of participants in the occupation, and soldiers of the allied armies. One of the photographs, labeled as having been exhibited at the Louisiana Purchase Exposition (1904), is of the triumphal march through the Forbidden City, which involved contingents from each of the allied armies. There is also a picture of the photographer and his equipment and of a group of photographers prepared to shoot the triumphal march.[12]

O'Keefe's photographs rarely involved human figures, unless the piece was staged, and they appear to have been almost exclusively used to produce the visual record Chaffee had ordered of the encounter with Boxer China. What is perhaps most important to emphasize about O'Keefe's work is that it primarily provided illustrations to accompany the *already* written accounts of the American occupation produced by army command. The image followed on the text, with the latter functioning as a determinant of the former. At the same time, O'Keefe recorded little of the warfare itself; there is only one picture that has any signs of death and destruction.[13] If there was an ideological impetus in these pictures, therefore, it lay not in warfare itself but in the way Beijing was opened to the photographer's gaze, a gaze which sought physical reference points whose meaningful content was to be filled in by a source outside the photograph proper. Like the official report, the camera spent little time dwelling on death and destruction.[14]

A similar pattern of imperial state-based mobilization is discernible in what was perhaps the most ambitious photographic project launched in Beijing: a documentary view of the city and its environs carried out by a team of Japanese engineers from the University of Tokyo. Led by Ito Chuita and the photographer Ogawa Kazuma, the team published a collection under the title *Shinoku Pekin kojo shashincho* (Photographs of the Palace Buildings of Peking) in 1906. Apparently the only such publication contemporaneous with the occupation, the volume contained 170 photographs, with text in Japanese, Chinese, and English. The preface to the work indicates that the project was designed to document and expose that which "on account of secrecy" had been "jealously kept from public sight."[15]

Printed on oversize folio pages, the photographs themselves are quite stunning. In addition to images of all of the palaces and many of the side halls of the Forbidden City, the collection is of interest in the way human forms are related to architectural features. A picture of the Prayer Hall at

the Temple of Heaven was taken with a Sikh guard standing at the door. At the Temple of Agriculture a blanket hangs over a fence as a shirtless American soldier gazes out a window at the camera. The approach to the Supreme Harmony Hall was shot while foreign "tourists" walked toward the entrance door. In a Buddhist temple, two Europeans appear to be making a sketch or a rubbing. There is even a photograph of Chinese people near the Chaoyang gate getting water and fishing in the city moat.

These apparently candid compositions were seldom present in other photographs. Here, however, the composition may have had more than one purpose. According to the preface to the volume, this photographic record of Qing palaces was done for the purpose of "architectural study," that is, to enable the analysis of "the arrangement, construction, and decoration" of the Forbidden City and other palace grounds in the area.[16] Interest in the Qing imperial palaces for reasons other than punishment and humiliation was unusual, and at least two decades ahead of any similar kind of systematic archiving effort by Europeans or Americans.[17] As Jordan Sand has argued, Japanese interest in Qing imperial forms was part of an effort, in which Ito Chuita played a part, to produce a new architecture that would draw on East Asian traditions.[18] In this case, therefore, the photographing of Qing palaces and temples, with human beings occasionally in the frame to indicate a sense of scale, was designed not only to provide a visual record of events of 1900, but to document simultaneously a dying tradition, punctuated by the presence of foreign soldiers and "tourists" at the center of the old empire. The Japanese team treated the Forbidden City as if it were an exhibition that could then be salvaged to produce whole new realities in the form of a "traditionalist" East Asian architecture.

Other kinds of documentary photography are also worth consideration. For example, there were the many photographs that appeared in memoirs and histories published in the wake of the Boxer Uprising. The Reverend Arthur Smith's *China in Convulsion* (1901) collected the pictures of several missionary photographers, such as the Reverend C. A. Killie, who took photographs in the Forbidden City in April 1901.[19] There are shots of the imperial throne room and palace where the emperor lived, the ruins of the legation quarter, and many street scenes, including ones showing people identified as "Boxer Types" and "Manchu Types." Smith's volumes also contain a number of pictures of scenes from the siege, a group photograph of missionary siege survivors, ruined churches and mission stations, and some of the "missionary martyrs." Thus, the images in the Smith volumes provide

visual documentary evidence for the main stories of 1900: the siege of the legations, the persecution of Christians, and the punishment or humiliation of the Chinese emperor.

There are at least two photographs that appear to do more than document events, however. The first of these is a photograph captioned "Dr. Ament Receiving Village Deputation" set in Smith's text where the "ignorant charges" leveled by Mark Twain concerning missionary looting are disproved.[20] The faces of Chinese male villagers smiling at the camera presumably reinforces Smith's rebuttal. The other photograph shows "The First Train Passing through the Wall of Peking" at the "Great British Gate,"[21] an opening blasted through the outer wall of Beijing for the laying of track into the Temple of Heaven, the site of the British encampment during the occupation of the city. We see the blur of smoke from the stack and several soldiers standing beside or near the train, while a solitary upper-class Chinese person stands looking at the train. The composition is significant. No trains had ever entered Beijing before. Breaching the city wall, moreover, was understood as more than a utilitarian act: it also was thought of as striking at the pride of the city's wall-obsessed inhabitants. In these two instances, the camera does more than document. In staging and fixing an ideologically charged scene, the photography complex participates in and structures the punishment of China for transgressions against "civilization." To put this another way, even in its documentary form, the photography complex was more than supplement. Visual technology reworked the ground on which Western superiority was based and incorporated the masses into imperial adventures in new and productive ways.[22] In the case of China, words might demonstrate just how depraved, backward, or stagnant the Chinese were beneath their vaunted claims of cultural superiority. But the photography complex simultaneously depicted such shortcomings, and their opposite, Western moral and technological supremacy.

PUNISHMENT

As we have seen, the photography complex documented the progress of the allied expeditionary force into China, meticulously recording the details of its movements and providing the visual imagery for collateral projects such as the "missionary apologetics" launched by the Reverend Arthur Smith in *China in Convulsion*. In these instances, the photography complex was more than "a mirror with a memory" of events that unfolded in front of the camera's lens. It was an apparatus of action and intervention that helped

shape the reception of events in the aftermath of the war. Probably the best example of the constitutive aspects of the photography complex is the way the camera penetrated, revealed, and recorded what had previously been denied to the gaze of Euro-Americans, specifically the Qing Dynasty's audience halls and residences known to Europeans as the Forbidden City. These buildings were not only located in the very center of Beijing (just north of the foreign legation quarter), and thus seen as occupying the very heart of China's peculiar form of "Oriental despotism," but more important, they were a place no member of the Euro-American legations had entered since the establishment of legations in Beijing in 1861. It was also believed by foreigners that the city was the most "sacred" place in all of China, China's holy of holies.

Following the relief of the legations in August 1900, the palaces took on great importance as emblems of Chinese haughtiness and sites for the staging of humiliation. Desecrating the Forbidden City would be a direct blow to the emperor and his court, a fitting symbolic retaliation for having attacked Euro-Americans.[23] Western diplomatic and military officials in Beijing decided to perform an act of humiliation by staging a triumphal march directly through the center of the Forbidden City. Since many also believed (erroneously) that no "white man" had ever stepped inside the Forbidden City, this event could also be constructed in terms of a masculine geographical "discovery" expedition, much like those into Africa, Afghanistan, and other non-"white" and hence "dark" areas of the world. The march took place on August 28, 1900, with contingents from each of the eight armies marching right along the central axis through the palaces.[24] Cameras followed each step of the route, exposing the forbidden to the gaze of strangers and disclosing the city's secrets. A series of photographs of the march was published in *Leslie's Weekly* on November 3, 1900. The captions revel in the fact that the sacred had been violated and opened to scrutiny, while the photographs perform and record the humiliation of the Chinese emperor and his palaces.

Once the palaces had been thus ritually opened, the photography complex, with its capacity to write with light, was the ideal tool for accomplishing a further discovery and exposure of the dark interior of the Forbidden City. The process began with numerous photographs taken of the emperor's thrones and of the private quarters of the emperor and empress dowager.[25] Eventually the entire Forbidden City was inscribed by light onto photographic plates, developed, and widely circulated. Later, the palaces and other

imperial preserves, such as the Temple of Heaven and the Summer Palace outside of Beijing, were photographed, often with other kinds of staged events under way. For example, the thrones of the Forbidden City could be used as locations for diplomats such as the French minister M. Pichon and his entourage on which to pose; the Meridian Gate courtyard could be used for a memorial service for Queen Victoria in 1901; the grounds of the imperial palaces could be used to pose groups of visitors; and the stairs of the Prayer Hall at the Temple of Heaven made an ideal location for photographing the entire 16th Bengal Lancers in full dress uniform.[26]

In these and other instances, the photography complex was an integral part of the performance of Western imperial power in north China, making each of these acts of desecration more meaningful because they could be "staged" over and over again by simply taking additional photographs and reproducing the image (as has been done in a sense by showing them here). Moreover, because of its unusual capacity to act simultaneously as a participant, instrument, and record-keeper of aggressive acts of humiliation and punishment, the photography complex could both teach lessons (If you trifle with us, we will expose your secrets to the entire world) and record the reactions of the students to the lesson. Perhaps no image better captures the indexical and the constitutive aspects of the photography complex than an image that appeared on the cover of *Leslie's Weekly*, a popular American illustrated newspaper, on November 3, 1900 (figure 11.1). The caption reads, "Mandarins in the Palace Court-yard—Chinese watching with Indignation and Astonishment the Desecration of the Sacred City by the Allied Forces."

Text/Image—Image/Text

The photograph of Qing officials purportedly expressing shock and indignation at the presence of Westerners in the Forbidden City raises the question of the relationship between text and image in the photography complex. In this case, regardless of what might be interpreted from the expressions on the faces of these palace attendants, without the text, the image, if not mute, certainly has a limited vocabulary (men in long gowns with strange hats, one of whom is wearing spectacles. Are they Mandarins at all? Is this a staged event?). At a minimum, therefore, the caption seems essential for citing place and time. But this one does a bit more. Like the photographs of the march through the Forbidden City, it positions the image within a his-

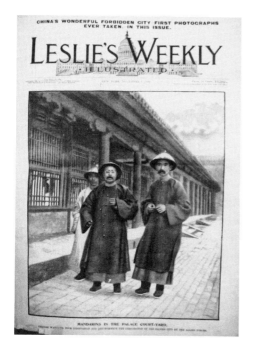

Fig. 11.1. "Mandarins in the Palace Court-yard." Cover of *Leslie's Weekly*, November 3, 1900.

tory of contact between China and Euro-American nation-states and, more broadly, within a history of colonial encounters. In the former case, the caption directs attention to the exclusion of Westerners from the imperial palaces throughout the nineteenth century. In the latter case, we are shown that it was not uncommon for Western armies to desecrate the sacred sites of others as an act of retribution or violent pedagogy. And while these Qing officials might be indignant and shocked, they are also quite helpless, as the photograph shows.

Whether specific to China or to other colonial situations, the point is that the references mobilized to help the image speak exist outside of the image proper. They are drawn from imperial archives, those vast epistemological networks for gathering, processing, cataloging, and filing information about other people and places.[27] These information systems were not only essential for planning and administering the work of Western imperial officials both in the colonies and in the imperial metropole, but through the broad dissemination in popular media of imperial knowledge about others they provided the fundamental touchstones for the journalistic coverage of

any event that might occur across the expanse of empire and in areas peripheral to it. To put this another way, any image produced in the photography complex existed in relation to a preexisting body of imperial knowledge and popular reporting about China and the Chinese people.

The capacity for linking elements of the epistemological complex of empire with those generated through the photography complex was, therefore, critical. As a way of considering this relationship, I turn again to Bruno Latour and his discussion of objects, such as photographs, that he has termed *immutable mobiles*, immutable in the sense that they do not alter their material character or degenerate as they travel and in the sense that they can achieve *optical consistency*. Such traveling inscriptions and images are consistent and comparable with each other because they are presentable, legible, scalable, and combinable with other, similarly constructed things on flat surfaces (e.g., Mercator projection maps, census data, commercial reports, notes on natural history and human behavior). With real subjects and objects in the world translated onto the two-dimensional surface of the page or the plate, they could now be manipulated through various representational devices: English descriptive prose, statistics, tables, charts, and maps. Once this sort of optical consistency was achieved, once the drawings, the numbers, the images, and the descriptions were arranged on a common surface and in a compatible scale, the photographic immutable could become highly mobile. On paper, faraway things were transported to other sites where they could be held in the hands of one person and scanned by his two eyes, as well as reproduced and spread at little cost throughout the networks of empire. It was thus possible to project, at ever accelerated rates, instances of one time and space into other times and other places. At collection sites, accumulated information of this kind allowed work to be planned and manpower to be dispatched. It also allowed authority to collect at the site where the many immutable mobiles converged and, in cases such as the one considered here, a consensus to be forged by the imperial state about its actions in China.[28]

Latour's description of immutable mobiles seems a useful way to introduce a booklet published by the Visitors' Inquiry Association at the famous resort town of Brighton. Its bold black ink announces against a blood-red background UNIQUE PHOTOGRAPHS OF THE EXECUTION OF BOXERS IN CHINA. Selling for the hefty sum of five shillings (an illustrated tourist guide to Brighton was advertised in the same publication for sixpence),[29] the booklet presented four photographs in an order that created the illusion

of a temporal sequence. Probably printed in the screened halftone engraving process,[30] they were accompanied by a text that told a story about public executions in China within the framework of the unquestioned moral superiority of the British.

The first photograph, "Led to Execution," is followed by a full-page discussion by an author identified only as R. N. The opening sentences set the style of the commentary. It is a collection of clichés about China and the Qing realm, facts or assertions that the photograph purportedly confirms. Drawing attention to the first photograph, R. N. notes, "These Illustrations, the result of the camera, . . . give some idea how callous and indifferent the Chinese are to their final exit from the world; they commit suicide as a solution of a difficulty, and endure the most cruel and painful tortures with indifference. . . . The Mongolian race is confessedly obtuse, nerved and insensible to suffering. . . . Chinese criminals do not suffer nearly as much as members of more sensitive races would under similar conditions."[31]

This collection of "Chinese characteristics" is imperial archival knowledge of the first order. The passage comes from the article on China written by Robert K. Douglas, a former British consul in China; a professor of Chinese at King's College, London; and keeper of the Oriental and Printed Books collection at the British Library, for the ninth edition of the *Enyclopaedia Britannica*. R. N. copied passages verbatim without citation.[32] But that is not the most interesting point to be made about this instance of plagiarizing the imperial archive. The unimpeachable source on the physical characteristics of the "Chinaman" and Chinese cruelty does more than simply provide racial details to accompany the photographs. Here the archive functions not only to create a precise interface between knowledge of the locale and the imperial state, but to ensure that the latter is not polluted by the former: photograph confirms text, text reinforces photograph, rendering a timeless and remote "China-land." There is no acknowledgment, indeed, no hint that the activities of the British imperial state might in some way be connected to what is recorded in the photographs. Instead, we are told that although there is no apology for "the refined cruelties inflicted on Chinamen by Chinamen," the "presence of European officers at 'The Executions' prevented cruel and needless torture . . . torture of any description being very abhorrent to an Englishman."[33]

From this position of superiority constituted by the graphic display of Chinese executions, the author could conclude, "These unique illustrations

cannot be viewed without pain and repugnance. However, it is not with any view of gratifying a morbid curiosity that these are offered to the public, but for a three-fold purpose: To enlist our sympathy for an unfortunate people; to arouse in our hearts a strong abhorrence of cruel practices; and to cause us to feel thankfulness that we live in a land where Justice is tempered with Mercy."[34]

While this conflation of the social world of the viewer with the interests of the imperial state may seem unexceptional—it is repeated in the press coverage of all the "little wars" of the British empire in this era[35]—the combination of image and archive serves to position this assault of Chinese "barbarisms" against Christian civilization within the masculine moral universe of British imperial warfare. In operations like this one, the photography complex helped enfold China into a global narrative of the righteous use of violence and the just punishment of the guilty.

Virtual Tours

Perhaps the most spectacular image or text of the time, and one that found innovative ways of resolving the contradictions of Euro-American behavior in China, was the stereographic project of James Ricalton. Published under the title *China through the Stereoscope*, with maps, diagrams, and a lengthy text written by Ricalton, the work was part of Underwood & Underwood's "stereoscopic tours" series that included India, Palestine, Russia, the Paris Exposition of 1889, and southern and eastern Europe. The form itself, now mostly forgotten, was one of the more ambitious representational projects of its time. Indeed, in terms of technological sophistication and the way it melded multiple media, stereography was both the state of the art and ahead of its time. It was also the form of photography for which Oliver Wendell Holmes imagined vast libraries.[36]

Stereography had been a photographic technology since the middle of the nineteenth century. Its basic purpose was to add a level of realism to the image by providing an exaggerated illusion of depth, or "hyperspace,"[37] in the photograph. This was done with a double-lens camera, whose negative was used to print side-by-side double images taken at slightly different angles. The results were then viewed through a stereoscope, a handheld mechanism with two lenses mounted at one end of a bar or piece of wood approximately twenty inches long, with a divider between the lenses. At the other end was an adjustable holder for a card printed with the double

image.[38] One slid the card holder along the bar while looking through the viewer, until the image clicked into an appearance of three dimensions.[39]

By the 1890s, although stereographs were available throughout Europe, the industry was dominated by companies based in the United States. Among these was Underwood & Underwood. Originating in Ottawa, Kansas, the company had expanded to New York and Baltimore by 1891, and to Toronto and London by the end of the century. In 1901, Underwood was producing 25,000 stereographs a day and 300,000 stereoscopes a year. The company pioneered a number of innovations, one of which is particularly relevant here. This was the boxed set, a kind of household version of the vast library about which Holmes fantasized. The sets ranged in size from ten to one hundred stereo cards and included maps, diagrams, and a guidebook. Imagined as a virtual tour of a famous or exotic place, Underwood's sets were available with English, French, German, Russian, Spanish, and Swedish captions and tour texts.[40] In addition, a unique copyrighted map was included that showed the exact position, direction, and boundaries of each stereograph.[41] With all this, plus the tour book, the viewer could mentally place himself or herself in the position of the camera, purportedly allowing a vision of a faraway world as it actually is. Like other boxed sets, *China through the Stereoscope* was made up of one hundred stereographs, a text, and eight maps; it sold in the United States for $17.60.[42]

Given both the dissemination of the images produced in this medium and the nature of the medium itself, the stereograph and the stereographic tour served to reinforce the more general cultural phenomenon of approaching the world as if it were an exhibition, while also generating new techniques and methodologies to do so.[43] Critical to this process was the constitution of new subject positions made by the wedding of the three-dimensional viewing apparatus with a written narrative and multiple kinds of diagrams. Indeed, one can imagine a complex subject made up of stereographic image, stereoscope, one or more viewers, diagram consulters, and readers or reciters of the travel text. What was operating here, in other words, was the potential for an active and interactive experience that offered up the world in a kind of hyperreal mode of presentation.

If we turn now to Ricalton's China tour, we may be better able to grasp some of the ideological work the photography complex can do. However, it should be borne in mind that because we have lost ready access to stereographic technology, there are certain limitations to what can be addressed. Today we confront the images as flat surfaces, whereas Ricalton discussed

them in the tour book as three-dimensional. However, while we may not be able to replicate the collective subject of the virtual tour, we can make an approximation.[44]

A perusal of the images makes it clear that Ricalton composed his stereographs to take full advantage of three-dimensionality: he photographed the emperor's throne at an angle, instead of head-on as most other photographers did [60], and placed his camera off to the side of the marble bridge at the Summer Palace so that there is a marked distance from the lower left foreground to the upper right background [70]. In addition, in virtually all of his pictures of architecture and scenery, there are human figures, sometimes many layers deep into the distance, that provide not only a sense of scale but a feeling of human contact, even intimacy [see 57; 52, a Beijing resident standing among the ruins of the legation quarter; 65, Imperial Observatory with a resident in the foreground; 69, Chinese man in foreground, Hill of Ten-thousand Ages in background].

Ricalton's photographic technique made for extremely dramatic compositions. This was especially the case in his coverage of the battle of Tianjin, where he insisted on showing at least some of the "horrors" of war. The dead, the wounded, and the destruction of the city appear in a succession of vivid shots [35, 39, 40]. One of these, titled "Terrible Destruction Caused by Bombardment and Fire, Tientsin" [41], is accompanied by a text that talks about the "sadness" of a deserted city, particularly one "sacked, looted, and in ashes, by a Christian army." The picture is bisected by a long thoroughfare, flanked by destroyed houses on either side. Up this street comes a "slow-moving line of homeless, weeping human beings—their homes in ashes, without food, friendless, and . . . their kindred left charred in the ruins of their homes." This picture of "pathetic desolation," painted in words and images, like much of the social realism common to the muckrakers of the era, appears to build sympathy for the victims of this disaster, humanizing the Chinese even as their way of life is shattered.[45]

Immediately, however, a second image appears, one that flips the entire tone of the presentation. The next stereograph is titled "Some of China's Trouble-makers—Boxer Prisoners at Tientsin" [42]. Often reproduced, this image is accompanied by a description that thrusts us out of the world of universal humanist empathy and into the realm of Arthur H. Smith's *Chinese Characteristics*.[46] Ricalton tells us that the group depicted had been rounded up by the "boys" of the Sixth Cavalry (in the background), who were certain that one of the Chinese, who was carrying a weapon, was an actual Boxer.

One of the soldiers, grabbing the "real thing" by the pigtail, thrusts him into the front row, where he sits, arms across his knees, squinting slightly at the camera. Ricalton then invited his viewers to take a closer look:

> This is truly a dusky and unattractive brood. One would scarcely expect to find natives of Borneo or the Fiji Islands more barbarous in appearance; and it is well known that a great proportion of the Boxer organization is of this sort; indeed we may even say by far the larger half of the population of the empire is of this low, poor, coolie class. How dark-skinned, how ill-clad, how lacking in intelligence, how dull, morose, miserable and vicious they appear! This view was made during a very hot day in a torrid sun: and still they sit here with their heads shaven and uncovered without a sign of discomfort.[47]

With race, social status (i.e., coolies), character, and physical peculiarities now firmly established—thematically this will continue through the rest of the journey—Ricalton recalls the form of the tour. In spite of "pathetic desolation" and vicious dark-skinned natives, this is travel in an exotic land, and we must return to the exhibition. "We are but a short distance from the Pei-ho. Leaving the Boxers with the guards, let us stroll to the river, where we may witness a novelty in transportation."

What are we to make of these abrupt shifts from sympathy to racial denigration to the soothing monologue of the tour guide? If we pause for a moment and compare the image and text of Ricalton with that found in the Brighton booklet, something of interest suggests itself. We have seen how both encourage the viewer and reader to see the images of China in terms of the accompanying text, which itself is a product of conventional wisdom. Although each of them expresses a distaste for violence, recall that the Brighton booklet firmly displaces aggression onto the Chinese people. Ricalton had a far more difficult problem because his stereographs included images of the destruction of Chinese cities by "Christian armies."

As the sequence discussed here indicates, Ricalton's presentation of Christian barbarism, repeated on other occasions throughout the text, was negated or justified by the encounter with the Boxers, producing what appears to be a zero-sum outcome. Yet not quite. Christian barbarism, as distasteful as it appeared, was accompanied by outward expressions of empathy and concern. The Tianjin sequence also included, for example, American soldiers caring for a wounded Japanese soldier [38]. The people of China, on the other hand, remain a permanently racialized other—foregrounded

in one set of text and photographs through a comparison of the noses of Chinese and Tartar women[48] [67 and 68]—whose responses and reactions were predictable, knowable, and always already well documented as "Chinese characteristics." Perhaps this is why the sequence ends with a diversion; that is, we are pulled away from the unequal exchange that the tour guide has created and whisked to the Summer Palace on the outskirts of Beijing. Violence thus becomes one more element of the exhibition offered up by the photography complex, to be consumed but not unnecessarily fretted over.

Archives, Reproduction, and Dissemination

The effectiveness of the photography complex as an element of Western imperialism, as has already been suggested, attained a reach beyond the immediate spatiotemporal staging area of empire building. In conjunction with other apparatuses of empire, the complex functioned as part of a material and discursive network that not only kept the administrative functionaries of empire informed, but helped forge a popular consensus at home for imperial adventures abroad. Books such as Arthur Smith's *China in Convulsion* and the Brighton booklet might be understood, therefore, as collection points for bringing the output of the photography complex into conjunction with China knowledge and as vehicles of dissemination to the general populations of Europe and North America. But they were by no means the only or even the most pervasive vehicle in which text and image moved through the realm of the popular. Perhaps the most common form in which images of Boxer China appeared was the weekly illustrated newspaper.

In Great Britain, France, and the United States, the illustrated newspapers found in the occasion of the Boxer Uprising an opportunity to recirculate the late nineteenth-century photographic archive of China. While the quantities of published material varied from paper to paper, there seemed to be ample resources for providing illustrations to accompany the reports of events flowing into imperial metropoles. Such insertions from the visual archive not only aligned past China knowledge with present events but supplied resources that could be mobilized to project or anticipate events to come. On July 28, 1900, a month before the relief of the legations in Beijing, *Leslie's Weekly* published two photographs on its front page. The top photograph was of a public execution in China; the bottom showed the aftermath of a mass execution, with Europeans standing over decapitated

corpses. A *Leslie's* editorial intervention boldly proclaimed THE THIRST OF THE CHINAMAN FOR HUMAN BLOOD. Less provocatively framed, the same two photographs also appeared in *La Vie Illustrée* on July 6, 1900 (pp. 224 and 229), with the bottom image labeled "Hong Kong—Execution of Pirates." I will have more to say on the lower photograph shortly. For now it is sufficient to note that the top image also appeared in the London-based *Black & White* on July 14, 1900 (p. 78). What is striking about these publications is that editors in three countries decided that these same images of beheadings were critical for understanding what was happening in China. Moreover, by framing events in these terms, the editors not only anticipated things to come but encouraged readers to fantasize about the fate of Western diplomats and missionaries in north China.

Following the entry of allied forces into Beijing on August 18, the illustrated newspapers vied with one another to provide visual images of the effects of the uprising and of subsequent acts of "retributive justice." The *Illustrated London News* (ILN), one of the most widely circulated British illustrated weeklies at the time, ran a series of drawings depicting the fighting in and around Beijing in its September and October issues. The first photographs were printed on October 20, 1900, barely two months after the relief of the legations, providing some sense of the rapidity of communications at the time. These photographs showed the massive destruction of the legation quarter area. Later issues printed photographs of the trophies collected by the allied contingent, including Boxer and Qing imperial banners and the state seals of the emperor of China and the empress dowager.[49]

The mixed media of drawings and photographs used by the ILN as well as other papers is worth comment. Drawings had been a staple of the illustrated weekly for some time, and imperial warfare was a common theme of these pictures. Such images were an artist's renditions of military actions figured from the accounts of "special correspondents" often sent by telegraph or from official dispatches. Or they were drawings made by the correspondents themselves, which by the mid-1880s could be photographed and transferred to a wooden print block (photography-on-the-block).[50] Here, however, something quite different seems to be emerging. What we see in the drawings involving events in China in 1900 are pictures that mimic the compositions of photographs. In some cases, the relationship is direct: an engraving would often be made from a flawed negative taken on the scene. One such example can be found in the Parisian weekly *L'Illustration*. In its November 3 edition *L'Illustration* published a double-page drawing of the

French contingent marching into the Forbidden City when the allied forces staged their triumphal march (pp. 276–77). On February 1, 1901, *La Vie Illustrée* published a photograph almost identical to the drawing in *L'Illustration*, but taken either a moment before or after and from an angle slightly to the right, suggesting that the drawing was from a nonprintable photograph. These images direct attention to the interplay of old and new technologies of vision, providing evidence of the convergent relationship between the elements of the photography complex at this particular moment. Different visual media could be used in identical ways to advance imperial projects.

In other cases, it is more difficult to determine whether an actual photograph was the original of the drawing. Yet there are numerous drawings in publications such as the ILN that follow the conventions of photographic realism, of the "mirror with a memory." To put this another way, the structural composition of the drawings is such that even if they were not copied from photographs and given depth and visual subtlety through halftone engravings,[51] they seem to have been imagined as such, particularly insofar as they reference the compositional structure of the small group vignette as their model. The subject matter of these pictures is also consistent: it is of punishments and humiliations meant to impress "the Far Eastern mind."[52] So, for example, there are photograph-like drawings of the destruction of the walls of Tianjin as a means for punishing the entire population of the city, a depiction of the trial of a purported Boxer, and "Boxer thieves" tied together by their queues, surrounded by foreign soldiers, some laughing, some looking on sternly.[53]

There is also one of "Tommy Atkins," the universal British soldier,[54] standing at the center of the round altar of the Temple of Heaven (figure 11.2). The accompanying text reads, "A humorous touch is afforded by another drawing which represents Thomas Atkins occupying for the moment, before the admiring gaze of an Indian orderly, the centre of the Chinese Universe. This spot, marked by circular pavement, represents to the Celestial the centre of his Universe, as Delphi did to the Greeks of old. The symbolism of the picture might have been more complete had the counsels of Russia been less potent than they are just now in the ear of the Chinese government."[55] While the humiliation of the Chinese emperor and the Chinese people embodied by the posing of a British and an Indian soldier at the Round Altar is obvious, the last sentence, a reference to a perceived British weakness in

Fig. 11.2. "Tommy Atkins" at the center of the Chinese universe. From *Illustrated London News*, April 20, 1901.

the face of Russian ambitions and actions in East Asia,[56] draws the audience back to the hard realities and responsibilities of empire. This was a subject the *ILN* took every available opportunity to highlight. In this case, it helped readers understand that China and Russia posed threats to the defense of British interests in Asia.

But if drawings like that of Tommy Atkins and his Indian orderly imitated photographic compositions and incorporated visual images into broader imperial concerns, there were also a large number of photographs that were fit for direct reproduction. This was especially the case in the United States, where *Leslie's Weekly* was exemplary in its use of photographic images. Like the *ILN*, *Leslie's* published its first photographs from the allied invasion in October, running a full page showing "Death and Destruction" at Tian-jin, with close-ups of individual Chinese bodies photographed by Sidney Adamson, *Leslie's* special correspondent on the scene. On October 13, *Leslie's* cover carried two photographs, one of British cavalry troopers atop the wall

of Tianjin, the other of Chinese people fleeing the city with their belongings on their backs. Inside, their were several photographs of the allied forces on their "rapid march" to relieve the legations.

These photographs were nested, in turn, within a body of coverage of events in China that had opened spectacularly on July 21, 1900, with the execution photographs previously discussed. A week later a bright yellow cover with a dragon in the center proclaimed THE YELLOW HORROR in bold black letters. The August 4 edition provided a bird's-eye view of the theater of the war, showing the area from the Dagu forts on the coast to the walls of Beijing. Inside was a double-page spread and, from the photographic archive, images of the many Western-style buildings in the foreign concessions at Tianjin. But perhaps the most intriguing aspect of *Leslie's* coverage was its gleeful presentation of the penetration of China's holy of holies, the Forbidden City, discussed earlier. The foreign presence, including that of the camera, was presented as a humiliating lesson that "barbarism" needed to learn.

As coverage continued into 1901, *Leslie's* demonstrated the power of the photography complex, and the networks with which it was linked, to structure the meaning of global events such as the Boxer Uprising. By combining a variety of immutable mobiles—old and new photographs, drawings, maps, descriptive texts—*Leslie's* editors and craftsmen created a new China, one that was no different from any other place where natives had transgressed against a white world of "civilization" and "civilizing missions." Captured in the photography complex, Chinese cities, palaces, temples, and people performed as mute subjects the tasks assigned them by the production apparatus of the imperial state and its allies in the press. The results of this almost seamless blending of photographic image with textual knowledge about China fixed into place an authoritative and monotone account of the events of 1900, producing reality not only for audiences in Europe and North America but also, eventually, in China.

Because of the storage and preservation capacities of the imperial archive, images such as those collected here could be inserted into subsequent histories, structuring the understanding of 1900 for a succession of generations. Book lists on electronic distributors such as Amazon.com contain over a dozen recent titles on the Boxer Uprising, many of which contain images similar to those reproduced here. And this does not include publications in China itself, where the immutable mobiles of the photography complex have been assembled into a nationalist discourse to "never forget national

humiliations."[57] Thus, the China staged through the 1900 photography complex remains very much part of our global collective present.

Ghosts in the Archive

In this chapter I have attempted to place photographs within a broader context of imperial practice and to demonstrate how the complex structure of photographic production contributed to Euro-American imperial hegemony in the early part of the twentieth century. As an apparatus of empire, the photography complex could bring events from distant places to bear on the political and social dynamics of imperial metropoles. The output of the complex also linked to other modes of cultural production of the era, the exhibitionary and representational regimes discussed by Tony Bennett, Carol Breckenridge, Donna Haraway, Timothy Mitchell, and Thomas Richards being the most obvious examples. Given these powerful connections, it seems reasonable to wonder if there are ways of undermining the authority of these technologies of empire. Can the remnants of the nineteenth-century photography complex provide resources for counterhegemonic struggles in the present? Can they, as they seem to have done in China after 1949, provide elements that can contribute to the construction of alternative histories of Western expansion in the nineteenth century?

To the degree to which I have been successful in opening the question of photography as a complex form of agency in the colonial context, some counterhegemonic work may already have been done. It is also the case that any of the images produced here, as well as the vast storehouse still available in the imperial archives from which many of these images came, can be read against the grain of dominant narratives. Close scrutiny of the faces present at the executions depicted in the Brighton booklet, for example, might be interpreted as contradicting the *Britannica*-inspired characterization of the Chinese people as capable of expressing only insensibility to suffering. These faces suggest a variety of emotions, ranging from empathy and sympathy to perhaps even contempt for the foreigners and their devices. One might consider "A Street Scene after an Execution" in a similar way. Given the high moral tone of the Brighton booklet, what are we to make of the gazes of the Beijing residents at British artillery officers posing over the beheaded bodies of Boxers? Or of the pose itself? Similar postures—leg thrust forward, one hand on hip, the other on a walking stick—can be seen among the Euro-

peans standing over the bodies of "pirates" on the cover of *Leslie's Weekly*. Often seen in photographs from hunts in India and Africa, this "imperial" stance suggests that those punished for defying British imperial authority were not unlike trophies of war. How secure, then, is the high moral certainty in R. N.'s tone? Does not the contrast between the humane phrases that dot the text and the arrogant posture of these soldiers destabilize imperial condescension?

Incongruities between text and image are evident in a variety of other contexts as well. Mislabeled sites are not uncommon. In the images of the triumphal march, for example, *L'Illustration* has the French column exiting the north gate of the Forbidden City, while *Le Vie Illustrée* has them entering the palaces through the same gate. Such confusions are evident in other published sources and in the official record. There is also at least one case where an older photograph was labeled *as if* it recorded one of the events of 1900. The image in question is the one mentioned earlier, the execution of pirates in Hong Kong that appeared in *Leslie's Weekly* and *Le Vie Illustrée*. Prior to having seen these published copies, I saw the same photograph in 1992 on a research visit to the archives of the U.S. Army Military History Institute in Carlisle, Pennsylvania. In white ink directly on the print, it bore the label "Scenes after the Beheading of 15 Boxers in China." Thus, for some unknown pen wielder, *Leslie's* editorial speculation on future events in China had been moved into the realm of "fact," manufacturing a new reality in which the ten or eleven dead "pirates" were transmuted into those of an even larger body count of "Boxers."[58]

This particular photograph raises another issue. To this point, I have been careful to consider only photographs that have had a public life, that have, in other words, been reproduced and circulated. These are, however, not the only images in the imperial archives. As a way of ending this essay, I would like to deal with three photographs produced in the complex but apparently never published, that in themselves cut against the grain of the stern authority of imperial power, and that in at least one instance appear to mock it.

The first of these images (figure 11.3) is another example of an execution scene to be found in the archives of the U.S. Army Military History Institute. It is set in a street filled with European soldiers and civilians and is the final in a set of four photographs.[59] The third in the series makes it quite clear that the bulk of the audience observing the execution are Europeans; some are actually looking down from the top of the building below where the execution is taking place. Although no labels are on the photo-

graphs, this may well have been the execution of two Chinese officials reported in *Leslie's Weekly* on May 18, 1900. By the standards of other outputs of the photography complex, however, the photograph in question is not a very good production and certainly not as clear and vivid as the drawing on *Leslie's* cover. In addition to having caught another photographer in the act, it also has blurred sections indicating motion of the subjects within the frame. Lack of visual clarity is often the reason pictures like this one are not reproduced. But, given what I argued earlier, there may be another reason as well. Blurred images and the presence of another photographer in the picture immediately call into question any unmediated claims about colonial photography. Instead of focusing attention on the key event, the execution of a Chinese official, this photograph draws attention to itself and to the processes involved in fabricating photographs. Insofar as it makes visible that which the photography complex conspires to hide, it is indeed a bad photograph.

The second example comes from the India Office Archives in London. Two policemen flank four others who were no doubt part of the poor vaga-

Fig. 11.3. Blurred photo of execution. Courtesy of U.S. Army Military History Institute, Carlisle, Pennsylvania.

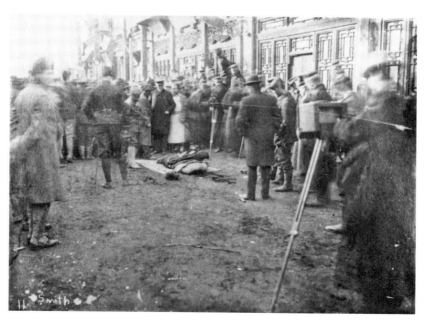

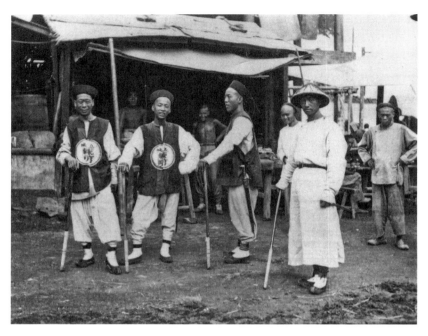

Fig. 11.4. Imperial Chinese soldiers. From a collection of photographs associated with the 3rd China War (Boxer Rebellion) (1900–1901). Courtesy of the Council of the National Army Museum, London.

bond class that made up a floating population in Beijing. Yet as disturbing as is the condition of these disheveled men, there is something even more unsettling about the photograph. It seems clearly staged, but to what end or purpose? An explanation written on the back of the photograph helps clarify matters. It reads, "The prisoners were told to look miserable for the photograph . . . certainly did." Not only is attention once again drawn to the process of photographic production, but perhaps even more than the Brighton photograph of British soldiers standing over decapitated bodies, this image suggests that lurking in the complex is a disturbing perversity, a desire to denigrate still further, through staged performances like this one, those who have already been brought low by a host of forces, domestic and foreign, around them.

The final example also draws attention to what is being staged before the camera (figure 11.4). From the National Army Museum archives in London, it is perhaps one of the few photographs in which anyone in Beijing is

caught smiling at the camera. But that is not the only thing that makes it unusual. Equally interesting are the poses of the three Qing policemen in dark hats. When this picture was taken, photographers such as Cornelius O'Keefe were constructing a documentary record of the soldiers in the contingents of other countries. In O'Keefe's case, he photographed soldiers from British India Army units standing three abreast in front and side view positions.[60] Perhaps these policemen had seen one of these staged events, or perhaps they had noticed the way Englishmen stood with a hand on one hip and a walking stick in the other. Regardless of the source of inspiration, the impression is of more than mimicry. They seem to be laughing at the photographer and his apparatus and mocking the posture of European soldiers.

Insofar as photographs like these disturb the regularities of the photography complex, they have subversive content. By drawing attention to the making of the image, by forcing us to consider the staged nature of the events before the camera, these pictures push us out of the frame and into the processes and technologies through which photographs were produced, circulated, and saved. If we return to where this chapter began, with Oliver Wendell Holmes's discomfort over the possibility that pure, unmediated "memory" could be subverted through the manipulation of the image, it should be clear that there was more at stake than the truth value of the photograph. The more profound issue indexed by these unstable images is the relationship between new technologies and the claims and powers of the imperial state. The value of the "bad" photograph, of staged misery, or of the Qing policeman's hand on his hip is that each in their own way helps demystify "the mirror with a memory" and thereby open to scrutiny mechanisms of imperial power and technologies of rule. Such images also suggest that a tool of empire such as the photography complex is not omnipotent: it, too, can be tricked and made to look foolish.

Notes

James L. Hevia, "The Photography Complex: Exposing Boxer-Era China (1900–1901), Making Civilization," in *Photographies East: The Camera and Its Histories in East and Southeast Asia*, ed. R. C. Morris, 79–119. Durham: Duke University Press, 2009.

1 Oliver Wendell Holmes, "The Stereoscope and the Stereograph," *Atlantic Monthly* (June 1859): 739 [reprinted in *Soundings from the Atlantic* (Boston: Ticknor and Fields, 1864), 122–65].

2 Holmes, "The Stereoscope and the Stereograph," 748–49.

3 Holmes, "The Stereoscope and the Stereograph," 742.

4 Daniel Headrick, *The Tools of Empire* (New York: Oxford University Press, 1981). See especially his discussion of efforts by historians to deny or limit the role of technology in European empire building, 5–8.

5 Bruno Latour, *The Pasteurization of France* (Cambridge, MA: Harvard University Press, 1988). Also see Donna Haraway, *Simians, Cyborgs and Women* (New York: Routledge, 1991).

6 For a discussion of these printing processes, see Estelle Jussim, *Visual Communication and the Graphic Arts: Photographic Technologies in the Nineteenth Century* (New York: R. R. Bowker, 1974), 82–83, and under each technique in the glossary, 339–45.

7 On surveillance, law, and evidence, see John Tagg, *The Burden of Representation* (Minneapolis: University of Minnesota Press, 1988), 66–102. For a more detailed discussion of the pedagogy of imperialism, see James Hevia, *English Lessons: The Pedagogy of Imperialism in Nineteenth Century China* (Durham: Duke University Press, 2003).

8 See National Archives and Record Administration (NARA), Washington, D.C., Record Group (RG) 395, 906, boxes 2 and 4 (hereafter NARA-WDC).

9 There is at least one photograph showing photographers at the triumphal march. It is a shot looking south from Tianan Gate; see U.S. National Archives, College Park, Md., NARA, folder 75140 (hereafter NARA-CP). On the triumphal march, see Hevia, *English Lessons*, 203–6. Motion pictures were also taken within the Forbidden City by William Ackerman; see NARA-WDC, RG 395, 898, no. 229, October 24, 1900. Ackerman was employed by the American Mutoscope and Biograph Company of New York; see Frederic Sharf and Peter Harrington, *China, 1900: The Eyewitnesses Speak* (London: Greenhill Books, 2000), 243–44.

10 O'Keefe had been a professional photographer working in Leadville, Colorado, when the Spanish-American War broke out. He enlisted in the army and was sent to the Philippines, where he covered the Filipino Insurrection in 1899–1900; see Sharf and Harrington, *China, 1900*, 246–47. O'Keefe also sold some of his China photographs to *Leslie's Weekly*, a publication discussed in detail below. O'Keefe's orders are in NARA-WDC, RG 395, 911, Special Orders 78, 24.

11 There are two references in NARA from General Chaffee to the adjutant-general of the army in Washington, D.C., indicating the shipment of photographs to his office; see NARA-WDC, RG 395, 898, no. 123, which mentions ninety-five photographs, and RG 395, 898, no. 498, which lists a group of photographs to illustrate reports Chaffee had forwarded on foreign armies (see below).

12 There are also some additional photographs at NARA-CP in the General Photographic File, U.S. Marine Corps, 1872–1912, 127–G, box 4. They include two of the triumphal march and one of the throne room in the Preserving Harmony Hall (Baohe dian) in the Forbidden City.

13 See NARA-CP, folder 88881.

14 For the official published account, see U.S. War Department, *Reports on Military Operations in South Africa and China* (Washington: U.S. Government Printing Office, 1901).

15 *Shinoku Pekin kojo shashincho* (Photographs of the Palace Buildings of Peking) (Tokyo: Ogawa Kazume Shuppanhu, 1906), n.p.

16 *Shinoku Pekin kojo shashincho.*

17 Osvald Sirén's similarly ambitious project would appear twenty years later; see *The Imperial Palaces of Peking* (1926; New York: AMS Press, 1976).

18 Jordan Sand, "Was Meiji Taste in Interiors 'Orientalist'?," *positions* 8(3) (2000): 637–74.

19 Arthur H. Smith, *China in Convulsion*, 2 vols. (New York: Fleming H. Revell, 1901). For Killie's photographs, see NARA-WDC, RG 395, 898, no. 469.

20 Smith, *China in Convulsion*, 2:730–31. On the Twain-missionary exchange, see Hevia, *English Lessons*, 206.

21 For a photograph providing clearer scale on the opening in the city wall, see Hevia, *English Lessons*, 200.

22 See, for example, Walter Benjamin, "The Work of Art in the Age of Mechanical Reproduction," in *Illuminations*, ed. Hannah Arendt, trans. Edmund Jephcott (New York: Schocken, 1969), 217–51. For a similar argument on imperialism and popular culture, see John MacKenzie, *Propaganda and Empire* (Manchester: Manchester University Press, 1986).

23 For a fuller discussion of "symbolic warfare," see Hevia, *English Lessons*, 195–206.

24 The event was well documented in image and text. See, for example, Henry Savage Landor, *China and the Allies*, 2 vols. (New York: Scribern's, 1901). The pictures were taken by Landor himself, probably with a Kodak box camera.

25 See Hevia, *English Lessons*, 267, 261.

26 The image is from a collection of photographs assembled in a volume titled *Military Order of the Dragon, 1901–1911.* The order was an international fraternal organization of officers from the eight armies that occupied Beijing in 1901. See Hevia, *English Lessons*, 305–8. Second from the right is Sarah Pike Conger, the wife of the American minister to China, and next to her is General James Wilson. The remaining people in the photograph are American solders and legation officials. On the photograph of the Bengal Lancers, see Hevia, *English Lessons*, 199–200.

27 Thomas Richards, *The Imperial Archive: Knowledge and the Fantasy of Empire* (London: Verso, 1993).

28 Bruno Latour, "Drawing Things Together," in *Representations in Scientific Practice*, ed. Michael Lynch and Steve Woolgar (Cambridge, MA: MIT Press, 1990), 16–68, esp. 26–35.

29 *Unique Photographs of the Execution of Boxers in China* (Brighton: Visitors' Inquiry Association, n.d.). I received the booklet from Bruce Doar as a gift in Bei-

jing in 1991. He said he had bought it at a book sale in Melbourne a few years earlier. It bears evidence of having been in an Australian public library.

30 For a description of the process, see Jussim, *Visual Communication*, 345.

31 *Execution of Boxers*, 3, 5.

32 The ninth edition of the *Britannica* was published in 1874. I have consulted the 1878 Scribner's edition. See "China," 5:626–72. The passage in question is on 669. The eleventh edition of the *Britannica* (1910–11), while retaining much of the descriptive account of capital punishment in Douglas, dropped the elements cited here. While it may seem odd to characterize the *Britannica* as part of an imperial archive, its frequent citation in British military intelligence reports on Africa and Asia seems enough justification. See James Hevia, "Secret Archive: The India Army Intelligence Branch and 'Reconnaissance' in China, Central Asia, and Southeast Asia," paper presented at the Barney Cohn Memorial Conference, University of Chicago, May 13–14, 2005.

33 An almost identical descriptive tone combined with claims that projected responsibility for the executions wholly onto the Chinese people can be found in *Leslie's Weekly*, May 18, 1901, 484. Under the title "The Awful Reality of Chinese Executions," the author claimed that executions by beheading in present-day China were even more hideous than in sixteenth- and seventeenth-century England.

34 *Execution of Boxers*, 6.

35 See Bryon Farwell, *Queen Victoria's Little Wars* (New York: Norton, 1972), for a stunning catalog of these wars (364–71). Farwell also includes "illustrations" culled from photo archives and the graphic press.

36 Holmes, "The Steroscope and the Stereograph," 748.

37 See William Darrah, *The World of Stereographs* (Gettysburg, PA: W. C. Darrah, 1977), 3.

38 Darrah, *The World of Stereographs*, 1–5. Ample pictures of the stereoscopic viewer can be found online via Google; search for "images for stereoscopic viewers," accessed May 13, 2013.

39 This, at any rate, has been my experience with the stereograph. An enormous collection of images can be seen with stereoscope viewers at the Library of Congress, including Ricalton's China tour, discussed below.

40 Darrah, *The World of Stereographs*, 46–48. Underwood also developed a unique distribution system that employed clean-cut college and seminary students as salesmen. The young men were trained to canvass school superintendents, librarians, and bankers in territories assigned to them.

41 It is extremely difficult to assemble these various sources in one place to reproduce the experiences of early twentieth-century stereoscope users. Extant texts, images, and maps are dispersed in different parts of libraries, or holdings are incomplete.

42 Sets were also marketed in smaller, less expensive units, including one on Beijing made up of thirty-one stereographs, text, two maps, and a diagram of Bei-

jing for $5.25. See James Ricalton, *Pekin* (New York: Underwood and Underwood, 1902). The Library of Congress's copy of this volume contains the maps and diagram. The other subunits were "Hong Kong and Canton," with fifteen photographs and three maps, $2.50; and "The Boxer Uprising Chefoo, Taku, and Tien-tsin," with twenty-six photographs and three maps, $4.40. As near as I can estimate, the Library of Congress stereographic collection has a complete set of the Ricalton China tour. There are also echoes in the stereographic package of the eighteenth-century phenomenon "world in a box." See Anke te Heesen, *The World in a Box: The Story of an Eighteenth-Century Picture Encyclopedia* (Chicago: University of Chicago Press, 2002).

43 Since international exhibitions were a major theme of stereography, one is also tempted to suggest exhibitions of exhibitions. On the exhibitionary regime, see Timothy Mitchell, *Colonizing Egypt* (Berkeley: University of California Press, 1974); Tony Bennett, *The Birth of the Museum* (New York: Routledge, 1995).

44 Ricalton's stereographs and text are in Christopher Lucas, *James Ricalton's Photographs of China during the Boxer Rebellion* (Lewiston, ME: Edwin Mellen Press, 1990), 176–77. In this publication a single, as opposed to a double, image is reproduced and diagrams and maps excluded. Numbers in brackets refer to plate numbers in Lucas.

45 Lucas, *Ricalton's Photographs*, 176–77.

46 Arthur H. Smith's *Chinese Characteristics* (1894; Port Washington, NY: Kennikat Press, 1970) became a staple for missionaries going to China.

47 Lucas, *Ricalton's Photographs*, 178.

48 Ricalton made the comparison in order to point out that the Tartars were considered by "some authorities" to be the "most improvable race in central Asia." Lucas, *Ricalton's Photographs*, 225–26.

49 *ILN*, December 29, 1900, 980–81, and July 20, 1901, 89–90.

50 See John Springhall, "'Up Guards and at Them!' British Imperialism and Popular Art, 1889–1914," in *Imperialism and Popular Culture*, ed. John MacKenzie (Manchester: Manchester University Press, 1989), 49–72. He discusses *ILN* production processes for drawings and photographs; see 51–55, 59–61.

51 See Jussim, *Visual Communication*, 138–40, on halftone engravings of drawings and paintings.

52 *ILN*, October 13, 1900, 516.

53 See *ILN*, April 6, 1901, 489, and March 1, 1901, 299. *Black & White*, another London weekly, published a photograph of reputed Boxers tied together by their queues, March 2, 1901, 285.

54 The name comes from early nineteenth-century British army regulations, where it is used on sample forms. See also the Rudyard Kipling poem "Tommy," in *Barrack-Room Ballads* (New York: Signet Classics, 2003), 7–9, which was first published in 1890.

55 *ILN*, April 20, 1901, 566.

56 At the time, Russian forces occupied Manchuria and, many British critics

feared, were in a position to seize all of China north of the Yangzi River. See, for example, Alexis Krausse, *Russia in Asia: A Record and a Study* (1899; New York: Barnes and Noble Books, 1973) and *The Story of the China Crisis* (New York: Cassell, 1900); D. C. Boulger, "The Scramble for China," *Contemporary Review* 78 (1900): 1–10.

57 The quotation is a translation from a monument at the Summer Palace (Yuan-mingyuan) in Beijing, an extensive ornamental garden destroyed by the British in 1860 for the Qing Dynasty's transgressions against "civilization." For a discussion of this monument, as well as museum displays, many of which include photographs discussed here, see James Hevia, "Remembering the Century of Humiliation: The Yuanmingyuan and Dagu Museums," in *Ruptured Histories: War, Memory, and Post-Cold War Asia*, ed. Sheila Miyoshi Jager and Rana Mitter (Cambridge, MA: Harvard University Press, 2007), 192–308.

58 The photo is in an album attributed to J. D. Givens titled "Scenes Taken in the Philippines, China, Japan and on the Pacific (1912)." See RG 49–LD. 222–23, photo 187, U.S. Army Military History Institute, Carlisle, Pennsylvania. This same image, I am fairly certain, has appeared on a postcard once sold on the website of a company located in Vienna; see http://www.collect.at.

59 These photos are in the James Hudson album, 44–47, U.S. Army Military History Institute, Carlisle, Pennsylvania.

60 See NARA-CP, folder 74956, 7th Rajputs; folder 74955, 24th Punjabs; and folder 74954, 1st Sikhs.

Colonial Theaters of Proof:

Representation and Laughter in

1930s Rockefeller Foundation

Hygiene Cinema in Java

Eric A. Stein

The Rockefeller Foundation efforts in 1930s hookworm prevention campaigns among rural populations in Dutch colonial Java relied on film as a technique of health persuasion. Forms of visual representation within Rockefeller Foundation hygiene films assumed an audience that was scientifically and cinematically illiterate. Drawing on textual readings of the films, this chapter explores the construction of causality and magnification as forms of "proof" within film narratives and the use of slapstick humor to draw in audiences. The memory fragments of octogenarian Javanese viewers suggest that the films instigated a state of play in which laughter both mocked the latrine construction efforts of local health agents and also enabled those agents to enter the private sphere of the home for further health interventions. The implication of such pairings between colonialism and entertainment for thinking more broadly about power also are explored here.

In the mid-1930s, local "hygiene technicians" (*mantri hygiëne*) who were trained as part of Rockefeller Foundation hookworm prevention campaigns brought outdoor hygiene cinema to the crowded public squares of rice-farming villages throughout Banyumas, Central Java. Even today, people in Banyumas who are now in their eighties remember that the monthly silent films were more popular than the Javanese shadow puppet (*wayang kulit*) theater and were "looked forward to continuously." They referred to the films as *komidhi sorot*, a Javanese term which could be translated as "light-beam circus" or perhaps more accurately as "spotlight theater." Seventy years after the spotlight theater ended its run, these Banyumas villagers can still recall being startled by the "pictures of worms that were still alive" and seeing images of "stick-thin" parasite-infected bodies with "bulging stom-

achs" projected on the cinema screen. Often the hygiene technicians showed comedy and drama reels to accompany the health films and entertain the throngs of villagers, nearly all of whom had never before seen moving pictures. Before the komidhi sorot, "there were only tales about films playing in the city," one woman explained, but those were only "for the rich . . . sadly, they cost five *ketip*."[1] Unlike the oil-burning lamps that cast the shadows of the traditional wayang kulit puppet performances and reaffirmed the moral order of the Javanese world, the diesel-powered electric light of the film projectors was intended to usher a new colonial modernity into the village that was premised on the illumination of the etiological order of tropical disease. Drawing on textual readings of the hygiene cinema and the memory fragments of octogenarian Javanese viewers, this chapter explores colonial attempts to visually prove the need for rural hygiene in 1930s Banyumas and considers how such endeavors may have been challenged by the uncontrollable laughter of Javanese audiences and the structural limits of the villages.

In *The Pasteurization of France*, Bruno Latour describes Louis Pasteur's attempts to certify the validity of germ theory in the 1880s by engaging the skeptical audiences of anticontagionists and believers in "morbid spontaneity" with dramatic displays of microbial potency: "Pasteur's genius was in what might be called the theater of the proof. . . . Pasteur invented such dramatized experiments that the spectators could see the phenomena he was describing in black and white. Nobody really knew what an epidemic was; to acquire such knowledge required a difficult statistical knowledge and long experience. But the differential death that struck a crowd of Chickens in the laboratory was something that could be seen 'as in broad daylight.' . . . To 'force' someone to 'share' one's point of view, one must indeed invent a new theater of truth."[2] Like Pasteur's anthrax experiments on goats, chickens, and cows, early twentieth-century health propaganda movies in the United States and Europe similarly attempted to construct "theaters of proof" that would "force" audiences to "share" the perception that invisible pathogens accumulated on the feet of flies, in mosquitoes, in the bodies of prostitutes, in the lungs of the sick, and in deposits of excrement. Health agencies deployed film technology as an ideal mode for visualizing the invisible, narrating causal chains of contagion, and projecting a sense of objectivity.[3] Films used microscopy to isolate and magnify images of parasites and other pathogens in motion, swimming in the bloodstream, and feeding on bodily organs.[4] As Kirsten Ostherr suggests in *Cinematic Prophylaxis*, such scenes fostered the "representational inoculation" of audiences, train-

Bruno Latour, "The Pasteurization
of France"
(Cambridge, M.A: Harvard
University Press, 1986),
85-86

ing viewers to identify and categorize threatening situations and the social types that carried disease.[5] Beyond its function as "theater of proof," the hygiene cinema held the potential to become a "cultural technology for the discipline and management of the human body."[6]

While health propagandists envisioned presentations of germs and germ carriers in the theater as potent forms of visual proof, cinematic constructions of microbial dangers and social deviance also met with popular misunderstandings, contestations, and various forms of censorship. In the United States and Britain, certain early twentieth-century health propaganda films, such as those centered on the sexual deviance of the syphilitic body, stirred the disgust and moral anxieties of viewing publics, film critics, and religious coalitions, leading to the establishment of institutional production codes for the monitoring and censorship of "improper" content.[7] Such protests and restrictions instigated the general decline of documentary film genres in popular movie houses by the 1930s. As Martin Pernick explains, "producers, exhibitors, and critics began to demand movies that provided entertainment, not intellectually demanding, emotionally upsetting, or aesthetically unpleasant medical topics."[8] Though health propaganda films continued to be shown in schools and military barracks, studies of their effectiveness sometimes found that they failed to inspire long-term modification of viewers' sexual practices or hygienic behaviors.[9] The spectacular nature of film technology perhaps entailed a reduction of the message to the medium: the hygiene film produced a mass spectacle that divorced viewers from their everyday experience and failed to connect psychologically with behavioral imperatives.[10]

If anxieties and limits arose from American and European hygiene cinema unmediated by translation, colonial "theaters of proof" presented to Asian or African populations were understood to entail additional challenges to the process of truth production. Pasteur expected the audiences of his experiments to already share fundamental ideas about causality, experimental processes, evidence, and certainty; furthermore, they came from similar class and cultural backgrounds and perhaps granted Pasteur credibility as a scientific "gentleman."[11] In contrast, colonial filmmakers had to face their own Orientalist conceptions of their viewers' irrationalities and fundamental differences, which they believed could make the messages of the health films illegible and impossible to "share." Colonial theaters of proof, therefore, constituted an ethnographic zone of reverse cultural translation. Unlike ethnography, which translates "foreign" culture into the ethnographer's

"own" language, creating theaters of proof in the colonies evoked the discomfort one faces when attempting to translate from one's native language into that of the "other." Filmmakers, concerned that audiences would be unable to comprehend the basic principles of causation and certainty, sometimes included those lessons alongside specific discussions of worms and germs. They also attempted to circumvent such difficulties entirely through the use of narrative techniques that appeared to be universally transparent.

In colonial Africa, public health filmmakers fretted over the perceived burden of designing materials that could effectively reach illiterate "others," whom they feared would be overly mesmerized and perplexed by the biomedically based evidentiary technologies used in the films of the metropole. As Megan Vaughan describes in *Curing Their Ills*, colonial administrators in 1940s Africa studied audience reactions to hygiene films and hypothesized that "inappropriate" laughter arose because of the strangeness of the film narratives.[12] George Pearson, a director in the British Colonial Film Uni delighted in sharing stories of African misperceptions that mosquitoes magnified enormously on film screens were showing real monstrous insects in actual scale.[13] Thus, although health propagandists were troubled by supposed African cinematic illiteracy, such evidence of difference was also used to reconfirm their own logical civility and authorize the necessity of colonial education efforts to bridge such epistemological divides.

The Rockefeller Foundation projects in Java, attuned to this supposed crisis of cross-cultural cinematic representation, both studied Javanese audience reactions to "abstract" visual processes like magnification and produced "transparent" film narratives that appeared continuous with Javanese experiential reality. The first section of this chapter examines several films — on hookworm control, latrine construction, plague prevention, as well as technology and comedy clips — that were recovered from a trash pile behind a former regional medical administration building in Purwokerto, Central Java, in 2002.[14] These films, likely to be the same ones shown in Banyumas villages in the 1930s, exhibit a range of narrative styles, visual techniques, and intended audience positions. Some are like those shown in metropolitan theater houses, designed to shock and disgust with vivid images of immense parasites squirming on the screen. Others adopt a didactic format that points directly at the viewer, constructing the position of student in a classroom setting. While the films reveal a concern with cinematic illiteracy and establishing "proof," they also demonstrate an appreciation for the dynamics of Javanese audiences through the inclusion of comic elements that

parallel the wayang theater and set a place for the hygiene technicians to enter homes and backyards and inspect latrines.

The second section situates the memories of the films within the wider history of the hygiene projects in late colonial Banyumas. Shown in the mid-1930s during the height of economic depression, famine, and forced labor transmigration to Sumatra, the mass entertainment of the hygiene films provided an unusual contrast with the forms of material and symbolic violence that inhabited the late colonial world. I suggest that the hygiene projects instigated a particular state of play, in which villagers renamed the hygiene technicians "outhouse technicians" and read the thin-bodied, bulging stomachs of hookworm victims projected on the screen as *Gareng*, a comic figure within the wayang pantheon that evoked public laughter. While the collective agency of laughter may have redefined hookworm-infected bodies as shameful, structural limits of poverty prevented many Banyumas villagers from following the hygiene films' prescriptions to construct latrines, even into the present.

Difference, Representation, and Proof

The Rockefeller Foundation International Health Division (IHD) projects in Java were part of much broader hookworm eradication campaigns that extended to over sixty countries and colonial territories in Europe, Asia, Africa, Latin America, the Caribbean, and the U.S. "South" from 1913 to the 1930s.[15] The campaigns in Java, which spanned a fifteen-year period from 1924 until 1939, carried on far longer and later than any of the other hookworm campaigns and evolved into an intensive rural population engineering scheme that was intended to reach all aspects of Javanese hygienic and sanitary life. By the late 1930s, John L. Hydrick, the Rockefeller Foundation field officer for the Netherlands East Indies, had generated a particularly utopian vision of rural hygiene in which Javanese peasants were to actively embrace handwashing, toothbrushing, boiling water, sweeping yards, and whitewashing homes, while at the same time willfully assembling the "costless" rudimentary bamboo infrastructure of water spigots and latrines that prevented communicable disease.[16] Hydrick used the language of "awakening" to describe the process through which Javanese subjects, after educational home visits by hygiene *mantri* (technicians) and public film events, were to rationally identify and respond to the pathogenicity of worms and germs. The fundamental assumption of Hydrick's projects was that with

adequate persuasion villagers would come to desire instruments of hygiene as vital commodities to the same extent that they desired other basic needs they could already afford: rice, fuel, transportation, and shelter. The strategy presaged the core principles of more recent sustainable development and community participation paradigms, while at the same time placing responsibility for health not on colonial authorities but on villagers themselves.

As an outsider to the Netherlands East Indies encroaching on its medical sovereignty, Hydrick faced prolonged tensions with the Dutch Public Health Services (Dienst der Volksgezondheid; DVG).[17] In 1923, Dr. Van Lonkhuijzen, head of the DVG, preempted Hydrick's arrival on Java with an anti-American and anti-Rockefeller speech in the Netherlands Indies People's Council (Volksraad).[18] Although the DVG had already instituted a division of Medical-Hygiene Propaganda in 1920, several years before Hydrick arrived, Dutch medicine in the colony was largely clinical, focused on hospital care rather than rural prevention.[19] Within this clinical climate, Hydrick struggled to establish the credibility of his work for much of his stay in the Indies, but received limited acceptance by the end of 1926, when the Netherlands Indies governor general gave Hydrick the title of Advisor for Medical Propaganda after proving the effectiveness of his latrine promotion techniques.[20] Having secured at least a tenuous partnership with the DVG, by the late 1920s Hydrick developed a studio and manufacturing plant in which he produced numerous silent films, slides, photographs, charts, posters, and placards as part of his role as advisor to the Medical-Hygiene Propaganda Division of the Netherlands East Indies colony.[21] He distributed these materials on "huge motor lorries" that traveled through villages, dispersing the fundamental tools used by the hygiene technicians to educate rural publics.[22] After 1933, the cornerstone of Hydrick's projects in Java was the Poerwokerto Demonstration Unit in Banyumas, a bounded area with sixty "model" villages and a school for training hygiene mantri, in which Hydrick could put his various educational experiments to the test. The Demonstration Unit served as its own "theater of proof" in which the many visiting diplomats and health officials from neighboring colonies who traveled through Java could witness the civilizing philanthropy of the Dutch East Indies and the ingenuity of the Rockefeller Foundation. By the end of the 1930s, the head of the DVG called Hydrick's Demonstration Unit in Poerwokerto the "centre of rural hygiene" for all of the colony.[23]

Although Hydrick departed from the Netherlands East Indies in 1939, his projects were carried on by the many Indonesian physicians he had trained

during his fifteen years in the colony. When Dutch soldiers arrived in Banyumas in 1947 as part of an effort to retake the colony after the Japanese occupation during World War II, Indonesian nationalist doctors fighting in the War of Independence fled to Magelang farther to the east and reestablished Hydrick's school for training hygiene mantri, claiming the project of rural hygiene for the coming Indonesian nation. While curative care was expanded through the creation of new medical facilities under the new Republic of Indonesia, the key features of the Rockefeller Foundation rural hygiene model were retained and further developed by Dr. Raden Mochtar, a key figure in the Rockefeller Foundation projects in the late 1930s who served as the head of the Division of General Hygiene for the Indonesian Department of Health through much of the 1950s.[24] Some of the hygiene films may have been shown in new rural hygiene demonstration areas outside of Banyumas at that time, as part of the nationalist imaginary of a strong and hygienic Indonesian citizenry.[25] Thus, the project of rural hygiene education as well as *translation* continued into the Sukarno period, with urban elite doctors viewing Javanese publics as scientifically challenged and in need of supplemental lessons on magnification and causality.

Hydrick's hygiene propaganda materials anticipated and *invented* the problem of Javanese scientific and cinematic "illiteracy" by breaking down disease processes into multiple parts. He understood hookworm in particular as a complex problem having chains of communicative causality, visible effects on the body, internal experiences of sufferers, stages of curing, and extensive processes of prevention. Hydrick treated each of these dimensions as susceptible to Javanese misrecognition, creating specific evidentiary techniques and narratives that would illuminate the validity of Rockefeller Foundation etiologies and cures. The problem of causality—of worms entering the body and causing sickness, of purgatives entering the body and causing wellness, and of latrines entering the village and preventing worms—was addressed through a number of "before and after" narratives that relied on temporal sequence to establish validity. Like the hygiene cinema in Europe and the United States, the invisibility of pathogens was perceived to be an additional problem that required proof through magnification. Yet in Java Hydrick also presumed that the process of magnification was beyond basic Javanese comprehension; therefore, he devised a series of materials to show the ways that lenses could enlarge visible objects already known within the Javanese experiential world. These dual frames of causality and magnification were applied to the various dimensions of the disease processes de-

picted within the hygiene films, creating narratives intended to compel Javanese audiences to "share" the truth and adopt hygienic lifestyles.

Both of these elements are prominent within the Rockefeller Foundation hygiene film *Unhooking the Hookworm*, a Dutch-Malay version of which was present in the former medical administration offices in Java. The Rockefeller Foundation International Health Board released the ten-minute silent film in 1920 to be shown at fairs and public events to Southern rural communities in the United States, before it was translated and shipped out to the various hookworm campaigns abroad.[26] Like other hygiene films of the times that astonished audiences with visual tricks, *Unhooking the Hookworm* used cinema microscopy to show worms hatching from eggs within the bloodstream, as well as slide stains of the depleted red blood cells of severely anemic hookworm sufferers. Stop-action "claymation"-like sequences mimicked the microscopic by depicting worms invading the body through pores, feeding on the inside of the intestines, and draining the body's blood. The primary narrative of the film follows the kind of causal before-and-after theme that was standard to many health propaganda movies. At the start, a white Southern child of approximately ten years of age turns down his friend's request to go swimming because he is "too tired." The camera view enters the boy's body and shows the worms hatching from microscopic eggs and writhing inside before turning back in time to the various sources of soil pollution that led to the infection. The film then traces the path of hookworm larvae through the body on an animated anatomical chart supplemented with microscopic views, showing how it enters through the feet, travels in the blood to the heart, and makes its way to the lungs, where it is expectorated, swallowed, and enters the digestive system where it latches onto the intestines with a "poison fang" that draws the blood. The boy's father takes him to a doctor, who slips away into his laboratory to perform additional microscopy on the boy's fecal sample and prescribes, from an unusually well-stocked pharmaceutical collection, an oil of chenopodium tablet to kill the worms and Epsom salts to purge the remains. After taking the drugs and purging the worms, which make a brief appearance nestled in a small heap, the boy regains his vital energy and runs off to the local pond to swim with his friends. The film ends with the prescriptive advice to improve poor latrines to avoid repeat infection. The before-and-after narrative establishes a clear chain of causality that details the origin of infection, the internal etiology of the worm larvae, the bodily state of the sufferer, the mode of

diagnosis, the method of cure, and the end result, all of which is copiously supplemented with microscopic views into the body and soil.

In contrast with the complex, nonchronological causality and technological perception used in *Unhooking the Hookworm*, hygiene films produced in Java exhibit a causal simplicity that follow uninterrupted, unidirectional sequential chains and make very careful use of technologies of magnification. One of the films from the Java collection replicates the "before and after" theme of *Unhooking the Hookworm*, narrating the story of Kromo, a Javanese rice farmer who learns the truth of his debilitating hookworm infection from a visiting hygiene technician, takes the cure, and regains his productive capacities.[27] The use of the term *Kromo*, a somewhat antiquated colonial Malay word for the "common people," is meant to refer not only to the man in the story but the whole of the Javanese peasantry. As Vaughan suggests, such film narrative techniques were used in African hygiene campaigns to create "audience positions" that attempted to establish a unified subjectivity for the viewing crowd.[28] Similarly, Javanese audience members, expected to self-identify as Kromo, were to look to the everyman depicted in the film and feel his suffering, admitting their shared illness experience. For Hydrick, the use of the name "Kromo," the everyman, to depict the lead character in his film on hookworm reflects his wider epidemiological belief in the Javanese as inherently diseased, as he claimed that "the statement that every Javanese is a hookworm carrier seems to be true in a general way, judging from the results of our investigation."[29]

The film begins with Kromo working in the rice fields alongside his friend, Simin.[30] Showing his anemic exhaustion by wearily turning the soil while Simin works heartily beside him, Kromo excuses himself from the fields and walks back on the dirt road toward his home in the village. He soon slows to a halt and sits on the ground at the side of the road, removing his shirt and placing his head in his hands, too weak to continue (see figure 12.1).

The film text, appearing in a split frame with Malay on the left and Dutch on the right, narrates the subject's inner experience: "For a long time Kromo has felt this way, that his body is easily exhausted, lacking strength and uncomfortable. It is probably the sickness." After returning to his home, Kromo suffers in bed and sits wearily in his yard, later visited by his friend, Simin, who sends along the hygiene mantri. In the next scene, the mantri, wearing a pith helmet, a formal Western-style jacket, and a Javanese sarong,

Fig. 12.1. *Kromo at the side of the road*. Image taken from DVG Medical Hygiene Propaganda film slide, ca. 1930s. Courtesy of General Sudirman University Library.

squats in front of the home next to Kromo and Kromo's wife and daughter, unfolding various health posters that explain the sickness (see figure 12.2). One of the posters shown to the viewer presents a simplified causal narrative, depicting a thin, sickly boy on the left with the caption "before treatment" and the same boy on the right, now fat and healthy with the caption "after treatment" (see figure 12.3). Without delving into the etiology of the disease, the film uses the indisputable evidence of the before-and-after narrative to reference Kromo's own pathology and suggest treatment. At the end of this session, the text reads "Kromo understands how great the benefit is of having a latrine. He intends to make one." Later, Simin shows Kromo his own well-constructed, whitewashed latrine and helps him dig a latrine in his own yard. After it is completed, Kromo and his family seek treatment for worms, lining up with other villagers to drink the purgative medicines set out by the mantri on a table in the public square.[31] Several days after taking the medicine, Kromo feels better and heads out to the rice field. His body is full of energy, he swings his arms and leaps effortlessly over fallen palm

Fig. 12.2. *Hygiene mantri in home visit with Kromo*. Image taken from DVG Medical Hygiene Propaganda film slide, ca. 1930s. Courtesy of General Sudirman University Library.

fronds on his way to returning to work with Simin, where he easily lifts a heavy load of *padi* (rice) on his back and shares a cigarette with his friend on the way to the rice mill in the final scene.

The Kromo tale exhibits the standard devices of the before-and-after narrative. Simin serves as the masculine, robust, and knowing foil who contrasts with Kromo's productive weakness, gendering his pathology. Unlike the VD films of the 1920s United States that depended on similar contrasts, the Kromo film avoids an explicitly moralizing tone and instead presents hookworm as a public unknown that could be understood through the teachings of the hygiene mantri. The emphasis on Kromo's internal emotional states as he suffers from debilitating weakness intends to draw the empathy and identification of the audience, who Kromo nominally represents. The process of fighting hookworm is depicted as an opportunity for enhanced comradeship between Simin and Kromo, who work closely together to construct the latrine and harvest padi, evoking the Javanese/Malay principle of "mutual aid" (*gotong-royong*). The narrative is thus tailored specifically to imagined Javanese audiences: it is devoid of complex etiological

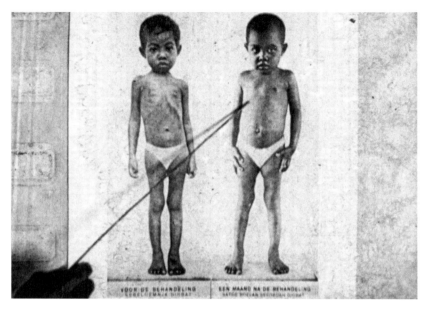

Fig. 12.3. *Before and After Treatment*. Image taken from DVG Medical Hygiene Propaganda film slide, ca. 1930s. Courtesy of General Sudirman University Library.

descriptions, cinematic illusions, or signs of Dutch presence aside from the Dutch caption text that appears beside the Malay and was illegible to largely illiterate viewers.[32]

Other "before-and-after" films adapted a clearly moralizing tone. A film on plague prevention from the collection appears to be an earlier Dutch production from campaigns in the 1920s, produced during a virulent plague epidemic in Central Java.[33] It begins with a Javanese village head kneeling before a white-clad Dutch official to report a plague death. The official passes this information on to a Javanese "intelligence technician" (*mantri-inlichter*), who rides off on his horse to inspect the village in question. The caption introduces the location of the plague death as a "village that has not yet been upgraded," showing the disheveled bamboo home of the mourning inhabitants. After drawing their blood for a plague test, the mantri overturns the order of the house, digging out rats in wall cavities, from under beds, in unused kitchen stoves, in woodpiles, and from inside the bamboo roof beams his assistants tear out and split in half lengthwise. The mantri established the significance of each rat as a marker of sanitary and moral failure by swinging each one by the tail in the direction of the widow, point-

ing out her guilty complicity in the rat-friendly conditions of the home that led to her husband's death by plague. In one instance, the Dutch official, who arrives later in the story, dangles a dead rat pulled from a hollow beam inches from the face of a watching villager. Such indisputable proof of the inadequacy of village architecture, which had become a breeding ground for plague-ridden vermin, justified the leveling of existing homes and the project of total reconstruction, as is depicted in the second half of the film.

Films produced by Hydrick as part of his rural hygiene campaigns also aspired to shock audiences with the visual presentation of disease. Victor Heiser, the Rockefeller Foundation IHD director for the Far East, visited Hydrick's film studios in the early 1930s and described the films and other propaganda materials as having content that was "very disgusting."[34] In one badly damaged film from which only several film strips were salvageable, a distinct method of portraiture evokes disgust: Javanese subjects are shown holding pans containing the heaps of worms that had been expelled from their bodies following vermifuge treatments. The technique was not specific to Hydrick's work, but is a photographic theme present in Rockefeller Foundation projects in other countries; often, captions beneath such photos stated the precise number of worms lying in the heap.[35] These dramatic scenes suggest an epidemiological confessional, in which the subject, isolated and individuated by the genre of portraiture, reveals inner infection. The image of the expelled worms, killed by the vermifuge medication, signifies the truth of the diseased Javanese body and aimed to turn audience disgust inward, toward the wormy self. As Laura Citrin has argued, disgust serves as a powerful moralizing emotion.[36] Hydrick used images of worms, flies, yaws-infected bodies, plague rats, and other filth to distinguish between morally valid and invalid action by producing visceral reactions within audiences. Such scenes of writhing worms were among the few salient images that older Banyumas villagers recalled almost seventy years after watching them, perhaps because they were so deeply tied to moralizing sentiment.

While the enlarged adult worms on the screen demonstrated the efficacy of the purgative treatments and revealed inner pathology, Hydrick was particularly concerned with showing the hookworm larvae—the invisible pathogens in the polluted soil that originated from unhygienic defecation practices.[37] But Hydrick was clearly troubled by the process of magnification, which he believed to be too complex and abstract for Javanese peasants to comprehend. Before microscopes could be used to show invisible

[handwritten margin note: Laura Citrin, "Disgust and the 'normal' Corporeality How Cultural Ideologies about Race Gender]

pathogens, as in the U.S. film *Unhooking the Hookworm*, Hydrick prepared audiences with careful explanations of the process of visual enlargement. In several recovered film clips and other propaganda posters, magnification is broken into a multistage process recapitulating an imagined evolution of the technology itself. First the known is presented: coins and earthworms are placed together and then inside the enlarging lens of an ordinary glass of water, demonstrating that magnification can be carried out even with existing tools in the village. From there a magnifying glass—like the one that some of the hygiene mantri carried on their village rounds—shows smaller objects, such as ants, expanded in size. Finally a microscope shows a single ant appear larger under each power of lens until magnification has reached the scale where the hookworm larvae could be shown. In what is one of the more powerful images within Hydrick's propaganda work, rural peasants line up to look through a microscope set up by a watching hygiene mantri, bringing the laboratory into village life. Hydrick not only made such careful presentations of magnification, but studied the results as well. Dr. Soemedi, the regional director of the Poerwokerto Demonstration Unit, tested viewer comprehension of magnification in West Java, finding that 76 percent of uneducated villagers and 100 percent of educated villagers understood the process after watching the films.[38] The success of the simplified approach was thus verified for Hydrick, who relied on proof of the invisible to displace spirits, winds, and other notions of pathogenicity that inhabited the Javanese worldview.

Though Hydrick's theater of proof assumed "native" irrationality and technological infancy, memory fragments of the past suggest another reading of Javanese encounters with mantris and propaganda. When I asked an older Javanese man about the mantris' use of magnifying glasses to teach people about hookworms, he denied the possibility that magnification was any barrier to villager's understandings of the cause of their illness, explaining that "of course we knew what was making us sick, every time we defecated we could see the worms coming out." Though such memories are inflected with present Javanese biomedical understandings, the logic of the man's statement—that worms *were* visible and needed no explanation—challenges Hydrick's perception of Javanese villagers as too rationally immature to draw such causal inferences. Yet, as much as it served as an instrument of visualization intended to bridge epistemological gaps, Hydrick's obsession with the microscope was also bound to the colonial use of technology

as a "measure of man" that placed Javanese subjects within hierarchies of rule by revealing their scientific inferiority.[39]

These hierarchies of rule were further extended through the project of rural hygiene itself by transferring not the "modern" technologies of gleaming porcelain, septic tanks, and iron faucets, but the *makeshift* sanitary technologies that could be cobbled together from the "free" stones, bamboo, palm leaves, and clay that surrounded the rural environs. While Andrew Balfour, a leader in the field of tropical medicine, advocated the use of "sanitary makeshifts" during the "exceptional circumstances" of wartime, in Java Hydrick envisioned such improvised technological "exceptions" to be the permanent solution to the problems of disease.[40] A three-part film from the collection extensively details the various techniques for constructing latrines using rudimentary techniques and low-cost materials. Javanese workers are shown digging latrine pits with hoes, shovels, and manual ground bores; lining the pits with woven bamboo tubes covered with tar pitch or clay segments spun on a potter's wheel; fashioning latrine bases from stones or casting them from sand and cement; and constructing the outer walls and roof out of bamboo and grass. The film is eminently practical, serving as a technical manual for the construction of such sanitary makeshifts without any explicit narrative or character development beyond the processes of latrine craftsmanship. In several parts, the actors in the films communicate directly with the audience, looking toward the camera and pointing out features of the sanitary works. In this respect the film serves as a live, teaching agent and the audience members, through the eyes of the film camera, the individuated "I" of the learning subject receiving a schoolroom lesson. At times this lesson is painfully simplified: in one scene two men show a cast cement latrine base with its wooden mold, pointing to their own feet and then to the raised footholds on the latrine base, showing viewers how to defecate while squatting—a rudimentary act already well known in Javanese life. While such technologies might have formed the basis for a late colonial "sustainable development" that empowered Javanese villagers to become active agents in the construction of their own sanitary works, the idea that rural Java should obtain health while remaining in the "bamboo age" intended to sustain the countryside in its peripheral position within the colony and world economy alike.[41]

High technology remained a lofty ideal that floated above the rural space of the Indies colony, briefly touching ground as a means of civilizational

contrast. Among the films present in the former medical administration office was a reel depicting the flight and landing of the *Uiver*, the famous KLM Douglas DC 2 airplane that was much revered by the Dutch for capturing second place in the 1934 race from London to Melbourne. In the film, the *Uiver* lands in Bandoeng, then called the "Paris of the East," and is greeted by an enormous crowd of Dutch and Indonesian spectators. After a festive motor parade through the city the flight crew returns to the plane and takes off for the next destination. In his book *Engineers of Happy Land* on the technologies of late colonial Indies life, Rudolf Mrázek explains that "like air conditioning, for instance, the airplane was the most wonderful technology of time and place, technology useful by being and making up the trivial."[42] This triviality and lightness depicted in film called forth a curious audience of villagers to witness the wonderment of the colonial world. Though Indonesian nationalists complained that "air transport had no significance for the indigenous population" as they were largely excluded as passengers,[43] its use as a signifier of the modern—sleek, sterile, modern, and soaring far above the filth on the ground—made it useful as a potent parallel to the kinds of hygiene encouraged by the mantri.

Dr. Soemedi, the regional director of Hydrick's Purwokerto Demonstration Unit, wrote that the "theatres in the villages always served as an attraction," drawing in mass audiences, young and old.[44] The task of generating an audience was carried out through the inclusion of technological spectacles like the *Uiver* as well as other mass entertainment features. Another film in the collection, *Salim and Sarinah*, was well remembered by older Banyumas villagers. One man recalled the specific chase scene at the start of the film in which colonial police leap from behind bushes to break up a village gambling ring, sending startled gamesters diving into ponds and rolling down embankments until they are finally wrestled to the ground and apprehended. Such scenes of tripping, diving into water, and falling over embankments imparted a slapstick element that elicited the laughter of contemporary viewers during a 2002 showing of the films at General Sudirman University in Central Java and most likely produced a similar response in the 1930s. Slapstick elements were woven into stories of hookworm illness and recovery, creating unusual hybrids of medicine and comedy. In the Kromo and Simin tale described earlier, Kromo's hookworm infection is exaggerated through various comic pratfalls as he struggles wearily to carry out his work. As Kromo digs the hole for his latrine, his hoe lodges in the soil and he loses his grip, sending him plunging onto his backside into the dirt. After

Simin takes over and finishes digging the deep pit, Kromo reaches in feebly to pull him out, causing both men to trip over the dirt heap and topple onto their backs. When the latrine cover is completed and ready for use, Kromo demonstratively squats over the hole while fully clothed, teaching the viewer the proper position for defecation in a clearly gratuitous manner.

Hydrick, possibly following the advice of the Javanese staff who worked beside him on the film projects, appears to have recognized the value of generating a festive atmosphere that would maximize attendance at the film showings. In calling forth public laughter around the subject of hookworm, Hydrick was, perhaps intentionally, fostering a warmer private reception for the hygiene technicians as they visited individual villagers' homes, talked with families, inspected yards, and checked latrines. The following section draws on archives and memory to explore the social, political, and economic context in which rural hygiene entered Banyumas in the 1930s. It considers how the films, in provoking laughter, also opened the door for the mockery of the mantri and alternative readings of hookworm bodies.

Of Wayangs and Worms

The conditions of life in rural Banyumas during the 1930s were particularly unwelcoming for persuasive rural hygiene projects that intended to "awaken" the interest of the Javanese in building their own sanitary infrastructure. L. M. Gandasubrata, the *bupati* (regional governor) of Banyumas from 1933 to 1950, writes in his published memoirs of the severe depression that affected rural populations throughout the area in the early part of the 1930s, right as Hydrick began his model projects.[45] By 1933, all five of the sugar factories in Banyumas had closed, suddenly evaporating the millions of guilders paid out to area peasants for land rents.[46] Although the government insisted that "under the Netherlands flag no hunger exists," Gandasubrata remembered that time as one of severe poverty and malnutrition. In response to these conditions, the Dutch Resident of Banyumas planned an intensive program of transmigration out of Java to the low-population-density areas of Sumatra and Sulawesi, where villagers were promised extensive landholdings—up to two acres—and a new life in the cleared jungle settlements.[47] Almost a quarter of a million people are reported to have migrated out of the wider Banyumas residency between 1932 and 1941, nearly a tenth of the total population.

Today, villagers in Banyumas recall the flow of people to Sumatra in the

1930s not as voluntary transmigrations but as forced labor migrations to work Dutch plantations. One man now living in an isolated hillside settlement who claimed to be in his nineties told the story of how he was conscripted into labor during the colonial period by a *culik* who sent him to Sumatra.[48] There he was forced to work in the palm oil and rubber plantations until after the Japanese occupation, when he married a Batak woman and returned to Java. In Javanese, the term *culik* means "a bogeyman who pries people's eyes out."[49] But the man had used the term *culik* to refer to its other, perhaps related, Indonesian usage, meaning "to kidnap" or "abduct." Some villagers called the forced labor abductions *werk*, possibly remembering the term used by Dutch-speaking plantation owners or local Javanese agents who procured labor. One man suggested that a mantri culik existed who would come, along with village police, to bring people away to Sumatra. There, he said, the work was very difficult and people would come away with a kind of yaws infection on their upper backs. Others remembered on separate occasions the specific names of three wealthy members of the Banyumas elite who would drive through the villages in a "bulging, puffed up" (*njembluk* in Banyumas Ngoko, the local dialect) brand of car, looking for stray people to sell off in Poerwokerto. From there, those who were abducted would later be sent on to Deli, the capital of the Sumatra plantation zone. Many recalled that when such a car, or a jeep, would drive through the village, someone from the village would yell "Werk! Werk!" and they would hide far from the road. Such rumors and memories index a particularly unsettled late colonial structure of feeling, in which the bodies of rural peasants were simply up for grabs within a wider extraction economy.

If colonial violence was specifically tied to forced labor migrations to Sumatra during the depression of the 1930s, it was more subtly recalled as internal to the everyday processes of order and authority. As a village shadow puppeteer (*dhalang*), today in his late eighties, explained, "Dutch rules were disciplined and dictatorial. . . . People going to village meetings wore a batik head cloth. If someone didn't wear it he would be struck by the village head for not properly respecting the meeting. At that time I had to lower myself before the assistant village head, in the old style."[50] Furthermore, strict rules were placed on the use of the drainage canals that irrigated the rice fields, resulting in steep fines for violations like bathing and defecation. Local officials could also be fired for infractions of rules, such as failing to report a death in the village to the proper authorities. People recalled being afraid of the mantri *cacar*, who came through villages periodically to give small-

pox vaccinations. The hygiene mantri, whose position as colonial "middle figure"[51] was conceptually tied to the authority of the smallpox vaccinators and the "kidnapping" mantri, was sometimes feared as well. As a former hygiene mantri recollected, often no one would answer the door when she arrived for a house visit, but when she stooped down she could sometimes see people's feet through the space beneath the door, as residents kept still to avoid detection. Although Hydrick selected the hygiene mantri from among the known local elite who had deep genealogical ties with village society, their connection to the authority of the colonial state placed them in a threatening position even though their work was primarily educational.

Other recollections surrounding the mantri were quite different from those describing conscripted labor and colonial authority. Some villagers' stories suggest that at the same time the rural hygiene cinema served as a biomedical "theater of proof," it also cultivated a warm sociality in the 1930s, of which the mantri are a large part, which remains a locus of present nostalgia. Hydrick suspected that mass propaganda efforts like films and public lectures could only "awaken a temporary interest" in hygiene and therefore favored the routine visits of the hygiene mantri to individual homes as the principal means of public health education.[52] The films paved the way for such visits in the chilling climate of 1930s rural Banyumas by introducing the mantri to entire village publics at once and placing them at the center of the mass entertainment spectacles. At the films, the mantri gave health speeches and translated the film captions into Banyumas Javanese, playing the role of narrator for audiences who could read neither Dutch nor Malay. This softening of audiences had an endearing effect, as several of the mantri continue to be remembered in very positive terms by older Banyumas villagers.

The monthly or bimonthly arrival of the komidhi sorot generated widespread anticipation among village publics. People in Banyumas recall that five days before the films were to be shown an announcement was given by the village officials and "news began circulating all around" that the event was coming. On the day of the showing, someone would run through the village calling out through a loudspeaker "Filem! Filem! . . . Filem! Filem!" generating excitement for the coming event. The films showed at eight in the evening, but "before seven pm there were huge crowds . . . people weren't playing around." The atmosphere was festive, with vendors selling peanuts and other snacks, and children gathered together in large groups to watch the films where they played in public squares, at village halls, or in the mantri's own front yard. Many remembered the film showings to be filled with

laughter, as audience members conjoined in pleasurable entertainment brought by the new film technologies of the "spotlight theater."

Though it was "more popular" than the shadow puppet (wayang kulit) theater, the hygiene cinema mirrored its form in several ways. The serious, moralizing depictions of contagion and convalescence correspond with the formal, high Javanese moral narratives of the Mahabharata tales, which occupied the majority of both theatrical events. By inviting laughter to lighten the project of rural hygiene through the inclusion of slapstick elements, the outdoor cinema also acted like the comic *gara-gara* interlude of the wayang kulit theater. The gara-gara, which takes place late into the night, entertains with the ribald, slapstick humor of farting, punching, and wrestling puppets. Thus, both the wayang kulit and the spotlight theater lingered on the lower bodily stratum. Yet unlike the wayang kulit performances, in which elite male, invited guests sit watching the shadows on one side of the screen while the uninvited masses watched the "live" puppets and puppeteer from the other,[53] the hygiene cinema demanded that the entire audience sit together on one side of the screen, producing a leveling effect.

By fostering a "circus" aspect of the komidhi sorot that mirrored the gara-gara, Hydrick unleashed raucous pleasures of public sociality that were rooted in the carnivalesque. While the cinematic carnival may have softened audiences to the coming of the mantri, it also introduced a state of play that left the mantri, as well as the films, open to mockery. It was perhaps in this carnivalesque frame that the hygiene mantri came to be publicly renamed as the "*mantri kakus*," a term that translates as "outhouse technician." Older Javanese use the term *mantri kakus* with an inflection of humor to describe the work of the hygiene technicians, whose Dutch title, *mantri hygiene*, they no longer recall. In Dutch, the word *kakus* has a still more foul translation, referring to shit rather than its receptacle. The mockery of the "outhouse technicians" thus subverted the hierarchies of indirect rule, placing the elite, educated mantri of the high Javanese world conceptually among the peasants' filth they sought to hygienically contain.

Though the content of the films evoked public laughter, what people were laughing *at*, however, is not entirely clear. In his study of Javanese language and internal life, James Siegel suggests that the "figures of the wayang permeate Javanese thinking to the point where the puppet theatre is the richest source of metaphor and imagery in Java."[54] Banyumas villagers described the thin bodies, swollen stomachs, and bulging eyes of hookworm victims as looking like Gareng, a popular figure of the wayang pantheon (see

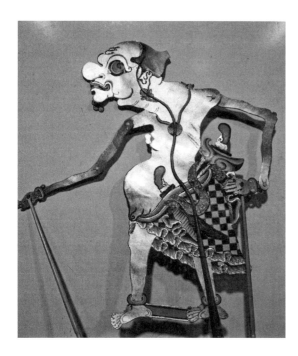

Fig. 12.4. *Gareng*.
Photograph by author;
courtesy of the University
of Michigan School of
Music.

figure 12.4). Gareng is one of the *punakawan*, the comic, misshapen sons of Semar who emerge in shadow puppet performances especially during the gara-gara interlude late in the night to entertain with slapstick humor. Ward Keeler suggests that the punakawan are as "well-loved and intimately known as brothers to Javanese," much like the Marx Brothers for film audiences of the 1930s: "They can mock each other, argue, and have fist-fights. They can fight against their enemies, using trickery, farming tools, and even excrement. Semar often uses his great flatulence to lay an opponent low. They can sing and dance, weep, beg for money, and express their fears. . . . Of low status, deformed, and dependent, the punakawan might seem to be perfect representatives of what Victor Turner calls marginality—anti-heroic, anti-structural, the domain of those who criticize and reject the distinctions on which a society's power structure is based."[55]

Gareng's ability to fling excrement and engage in other acts of symbolic deviance is tied to the comic nature of his misshapen form, which marks him as outside the domain of "human" status and structure. A Banyumas dhalang has suggested that the comic form of Gareng's body is random, only resembling the bony arms, reddened eyes, and bulging stomach of a hook-

worm victim because such exaggerations are "naturally" humorous. Yet other wayang figures also appear to emulate the disfigured, diseased bodies present within Javanese publics. In 1935, a Chinese physician noted the "remarkable connection" between the bulging red nose of the wayang figure Boeto and the similarly bulging, red noses of victims of rhinoscleroma, a yaws-like disease common in Java that caused such facial lesions. Javanese colleagues supported the Chinese physician's claim by noting that the nasal sound (in Dutch, *neusspraak*) of rhinoscleroma patients' voices, altered by the lesions, were just like that of the shadow puppeteer's voice when playing Boeto.[56] Such instances of art similarly imitating life in the figure of Gareng suggests a Javanese reading of the hookworm-infected body-type as comic that predated the Rockefeller Foundation projects arrival in Banyumas. When present-day villagers in Karang Wetan talked about the enlarged images of half-naked hookworm victims projected on the film screens, they also recalled bursting into laughter over such scenes. During a screening of the films for a small audience in 2003, the image of a bony, hookworm-infected man elicited laughter again. These instances of laughing at the "wrong" time—during the depiction of a hookworm-infected body intended to evoke fear—revealed more than just nervousness, but perhaps a ribald reading of a Garengesque physique.[57]

While the cinematic carnival may have opened up the Rockefeller Foundation projects to mockery and inappropriate laughter, such apparently subversive acts did not necessarily disrupt the process of hygiene education. In his discussion of carnival, Mikhail Bakhtin suggests that the collective social laughter over the lower bodily stratum holds generative powers.[58] One might read the laughter over the mantri and films as having a similar generative power through its incitement to discourse: after the films played and the "outhouse technicians" made their visits, people talked about hookworm, latrines, and feces, and did so in particular ways. Such incitements to discourse generated evaluative claims about bodies and cleanliness. Seeing the enlarged, hookworm body projected on the screen may have evoked inappropriate laughter, but that laughter also collectively defined the hookworm body as inappropriate. It also opened a space for the mantri to enter into homes and into the memories of Banyumas villagers as part of a coherent narrative about their pasts. As Pak Narto, a former colonial police officer and village official, assured me, "after the outhouse technicians came and showed the films, everyone in the village constructed latrines."

Contrary to Pak Narto's claim, not everyone in his village built latrines in the 1930s nor even have them in the present. Some village social elite owned latrines even before the hygiene mantri began their work, as a mark of status and a form of association with the modernity of the late colonial world. Several small landholders recalled that it was only "*wong sugih-sugih*," the wealthy, who could afford to construct the latrines even after the mantri arrived. Bu Lilis, a female mantri, suggested that poorer people in Banyumas were forced (*terpaksa*) "to *not* make them" and those who did could rarely afford to finish the construction process. Besides the cost of materials and the lengthy labor time—which Hydrick had factored out of his equation— the ephemerality of the latrine, which fills to capacity and must be dug out or replaced every several years, served as a further deterrent to its construction. Hydrick's sanitary "costless" latrine was a major work of physical labor, requiring a full week to complete (time which may have been used to earn wages) and was prohibitively expensive for many in rural Banyumas particularly during the economic malaise of the 1930s.[59] Yet the moralizing tales of the spotlight theater and the mantri home visits left an endearing message that building a latrine was the *correct* thing to do, a message that Pak Narto, the colonial police officer, repeated in his invented claims about the past.

The creation of theaters of proof in 1930s Java fit with the Netherlands Indies governor general's claim that "300 more years of Dutch rule" were needed in the colony before any Indonesian autonomy could be allowed.[60] As Latour suggests, and colonial health officials recognized, "the microbe is a means of action"; it enables public health institutions to function effectively through shared notions of pathogenicity with subject populations.[61] Forcing colonial subjects to "share" the "truth" about germs was understood to be critical to the maintenance of sanitary order and was perhaps thought to be a precondition for granting Indonesia status as a modern, independent nation. Yet the project of sharing this truth about microbes was troubled by colonial ideologies of representation and translation that raised anxieties over potential Javanese misunderstandings of biomedical etiologies. Hydrick's hygiene films attempted to compensate for perceived Javanese irrationality by creating simplified narratives that established clear links of causality between sickness and cure. In seeking to illuminate the presence of invisible pathogens with microscopic technologies, Hydrick also infan-

tilized audiences by teaching the fundamentals of magnification, which, as Javanese viewers claimed, were already obvious. Whether or not Javanese audiences came to "share" the truth of germs in the 1930s is a question that perhaps cannot be answered through recourse to memory alone; however, people's nostalgic memories for the hygiene films reveal a parallel process of colonial power with lasting effects even into the present.

Hydrick understood the value of entertainment to draw in audiences and open up their homes to the more intimate educational visits of the hygiene mantri. In presenting airplanes, chase scenes, and comic pratfalls, Hydrick had fashioned what film historian Tom Gunning calls an "aesthetic of attraction," based on curiosity and "scopic pleasure."[62] This aesthetic enabled the hygiene projects to partially break with the coercive police identity that characterized other forms of colonial village authority. As a technique of power, the use of performance to balance coercive rule has a continued history in Indonesia: after murdering leftist puppeteers and artists during the 1965–66 anticommunist massacres, President Suharto's New Order regime employed its own legions of comedians, puppeteers, and artists to provide public entertainment and also control the voice of mockery.[63] After the 1930s, the next time rural Banyumas Javanese recall watching movies in the village and being treated to comedy troupes was during the intensive birth control campaigns of the early 1970s, in the formative stages of Suharto's rule. Rudolf Mrázek, in recalling the film technologies of the late colonial world, notes that "The light, and even the shadows, in the Indies movie houses were man-made. The electric switch was in a professional hand. These indeed, are the most impressive, and most troubling, images of the late-colonial period: people floodlighted, and rulers watching the light effect."[64] The laughter that arose from audiences watching the films was also man-made, and listened to by rulers who tried to discern its meaning. Yet for all of the investment in constructing theaters of proof in the late colonial Indies and studying their effects, a fundamental block remained that prevented Hydrick and colonial health authorities from fully recognizing and acting on the deep structural inequalities that prevented the construction and use of latrines. Although most people in contemporary rural Banyumas understand the problem of germ and parasitic contagion, this block remains present within the logics of health policy, such that the drainage canal that runs from the city of Purwokerto through the villages in Banyumas is now known, jokingly, as the "longest toilet in Java."

Notes

Eric A. Stein, "Colonial Theatres of Proof: Representation and Laughter in the 1930s Rockefeller Foundation Hygiene Cinema in Java," *Health and History* 8(2), Health, Medicine and the Media (2006), 14–44. Permission to republish granted by Hans Pols, editor of *Health and History* and representative of the Australian and New Zealand Society of the History of Medicine.

1 In the 1930s five *ketip* was the equivalent of fifty cents, more than ten times what a farm laborer could earn in a single day, making the urban film screenings both distant and prohibitively expensive.

2 Bruno Latour, *The Pasteurization of France* (Cambridge, MA: Harvard University Press, 1988), 85–86.

3 As Ulf Schmidt notes in his discussion of Nazi propaganda movies, "The film camera was seen as a machine that could not lie; the film itself as an apparently objective representation of reality." Ulf Schmidt, *Medical Films, Ethics, and Euthanasia in Nazi Germany* (Husum, Germany: Matthiesen, 2002), 41. On the perceived advantage of the film medium for demonstrating links of causation see Marianne Fedunkiw, "Malaria Films: Motion Pictures as a Public Health Tool," *American Journal of Public Health* 93(7) (2003): 1046–57. See also Martin Pernick, *The Black Stork: Eugenics and the Death of "Defective" Babies in American Medicine and Motion Pictures Since 1915* (New York: Oxford University Press, 1996).

4 See Lisa Cartwright, *Screening the Body: Tracing Medicine's Visual Culture* (Minneapolis: University of Minnesota Press, 1995).

5 Kirsten Ostherr, *Cinematic Prophylaxis: Globalization and Contagion in the Discourse of World Health* (Durham: Duke University Press, 2005), 2–7.

6 Cartwright, *Screening the Body*, 3. Cartwright explains that the "microscopic motion picture . . . is a mechanism through which science reorganized its conception of the living body" (82). Viewers could similarly reorganize their own bodily conceptions around depictions of internal pathogens and potentially learn to defer to the vital authority of health agencies. Latour explores the construction of the microbe as a social agent, "not an idea floating in the head of scientists [but] a means of locomotion for moving through the networks that they wish to set up and command" (Latour, *Pasteurization of France*, 45). Beyond the laboratory space in the sphere of public health, such networks relied on viewers to uphold the same criteria of validity as medical professionals who organised health interventions.

7 On film censorship in Britain, see Annette Kuhn, *Cinema, Censorship, and Sexuality, 1909–1925* (London: Routledge, 1988). For the United States see Pernick, *The Black Stork*; and Ostherr, *Cinematic Prophylaxis*.

8 Pernick, *The Black Stork*, 121.

9 John Parascandola, "VD at the Movies: PHS Films of the 1930s and 1940s," *Pub-*

lic Health Reports 111 (1996): 173–76. Such studies, however, rarely deterred public health officials, who sought to develop more compelling film narratives and visuals that might be more able to touch the bodily habitus of audiences.

10 Tom Gunning has argued that viewers of early twentieth-century films were treated to an "aesthetic of astonishment" that was understood to be divorced from empirical reality. Watching Lumière's *Arrival of a Train at the Station*, in which a train appears almost to roll into the theater, audiences were pleasurably entranced rather than startled in terror: "The peculiar pleasure of screaming before the suddenly animated image of a locomotive indicates less an audience willing to take the image for reality than a spectator whose daily experience has lost the coherence and immediacy traditionally attributed to reality." Tom Gunning, "An Aesthetic of Astonishment: Early Film and the (In)Credulous Spectator," in *Viewing Positions*, ed. Linda Williams (New Brunswick, NJ: Rutgers University Press, 1994), 126.

11 On the construction of the "gentleman" in science see Steven Shapin, *A Social History of Truth: Civility and Science in Seventeenth-Century England* (Chicago: University of Chicago Press, 1994).

12 Megan Vaughan, *Curing Their Ills: Colonial Power and African Illness* (Stanford, CA: Stanford University Press, 1991), 185.

13 Vaughan, *Curing Their Ills*, 191.

14 After hearing about the hygiene films from villagers, I searched for them extensively in Banyumas, hoping to find some preserved in the local archive of the Regional Health Services. The end of the Suharto period in 1998 resulted in a reshuffling of administrative locations. In Banyumas I was told that all old medical records were now housed in the Department of Transportation, although it took repeated visits before officials there would admit to such holdings. Behind the office in a decaying unused bathroom filled with a rusted refrigerator and empty oil cans, we found a stack of twelve film canisters resting directly on the mouth of a squat toilet, along with a broken projector and a film reeling device discarded nearby. The majority of the films were labeled with the stamp of the 1930s Medisch-Hygienisch Propaganda Division of the Dienst der Volksgezondheid. These films were most likely those shown in villages by the hygiene mantri in Banyumas, as several of the villagers' recollections matched exactly with the narrative content. The films are currently housed in General Sudirman University's Department of Public Health Library, Purwokerto, Central Java, Indonesia.

15 On the Rockefeller Foundation hookworm projects see Anne-Emanuelle Birn and Armando Solorzano, "The Hook of Hookworm: Public Health and the Politics of Eradication in Mexico," in *Western Medicine as Contested Knowledge*, ed. Andrew Cunningham and Bridie Andrews (Manchester: Manchester University Press, 1997); Christian Brannstrom, "Polluted Soil, Polluted Souls: The Rockefeller Hookworm Eradication Campaign in Sao Paulo, Brazil, 1917–1926," *Historical Geography* 25 (1997): 25–45; Marcos Cueto, "The Cycles of

Eradication: The Rockefeller Foundation and Latin American Public Health, 1918–1940," in *International Health Organizations and Movements, 1918–1939*, ed. Paul Weindling (Cambridge: Cambridge University Press, 1995); John Ettling, *The Germ of Laziness: Rockefeller Philanthropy and Public Health in the New South* (Cambridge, MA: Harvard University Press, 1981); James Gillespie, "The Rockefeller Foundation, the Hookworm Campaign and a National Health Policy in Australia, 1911–1930," in *Health and Healing in Tropical Australia and Papua New Guinea*, ed. Roy MacLeod and Donald Denoon (Townsville, Qld.: James Cook University Press, 1991); Soma Hewa, *Colonialism, Tropical Disease and Imperial Medicine: Rockefeller Philanthropy in Sri Lanka* (Lanham, MD: University Press of America, 1995). For details on the Rockefeller Foundations on Java, see Terence Hull, "The Hygiene Program in the Netherlands East Indies: Roots of Primary Health Care in Indonesia," in *The Political Economy of Primary Health Care in Southeast Asia*, ed. Paul Cohen and John Purcal (Canberra: Australian Development Studies Network, ASEAN Training Centre for Primary Health Care Development, 1989); Hans Mesters, "J.L. Hydrick in the Netherlands Indies: An American View on Dutch Public Health Policy," in *Health Care in Java, Past and Present*, ed. Peter Boomgaard, Rosalia Sciortino, and Ines Smyth (Leiden, Netherlands: KITLV Press, 1996); and Eric Stein, "The Economics of Hygiene in the Netherlands Indies, 1900–1942," in *Michigan Discussions in Anthropology: Passages to Anthropology* (Ann Arbor: University of Michigan Press, 2000).

16 See especially John Hydrick, *Intensive Rural Hygiene Work and Public Health Education of the Public Health Service of Netherlands India* (New York: Netherlands Information Bureau, 1937).

17 Hereafter I use DVG as an abbreviation for the Dutch Dienst der Volksgezondheid of the Netherlands East Indies.

18 Memorandum from Hydrick to Heiser, October 7 1931, folder 8, box 2, series 655 L, RG 1.1, Rockefeller Foundation Archives, Rockefeller Archive Center, Sleepy Hollow, NY, (hereafter RAC). Dr. Van Lonkhuijzen's Volksraad speech was on June 28, 1923.

19 A modest literature on the history of public health in the Netherlands Indies provides a general outline of this clinical orientation, but no single work provides a comprehensive perspective that draws on primary sources. On the limited scope of the DVG see Norman Owen, ed., *Death and Disease in Southeast Asia: Explorations in Social, Medical, and Demographic History* (Oxford: Oxford University Press, 1987). A number of shorter pieces and chapters provide some discussion of particular areas of DVG activity. See Peter Boomgaard, "The Welfare Services in Indonesia, 1900–1942," *Itinerario* 10(1) (1986): 57–81, and Peter Boomgaard, "Dutch Medicine in Asia," in *Warm Climates and Western Medicine: The Emergence of Tropical Medicine, 1500–1900*, ed. David Arnold (Amsterdam: Rodopi, 1996). On pre–twentieth-century Dutch medicine in Asia and Netherlands Indies more generally see Dirk Schoute, *Occidental Therapeutics in*

the Netherlands Indies during Three Centuries of Netherlands Settlement, 1600–1900 (Batavia: Netherlands Indies Public Health Service, 1937). On the history of nursing, see Rosalia Sciortino, *Care-Takers of Cure: An Anthropological Study of Health Center Nurses in Rural Central Java* (Yogyakarta: Gadjah Mada University Press, 1992). On medical education see Daniel De Moulin, "The Teaching of Medicine in the Dutch East Indies," in *Dutch Medicine in the Malay Archipelago, 1816–1942*, ed. A. M. Luyendijk-Elshout (Amsterdam: Rodopi, 1989).

20 Letter from the governor general to the minister of colonies, April 10, 1934, no. 15, Ministerie van Koloniën 1900–1963, Openbaar Verbaal, Algemene Rijksarchief, The Hague. According to Victor Heiser, the director of the Far East for the Rockefeller Foundation IHD, Hydrick won this respect and acceptance through a wager against Van Longkhuijzen to determine whose latrines were most well used by indigenous populations. (Victor Heiser officer's diary, January 15 1926, RG 12.1, RAC.)

21 Though Hydrick's first studio was destroyed by fire in 1928 and all of the films lost, he rebuilt in a larger space and continued producing hygiene propaganda materials into the 1930s. (Personal communication with Terence Hull.) Of films I recovered from Banyumas that had date markings, all were produced after 1930.

22 Heiser to Russell, February 26 1928, folder 7, box 2, series 655 L, RG 1.1, RAC.

23 Letter from Dr. Offringa to the minister of colonies, January 3, 1936, no. 25, Ministerie van Koloniën 1900–1963, Openbaar Verbaal, Algemene Rijksarchief, The Hague.

24 See Eric Stein, "Vital Times: Power, Public Health, and Memory in Rural Java," PhD diss., University of Michigan, 2005.

25 Sukarno had instituted the phrase "Healthy People, Strong Nation" during his nationalist campaigns under the Japanese occupation. See na, "Mobilizasi Dokter," *Berita Ketabiban* 1–3 (1943): 28. (Note, the date appears on the original source as "2603," which refers to the Japanese calendar since it was printed during the time of the Japanese occupation of Java.)

26 For details on the film *Unhooking the Hookworm*, see Rockefeller Archive Center, "Unhooking the Hookworm," http://www.rockarch.org/feature/hookworm .php (accessed May 17, 2013). The use of the diseased bodies of poor whites as a moral cautionary tale to be viewed by colonized Asians and Africans appears to disrupt the colonial "poetics of pollution" that contrasted the closed, immaculate bodies of whites with the open, polluting bodies of the nonwhite "other," as Warwick Anderson has described in his article "Excremental Colonialism: Public Health and the Poetics of Pollution," *Critical Inquiry* 21 (1995): 640–69. Such contradictions might be resolved, as Rudolf Mrázek has suggested (personal communication), by considering the primacy of scientific narratives that insisted on the universality of disease and medicine for colonizer and colonized alike.

27 Although the first segment of the film was heavily damaged and unplayable, I

was able to recover several viewable film slides that provide an outline of the first several minutes of the story.

28 Vaughan, *Curing Their Ills*, 185.

29 John L. Hydrick, "Fourth Quarter Hookworm Report 1924–25," folder 364, box 57, series 652, RG 5.2, RAC, 6.

30 The name Simin refers to the Javanese term meaning "formerly, previously," which may indicate that Simin is an older sibling or friend, or suggest that Simin already knew about hookworm and had made his own full recovery.

31 The public line-up around the "medicine table" was a common theme in the hygiene films and reflected a practice of Dutch medicine in rural villages more generally, in which village headmen gathered inhabitants for smallpox vaccinations or other drug treatments by visiting mantri.

32 Rudolf Mrázek has suggested that presence of Dutch in the hygiene films maintained a linguistic hierarchy that indexed the order of colonial authority, even in the absence of other markers of Dutch rule (personal communication).

33 See Terence Hull, "Plague in Java," in *Death and Disease in Southeast Asia*, ed. N. G. Owen (Oxford: Oxford University Press, 1987). Hull reports that plague outbreaks in 1920s Java resulted in the interruption of travel, the placement of tens of thousands of people into isolation camps, the confiscation of property, and the burning of homes (212). It also led to the refurbishment of 1.5 million houses to make them rat-proof and several such refurbishments are depicted in the film.

34 Victor Heiser officer's diary, February 24 1931, RG 12.1, RAC, 11.

35 For such an example see John L. Hydrick, "First Quarter 1934 Report," box 226, series 655, RG 5.3, RAC. It is difficult to imagine how rural villagers might have comprehended their own participation in the photographing of such propaganda scenes. While I did not encounter any Javanese who recalled having been the subject of such propaganda, I imagine that the experience must have been quite unsettling, particularly for those who also posed with their own worms as part of their first photographic experience.

36 Laura Citrin, "Disgust and 'Normal' Corporeality: How Cultural Ideologies about Gender, Race, and Class are Inscribed on the Body," PhD diss., UMI Dissertation Series, 2004.

37 As Naomi Rogers suggests, the problem of invisibility similarly troubled health officials in the United States, who "sought to make germs as fearful as filth, but unlike garbage, overflowing sewers, or inadequate privies, germs were not visible to ordinary citizens. Flushing streets and disinfecting buildings were dramatic methods of hoarding a community's health, but officials could not be observed in the act of killing germs." Naomi Rogers, "Germs with Legs: Flies, Disease, and the New Public Health," *Bulletin of the History of Medicine* 63 (1989): 599–617, 600.

38 Somedi, "De Film als Propaganda-Middel bij Hygiënewerk," *De Hygienische Organisatie Bulletin* 46 (1937): 1–3, 1.

39 See Michael Adas, *Machines as the Measure of Men: Science, Technology, and Ideology of Western Dominance* (Ithaca, NY: Cornell University Press, 1989).

40 Andrew Balfour, *War against Tropical Disease* (London: Beilliere, Tindall & Cox, 1920), 99.

41 On the duplicity of such strategies of development see Edward Murphy, "Developing Sustainable Peripheries: The Limits of Citizenship in Guatemala City," *Latin American Perspectives* 31(6) (2004): 48–68.

42 Rudolf Mrázek, *Engineers of Happy Land: Technology and Nationalism in a Colony* (Princeton: Princeton University Press, 2002), 115–16.

43 Mrázek, *Engineers of Happy Land*, 116.

44 Somedi, "De Film als Propaganda-Middel," 1.

45 L. M. Gandasubrata, *Kenang-Kenangan 1933–1955* (Purwokerto: n.p., 1952).

46 Gandasubrata, *Kenang-Kenangan*, 3.

47 In Java, only the wealthiest landholders could afford to own two or more acres of land. During my research in 2002–2003 in Banyumas, wealthy elites, including village officials, often owned only a single acre of wet rice fields.

48 These memories were discussed with the author during unstructured interviews carried out with approximately twenty-five Javanese villagers over eighty years of age in the Banyumas region of Central Java in 2002–2003.

49 Stuart Robson and Singgih Wibisono, *Javanese English Dictionary* (Hong Kong: Periplus Editions, 2002).

50 At the same time villagers complained about the severity of the Dutch rules, they also expressed a longing to return to the order and authority of that period. On the complexities of Javanese memory, see Ann Stoler, *Carnal Knowledge and Imperial Power* (Berkeley: University of California Press, 2002).

51 On colonial "middle figures" see Nancy Hunt, *A Colonial Lexicon* (Durham: Duke University Press, 1999).

52 Hydrick, *Intensive Rural Hygiene*, 20.

53 On such social divisions see Ward Keeler, *Javanese Shadow Plays, Javanese Selves* (Princeton: Princeton University Press, 1987), 218.

54 James Siegel, *Solo in the New Order: Language and Hierarchy in an Indonesian City* (Princeton: Princeton University Press, 1986), 87.

55 Keeler, *Javanese Shadow Plays*, 208–10.

56 Lie Hing Dhiam, "Rhinoscleroom," *Geneeskundige Tijdschrift voor Nederlands Indië* 75 (1935): 2162–64.

57 Villagers in Karang Wetan also associate other wayang figures with visible sickness, such as Bilung, whose head scabs are thought to be scabies. It is impossible to discern whether the wayang figure was created with the sickness in mind or if the association arose later as audiences compared the characters to the diseased.

58 Mikhail Bakhtin, *Rabelais and His World* (Bloomington: Indiana University Press, 1984).

59 Dwikurniarini reports that the cost to have a latrine built in the 1930s was 3 guilders or 350 cents, over 100 times the daily wage of a farm laborer. See

Dina Dwikurniarini master's thesis "Epidemi di Karesidenan Banyumas tahun 1870–1940," Universitas Gadjah Mada, 1999, Yogya, Indonesia, 141.

60 He made this claim in 1936, right as Hydrick's projects received full recognition and endorsement from the Indies government. Harry Benda, *Continuity and Change in Southeast Asia* (New Haven, CT: Yale SouthEast Asia Studies, 1972), 237–38.

61 Latour, *Pasteurization of France*, 45.

62 Gunning, "Aesthetic of Astonishment," 121.

63 Laurie Sears, *Shadows of Empire: Colonial Discourse and Javanese Tales* (Durham: Duke University Press, 1996), 225–34.

64 Mrázek, *Engineers of Happy Land*, 111.

Colonialism and the

Built Space of Cinema

Brian Larkin

———————————

The history of cinema in Nigeria is split between two overlapping but sepa-
rate institutions. One is mobile cinema (*majigi*), traveling to communities
physically, in the early days of itinerant cinema vans, and electronically,
when the work of mobile cinemas was taken over by television. Majigi was
a bureaucratic state institution. Mixing documentary with newsreel and fic-
tion films advancing publicity for the state and its development projects,
majigi addressed viewers as citizens, not consumers. It played films largely
made by Nigerians about Nigerian issues. Commercial cinema, by contrast,
was an entertainment medium designed to make money and existed largely
outside of state control. It generated a new style of urban leisure and places
where northern youths gathered to see and be seen. Commercial cinema is
based on the exchange of money for the promise of an experience, a thrill
of excitement, romance, or comedy. *Sinima*, as it is known in Hausa, stands
in distinction to majigi; showing fiction films[1] dominated (until recently)
by Indian, American, and Chinese images. In the moral order of north-
ern Nigeria, mobile cinema was socially legitimate. Its origins lay in show-
ings in the emir's palace or at colonial rituals that staged royal and colo-
nial authority. Commercial cinema, by contrast, was, and remains, socially
marginal, viewed by mainstream Hausa society as a lower class, un-Islamic
activity. Commercial cinema is of a radically different sort from majigi, in-
stitutionally, textually, and in the modes of leisure it promotes. This chapter
analyzes the origins of cinema in Kano, examining the built space of theaters
to see how cinema came to be suffused with an illegitimate and immoral
ambience.

The introduction of cinema theaters in colonial Kano inaugurated a
series of controversies among urban Hausa. It upset gendered and racial

divisions of public space by creating new modes of sociability and offered new, Western-derived forms of leisure based on a technological apparatus that was religiously questionable. These controversies can be seen as moments of struggle in the reterritorialization of urban space, the attempt to reassert Hausa moral values in the face of an encroaching colonial modernity. Cinema is a technology whose place in Hausa social life had to be defined. Its built form, the stories and rumors surrounding it, and the words used to refer to the technology itself all contain traces of the history of colonialism and the reaction of urban Hausa to the colonial experience. They tell us about the way that cinema as technology entered into Hausa space and took hold in the Hausa imagination.

Until recently, in African postcolonies like Nigeria, a trip to the cinema has always been translocal, a stepping outside of Africa to places elsewhere.[2] To move from the foyer into the dark night of the cinema hall was to be magically transported into a universe where American realities, Indian emotions, and Hong Kong choreography have long occupied Nigerian cinema screens. But cinema theaters are a peculiar kind of social space marked by a duality of presence and absence, rootedness, and transport, what Lynne Kirby refers to as the paradox of travel without movement.[3] Cinema is made distinctively modern by this ability to destabilize and make mobile people, ideas, and commodities. This can be experienced as threatening, eroding "the cultural distinctiveness of place,"[4] but it can also reaffirm and intensify forms of belonging by providing a cultural foil against which local identities may be hardened. While often seen as engines of mobility, cinema theaters are also deeply parochial, intimate parts of the urban landscape drawing around them social practices that make cinema-going an event that always exceeds (and sometimes has little to do with) the films that are shown on the screen. My focus here is on the materiality of the cinema theater, its sensuous and formal characteristics through which "we are able to unpick the more subtle connections with cultural lives and values."[5] Theaters, like radios or mobile projectors, have specific technical qualities that govern what they do in the world. These have origins in human intentions but in practice are relatively autonomous and can never quite be captured by them. Cinema theaters offer an emotional experience based on a sensory environment regulated by specific relations of lighting, vision, movement, and sociality.[6] In colonial Nigeria this emotional experience was mapped onto an urban landscape in rapid transformation, and cinema was both shaped by and contributed to the remapping of the sensory experience of the city.

By examining the interplay between the material qualities of the theater and the social practices they set in motion, we can gain insight into the experience of colonial urbanization in Kano.

Producing the Cinematic Environment:
Cinema, the Phenomenology of the Surface, and Colonial Modernity

Objects that were once new and symbolized modern life but whose historical moment has passed become inadvertent but dense signifiers of transformations in social structure. Walter Benjamin built a powerful hermeneutics around these sorts of objects—those swollen with the force of history, but whose significance had ebbed with transformations in social and economic structure. According to his friend Theodor Adorno, Benjamin created a "petrified . . . or obsolete inventory of cultural fragments" that provided concrete embodiments of historical process or "manifestations of culture."[7] Benjamin shared this evocative theorizing of material culture with Siegfried Kracauer, who also pioneered the historicophilosophical interrogation of the marginal, momentary, and concrete. Like Benjamin, Kracauer was interested in surface phenomena and argued that their marginal, mass-produced nature revealed the social order. "The position that an epoch occupies in the historical process can be determined . . . from an analysis of its unconscious surface-level expressions," he wrote in his essay "The Mass Ornament," arguing that these "expressions . . . by virtue of their unconscious nature, provide unmediated access to the fundamental substance of the state of things."[8]

For Kracauer and Benjamin, the quotidian landscapes of life—posters on the walls, shop signs, dancing girls, bestsellers, panoramas, the shape, style, and circulation of city buses—are all surface representations of the fantasy energy by which the collective perceives the social order. This structure creates an interpenetrated analysis of urban culture in modernity, one in which strikingly different phenomena are structurally linked. The stained concrete of Nigerian cinema theaters, the open-air screens, and their proximity to markets reveal knowledge of "the state of things," which in Kano refers to the imposition of a colonial, capitalist modernity. Cinema theaters were part of a much wider transformation of the restructuring of urban space and leisure practices under colonial urbanism.[9] Like the beer parlors, theaters, railways and buses, public gardens, libraries, and commercial streets that preceded them, cinema theaters created new modes of public association

that had to be regulated—officially by the colonial administration and unofficially in local Hausa norms.

The ambivalent place of cinema theaters and the social uncertainty around how to understand them is something that plagued cinema's rise in Europe and the United States. Miriam Hansen argues that cinema-going emerged as a leisure practice in the United States by catering to young women who were entering into the new industrial workplace and who had for the first time disposable income outside the control of fathers or husbands.[10] She argues that the rise of cinema is part of a wider transformation in the gendered construction of public space and that, as in Nigeria, this transformation was highly controversial.[11] The ambivalence of many Nigerians to the social space of the cinema is simply part of the common anxiety produced as societies come to terms with the new political and social possibilities that technologies bring. Reactions by local Arab, African, or Asian populations against the introduction of cinema cannot be glossed as the antimodern stance of traditional societies toward modernity but more properly should be studied as a common reaction by all societies to the epistemic uncertainty produced by new technologies.

The Evolution of Urban Kano

The spatial arrangement of cinema theaters in urban Kano was mapped onto a terrain that was already the site of intense confrontation. This tension began in 1903, when, after conquest, the British began to construct a modern city outside the mud walls of Kano. Administratively and symbolically, the British divided Kano in two: the walled *birni* (old city) and the modern *Waje* ("Outside") or township. The birni was dominated by the political rule of the emir and the economic importance of the trading families based around the Kurmi market, one of the major precolonial nodes in the trans-Saharan trade. In the birni, pre-British custom remained strong and, under the principles of indirect rule, was actively protected from the transformations of colonialism. Missionization and Western education were restricted; families still lived in domestic compounds which were largely passed down through inheritance rather than rented or sold; female seclusion and strict sexual segregation were the norm to be aspired to; prostitution and the sale of alcohol were forbidden and the values of conservative Islam upheld.

Economically, ethnically, and culturally, the township provided a strong

contrast to this pattern. It was divided into several different areas: a commercial area, "Asiatic" quarters for Syrians and Lebanese, the Sabon Gari for non-Hausa Nigerians, and a European section, the GRA (Government Residential Area). As Kano grew under colonial rule it did so steadily in the birni and explosively in the township. In this latter area the new banks, companies, and businesses were established that connected northern Nigeria to the economies of Europe and the United States, and this area became the motor of the Kano economy. Alongside its factories and businesses stood social clubs and restaurants, beer parlors and dance halls.

Erecting this new city entailed hardening a series of ethnic, architectural, and symbolic cleavages in Kano. The red and brown ochre of the birni contrasted greatly with the lush greenery of the European sections of the township. The broad, sweeping crescents and star-shaped intersections of the European residential areas were based on the garden city designs of Ebenezer Howard.[12] There, residences were set back from the road by large green gardens (an innovation in a climate as arid as northern Nigeria) and were well ventilated, according to sanitary rules aimed at preventing the spread of disease. The openness of the European area was predicated on its opposition to the congested and, to Europeans, chaotic and disease-ridden interior of the birni.[13] When the British came to lay out the design for Kano's development, the fear of contamination was encoded into the built environment. According to colonial planning regulations, Europeans were to be separated from Africans by buffer zones of at least 440 yards.[14] All Africans except for domestic servants were prevented from residing in any European area, and servants' quarters were required to be at least 150 feet from European residences.

Waje was separated from the birni more than just physically and aesthetically. Waje contained the companies, banks, railway station, and post office that were the economic and communication engines of the new colonial economy. It quickly eclipsed the economic importance of the birni, which in precolonial times had been one of the most important trading centers in West Africa. As southern Nigerians began migrating in numbers to fill the positions made available by the new economy, they brought with them their religious and cultural values, many of which were at odds with those of their Hausa neighbors. As this urban development took place, *Kanawa* (Kano Hausa) saw the birni as the repository of traditional Muslim Hausa values, while the modern Waje became defined as an area marked by *kafirci* (pagan-

ism). The physical segregation instituted by the British reinforced the sense of cultural and ethnic distinction.

An Enclave of Disrepute

In 1975, the Hausa scholar Ibrahim Tahir described Sabon Gari as "the home of strangers, on their way to assimilation, Nigerian and foreign Christians, the European Christian, *Nasara* or Nazarene, the urban drifter, the wage worker, the prostitute, and the pimp. It contains churches, beer houses and dance halls, hotels and brothels. There deviant conduct prevails and custom does not have a stronghold."[15]

His opinion does not much differ from the 1926 view of the British resident of Kano, who described Sabon Gari as "an enclave of disrepute"[16] full of "dissolute characters." Arjun Appadurai has written that the symbolic definition of what constitutes a locality is the outcome of a deliberate set of actions. The production of a neighborhood, he argues, "is inherently the exercise of power over some form of hostile, or recalcitrant environment, which may take the form of another neighborhood."[17] For colonized Hausa, whose ability to define urban space had been decisively taken from them by the British, the emergence of an economically aggressive, physically expansive township over which they had little or no control was a tremendous challenge to their own ability to shape the nature of urban life.

Sabon Gari, literally "New Town," was created in 1913 after the establishment of the Lagos–Kano railway led to large migration from southern Nigeria. In 1914, the British incorporated the area into the township (the area administratively under British control), a seemingly commonsense idea that was to have profound ramifications for ethnic relations in the city. The idea stemmed from F. D. Lugard's principle of indirect rule,[18] whereby, in return for political allegiance, the British promised to preserve Hausa political, religious, and cultural structures and protect them from alien influences, especially Westernization. In keeping with this policy, European companies were not allowed to trade in the birni, Christian missionaries were restricted in their activities in the north, and the Kano emir retained political control over the northern Muslim areas of Kano (the old city and Fagge, a traditional trading area north of the city). Southerners were seen as necessary because they "spoke, read, and wrote the language of the colonizer,"[19] but while this made them useful to colonialists, there was a fear that they would

culturally influence their northern compatriots. Segregation was intended to prevent this. "Controlled in this way," as the historian David Allyn describes it, the aliens "would provide necessary services for the government and European firms but would have limited opportunity for contaminating the highly-regarded culture of their Hausa-speaking neighbors."[20]

Sabon Gari was allowed to develop at a different rate and in a separate fashion from the old city because it was placed administratively under British, rather than native, rule. A few decades previously, in precolonial times, all migrants wishing to trade in the north would have been subject to the legal regimes and cultural norms of Hausa society. Instead, Sabon Garis, which existed in all major northern cities, had little reason to conform to or even respect Hausa institutions. The Nigerian historian C. N. Ubah argues that this administrative division estranged and opposed southern and northern Nigerians, a state of affairs which continues until this day. Consequently, the physical space of the city mirrored the philosophical prerogatives of indirect rule. Kano developed as a city split into discrete, separable areas. Each area was built according to its own cultural logic so that the progressive liberal values of the garden city movement were objectified in the spacious, aerated homes of the GRA, while the multiple-occupant tenements and the grid streets of the Sabon Gari stood in contrast to the high mud walls and narrow alleys surrounding the traditional northern family house. Each area had its own ethnic group, often its own economic base, and, after time, its own moral ambience. The intensity of this separation can be seen in the fact that southern migrants were officially known by the oxymorons of "native foreigner" or "alien native," a vivid example of Georg Simmel's argument that the stranger embodies the contradictory principles of nearness and remoteness, that while being outside, he or she is always "an element of the group itself."[21]

Urban Kano developed in this segregated, politically charged way, in which tensions between colonizer and colonized were mediated through interethnic conflicts and found their expression in the atmospheres and reputations which came to mark different areas of the city. For Hausa, the emergence of a Kano city outside of their control, free from the religious and social limits by which Hausa space is produced, and existing alongside the traditional boundaries of the birni was unruly, ambivalent, and threatening. Intensely negative stereotypes were one of the few means available of asserting some sort of moral control over it. Yet inevitably for others, probably because of that stereotyping, cinema became deeply attractive, a source

of economic and recreational life that remained illegitimate yet seductive. Waje, and Sabon Gari in particular, became the moral antithesis of proper Hausa space. It was the home of *iskanci* (dissoluteness) and *bariki* culture, a complex that refers to a mix of overlapping immoral behavior such as drinking alcohol, consorting with prostitutes, and, over time, attending cinema. The historian Bawuro Barkindo describes life in Sabon Gari as "permissive," that for "the majority of *Kanawa*, birni was home, and one only ventured to waje out of necessity. Its life was an evil which was tolerated because one had no choice."[22] Onto this highly politicized grid cinema theaters were mapped. They became defined by the moral ambience of the areas in which they were situated, and over time, their own charged atmosphere was used to define the areas in which they were housed. If, initially, Hausa Muslims ventured to Waje out of necessity, as Barkindo asserts, then we must analyze the emergence of cinema-going in the light of this taboo, examining cinema as a space of illegitimacy and attendance as a leisure practice that is transgressive.

The Moral Aura of Cinematic Space

The first commercial film screenings in Kano took place in Sabon Gari, as one-time showings set up in dancehalls, such as the Elsiepat, where they were sandwiched between dances and prize-giving.[23] By 1934, however, cinema had become popular enough that the British resident of Kano could report that films were being shown "with considerable frequency,"[24] and within three years the first cinema built for the purpose, the Rex, opened. Funded by a Christian Lebanese businessman, Frederick George, the Rex was built as an open-air or "garden" cinema and consisted of two rooms as well as a bar which the businessman proposed "to build quite decently and with stones."[25] While the colonial government rejected the application for a bar, it did issue a series of temporary liquor licenses so that like the Elsiepat, the Rex linked the recreation of watching films with that of drinking alcohol. This exhibition format was repeated two years later when J. Green Mbadiwe, a hotel owner in Kaduna, the capital of northern Nigeria, applied for a license to build a more formal and elaborate hotel and cinema complex in Kano. It was to include "all the latest amenities usually associated with first-class Hotels and Cinemas in the aristocratic world."[26] His application was denied but his proposal shows the conceptual construct of what people in Nigeria expected the space of cinema to be. Mbadiwe's

proud insistence on the quality of construction material, and his boast that Kano cinemas would be like "first-class" cinemas in "the aristocratic world" not only reveals the elite, foreign nature of cinema but also conveys cinema-going as a standardizing practice of modernity, the presence of which could bring a city into a cosmopolitan urban world. Cinema, from the point of view of its Lebanese innovators, was both a place and a practice from which Africans were to be excluded and which was beyond the pale for Muslim Africans with a religious prohibition on alcohol.

One reason that cinema was such an unruly space is that it challenged the existing hierarchies of public space in colonial northern Nigeria. Could white and black people attend? Could different ethnicities intermix? Were women, expected to be in seclusion, to be allowed? Mbadiwe attempted to address this by proposing to divide his cinema into two discrete com-partments, one for Europeans (with alcohol served) and one for Africans. These would be approached through separate entrances and connected by a fire door but this, he assured the authorities, "will be always locked."[27] For the British, however, overt racial segregation was potentially controversial. They rejected Mbadiwe's application and informed Frederick George that his cinema must be open to all and that no liquor license could be issued. Alcohol was a problem for the British because Hausa viewers would inevi-tably attend. George responded by reasserting his aim informally rather than formally. He reserved two nights a week for Europeans and Syrians (Leban-ese) and imposed this by a differential pricing policy. "It is fair to say," wrote the acting resident of Kano, "that if an African sought admission on one of these nights and was prepared to pay 3/6d he would not be refused admis-sion but the number of Africans who would pay 3/6d admission, when they can attend exactly the same performance on another night for 2/-, 1/- or 6d is very small."[28] George then applied for temporary liquor licenses for one night only (the nights when Europeans attended) and received temporary licenses regularly for a number of months, ensuring that the opening of the first cinema theater in Kano yoked the un-Islamic presence of alcohol to the transgressive space of the cinema.[29]

Mbadiwe's plan to segregate the audience in separate auditoriums reveals how the physical space of the cinema can be the outcome of local ideolo-gies of hierarchy. The spacing of seats in Nigeria, for instance, came after the secretary of the northern provinces wrote to the chief secretary in Lagos about his concern for fire safety regulations; the physical arrangement of the cinema thus incorporated colonialist conceptions of African mentality: "As

regards seating: In view of the natural tendency of some Africans when in a crowd to be seized by panic at the mere rumor of danger it is thought that in Cinema halls in Nigeria much wider spaces should be allowed between fixed seats, wider alleyways and more and wider means of exit than is obligatory in England."[30]

In many parts of the British Empire the regulations surrounding cinema construction were imported from cinematograph laws established in Britain. But as the debate about segregation underscores, how cinemas were built was often shaped by racial ideologies and political and cultural relations. Out of these bureaucratic battles between colonialists and Lebanese entrepreneurs cinematic space emerged, located in particular areas, built to certain specifications, and open to prescribed audiences. For Muslim Hausa, a foundational link was secured between cinema and a complex of activities that were deeply antithetical to ideal Muslim values. This made the introduction of theaters so controversial and their presence a lightning conductor around which the Hausa critique of colonialism could be levied.

Cinema and Translocal Space

While cinema may seem strikingly modern in its capability to transport people's imaginations and transform local identities, these attributes also define some of the most historically important public spaces in Kano, most especially the mosque and the market. These arenas can be defined as threshold spaces that mediate the boundaries and construct continuities between indigenous place and the wider world. As open, public spaces and the sites of ethnic and gender interaction, markets and cinemas are inherently unstable. Their publicness necessitates the coming together of strangers, potentially cutting across class, religious, ethnic, and gender boundaries. In the (racially, ethnically, and sexually) segregated environment of colonial northern Nigeria, this took on added significance, and it is no surprise that most markets (and cinemas) were located on the boundaries separating the segregated areas of urban Kano. Cinema may be modern in providing a space for a new mode of commodified leisure, creating new arenas for public association, but this new space was defined by its association and linkage with the older spaces of the mosque and market, with which it shared significant symbolic similarities.

In Kano mosques are often defined by their locality, by association with the individual who paid for their construction. Attending a particular

mosque can be a mark of loyalty, reinforcing relations of hierarchy, class, and religious ideology. As religious institutions, mosques erase their local significance by creating an experience of transnational religious affiliation. As Michael Gilsenan argues, the mosque produces a "field in which certain social forms and relationships that are vital to the identity of groups in the ordinary [local] world are neutralized by forces defined as religious [trans-local]."[31]

Mosques are spatially oriented toward Mecca, the sacred center of Islam. This translocal orientation is physically inscribed in the mosque in the form of the *mihrâb*, the recess that signifies worshipers are praying in the direction of Mecca. It is also reinforced through everyday Muslim practice. Religious prayer is based on Arabic, a foreign language for most Muslims in the world and one identified with the religious centers of the Middle East. The translocal orientation of Islam is demonstrated most famously in the directive that all Muslims, as a matter of faith, should try to make the pilgrimage to Mecca at least once in their life.

The public spaces of prayer and ritual in Kano oscillate between emphasizing local (Hausa) relations of space and power while imaginatively transporting worshipers to sacred places in the wider Muslim world. Because of the mosque's complex range of meanings as a public space (religious, social, economic, and political), Gilsenan compares it to the other important public space in Muslim life, the market, arguing against the view of the market as the secular antithesis of the mosque. He points out that all major religious sites in the Middle East also have been market towns. Just as the mosque is not solely a religious space, neither is the market solely economic since it also provides an arena for personal, social, and even religious interaction.

Where Gilsenan stresses the links between markets and mosques as public stages that reveal the divisions and separations between people in a village society, I wish to emphasize the links between markets and cinema theaters. This is because for *Kanawa* (Kano Hausa) both places are socially ambiguous and potentially dangerous. A market is a public, open space, which, as Adeline Masquelier has discussed, makes it socially unbounded, a place where strangers, spirits, and witches mix.[32] This unboundedness contrasts with the ideal of domestic female seclusion (*kulle*, in Hausa), and Masquelier cites the proverb, *kasuwa bai gidan kowa ba*, the market is anyone's home, highlighting the distinction between the unsafe public space of the market and the secure, private environment of home.[33] The fundamental spatial duality of the market makes it most homologous to the mosque and the

cinema. While rooted in a particular place, it is the site for the international exchange of commodities and information.

Cinema theaters mimic the symbolic and spatial qualities of markets in Kano. Nearly all theaters are located adjacent to, or near, major markets, usually on the spatial boundaries between different areas. The Rex, the first cinema in Kano (since demolished), was built next to the Sabon Gari market, separating Sabon Gari (southern Nigerians), Fagge (non-Hausa northerners and Arabs), Bompai (Europeans), and the commercial district. The Orion and Plaza were built just outside the gates of the birni, one near the Kofar Wambai market, the other near the Kantin Kwari market, on the boundary between the birni and Fagge. The El Dorado, located on the edge of Sabon Gari, a short walk from the market, marked off that area from Bompai, as did the Queens a mile or so to the north. El Duniya was also located close to Sabon Gari market, but a little to the south, separating it from Fagge and Fagge from the commercial district.

Cinemas are linked to markets for obvious economic reasons. Markets are centrally located, with good transport, and they are hosts to large numbers of potential audience members. Yet the consequence of this is that cinema theaters and markets share the symbolic work of defining the moral division of urban space, emphasizing boundaries between different areas and thus different ways of living in the world. The Rex, for instance, separated the winding alleys of Fagge from the grid system of Sabon Gari and the open crescents of the township, culturally mediating between Christian southern Nigerians, northern Muslims, and Europeans. Like the morally legitimate space of the mosque, cinema theaters define local social relations of space, marking the gendered, ethnic, and moral attributes that delimit who is allowed to move where. Urban spaces such as markets, cinema theaters, and mosques are not just given entities but comprise sets of social and political relations, moral ideas of what it is to live in the world, that are internalized into the routines and habits of everyday life. Layered on top of these conflicts and substantially adding to them was a sustained religious critique of both the ontology of cinema and the structure of cinema exhibition. According to Lawan Abdullahi, an older Hausa man I spoke with who went regularly to the cinema in the early 1950s, cinema was universally condemned by religious authorities and elders. For the religious, because cinema appeared to take for itself the power to create life by showing a dead person walking, it was effectively usurping a prerogative reserved for Allah and was a form of *shirk* (a denial of the oneness of God) and magic. The result was that a

series of *fatwas* (advisory, but not compulsory, legal opinions) condemned cinema as un-Islamic.[34] Abdullahi's opinions were echoed almost verbatim by Sheikh Nasiru Kabara, one of the most important religious authorities in postwar Nigeria, a key figure allied with the Native Administration, and himself a sometime member of the cinematic censorship board.[35] Kabara recounted the accusations of shirk and magic. "Local mallams," by which Kabara meant poorly educated neighborhood Islamic teachers, posed the question, "If someone is killed in a film did he die? If not, then this is magic," and cited the Qur'anic story of the fight between Musa (Moses) and the pharaoh. In this story, Musa is attacked by the cream of the pharaoh's sorcerors, and his victory over them is proof of the superiority of the power of Allah over the power of magic. These local mallams, Kabara recounted, also questioned the Islamic legality of watching images. In all of these instances it is the technology itself, irrespective of content, that is essentially un-Islamic. The early Hausa names for cinema—*majigi*, derived from the word *magic*,[36] and *dodon bango*, literally, "evil spirits on the wall"[37]—indicate how deeply this sense of enchantment and magic was felt.

Religious critiques of modern technologies are the result of specific historic conjunctures and must be understood as situational rather than as inherent "antimodernism." Barry Flood, in his discussion of the history of Islamic iconoclasm (written after the destruction of the Bamiyan temples by the Taliban government in Afghanistan), argues that Islamic societies have veered between using representational iconography and rejecting it, and he ties the moments when certain societies become iconophobic to specific political conflicts in which these societies were engaged.[38] Talal Asad argues similarly that the rejection of Western technologies (by Saudi society) has to be understood in the context of Islamic tradition. He defines tradition not as an essentialized repudiation of change but as a socially organized mode of transmitting knowledge and power. Islam consists of a discursive tradition made up of sets of texts (foremost among them the Qur'an and *hadith*) and established bodies of practices that scholars draw on to legitimize and enforce conduct in the present. He counters simplistic arguments of Islamic antimodernism by pointing out that while Saudi *ulama* (religious authorities) reacted strongly against many forms of modern technology, innumerable other forms—new modes of transport, electricity, medicine, building, and so on—were accepted with little or no objection. "What the ulama are doing [when appearing to resist 'everything modern'] is to attempt a definition of orthodoxy—a reordering of knowledge that governs the 'correct'

form of Islamic practice. . . . That is, like all practical criticism, orthodox criticism seeks to construct a relation of discursive dominance."[39] Resistance to change is not a knee-jerk reaction, according to Asad, but a deliberative and selectively invoked tradition of criticism of innovation that is *internal* to Islamic practice and not simply a reaction to the spread of modernity. The rejection of cinema among certain elements of Hausa society in the 1940s and 1950s must be seen in this context as intimately involved with the wider symbolic conflict over the nature of technology and its role in colonization in northern Nigeria.

Conservative reactions to new technologies are not limited to Islam, as scholarship in early cinema has abundantly shown, though the essentialized linkage between Islam and antimodernism often requires this to be restated. Africanist scholars[40] have argued that stories of African wonder at technologies were a form of oral culture among Europeans, rather than Africans, fostered by rumor and exaggeration that spread widely among Europeans in different African colonies. These stories can be analyzed as examples of the colonial sublime, of investment in technology overwhelming African senses with the experience of European greatness. But, as Timothy Burke also argues, we must take seriously these stories and how they reveal the strangeness of technologies.[41] Miriam Hansen has pointed out that cinema as a cultural practice—the proper relations between viewer, projector, and screen—had to be learned and that early audiences in the United States effectively had to be trained in practices of what cinema, and being an audience, meant. How these technical capabilities come to be regularized is an often highly unstable process that is important precisely because it highlights the interaction of technology with society. Charles Ambler is right to assert that the popularity of cowboy movies with Copperbelt audiences and their vibrant reactions to them demonstrated "little evidence of 'primitive' machine terror,"[42] but the fact that audiences quickly became habituated to such films should not forbid analysis of the period when none of this could be taken for granted. The Copperbelt audiences he describes were clearly familiar with cinema-going as a practice. They had learned appropriate modes of viewing film (cheering, mimicking actions on the screen) and were trained in bodily modes of reception (talking like cowboys, having a "cowboy attitude").[43] But these practices take time and discipline before they are internalized and reproduced as natural. In Nigeria, the difference of opinion between Kabara and "local mallams" over the acceptability of film, or between sections of Hausa society bitterly opposed to cinema and others

whose members attended regularly are precisely the data we can draw on to see how this process of incorporation took place in the dance between technics, religion, and society in colonial northern Nigeria.

When Sheikh Nasiru Kabara criticized the Islamic reaction against cinema as due to ignorance, he is not referring simply to "primitive" ignorance of modern technologies (though this is probably partly responsible) but also to the ignorance of "local mallams" as to the proper application of Islamic law. He poses himself in contrast, as someone better educated religiously and also cosmopolitan in that he can draw on a range of Islamic learning from across the Muslim world. His defense of cinema is a good example of how Islamic tradition (in this case Islamic law) is mobilized to achieve discursive dominance over other Muslim authorities that Asad describes. This is particularly important because Kabara was implicated by the controversy in potentially unsettling ways. As a major religious figure, he was closely allied to Hausa royal elites, and while he was relatively independent of the British—certainly compared to the emirs and aristocracy who took part in colonial government—his closeness to the aristocracy placed limits on his ability to critique their positions. As the British placed sustained pressure on the emir of Kano and other elites to allow and to visibly support cinematic projection in colonial mobile cinema units, to declare all film un-Islamic potentially placed those elites in the untenable position of being against Islam. Kabara's support of cinema projection was no doubt part of his wider acceptance of new scientific and technological innovations in Hausa society, but it also created a religious legitimation for those Muslims walking the ambiguous line of preserving Islamic faith while incorporating the aggressive new changes brought about by colonial society. But his support only extended so far. While Kabara legitimated projection, he condemned commercial cinema itself as un-Islamic, distinguishing between the (acceptable) ontology of film technology and the un-Islamic social arena of cinema houses themselves. The reason commercial cinema was un-Islamic, he argued to me, was first because of content. Cinemas mainly played Indian films whose actresses were so beautiful they aroused audiences and corrupted their hearts. Moreover, the non-Islamic origins of many actresses ("they worship cows") could lead Muslim men astray.[44] Second, and decisively, the fact that cinema houses were open to both men and women fundamentally contravened the Islamic separation of sexes and meant that cinemas could only attract 'yan iska (dissolute lay-abouts), who consorted with prostitutes and were involved in other illicit activities. "There is noth-

ing Islamic in cinema houses," Kabara concluded after a long defense of cinema itself. His critique of cinema was not its colonial origins. Nor was it the nature of iconic cinematic representation. Rather (and in this reflecting the dominant opinion of Hausa society), he condemned the moral ambience that surrounded cinema houses because of the way these sites have evolved in Hausa society. As illicit moral spaces, commercial cinemas repelled respectable people, attracting only the marginal, the young, or the rebellious. Commercial cinema, as a social space and a mode of leisure, was neither universalizing nor standardizing in any simple way but emerged, over time, as a result of the interaction of the material qualities of the apparatus and its modes of exhibition and the particular social context in which they evolved.

Young Turks

For all of its controversy, and perhaps because of its rejection by religious elites and elders, cinema-going quickly became established among Hausa youth. This is significant given the colonial intent to impose cinema as an elite, white-only, form of leisure, and the wider Hausa rejection of cinema. "The local outlook is as follows," wrote one colonial official in the early 1950s. "The intelligent and educated malams[45] simply do not go. . . . They disapprove of the sort of low-type Hausa that revels in the cinema."[46] Its disreputable nature meant that women who attended were seen as *karuwai* (independent women/prostitutes), and their presence added significantly to the illicit nature of the arena. Sexual availability and sexual activity in the cinema meant that pleasure and desire were to be found on and off the screen, the eroticism of one context feeding into the other. Despite the best of intentions of Frederick George of the Rex, cinema went from being elite to marginal at an impressive speed. As early as 1948, the resident of Kano could write, "Among a large youthful class of Kano City, Fagge and Sabon Gari which has money to spare in its pockets it has become the thing to do to go to the Cinema quite regardless of whether they understand what they see and hear or not."[47] This statement is interesting for several reasons. It depicts a mixed ethnic clientele for cinema at this time (Kano city was wholly Hausa Muslim, Sabon Gari was dominantly southern Christian, and Fagge was a mixed-ethnic area comprised mainly of non-Hausa Muslim northerners). It also indicates the emergence of a leisure class[48] of people working largely in and around the new colonial economy. The emergence of leisure, as Phyllis Martin has pointed out, involves the reordering of cate-

gories of time and space brought about by the new economy but at the same time involves the emergence of new practices of self-expression.[49] Resident Featherstone's comment about audience members' lack of understanding misses the importance of cinema-going as a social, as well as a visual, event. One viewer told Featherstone that although he did not always understand the films being shown, "he went regularly to the cinema to be seen and to see his friends."[50] Cinema-going was becoming established as a social activity, an experience that was always much more than the viewing of the film itself.

Alhaji Lawan Adamu, one of the young Turks going to the cinema regularly in the early 1950s, certainly saw cinema in this light. Adamu was a well-educated, young colonial bureaucrat, part of the emerging class of Western-educated Hausa Muslims (called *'yan boko* in Hausa).[51] He said cinema was *very* popular with Hausa youth at the time precisely because it did not require any education. He characterized the audience as a few "rebels" like himself and mostly *'yan daba* (hooligans) who were organized into "hunting groups" and would go around with dogs.[52] Adamu also argued a commonly held belief in Kano that cinema acts for these youths as a safety valve, a way of relieving tension and boredom without resorting to violence. He also said that by the mid-1950s there were many Hausa leaving the old city each night. To do this, in the context of contemporary Hausa society, was consciously to transgress from a moral to an immoral area. It put Adamu in touch with a cosmopolitan Western world he regarded with interest as well as suspicion, but more than this, it was a powerful mode of self-expression that defined him and his friends as confident, socially rebellious young Turks. As a social space and leisure activity, cinema theaters drew their moral aura from their social and moral place on an urban landscape in the process of transformation.

The Palace, El Duniya, and the Maintenance of Hausa Moral Space

The introduction of cinema theaters in Kano intervened in an ongoing conflict over the moral definition of urban space under colonialism.[53] How cinema theaters were to be built, what they were to show, and where they were to be located were all intensely debated issues whereby the transformative spatial and social ideologies of colonialism were debated and enacted. Conflicts in the Hausa community over the location of cinema theaters are an example of what Appadurai has referred to as the reterritorialization of urban space,[54] one that was rapidly expanding outside of Hausa control.

Specifically, the attempt to prevent the building of a cinema theater in the old city of Kano can be seen as an attempt to reassert the Muslim basis of Hausa life in opposition to the encroachment of non-Muslim (European and southern Nigerian) cultural and religious values. Cinema theaters became markers of neighborhoods, embodying the moral qualities that allowed these neighborhoods to exist. For urban Hausa the cinematic experience was (and is) embedded in the history of ongoing debate over the nature and regulation of urban public space.

In 1949 Frederick George wrote the resident, Kano emirate, asking for permission to build a cinema, the Palace, in the birni, in Jakara quarters, next to Kurmi market. When the application for the Palace was received, cinemagoing was well established in Kano; many Hausa regularly left the old city to travel to one of two cinemas located in Waje. The uniqueness of this application was that the Palace was to be the first cinema theater constructed in the confines of the birni. The application sparked off a firestorm of protest, rumors, and even rioting that directly probed the power of colonial authorities and the limits of Hausa authorities in relation to that power. I can date the application and the opening of the Palace from the colonial archives in Kaduna that contain copies of the application file. However, the story of the Palace I engage with rests on rumors and prejudice, stories and memories that do not provide an objective history of the Palace as much as they reveal the social place that it and other cinemas occupy in the social imagination. Rumors about cinemas, stories that have come down from parent to child, are a form of local hermeneutics. They are quasi-religious allegories by which people divine the "real" motives underlying phenomenal events.[55]

The decision of Emir Sanusi to allow the construction of the Palace cinema provoked a strong backlash in different sections of the Hausa community. Kano ulama were outraged by the penetration of this disruptive, sexual arena into the Islamic space of the birni. The more conservative among them issued fatwas forbidding the showing of films and citing the religious injunction against the creation of images as evidence that the technology itself was *kafirai* (pagan). As Emir Sanusi himself had authorized the construction of the theater, to attack it was tantamount to an attack on emirate authority and Sanusi himself. This was particularly the case as Sanusi's father, Emir Abdullahi, had refused to allow any cinemas to be built in the birni, citing their negative effect on women.[56] The conflict was seized on by politically active, Western-educated Hausa—the 'yan boko—who saw the dispute as a means of critiquing emirate authority. Perhaps because of

this, when the fatwa came before the Emirate Council, the panel refused to endorse it, since this would be seen as supporting the challenge to the emir's authority. This refusal only widened the issue, allowing the young radicals to argue that the emir was in the control of colonial overlords and contemptuous of the will of the people. Lawan Abdullahi, who worked in colonial government during this period, told me that the British resident indeed placed great pressure on the emir to allow the Palace construction to go ahead.[57] Maitama Sule, an important Kano political figure and himself a young radical at the time, said that opposition to the Palace brought together and mobilized young, Western-educated Hausa active in education and politics (ironically, Lawan Abdullahi describes these as precisely the sort of "rebels" most likely to be attending cinema). The young men wrote in the press attacking the emir and organized petitions against the construction, infuriating the emir and his advisors.

In 1951, while the controversy over the Palace was raging, but before the cinema was actually open, matters were brought to a symbolic head when the El Duniya cinema burned down, killing 331 of the 600 people in the audience.[58] The government inquiry that followed established that the fire began in the projection room with flammable nitrate films. From there it rapidly spread along the ceiling as the insulation used for soundproofing began to burn. Fire doors were locked and people were trampled in the rush to exit at the back. Hausa complicity in the tragedy was reinforced by the fact that 82 percent of the cinema audience during the afternoon performance was Hausa, not southern Nigerian or European. The youngest person to die was nine years old.

The colonial state's functional explanation was accepted by Hausa as explaining how but not why the disaster occurred. For a long time, rumors had been circulating about cinemas—that mosques would be torn down to make way for them; that one was to be built on the grounds used for the celebration of the Eid festival—rumors which posed this new "Christian" space as an aggressive attack on Islam. Many believed that the fire was direct divine retribution for Hausa participation in illicit and immoral activity and for the growing Westernization of Hausa society. A series of rumors emerged to explain the tragedy. Most common, and still widely believed, was the accusation that the film being shown that night in the El Duniya contained the image of the Prophet Mohammed, harnessing the colonial technology of representation for blasphemous ends. Others believed that during construction of the theater people passing every day cursed (*tsine*)

the theater, so that the theater was engulfed not just by flames but by these curses' combined magical force.[59]

In a religious society such as Kano, where God's intervention in the material world is a day-to-day occurrence, rumors and stories become part of a critical discourse in which everyday events are interrogated. Stories about the El Duniya represent conflict and ambivalence about the Western cultural arena that was infiltrating the Hausa moral world. They argue for the profane nature of cinematic representation, making it guilty of the heresy of representing Mohammed, and they do so for political reasons. These rumors grew so strong that the colonial government was forced to take official notice and counter them over the radio. Twice daily for two days in four different languages, the Radio Diffusion Service (RDS) announced that there was no truth to the stories that the people handling the bodies of El Duniya victims had died, or that Native Authority warders who helped victims of the tragedy had all gone mad, or that prisoners from Kano prison (who helped in handling the corpses) could not eat for days afterward.[60] The government used its technologically mediated information order to counter the swirl of oral rumors, but stories about the El Duniya became part of the folklore of Hausa society. They were an informal moral economy by which cinema was discussed and judged in Kano, and the enormity of the disaster lived long in the popular imagination. Two years after the event there was a complaint to the RDS that it should stop playing Hausa songs about El Duniya because parents still found it too upsetting; a year later, in 1954, that feeling remained so intense that the RDS agreed to a ban on playing songs about El Duniya altogether.[61]

On July 2, 1952, a year after the El Duniya burned down, the Palace finally opened after months of controversy. A small riot ensued. The emir called in police to quash the violence and to arrest youths demonstrating against the opening.[62] Three months later, the British superintendent of police reported that ever since the Palace opened, youths outside the open-air theater had been regularly stoning patrons inside. Worse, he complained, the alkali (Muslim judge) to whom the cases were being reported was letting the youths go free, making it difficult for the police to ensure "good order" during cinema performances.[63] For young radicals, the campaign against the Palace was about the undue British influence over the emir and whether the emir would stand up for Hausa cultural values or be an agent of colonial authority. They continued organizing meetings against the Palace, raising the matter as a public controversy and appealing against the cinema's license.

Maitama Sule, active against the Palace when he was young, still remembers an anti-Palace song written by the poet Abdulkadir Danjaje:

> Now that there's a cinema house in Jakara
> Soon there will be alcohol at Madataye
> Now that there's a cinema house in Jakara
> Soon there will be alcohol in Madataye.[64]

Sule said that Emir Sanusi reacted to the controversy in two ways. First, he forbade any woman from attending the theater out of concern for proper morality. Second, outraged by the public challenge to his authority, he refused to even consider an appeal against the Palace license that came before him, prompting some of the more radical figures to suggest that the emir should be reported to the British regional governor for not following proper legal procedure. This appeal never happened as the "patricians" (Sule's term) among the radicals would not countenance bringing a case against the emir to the British authorities. As a result the group split for quite some time. When it came back together the matter of the Palace was effectively finished, but, according to Sule, the core of people mobilized by this issue went on to form the nucleus of the Northern Elements Progressive Union, the dominant northern progressive party of the independence era. This gives the conflict over the Palace a significant place in Nigerian political history.

Conclusion

Ironically, or perhaps inevitably, the Palace became the immoral social space that its opponents feared. It became a notorious place where, as one friend told me, men would go to drink alcohol, take drugs, and engage in sex with women and other men ("There! There! Right there in the seat next to you!"). In the early 1980s the governor of Kano state, Sabo Bakin Zuwo, who came from Kano's old city and was a veteran of the anti-Palace campaign, closed the cinema down and, in a grand populist gesture, converted it into a clinic. To this day hundreds of Hausa youths travel nightly through the mud gates marking the city's boundaries to cinemas that lie outside in Sabon Gari, Fagge, and Nassarawa.

The resistance to the construction of the Palace cinema was an effort by Hausa Muslims to reestablish the moral and spatial equilibrium of urban Kano society. The growth of a metropolis *outside* of what formerly consti-

tuted the city, the shift in economic and political balance from the birni to the township and Waje, and the rise of a substantial migrant population of "native foreigners" who owed little allegiance to existing political structures (some of whom openly mocked local religious and cultural practices) helped create a situation where the assertion of Hausa control over a threatened political and social world became increasingly important. When the Palace as a foreign, immoral, and potentially irreligious institution was built in the birni, it threatened to erode the carefully produced social, religious, and political division between the birni and Waje, collapsing two very different moral spaces and making protest almost inevitable.

After the controversy over the Palace, Lebanese entrepreneurs never attempted to situate a theater in the birni again. As a compromise, two theaters were built just outside the city walls: the Orion in Kofar Wambai and the Plaza in Fagge. This construction is a testimonial to the fact that since the 1950s Hausa people have made up the dominant cinema-going population in Kano. Despite, or perhaps because of, the fact that cinema theaters occupy an ambiguous moral position in Hausa society, certainly much more than they do in Yoruba or Ibo society, cinema-going has never waned in popularity among Hausa youth.

Cinema theaters in Kano are not discrete buildings but integrated nodes in an urban environment from which they draw their significance and, indeed, which they help define. As the site for screening fantastic texts of love and adventure, cinema theaters project Hausa audiences into the imagined realities of American, Indian, and British culture. Here my focus has been on the place of theaters as part of a wider urban materiality produced by, and thus expressive of, transformations in colonial modernity. Their social significance cannot be divorced from the other technologies and public spaces produced under colonial rule. Cinema theaters in Kano came into being only twenty years after the construction of the Kano–Lagos railroad and were built in areas created for the masses of male migrants brought into Kano; they were sited alongside the new colonially constructed markets marking the borders and moral qualities of the new metropolis; and they formed part of the construction of new modes of sexual and ethnic interaction produced by the transformation in urban public space. Encoded in the physical space of the theater, in the dirty bricks and broken lights, and in the walls that divide the arena are traces of history of colonial rule and colonial urbanism.

J. Green Mbadiwe never received permission to build his hotel/cinema,

and the Rex could never operate as a garden cinema serving gin and tonics in the cool evening to a film-watching audience, but these origins and the force of these intentions cast a long shadow over how cinema evolved in Hausa society. They call into question the assumption that cinema is a universal technology—a similar arrangement of tickets, seating, projection, and screen—that is the same everywhere, promoting similar modes of leisure and standard cultural experiences. In its place the cinema theater emerges as a hybrid, mixing the standardizing qualities of technology (as a mode of projection, seating, etc.) with the social and political singularities of Hausa society. Together they created the grounds from which the experience of cinema and cinema's larger place in the urban experience of Kano city was formed.

Notes

Brian Larkin, "Colonialism and the Built Space of Cinema," in *Signal and Noise: Media, Infrastructure, and Urban Culture in Nigeria*; 123–45, 266–69. Durham: Duke University Press, 2008.

1 The Nigerian government has used cinema politically to show films as a way of reaching a broader population for political purposes. For instance, after the Maitatsine riots of 1991, all northern cinemas showed a government-made film depicting the devastation caused by the millenarian Muslim leader Muhammad Marwa and, crucially, showing his dead body to confirm his mortality. But these occurrences are rare.

2 In the 1930s, 1940s, and 1950s, mainstream Nigerian cinemas were dominated by British and American movies. In the 1950s cinemas began screening the odd Egyptian and Indian film. By the mid-1960s Egyptian films had disappeared and Indian films had begun to vie with Hollywood for popularity. Hong Kong cinema rose in popularity during the 1970s. Until the rise of Nigerian videos, African films have rarely been shown regularly at mainstream cinemas in northern Nigeria, the notable exception being the traveling Yoruba films which emerged from the Yoruba traveling theater tradition. For the most part these films were screened not in mainstream theaters but in rented halls formerly used for theatrical performances.

3 Lynne Kirby, *Parallel Tracks: The Railroad and Silent Cinema* (Durham: Duke University Press, 1997).

4 Michael Watts, "Place, Space and Community in an African City," in *The Geography of Identity*, ed. Patricia Yeager (Ann Arbor: University of Michigan Press, 1996), 64.

5 Daniel Miller, "Why Some Things Matter," in *Material Cultures: Why Some*

Things Matter, ed. Daniel Miller (Chicago: University of Chicago Press, 1997), 9.

6 The Russian film historian Yuri Tsivian (*Early Cinema in Russia and Its Cultural Reception* [New York: Routledge, 1994]) provides an elegant account of cinema-going as a sensory activity, paying attention to the temperature of the auditorium, the placing of the projector, the quality of light, and the nature of aural and visual interference.

7 Cited in Susan Buck-Morss, *The Dialectics of Seeing: Walter Benjamin and the Arcades Project* (Cambridge, MA: MIT Press, 1989), 58.

8 Siegfried Kracauer, *The Mass Ornament: Weimar Essays*, trans. Thomas Y. Levin (Cambridge, MA: Harvard University Press, 1995), 75.

9 Timothy Mitchell, *Colonising Egypt* (Berkeley: University of California Press, 1991); Phyllis Martin, *Leisure and Society in Colonial Brazzaville* (Cambridge: Cambridge University Press, 1995); Elizabeth Thompson, *Colonial Citizens: Republican Rights, Paternal Privilege, and Gender in French Syria and Lebanon* (New York: Columbia University Press, 2000).

10 Miriam Hansen, *Babel and Beyond: Spectatorship in Silent American Films* (Cambridge, MA: Harvard University Press, 1991).

11 See also Annette Kuhn, *Cinema, Censorship, and Sexuality, 1909–1925* (London: Routledge, 1988); Anne Friedberg, *Window Shopping: Cinema and the Postmodern* (Berkeley: University of California Press, 1993); Tsivian, *Early Cinema in Russia*; Michael Chanan, *The Dream That Kicks: The Prehistory and Early Years of Cinema Entertainment in Britain* (1982; London: Routledge, 1996).

12 Alan Frishman, "The Spatial Growth and Residential Patterns of Kano, Nigeria," Ph.D. diss., Northwestern University, 1979.

13 For an interesting discussion of the symbolic distinctions between European and "traditional" quarters, see Mitchell, *Colonising Egypt*.

14 T. S. Rice, Memorandum on Segregation and Town Planning, 1921, KNA (Kano Native Authority) Kanolocauth 5/2 142/1923; cited in Frishman, "Spatial Growth and Residential Patterns."

15 Ibrahim A. Tahir, "Scholars, Saints, and Capitalists in Kano, 1904–1974: The Pattern of Bourgeois Revolution in an Islamic Society," Ph.D. diss., Cambridge University, 1975, 110.

16 This phrase, which may well sum up the entire symbolic value of Sabon Gari in the eyes of Kano Hausa, was coined by Resident Alexander of Kano in a speech to the Conference of Residents in 1926; *Record of the Proceedings of Conference of Residents, Northern Provinces, 1926* (Lagos: Government Printer, 1927); cited in David Edley Allyn, "The Sabon Gari System in Northern Nigeria," Ph.D. diss., University of California, Los Angeles, 1976, 138.

17 Arjun Appadurai, *Modernity at Large: Cultural Dimensions of Globalization* (Minneapolis: University of Minnesota Press, 1996), 184.

18 F. D. Lugard, *The Dual Mandate in British Tropical Africa* (London: W. Blackwood and Sons, 1922).

19 C. N. Ubah, "The Political Dilemma of Residential Segregation: The Example of Kano's Sabon Gari," *African Urban Studies* 14 (1982): 54.

20 Allyn, "The Sabon Gari System," 87.

21 Georg Simmel, *The Sociology of Georg Simmel*, trans. Kurt H. Wolff (Glencoe, IL: Free Press, 1950), 402.

22 Bawuro M. Barkindo, "Growing Islamism in Kano City since 1970: Causes, Forms and Implications," in *Muslim Identity and Social Change in Sub-Saharan Africa*, ed. Louis Brenner (Bloomington: Indiana University Press), 94.

23 This mode of exhibition mimics the history of film in the United States and Britain, where the first films were often shown as part of a wider program of burlesque (see Hansen, *Babel and Beyond*), or vaudeville (see Chanan, *The Dream That Kicks*), sandwiched between singers, comedians, and dancers so that they were only one element of the evening's entertainment.

24 Nigerian National Archives, Kaduna (NAK), Kano Prof. 1391, Kano Township Annual Report 1934.

25 NAK, Kano Prof., 2600, The West Africa Picture Co., (1) Application for C. of O., (2) General Correspondence.

26 NAK, Kano Prof., 4430, Mr. J. Green Mbadiwe, application for permission to erect a hotel and cinema at Kano.

27 NAK, Kano Prof., 4430, Mr. J. Green Mbadiwe, application for permission to erect a hotel and cinema at Kano.

28 NAK, Kano Prof. 2600, The West Africa Picture Co., (1) Application for C. of O., (2) General Correspondence.

29 After a few months the loophole was closed and the sale of alcohol banned; NAK, Kano Prof. 2600, The West Africa Picture Co., (1) Application for C. of O., (2) General Correspondence.

30 NAK/MIA Kaduna, 2nd collection, vol. 2, R.1493, Cinematograph Audience, 1932–1952, Letter No. 16497.10A, Secretary, Northern Provinces, to Chief Secretary Lagos, February 6, 1932.

31 Michael Gilsenan, *Recognizing Islam: Religion and Society in the Modern Middle East* (London: I. B. Tauris, 1992), 176.

32 Adeline Masquelier, "Narratives of Power, Images of Wealth: The Ritual Economy of *Bori* in the Market," in *Modernity and Its Malcontents: Ritual and Power in Postcolonial Africa*, ed. Jean Comaroff and John L. Comaroff (Chicago: University of Chicago Press, 1993), 3–33.

33 While Masquelier is right that markets have these larger cultural resonances, they also contain more earthly dangers. Thieves and hooligans (*'yan daba*) also frequent the market, and since 1953 the Sabon Gari market has been perhaps the greatest flashpoint for interreligious and interethnic rioting in Kano.

34 Several informants spoke to me about these fatwas but in a very general way; I was unable to find any written fatwas.

35 Sheikh Nasiru Kabara, interview with author, January 23, 1995, Kano.

36 Later, of course, this name began to be applied mainly to mobile film units.

37 Both terms were later replaced by the more neutral *sinima* or *silima*.

38 Finbarr Barry Flood, "Between Cult and Culture: Bamiyan, Islamic Icono-clasm and the Museum—Afghanistan," *Art Bulletin* 84(4) (2002): 641–59.

39 Talal Asad, *Geneaologies of Religion: Discipline and Reasons of Power in Christianity and Islam* (Baltimore: Johns Hopkins University Press, 1993), 210.

40 For example, see Timothy Burke, *Lifebuoy Men, Lux Women: Commodification, Consumption and Cleanliness in Modern Zimbabwe* (Durham: Duke University Press, 1996); Timothy Burke, "Our Mosquitoes Are Not So Big: Images and Modernity in Zimbabwe," in *Images and Empires: Visuality in Colonial and Post-colonial Africa*, ed. Paul S. Landau and Deborah Kaspin (Berkeley: University of California Press, 2002), 41–55.

41 Burke, "Our Mosquitoes Are Not So Big."

42 Charles Ambler, "Popular Films and Colonial Audiences: The Movies in North-ern Nigeria," *American Historial Review* 106(1) (2001): 81–105.

43 See Filip De Boeck, with Marie-Françoise Plissart, *Kinshasha: Tales of the In-visible City* (Antwerp, Belgium: Ludion, 2006); C. Didier Gondola, "Tropical Cowboys: Westerns, Violence, and Masculinity among the Young Bills of Kin-shasha," *Afrique et Histoire* 7(2) (2009): 75–98.

44 Kabara interview.

45 This word is used to refer specifically to Islamic teachers but more generally to any adult male.

46 Minute by M. H. (?), October 20, 1954, in response by a letter from the director of education, Northern Region, September 15, 1954, requesting an assessment of censorship, HCB, Simple list of files removed from cabinet, R918, Films and Film Censorship.

47 Letter, E. K. Featherstone, resident, Kano, to secretary, Northern Provinces, January 9, 1948, HCB, Simple list of files removed from cabinet, R918, Films and Film Censorship.

48 Martin, *Leisure and Society in Colonial Brazzaville*; Emmanuel Akyeampong and Charles Ambler, "Leisure in African History, an Introduction," *International Journal of African Historical Studies* 35(1) (2002): 1–16.

49 Martin, *Leisure and Society in Colonial Brazzaville*.

50 Letter, E. K. Featherstone, resident, Kano, to secretary, Northern Provinces, January 9, 1948, HCB, Simple list of files removed from cabinet, R918, Films and Film Censorship.

51 *Boko* refers to Hausa language written in roman script as opposed to precolonial Hausa which was written in Arabic script (*ajami*). '*Yan boko* derives from West-ern education but came to refer largely to the elites working in the new bureau-cracy. Initially it was a term of abuse, directed at those whom many Hausa Mus-lims regarded with deep suspicion. For a discussion of this, see Tahir, "Scholars, Saints, and Capitalists in Kano."

52 'Yan daba do indeed have relations with traditional hunting groups in rural areas, though in contemporary northern Nigeria they are largely seen as urban

hooligans. Then as now, the fact that they travel with hunting dogs (in Islam dogs are seen as unclean animals) heightens both their relative autonomy from traditional religious norms as well as the basic intimidation factor that surrounds them; see Abdulkarim Umar 'Dan Asabe, "Yandaba: The 'Terrorists' of Kano Metropolitan?," *Kano Studies*, special issue: Youth and Health in Kano Today (1991): 85–112; and Conerley Casey, "'States of Emergency': Islam, Youth Gangs and the Political Unseeable," paper presented to the Sawyer Seminar, Emory University, September 26, 2002.

53 In using *moral* I refer to two things: cinema in Kano is defined as an immoral, sexualized space, one that (unlike in the United States) never achieved social legitimation; on another, underlying level, I follow T. O. Beidelman's (*Moral Imagination in Kaguru Modes of Thought* [Washington: Smithsonian Institution Press, 1993]) concept of morality as the set of images and practices through which people both comprehend their world and act within it in ways that confirm and subvert their moral understanding. Space, for Beidelman, is a "moral metaphor," a social product that encodes the imagined order of society and personhood and reveals basic ideas about, and conflicts between, the individual and society. Beidelman's assertion of the active presence of the imagination in moral space has the advantage of foregrounding the concept of space as formed by human action, as something produced.

54 Appadurai, *Modernity at Large*.

55 Ann Stoler, "'In Cold Blood': Hierarchies of Credibility and the Politics of Colonial Narratives," *Representations* 37 (1992): 151–89; Adeline Masquelier, "Of Headhunters and Canibals: Migrancy, Labor, and Consumption in the Mawri Imagination," *Cultural Anthropology* 15(1) (2000): 84–126; Luise White, *Speaking with Vampires: Rumor and History in Colonial Africa* (Berkeley: University of California Press, 2000).

56 Interview with Alh. Maitama Sule, Dan Masanin Kano, August 1, 1995, Kano.

57 Lawan Abdullahi, interview with author April 2, 1995, Kano.

58 See *Report of the Commissioner Appointed by His Excellency the Governor to Enquire into the Circumstances in Which a Fire Caused Loss of Life at, and Destroyed, the El-Dunia Cinema, Kano, on the 13th Day of May 1951*, Justice Percy E. Hubard, NAK, Zaria Prof., vol. 2, EDU, 5 Cinema Cinematographs, Cinema Office, (2) Mobile Cinema Routine Correspondence. See also NAK, Kano Prof., 7564, El Dunia Disaster. Colonial Office, 583/317/8, Cinema Disaster at Kano, 1951.

59 The power to curse (tsine) is a powerful magical attribute in Hausa society as elsewhere in Africa. Certain people are believed to have the power to make their curses come true, though if they are not evil people they may have this ability and not realize it. One person explained the rumor to me by saying that so many people were cursing the construction of the El Duniya that the combined weight of all these curses brought the theater down.

60 NAK, MOI (Ministry of Information), 55, Broadcasting, Radio Diffusion Service and BBC.

61 NAK, Kano Prof., 4364/s.13, Radio Distribution Service Programme Sub-committee and Advisory Committee.

62 Alhaji Abdullahi Adamu, interview with author, April 2, 1995, Kano.

63 NAK, Kano Prof., 6945, Jakara Palace Cinema, Letter to S. D. O. K. from Senior Superintendent of Police, Kano, N.A. P.G.F, Sewall, September 6, 1952.

64 Alh. Maitama Sule, 'Dan Masanin Kano, interview with author, August 1, 1995, Kano. Jakara and Madataye are both quarters in Kano birni. The song clearly refers to Hausa fears of encroaching Westernization and immorality in Muslim areas.

The image that introduces this section of our volume is Yinka Shonibare's *Scramble for Africa* (2000), commissioned by the Museum for African Art in New York for an exhibition titled *Looking Both Ways* (see figure S2.1).[1] Short-listed for the 2004 Turner Prize, *Scramble for Africa* is an installation piece described thus: "14 figures, 14 chairs, table, overall dimensions: 132 × 488 × 280 cm." What this catalog description does not specify is that the figures are dressed in signature Shonibare "Dutch wax," a fabric that "looks 'African' and is of the sort worn to indicate black pride in Brixton or Brooklyn, [but] is, in fact, printed fabric based on Indonesian batik, manufactured in the

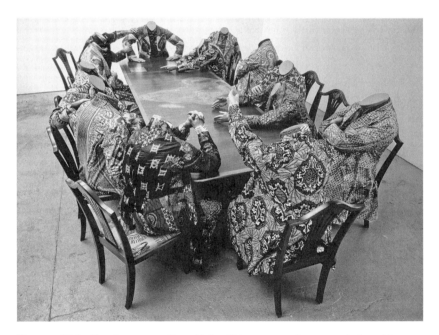

Fig. S2.1. Yinka Shonibare, MBE, *Scramble for Africa*, 2003. 14 figures, 14 chairs, table, Dutch wax printed cotton textile. Overall 132 × 488 × 280 cm (52 × 192 × 110 in). Copyright © the artist. Courtesy of the artist and private collection.

Netherlands, Britain, and other countries (including some in west Africa) and then imported back to west Africa, where it is a popular, but foreign, commodity."[2] Clothed thus in Victorian-style dress, the headless figures—with café au lait–colored hands—are seated on chairs placed around a table embossed with a highly burnished map of Africa, their body language clearly suggesting an intense discussion in progress. The title of Shonibare's installation echoes a landmark imperial event, the so-called scramble for Africa that was put into motion at the end of a conference convened by Otto von Bismarck in Berlin in late 1884 and completed by February 1885. It resulted in sanctioning the partition of Africa in a thoroughly gentlemanly fashion between Britain, France, Germany, Portugal, Italy, and Belgium. As numerous commentators have noted, no leaders of African states were present at this event or even invited "for a slice of this magnificent cake."[3] In Shonibare's postcolonial re-dressing of this event, Africa is brought back to the table, so to speak, if only ironically in the "African" clothing worn by the figures and in the complexion of the hands, while at the same time, the headlessness of the "European" is a sly retort to the anonymous "faceless" native who populates the colonial textual and visual archive.[4] The burnished map on the table gestures to the many printed maps that were used to conduct the "paper" partitioning of Africa in Europe, as well as newspaper photographs of the stately Berlin conference room in which a large wall map of the continent loomed over the delegates. Who indeed can forget Joseph Conrad's memorable words from his *Heart of Darkness*, when his protagonist Marlowe visits Brussels, the seat of Leopold II's rapacious International African Society: "Deal table in the middle, plain chairs all around the walls, on the one end a large shining map, marked with all the colors of a rainbow. There was a vast amount of red, Marlowe observed, good to see at any time, because one knows some good work is done there, a deuce of a lot of blue, a little green, smears of orange, and on the East Coast, a purple patch, to show where the jolly pioneers of progress drink the jolly lager-beer."[5]

Shonibare's burnished map reproduces in astonishing detail some of these differences, even while it gives prominence to European names and divisions of the great continent prior to the act of formal partitioning. "What I find interesting is the idea that you cannot define Africa without Europe," he says provocatively in his conversation with Okwui Enwezor. "The idea that there is some kind of dichotomy between Africa and Europe—between the 'exotic other' and the 'civilized European,' if you like—is completely

simplistic. So I'm interested in exploring the mythology of these two so-called separate spheres, and in creating an overlap of complexities."[6] Thus in his artwork, clear-cut identities between metropole and colony are thrown overboard, leaving us instead to ask: Who is European? What is African? How can we tell them apart? Why, indeed, should we keep them apart when they have emerged in concert?

In her analysis of Shonibare's oeuvre, Nancy Hynes observes that the Victorian era "with its heady mixture of empire and colonialism, corruption and constraint," has been a rich source of inspiration for the artist.[7] As she also notes, the materials he works with—the Dutch wax fabrics—are revelatory of the postcolonial charge that runs through Shonibare's eclectic creativity. "For Shonibare, the cloth is an apt metaphor for the entangled relationship between Africa and Europe, and how the two continents have invented each other, in ways currently overlooked or deeply buried."[8] As such, his work brilliantly exemplifies the mutually constitutive relationship between modern empire formation and art practices and visual regimes that is the signature concern of this volume. At the same time, his installation pieces also gesture to some of the key conceptual concerns of the essays reproduced in this section, titled "Postcolonial Looking," in which we shift the focus from image-making technologies to image workers, especially those resident in the colonies but also those who "voyage in" to Europe, to the putative white heart of empire. In particular, we are interested in foregrounding essays that enable us to problematize acts of looking (back) in an age when many new technologies of image-making have reconfigured regimes of seeing and being seen. Taking our cue from Shonibare, we, too, are interested in exploring the overlap of complexities that course through "subaltern" acts of seeing.

As these essays demonstrate, we have come a long way from the initial days of colonial studies when the subalternized native was an anonymous shadowy figure on the grand stage where the imperial drama was being played out, either passive and mute, or chattering incoherently and acting chaotically and in need of the calm, governing hand of the master. We have also come a long way from nativist attempts in the first flush of decolonization and nationalism to recuperate the originary, authentic, and pure elements of the self and community, untouched by Europe. Instead, the current moment comes with the recognition that it is not possible fully to escape Europe, or even desirable to do so, as Shonibare's work so aptly demonstrates for us. Nor is it possible to construe Europe's domestic his-

tory as if it were untouched by its overseas involvements. Ella Shohat and Robert Stam put it most bluntly among a whole array of scholars who have advanced our understanding in this direction: "Although a Eurocentric narrative constructs an artificial wall of separation between European and non-European culture, in fact Europe itself is a synthesis of many cultures, Western and non-Western. The notion of a 'pure' Europe . . . is premised on crucial exclusions. . . . All the celebrated milestones of European progress—Greece, Rome, Christianity, Renaissance, Enlightenment—are moments of cultural mixing. The 'West' then is itself a collective heritage, an omnivorous mélange of cultures; it did not simply absorb non-European influences, as Jon Pietersie points out, 'it was constituted by them.'"[9]

Today we have an eclectic range of approaches underlying which lies a preoccupation with putting Europe back in its place, so to speak, after it has been everywhere in the age of empires, casting "its shadow and its substance on the rest of the world."[10] Some are concerned with demonstrating that many ideas that we think of as quintessentially European were frequently incubated and tested in the colonies before being imported back to Europe, as revealed for instance by Gwendolyn Wright's work on urban development and architectural practices in the French colonies of Morocco, Madagascar, and Indochina, or by Kapil Raj's analysis of the Survey of India's operations which reveals not only the involvement of native labor but also mapping practices in the colony that were in advance of cartographic operations in England.[11] Other scholars, influenced by Homi Bhabha's fertile theories of mimicry, sly civility, and hybridity, focus on how some founding objects and practices of the metropolitan world became erratic, eccentric, and "de-formed," as they leave Europe and reach their colonial address.[12] Gyan Prakash's analysis of the exhibitionary complex as this played out in British India is exemplary here, as is Michael Taussig's Panamanian ethnography which, even while not engaging with Bhabha, demonstrates (via a recourse to Walter Benjamin) how the West's mastery was undone when it saw itself reflected in "the handiwork of the Other."[13] Dipesh Chakrabarty's project for "provincializing" Europe has taught us that metropolitan practices and forms might be indispensable in/for (post)colonial modernity but also inadequate, compelling us to look for histories that open up experiences that are unassimilable and untranslatable. The goal here is a narrative refusal to collapse the difference of the (post)colony's history into the sameness of Europe and to reject confinement to "the imaginary waiting-room of his-

tory," the not-yet, not-now limbo in which the colonial condition stuck most of the world outside the industrialized West.[14]

Several scholars take the colonial project right back into the empire's heartland in Europe to variously question the fiction of an originary Europe, to demonstrate how that continent itself was crucially (re)constituted in modernity through its overseas entanglements, and to disclose the absent(ed) presence of the Other in the putative pure and white metropolitan life-world. We have already flagged Edward Said's pioneering arguments in this regard. Christopher Pinney's call for "creolizing" Europe, which we have included in this volume, is another take on this question, as is Salah Hassan and Iftikar Dadi's important curatorial project involving academics, artists, and art critics, "Unpacking Europe."[15] In taking Europe head-on in this manner, this body of scholarship questions boundaries of all sorts, geopolitical and disciplinary. As Susan Buck-Morss observes: "When national histories are conceived as self-contained, or when the separate aspects of history are treated in disciplinary isolation, counterevidence is pushed to the margins as irrelevant. The greater the specialization of knowledge, the more advanced the level of research, the longer and more venerable the scholarly tradition, the easier it is to ignore discordant facts. . . . Disciplinary boundaries allow counterevidence to belong to someone else's story. . . . For instance, there is no place in the university in which the particular research constellation 'Hegel and Haiti' would have a home."[16] Indeed, her own essay titled "Hegel and Haiti" shows what follows when a constellation of facts hitherto kept apart come together to find a resonant home. Her exploration of the question "Where did Hegel's idea of the relationship between lordship and bondage originate?" takes her outside Europe, to Haiti and the Haitian slave revolution of 1804–5, an event that surrounds Hegel's text "like invisible ink."[17] Reading against the grain of *The Phenomenology of the Mind* (1807) and the drafts dated to 1803–6 that preceded it, Buck-Morss reveals the occluded presences there and concludes: "Beyond a doubt Hegel knew about real slaves and their revolutionary struggles. . . He used the sensational events of Haiti as the linchpin in his argument . . . the actual and successful revolution of Caribbean slaves against their masters is the moment when the dialectical logic of recognition becomes visible as the thematics of world history, the story of the universal realization of freedom."[18] Indeed, the failure to recognize this connection, even to ask the question of the relationship of Hegel to Haitian slavery, afflicts not just Hegel schol-

ars; she also takes to task a classic work like Simon Schama's celebrated *The Embarrassment of Riches* for its scandalous neglect of the constitutive role of African slavery, the slave trade, and slave labor in underwriting the so-called Dutch Golden Age. "The consequence of this scholarship is partial blindness among seas of perspicacity, and is characteristic of Western academic scholarship."[19] Her own brief is to show us a different reality in the presence of the enslaved black body in the very heart of the bourgeois households in the Netherlands as depicted in the paintings of the times.

Entangling Europe and its (post)colonies thus within the same analytical frame bringing together discordant facts and discrepant experiences hitherto kept apart, enables us to produce *un*disciplined revelations and *un*bound showings that blast open the apparent continuum of world history to disclose innovative ways of thinking for a new millennium about old questions of conquest and domination, resistance and subversion, image and power. Innovation occurs, Shohat and Stam prompt us, "on the borders of cultures, communities, and disciplines." Quoting from Salman Rushdie, they write, "newness enters the world [through] hybridity, impurity, intermingling, the transformation that comes of new and unexpected combinations" and conclude that "mélange, hotchpotch, a bit of this and a bit of that" is at the very heart of postcolonial looking.[20] This section of our volume is thus concerned with exploring how newness enters the hegemonic world of the imperial optic through the image-work on the (post)colonial margins of the metropole, when image-workers residing there seize Europe's prized image-making technologies and deploy them to their own ends, in the process sometimes reproducing the center, at other times irrevocably transforming it.

Subaltern Seeing: An Overlap of Complexities

In the first of our selections in this sub-section,[21] historian of architecture Zeynep Çelik takes us to one such "margin," the Ottoman Middle East and French North Africa, to remind us that subaltern image-work in colonial contexts can take many routes and many guises in the course of "speaking back to Orientalist discourse." There is no homogeneous response, let alone a singular form of resistant image-work. Thus on the one hand, she points to the late nineteenth- and early twentieth-century painterly work of Osman Hamidi that brings to the foreground his fellow natives dressed in Oriental garb and cast in Orientalist situations, but subtly repositioned

as "thinking, questioning, and acting human beings who display none of the passivity attributed to them by the European painters." Similarly so the photographs produced on Sultan Abdülhamid's command that deliberately showcase his modernizing project for a skeptical West that had confined his empire to an unchanging past marked by fanaticism, irrationalism, sensuality, and despotism. On the other hand, in the 1940s in the building work of the Egyptian architect Hassan Fathy with its vernacularist idiom, she shows the deep entanglements between colonial projects and those created in conscious opposition to them. Contending with the metropole from the margins means taking on the iconic, as Algerian feminist Assia Djebar and filmmaker Kamal Dahane do with the visions of Algeria produced in two authoritative European paintings separated by almost a century, Eugène Delacroix's *Les Femmes d'Alger dans leur appartement* (1834, figure 14.3, this volume) and Pablo Picasso's *Les Femmes d'Algers* (1955, figure 14.4, this volume). This is a form of resistance that takes the route of "reloading" and "recharging" with new meanings, putting the former imperial image to new work, this time in the cause of the postcolonial present.

Historian Sumathi Ramaswamy offers another take on how the iconic image-work of imperialism is reloaded and recharged with new meanings in her analysis of the fate of the mapped image of British India. This hegemonic cartographic image of their most important colony, as a measured whole stretching with a peninsular form across a more or less fixed grid of latitudes and longitudes, was among the proudest achievements of a rationalizing British colonial state that professed to wean its subjects away from their irrational traditions to make them modern. Many of these subjects—especially those who went to colonial schools and those who became part of the state's evolving bureaucratic regime—did become good learners, and to this day the scientific empire of mathematical geography and cartography holds sway in the subcontinent long after colonial rule has formally ended. Ironically, the imperial cartographic image does indeed come to prevail in the national maps of the new nation-states created in the region. Yet there are struggles and transformations outside the realms of science and state where this image was first put in place and then consolidated. Ramaswamy documents how some colonial and postcolonial Indian artists, whom she styles "barefoot cartographers," challenged the seizing of their land by the modern and statist science of cartography by producing another vision and version of the same land as an anthropomorphic being imagined as Mother India. In the work of such barefoot cartographers, the imperial map of India

is not abandoned; on the contrary, it is appropriated and put to a very different use as the abode of the mother/goddess to whom is due love, allegiance, and ultimately sacrifice to the point of death. The secular science of cartography is exposed thus to the "contamination" of affect and religiosity from which it had largely insulated itself as a statist endeavor.

Looking (back), therefore, is a complex and heterogeneous business in the (post)colony with all manner of new ways of seeing jostling for attention alongside older and prior modes, some recuperated under the very force of imperial project. No scholar has possibly been more influential in reminding us of this for the British India context than anthropologist Christopher Pinney with his range of scholarly work on numerous visual media, especially photography and chromolithography. In this volume, we have reproduced two of his most provocative essays, the first of which, "Notes from the Surface of the Image" (in part 1) contrasts the hegemonic "panoptical gaze" of the imperial photographer—which becomes also the gaze of the native elites and middle classes—with the "surfacist" looking habits of subaltern Indian and West African photographers and their viewers. In the subaltern sectors of the postcolony, the concern is not so much with the photograph as a window on a reality enshrined in its depth that observes in a detached manner, but with the photograph "as a surface, as a ground on which presences that look toward the viewer can be built." As such, immediacy and openness to sensual takeover by the image triumphs over clinical looking, as the impulse is to close the gap between the viewer and the image. Looking becomes touching, the eye necessarily also supplemented by the hand to produce an embodied "corpothetic" gaze.

Art historian Krista A. Thompson, whose research interests lie in the study of the visual culture of the African diaspora, offers a counterargument in her focus on the persistence, rather than the overcoming, of the colonial in the postcolonial Anglophone Caribbean. Her piece—abstracted here from a chapter of *An Eye for the Tropics: Tourism, Photography, and Framing the Caribbean Picturesque*[22]—brings to our attention a humble but ubiquitous object of colonial and modern visual culture: the photographic postcard.[23] "Like messages in a bottle washing up on their shores of origin a century later," these picture(sque) postcards recycled "tropicalized" images of the islands and are much sought after in the Caribbean. In an argument that resonates with Roger Benjamin's observations about the popularity of nineteenth-century "Orientalist" paintings among Arab and Turkish collectors today that has been discussed in this volume's introduction,[24] Thomp-

son shows how (the largely white) postcolonial publishers and authors in the islands reach into the colonial archive—a "visual image bank"—and recuperate picturesque visions long forgotten or discarded, possibly bringing them to a greater viewership than they ever formerly attracted. In this process, the picturesque is accorded a "documentary" and "objective" status that it never possessed, as these postcards are viewed anew to reconstruct "the way we were." In such accounts, the "colonial" postcard gains new authority as a "national" document fueled by a nostalgia across race and class for the time when the British governed these islands. Paradoxically, even Caribbean scholars interested in recuperating lost black pasts drop their well-honed spirit of critical suspicion that they reserve for a textual archive and turn to these as "transparent" and "true" images that seemingly give them access to a history "from below," as it were. In these academic writings, "the contrived touristic image reappears, wearing the invisible mask of history, as the past as it was, not the past as it was produced."

Thompson ends by spelling out the challenge that faces all postcolonial scholars who work with images—and texts—left behind by colonizing regimes that largely denied historicity to their subjects: how do we use such archives, then, to produce new—and contested—histories of the native and the formerly colonized? One response to this question is provided in film historian and theorist Robert Stam's essay, "Fanon, Algeria, and the Cinema," which takes us back to French North Africa—where this subsection began with Zeynep Çelik—and also points ahead to our next subsection on the native (artist) doing image-work in the heart of empire. Stam brings together "Fanon" and "cinema," not only because the kinetic prose of the psychotherapist was so cinematic and because of Fanon's own early theorization on cinematic spectatorship and identification, but also because so many avant-garde films have taken recourse to Fanonian imagery and inspiration.[25] In particular, he examines two films deeply indebted to Fanon: *The Battle of Algiers* (1966) directed by the Italian Gillo Pontecervo (in collaboration with Algerians), and *Black Skin, White Mask* (1996) directed by the British filmmaker Isaac Julien, the latter "a theorized orchestration of looks and glances, captured and analyzed in all their permutations." At a time when most French films ignored the Algerian war, and most mainstream Hollywood films continued to put out enduring Orientalist stereotypes that reduced North Africa to a stage for the exercise of the white man's heroism or romance, *The Battle of Algiers* (banned in France until 1971) brought the bloody battle to movie theaters, giving primacy of place to

Arabic-speaking Algerian protagonists. In the process, the official French version of the Algerian revolution was powerfully contested with alternate image-work, using "the identificatory mechanisms of the cinema on behalf of the colonized." The passive (and sensuously indolent) Algerian of the dominant Orientalist narrative reemerges as a fearless revolutionary, in the process creating an alternate archive of memory for this critical anticolonial war.[26] This is also the case with Julien's film, which, however, reminds us that we now inhabit a world that is no longer fissured by a Manichean differentiation between "us" and "them," "black" and "white," "Europe" and "Other," which sustained both colonial and nativist visions. This is a realm of "miscegenated" aesthetics and of a sense of "in-between-ness," of "resistance with intimacy." At the same time, Julien's film provokes Stam to ask—in an appropriate conclusion to this part—could it be that "the goal of the colonized is not to win a reciprocal gaze, but to put the colonialist out of the picture altogether?"

Regarding and Reconstituting Europe

Having circled the wagons, in a manner of speaking, in the previous section with our tour of the "margins" which took us from the Ottoman Middle East through French North Africa to India and West Africa and the Caribbean Islands, and ending with Julien's film on Fanon and Algeria, we (re) enter the center with three final selections that take Europe on from within. Here, one is reminded of Gayatri Chakravorty Spivak's comment that when the hegemonic is placed in the position of the Other, a fundamental transformation begins to happen.[27] Thus the goal is to collapse distinctions between the here and the elsewhere and undo stable identity formations in the metropole that set up impermeable boundaries around a center seemingly untouched by distant and foreign Alters. This is precisely what anthropologist Christopher Pinney invites us to do in his essay "Creole Europe," in which he argues that Europe as well was a "contact zone," where disparate cultures met and grappled with each other.[28] Yet its heterogeneity has been all too readily masked, the fiction of an originary Europe, pristine pure and white, delivered linguistically and discursively. Thus, chintz, a fabric that emerged elsewhere and whose presence should summon up memories of Other places, is domesticated into the English language and made one's own, its origins in the distant tropics occluded and forgotten. Europe's own assumption of self-sufficient immanence is thus based on a distancing from

the world of corporeality, materiality, and tactility. When we do a new "material world" history—when we hold a piece of chintz in our hand, feel it, and touch it, in the spirit of what Goethe called "delicate empiricism"—we are reminded of the Other as Alter, of the persistence of "the sensuous in the face of the abstract." The very objectness of the object puts pressure, alerts us to its sheer otherness, to its origins elsewhere. The goal is to demonstrate through an uncovering of such "xeno-figures" that "Europe was always a reflection of other times and places, never a self-present unity awaiting its replicatory colonial enunciation." Pinney thus offers us a theoretical agenda—the revelation of the "colonial" origins of things and practices that have been deemed quintessentially European—and a methodology that turns around a new aesthetics that he calls "transhuman corpography" in which we are forced to contend with the corporeality and sheer materiality of objects that reveal the otherness of the Other.

While Pinney invites us to do a figural/sensory history that liberates the chintzes and willow patterns and bent leaves from their "subaltern" position in a Europe that fences itself off from its (tropical) Other, literary critic Simon Gikandi dares us to take on "the master"—the hallowed modernist Pablo Picasso—and expose the fact that although he was the father of primitivism (the movement when the Other became a catalyst for modern art in the metropole), he had little regard for the cultures and bodies that enabled his art—and reputation and fame. Indeed, Gikandi argues—in terms that resonate with Pinney's contentions in "Creole Europe"—that Picasso's modernist revolution was made possible through a meticulous separation of the African's art from the African's body and possession, through a conscious process of abstraction and distance from the corporeal.[29] Picasso loved the African's object, but not the Negroes who produced and used them, and this despite his avowed support for anticolonial movements. As Gikandi scathingly puts it, Picasso and his fellow modernists "needed the primitive in order to carry out their representational revolution, but once this task had been accomplished, the Other needed to be evacuated from the scene of the modern." The task of the postcolonial critic, then, is to reinsert the Other back into the scene of the modern to disclose its *constitutive* role and write back against not just the modernist artist but the canon of modernism as well, which also engages in a similar process of disavowal. Whereas Pinney sets out "to reveal the parallel, uncanny presence of exotic objects within a materially creolized Europe," Gikandi borrows Derrida's term "hauntology," the revelation of the manner in which an entity called

Africa "haunts" Picasso's work and "entangles" European modernism more generally.

It is fitting that we end this volume with a discussion of another work by Yinka Shonibare titled *Double Dutch* (1994), which art historian, critic, and curator Olu Oguibe draws on to reflect on the choices facing "artists in the Western metropolis whose backgrounds are 'elsewhere.'" The code of "the culture game" is to self-exoticize, submit to the test of "tolerable difference" (rather than dangerous Otherness), and pass the test or else fail and be confined to obscurity. Born in London of African parents and raised in Lagos, Nigeria, and then returning to Britain as a teenager who went on to pursue a career as a professional painter and installation artist, Shonibare failed to pass the critical test of safe difference in the late 1980s. Success came in the 1990s—with *Double Dutch*—when he passed "the test of difference by engaging and outwitting it rather than confronting or denying it." His *Double Dutch*—with its signature Dutch wax fabric discussed earlier in this essay—is exemplary of this attempt at "outwitting," for Shonibare was immediately embraced by the same establishment that had formerly rejected him when he had not owned up in his artwork to his Otherness. In Oguibe's nuanced reading, *Double Dutch* is one of the most important late twentieth-century works of cultural contestation, for as we have already recalled, the so-called African fabric was a metropolitan product, "conceived, manufactured, marketed, and consumed without stepping across the border to any exotic ancestral homeland elsewhere." Where others have submitted to the test of difference, like Chris Ofili with his elephant dung artworks that consciously invoked a putative African connection, Shonibare has played the culture game by slyly outsmarting those who demand difference from the Other: "The signifier that would denote and inscribe his Otherness is, after all, entirely British and has little or nothing to do with Africa or Elsewhere." The culturally hegemonic, as we know, is not used to being relativized. But that is exactly what Shonibare has done by engaging with the culture game so well that the postcolonial subaltern player ends up by being the (new) master of the game.

Notes

1 For Shonibare's reflections on this particular work, see Yinka Shonibare, "Of Hedonism, Masquerade, Carnivalesque and Power: A Conversation with Okwui Enwezor." in *Looking Both Ways: Art of the Contemporary African Dias-*

pora, ed. L. A. Farrell (New York: Museum for African Art, 2003). See especially his comment, "It's a kind of exaggerated representation of a truly grotesque moment in African history, a moment that to me is highly responsible for the state that Africa is in now" (175). See also Olu Oguibe, "Finding a Place: Nigerian Artists in the Contemporary World," *Art Journal* 58(2) (1999): 30–41.

2 Nancy Hynes, "Yinka Shonibare: Re-Dressing History," *African Arts* 34(3) (2001): 60–73, 93–95; quotation on 60. Thus in his *Mr. and Mrs. Andrews without Their Heads* (1998), which is on the cover of the present volume, Shonibare takes up an iconic painting by the eighteenth-century artist Thomas Gainsborough and reclothes the protagonists of that work in this signature fabric. For Shonibare's thoughts on his choice of Dutch wax, see Shonibare, "Of Hedonism, Masquerade, Carnivalesque and Power," 164.

3 This phrase was used in a letter Leopold II of Belgium wrote to his ambassador in London in 1876.

4 The artist himself has a different take: "As is customary when I address issues of power, the fourteen figures are headless. They wear Victorian men's suits made out of 'African' printed fabric. I want to produce something signifying both the absurd and the grotesque" (Shonibare, "Of Hedonism, Masquerade, Carnivalesque and Power," 175). Similarly, in *Mr. and Mrs. Andrews without Their Heads*, Gainsborough's sedate landed gentry couple are rendered both headless and estate-less, giving a sharp "post-colonial twist" to the famous English painting (Hynes, "Yinka Shonibare," 63). In a conversation with Okwui Enwezor, Shonibare spoke of his response to Gainsborough, "A contradiction always lies behind the pleasure and excess on the surface. That pleasure and excess are nearly always underpinned by exploitation, but the interesting thing for me is the notion of complicity: I clearly would enjoy the trappings of aristocracy. I cannot morally justify how they come about, but I know I would enjoy them — I consider myself a hedonist. I also don't believe for one moment that one's blackness should mean that one should always be on the margins of society, or suffering in some way. This is an important political stance in my practice" (Shonibare, "Of Hedonism, Masquerade, Carnivalesque and Power," 176).

5 Joseph Conrad, *Heart of Darkness* (1899; New York: Knopf, 1993), 13.

6 Shonibare, "Of Hedonism, Masquerade, Carnivalesque and Power," 163.

7 Hynes, "Yinka Shonibare," 62.

8 Hynes, "Yinka Shonibare," 60.

9 Ella Shohat and Robert Stam, "Narrativizing Visual Culture," in *The Visual Culture Reader*, ed. N. Mirzoeff (London: Routledge, 1998), 29. The unpublished essay by Jan Pietersie cited by the authors is titled "Unpacking the West: How European Is Europe?" Shohat and Stam themselves advocate "a polycentric, dialogical, and relational analysis of visual cultures existing in relation to one another. . . . The emphasis in 'polycentrism' is not on spatial or primary points of origins or on a finite list of centers but rather on a systematic principle of differentiation, relationality, and linkage" ("Narritivizing Visual Culture," 46).

10 Peter Ekeh, quoted in Salah M. Hassan and Iftikhar Dadi, 2001. "Introduction: Unpacking Europe," in *Unpacking Europe: Towards a Critical Reading*, ed. S. M. Hassan and I. Dadi (Rotterdam: Museum Boijmans Van Beuningen, NAi Publishers, 2001), 13.

11 Gwendolyn Wright, "Tradition in the Service of Modernity: Architecture and Urbanism in French Colonial Policy, 1900–1930," in *Tensions of Empire: Colonial Cultures in a Bourgeois World*, ed. F. Cooper and A. Stoler (Berkeley: University of California Press, 1997); Kapil Raj, "Circulation and the Emergence of Modern Mapping: Great Britain and Early Colonial India, 1764–1820," in *Society and Circulation: Mobile People and Itinerant Cultures in South Asia, 1750–1950*, ed. C. Markovits, J. Pouchepadass, and S. Subrahmanyam (New Delhi: Permanent Black, 2003). A forerunner in colonial studies in this regard, albeit based completely on a textual archive, is Gauri Viswanathan, *Masks of Conquest: Literary Study and British Rule in India* (New York: Columbia University Press, 1989).

12 Homi Bhabha, *The Location of Culture* (London: Routledge, 1994).

13 Gyan Prakash, "Staging Science," in *Another Reason: Science and the Imagination of Modern India* (Princeton, NJ: Princeton University Press, 1999); Michael Taussig, *Mimesis and Alterity: A Particular History of the Senses* (New York: Routledge, 1993).

14 Dipesh Chakrabarty, *Provincializing Europe: Postcolonial Thought and Historical Difference* (Princeton, NJ: Princeton University Press, 2000). See also Sumathi Ramaswamy, *The Goddess and the Nation: Mapping Mother India* (Durham: Duke University Press, 2010), and Ramaswamy's essay in this volume (chapter 16). For a counterargument emerging out of art practice in which he writes about "the crippling predicament" faced by non-European artists in "the global culture game" predicated on "the demand for difference," see Olu Oguibe, *The Culture Game* (Minneapolis: University of Minnesota Press, 2004), xiv–xv.

15 Salah M. Hassan and Iftikhar Dadi, eds., *Unpacking Europe: Towards a Critical Reading* (Rotterdam: Museum Boijmans Van Beuningen, NAi Publishers, 2001). For another curatorial project along these lines, see Mora J. Beauchamp-Byrd and M. Franklin Sirmans, *Transforming the Crown: African, Asian and Caribbean Artists in Britain, 1966–1996* (New York: Franklin H. Williams Caribbean Cultural Center/African Diaspora Institute, 1997).

16 Susan Buck-Morss, "Hegel and Haiti." *Critical Inquiry* 26 (2000): 822.

17 Buck-Morss, "Hegel and Haiti," 846. For a comparable discussion of John Ruskin's occlusion of race and slavery in his discussion of Turner's famous painting "The Slave Ship," see Paul Gilroy, "Art of Darkness: Black Art and the Problem of Belonging to England," in *Small Acts: Thoughts on the Politics of Black Cultures* (London: Serpent's Tail, 1993), 74–85.

18 Buck-Morss, "Hegel and Haiti," 852.

19 Buck-Morss, "Hegel and Haiti," 825.

20 Shohat and Stam, *Narrativizing Visual Culture*, 46.

21 We borrow the phrase "an overlap of complexities" from Yinka Shonibare, as quoted earlier ("Of Hedonism, Masquerade, Carnivalesque and Power," 163).

22 Published in 2006 by Duke University Press.

23 For one of the earliest works to consider the place of the picture postcard as "the fertilizer of colonial vision," see Malek Alloula, *The Colonial Harem*, trans. M. Godzich and W. Godzich (Minneapolis: University of Minnesota Press, 1986). In recent years, the scholarship on the colonial postcard and its post-colonial aftermath has considerably expanded. See especially David Prochaska, "Fantasia of the Photothèque: French Postcard Views of Colonial Senegal," *African Arts* 24(4) (1991): 40–47, 98; David MacDougall, *The Corporeal Image: Film, Ethnography and the Senses* (Princeton, NJ: Princeton University Press, 2006); and Saloni Mathur, *India by Design: Colonial History and Cultural Display* (Berkeley: University of California Press, 2007).

24 Roger Benjamin, "Post-Colonial Taste: Non-Western Markets for Orientalist Art," in *Orientalism: From Delacroix to Klee (Exhibition Catalog)* (Sydney: Art Gallery of New South Wales, 1997), 32–40.

25 See particularly Stam's comment, "Indeed, Fanon's aura hovers over the entire initial phase of Third Worldist cinema," which provides "an audio-visual gloss on Fanonian concepts."

26 For a recent argument on the importance of this film as a "countervisual" narrative, see Nicholas Mirzoeff, *The Right to Look: A Counterhistory of Visuality* (Durham: Duke University Press, 2011), 239–56. For a feminist analysis that considers *The Battle of Algiers* through a sophisticated analytic of mourning and melancholia, see Ranjana Khanna, *Algeria Cuts: Women and Representation, 1830 to the Present* (Stanford, CA: Stanford University Press, 2008), 103–23.

27 Gayatri Chakravorty Spivak, *The Post-Colonial Critic: Interviews, Strategies, Dialogues*, ed. Sarah Harasym (London: Routledge, 1990), 121.

28 The reference here is to Mary Louise Pratt's influential concept, discussed in the introduction of this volume.

29 See also in this regard Sieglinde Lemke, "Picasso's 'Dusty Manikins,'" in *Primitivist Modernism: Black Culture and the Origins of Transatlantic Modernism* (Oxford: Oxford University Press, 1998), which points to the irony of African American artists encountering "African" art through the mediation of European modernists.

PART 5

Subaltern Seeing: An Overlap of Complexities

"Opium!
Submission!
Kismet!
Lattice-work, caravanserai
 fountains
a sultan dancing on a silver tray!
Maharajah, rajah
a thousand-year-old shah!
Waving from minarets
clogs made of mother-of-pearl;
women with henna-stained noses
working their looms with their feet.
In the wind, green-turbaned imams
 calling people to prayer"
This is the Orient the French poet sees.
This
 is
 the Orient of the books
that come out from the press
at the rate of a million a minute.
But
 yesterday
 today
 or tomorrow
an Orient like this
 never existed
 and never will.[1]

This quotation comes from a much longer poem, titled "Pierre Loti" and written by the great Turkish poet Nazim Hikmet in 1925. Hikmet's target is not so much Loti himself as European imperialism, and his angry response is charged by his Marxist worldview and his proto–Third Worldism. Nevertheless, his speaking back to Orientalist discourse follows a turn-of-the-century Ottoman intellectual tradition. To refer to two earlier literary examples, Halit Ziya's 1908 novel *Nesl-i Ahîr* (The First Generation), opens with the protagonist's quarrel with a book written by a European author on the "Orient." Although a great deal more placid than the poet's penetrating voice, the sentiments of this fictional character, a well-educated Ottoman man on a boat returning from Marseille, are also in revolt against Orientalist misconceptions: "Whenever he began reading a book on the East, especially on his own country, he felt inclined to leave it. As he witnessed the Western writers' accounts of a lifestyle they attempted to discover under the brightness of an Eastern sun that blinded their eyes and amidst the ambiguities of a language they did not understand, his nerves would unravel and his heart would ache [rebelling against] their idiotic opinions and their self-righteous courage that produced so many errors."[2]

Ahmed Mithad Efendi, another prominent Ottoman writer, dealt with the same theme in his 1889 *Avrupa'da Bir Cevelan* (A Tour in Europe), focusing on (among other things) the European fantasy about the Eastern woman. He captured the Ingresque formula to indicate the epistemological status such representations had achieved:

> [This] lovable person lies negligently on a sofa. One of her slippers, embroidered with pearls, is on the floor, while the other is on the tip of her toes. Since her garments are intended to ornament rather than to conceal [her body], her legs dangling from the sofa are half naked and her belly and breasts are covered by fabrics as thin and transparent as a dream. Her disheveled hair over her nude shoulders falls down in waves. . . . In her mouth is the black end of the pipe of a *narghile*, curving like a snake. . . . A black servant fans her. . . . This is the Eastern woman Europe depicted until now. . . . It is assumed that this body is not the mistress of her house, the wife of her husband, and the mother of her children, but only a servant to the pleasures of the man who owns the house. What a misconception![3]

Ahmed Mithad's "correction" of the distortions he sarcastically describes has its own problems, of course. It is static; it is also based on a struggle for

power; it replaces one "truth" with another; and it reclaims the hierarchy by inverting it.[4] I address these complex issues only tangentially; I limit myself, instead, to the presentation of several artistic and architectural responses to Orientalism in an attempt to contribute to the triangulation of recent critical scholarship in art history that examines the Orientalist discourse from the "Western" perspective. The study of Orientalist art owes a great deal to Edward Said's groundbreaking book, *Orientalism* (1978). Said enhanced the importance of viewing cultural products through a lens that highlights the underlying politics of domination, specifically where the "Orient" is concerned. Art and architectural history responded to Said's challenge and, not surprisingly, followed the model established by *Orientalism*, thus engaging in analyses of artworks that contributed to the construction of an "Orient." They offered innovative and critical readings of Orientalism, but focused solely on the "West." As Said himself stated, *Orientalism* was a study of the "West" alone. It was not intended as a cross-cultural examination of and did not claim to give voice to the "other" side, an issue Said addressed in his later writings.[5]

Triangulation is a technical term borrowed from engineering and adapted by sociology as a research tool. Used in land surveying to determine a position, it offers the possibility of multiple readings in history. In Janet Abu-Lughod's words, triangulation is based on the understanding that "there is no archimedian point *outside* the system from which to view historic reality."[6] My approach to Orientalism from the "other" side, the side of "Orientals," is aimed to bring another perspective to the discourse. Studied from this unconventional corner, Orientalism reveals a hitherto concealed dynamism, one that is about dialogue between cultures and about contesting the dominant norms. When the Oriental artists and intellectuals speak and begin shaping the terms of the debate, the Orient as represented by the West sheds its homogeneity, timelessness, and passivity and becomes nuanced and complicated. It can no longer fit the frozen categories.

My first case study is the late nineteenth/early twentieth-century Ottoman painter Osman Hamdi, whose artistic career centers on speaking back to Orientalism. His response takes place within the very norms and artistic format of the school he addresses his critique to. Osman Hamdi's pursuit is deliberate and consistent. Nevertheless, there are other "corrective" messages to Orientalism in the Ottoman discourse, although not always explicit. Consider, for example, Prince Abdülmecid's *Beethoven in the Palace* (ca. 1900), which depicts a truly oppositional palace scene to the one we

know from Orientalist paintings. A trio, consisting of a male cellist and two women, one playing the violin, the other the piano, performs for an audience of three women and one man, the prince himself. These men and women, dressed according to the latest European fashions, are immersed in the music as performers and listeners. The interaction between genders is established through music and the artistic communication implies mutual respect. The room is lavishly decorated with turn-of-the-century European furniture, including a paysage painting hanging on the wall, an equestrian statue on a pedestal, and a bust of Beethoven. In another example that contradicts European representations of Oriental women, Ömer Adil's *Women Painters' Atelier* (ca. 1920) shows a studio in the School of Fine Arts in Istanbul, where Ottoman women are engaged in a serious study of art—albeit in a segregated setting.[7]

Halil Bey, the flamboyant Ottoman ambassador to Paris in the mid-1860s and well known at the time for his spectacular painting collection that included Ingres's *Le Bain turc* (1862), seems to have pursued another subtle way to deal with Orientalism.[8] Two years after he purchased *Le Bain turc*, Halil Bey bought Courbet's *Les Dormeuses* (1867), another painting with lesbian undertones, which he hung next to Ingres's bath scene. Admitting that it would be difficult to prove his thesis factually, art historian Francis Haskell feels tempted to speculate that perhaps Halil Bey showed the Ingres canvas to Courbet and suggested that he paint a "modern counterpart" to Ingres's "Oriental fantasy."[9] Courbet's painting is devoid of the paraphernalia that act as "signs" of the Orient and that speckle Ingres's canvas to make his bath unmistakably "Turkish." In this light, one is tempted to push Haskell's speculation a step further and read Halil Bey's intervention as a deliberate gesture to resituate the scene depicted in *Bain turc* in a European setting, thereby evacuating the bath from Ingres's Orientalist implications.

During the years that corresponded to Halil Bey's tenure as ambassador, Osman Hamdi was a student in Paris. There he was drawn to the atelier of Gustave Boulanger and possibly also to that of Jean-Léon Gérôme, and his own work matured under the technical and thematic influence of the French Orientalist school. Nevertheless, his "scenes from the Orient" provide acute and persistent critiques of mainstream Orientalist paintings. They represent a resistant voice, whose power derives from the painter's position as an Ottoman intellectual, as well as from his intimate acquaintance with the school's mental framework, techniques, and conventions. Osman Hamdi's men and women—dressed in the colorful garments in the Orientalist fash-

ion and placed in "authentic" settings—are thinking, questioning, and acting human beings who display none of the passivity and submissiveness attributed to them by European painters.

Osman Hamdi addressed the major themes of Orientalist painters from his critical stance as an insider on the outside. In contrast to the constructions that convey fanaticism, exoticism, and even violence in Gérôme's series of paintings on Islamic worship, for example, Osman Hamdi presented Islam as a religion that encouraged intellectual curiosity, discussion, debate, even doubt.[10] In painting after painting, his men of religion, reading and discussing books, maintain their upright posture as an expression of their human dignity, against a background of meticulously articulated architectural details. To refer to a few examples, *Discussion in Front of the Mosque* (ca. 1906) depicts three "teachers," one reading aloud (commenting on?) a book, while the others listen with great attention, holding on to their own texts. The same theme, but now showing only one man in the audience of a savant, is portrayed in *In the Green Mosque in Bursa* (ca. 1900). *The Theologist* (1901) focuses on yet another scholar surrounded by books, reading in a mosque.

Osman Hamdi's repertoire of women, both in public and domestic spaces, makes a statement about their status in the society. Dressed in elegant and fashionable clothes, they are shown moving freely in the city and sometimes interacting with men as they attend to business. The home scenes provide a striking alternative to the myriad familiar and titillating views of harem and bath by French painters. Several of his works, among them *The Coffee Corner* (1879) and *After the Iftar* (1886), depict a couple in a tranquil domestic environment, the seated man being served coffee by the woman. Although the hierarchical family structure is not questioned, the man of the house is not the omnipotent, amoral, sensual tyrant of European representations, enjoying his dominion over scores of women at his mercy and pleasure. Instead, a dialogue is offered that redefines the gender relationships in Orientalist paintings. The scenes that show only women in domestic interiors may belong to the long lineage of *Les femmes dans leur appartement*, but Osman Hamdi's women try to reveal another "truth" about the activities that take place in upper-class Muslim homes than the ones suggested by Delacroix and Gérôme. He hints, for example, at domestic work by showing laundry drying in the background.

Among the themes Osman Hamdi addressed from the checklist of Orientalism is a grooming scene that speaks back to the particular European

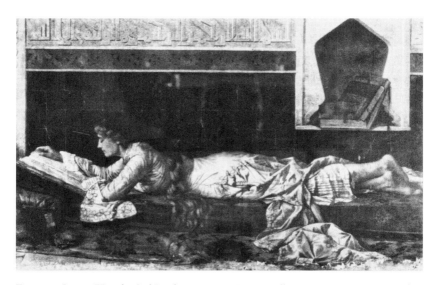

Fig. 14.1. Osman Hamdi, *Girl Reading*, ca. 1893. Private collection, Izmir. From Mustafa Cezar, *Sanatta Batıya Açılış ve Osman Hamdi* (Istanbul, 1971).

obsession with the Eastern female body. In *Girl Having Her Hair Combed* (1881), Hamdi Bey recasts both the young woman being tended to and the servant. The Ottoman painter's upper-class demoiselle has control over her own body as she watches herself attentively in the mirror, clearly supervising her coiffure. With this painting, Osman Hamdi counteracts Gérôme's *Le Bain* (1880), whose centerpiece is a young woman in a bath being washed by a black slave. The viewer does not have access to her facial expression, but only to her naked back, her posture and bent neck suggesting her helpless abandonment to her fate in the aftermath of this sensual preparation. Osman Hamdi's servant is a worker, simply doing her job; Gérôme sets a mysterious tone for what is to come by providing a contrast charged with innuendoes.

Osman Hamdi's reaction to the cliché of the "Oriental" woman as sex object becomes even more acute when he focuses on a single woman. His response to Orientalism's innumerable reclining odalisques is *Girl Reading* (ca. 1893; figure 14.1). The painting shows a young woman stretched out on a sofa, totally immersed in a book. Her relaxed and casual tone implies that she is not reading a religious text, but perhaps a work of literature. The composition has the familiar collage of Orientalist details, complete with rugs, tiles, inscriptions, and "Islamic" architectural elements, but the shelves be-

hind her are filled with books, making the statement that reading occupies an important part of her life. The "girl" is hence given back her thinking mind and intellectual life, which had been erased by Orientalist painters.

Corresponding to the time when Osman Hamdi was voicing his individual response to Orientalist representations of his country, an official venture attempted to bring a similar corrective. On the occasion of the 1893 World's Columbian Exposition, the Ottoman Sultan Abdülhamid II presented fifty-one photography albums to the "National Library" of the United States.[11] The ornately bound albums, which contained 1,819 photographs by various Istanbul photographers, drew the image of the empire according to the conceptions of its ruling elite. Now at the Library of Congress, the Abdülhamid albums cover the empire in several categories. Although historic grandeur, expressed by photographs of major monuments from the Byzantine and Turkish periods, as well as natural landscapes are given their due respect, the major theme is that of modernization. Modernizing reforms to rejuvenate the empire had been in place since the eighteenth century in response to successive military defeats experienced by the Ottoman army. In search of quick and practical remedies, the Ottoman rulers first imported technological innovations that were seen as proof of European superiority. Nevertheless, the exposure to the West soon embraced other fields and the history of the late Ottoman Empire became a history of Westernization. This significant development that affected all aspects of Ottoman life remained prominently absent from Orientalist accounts.

Modernization covered many areas, extending from military reforms to education to artistic production. It introduced, for example, a new architecture based on European models. One of the most telling statements regarding architectural modernity was made by the construction of Dolmabahçe Palace in 1856. It pointed to the official acceptance of Western models not only as fashionable novelties but also to bring radical transformation to lifestyles. The overall organization of the palace, based on Beaux Arts principles of symmetry, axiality, and regularity, was complemented by its ornate classical facades that evoked the contemporary French Empire style. Its main facade turned toward the Bosphorus, the impressive mass of the Dolmabahçe Palace was highly visible from various vistas and defined a new image of monumentality for the capital. The interior spaces corresponded to changing fashions in the everyday life of the palace: European furniture filled the rooms, revealing new customs that ranged from eating at elaborately set tables on high-backed chairs as opposed to the former pattern of

sitting on the floor or on low couches around a tray, to substituting built-in couches for armchairs and sofas in living rooms in a redefinition of socializing habits. The paraphernalia that filled the rooms—including crystal chandeliers, armoirs, sideboards, and European paintings—contributed further to the rupture with the former decorative traditions that relied, for example, on an extensive use of tiles on wall surfaces. Dolmabahçe's exterior and the interior photographs in the Abdülhamid albums hence offered a very different palace from the older Ottoman palaces. They also contradicted the palaces of the Orientalist discourse that had constructed imaginary *serails*.

Among other aspects of modernization, industrialization was underscored by photographs of factories, docks, and arsenals. From the 1840s on, a number of state-run industries were founded on the outskirts of Istanbul. They included foundries that produced iron pipes, steel rails, swords, and knives and factories that specialized in textiles, glass, paper, chemicals, and rubber. Boats were made and maintained in modern arsenals. The products were exhibited in all major European universal exhibitions and a considerable sample was sent to the World's Columbian Exposition in Chicago in 1893.[12] The photographs of modern production facilities in the Abdülhamid albums delivered a picture of the industrial environment in the empire.

Educational reforms, conveyed through photographs of new school buildings, occupied the largest component of the exposé. To demonstrate the widespread nature of modern education, photographs of schools included the entire spectrum, from the highest institutions of learning (such as the law school) to middle and elementary levels and offered examples from diverse regions of the imperial territory. Certain institutions of great prestige were given more space. For example, an entire album was dedicated to the Imperial High School of Galatasaray, where instruction was given in Turkish and French. The photographs flaunted the building in its expansive garden, the age range of students from elementary through high school, students with their distinguished teachers, and even gym classes. Another important educational establishment was the school of medicine, shown in one photograph with its entire population. The emphasis on science and scientific research was revealed by a photograph of a group of medical students in front of a cadaver, other relevant artifacts framing the view. Respect for learning and knowledge permeated the albums in various forms, for example, by interior views from the museum of the Imperial Maritime College and the Imperial Library (figure 14.2). A scholar of theology, as judged from his attire, reading in a well-equipped modern library in a converted

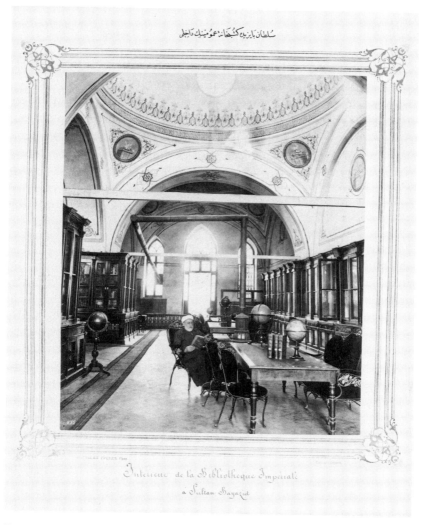

Fig. 14.2. Imperial Library, Istanbul. Abdülhamid II Albums, Prints and Photographs Division, Library of Congress, Washington, DC.

historic building made a statement about the enlightened nature of Islam and its compatibility with contemporary ideas—just like Osman Hamdi's religious figures.

To demystify another "misconception," the albums dedicated many photographs to women's education. Paralleling the photographs on the education of boys, many girls' schools where modern instruction was pursued were included. Groups of students carrying their books and diplomas—younger counterparts to Osman Hamdi's *Girl Reading*—strove to give further proof to the status of women in modern Ottoman society. Women appeared in the albums in one other classification: health care. A special hospital for women received extensive coverage, including the administration building and a group of doctors. Other photos show the exteriors and interiors of individual pavilions that met high hospital standards for the turn of the century. These photographs also introduced a category of working women: nurses. It is significant, however, that the distant figures of the nurses and the tuberculosis patients constituted the only mature women in the albums; the rest were schoolgirls.

The Abdülhamid II albums, then, provide an imperial image that is circumscribed in many aspects but that clearly reflects the official intention to represent the empire in a progressive light. This was a form of answering back to the European discourse that froze Ottoman culture and society in an undefined and imagined past by reductive formulas about fanatic religious practices, irrationality, ignorance, and mindless but sumptuous living. The albums attempted to transform the end-of-the-century image of the empire as the "sick man of Europe" into a rejuvenated, dynamic, and modern one.

The Ottoman Empire may have been on its way to disintegration in the face of the changing global power structure during the late nineteenth and early twentieth centuries, but it was still independent and maintained something from its past prowess. My two other case studies come from colonial contexts, where "speaking back" takes on different forms. Granted that Westernization reigned in all Ottoman social and cultural realms, the relationship between dominating and dominated cultures was far more entangled in a colonial situation. The colonial discourse that punctuated cultural differences also led to the construction of "traditions" for colonized territories. The later adoption, interpretation, and transfiguration of these traditions reveal intriguing questions about issues of authenticity in an age that desperately looks for a sense of national identity while engulfed by globalization.

Research and writing on "non-Western" architecture had already co-alesced into a significant body of literature by the end of the nineteenth century in Europe. Nevertheless, in the 1920s and 1930s a major turn from monumental to residential forms occurred in the architectural discourse. North African French colonies present a particularly rich case study as their vernacular architecture was the subject of scrupulous documentation and analysis. The focus originated in part from European modernist sensibilities that saw in the cubical, whitewashed masses and sparse spaces of North African medinas potential sources of inspiration for a modernist vocabulary. It was also connected to the growing housing shortage in colonial cities. French architects in charge of the construction programs undertaken by the colonial administration relied on regional vernacular forms to find appropriate stylistic and spatial models for contemporary housing projects.

Popular books, such as Victor Valensi's *L'Habitation Tunisienne* (Paris, 1923), A. Mairat de la Motte-Capron's *L'Architecture indigène nord africaine* (Algiers, 1923), and Jean Galotti's *Les Jardins et les maisons arabes au Maroc* (Paris, 1926) — the last with sketches by Albert Laprade, one of the leading architects working in Morocco at the time — presented a wealthy collection of images depicting vernacular buildings, often in their urban or landscape settings. These books played an important role in disseminating the image of North African vernacular architecture in the *métropole* and *outremer*. Le Corbusier's own interest in vernacular architecture and his recurrent incorporation of sketches and photographs in his publications to support his arguments for a modern architecture and urbanism enhanced the entry of North African "indigenous" forms into the discourse of modernism.[13] Furthermore, the creation of temporary quarters, deemed "authentic," in the world's fairs from the second half of the nineteenth century on, culminating in the extensive Tunisian section of the 1931 Paris Colonial Exhibition, played a crucial role in the dissemination of North African vernacular imagery.[14]

When French architects built housing schemes for "indigenous" people, they relied on the commentary and documentation developed by the colonial discourse on the North African vernacular. A striking example is the new medina of Casablanca (the Habous Quarter) intended to accommodate the growing Moroccan population of the city. Designed by Laprade and built in the early 1920s, the scheme combined the "customs and scruples" of Moroccans with French considerations for "hygiene"[15] and highlighted the contrast between the street and the courtyards of the houses. Reinter-

preting local "traditions," Laprade created "sensible, vibrant walls, charged with poetry." These walls defined cubical masses, but their irregularity gave them a "human" touch. However, the project was more than a stylistic exercise; the architect's ambition was to integrate into his design "values of ambiance" as well as a "whole way of life." The spatial and programmatic qualities adhered to these goals: there were narrow streets and courtyard houses, markets, neighborhood ovens, public baths, mosques, and Quranic schools brought together in a stylistic integrity that had "preserved everything respectable in the tradition." Laprade implied that he had improved local architecture by appropriating what was seen as valuable by modernist architectural discourse and by eliminating what was not considered "respectable."[16]

Similar projects were carried out in other North African colonies. About two decades later, the Cité Musulmane el Omrane in Tunis repeated the whitewashed houses with courtyards, but no openings to the exterior, now utilizing vaults on roofs. The architects (G. Glorieux and L. Glorieux-Monfred) organized the site plan according to a relaxed orthogonal street network that allowed for a certain flexibility in the positioning of individual units and their collective massing. If Cité el Omrane formulized the principles for residential patterns, another Tunisian project dating from the same period, the mosque and market in Bizerte, articulated the essence of community center for the Muslim population. Rows of vaulted small shops fronted with colonnades framed the public space, significantly named Place de la France; a mosque attached to the market structures stood out with its shifted angle oriented toward Mecca, its multiple domes, and its square minaret. The cumulative image from both projects was that of a dense settlement, composed of small and simple repetitive units woven together with some irregularity, vaults and domes further uniting the scheme on the roof level. The persistence of this pattern in the new residential projects for the indigenous people reinforced the sociocultural duality already existing and already nurtured in the colonial cities. A comparison of Cité el Omrane with its contemporary Quartier Gambetta housing project, again in Tunis but intended for Europeans, acknowledges the policy to maintain, enhance, and express cultural differences between colonizer and colonized. Quartier Gambetta was envisioned as a Corbusian grid of longitudinal apartment blocks, separated from each other by spacious gardens.[17]

During the very same years (the mid-1940s), the Egyptian architect Hassan Fathy turned to the vernacular of the Egyptian countryside in

his own search for authenticity and proposed an architectural vocabulary for the "poor" that echoed the prototypes offered by French architects in their North African colonies. Fathy's pioneering drive to return to a past of purity, decontaminated from the ills of rapid change, was in reaction to the unquestioning subscription to modernity that had resulted in "cultural confusion" and loss of tradition in Egyptian cities and villages.[18] As such, it was symptomatic of "the passion with which native intellectuals defend the existence of their national culture," analyzed critically by Frantz Fanon.[19]

Fathy was a cosmopolitan architect, with strong intellectual ties to Europe and in close touch with recent developments in the profession. His designs for the village of New Gourna, then, should be historically contextualized and not read as isolated experiments of a lone visionary and abstracted from French colonial architectural experiments in North Africa. Fathy's courtyards, private streets, and residential clusters, his aesthetics founded on simple forms (the square domed unit, the rectangular vaulted unit, and the alcove covered with a half dome), his public building types (markets, crafts khan, mosque, bath), and even his socially ambitious program had counterparts in the French projects. In New Gourna, Fathy attempted social reform by revitalizing the traditional way of life both in the built environment and in the patterns of production, which were founded on crafts and construction materials, specifically brick making. This approach echoed Laprade's idea of allowing for "a whole way of life" in the new medina of Casablanca. To return to Fanon's analysis of the "native intellectual," in his attempt to express national identity Fathy relied on techniques and language borrowed from European architects. Like Fanon's "native intellectual," Fathy ended up creating a "hallmark which wishes to be national, but which is strangely reminiscent of exoticism."[20]

Considering the profound impact of the colonial heritage, cultural critic Masao Miyoshi argued that "return to 'authenticity' . . . is a closed route" and that there is no such concept as "authenticity."[21] Situating Fathy's architecture and that of the French architects building in the colonies in relation to each other shows how deeply interlaced were colonial productions and those conscientiously created in opposition to them. However, regardless of the contamination in the concepts of purity and authenticity, the meanings behind formal resemblances shift radically. The similar forms and programs of the French architects and Fathy stemmed from different agendas and carried different future implications. For Fathy, a return to vernacular forms meant endowing contemporary Egypt with a cultural image, a mani-

fest identity in the face of the universalizing power of Western technology; it was an act of resistance. For the French colonist, in contrast, the emphasized difference of North African cultures enhanced the power of France, not only because it displayed the diversity of its possessions but also because of its expression of tolerance toward the subjugated culture.

The intricate relationship between colonial definitions and adaptations of North African vernacular and Fathy's vocabulary has been overlooked by architectural historians and critics, who abstracted Fathy as a pioneer in a unique search for authenticity—a position that trivializes the complexity in Fathy's thinking and his worldly status among the leading architects of the twentieth century. Nevertheless, the extraordinary popularity Fathy's architecture enjoyed in a wide range of Third World (and some First World) countries makes a statement about the more discreet meanings behind the familiar forms and the significance of the search for expression of cultural identity, albeit still caught up in the exercise of "exoticism" that Fanon criticized in the late 1950s. It also points to the enduring otherness created by the colonial discourse—appropriated, twisted, and turned by the Third World architect to be endowed with an oppositional symbolism that expresses self-identity.

My last case study is Eugène Delacroix's *Les Femmes d'Alger dans leur appartement* (1834), or rather, the authority this painting carries as a reference point, as a *lieu de mémoire* during the colonial and postcolonial periods (figure 14.3). As a window into the harem of a Muslim house in the casbah of Algiers, Delacroix's painting alluded to penetrating into the most private, the most sacred part of Algerian society. An official commission charged with political meanings, it represented the conquest of Algeria by entering the Algerian home. A masterpiece, it had always been a popular subject of study, but its importance as a political symbol was highlighted in about 1930, the centennial of Algeria's occupation.[22]

In her renowned book, also titled *Les Femmes d'Alger dans leur appartement* and published in 1979, Algerian writer Assia Djebar reads this painting in reference to Pablo Picasso's *Les Femmes d'Alger* (figure 14.4). One marking the beginning of French colonization, the other the end, the paintings evoke divergent interpretations for Djebar, sparked by differences in the visions of the two European artists, but more important, in the sociocultural transformations brought by the French occupation and the Algerian War. It is not Delacroix's "superficial Orient" that Djebar cares to dissect, but the subtler implications of the painting, especially the fact that the scene

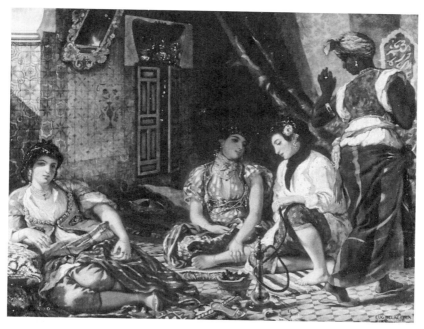

Fig. 14.3. Eugène Delacroix, *Les Femmes d'Alger dans leur appartement* (*Women of Algiers in Their Apartment*) ca. 1834. Musée du Louvre. Photo credit: Art Archive of Art Resource, New York.

makes the observer conscious of his unwarranted presence in the intimacy of this room, which is enclosed on the women frozen in an act of waiting, passive and resigned.[23]

Picasso obsessively reworked Delacroix's theme during the first months of the Algerian War, producing fifteen paintings and two lithographs from December 1954 to February 1955.[24] Djebar argues that in Picasso's work, the universe of the women of Algiers has been completely transformed from Delacroix's "tragedy" into a "new happiness" by means of a "glorious liberation of space, an awakening of body in dance, energy, free movement." Their previous hermetic situation has been preserved, she tells us, but now reversed into a condition of serenity, at peace with the past and the future. Djebar associates the "liberation" at home with the occupation of the city's public spaces by women resistance fighters taking part in the war. She establishes a metaphorical relationship between fragments of women's bodies and the explosives they carried under their clothes. She also provides a critique of women's conditions in Algeria following independence by arguing

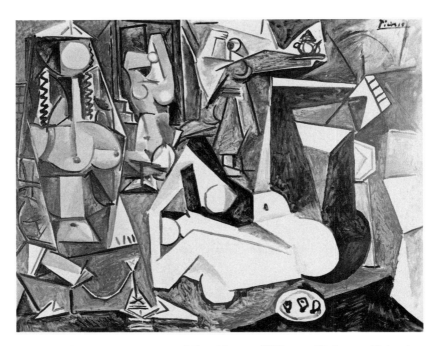

Fig. 14.4. Pablo Picasso, *Les Femmes d'Alger* (Variation "N"), 1955. Washington University Gallery of Art, St. Louis. © Estate of Pablo Picasso/Artists Rights Society (ARS), New York.

that the grenades women hid under their clothes "as if they were their own breasts" exploded against them.[25]

Djebar's reading of Delacroix's and Picasso's works to frame the dramatic change in women's lives during her country's *nuit coloniale* and its aftermath calls for continued debate and possibly disagreement, especially given Picasso's "continual struggle in the *Femmes d'Alger* series to reconcile distance with presence, possession, and watching."[26] What matters, however, is the fact that Djebar reestablishes the connection between domestic spaces and women's lives by relying on the authority of one of the most blatant symbols of French colonialism and the artistic tradition based on the reproductions and reinterpretations of this symbol, thereby accentuating the entanglements of her message. Delacroix's painting becomes a place of memory that can be turned around and recharged with new meanings. Djebar's stand does not imply "giving in" to the colonizer culture, but rather deploying it to broaden her critique.

Djebar is not alone in reloading colonial cultural formations with new meanings and providing complicated linkages between contemporary Algerian questions and the country's recent history. For example, in Kamal Dahane's 1992 documentary film, itself titled once more *Les Femmes d'Alger*, Delacroix's painting reemerges; the famous setting is re-created in the last scene, but now is emptied of women. Following the themes pursued in the film, Dahane suggests that the women have decided to leave Delacroix's symbolic realm in an act of resistance to present-day political and religious movements that attempt to ban them from public life and restrict them to the domestic realm. Novelist Leila Sebbar, whose work has been acknowledged as belonging to the "Maghrebian literature from France," takes another leap and brings Delacroix back to France, to the realities of postcoloniality in the former métropole. When she sees Delacroix's famous painting in the Louvre, the protagonist of Sebbar's *Les Carnets de Shérazade* associates Delacroix's women of Algiers with the Maghrebi women imprisoned in dismal, small apartments on the outskirts of French cities.[27]

Hearing "other" voices complicates the meanings and contextual fabrics of the art objects and disrupts inherited historiographic legacies. This, in turn, helps contest the familiar reductive formulas that explicate sociopolitical relationships and reestablish them in their social density.[28] Furthermore, as Gayatri Chakravorty Spivak observes, when the "hegemonic discourse" repositions itself so that it can "occupy the position of the other," it, too, becomes subject to a major transformation, to its own decolonization.[29]

Notes

Zeynep Çelik, "Speaking Back to Orientalist Discourse," in *Orientalism's Interlocutors: Painting, Architecture, Photography*, ed. J. Beaulieu and M. Roberts, 19–42. Durham: Duke University Press, 2002.

 Since the publication of this essay, the scholarship on the topic, especially on Osman Hamdi, has grown considerably, opening up new perspectives. For two intriguing views, see Edhem Eldem, "Making Sense of Osman Hamdi Bey and his Paintings," *Muqarnas: An Annual on the Visual Culture of the Islamic World* 29 (2012): 339–93; and Wendy M. K. Shaw, *Ottoman Painting: Reflections of Western Art from the Ottoman Empire to the Turkish Republic* (London and New York: I.B. Tauris, 2011), 66–77.

1 Nazim Hikmet, "Pierre Loti," in *Selected Poems of Nazim Hikmet*, ed. and trans. Taner Baybars (London: Jonathan Cape, 1967), 19–20.
2 Halid Ziya Uşakhgil, *Nesl-i Ahîr* (Istanbul: Inkilap Kitapevi, 1990), 21. This is

the first printing of *Nesl-i Ahîr* as a book; it was serialized in 1908 in an Istanbul newspaper, *Sabah*. Unless otherwise noted, all translations are mine.

3 Ahmed Mithad, *Avrupa'da Bit Cevelan* (Istanbul, 1890), 164–65.

4 For further discussion on these issues, see Zeynep Çelik and Leila Kinney, "Ethnography and Exhibitionism at the Expositions Universelles," *Assemblage* 13 (December 1990): 34–59.

5 Among Said's writings dealing with this issue, see, for example, Edward Said, "Intellectuals in the Postcolonial World," *Salmagundi*, nos. 70–71 (spring–summer 1986): 44–64; "Third World Intellectuals and Metropolitan Culture," *Raritan* 9(3) (1990): 27–50; and *Culture and Imperialism* (1993; London: Vintage, 1994). For the first article to explore Said's significance on nineteenth-century art, see Linda Nochlin, "The Imaginary Orient," *Art in America* 71(5) (May 1983): 118–31, 187–91.

6 Janet Abu-Lughod, "On the Remaking of History: How to Reinvent the Past," in *Remaking History*, ed. Barbara Kruger and Phil Mariani (Seattle: Bay Press, 1989), 112.

7 Systematic art education for girls in the Ottoman Empire began with the establishment of *rüştiyes*, secondary girls' schools, in 1858. In these schools, drawing (*resim*) constituted part of the curriculum and, with calligraphy, painting, and dressmaking, complemented the academic core of grammar, arithmetic, and geography. Painting and drawing were also part of the education of upper-class girls, taught by private instructors at home. The School of Fine Arts (Sanayi-i Nefise Mekteb-i Alisi), based on the French model, was established in 1881. It consisted of three departments: architecture, painting, and sculpture. Women's enrollment in the School of Fine Arts would have to wait until the 1910s. On the education of girls in the late nineteenth-century Ottoman Empire, see Serpil Çakir, *Osmanlı Kadın Hareketi* (Istanbul: Metis Kadm Araştirmalan, 1994), 219–25, and Fanny Davis, *The Ottoman Lady* (New York: Greenwood Press, 1986), 45–60. For the School of Fine Arts, see Mustafa Cezar, *Sanatta Batiya Açiliş ve Osman Hamdi* (Istanbul: Iş Bankasi Yayinlari, 1971).

8 Halil Bey's reputation as an art collector and a bon vivant overshadows his career as a statesman, his commitment to progressive politics, and his involvement in the Young Turk movement. See Zeynep Inankur, "Halil Şerif Paşa," *P* 2 (summer 1996): 72–80.

9 Francis Haskell, "A Turk and His Pictures in Nineteenth-Century Paris," *Oxford Art Journal* 5(1) (1982): 45.

10 For an astute analysis of Osman Hamdi's paintings, see Ipek Aksüğür Duben, "Osman Hamdi ve Orientalism," *Tarih ve Toplum*, no. 41 (May 1987): 283–90.

11 For an informative article on the Abdülhamid II albums, see William Allen, "The Abdul Hamid II Collection," *History of Photography* 8(2) (April–June 1984): 119–45.

12 For a concise discussion of the industrialization efforts in the Ottoman Empire in the nineteenth century, as well as the inherent contradictions, see Zeynep

Çelik, *The Remaking of Istanbul* (Berkeley: University of California Press, 1986), 33–37.

13 The most widely disseminated of Le Corbusier's publications is *La Ville radieuse* (Paris: Éditions Vincent, Fréal, 1933). Corbusier's interest in non-Western vernacular architecture goes back to the 1910s, to his *Voyage en Orient*.

14 Valensi's design mimicked an "organic" settlement, down to uses of patched building materials and irregular plastering. In the words of a contemporary critic, the architect had "forced himself to reconstitute something badly built, and he succeeded perfectly." See Anthony Goissaud, "A l'exposition coloniale, le pavilion de la Tunisie," *La Construction moderne* 18 (October 1931). For the presentation of colonial architecture in the expositions, see Zeynep Çelik, *Displaying the Orient: Architecture of Islam at Nineteenth Century World's Fairs* (Berkeley: University of California Press), 1992.

15 Léandre Vaillat, *Le Visage français du Maroc* (Paris: Horizons de France, 1931), 12.

16 Albert Laprade, "Une ville créée spécialement pour les indigènes à Casablanca," in *L'Urbanisme aux colonies et dans les pays tropicaux, La Charité-sur-Loire*, ed. Jean Royer (Paris: Delayance, 1932), 1, 94–99; Vaillat, *Le Visage français du Maroc*, 15–17.

17 For these projects, see the "Tunisie" issue of *L'Architecture d'aujourd'hui*, no. 20 (October 1948). Cité Musulmane el Omrane and Quartier Gambetta are presented next to each other in the pages of *L'Architecture d'aujourd'hui*, emphasizing the spatial and aesthetic differences between the two schemes.

18 Hassan Fathy, *Architecture for the Poor* (Chicago: University of Chicago Press, 1973), 19–20.

19 Frantz Fanon, *The Wretched of the Earth*, trans. Constance Farrington (New York: Grove Press, 1963), 209.

20 Fanon, *Wretched of the Earth*, 223.

21 Masao Miyoshi, "A Borderless World? From Colonialism to Transnationalism and the Decline of the Nation-State," *Critical Inquiry*, no. 19 (summer 1993): 747.

22 Le Corbusier's *Les Femmes de la Casbah*, painted on a wall in Eileen Gray's house in Cap Martin, known as E. 1027 and built between 1926 and 1929, dates from this period. The authority of Delacroix's painting as a cultural paradigm did not remain restricted to "high" art alone; the scene and the setting were enacted in colonial popular culture, most memorably in postcards.

23 Assia Djebar, *Les Femmes d'Alger dans leur appartement* (Paris: Des Femmes, 1979), 170–78.

24 For a comparative discussion of various versions of Picasso's *Femmes d'Alger*, see Leo Steinberg, "The Algerian Women and Picasso at Large," in *Other Criteria: Confrontations with Twentieth-Century Art* (New York: Oxford University Press, 1972), 125–234.

25 Djebar, *Femmes d'Alger*, 186–89.

26 Steinberg, *Other Criteria*, 130. Picasso's sympathy for the Algerian side in the war is expressed most blatantly in his drawing of Djamila Boupacha, whose accounts of torture had made her a cause célèbre in France and throughout the world. The portrait was published in 1962 on the cover of *Djamila Boupasha*, written by Gisèle Halimi, with an introduction by Simone de Beauvoir.

27 Leila Sebbar, *Les Cornets de Shérazade* (Paris: Stock, 1985), 152. For an analysis of this novel, see Françoise Lionnet, "Narrative Strategies and Postcolonial Identity in Contemporary France: Leila Sebbar's *Les Cornets de Shérazade*," in *Writing New Identities*, ed. Gisela Brinker-Gabler and Sidonie Smith (Minneapolis: University of Minnesota Press, 1997), 62–77.

28 Edward Said, *The World, the Text, the Critic* (Cambridge, MA: Harvard University Press, 1983), 23.

29 Gayatri Chakravorty Spivak, *The Post-Colonial Critic: Interviews, Strategies, Dialogues*, ed. Sara Harasym (New York: Routledge, 1990), 121.

Maps, Mother/Goddesses,

and Martyrdom in Modern India

Sumathi Ramaswamy

The geography of a country is not the whole truth. No one can give up his life for a map.
—Rabindranath Tagore, *The Home and the World*

The best of all Good Companions to take with you to a strange place is undoubtedly a MAP.
—W. W. Jervis, *The World in Maps: A Study in Map Evolution*

The strange place to which I take you in this chapter is death, specifically, death for the nation's territory, although whether a map is undoubtedly a good companion for you on this journey I leave for you to decide, for I hope to persuade you to the contrary.

Several years ago, Benedict Anderson suggested that in an age marked by the dissolution of older beliefs regarding fatality and immortality and the paralyzing disenchantment that followed, nationalism emerged to recalibrate the meaning of death. He further insisted that unless we explore the connection between nationalist ideologies and death and immortality, it is impossible to understand why so many millions kill and are willing to die on behalf of what is, after all, an abstraction: "These deaths bring us abruptly face to face with the central problem posed by nationalism: what makes the shrunken imaginings of recent history generate such colossal sacrifices?"[1] More recently, Joan Landes has insisted, "The nation is a greedy institution—economically, physically, and emotionally. It is the object of a *special kind of love*—one whose demands are sometimes known to exceed all others, even to the point of death."[2]

In this chapter, I reflect on these assertions by considering patriotic pictures produced in colonial and postcolonial India in order to understand how these attempt to transform the national territory into a tangible and

enduring object of such a special kind of love that it is deemed deserving of the bodily sacrifice of the citizenry. In doing so, I intend this pictorial essay to advance our understanding of "the *passion* of nationalism, of the heroism, self-sacrifice and sense of righteousness which it can provoke."[3] What place do patriotic pictures occupy in the economy of such passion? This is the question I set out to answer by introducing the three anchor images of this chapter.

The first of these, a print from the late 1940s from Calcutta, shows Mother India, or Bharat Mata, the female personification of the Indian nation and its territory (figure 15.1). Holding the Indian national flag in one hand, she stands on a partially visible terrestrial globe, on which is also perched a figure identifiable to the visually cued Indian viewer as Bhagat Singh, a young man from Punjab who was hanged by the British colonial state on March 23, 1931. He is handing her his bloodied head, presumably severed by the sword that lies next to him, while blood from his decapitated body flows onto the globe, and onto some roughly marked territories that appear to be parts of India and the adjacent country of Burma. In return, Mother India blesses him for his act of corporeal sacrifice.[4]

The second picture from around the same time was printed in Bombay soon after Mohandas Gandhi's assassination in New Delhi on January 30, 1948 (figure 15.2). The Mahatma's life story is arranged in visual vignettes around the central image of his bullet-marked body standing on a terrestrial globe, onto which is painted the rough outline of a place we recognize as the subcontinent. As in figure 15.1, in this picture as well, the blood from his carefully placed wounds drips down to Earth, forming a puddle on the map of India. That the artist did not miss the tragic irony of the apostle of nonviolence being gunned down by an assassin's bullet is clear from the smoking revolver placed on the map of India drawn on the globe.

Fast-forwarding to 1984 and to the assassination of Prime Minister Indira Gandhi on October 31, my third image is an election billboard from December of that year on display in a crowded marketplace in Hyderabad (figure 15.3). Blood from Indira's wounded body, draped in a white checked sari, flows onto a map of India holding her dying body. Inscribed across the billboard in Telugu is the paraphrase of a statement that Indira uttered in Hindi, rather presciently, a day before her death in a campaign speech in Bhubaneshwar: "When my life is gone, every drop of my blood will strengthen the nation."

"What do these pictures want?," I ask, inspired by the argument of W. J. T.

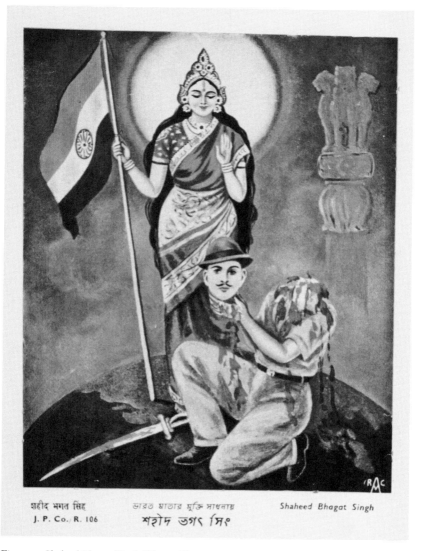

शहीद भगत सिंह
J. P. Co. R. 106

ভারত মাতার মুক্তি সাধনায়
শহীদ ভগৎ সিং

Shaheed Bhagat Singh

Fig. 15.1. *Shaheed Bhagat Singh* (Martyr Bhagat Singh), artist not known, late 1940s. Chromolithograph published by Rising Art College. Calcutta. Courtesy of Christopher Pinney, London.

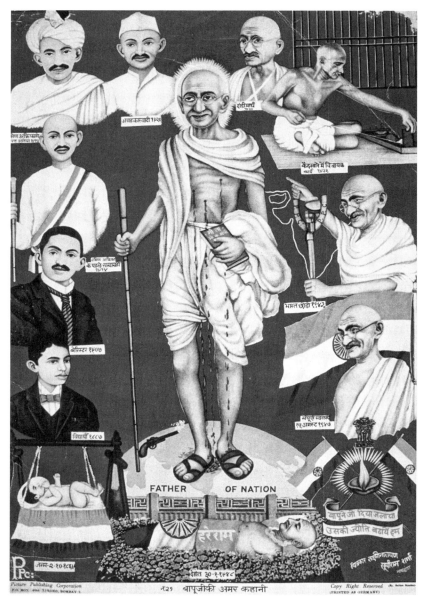

Fig. 15.2. *Bapuji Ki Amar Kahani* (Gandhi's Eternal Story), Lakhshminarayan Khubiram Sharma, ca. 1948. Print published by Picture Publishing Company, Bombay. In collection of the author.

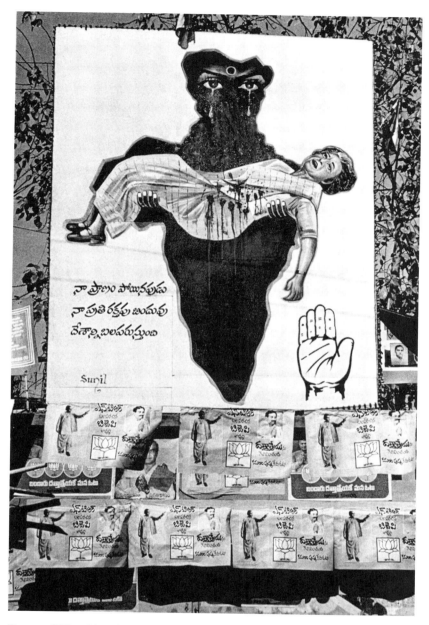

Fig. 15.3. "When My Life Is Gone, Every Drop of My Blood Will Strengthen the Nation,"
Election Hoarding, Hyderabad, 1984. Photography by Raghu Rai. Courtesy of Raghu
Rai, New Delhi.

Mitchell's book by the same title.[5] And correspondingly, what does the map of India—the common protagonist of all three pictures—want of its viewer? To anticipate my response, I suggest that it wants the patriotic Indian to be prepared to surrender life and limb to the Indian national territory, much in the manner of Bhagat, Gandhi, and possibly Indira. It wants martyrs for its cause. But I am getting ahead of myself—I need to begin with the ruses by which a place named India, deemed to occupy a particular part of Earth's surface, came to be visually inscribed on a sheet of paper, and seemingly attained a life of its own from this very act of cartographic emplacement.

Geo-Graphing India

As others have argued, the mapped form of the nation enables the whole country to be seen at one glance and synoptically, allowing the citizenry to take "visual and conceptual possession" of the entirety of the land that they inhabit as an imagined collective.[6] The historian of the European Renaissance J. R. Hale once observed that without a map, "a man could not visualize the country to which he belonged."[7] More recently, Thongchai Winichakul has insisted that "our conception of the nation with its finely demarcated body comes from nowhere else than the political map. . . . A modern nation-state *must* be imaginable in mapped form."[8] If it were not for the map of the nation, in these readings, the geo-body would remain an abstraction, leaving its citizen-subjects without any visual means to *see* the country, especially as an integral whole, to which it is anticipated they are attached. Arguably, without the aid of the map, it would simply not be possible to even conceive of the country as a unified bounded whole, let alone see it. Patriotism in modernity requires peculiarly novel technologies of persuasion. On the face of it, the map of the national territory is among the most intriguing—and compelling—of these technologies.

Yet much work has to be done with and on the modern map of the nation to make it patriotically adequate and efficacious, to compel men (and some women) to die for and on its behalf. For even though the map form might enable the nation-space to be synoptically seen and perceived as a unified whole, and though it might allow the state to make the country visually legible and controllable,[9] it also renders it profoundly unhomely, laid out on an impersonal cartographic grid on the face of Earth, emptied of quotidian meanings and local attachments and, most consequentially, voided of prior sentiments of longing and belonging. As recent scholarship on the

disciplinary histories of geography and cartography demonstrates, the procedures and protocols of these globalizing sciences over the course of the late eighteenth and the long nineteenth century overwhelmingly resulted in their seizing intellectual possession of Earth and asserting mastery over it through empirical observation, systematic classification, and calculating rationalization.[10] The world came to be cognitively tamed as it was measured, mapped, and rendered manageable. These sciences are a telling example of the Cartesian imperative to see the world as a representable object that Martin Heidegger wrote about when he proposed that "the fundamental event of the modern age is the conquest of the world as picture." In the age of the world picture, "the word 'picture' now means the structured image that is the creature of man's producing which represents and sets before. In such producing, man contends for the position in which he be that particular being who gives the measure and draws up the guidelines for everything that is."[11] Consequently, the age of the world picture does not mean a picture of the world in the sense of being its copy, "but the world conceived and grasped as a picture,"[12] so that it appears as an "enframed" image. For Heidegger, such an enframing is revelatory of the emergence of the modern subject, who stands abstracted from a world that he could observe, manipulate, and have at his "disposal." "The fact that the world becomes picture at all is what distinguishes the essence of the modern age. . . . There begins that way of being human that mans the realm of human quality as a domain given over to measuring and executing, for the purpose of gaining mastery over that which is as a whole."[13] Conceived, grasped, and enframed as a disposable object of calculation and mastery, Earth stands disenchanted.

If we follow Max Horkheimer and Theodor Adorno in their assertion that the "program of the Enlightenment was the disenchantment of the world; the dissolution of myths and the substitution of knowledge for fancy,"[14] then the colonial program in India, launched at the height of the European Enlightenment, was the progressive, albeit fitful and incomplete, disenchantment of a place named India. For the colonial state in India, ruling the country was premised on knowing the country, such knowing and subsequent mastery beginning with the topographical, and doggedly dedicated to the "geo-graphing" of the land as it was made visible to the eye, measurable by instruments, and chartable on a map.[15] Convinced that "Hindus as a rule are deficient in observation," and that they lack scientific curiosity, the colonial project claimed to write the true and correct geography of India,

rescuing it empirically from the "fabulous" and "fanciful" spatial conceptions embedded in Hindu texts.[16] Regardless of the prevalence of enchanted or picturesque visions of land and landscape produced within an Orientalizing episteme, the India of *official* colonial geography was an abstract, rational, mathematized place, emptied of fanciful "inspiration" and fabulous imagery.[17] As Christopher Bayly notes, colonial Indian geography schoolbooks, modeled as they were on an eighteenth-century British geographic tradition influenced by John Locke and David Hume, were "relentlessly matter-of-fact and empirical. Geography was a science of measurement and description," interrupted every now and then with "unsystematic racialist assertion."[18] In particular, the method of colonial geography was "deliberately dry and un-theoretical, *an antidote to romance and imagination*."[19] Not surprisingly, it banished native spatial visions that were not compatible with such aspirations to the margins of the normative.

That many Indians in the colonial and postcolonial period succumbed to the lure of the map form, which enabled their country to be normatively presented as whole and complete is quite clear from the hold of the science of cartography on official practice and, in some measure, on the popular imagination well after British rule ended in the subcontinent. Yet to many others, the map of India in and of itself appears not to have been an adequate representative device for picturing their country as *homeland* and *motherland*. It is to some such dissenting voices that I now turn in order to explore their potential to disrupt the disenchanted disciplines of modern geography and cartography, as well as to mark the inherent limitations of such transgressions. For, at the very least, this dissent leads me to ask, can the patriot feel "at home" in a geo-graphed India? Where indeed is the home(land) that the patriot is willing to kill and die for after geography and cartography have done their disciplining work? How is a space of calculation transformed into a field of care in which the devoted citizen might dwell with a sense of longing and belonging?[20]

To respond to such questions, I begin with three voices—all male, all elite and upper caste, all Bengali Hindu, and all products of a modern education—from roughly the same moment in the early years of India's long nationalist century. First, a character named Sandip in the 1916 Bengali novel *Ghare Bhaire* (*The Home and the World*), written by one of the emergent nation's foremost thinkers, Rabindranath Tagore, insists that when he gives up his life fighting for the nation, "it shall not be on the dust of some map-made land," for "the geography of a country is not the whole truth.

No one can give up his life for a map."[21] The sentiment expressed by Rabindranath's fictional protagonist finds a real-life echo in Bipin Chandra Pal, a nationalist who was just as forthright in refusing to entirely cede to colonial science the terrain that was India in a book revealingly titled *The Soul of India*: "The outsider knows her as India. The outsider sees her as *a mere bit of earth*, and looks upon her as *only* a geographical expression and entity. But we, her children, know her even today . . . as our Mother."[22] A few years earlier, across the subcontinent in Baroda, when an interlocutor asked his then-teacher Aurobindo Ghoshe for advice on how to become patriotic, he is believed to have pointed to a wall map of India hanging in his classroom and replied, "Do you see this map? It is not a map, but the portrait of *Bharatmata* [Mother India]: its cities and mountains, rivers and jungles form her physical body. All her children are her nerves, large and small. . . . Concentrate on Bharat [India] as a living mother, worship her with the nine-fold *bhakti* [devotion]."[23]

All three utterances are revealing, for they signify not an outright rejection of the colonial geographic and cartographic project as much as an underscoring of its inadequacy ("not the whole truth," not "a mere bit of earth," "not [just] a map"). The modern map form of the country is indispensable, for, after all, it gives concrete shape to India in its entirety, following the precise protocols of mathematical cartography; it provides the basis for rule and governance, and it demarcates what belongs within its borders and what does not. In other words, it gives tangible form to a nation yearning for form. But nonetheless, as these voices from the start of the new century testify, doubts surfaced about this novel device that magically gave form to the ephemeral abstraction that is the nation: could one (be made to) die for such a map, for the sake of what were, after all, lines drawn on a piece of paper? Indispensable it might be, but in and of itself, it seemed inadequate to compel the patriot to sacrifice life and limb.[24] This inadequacy was to be countered and compensated for by reminding Indians, in case they had forgotten this ancient truth under the hegemony of empire and its schooling and bureaucratic practices, of what "India" really was: not a "mere bit of earth" nor the "dust of some map-made land" of statist geography but a "living mother," Bharat Mata or Mother India. Her body—female, divine, Hindu—comes to be deployed—poetically, prosaically, and pictorially—to anthropomorphically (re)claim an India seized and enframed as map by scientific geography and cartography.

Anthropomorphized Map, Carto-Graphed Mother/Goddess

Much has been written by others on the emergence of the gendered representation of India as "Mother India" in the last quarter of the nineteenth century in Bengal, from where her popularity soon spread over the subcontinent during the course of the next few decades.[25] This exceptional female figure appears as both divine and human; as "Indian" but also reminiscent of female figurations of the nation from other parts of the world, especially the imperial West; as invincible but also vulnerable; as benevolent but also bloodthirsty; as comely maiden but also as ageless matron; and as guardian goddess of the nation but at the same time in need of her sons' care and protection. Here, I build on this scholarship while drawing attention to the specific ways in which the gendered and divine form of Bharat Mata is pictured in a whole host of visual media, including calendar art and wall posters, paintings, textbook illustrations, and jacket covers of nationalist pamphlets and books, newspaper cartoons and mastheads, advertisements, and the occasional commercial film.[26] While the persistence of the figure of Mother India in such pictures may not be surprising given the popularity of female divinities in the region, her association with modern cartographic devices such as maps and terrestrial globes is an innovation indeed. For, as historians of cartography insist, mapped knowledge is "hard won knowledge," a product of sustained cultural, intellectual, and pedagogic work.[27] That even the relatively unlettered and unschooled frequently used the map form of the nation—its geo-body—to picture Mother India at a time when literacy rates in the colony were appallingly low is remarkable testimony to the emergence of a set of practices and techniques that I refer to as "barefoot cartography," whose primary creative influence and aesthetic milieu is the art of the bazaar.

Patricia Uberoi has defined bazaar or calendar art as "a particular style of popular color reproduction, with sacred or merely decorative motifs . . . The art style extends beyond calendars and posters. In fact, it is a general 'kitsch' style which can be found on street hoardings, film posters, sweet boxes, fireworks, wall-paintings, and advertising, and in the knick-knacks sold in fairs."[28] In this wider sense, bazaar art is ubiquitous across the nation, providing it with a shared visual vocabulary across regions and communities otherwise divided from each other.[29] Historian of art Kajri Jain has brilliantly analyzed the social, moral-ethical, and commercial networks within which bazaar images have been produced, evaluated, disseminated, and con-

sumed from the late nineteenth century into the present.[30] And Jyotindra Jain has usefully shown how this art form uses "a visual language of collage and citation which, in turn, act[s] as a vehicle of cultural force, creating and negotiating interstices between the sacred, the erotic, the political, and the colonial modern."[31] Most influentially, Christopher Pinney has insightfully explored the visual politics of the deployment of bazaar imagery, which is enormously revealing of the "corpothetic" sensibility that undergirds its anticolonial impulses.[32]

My own work builds on this scholarship while focusing on the deployment of the modern map form of the nation in and by that sector of bazaar art that I identify as patriotic because of its investment in and devotion to the territorial idea of India (albeit variously configured over time and across different interests). My conceptual analytic of barefoot cartography is meant to distinguish patriotic art's investment in the map form from the state's command mapmaking ventures, which are conducted with modern instruments of surveillance, measurement, and inscription by trousered and booted men of secular science.[33] As I have already emphasized, the modern state's normative involvement in mapping is instrumental and regulative: to make land visually legible for rule and resource management and to determine sovereignty and police borders. From this perspective, the modern map is a classic example of a "state simplification," and as such, it attempts to systematize and demystify the state's terrain in the dispassionate interest of command and rule.[34] In contrast, barefoot cartography in India, even while cheekily reliant on the state's cartographic productions, routinely disrupts it with the anthropomorphic, the devotional, and the maternal. Undoubtedly, the barefoot is in contested intimacy with command cartography, as it dislodges the state's highly invested map form from official contexts of production and use and re-embeds it—sometimes to the point of only faint resemblance—in its own pictorial productions; in doing this, barefoot mapmaking reveals its own corpothetic and idolatrous investment in national territory, in contrast to command cartography's mathematized grids and lines of power. In particular, barefoot cartographic work suggests that, at least for some Indians, the map of India—that symptomatic scientific artifact used to delimit a measured territory called India—is not an adequate representation in and of itself for mobilizing patriots to the point of bodily sacrifice, indispensable though it might be for bestowing a credible form upon the emergent nation. It has to be supplemented by something else, and that something else is more often than not the gendered divinized body

of Mother India. Thus, barefoot mapmaking is not antagonistic or antitheti-
cal to state and scientific cartography in a simplistic manner. Rather, after
the fashion of so much else in colonial India, where the gifts of empire and
science were simultaneously disavowed and desired, patriotic popular map-
making takes on the map form but pushes it in directions not necessarily
intended for it by either science or state.

India's barefoot mapmakers are almost always male, generally Hindu,
and not always products of formal schools or art training. Even with no
obvious education in maps or training in their use, in the science of their
production, or the aesthetics of their creation, these men play no small role
in popularizing what Benedict Anderson refers to as the "logo" outline form
of the national geo-body so that it becomes recognizable and familiar, not
needing the crutch of naming or identification, "pure sign, no longer com-
pass to the world."[35] Regardless of the various social, economic, regional,
and ideological differences that might prevail among them or the changes
they might undergo over time, these men warrant being treated as a uni-
fied field in terms of their inexpert, undisciplined, and informal relation-
ship to the science of cartography and its mathematized products, to which
they turn for various purposes. Their lack of specialist cartographic exper-
tise should not, however, be read to mean that they are naive or apolitical.
On the contrary, there are highly complex and competent ways in which a
specialized product—one of the most prized inventions of Europe, and con-
solidated by colonial surveyors and their Indian assistants through many de-
cades of triangulation, measurement, and inscription—is dislodged from its
official circles of circulation and use and put to purposes that exceed those of
science or state. In fact, I would even venture that in the late colonial period,
when few Indians went to school and studied geography books or encoun-
tered maps and globes in their classrooms, it was through the mass media
that the map form of the nation was rendered familiar to the average citizen,
as it traveled—albeit in a highly condensed, even caricatured, form—across
the subcontinent, incorporated into newspaper mastheads and cartoons,
merchandise labels and advertisements, god posters and calendars, and such.
As it has circulated in this manner, the fidelity and integrity of the mapped
form of the nation has varied, ranging from rough-and-ready sketches of the
Indian geo-body to highly specific renderings with an astonishing attention
to physiographic detail. From such a motley range of barefoot cartographic
creations spanning the twentieth century, I have identified five different
ways in which the anthropomorphic form of the mother/goddess is thrown

into the company of the nation's geo-body represented by the map of India and vice versa. The result of this convergence is that the mathematized map of India is "anthropomorphized," while the gendered body of Mother India comes to be "carto-graphed."

First and most commonly, Bharat Mata literally occupies the map of India, partly or substantially filling up cartographic space with her anthropomorphic form. There are many ingenious ways in which her body blurs or undoes the carefully configured boundaries and borders of command cartography. This is particularly true of contested national spaces such as Kashmir or Pakistan, even parts of Sri Lanka, which are frequently claimed by ingenious arrangements across the map of Mother India's limbs, hair, or clothing. If in such pictures the body of the mother/goddess, distinct from the outline map of the nation, anthropomorphizes the map by moving in to occupy it, there are others in which parts of Bharat Mata merge with the Indian geo-body so that the two are, in parts, undistinguishable. Thus, in a circa 1931 lithograph that was proscribed by the colonial state, the lower half of Mother India's body disappears into the map of India (extending toward and including Burma), on which are delineated the country's rivers, mountain ranges, and other physical features. The dependence of barefoot cartography on statist mapped knowledge is clearly on display here, as is the fact that the latter is not simply taken on board without adjoining it with the anthropomorphic form of Mother India. Thus, an image such as this connects with an important suggestion made by some key intellectuals early in the twentieth century that there is no distinction between the country named India by colonial geography and Bharat Mata, who resides in all its constituent parts. As Aurobindo Ghose insisted rhetorically in 1905, "What is a nation? What is our mother country? It is not a piece of earth, nor a figure of speech, nor a fiction of the mind. It is a mighty female power (*shakti*), composed of all the powers of all the millions of units that make up the nation."[36]

In a third configuration, rather than occupying the cartographic space of India or merging with it, Bharat Mata stands (or sits) on a map of the nation whose outline is sometimes sketched on a terrestrial globe that is sometimes shown partially and, at other times, as a whole sphere gridded by latitudes and longitudes (e.g., figure 15.1). In such pictures, Mother India appears as the mistress of a carto-graphed world, her crowned head reaching into the firmament as the national territory that she embodies on the globe on which she rests is visually inscribed, frequently, as the only one that matters on the

face of this Earth. The conceit of the modern terrestrial globe, Denis Cosgrove's recent study shows, is that it seemingly privileges no specific point on Earth's surface, "spreading a non-hierarchic net across the sphere." The dispassionate and disenchanted goal of the science of cartography in this regard is to generate "uniform global space."[37] Yet India's barefoot mapmakers betray their patriotic predilections by appropriating the normative terrestrial globe and putting it to a very different purpose by virtually erasing the presence of other lands and other nations from the surface of Earth, so that frequently only "India" looms large and visible, anthropomorphized and sacralized by the body of Bharat Mata perched perkily on it.

In terms of a growing intimacy between the mother/goddess and the mapped form of the nation, the most consequential development occurs when the map of India as ground and as prop is dispensed with. In its place, Mother India's anthropomorphic form literally comes to stand in for the map of India, outlining in this process the cartographic shape of the country. In such pictures, even without a map form, the mapped image of the country is presumed. For example, a 1937 chromolithograph titled *Vande Mataram* (I Revere the Mother), printed in the South Indian city of Coimbatore (possibly to celebrate the recent victories of the Congress Party in the country-wide elections), shows Bharat Mata clad in the flag of the nation. The contours of her body sketch out the mapped outline of India, as her tricolor sari (with the Gandhian spinning wheel drawn along its border) billows out to claim the territorial spaces of the emergent nation.

Finally, especially in the years after Independence, Mother India moves out of the cartographic space of the nation to either sit or stand in front of the map of India, which appears as a shadowy silhouette in the background. Such pictures offer an important contrast to the dominant representation in the earlier decades of the century of the carto-graphed Bharat Mata. As if with freedom from colonial rule, Mother India's claim on India's geo-body is secure enough to not have her occupy it or merge into it, as her visual votaries obviously felt compelled to do during the colonial period. The map of India continues to be necessary to her visual persona because it establishes, along with the flag of the nation, the distinctiveness of Bharat Mata as a territorial deity of the country. All the same, as the freedom movement draws to a close and India's independence from colonial rule is secured, the map of India can be relegated to the background, a shadowy prop into which she can move in times of national crisis or threat.

In his memoirs, published in 1936 at the height of the anticolonial

struggle against British rule, Jawaharlal Nehru, destined to become the new nation's first prime minister, worried over the mystifying corporeality that seemingly animated the patriotic common sense of his fellow citizens: "It is curious how one cannot resist the tendency to give an anthropomorphic form to a country. Such is the force of habit and early associations. India becomes *Bharat Mata*, Mother India, a beautiful lady, very old but ever youthful in appearance, sad-eyed and forlorn, cruelly treated by aliens and outsiders, and calling upon her children to protect her. *Some such picture rouses the emotions of hundreds of thousands and drives them to action and sacrifice.*"[38] The nation, we have been told, yearns for form. What these pictures reveal to us, what even Nehru's rationalism concedes, is that in colonial and postcolonial India, that yearning is never just content with the form bestowed on the country by the scientific map, indispensable though it may be in delineating borders and boundaries, measuring distances between places, and drawing out the contours of mountains and rivers and forests and fields. For "action and sacrifice," patriotic pictorial practice routinely turns to the figure of Mother India to supplement the mapped form in the many ways that I have identified—occupying it and filling up cartographic space; merging partly with it; seated or standing on it; vacating it in order to relegate it to a shadowy silhouette; and most destabilizing of all, dispensing with it entirely. Once brought into proximity with the country's map form, the plenteous divine female body shows up the insufficiency of one of the Enlightenment's and colonial science's most consequential inventions. In the process, the map stands anthropomorphized, divinized, and feminized. The ground is pictorially prepared, in a manner of speaking, for the map to receive the sacrifice of men.

Between Men, Map, and Mother

In resorting to the figure of Mother India to supplement the mapped form of the nation, barefoot cartography reveals as well its preoccupation with male bodies, especially the "big men" of official Indian nationalism.[39] Such men are, as is apparent from the titles of patriotic prints, the "Jewels of India," the "Architects of Indian Resurrection," the "Gems of the Nation." When women appear at all in the company of the map of India, which is not all that frequently, they are invariably shadowy presences or pictured as honorary men; they are generally not the principal object of the barefoot mapmaker's adulation. In striking contrast to much popular art in India,

where women are hypervisible in incarnations ranging from the goddess to the vamp, it is men who are accorded prominence in patriotic pictures, thus reiterating the dominant truth about nationalism as a masculinist project, fantasy, and hope. In such pictures, Bharat Mata appears as "the conduit through which collusions and collisions" between patriotic men are worked out, allowing in this process bonds of male homosociality to evolve between them.[40] Drawing on Eve Sedgwick's work,[41] I suggest that the nation is preeminently pictured as a male homosocial arena in which men jostle for power and privilege but also work out their mutual fascinations, anxieties, and hostilities through and around the exceptional figure of Bharat Mata.

Thus, in many productions of barefoot mapmakers, Mother India shares the cartographic space of India that she occupies with male patriots, many of them identifiable figures from the dominant official nationalist pantheon, most especially Mahatma Gandhi or "Bapu," "Pandit" Nehru, and "Netaji" Bose (but never, of course, Muhammad Ali Jinnah).[42] Together, the extraordinary mother and her devoted, mostly Hindu sons pictorially repossess what had hitherto appeared to be the domain of the British Empire—colored pink or red—in numerous colonial maps, atlases, and globes. Indian territory now passes under their joint custodianship, a custodianship in which the new (big) men of India own and rule the territory in the name of the mother. As Manu Goswami has noted in her study of the new discourses on territory that emerged in late colonial north India, "The resolutely 'subject-centered' language of possession was transposed from individuals (upper-caste, Hindu, male) in relation to land to Bharat [India] as a national territorial possession. Bharat Mata marks the historically significant reconstitution of colonial spatiality into national property."[43] These patriotic pictures are exemplary of this significant reconstitution in that they draw on the artifact of the map, through which all manner of claims to territorial possession have been imagined, anticipated, and made in modernity, and in that they deploy the figure of the mother—convenient for the transformation of the mathematized colonial territory of India from a terrain of statist calculation into a nationalist homeland—to seal the deal in favor of the male citizenry.

Not surprisingly, when she appears in the company of her men, Bharat Mata is generally shown as a stilled figure whose primary visual function is to draw attention to the activity going on around her, namely, the labor performed on behalf of the map of the nation and its territory by prominent male citizens. In return for their patriotic and filial service, her hand reaches

out to bless the men occupying the map of India, almost as if signaling her approval of *their* proprietary relationship to *her* territory. So much so that, especially around the time of Indian Independence and after, Mother India's body is dispensed with completely, and only the heads or busts of her sons occupy the map of India in a gesture that Pinney has aptly characterized as the mapping of "physiognomy onto cartography."[44] It is as if with freedom from colonial rule, the male citizenry's proprietary claim over Indian national territory is also secure, and map and man can relate directly to each other without the mediating figure of the mother.

In barefoot cartography and the patriotic imagination that animates it, the ideal of masculinity is pictured as placing one's life and limb at the service of map and mother. Rejecting worldly pleasures and privileges, the ideal Indian man casts himself in this role, and he is pictured as selflessly dedicated to Mother India and the territory she embodies, although there are diverse models of filial service on display. Self-effacing service to the nation and its territory might be the road to visibility in the world of patriotic pictures, yet barefoot cartographic practice also reveals its ambivalences and anxieties—as well as pride—about the ultimate patriotic endgame for men, the crowning glory of martyrdom. The martyred male body—"the body in bits and pieces,"[45] bloodied, decapitated, or hanged—is the honorable prize of the pictorial transaction between men and maps in the name of the mother. Thus, nationalist ideology—masculinist though it might be in conception and practice—brought with it its share of burdens and tragedies for men along with privilege, power, and visibility. Male martyrdom to map and mother in the name of India, subsequently offered to other male citizens as worthy of emulation, is exemplary of this net of risk and death in which some men found themselves entangled.[46]

We get a glimpse of the barefoot mapmaker's ambivalence about these larger-than-life men and their apparent mastery in prints that depict the life story of the leader as a pictorial biography. In contrast to Mother India, who rarely appears aged, decrepit, or dead in any patriotic production, being as she is both the immortal goddess and the very embodiment of an ever-youthful nation, however ancient its origins, her sons are very mortal indeed: they are born, grow into young men, age into adults, and even die, their very mortality ultimately marking the limit of their mastery. An example of this is a print from the 1950s, *Jawahar Jiwani* (Life of Jawahar), by the same artist who produced one of the anchor images discussed earlier (figure 15.2). The focus of this print is Prime Minister Nehru, who stands

on a globe centered on a partially outlined map of India (left unnamed). His feet are firmly planted on Indian territorial space, making it his own even as his body and head reach into the firmament, suggesting that here is a man who has the world and India at his feet. Any sign of enduring mastery, however, is undone by the fact that he looks quite old, his customary pensive look supplemented by unmistakable signs of aging. He may be a master of the globe and of India, but that he is still a mere mortal is clearly underscored by the artist in the representation of various episodes from his life ranging from his birth to his development into youth and his maturation into adulthood and old age, arranged as visual vignettes around the central figure of the frail, aging prime minister. A lifetime achieving mastery, the print appears to suggest, leads not to perennial immortality but to old age and eventually death.

This is even more striking in the print by the same artist that I introduced earlier titled *Bapuji ki Amar Kahani* (Gandhi's Eternal Story, figure 15.2). Painted by the Nathadwara artist Lakshminarayan Khubhiram Sharma, the poster presents a series of visual vignettes of Gandhi from his birth in a cradle swathed in the (recently created) Indian national flag to his death, his body ready for cremation and draped in the tricolor, his last words *Hare Ram*, "O God," inscribed in Hindi across it. Sharma appears to have modeled these vignettes on readily available photographs of Gandhi at key moments in his eventful life: as a young London-bound student, as a stylish barrister in South Africa, as a *satyagrahi* who had cast off his Western ways, and then, from his later career as a nationalist leader back in India, launching and leading the historic Dandi march, behind bars at his spinning wheel, launching the Quit India movement, and so on. These vignettes are, in turn, arranged clockwise around what Sharma obviously saw as the central feature of Gandhi's "eternal" life—his martyrdom for the nation and its map, an image that does *not* exist in the photographic record. Occupying the center of the poster is the smiling, *dhoti*-clad image of Gandhi, holding a staff in one hand and carrying a red book (possibly the Bhagavad Gita, his favorite scripture) in the other. Bright red blood from three carefully placed bullet wounds in his chest drips down to form a puddle on the outline map of the Indian nation etched on the face of a terrestrial globe. Photographic realism gives way to patriotic mythography.

The patriotic artist's visualization of the Mahatma's bloodied cartographed body is taken to its logical extreme in a recent painting by one Dr. Vijay Goyal on exhibit in the National Gandhi Museum in New Delhi

in which the artist has painted in oil and blood Gandhi standing on a globe with the outline map of India (and some adjoining territories). That the doctor-turned-artist was willing to use blood—perhaps his own—to pictorially reenact and perform on canvas the primal act of the Mahatma's bleeding to death for the nation and map is a telling, if macabre, indication of the corporeal penchants of patriotic art. Goyal's literally bloody painting shows Gandhi with not one but three heads (two of them painted in the colors of the national flag), signifying his apotheosis and his assimilation into the Hindu pantheon with its many multiheaded and multilimbed gods. Indeed, in the pictorial transaction between (big) men and the map in the name of the mother, Gandhi's special task is to secure the blessings of the (Hindu) gods for the project of Indian nationalism. His body serves as the conduit between the earthly India, which is metonymically represented by the map form, and the celestial realm, which is inhabited not just by the deities of the Hindu pantheon such as Krishna or Shiva but also, in the eclectic spirit of Gandhian nationalism, by the Buddha and Jesus. With his progressive canonization and apotheosis, especially after 1948, Gandhi, too, leaves the earthly realm and joins this divine sphere, from which he showers his blessings on "India" and the men (and the occasional women) who occupy it, pictorially transforming in the process the disenchanted terrain of colonial calculation into the hallowed *punyabhumi* (blessed land) of the (Hindu Indian) nationalist imagination. A revealing example of this is an anonymous print possibly from 1948 and published by the Bombay-based Shree Vasudeo Picture Co. titled *Swargarohan* (Ascent to Heaven), in which Gandhi rises to heaven in a pavilion. The Hindu trinity—Shiva, Vishnu, and Brahma—along with their wives, waits to welcome him. Instead of eagerly looking toward this heavenly welcome, he gazes down on the world below that he has departed from, signified in the print by a globe on which is drawn a physiographic map of India, clearly appropriated from command cartography. Gandhi's apotheosized gaze, however, transforms India from a mere geo-graphed land on the face of Earth into a special territory worth dying for, as he demonstrated in and by deed.[47]

His sacrifice for map and mother is all the more endearing to the patriotic artist, for if there is one man who is shown most masterfully in command of the Indian map in these pictures, it is certainly Gandhi, who is undoubtedly the most ubiquitous hero of this genre of political art. Although in his prolific verbal discourse, Gandhi did not invoke Mother India as often as some of his contemporaries, especially those who were overtly Hindu nationalist,

he is clearly her favorite son in popular Indian visual productions. In posters and prints from the 1920s on, she looks to him to save her, smiles upon him as he breaks the chains that bind her, sheds tears over his passing, gathers up his bullet-punctured bloodied body into her arms, and heralds his entry into heaven. His inexhaustible command of nation and territory is striking in a circa 1948 picture by K. R. Ketkar, *Amar Bharat Atma* (Immortal Soul of India), which visualizes Gandhi's cremation at Rajghat in New Delhi. As the fumes from his funeral pyre vaporize into the skies above, they are transformed into the shadowy contours of a cruciform map of India, out of which Gandhi's head emerges, smiling cheerfully over his own cremation. The print seems to suggest that even in death, Gandhi's body and the geo-body of the nation are inseparable: such is the strength of the bond between the map and this particular man, who is the "immortal soul of India."

Gandhi's apotheosis also provides the occasion for the patriotic artist to imagine what life after death might be like for the nation's martyrs. In prints published around 1948, such as *Gandhiji ki swargyatra* (Gandhi's Pilgrimage to Heaven), by the Bombay-based poster artist Narottam Narayan Sharma,[48] and in the Calcutta artist Sudhir Chowdhury's *The Last Journey of Bapuji*,[49] the Mahatma is shown being carried to paradise in a celestial chariot pulled by either angels or swans; waiting to greet him in the heavens above are the Hindu gods, as well as the Buddha, Jesus, and Nanak. In another anonymous circa 1948 print called *Svarg mein Bapu* (Gandhi in Heaven), while Gandhi ascends to heaven on a winged bird, Mother India (her sari and flowing tresses carefully arranged to produce a rough mapped shape of India) stands below with tears flowing down her face, recalling another dramatic print from Calcutta called *Bapuji on Eternal Sleep* (ca. 1948) in which she, in a manner that powerfully echoes the Pietà, holds Gandhi's bullet-scarred body in her arms, blood from his wounds dripping down to Indian territory lush and luxuriant.[50] Such prints appear to suggest that although Gandhi might have died a mortal, he lives on eternally, as befits a true martyr. Not surprisingly, in Sharma's *Bapuji Ki Amar Kahani*, the Mahatma's dead body is visually subordinated to the martyr's living body, which wears a beatific smile notwithstanding the multiple wounds that puncture the chest (figure 15.2).

The patriotic artist's adulation of Gandhi and his pictorial honoring of his martyrdom are perhaps not surprising in that he visually reiterates official as well as popular nationalism's reverence for the Mahatma, although his recasting as a carto-graphed body is a singular contribution of bare-

foot mapmaking, as I will explain a little later. The most dramatic images of martyrdom for map and mother in patriotic visual practice are perhaps not so much of Gandhi, however, but of a relatively unknown young man who came to be immortalized through popular pictures. On March 23, 1931, Bhagat Singh (b. 1907), a young Punjabi with avowedly socialist and atheist views on the nation and the world, was hanged by the colonial state (along with his "co-conspirators," Rajguru and Sukhdev) for assassinating a British police officer in Lahore in 1928. Almost immediately, Bhagat Singh's execution became the subject of the patriotic artist's visual imagination and has remained popular until today, much of this art converting his death through hanging into martyrdom by the sword for mother and map. A new category of male patriot thus became popular in patriotic visual imagination, frequently designated by a complex and charged category, *shaheed* or "martyr." The Arabic word *shaheed*, used in a Qur'anic context and in an Islamic universe for pious Muslims who died heroically bearing witness to God's truth, is resignified to refer to patriots who willingly—even eagerly—shed their blood for the ostensibly secular truth of the nation and its map.

In his exploration of Indian chromolithographs, Pinney rightly notes the compelling prominence of this hitherto unknown young man in popular visual practice of the last century, so that in an official colonial inscription, "for a time, he bade fair to oust Mr. Gandhi as the foremost political figure of the day."[51] Offering a skillful analysis of Bhagat Singh's visual persona in popular prints (in which he always appears as a young man with a striking moustache, wearing Western clothes, his head adorned by the ubiquitous trilby), which are interpreted as the artist's admiration for his "audacious mimicry" and ability "to pass" as the white man, Pinney also insists that "official nationalism may have decried the activities of revolutionary terrorists, but popular visual culture asserted the nation's debt to those prepared to kill and be killed in the cause of freedom."[52] Indeed, it is with Bhagat's death that martyrdom for the nation becomes a sustained visual subject that captures the imagination of India's barefoot mapmakers, as well as the attention of the colonial state's censorship apparatus.

Some time after Bhagat's death by hanging appeared a print titled *Bandhan Mein Bharata Mata Ka Bhent: Lahore Conspiracy Case Decision—Sentenced to Death, No. 1403*. Proscribed by the colonial authorities, the print features Bharat Mata as a two-armed goddess, her hands bound in chains; only the upper part of her body is visible, the lower half merging into a topographic outline map of India, on which the principal rivers and some

mountain ranges are faintly visible. Facing her are the decapitated bodies of several young men whom the print identifies as J. N. Dass, S. Bhagat Singh, Rajguru, and Sukhdev. Strikingly, each decapitated male body is shown dispassionately offering his head to Mother India, Bhagat Singh's standing out prominently with trilby still proudly on, eyes staring defiantly ahead. In this print, and in others published around the same time and subsequently, the severed heads of these youthful martyrs, especially Bhagat's, are described in Hindi as *bhent* (gift) or as *bali* (sacrificial offering), and additionally qualified in English or Hindi as "first," "curious," and even "wonderful." The recipient of this "wonderful" or "curious" bhent or bali is invariably Mother India, who sometimes receives the head(s) impassively, at other times with tears flowing down her face, her arms and legs bound in chains, but also sometimes, reaching out to receive the macabre offering all too eagerly. Frequently she is in the company of the map of India: occupying it, merging with it, or sitting on a globe with the outline of India drawn on it. Even when the map of India is not present, Indian national territory is almost always suggested in the background by snow-capped mountains, luxuriant green fields, gushing streams, and silhouettes of temples, pictured through an aesthetic that I characterize as "patriotic pastoral."[53] In many such pictures, the lush, life-affirming plenitude of the background only shows up more dramatically the act of life-effacing martyrdom to map and mother being performed in the foreground.

Most strikingly, in many a print, blood from Bhagat's severed head (and, sometimes, his decapitated torso) gushes out to form a puddle on the map of India (see, e.g., figure 15.1). When Richard Lannoy traveled in India in 1958, he photographed a patriotic print of Bhagat Singh posted in a goldsmith's stall alongside some "god posters" in a Banaras bazaar. The print shows Bhagat kneeling on a globe with the partial outline of the map of India drawn on it and colored yellow. Blood from his decapitated body flows down as red rivulets onto the map below him, while blood from his severed head, which he offers to Mother India, gathers in a puddle at her feet.[54] Years later, in a recruitment poster from the mid-1960s called *Ma ki pukar* (Mother's Call), Bharat Mata occupies a map of India, the halo around her head characteristically occluding the contested territory of Kashmir. Bhagat Singh, dressed in white shorts and shirt, kneels in front of her and dispassionately hands over his severed head (with eyes closed, but still wearing the trilby). Blood from the severed head gushes onto Bharat Mata's feet and onto the map of India; bright red blood also spurts out of the decapitated torso. Although

it is important to reiterate that Bhagat was executed by hanging and not by decapitation, his martyrdom for mother and map is generally shown as such, for it allows the barefoot mapmaker to connect his death at the hands of a cold, calculating colonial state apparatus to the desired and desirable death of other exemplars of selfless devotion—such as the eighteenth-century Sikh martyr Baba Dip Singh, but others as well across India's many religions, including Islam—whose passing is depicted in a similar manner as bloody bodily mutilations in popular devotional art.[55]

What of Bharat Mata's role in this visual pedagogy constituted around the wounded or decapitated body of the martyr?[56] Another picture from the early 1930s by Prabhu Dayal might be helpful here. Titled *Svatantrata Ki Vedi par Biron Ka Balidan: Bharat Ke Amar Shaheed* (Sacrificial Offerings on the Altar of Freedom by [Our] Heroes: India's Immortal Martyrs), it shows a female figure with a crown on her head standing in the foreground with a bloodied axe in one hand and a severed head in another, while other heads and decapitated bodies lie strewn around. Two young men—one of them clearly Bhagat Singh in his trademark trilby—wait before "the altar of freedom," their heads ready to be axed by the goddess. In this print, Prabhu Dayal pictures the unnamed goddess (possibly Mother India) as directly responsible for the death of her devoted sons in a manner comparable to several bloodthirsty goddesses of the Hindu pantheon. This is a rare picturization, for in a majority of other cases, the most Bharat Mata does is arm her warriors with the sword of battle—the sword with which they presumably kill others, and possibly behead themselves as well. As the national movement picks up in fervor and as Gandhian nonviolence appears to yield few concrete results, the print suggests that the mother might not be satisfied with anything less than the bloody offering of the heads (*balidan*) of her most devoted sons.

Indeed, the corporeal fragment of the severed bloodied head as the gift (bhent) or sacrificial offering (bali) to map and/or mother becomes such an overdetermined signifier of (youthful) male martyrdom in the patriotic visual economy that even the premature and accidental death of Subhash Chandra Bose—who was not executed by the colonial state—is pictured in a similar manner in prints such as *Subhashchandra Bose Ki Apoorva Bhent* (Subhash Chandra Bose's Extraordinary Gift) by an unknown artist, possibly from around 1945. Here, a headless Subhash—a favorite of the patriotic artist—stands upright, holding his own severed (and smiling) head, from which blood gushes onto a framed outline map of India inscribed with

his trademark slogan *Jai Hind*, "Victory to India." Here, the martyr's blood appears to pictorially nourish and rejuvenate the nation's geo-body, presumably also fed by the bloodied bodies attached to the other severed heads shown in the picture. Similarly, in a striking circa 1947 print called *Shaheed Smrity* (Memory of Martyrs), the Bengali artist Sudhir Chowdhury places Bharat Mata in a patriotic pastoral landscape with the sun rising on the horizon.[57] Nehru (no great patron of this brand of violent nationalism) stands in front of her, gesturing to a number of plates that have been placed before her, clearly as a ritual offering on the occasion of the Independence of India. On each plate is the head of a young man, each one identified by name: Bhagat Singh, Khudiram Bose, Surya Sen, Debvrata, Rameshwar, and Kanailal Dutt. These men were either hanged or shot to death for various anticolonial intransigencies and assassinations, but here their deaths are pictorially translated as decapitation, and their heads are visualized as ritual offerings to Bharat Mata in a manner that echoes Nanak's injunction to his Sikh followers, "If you want to play the game of love, approach me with your head on the palm of your hand. Place your feet on this path and give your head without regard to the opinion of others."[58]

Indeed, there is a new "game of love" at play in twentieth-century India, and its object is the nation—and the mother and the map. This love finds expression in barefoot cartographic practice in an emergent aesthetic of the wounded and dismembered male body centered on the severed head, decapitated torso, bullet-scarred chest, and gushing life-blood locked to the nation's anthropomorphized geo-body. The martyred male is a dispassionate carto-graphed body sacrificed to the untarnished whole that is the national territory. This, barefoot cartographic work seems to suggest, is the ultimate fate of masculine patriotism in modern India—and one that has the blessings even of the apostle of nonviolence, Gandhi, who in several prints even showers his blessings on such violent expressions of devotion to Bharat Mata. The martyred male body, even when in bits and pieces, invariably appears in a state of perfect composure, devoid of pain or suffering, even taking pleasure in sacrificing itself to the whole that is the nation. It is indeed an exceptional body, prepared to go to bits and pieces so that the body politic does not. At the same time, these pictures disavow the empirical fact of death, as the selfless patriot is shown transcending death by identifying with the greater life of the nation that lives on and, indeed, is renewed by the shedding of his blood.

What of women martyrs in this macabre visual pedagogy constituted

around the wounded or decapitated male body in the service of map and mother? Although feminist scholarship has recovered the stories of several women from the 1930s who were involved in anticolonial acts of insurgency to the point of death,[59] their passing is not visually celebrated by the barefoot mapmaker in the manner reserved for male martyrs as sacrifice to map and mother. Indeed, in this regard, contrary to Pinney's provocative argument about popular visual culture in India offering an alternative take on the official narrative sketched out by a dominant nationalism,[60] patriotic artists are rather evasive in visualizing the death of the female patriot. To do this would possibly expose Mother India herself to pictorial death and herald the end of the patriotic project.

This is why I think that the violent death of Prime Minister Indira Gandhi in October 1984 offers a visual dilemma for barefoot cartography. In comparison with the men I have discussed here, and especially unlike the man with whom she shared her famous surname and unlike her equally famous father Jawaharlal, Indira is not a particular favorite of India's patriotic artists, who generally picture her in rather unimaginative and uninteresting ways.[61] This was to change after the 1971 Bangladesh liberation war, when she came to be likened to the goddess Durga in popular and visual discourses, her own secular and socialist political inclinations notwithstanding. Popular pictures, political iconography, and the modernist imagination of artists such as Maqbool Fida Husain also consolidated the image of Indira as India, and India as Indira, so that Mother India seamlessly became Mother Indira and vice versa. Indira comes to occupy the map of India in a manner that echoes images of Bharat Mata from earlier in the century. It is such a woman and icon whose violent assassination confronted artists of modern India, and they responded in various ways. On the one hand, Husain painted a series of fascinating abstract images of the event showing Indira's faceless body falling horizontally to the ground. At the other end of visual spectrum, folk artists of Bengal produced a scroll painting narrating the life of the prime minister that begins with a carto-graphed Indira holding aloft the Gandhian flag (with its trademark spinning wheel) and ends with her ascent to heaven after her assassination.[62] The poster artists of the bazaar responded in inconsistent ways to the horror of the assassination. On the one hand, in N. Sharma's *Prime Minister of India*, which visualizes the life story of the prime minister in a manner akin to L. K. Sharma's picturing of the life of the Mahatma that we saw in figure 15.2, the fact of her violent death is completely glossed over as Indira's body is shown peacefully at rest.[63] On

the other hand, soon after her assassination, the Meerut-based H. R. Raja, who earlier had produced images of the martyrdom of Bhagat Singh, Chandrasekhar Azad, and others, painted *Indira Gandhi: Mere Khun Ka Har Katara Desh Ko Mazbut Karega* (Indira Gandhi: Every Drop of My Blood Will Strengthen the Nation).[64] As Pinney notes,

> Indira is reported to have said this ["every drop of my blood will strengthen the nation"] at a rally in Orissa shortly before her death and her supporters believed this to be her premonition of her own murder. . . . Raja mirrors this linguistic message with a visual trace of Indira's blood—several drops and rivulets at the bottom left of the image—on what must be the surface of the image. Like all his [Raja's] images, this picture lacks depth. Indira is not a body located in three-dimension space but a flat representation looking out at the viewer, and the most significant space of the image is not behind the picture plane, but *in front*, where the blood drips. . . . In Raja's portrait the only space that matters is that between Indira and the viewer, the space determined by her gaze meeting one's own and in which the viewer can reach out and touch the blood on the surface of the image.[65]

Raja was heir to a tradition of producing political pictures that did not hesitate to show the martyrdom of men such as Bhagat or Bose in the most macabre manner. And yet, he refuses to show a decapitated or even wounded Indira here, although the very manner of her death, as well as the martyred status she had attained by virtue of such a death, lends itself to such representation.

Indira's ruling Congress Party did not, however, hesitate to turn macabre in this regard. Soon after the assassination, a number of street hoardings were put up in public spaces in the South Indian state of Andhra Pradesh during the national elections of December 1984 (which carried the Congress and Indira's son Rajiv to power). These show her dead face in profile, mapped across the Indian geo-body, or the bloodied body of the slain woman occupying a map of India, blood from her wounds dripping profusely down to the map.[66] Inscribed across these hoardings are words from her last speech, "When my life is gone, every drop of my blood will strengthen the nation."[67] The most dramatic of such hoardings shows a highly anthropomorphized map of India (colored black) holding the slain body of Indira in its "arms" (figure 15.3). Blood from Indira's slain body drips down onto the map of India, its red color standing out against the white background of

Indira's checked sari and the black map. Tears flow down the map's "face." Inscribed once again in Telugu are Indira's last words: "When my life is gone, every drop of my blood will strengthen the nation."

In contrast to the carto-graphed male martyr, who wears an air of serene composure, even nonchalance, Indira's face in these hoardings is contorted and grotesque. This is certainly a body in pain, to draw on Elaine Scarry's formulation,[68] not one that seemingly enjoys or transcends it. There is no attempt in these images to flinch from visually imagining "the female subject in her apprehension of pain."[69] In turn, the death of Mother Indira has transformed the map of India as well in figure 15.3. Painted a solid, even demonic black, it is simultaneously a geo-body that has been reduced to tears as it clutches at her wounded, bleeding body. The dangers of visualizing the carto-graphed body of any female martyr, but especially someone like Indira, are on full display here. Assimilated as she is into the figure of Mother India so that "India is Indira, Indira is India," the death of Indira also means the potential destruction and demise of Bharat Mata and, hence, of the map of India and the territorial totality that it iconizes. The limits of the barefoot mapmaker's patriotism are reached in this hoarding, which runs the risk of pointing to the death of the very mother and map for which many of its martyrs gave up their lives in his visual imagination.

The Carto-Graphed Martyr in the Age of the National Picture

Every now and then, barefoot mapmaking appears to perform an autocritique of its own praise practices. A striking illustration published in November 1931 on the cover page of the Hindi magazine *Abhyudaya* shows a map of India with the emaciated (and dead or dying) body of a peasant—the Everyman—crucified on the cross of *lagaan* (tax) occupying the outline map of India, blood from his wounds dripping on to the nation's geo-body (figure 15.4). His hands still pathetically hold on to a small sickle in one and a sheaf of grain in the other while birds representing smallpox, drought, deluge, poverty, and influenza peck away at him; his grieving family huddles at the base of the cross. The farmer-as-martyr surely mocks the more dominant image of the map of India as the abode of the plenteous and glorious Bharat Mata, as we are reminded by Nehru's powerful rationalist critique of "the force of habit" that anthropomorphized India as "Mother India, a beautiful lady": "And yet India is in the main the peasant and the worker, not beautiful to look at, for poverty is not beautiful. Does the beautiful lady of our

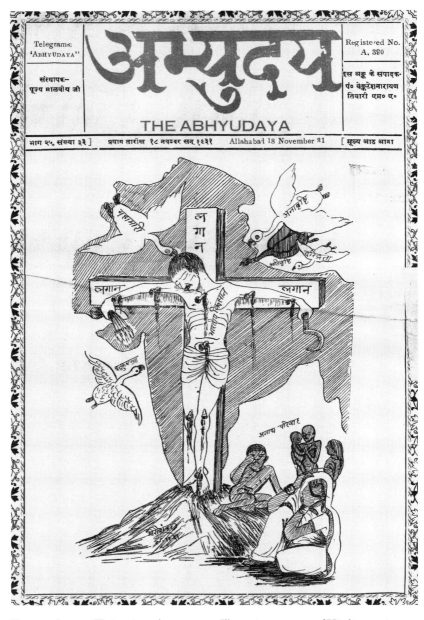

Fig. 15.4. *Lagaan* (Tax), artist unknown, 1931. Illustration on cover of Hindi magazine *Abhyudhaya*, Allahabad. PP Hin F 49 British Library (APAC: Proscribed Publications Collection), London. © The British Library Board.

imaginations represent the bare-bodied and bent workers in the fields and factories? Or the small group of those who have from ages past crushed the masses and exploited them, imposed cruel customs on them and made many of them even untouchable? We seek to cover truth by the creatures of our imaginations and endeavor to escape from reality to a world of dreams."[70]

I return us from the world of Indian visual dreams to scholarly reality by focusing on the carto-graphed body of the patriot/martyr, a product of the contingent intersection of the cultural politics of corporeality and cartography in the age of the national picture. The carto-graphed body of the patriot/ martyr, I want to insist, is specifically the outcome of a scholarly exercise in pictorial history, for it is only this kind of historical investigation that brings it to visibility. As Mitchell notes, "An imbrication of the sayable and the seeable, telling and showing, the articulable and the visible occurs at every level of verbal expression, from speech to writing to description, figuration, and formal/semantic structure."[71] Correspondingly, rarely do images circulate in public spaces without some connection to the verbal and the textual; there are few pure images untouched by the verbal, the discursive, and the linguistic. Pictorial history challenges us to dwell on the overlapping zone between the sayable and the seeable so as to shuttle back and forth between the two. It exhorts us to explore those aspects of the human experience that are unsayable and nonverbalizable, but also correspondingly, to come to terms with those that are unpicturable, even unseeable. Such a study compels us to pay attention to phenomena that cannot readily or immediately be translated into language, that are unsayable and *only* seeable. The image of the carto-graphed patriot/martyr, then, is one such only seeable image. It is the sedimentation of an ineffable surplus that can only be excavated by the practices of a new pictorial history that takes seriously Mitchell's argument that pictures "want equal rights with language, not to be turned into language."[72] Poetry and prose on the patriots and martyrs whom I have considered in this chapter abound in the official and subaltern verbal archives of the subcontinent, yet these will not yield the figure of the carto-graphed martyr, which is exclusively a product of the pictorial archive. Such images recall for me the title of James Elkins's powerful book, *On Pictures and the Words That Fail Them*.[73]

In the visual economy of popular messianic nationalism, to invoke Pinney,[74] Bhagat's death, and the death of other martyrs, made sense only when seen as an act of selfless sacrifice for the mother/land. Ironically, the only way to see that motherland as an integral whole is to resort to the indis-

pensable modern science of cartography, inadequate though that might be in capturing the affective intensity with which the patriot relates to the geo-body of the emergent nation. And this is because the form of the map *alone* makes India visible as an integral whole and identifiable as a particular piece of bounded territory on the face of Earth. Barefoot cartographic practice transforms that which is indispensable but inadequate by supplementing the mapped form of the nation with the anthropomorphic presence of Mother India, producing in the process a cartography of affect and patriotic efficacy to counter the impersonal and gridded lines of power of command cartography. Its productions synoptically enframe the map of India, the mother/goddess, and the martyr's body to pictorially show what is unutterable and verbally inexpressible. The carto-graphed body of the martyr with its livid blood dripping down to the map of the nation is the ineffable surplus made visible by the practice of pictorial history. In the words of Tagore's Sandip (with whose pronouncement I began this chapter), "Such are the visions which give vigor to life, and joy to death!"[75]

Notes

Sumathi Ramaswamy, "Maps, Mother/Goddesses, and Martyrdom in Modern India." *Journal of Asian Studies* 67(3) (2008): 819–53. Reprinted with permission of the publisher.

Versions of this chapter were presented at seminars in Ann Arbor, Berkeley, Chennai, Durham, New Delhi, London, Paris, Toronto, and San Antonio; I wish to thank the audiences at all these venues for their suggestions. I am also grateful for the critical reading by anonymous referees of an earlier incarnation of this essay, and to Lee Schlesinger and Raji Sunder Rajan for their comments and feedback. This essay incorporates in a highly condensed form arguments that I develop at length in my book, *The Goddess and the Nation: Mapping Mother India* (Durham: Duke University Press, 2010).

1 Benedict Anderson, *Imagined Communities: Reflections on the Origin and Spread of Nationalism* (London: Verso, 1991), 7.

2 Joan B. Landes, *Visualizing the Nation: Gender, Representation, and Revolution in Eighteenth-Century France* (Ithaca, NY: Cornell University Press, 2001), 2; emphasis added.

3 Gavin Kitching, "Nationalism: The Instrumental Passion," *Capital and Class* 25 (1985): 109.

4 The print is possibly based on a painting done in the 1930s by Rup Kishore Kapur (1893–1978) that might have been published soon after as a chromo-

lithograph. We learn from Kapur's grandson that "The day Bhagat Singh was hanged, [Kapur] painted in a day [a picture] of Bhagat Singh beheaded, giving his head on a plate to Bharat Mata. Bharat Mata is weeping. He painted it and [displayed it in Sambal] and shouted Bande Mataram [I revere the Mother] and he was taken by the police and was imprisoned for one or two years" (quoted in Christopher Pinney, *Photos of the Gods: The Printed Image and Political Struggle in India* [Delhi: Oxford University Press, 2004], 128).

5 W. J. T. Mitchell, *What Do Pictures Want? The Lives and Loves of Images* (Chicago: University of Chicago Press, 2005).

6 Richard Helgerson, "The Land Speaks: Cartography, Chorography, and Subversion in Renaissance England," *Representations* 16 (1986): 51.

7 Quoted in J. B. Harley, "Meaning and Ambiguity in Tudor Cartography," in *English Map-Making, 1500–1650*, ed. Sarah Tyacke (London: British Library, 1983), 26.

8 Thongchai Winichakul, "Maps and the Formation of the Geo-Body of Siam," in *Asian Forms of the Nation*, ed. Hans Antlöv and Stein Tønnesson (London: Curzon Press, 1996), 76.

9 James C. Scott, *Seeing Like a State: How Certain Schemes to Improve the Human Condition Have Failed* (New Haven, CT: Yale University Press, 1998), 11–52.

10 Anne Godlewska and Neil Smith, eds., *Geography and Empire* (Oxford: Blackwell, 1994).

11 Martin Heidegger, "The Age of the World Picture," in *The Question Concerning Technology and Other Essays* (New York: Garland, 1977), 134.

12 Heidegger, "The Age of the World Picture," 129.

13 Heidegger, "The Age of the World Picture," 130–32.

14 Max Horkheimer and Theodor W. Adorno, *Dialectic of Enlightenment*, trans. John Cumming (New York: Seabury, 1972), 3.

15 Matthew Sparke, *In the Space of Theory: Postfoundational Geographies of the Nation-State* (Minneapolis: University of Minnesota Press, 2005), xiv.

16 Sumathi Ramaswamy, "History at Land's End: Lemuria in Tamil Spatial Fables," *Journal of Asian Studies* 59(3) (2000): 595.

17 Matthew H. Edney, *Mapping an Empire: The Geographical Construction of British India, 1765–1843* (Chicago: University of Chicago Press, 1997).

18 Christopher Bayly, *Empire and Information: Intelligence Gathering and Social Communication in India, 1780–1870* (Cambridge: Cambridge University Press, 1996), 311–12.

19 Bayly, *Empire and Information*, 309; emphasis added.

20 Yi-Fu Tuan, *Space and Place: The Perspective of Experience* (Minneapolis: University of Minnesota Press, 1977).

21 Rabindranath Tagore, *The Home and the World*, trans. Suvendranath Tagore, reprint edition (Madras, Macmillan, 1985), 90–91. First published at the height of World War I and translated into English (under the author's supervision) in

1919, *Ghare Baire* has been hailed by most critics as a passionate critique of nationalism, especially its more extremist, violent, and irrational manifestations. Tagore's Sandip is the very antithesis of the ideal man and citizen of the world, to which the poet-novelist himself aspired.

22 Bipin Chandra Pal, *The Soul of India: A Constructive Study on Indian Thought and Ideas*, 2nd ed. (Madras: Tagore, 1923), 106; emphasis added.

23 Quoted in J. H. Dave et al., *Munshi: His Art and Work*, vol. 1 (Bombay: Shri Munshi Seventieth Birthday Citizens' Celebration Committee, 1962), 38.

24 Here, I am adapting Dipesh Chakrabarty's well-known call to "provincialize" Europe and its thought (Dipesh Chakrabarty, *Provincializing Europe: Postcolonial Thought and Historical Difference* [Princeton: Princeton University Press, 2000]).

25 For a review of this literature, see Sumathi Ramaswamy, "The Goddess and the Nation: Subterfuges of Antiquity, the Cunning of Modernity," in *The Blackwell Companion to Hinduism*, ed. Gavin Flood (Oxford: Blackwell, 2002), 551–68. The neologism "carto-graphed" in this section is meant to draw attention to the yoking together of the human or divine body and cartographic products such as maps and globes to produce a particular kind of spatial knowledge. In this study, a carto-graphed figure is one that is inscribed in the form of a map or drawn to accommodate, outline, or be attached to the map form of a country.

26 Sumathi Ramaswamy, "Maps and Mother Goddesses in Modern India," *Imago Mundi* 53 (2001): 97–113; Sumathi Ramaswamy, "Visualizing India's Geo-Body: Globes, Maps, Bodyscapes," in *Beyond Appearances? Visual Practices and Ideologies in Modern India*, ed. Sumathi Ramaswamy (New Delhi: Sage, 2003), 151–90; Geeti Sen, *Feminine Fables: Imaging the Indian Woman in Painting, Photography, and Cinema* (Ahmadabad: Mapin, 2002); Erwin Neumayer and Christine Schelberger, *Bharat Mata: Printed Icons from the Struggle for Independence in India* (Delhi: Oxford University Press, 2007).

27 Denis Wood and John Fels, *The Power of Maps* (New York: Guilford Press, 1992), 5.

28 Patricia Uberoi, "Feminine Identity and National Ethos in Indian Calendar Art," *Economic and Political Weekly (Review of Women's Studies)* 25(17) (1990): WS46.

29 Sandria B. Freitag, "Visions of the Nation: Theorizing the Nexus between Creation, Consumption, and Participation in the Public Sphere," in *Pleasure and the Nation: The History, Politics and Consumption of Public Culture in India*, ed. Rachel Dwyer and Christopher Pinney (Delhi: Oxford University Press, 1999), 35–75.

30 Kajri Jain, *Gods in the Bazaar: The Economies of Indian Calendar Art* (Durham: Duke University Press, 2007).

31 Jyotindra Jain, "Morphing Identities: Reconfiguring the Divine and the Political," in *Body City: Siting Contemporary Culture in India*, ed. Indira Chandrasekhar and Peter C. Seel (New Delhi: Tulika Books, 2003), 13.

32 Pinney, *Photos of the Gods*. By "corpothetic," Pinney means the sensory embrace

of and bodily engagement with images that is so characteristic of the modern visual regimes of the subcontinent, especially at the popular and devotional level across numerous religious, regional, and ethnic divides.

33 I write this in spite of the fact that recent scholarship has effectively shown the extensive reliance by the British on native subordinates (bare feet and all!) in the work of the colonial surveys and mapping of the subcontinent (Kapil Raj, *Relocating Modern Science: Circulation and the Construction of Scientific Knowledge in South Asia, 17th–19th Centuries* [Delhi: Permanent Black, 2006]). My use of this conceptual category also draws on the everyday reality of the average Indian's privileging of bare feet to perform numerous tasks ranging from the sacred to the mundane. Further, many images of artists at work on the subcontinent show them doing so with bare feet. As important, though, the analytic is meant to capture a metaphorical sense of "barefoot-ness" as a condition of being that facilitates a more earthbound and sensory, even corpothetic, relationship to soil, land, and territory than is arguably possible when following the protocols of a lofty and rarified science such as cartography.

34 Scott, *Seeing Like a State.*

35 Anderson, *Imagined Communities*, 175.

36 Aurobindo Ghose, "Bhavani Mandir," in *Bande Mataram: Political Writings and Speeches, 1890–1908.* Vols. 6 and 7 of *The Complete Works of Sri Aurobindo* (Pondicherry: Sri Aurobindo Ashram, 2002; orig. pub. 1905), 75–92, quotation on p. 83.

37 Denis Cosgrove, *Apollo's Eye: A Cartographic Genealogy of the Earth in the Western Imagination* (Baltimore: Johns Hopkins University Press, 2001), 105–6, 114.

38 Jawaharlal Nehru, *An Autobiography* (1936; Delhi: Oxford University Press, 1980), 431; emphasis added.

39 I borrow the term *big man* from the anthropological work of Mattison Mines, who uses it to develop a model of leadership and status building through "the redistribution of benefits, [the leader's] generosity as a broker, and [the leader's] prestige." Some women can also be "big men" (Mattison Mines and Vijayalakshmi Gourishankar, "Leadership and Individuality in South Asia: The Case of the South Indian Big-Man," *Journal of Asian Studies* 49[4] [1990]: 761–86).

40 Revathi Krishnaswamy, *Effeminism: The Economy of Colonial Desire* (Ann Arbor: University of Michigan Press, 1998), 47.

41 Eve Kosofsky Sedgwick, *Between Men: English Literature and Male Homosocial Desire* (New York: Columbia University Press, 1985).

42 Other than the anonymous Muslim body signified invariably by a fez-capped head, the only Muslim men whom I have seen in these pictures in the company of the map of India are those "loyalists" associated with the Congress Party, such as Maulana Abul Kalam Azad, and a relatively unknown associate of Bhagat Singh's called Ashfaqullah who was hanged by the colonial state in 1927.

43 Manu Goswami, *Producing India: From Colonial Economy to National Space* (Chicago: University of Chicago Press, 2004), 203.

44 Christopher Pinney, "The Nation (Un)Pictured: Chromolithography and 'Popular' Politics in India," *Critical Inquiry* 23(3) (1997): 847.

45 Brian Keith Axel, *The Nation's Tortured Body: Violence, Representation, and the Formation of a Sikh "Diaspora"* (Durham: Duke University Press, 2001), 149.

46 For a detailed analysis of the deployment of the discourses of martyrdom in contemporary Hindu nationalism, see Christiane Brosius, *Empowering Visions: The Politics of Representation in Hindu Nationalism* (London: Anthem Press, 2005), 233–78.

47 Sumathi Ramaswamy, "The Mahatma as Muse: An Image Essay on Gandhi in Popular Indian Visual Imagination," in *Art and Visual Culture in India, 1857–1947*, ed. G. Sinha (Mumbai: Marg Publications, 2008).

48 Pinney, *Photos of the Gods*, 140.

49 Neumayer and Schelberger, *Bharat Mata*, plate 259.

50 Neumayer and Schelberger, *Bharat Mata*, plate 261; Ramaswamy, "The Mahatma as Muse."

51 Pinney, *Photos of the Gods*, 124.

52 Pinney, *Photos of the Gods*, 136.

53 See also Jain, "Morphing Identities"; Pinney, *Photos of the Gods*, 93–103.

54 Richard Lannoy, *Benares Seen from Within* (Varanasi: Indica Books, 1999), plate 494.

55 For other examples and helpful discussions regarding them, see Brosius, *Empowering Visions*, 258–61, 322–23, and Louis E. Fenech, *Martyrdom in the Sikh Tradition: Playing the "Game of Love"* (Delhi: Oxford University Press, 2000), 158–77.

56 I borrow the notion of "visual pedagogy" from Antoine de Baecque's work on revolutionary France, in which he argues that images of the wounded bodies of the martyrs of the revolution were deployed again and again in paintings and prints in order to "make compassion arise," to "open the path of political awareness" in the community, and to produce "a ritualized call to political action" (*The Body Politic: Corporeal Metaphor in Revolutionary France, 1770–1800*, trans. Charlotte Mandell [Stanford, CA: Stanford University Press, 1997], 281–307).

57 Pinney, *Photos of the Gods*, 136.

58 Quoted in Fenech, *Martyrdom in the Sikh Tradition*, epigraph.

59 Geraldine Forbes, "Goddesses or Rebels? The Women Revolutionaries of Bengal," *Oracle* 11(2) (1980): 1–15.

60 Pinney, *Photos of the Gods*.

61 Neumayer and Schelberger, *Bharat Mata*, 181–92.

62 Richard Blurton, "Continuity and Change in the Tradition of Bengali PaTa-Painting," in *The Sastric Tradition in Indian Arts*, ed. Anna L. Dallapiccola (Stuttgart: Steiner, 1989), 1:425–51.

63 Neumayer and Schelberger, *Bharat Mata*, 192.

64 See Pinney, *Photos of the Gods*, 180.

65 Pinney, *Photos of the Gods*, 179–80.

66 Raghu Rai, *Indira Gandhi: A Living Legacy* (New Delhi: Timeless Books, 2004), 129, 142–43.

67 I thank Srinivasacharya Kandala for translating the Telugu texts in these pictures.

68 Elaine Scarry, *The Body in Pain: The Making and Unmaking of the World* (New York: Oxford University Press, 1985).

69 Rajeswari Sunder Rajan, *Real and Imagined Women: Gender, Culture, and Post-Colonialism* (London: Routledge, 1993), 33.

70 Nehru, *Autobiography*, 431.

71 W. J. T. Mitchell, "Interdisciplinarity and Visual Culture," *Art Bulletin* 77(4) (1995): 542–43.

72 Mitchell, *What Do Pictures Want?*, 47. As an adjective, *ineffable* refers to that which "cannot be expressed or described in language; too great for words; transcending expression; unspeakable, unutterable, inexpressible," according to the *Oxford English Dictionary*. W. J. T. Mitchell refers to images as "vehicles of experiences and meanings that cannot be translated into language" ("What Is Visual Culture?," in *Meaning in the Visual Arts: Views from the Outside*, ed. Irving Lavin [Princeton, NJ: Institute for Advanced Study, 1995], 208) and as "sedimentations of a non-verbalizable surplus" (*What Do Pictures Want?*, 9–10, 344).

73 James Elkins, *On Pictures and the Words That Fail Them* (Cambridge: Cambridge University Press, 1998).

74 Pinney, *Photos of the Gods*.

75 Tagore, *Home and the World*, 91.

Notes from the Surface of the Image:

Photography, Postcolonialism,

and Vernacular Modernism

Christopher Pinney

How do local visual traditions mediate modernity in ways that are independent from and critical of European modernity? Houston Baker, writing in *Modernism and the Harlem Renaissance*, asks the question of how one can seriously understand, say, W. E. B. Du Bois or Langston Hughes in a manner that doesn't characterize them (and reduce them) to being either "like" (or "not like") T. S. Eliot or Ezra Pound.[1] Baker's struggle is to break free from the model of a sovereign "Western" consciousness and reason of the sort that Dipesh Chakrabarty seeks to "provincialize" through the recovery of parallel practices.[2] Part of Baker's solution lies in his stress on the "deformation of mastery"[3] intrinsic to the Harlem Renaissance, an idea developed by Homi Bhabha in a rather different direction under the conjunction of the performative/deformative.[4]

A similar idea is explored here: that is, the manner in which local photographic traditions creatively deform the geometrical spatializations of colonial worlds. Postcolonial photographic practices give rise to a "vernacular modernism"; images that project a materiality of the surface, or what Olu Oguibe calls "the substance of the image."[5] In these practices the surface becomes a site of the refusal of the depth that characterized colonial representational regimes. *Surface* and *depth* refer here not simply to sedimentary layers, but rather to more profound positionalities that fuse the ethical/ political with the chronotopic. What might be termed "colonial" schemata positioned people and objects deep within chronotopic certainties as they sought stable identities in places from which they could not escape. "Postcolonial" practice negates this, however, by siting its referents in a more mobile location on the surface. This performative/deformative transforma-

tion also reflects the opposition that Michel de Certeau made between the panoptic "lust to be a viewpoint" and the "opaque mobility [and] appropriation of the topographical system" by the ground-dwelling pedestrian.[6] Colonial depth practices implied, and strove to be guaranteed by, a photographic surface that was invisible. The surface was a window onto a field of spatial and temporal correlations that encoded a colonial "rationality." The opacity of the surface becomes a refusal of this rationality and an assertion of cultural singularity. There are resonances also with Michael Taussig's attempt to refigure Walter Benjamin's "Work of Art" essay as serviceable for the late twentieth century.[7] Taussig is concerned with the tactile and haptic dimension of what Benjamin termed the urge "to *get hold*"[8] of objects (photographs) at close distance: the vernacular modernism described in this essay also reveals a desire to get hold of objects through photography, and this has a particular saliency in postcolonial contexts.

Photography and Depth

> Taking our stand upon the island, we will make a leisurely survey of the lake. . . . Let the reader endeavour to imagine this lovely panorama spread around him—every object in which is faithfully mirrored in the peaceful lake, whose surface on the first day that I visited it was smooth as glass itself—and he will then be able to form some idea of the kind of scenery which delights every visitor to this celebrated valley.[9]

> Beckoned inside, through a hardboard partition and stepping gingerly over trailing electric light cables, we follow Suresh into his studio. [He] then pulls back the red curtain revealing the *pièce de résistance* in this chamber of dreams. The great expanse of Dal Lake in Kashmir is laid open, shimmering beneath cascading pine-encrusted mountains, illuminated by efflorescent skies, and all offset by a foreground luxuriating in multi-coloured meadow flowers.[10]

In a scene from the popular Hindi film *Beta*, a love-stricken Anil Kapoor rubs a photograph of Madhuri Dixit, the still-unrequiting object of his affections. Kapoor's hand passes over the surface of the image, detecting some secret libidinal undulation, some hardly visible texture of desire that triggers in the subject of the photo an ecstatic murmur. Looking becomes touching, and the referent of the photograph mutates from the imprisoning depths of

the image to its sensual surface. Bombay cinema here plays out an erotics of looking and being, something close to the erotics described by Susan Sontag—a sensual immediacy.

I return to the "surfacism" that characterizes much popular small-town Indian photographic practice when later I explore its continuities with popular West African practices, notably the ways in which the use of backdrops, the creation of photographic mise-en-scène, and the postexposure manipulation of the image demonstrate a concern with the surface—or what Olu Oguibe calls "substance" of the image—rather than its narrativized indexical depths.

My later argument about popular "postcolonial" surfacist practices depends, however, on its opposition to an earlier practice that it repudiates and surpasses. This earlier practice privileges the time/space of photographic exposure and links these creational moments to the photographers' and photographic subjects' movements through time and space. The relationship between early photography and European travel is not accidental: the "normative" photograph encoded a practice of photography, which encoded a practice of travel. The ideology of indexicality authorized an autoptic practice of "being there." A flick through any basic history of photography reveals the powerful preoccupation with the changing location of the photographers and their equipment in real time/space conjunctions: early photographic technicians in their balloons, John McCosh in Burma, Roger Fenton in Russia and the Crimea, Francis Frith in Egypt, Felice Beato in Japan, Samuel Bourne in India,[11] and Timothy O'Sullivan and W. H. Jackson in the American West.

There is a "newness" in photographic practice that authorizes this engagement with spaces of alterity but also a resonance with more enduring epistemologies. The parallelism between the technology of photography and techniques of travel has been explored by David Tomas,[12] who has noted the way in which the transformation of the negative into a positive encapsulates a journey between different states. But this technological narrative was layered on a much earlier European tradition of conceptualizing knowledge spatially. The frontispiece to Anton Wilhelm Schowart's *Der Adeliche Hofmeister* (1693) showing "the Grand Tour as part of the educational system of the Baroque" visualizes this spatialization in which different disciplines of knowledge—including "Universal History, Exotic Languages, Geography and Politics"—are depicted as steps along an ambitious "peregrination."

Justin Stagl has situated such images in the context of the rise of a systematic theory of travel in sixteenth- and seventeenth-century Europe.[13]

In the rise of travel photography as practiced by those such as Roger Fenton, Samuel Bourne, and others, whose sought-after work has now come to define a canonical nineteenth-century photographic practice, we can trace the alliance of photography's technological possibilities with a chronotopic expectation that emerges out of this long history of the theorization of travel and the rise of autopticism, of "seeing with one's own eye."

Samuel Bourne's "Narrative of a Photographic Trip to Kashmir (Cashmere) and Adjacent Districts" will serve for the purposes of this argument as the paradigmatic text of this normative practice. Bourne begins by suggesting that "if I am right in supposing that the readers of THE BRITISH JOURNAL OF PHOTOGRAPHY take an interest in narratives of photographic travel in foreign lands, I could scarcely hope to interest them more strongly perhaps than by presenting them with some notes of a trip with the camera to the far-famed Valley of Kashmir."[14]

The weight and number of Bourne's photographic accoutrements necessitates the formation of a full-scale expedition with forty-two "coolies" plus his own retinue of servants, and the evidence of the insulating and world-conquering mentality that such military-like expeditional formations engender is readily apparent in Bourne's narrative, which—as has often been remarked—is peppered with a dislike of the dialogical spaces of face-to-face encounters ("listening to nothing the whole time but barbarous Hindostani") juxtaposed with epiphanal moments of ascendancy ("The whole rich valley of Kangra which is about forty miles long by fifteen broad, was spread beneath, bounded on the opposite side by a superb mountain chain"). The expeditional mode and its hostility to dialogical encounter has been illuminatingly discussed by Gerd Spittler,[15] who contrasts it with the productive vulnerability of the individual traveler.

Ascendancy appeals to Bourne because it facilitates an encompassing view ("Here and there I could see far down into obscure and apparently inaccessible glens"). The systematicity of imperial penetration was also important to Bourne ("There is now scarcely a nook or corner, a glen, a valley, or mountain, much less a country, on the face of the globe which the penetrating eye of the camera has not searched"[16]) and his photographic images are offered as exemplary instances of these formerly inaccessible zones, now made visible. The successful outcome of travel is evaluated in these moments

of height and distance, whereas closeness marks a failure ("I perceived that I should not be able to get a general view of the whole on account of the closeness of the wall which surrounded it"[17]). All these conflictual emotions and experiences are resolved in the epiphanal moment of his ascent above the Vale of Kashmir:

> The top was formed into a straight ridge or wall of snow about eight feet in width, on which I sat down to rest and survey the scene which opened around me. . . . The prospect was not only the most extensive but the most varied I have ever witnessed.
>
> Here I caught my first glimpse of the "Vale of Kashmir," which stretched away to the north like a level plain, with here and there a bright patch shining through the haze, like silver, the reflections from sheets of water. . . . To the right other pyramids of snow rose on the view in glorious and boundless succession, stretching, I presume, to the territory of Ladakh. Looking south (the way I had come) a succession of valleys and ridges followed each other for many a league, range beyond range, till they were lost in the higher summits and gigantic snows of Pangi, which in their turn mingle with the gloomy blackness of hovering clouds.
>
> What a scene was the whole to look upon![18]

Bourne's sentiments here echo Gustave Flaubert's different responses to the varied spaces of Cairo during his 1850 trip with the photographer Maxine Du Camp: "What can I say about it all? What can I write you? As yet I am scarcely over the initial bedazzlement. . . . Each detail reaches out to grip you; it pinches you; and the more you concentrate on it the less you grasp the whole. Then gradually all this becomes harmonious and the pieces fall into place of themselves, in accordance with the laws of perspective. But the first days, by God, it is such a bewildering chaos of colours."[19]

As Timothy Mitchell (who cites Flaubert in his great work *Colonising Egypt*) suggests, Flaubert contrasts a threatening experience of closeness (in which vision collapses into touch: "it pinches you") with the security of distance and height, which permits the detached observation of a totality ("in accordance with the laws of perspective"). Much later, Marcel Griaule—who had a well-known penchant for aerial photography—commented: "Perhaps it is a quirk acquired in military aircraft, but I always resent having to explore unknown terrain on foot. Seen from high in the air, a district holds few secrets."[20] The theme of the superior colonial knowledge afforded by aircraft could be the theme of a short book, where a key text would be

H. M. de Vries's *The Importance of Java as Seen from the Air*, which included a recommendation by the chairman of the local Batavian aviation association: "Now we, the children of the age, are without ado floating thro' the air in our aeroplane or balloon, propelled by modern machinery whilst, enabled thereto by the perfection of camera-lenses, we are in a position to fix on the sensitive plate what, from the dizzy height, has drawn our attention, and afterwards, with the help of the graphic art, to demonstrate, how the world underneath presents itself to the eye spying from the clouds."[21]

One of the photographs, *A Road Lined with Poplars*, that resulted from Bourne's excursion to Kashmir perfectly diagrams the diagonal sweep of a receding line of trees bisecting the picture plane into geometric fragments. Although for Rosalind Krauss, following Peter Galassi,[22] Bourne's image "empties perspective of its spatial significance and reinvests it with a two dimensional order every bit as powerfully as does a contemporary Monet,"[23] this flattening and graphicization of Bourne's image is the function surely of its poor reproduction in the sources available to Krauss (presumably just Galassi) and her detachment of it from Bourne's narrative which inserts its pictorial line of flight in the penetrative camera/imperialist penetration of north India.

Bourne's narrative and images map a space in which the world is, in Martin Heidegger's sense, a picture. In his fundamental and perplexing essay "The Age of the World Picture,"[24] Heidegger explored the manner in which a European modernity had produced a profound cleavage between man and the world. The world became a field of spatiotemporal certainty, a domain given over to measuring and executing what Maurice Merleau-Ponty later termed a "homogeneous isotropic spatiality." To Heidegger's characterization of this trope we might also add the crucial element of narrative: the world as picture also entailed interrogative pathways, forays in which lives became measured in terms of their "exploits" and the exploitation of the world as picture became the mark of lives successfully lived. Contemporary African and Indian postcolonial photography is concerned with a realm of denarrativized, deperspectivalized surface effects that operate in a zone of tactility quite different from the detached viewpoint advocated by early European practitioners such as Bourne. However, I am not suggesting that this refusal of narrative, perspective, and detachment is peculiar to photography. On the contrary, as I will show through a number of diverse examples, this is a refusal made in other media as well. Indeed, it is also a refusal, apparent in "moments of unease" within dominant painterly schemata

such as the northern "art of describing" discussed by Svetlana Alpers and the "madness of vision" apparent in the baroque.

Such an argument has been made by Martin Jay in his consideration of the multiple scopic regimes that have constituted modernity.[25] Jay argues that the prevailing history of the dominance of a single scopic regime—which he calls "Cartesian perspectivalism"—is too simple. The term *Cartesian perspectivalism* conflates Cartesian subjective rationality with Albertian conceptualizations of single-point perspective. Central to this notion is a disembodied vision, what Norman Bryson terms "vision decarnalised,"[26] and which I have elsewhere examined (following Susan Buck-Morss) as an "anaesthetics" as opposed to a "corpothetics."[27] Within Cartesian perspectivalism, Bryson suggests, "the body is reduced to . . . its optical anatomy, the minimal diagram of monocular perspective. In the Founding Perception, the gaze of the painter arrests the flux of phenomena, contemplates the visual field from a vantage-point outside the mobility of duration, in an eternal moment of disclosed presence."[28] Jay outlines a number of related consequences stemming from the rise of this new visual order. The gap between the viewer and what was represented in the image widened, and there was a general "deeroticisation" of the visual order as the world depicted in images was increasingly "situated in a mathematically regular spatio-temporal order filled with natural objects that could only be observed from without."[29]

Heidegger's "The Age of the World Picture" essay was produced in 1935—one year before Benjamin's "Work of Art" essay—and there are certain intriguing parallels between the two arguments. Both essays develop extraordinarily broad and ambitious evolutionary narratives. In Benjamin's optimistic history, a decay of an earlier situated aura is presaged by new technologies of picturing. In Heidegger's pessimistic history a positively valorized premodern dwelling is ruptured by Cartesian perspectivalism in which the world comes to be seen as picture—a zone of representation established as something exterior to existence. Picturing becomes inseparable from modernity: "The fact that the world becomes a picture at all is what distinguishes the modern age."[30]

Whereas for Parmenides "man is the one who is looked upon by that which is" in the modern age, "that which is . . . come[s] into being . . . through the fact that man first looks upon it."[31] Looking upon the world and constructing the world as picture entails man placing himself against and before nature as something separate: the world is "placed in the realm of man's knowing and of his having disposal."[32]

Jay opposes the assumption made by commentators as diverse as Richard Rorty and William Ivins Jr. that Cartesian perspectivalism has been the sole dominant regime since the Renaissance. He draws attention to other very different paradigms that at times dethroned the supposedly hegemonic Cartesian perspectival regime. Thus the "art of describing," which flourished in the Low Countries during the seventeenth century, rejected the narrative and perspective of earlier southern European Renaissance painting in favor of denarrativized visual texture. Instead of a fixed viewing position it demanded a mobile, roving eye, scanning the dispersed details in the images that frequently include words in addition to objects in its visual space.[33] Among the contrasts Alpers draws between this art of describing and earlier perspectival imagery are "light reflected off objects versus objects modelled by light and shadow: the surface of objects, their colours and textures dealt with rather that their placement in a legible space."[34]

The second moment of unease described by Jay held the possibility of a more radical refusal of perspectivalism. The baroque (a term probably derived from the Portuguese word for a misshapen pearl) is advanced by Jay as "a permanent, if often repressed, visual possibility throughout the modern era."[35] Drawing on Christine Buci-Glucksmann's work, Jay stresses the baroque's rejection of "the monocular geometricalisation of the Cartesian tradition, with its illusion of homogenous three-dimensional space seen with a God's-eye view from afar." The baroque is fixated with opacity, with the recursivity of surface and depth and "reveals the conventional rather than the natural quality of 'normal' specularity by showing its dependence on the materiality of the medium of reflection."[36] Elsewhere I have discussed popular Indian visual culture in terms of the baroque as invoked by Alejo Carpentier,[37] who in a 1975 lecture outlined a theory of the baroque's relation to magical realism that has a peculiar applicability to the images I shall shortly consider.

Although the baroque was, for Carpentier, a "constant of the human spirit,"[38] it needs also to be understood as a reaction to a spatial rationality. The baroque "is characterised by a horror of the vacuum, the naked surface, the harmony of linear geometry"; it "flees from geometrical arrangements."[39] Carpentier sees Bernini's St. Peter's cathedral in Rome as an exemplar of the baroque; it is like a caged sun, "a sun that expands and explores the columns that circumscribe it, that pretend to demarcate its boundaries and literally disappear before its sumptuousness."[40] To Carpentier's stress on the creole and hybrid nature of magical realism we can add Luis Leal's

observation that magical realism is an "attitude towards reality,"[41] and not just as a literary genre,[42] as well as Amaryll Chanady's claim that magical realism "acquires a particular significance in the context of Latin Americas status as a colonised society" and his observation that magical realism is a response to the "'rule, norm and tyranny' of the age of reason."[43]

This preoccupation with theoretical perspectives that have evolved out of the consideration of painting and literature may seem perplexing given that my concern is with photography. What I have tried to demonstrate, however, is that the "baroque"—the appeal to a haptic surface—is commonly invoked across different media. What all these surfacist strategies have in common is their emergence in specific postcolonial contexts as expressions of identities that in complex ways repudiate the projects of which Cartesian perspectivalist images are a part.

However, the distance is very slight between these abstract ideas and the practices of popular Indian and African photography to which I will very briefly turn. Judith Mara Gutman writes of one of Samuel Bourne's south Indian photographs (*View into Ootacummund*, 1867) in terms that closely mirror Dawn Ades's description of Claude's Italian landscapes: "A low level light is introduced into the foreground, then allowed to move in and out of trees, creating graceful lyrical turns among the leaves. The light builds to great majestic heights, with dramatic breaks of shadow, before fading out into the distance. Bourne wove a story into his image, guiding his viewers from the slower-paced rambling foreground through the building intensity of the middle ground, then quietly leading his viewers out into the distant future."[44] This image, which is so carefully constructed to permit the viewer's eye to travel through its internal space, can be contrasted with another photograph discussed by Gutman, *Women at Sipi Fair* (ca. 1905). This image, by an unknown Indian photographer, is subject to a very different spatial regime: "With no 'invitation into the picture, my eyes did not know how or where to enter. . . . There were no leads, as you find in Western imagery, to other parts of the image."[45]

The Realist Backdrop

Writing about American Civil War photography, Alan Trachtenberg has noted what he calls "historicism-by-photography," the notion—in the wake of the consecration of photography by war—that "historical knowledge declares its true value by its photographability."[46] Perhaps the clearest state-

ment of this transformation in the nature of historical events lies in Paul Valéry's conclusion, a hundred years after photography's introduction, that "the mere notion of photography, when we introduce it into our meditation on the genesis of historical knowledge and its true value, suggests the simple question: *Could such and such a fact, as it is narrated, have been photographed?*"[47]

Valéry's observation expresses a standard view of photography as indexical—as a chemical trace of the light bounced off objects passed before the lens—and as having an element of randomness that always eludes the photographer's desire to frame and construct the image. It is the incompleteness of the photographic filter that sets it apart from other media, such as painting and drawing. Implicit in this view is a desire for imprisonment within the time space of the everyday world, captured by the camera.

Photography can be used to position bodies and faces within history, and it can also be used as a means of escape. What Eduardo Cadava terms "photographic self-archiving"[48] positions bodies within specific chronotopes—it matters to some people when you went to France that the trace of the Eiffel Tower in the distance is the one in the center of Paris and not a simulacrum: as Bourdieu says, it "consecrates the unique encounter."[49] The central Indian chronotope I now want to briefly describe doesn't privilege these factors because its ludic photographic idiom is not concerned with fixing bodies in particular times and places; rather, it is concerned with the body as a surface that is completely mutable and mobile, capable of being situated in any time and space.

Whereas in some photographic traditions, backdrops are valued as a record of the subject's position in a particular actual space (usually, as Bourdieu notes, in encounters with places of high symbolic yield), very few people in Nagda (a town of 79,000 people in central India, about halfway between Delhi and Bombay) request to be photographed in the actual space of Nagda. This generally only happens in the process of photographing wedding processions as they make their way through the town's streets, or in the gardens of the local Birla *mandir*, an elaborate pseudo-archaic temple whose grounds have become a popular picnic spot for the town's wealthier inhabitants. The photographs taken here (largely by professional photographers who stalk the gardens) spurn the topographical specificity of the location in favor of formulaic backdrops (of the sort to be seen in Hindi films) of flowers and fountains.

When Nagdarites seek a photograph of themselves they nearly always

commission a photographer (for there are very few privately owned cameras) to photograph them *inside* a photographic studio. The "real" space of Nagda is continually rejected in favor of that within the photographer's premises. A backdrop will be chosen—perhaps the Taj Mahal, or a Dal Lake (Kashmir) scene, or a cityscape (seen from a motorbike). The same spatial/temporal dislocation can be achieved through "cutting"—the careful juxtaposition of cropped paper negatives and composite printing that allows brides and grooms in wedding albums to travel the length and breadth of India, one moment standing beside the Tower of Victory in Chittaurgarh and the next by the India Gateway in Delhi.

The "Subaltern" Backdrop

Writing in *Afterimage*, the anthropologist Arjun Appadurai has suggested that the widespread use of props and backdrops in popular postcolonial photography expresses a resistance to the documentary claims of photography and a foregrounding of critiques of modernity. Appadurai goes so far as to label the backdrop "subaltern," where "the backdrop resists, subverts or parodies the realist claims of photography in various ways. . . . In these postcolonial settings, photographic backdrops become less the site for debates about colonial subjectivity and more the place for . . . 'experiments with modernity.' That is, outside the taxonomising and coercive techniques of colonial observers and the colonial state, backdrops tend to become part of a more complicated dialogue between the posed photograph and the practices of everyday life."[50]

In Nagda, backgrounds are used not simply as a substitute in the absence of their referents, but as a space of exploration. This exploration is often geographic; within Nagda studios one can travel from Goa to Mandu to Agra and Kashmir merely by standing in front of different walls. But Nagda studios also function as chambers of dreams where personal explorations of an infinite range of alteregos is possible.

Double and triple portraits place a person beyond the space and identity that certain forms of Western portraiture enforce. These, along with the trick techniques of montage that are so common in Nagda portraiture, testify to the lack of any desire to "capture" sitters within bounded spatial and temporal frames. The replication of bodies and faces brought about by doubling and tripling fractures not only the spatial and temporal correlates that are implied by the perspectival window created by photography but

also suggests a different conceptualization of the subjects who are made to appear within this window. It is as if there is a homology between the spatial and temporal infractions of this representational window and the fracture of these local subjects.

But it is not only backdrops that suggest this African/Indian parallelism. There is also an explicitly articulated recognition by photographers that their task is to produce not an imprisoning trace of their sitters but to act as impresarios, bringing forth an ideal and aspirational vision of the bodies that sitters wish themselves to be.

"Coming Out Better . . ."

No one in Nagda—apart, that is, from the police and other agents of the state—sees any value in photography's potential to fix quotidian reality. It is rarely there to record or to memorialize the events and conjunctions of the past. It is prized, rather, for its ability to make people and places "come out better than they really are."[51] This is a phrase used by customers of Nagda's Sagar Studio, which is famous for its double color exposures. The proprietor, Vijay Vyas, observes that Nagdarites rarely desire "realistic" (*vastavik*) photographs: "They always say I want to look good. . . . Everyone says I am like this but I want to come out better than this in my photo [*is se bhi zyada acchha mera photo ana chahie*]. So we try."

"Coming out better" in a Nagda photograph is achieved through two routes: through the adoption of gestures and through the deployment of costume and props. Frequently the one implies the other. Vijay Vyas refers to any photo involving a gesture with the English phrase "action shooting": "action shooting or an action photo means you've got your hand in a certain way, holding it up to show your watch, one leg is higher than another, these are action photos." This refers to a set of techniques agreed on between the sitter and the photographer that allow a particular pose to emerge and that may jointly involve a gesture or look by the subject and the adoption of an appropriate camera angle by the photographer. Thus there are "poet" and "filmi" (i.e., film star) poses that both require low camera angles, and the creation of these involves a sort of theatrical direction by the photographer (figure 16.1).

Vijay, like several other Nagda studio owners, also has a collection of costumes available for the use of his clients, although they are the cause of considerable tribulations. The costumes include an all-in-one dress that can

Fig. 16.1. Composite print by Suhag Studios, Nagda, ca. 1980. Courtesy of
Suresh Punjabi.

be arranged to give different regional, caste, and class flavors. I asked Vijay
why his clients are so keen to wear different clothes when they are in front
of the camera: "For *shauq* [pleasure, to satisfy a desire]. They don't want to
wear their everyday clothes. They don't want *vastavik* [realistic] photos. . . .
They brush and braid their hair, put on [talcum] powder, put on cream,
put on lipstick, they change their dress, they wear good clothes, put on a
tie, wear a coat, they make sure their trousers are OK, then they say 'take an
action photo,' 'take my photo with this type of dress, Rajasthani dress, with
a *matka* [earthenware pot]' and so on."

Whereas Nagda popular photography does not seem to share much
with the solemnizing function of French photography described by Pierre
Bourdieu,[52] there are insights to be gained from some West African prac-
tices. Kobena Mercer describes the approach of the photographer Seydou
Keïta, active in Bamako, Mali, from the mid-1940s, as follows: "With vari-
ous props, accessories and backdrops, the photographer stylises the pictorial
space, and through lighting, depth of field, and framing, the camera work
heightens the mise-en-scène of the subject, whose poses, gestures and ex-
pression thus reveal a 'self' not as he or she actually is, but 'just a little more
than what we really are.'"[53] The comment at the end is by Seydou Keïta him-

self, and uncannily mirrors the observation by Vijay Vyas. Coming from an immersion in popular Indian photographic practices, one is immediately struck by similarities with documented studies of popular African photography: there appears to be a similar disinterest in realist chronotopes, a similar refusal of Cartesian perspectivalism, even as it exists in its attenuated contemporary Euro-American popular incarnations. Some of the apparent continuities can be in part explained by a continuity of personnel: the studios studied by Heike Behrend in Mombasa are largely Indian run,[54] and the powerful influence of Bombay cinema throughout West Africa[55] and the impact of Indian-produced iconography in Mami Wata devotion suggest possible lineages of influence.

The work of Seydou Keïta (whose championing by the art world as the key African photographer could be the subject of another essay) is particularly resonant with popular Indian portraiture. Seydou Keïta's clients had, however, a much more restricted choice of backdrops. As Seydou reported to the *Guardian* on April 19, 1997, "Between 1949 and 1952, I used my fringed bedspread as my first backdrop. Then I changed the background every two or three years." In another source, he adds that this introduced an element of indeterminacy: "Sometimes the background went well with their clothes, especially for the women, but it was all haphazard."[56]

These sporadically changed backdrops contribute significantly to the Seydou look—and to their refusal of the realist chronotope. Any location outside of the imaginary space of the studio is continually exceeded by the texture of Seydou's various bedspreads entering into harmonious and dissonant conversation with the clothes and accessories worn by his sitters (figure 16.2). This conjunction produces a Malian "art of describing," photographic surfacism that engages with texture, where everything springs out of the photograph toward the viewer, rather than a field of spatiotemporal certainty receding within the image.[57] This is what we might label "vernacular modernism": a refusal of external verification prompted not by Greenbergian angst but by a desire to consolidate the intimate space between viewer and image.

The most popular of Seydou's images date from the 1950s, perhaps because their subjects radiate the optimism of the winds of change of an imagined future (figure 16.3), rather than the weariness of Mbembesque postcolonial "banality."[58] The material discussed by Stephen Sprague in his wonderful article on Yoruba photography dates largely from the 1970s,[59] and the resonances with popular Indian practice are even more marked:

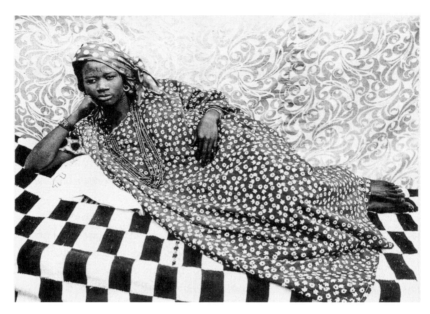

Fig. 16.2. Seydou Keïta, Untitled (reclining woman), 1956/57, Gelatin Silver Print. Courtesy CAAC—The Pigozzi Collection, Geneva © Seydou Keïta/IPM.

here is a world of surfaces and materiality that reach out to their embodied viewers.

As in Nagda there is a distrust of images that do not reciprocate their viewer's gaze: profiles and "unclear" images that do not fully reveal a face frustrate the real purpose of photography for Yoruba. Sprague describes a number of highly conventionalized poses and genres including the "formal photographic portrait" performed by older Yoruba. The subjects appear in their best traditional dress "squarely facing the camera" with legs well apart and hands on the knees or lap and "the eyes look directly at and through the camera."[60] Significantly, Sprague notes that although the technical con-straints of early photographic processes and the enduring influence of early British portrait photography are often adduced to explain these Yoruba practices, there is in fact no obvious relationship between the two.

The concern with the surface of the image and its production after the photographic moment is manifest in Yoruba practices in a number of ways, all of which have Indian parallels. Photographic cutouts are commonly made by pasting photographic images (and in some cases images from magazines) onto thin sheets of wood, to which a supporting base is added.[61] Double

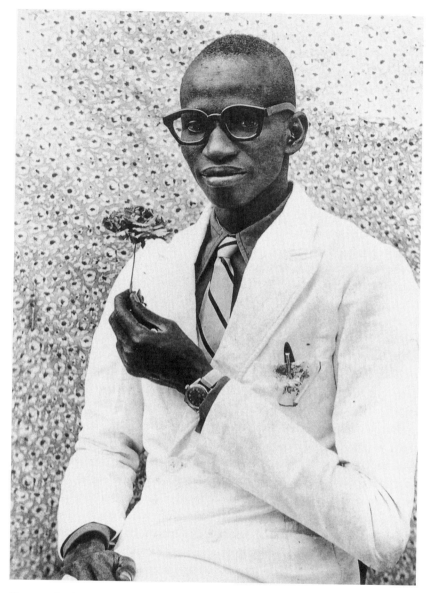

Fig. 16.3. Seydou Keïta, Untitled (man with paper flower), 1958/59, Gelatin Silver Print
Courtesy CAAC—The Pigozzi Collection, Geneva © Seydou Keïta/IPM.

and more complex composite printing, which fractures what Gombrich once called the "eye-witness principle,"[62] is commonly used, particularly in the representation of deceased siblings in the *ibeji* twin cult. Some studios, such as Sir Special of Ila-Orangun, mounted photographic images within mirrored frames, carefully scratching away the tain so that the outline of the photographed body could be seen from the other side,[63] a common technique in the display of religious chromolithographs in central India. Yoruba studios also produce complex ensembles that juxtapose photographic images with textual inscriptions (Sprague reproduces one with the slogan "To be a man is a problem"), creations that would look familiar to Nagda producers.

Both popular Indian and Yoruba surfacism is underwritten at every point by the desire for clarity and visibility, and in both locales the eyes of the subject become crucial markers of the image's ability to reciprocate the look of the viewer: the eyes become the fulcrum of the relationship between the picture and the world outside it. Sprague notes that one of the key conventions governing Yoruba photography is that "both of the subject's eyes must be always visible in a portrait. This convention . . . relates to the concept of *ifarahon*—of visibility of and clarity of form, line and identity."[64] This resonates very deeply with Nagda practices and with the more encompassing notion of *darshan*, of seeing and being seen, which also informs the Nagdarites' quest for frontality and visibility inscribed in a surface that looks out, thus reciprocating the gaze of the viewer.

But beyond this there is in much popular African and Indian photography a strikingly similar preoccupation with the materiality of the image and with the ways in which the surface of the photographic image becomes a site for the self-fashioning of postcolonial identities. What is striking about the practices discussed above is their discontinuity with the historical tradition out of which they emerge and their continuity with other contemporary postcolonial practices. Indian, African, Haitian,[65] and Chinese[66] popular practices are linked by a common concern, not with the space of the photograph as a window on a reality marked by internalized lines of flight, but with the photograph as a surface, a ground, on which presences that look out toward the viewer can be built. As Olu Oguibe elegantly describes this transformation, "the image in question is not the figure before the lens but that which emerges after the photographic moment."[67] If the photographic moment is dedicated to capturing the world as picture, what emerges afterward is the materiality of the image: what Oguibe calls its "substance" and

what I discuss in terms of surface. A shallow picture space, collage and montage techniques, over-painting, and complex sculptural mediations transpose the focus of photographic images from the space between the image's window and its referents to the space between the images' surface and their beholders. It is this "visual decolonisation"[68] that I have tried to conjure in these notes from the surface of the image.

Notes

Christopher Pinney, "Notes from the Surface of the Image: Photography, Post-Colonialism, and Vernacular Modernism," in *Photography's Other Histories*, ed. C. Pinney and N. Peterson, 202–20. Durham: Duke University Press, 2003.

I am grateful to Michael Godby for his invitation to Cape Town in 1999, where I presented the first version of this chapter.

1 Houston A. Baker, *Modernism and the Harlem Renaissance* (Chicago: University of Chicago Press, 1986).

2 Dipesh Chakrabarty, *Provincializing Europe: Postcolonial Thought and Historical Difference* (Princeton: Princeton University Press, 2000).

3 Baker, *Modernism and the Harlem Renaissance*, 49.

4 Homi K. Bhabha, *The Location of Culture* (London: Routledge, 1994), 241.

5 Olu Oguibe, "Photography and the Substance of the Image," in *In/sight: African Photographers, 1940 to the Present* (New York: Guggenheim Museum, 1996).

6 Michel de Certeau, *The Practice of Everyday Life*, trans. Steven Rendall (Berkeley: University of California Press, 1984), 93, 97.

7 Michael Taussig, *Mimesis and Alterity: A Particular History of the Senses* (New York: Routledge, 1993), 19–32.

8 Walter Benjamin, "The Work of Art in the Age of Mechanical Reproduction," in *Illuminations*, ed. Hannah Arendt, trans. Harry Zohn (New York: Schocken Books, 1968), 217; emphasis added.

9 Samuel Bourne, "Narrative of a Photographic Trip to Kashmir (Cashmere) and Adjacent Districts," *British Journal of Photography*, 9 parts (1866–67), 4.

10 Christopher Pinney, "The Nation (Un)pictured?: Chromolithography and Popular 'Politics' in India, 1878–1995," *Critical Inquiry* 23(4) (1997), 834–67, quotation on pp. 14–15.

11 See Robert Hershkowitz, *The British Photographer Abroad: The First Thirty Years* (London: Robert Hershkowitz, 1980).

12 David Tomas, "The Ritual of Photography," *Semiotica* 40(1–2) (1982): 1–25 and David Tomas, "Towards an Anthropology of Sight: Ritual Performance and the Photographic Process," *Semiotica* 68(3–4) (1988): 245–70.

13 Justin Stagl, "The Methodising of Travel in the Sixteenth Century: A Tale of Three Cities," *History and Anthropology* 4(2) (1990): 325.

14 Bourne, "Narrative," 471.

15 Gerd Spittler, "Explorers in Transit: Travels to Timbuktu and Agades in the Nineteenth Century," *History and Anthropology* 9(2–3) (1996).

16 Cited in James Ryan, *Picturing Empire: Photography and the Visualization of the British Empire* (London: Reaktion, 1997), 47.

17 Bourne, "Narrative," 475.

18 Bourne, "Narrative," 584.

19 Quoted in Timothy Mitchell, *Colonising Egypt* (Cambridge: Cambridge University Press, 1988), 21.

20 Quoted in James Clifford, "Tell Me about Your Trip: Michel Leiris," in *The Predicament of Culture: Twentieth-Century Ethnography, Literature and Art* (Cambridge, MA: Harvard University Press, 1988), 68.

21 H. M. de Vries, *The Importance of Java as Seen from the Air* (Batavia: H. M. de Vries, c. 1928), n.p.

22 Peter Galassi, *Before Photography: Painting and the Invention of Photography* (New York: Museum of Modern Art, 1981), 93.

23 Rosalind E. Krauss, "Photography's Discursive Space," in *The Originality of the Avant-Garde and Other Modernist Myths* (Cambridge, MA: MIT Press, 1985), 135.

24 Martin Heidegger, "The Age of the World Picture" (1935), in *The Question Concerning Technology, and Other Essays*, trans. William Lovitt (New York: Harper, 1977).

25 Martin Jay, "Scopic Regimes of Modernity," in *Vision and Visuality*, ed. Hal Foster (Seattle: Bay Press, 1988).

26 Norman Bryson, *Vision and Painting: The Logic of the Gaze* (New Haven, CT: Yale University Press, 1983), 95.

27 Christopher Pinney, "Piercing the Skin of the Idol," in *Beyond Aesthetics: Art and the Technologies of Enchantment* (London: Berg, 2001), 157–79. By *anaesthetics*, following Buck-Morss, is meant the realm of anti-Kantian decorporealized aesthetics. The neologism *corpothetics* is intended to evoke the domain of sensuous and corporeal aesthetics.

28 Bryson, *Vision and Painting*, 94.

29 Jay, "Scopic Regimes," 8, 9.

30 Heidegger, "Age of the World Picture," 130.

31 Heidegger, "Age of the World Picture," 131, 130.

32 Heidegger, "Age of the World Picture," 130. For an extended application of these ideas to the European practice of travel, see Christopher Pinney, "Future Travel," in *Visualizing Theory*, ed. Lucien Taylor (New York: Routledge, 1994), 409–28.

33 Jay, "Scopic Regimes," 12.

34 Jay, "Scopic Regimes," 12–13.

35 Jay, "Scopic Regimes," 16.

36 Jay, "Scopic Regimes," 17.

37 Christopher Pinney, "Indian Magical Realism: Notes on Popular Visual Culture," in *Subaltern Studies X*, ed. Gautam Bhadra, Gyan Prakash, and Susie Tharu (New Delhi: Oxford University Press, 1999), 201–33.

38 Alejo Carpentier, "The Baroque and the Marvellous Real," in *Magical Realism: Theory, History, Community*, ed. Lois Parkinson Zamora and Wendy B. Faris (Durham: Duke University Press, 1995), 93.

39 Carpentier, "The Baroque and the Marvellous Real," 93, 94.

40 Carpentier, "The Baroque and the Marvellous Real," 93.

41 Luis Leal, "Magical Realism in Spanish American Literature," in *Magical Realism: Theory, History, Community*, ed. Lois Parkinson Zamora and Wendy B. Faris (Durham: Duke University Press, 1995), 121.

42 Leal argues that the magical realist "doesn't create imaginary worlds in which we can hide from everyday reality: In magical realism the writer confronts reality and tries to untangle it, to discover what is mysterious in things, in life, in human acts" ("Magical Realism in Spanish American Literature," 121).

43 Amaryll Chanady, "The Territorialization of the Imaginary in Latin America: Self-Affirmation and Resistance to Metropolitan Paradigms," in *Magical Realism: Theory, History, Community*, ed. Lois Parkinson Zamora and Wendy B. Faris (Durham: Duke University Press, 1995), 135.

44 Judith Mara Gutman, *Through Indian Eyes: Nineteenth and Early-Twentieth-Century Photography from India* (New York: Oxford University Press/International Center for Photography, 1982), 17.

45 Gutman, *Through Indian Eyes*, 6.

46 Alan Trachtenberg, "Albums of War: On Reading Civil War Photographs," *Representations* 9 (1985): 1.

47 Quoted in Alan Trachtenberg, *Reading American Photographs: Images as History, Mathew Brady to Walker Evans* (New York: Hill and Wang, 1989), xii–xiv.

48 Eduardo Cadava, *Words of Light: Theses on the Photography of History* (Princeton: Princeton University Press, 1997), xxix.

49 Pierre Bourdieu, *Photography: A Middle-Brow Art* (Cambridge: Polity, 1990), 36.

50 Arjun Appadurai, "The Colonial Backdrop," *Afterimage* 24(5) (1997): 5.

51 The following three paragraphs are condensed from Christopher Pinney, *Camera Indica: The Social Life of Indian Photographs* (Chicago: University of Chicago Press, 1997), 178–80; the quoted material is from interviews with the author, translated from Hindi.

52 Bourdieu, *Photography*, 24.

53 Kobena Mercer, "Home from Home: Portraits from Places in Between," in *Self Evident* (Birmingham: Ikon Gallery, 1995), n.p.

54 Heike Behrend, "Love à la Hollywood and Bombay: Kenyan Postcolonial Studio Photography," *Paideuma* 44 (1988): 139–53, and Heike Behrend, "Imag-

ined Journeys: The Likoni Ferry Photographers of Mombasa, Kenya," in *Photography's Other Histories*, ed. C. Pinney and N. Peterson (Durham: Duke University Press, 2003), 221–39.

55 Brian Larkin, "Indian Films and Nigerian Lovers: Media and the Creation of Parallel Modernities," *Africa* 67(3) (1997): 406–40.

56 Quoted in Elizabeth Bigham, "Issues of Authorship in the Portrait Photographs of Seydou Keita," *African Arts* 32(1) (1999): 58.

57 Bigham ("Issues of Authorship," 57) summarizes some of these pictorial characteristics as compositional centrality and stability, with centrally fixed figures often shown frontally, fully, and within a shallow picture space.

58 Achille Mbembe, "The Banality of Power and the Aesthetics of Vulgarity in the Postcolony," *Public Culture* 4(2) (1992).

59 Stephen Sprague, "How I See the Yoruba See Themselves," *Studies in the Anthropology of Visual Communication* 5(1) (1978); reprinted as "Yoruba Photography: How the Yoruba See Themselves," in *Photography's Other Histories*, ed. C. Pinney and N. Peterson (Durham: Duke University Press, 2003), 240–60.

60 Sprague, "How I See the Yoruba See Themselves," 54.

61 I have not encountered this in Nagda, but one photographer/artist, Bishumber Dutt of Mussoorie in north India (whose work is described in David and Judith MacDougall's film *Photo Wallahs*), makes his living from the production of such life-size photographic cutouts (see David MacDougall, "Photo Wallahs: An Encounter with Photography," *Visual Anthropology Review* 8(2) (1992): 96–100.

62 That is, that an image depicts what one person could actually see.

63 Sprague, "How I See the Yoruba See Themselves," 59.

64 Sprague, "How I See the Yoruba See Themselves," 56.

65 Marilyn Houlberg, "Haitian Studio Photography: A Hidden World of Images," *Aperture* 126 (1992): 58–65.

66 In light of Sprague one could reread Sontag's account of popular Chinese photography to reveal its corpothetic and surfacist nature: "None is a candid photograph, not even of the kind that the most unsophisticated camera user in this society finds normal—a baby crawling on a floor, someone in mid-gesture . . . generally what people do with the camera is assemble for it, then line up in a row or two. There is no interest in catching movement" (Susan Sontag, *On Photography* [New York: Farrar, Strauss and Giroux 1979], 173).

67 Oguibe, "Photography and the Substance of the Image," 246.

68 Appadurai, "The Colonial Backdrop," 6.

CHAPTER 17

"I Am Rendered Speechless by Your Idea of Beauty": The Picturesque in History and Art in the Postcolony

Krista A. Thompson

We shall see that these two images are not without importance. That of the colonized as seen by the colonialist; widely circulated in the colony and often throughout the world (which, thanks to his newspapers and literature, ends up by being echoed to a certain extent in the conduct and, thus, in the true appearance of the colonized).

—Albert Memmi, *The Colonizer and the Colonized*, 1965

I admit the right of a man to write books or publish pictures which he knows are unfavourable and sometimes unfair advertisements of a people, but it is undoubtedly also the right as well [as] the duty of those of us who are unfavourably and unfairly advertised to protest.

—E. Ethelred Brown, *Daily Gleaner*, January 18, 1915

In the summer of 2000 in Jamaica, as the nation celebrated its thirty-eighth anniversary of independence from British rule, a series of incidents illustrated that colonial and touristic ways of visually imagining the island continued to pervade postcolonial Jamaican society. During that period a popular music video, starring Father Reese, the winner of the local National Festival Song Competition, played repeatedly on a local television station.[1] The musical composition, titled "Miss Jamaica," praised the island's beauty. To lend visual accompaniment to the lyrics, the musician took photographs of the island, often posing dramatically like a hunter before his pictorial prey—a mountaintop and flowers being chief among these elements. Periodically, the focus of his lens would fill the entire television screen, ushered in by the loud click of a camera's shutter, presenting viewers with a still shot of his photographic image. This reenactment of the process of creating snapshots of the island, using images that would be at home on any postcard of Jamaica, demonstrated that the island continued to be presented through

its ability to be like a representation—a picturesque locale—although now in the context of a national celebration.

Concurrently, the proceedings of a local Commission of Inquiry frequently occupied the local radio waves and animated the talk-show circuit. The public inquiry investigated the events of the previous summer, when authorities forcibly removed "street people" from Montego Bay (one of the main tourism centers on the island) and dumped them into the swamplands of another parish in the middle of the night. The cleansing of the landscape of "unsightly" persons again seemed in keeping with early twentieth-century colonial and elite interests in preserving a safe and picturesque environment for tourists.

In more literal ways colonial and touristic representations of the past inhabited the landscape of contemporary Jamaica. At the time, indeed, since the early 1990s, several local collectors have actively acquired photographs and postcards of Jamaica dating from the late nineteenth century and early twentieth from throughout the globe, reversing the representational tides that long flowed from the island. These late nineteenth-century photographs gained new visibility in the fin-de-siècle of the twentieth century through picture books and exhibitions. This visual repatriation was perhaps prefigured by the gift of a collection of more than two hundred postcards to the University of the West Indies Library, Mona, Jamaica—the Cousins-Hereward Collection—from the relatives of a deceased private collector in London in 1985. Since that time several Jamaican collectors have published books and catalogs on old postcards and photographs of the island—*Jamaica: The Way We Were*, *Photographs 1850–1940*, and *Duperly*[2]—with more books scheduled for publication. Additionally, in 1996 the Royal Geographic Society in London sponsored an exhibition, titled *Photos and Phantasms*, of photographs of the Caribbean from the start of the twentieth century (some of which had also circulated as postcards in the early 1900s) taken by the British geographer and photographer Harry Johnston. The exhibit, which first opened in London, returned the images to Jamaica (and other places they pictured—Barbados, Haiti, Cuba, and Trinidad), marking another large-scale migration of old photographic materials to the island in the 1990s. Photography enthusiasts also announced plans to create a photography museum in Kingston, which would give these images a permanent home.[3] Through all these initiatives the photographs acquired an unprecedented widespread local visibility, likely their greatest viewership since they first circulated a century ago.

Such photographic repatriations are not unique to Jamaica but can be found throughout the Anglophone Caribbean, particularly in locations with mature tourism industries. Publications of old photographs, particularly in the form of picture view-cards, appeared across the region in the 1990s: *Nostalgic Nassau, Glimpses of Our Past: A Social History of the Caribbean in Postcards, Bygone Barbados, Reminiscing: Memories of Old Nassau, The Bahamas in White and Black: Images from the Golden Age of Tourism, A Journey of Memories* [Trinidad], and *Reminiscing II: Photographs of Old Nassau*.[4] Publishers have also reissued old picture view-cards from the early twentieth century. *Back Then: Bahamian Style* (1996) is one such series. Postcards also populated the pages of scholarly historical publications across the region. Like messages in a bottle washing up on their shores of origin a century later, after traveling long and untraceable routes, many photographic images have returned "home."

But what do originally tourism-oriented postcards and photographs of the Anglophone Caribbean signify, in their newest resting place, for local residents? Or, as a reviewer of *Photos and Phantasms*, Gabrielle Hezekiah, pondered, "Who were these 'natives' in Johnston's photographs, and how can we understand our present fascination with the other even when that other is ourselves?"[5] Her question can be directed at local uses of and interpretations of colonial and touristic postcards and photographs generally. If many of these images served formerly as quintessential souvenirs of the tropical, the picturesque, and "civilized savagery" for colonists and tourists, what do such objects mean for contemporary residents? How do these representations, used in the past primarily as mementos for travelers, inform popular memory in the present? The contemporary interest in postcards from yesteryear, I argue, relates to local needs and desires for a society like the one pictured on many of the tourism-oriented photographs—a safe, disciplined, and picturesque locale. In the face of a number of postcolonial discontents and challenges, these touristic images act as visual placebos, assuring many local residents of the redemptive possibilities of their own nations.

These postcard books and historical accounts attest to the little-explored afterlife of colonial representations, their long and illustrious careers among (formerly) colonized populations. Whereas new scholarship on the "other histories of photography" has been attentive to how colonized peoples fashioned themselves as modern subjects in the photographic medium,[6] less work has analyzed how local inhabitants reinterpreted, reclaimed, or even republished the colonial photographic archive.[7] The recent reproduction

and recirculation of late nineteenth- and early twentieth-century photographs in books throughout the Anglophone Caribbean reveal that postcolonial subjects, in addition to creating alternate image-worlds in contradistinction to colonial photographs, also reconstructed their identities and histories—for better or worse—precisely through these colonial representations. It is not surprising that the postcard—an object created to traverse geographic boundaries and to bear handwritten traces of its users' interpretations—would figure prominently in these local postcolonial reappraisals and reuses of the colonial archive. That many publications frame postcards as transparent "windows into the past," however, raises questions about the consequences, contradictions, and even pitfalls of the postcolonial use of colonial photographs, of looking for "our histories" in the image pool of picturesque representations.

Several Caribbean artists have been attentive to the potential hazards of using colonial and touristic archives as objects of historical reconstruction and artistic inspiration. Trinidadian artists Christopher Cozier, Che Lovelace, and Irénée Shaw; once Bahamas-based artist Dave Smith; and British artist of Barbadian descent David Bailey all employ and deconstruct the postcard or tropicalized representations in their work. Many of these artists use the postcard, a form postcolonial critic Malek Alloula aptly deemed the "fertilizer of colonial vision,"[8] to denaturalize the islands' century-old tropicalized image, calling attention to the postcards' role in the production of this representational ideal of the islands. Their work evinces an ongoing and unresolved struggle to come to terms with the legacy of touristic representations on how local audiences imagine, represent, and define as representative their contemporary societies and their histories. The very different usages of the postcard in postcolonial Anglophone Caribbean society in the artists' works, local postcard publications, and history books attest to the longevity of and mutable meaning of colonial representations among an unintended audience—the (formerly) colonized.

The Sources of History: Imaging "Civilized Savagery"
in the West Indies Picture Postcard (1895–1915)

THE GOLDEN ERA OF THE PICTURE POSTCARD

A biography of the social life of the postcard in the Anglophone Caribbean must begin by retracing its origins, its producers, and its (intended) consumers. Postcards, while part of a wider colonial and imperial image pool,

have a distinct form and history. "Postal cards" of the West Indies reached their height of production during the "golden era" of postcard collection, 1895–1915.[9] In 1904 the Colonial Office in London specifically encouraged local officials in the islands to produce postcard series to stimulate the region's burgeoning tourist trade.[10] Colonial governmental bodies, passenger steamship companies, hoteliers, and local mercantile elites all seem to have heeded this call and created postcards for many islands in the West Indies, particularly in the first years of the twentieth century.[11] The postcards were often printed and sometimes retouched in Europe (Germany was a central postcard manufacturing center) or in the United States and then returned to the islands where they were offered for sale.

The intended consumers of Jamaica postcards included tourists, colonial officials, and the all-important potential tourist clientele. Postcard sellers frequently baited visitors specifically in their ads. They boasted "Picture Postcards: A big choice of views for visitors—Hope [Gardens], Castleton, Montego Bay, &c and many of the inhabitants and their pickaninnies" and deemed their shops the "Headquarters for Tourists [with] the Largest and Finest Assortment of Illustrated Jamaica Postcards."[12] Colonial officials stationed in the islands also purchased and collected postcards, as the Cousins-Hereward collection testifies. H. H. Cousins worked as the director of agriculture for the colonial government in Jamaica before returning to Britain with his substantial collection of postcards.[13] In addition, American and British companies and colonial governments targeted potential travelers as postcard viewers, distributing cards at colonial exhibitions and at ports of call to attract visitors, especially in places with direct steamship services to the islands.[14]

The postcards, like many tourism-oriented photographs, often depicted representations of ordered, cultivated, and nonthreatening tropical nature and presented images of an orderly, disciplined, and modernizing society generally. As curator of the Barbados Museum and Historical Society, Kevin Farmer concluded, after perusing his institution's collection of postcards of Barbados, many postcards represented the island as "an exotic location without danger."[15] The postcard, by making tropical nature into miniature views, further domesticated the islands' landscapes by literally rendering them picturesque—into thousands of possessable picture postcards.

Postcard producers also promoted the islands as premodern to travelers. The figure of the black island native and donkey—along with his barefooted, tree-climbing, sugarcane-eating representational counterparts—frequently

performed this role of tropical backwardness on postcards. One postcard of Jamaica produced by the United Fruit Company, for instance, referred to a black market woman and her beast of burden as the "Ford of the Rio Grande," casting the island as lagging far behind the modernity, enterprise, and technology of the United States on the scale of industrial evolution. Both place and people were imaged as aspiring to, yet lagging behind, the time and history of the "civilized world." The postcards presented the islands not just as geographically different, another foreign and tropical world, but as a place temporally apart, a universe trapped in the past.

In addition to postcard producers' choice of photographic subject and caption, they further embellished the islands' premodern and tropical image through hand painting and the sustained reprinting of certain postcards over decades. The removal of electrical lines in one version of the "Two Natives" card and the enhancement of tropical vegetation in the image evinces a familiar visual formula in Anglophone Caribbean postcard aesthetics, the subtraction of elements of modernity (electrical wires) and addition of signifiers of tropicality (tropical fruits and tropical nature) (see figures 17.1 and 17.2). That postcard producers circulated images of a premodern Caribbean, including the "Two Natives" representation, for decades further contributed to this ideal of unchanging and eternally primitive Caribbean societies, arresting the region in temporal representational stasis. The various stages of production and reproduction—selecting subjects, captioning, and overpainting—betray postcard makers' continual struggle to assert the tropical picturesque narrative through postcards and their attempts to control, stabilize, and contain the meaning of the cards and the image of the islands generally for potential travelers.

While some postcard producers aimed to cultivate the islands' tropical image and to steer the meaning of the postcards, travelers to the West Indies often used the miniature views to construct their own visual narratives on the island. At a time when few (but an increasing number of) travelers possessed the technological means to create their own photographs, tourists in the islands selectively culled the postcards in different Caribbean ports for mementos of their trips, choosing from the wider public archive for their personal remembrances. At the beginning of the twentieth century, postcards of exotic places occupied a coveted position in many travelers' albums, many of which would be publicly displayed in their sitting rooms.[16] As souvenirs (from the Latin verb *subvenire*, meaning "to come to mind") post-

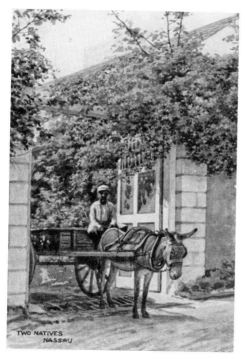
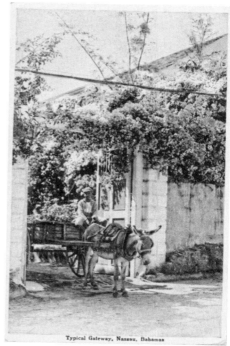

Figs. 17.1 and 17.2. City Pharmacy, Nassau, NP, "Two Natives, Nassau," 1907–14, divided-back postcard, 5.5 × 3.5 inches.

cards would serve as travelers' objects of recollection, tools to remember their past tropical sojourns. West Indies postcards doubly paid homage to the past, being souvenirs of past travels to the lands time had left behind.

Whether postcards resided in travelers' albums or traversed the oceans to designated recipients, they often literally bore their purchasers' handprint — their signature, date and place of use, and, on occasion, their interpretation of the image. Indeed, overlaid on producers' captions, postcard collectors frequently inscribed the image with their own meaning. Before 1902, when senders could not write messages on the back of the postcard, they literally scrawled their comments across the entire face of the pictorial image on the postcard, obstructing or becoming a part of the photographic representation. The postcard form thus recorded what Susan Stewart describes as the private experience of the public mass-produced image. The message marked the sender's personalization or interiorization of the image, his or her literal

appropriation of the exotic and foreign into narratives of the self.[17] As a result, the postcard form, while enlisted in the service of various touristic or colonial agendas, inherently and literally left a space open on the bottom or back of the image for alternative interpretations.

These handwritten remarks on Caribbean postcards frequently reveal the inevitable instability of the islands' civilized savagery and premodern image. Whereas some purchasers confirmed the naturalness and reality of this tropical ideal, others (even while using an image of a quintessential icon of tropical orderliness) viewed the islands as places of tropical danger. Handwritten testimonies to the presence of "Barbarians" (a spoof on Barbadians), "crocodiles," and "niggers" on the islands' picturesque postcards, for instance, highlighted the danger of the tropics and the savagery of "the natives."[18] From early on postcards became sites where competing ideas and ideals of the islands and their inhabitants were prescribed, inscribed, and destabilized.

Although many postcard producers imagined travelers as their primary consumers, postcards also gained a steady viewership among an unintended audience—the islands' local inhabitants. Local white elites, for one, purchased and collected postcards. They did so to such an extent that when a local black woman, Lizzie Anderson, featured on a popular postcard of the Bahamas, died, the *Nassau Guardian*, an organ of the white local, elite, reported to a readership obviously familiar with tourism-oriented photographs that "the deceased was well known as a hawker of poultry and was the original of the well-known photograph (taken several years ago) of a woman with a basket of turkeys and chickens on her head"[19] (figure 17.3). That the woman could be called to mind by reference to her photographic celebrity attests to the visibility and popularity of the form among the islands' elites. In addition to purchasing local cards, the upper classes also collected "postcards of London and Suburbs"[20] and postcards of local celebrations of Empire.[21] Thus, while postcard producers marketed the images as souvenirs for travelers to remember their journeys to tropical peripheries, local white elites appropriated the picture view-cards to consolidate their attachment to the metropole. Postcards of England, local commemorations of Britishness, and images of the island's civilized black British subjects served as visual mementos of mother England.

The islands' black inhabitants, the people most frequently pictured in postcards, also formed an unintended audience for these representations.

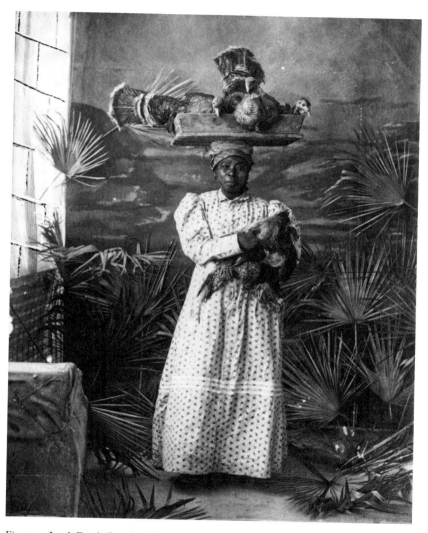

Fig. 17.3. Jacob Frank Coonley, "On the Way to Market," 1888–1904, albumen print, 8 × 6 inches. Courtesy of Brent Malone and the National Art Gallery of the Bahamas.

At the cost of 1 pence each, however, few black workers could afford to purchase and send postcards, much less collect them.[22] Hence, generally the class transcendence often attributed to the mass-produced postcard, the so-called poor man's art form, in Europe and the United States was not a feature in the region. Yet despite the seemingly prohibitive costs, there is evidence that some black inhabitants did acquire postcards. In 1908, for instance, a traveler to Nevis documented that local masqueraders wore costumes made out of postcards.[23] In this artistic reuse, masquerade participants appropriated and personalized the postcard for their own purposes. The "poor man's art form" literally became the poor black man's art form in Nevis, a Christmas masquerade costume. The islands' black population, although not frequent patrons of postcards, inevitably had access to these images, particularly in their places of employment. As store clerks, although racial and skin-color discrimination hampered black stewardship in areas tourists frequented, some blacks eyed the publicly displayed postcards at length. Black Bahamian Daisy Forbes, for instance, minded a Red Cross shop in Nassau in the 1940s, where she viewed some postcards with disgust and embarrassment. On her watch Forbes would hide what she considered the most offensive image, a version of the "Two Natives" postcard, ensuring that when travelers selected their remembrances of the island, the postcard would not form a part of their visual image bank.[24] In a limited way she steered the narrative of postcard representations, tipping the delicate scale of civilized savagery toward the former. Although she, like many other blacks, could not control the means of production, she exerted some control over the site of consumption.

Sustained critiques of postcards, and touristic images generally, throughout the first half of the twentieth century also reveal that local black audiences, across class, constantly surveilled the presentation of the island in the miniature universe of postcards, being particularly vigilant of the construction of the black race in these representations. A black activist and member of the grassroots association Jamaica League, E. Ethelred Brown, for instance, critiqued the singular focus in postcards on the most economically disadvantaged and uneducated segments of the black population. He advocated a boycott of the offending producers of postcards purporting to be "native scenes"—and declared it "the duty of those of us who are unfavourably and unfairly advertised to protest."[25] Decades later advocates for black rights on the islands from the middle classes continued to enlist their voices

in the ongoing protest over the touristic construction of blacks. In 1956, in the Bahamas, black suffragette Doris Johnson echoed this critique of the "revolting" portrayal of blacks in touristic representations—in particular she spoke out against a Development Board advertisement of an ape wearing a police uniform. While many postcards alluded to the similarity between blacks and animals, in the offending image they explicitly melded into one— the black policeman, the epitome of black discipline, was combined with the primordial image of savagery and prehumanity—the monkey.[26] Although postcard producers constructed the civilized savage image and naturalized this ideal through several devices, black critics of these representations constantly called attention to and protested the artifice of these pictures—the singular focus of their subject matter (black backwardness, poverty, tropicalness) and the constructed character of their form. These and other critiques not only reveal a long-standing local attack on the incessant focus on black "natives" in touristic representations but attest to the unyielding production of these images despite these outcries.

Thus contemporary postcard books utilize postcards borne out of the specific imaging needs of the islands' tourism industries at the beginning of the twentieth century and consumed primarily by travelers, colonials, and elites on the islands. This tropicalized image world was, however, from early on inherently open to alternative and even opposing meanings, as the changing captions and handwritten commentaries testify. The cards, as publicly displayed images, were also viewed by local audiences. While black inhabitants "wrote back" protesting the visual narratives of these representations these critiques and contestations left no traces on the archives—archives that centrally pictured the islands' black population. The absence of these perspectives on the tropicalized image world, unlike the producer's captions on postcards or the purchaser's handwritten commentary, would dramatically affect how subsequent viewers would interpret the photographs, read the narratives of these representations, and represent the past, particularly in postcard books and in historical accounts in the region. Or, to use historian Rolph Trouillot's terms, because blacks did not leave "concrete traces" on either the "making of *sources*" (postcards) or "the making of *archives*" (collections of postcards), it would dramatically affect "the making of *narratives*" and "the making of *history* in the final instance."[27]

NARRATING THE PAST THROUGH
THE POSTCARD BOOKS' FORM

In more recent times in publications throughout the postcolonial world unintended consumers of postcards have become primary ones. In many former colonies postcards have become central tools in the reconstruction of postcolonial histories of the subaltern and the deconstruction of the imperious imperatives of postcard makers. Algerian scholar Malek Alloula, most notably through his study of colonial postcards of Algerian women, aimed "to return this immense postcard to its sender," to use the images to explore, explode, indeed, to "exorcize" French colonial myths about Algeria.[28] Authors in the Anglophone Caribbean have also used postcards to reflect on the colonial past; their picture books, however, have done different work. Many contemporary authors of publications on Caribbean postcards have framed the old images as historically accurate representations of the past and proffer the picturesque society featured on postcards as visual evidence of the "better days" of colonial rule or the "golden age" of tourism. They not only privilege and reiterate the narrative of picturesque tropicality, originally created to appeal to tourists, but present key features of the islands' carefully crafted touristic image as historical fact to local audiences. This is evident even in the subtitle of one publication that framed the postcards as transparent windows onto "the way we were," to cite the title of a book on Jamaica.[29]

The typically brief texts that accompany the visual images in these publications further frame the postcards and photographs as documentary and objective representations of a former era. *Nostalgic Nassau*, for example, promises a "nostalgic peep into the past."[30] And Ann Yates, the author of *Bygone Barbados*, offers "Barbadians and visitors . . . a piece of our past."[31] On two occasions she describes her picture book as a "history" of Barbados.[32] The author of *The Bahamas in Black and White*, Basil Smith, also bills his book as "a valuable record of the way things were" and "a celebration of the work of this elite cadre of photographers who created the images that made The Bahamas famous."[33] The producers of these publications reintroduce these images as a visual history of the islands to local audiences (as is suggested in their use of the collective *we* and *us*) and visitors.

These books base much of their claims of historical accuracy or transpar-

ency on the simple fact that they use photographic postcard images, sub-scribing to the belief that the camera never lies. They work under the as-sumption that because they feature photographs, these images picture or document "the way we were." *The Bahamas in Black and White*, in the very title, invokes both its use of photographic images and a more colloquial understanding of "black and white," as something that is clear, documen-tary, and conclusive. Many of the titles point to the inclusion of photo-graphic materials by way of description, but they also index, by extension, the images' historical accuracy.

Unsurprisingly, given these documentary claims, several authors inter-pret the picturesque society featured on postcards as visual evidence of the "better days" of colonial rule. Yates, for example, lauds the images in *Bygone Barbados* as visual documents of the orderliness of Barbadian society in the colonial era: "These photographs give us a wealth of information, *they show a well ordered, law abiding, church going and diligent island* . . . with robust commerce, many gracious buildings, schools and churches."[34] The "well-ordered" image of the island she detects in the photographs is precisely the picturesque ideal makers of touristic representations had to project of pre-dominantly black societies to assure travelers of their safety in the tropics. Indeed, authorities wielded the importance of maintaining the islands' pic-turesque image as an upraised baton, as a tool in imposing discipline. The appearance of an orderly society Yates detects is precisely the image that tourism promoters aimed to transmit and enforce.

Some authors designate and celebrate the sites pictured in the cards, par-ticularly the places that epitomized the ordered tropical landscape, as his-torically important. In *Nostalgic Nassau*, for example, Shelley Malone and Richard Roberts lament the disappearance of the Royal Victoria Hotel's gardens. They express sorrow that "the once splendid exotic gardens are gone and sadly she awaits her demise. Ah . . . but, thanks for the memories dear lady."[35] In regard to a postcard of Victoria Avenue, another crown-ing example of an ordered tropical landscape and ode in appellation to the British Empire, they comment, "Today unfortunately [Victoria Avenue's] charm is gone, and it more closely resembles a parking lot."[36] They view their project as a way to preserve the past: "Before the best of old Nassau is completely forgotten, the authors hope to create an affection for the good (or bad, depending on your point of view) old days."[37] Many of the sites they cite as historically valuable are those that were designated as sights in early touristic campaigns. Generally, the books position both the societal

order and the physical locations long treasured in the visual economies of tourism and reinscribe these myths and spaces of touristic importance as the state of the past and historical treasures, respectively. They also position this era, which coincides with British colonial rule, as "the good old days," even though Malone and Roberts concede that some people may differ with their point of view.

Another trait of early postcards resurrected as historical fact in some of these accounts is the idea that the islands remained unchanged, that time, in essence, stood still during the colonial period. The authors of *Nostalgic Nassau* pick up on the "representational sameness" inherent in the postcard image world, but they interpret this as indicative of Nassau's unchanging character during the colonial era. They claim, "The Bahamas has altered more in the last thirty years [the Bahamas gained independence in 1973] than in the previous one hundred and thirty. Most of the early Victorian domestic architecture has disappeared, due to public apathy and the greedy demands of property developers with little appreciation of history."[38] They suggest that in the colonial era the island remained unchanged but that in the post-independence period "Old Nassau" had disappeared because of people who lack an appreciation of history. The authors base their historical claims on old postcard representations, which precisely imaged the islands as places outside of history, time, and modernity.

While postcards historically left a space open for competing interpretations, these publications present the materials in a more closed form, siphoning off possibilities for alternative interpretations. Even though at least one publication did acknowledge the viability of differing interpretations, the books share several organizational and design features that construct the interpretive frame for these representations and narrate the images as objective documents of the islands' former picturesque past. Although all books, of course, structure their narratives, the re-presentation of the multi-sided and multiply narrated postcards in the contemporary picture books would explicitly shape how the postcards could be read by their newest recipients—contemporary local viewers.

First, the writers seldom contextualize or describe the historical circumstances under which many of the representations they proffer were created; they do not allude to the touristic impetus behind many of these photographic creations. The books also do not address the issue of the original consumers toward whom these images were directed. Without describing the touristic impetus of these postcards, these books recirculate the images

in a contextual vacuum, or in a new context, as objective images of the region.

Second, few of the publications identify the particular creators or publishers of the image. Even when the authors mention the names of photographers in their introductory remarks, they seldom attribute particular representations to specific image makers. As a result of this authorial erasure, multiple images from numerous creators and publishers are recomposed into an anonymous visual pastiche. The paucity of research into photography in the Anglophone Caribbean in general may account in part for this lack of contextual information.[39] Many public photography archives in the region, including the National Library of Jamaica or Department of Archives and Public Records in the Bahamas, do not identify photographs or postcards by their makers. Rather, if their collections are systematically organized at all, they are classed by subject matter. The nonattribution of these images in the archives and in publications conceals the identity of photographers, revealing a seemingly collective, impartial, and transparent visual record of the islands.

Third, the mailing addresses and postal markings, which indelibly document many cards' previously traveled international routes (which often appeared on the verso of cards), are seldom reprinted in the publication. Interestingly, the postcard's authenticity, according to Stewart, was generally based on their being purchased in or sent from their place of origin—they had to be materially connected in some way to this originating locale.[40] The absence of postal marks in contemporary publications suggests that the currently perceived authenticity of the cards resides not in their places of origin (that is, the collections of persons in Europe and the United States). Rather, by downplaying the former transnational origins of many cards, the books' creators imply that the images never left home. Perhaps these earlier routes would disrupt the "rootedness" of the postcards—their ability to speak as objective documents about the origins and history of the islands. The publications reinstate the postcard as "native" to the islands and as "national" documents, when actually both the production and consumption of the postcards was a multilayered transnational process.

Fourth, the printed captions that originally appeared on many of the postcards and the senders' handwritten messages have often been eclipsed in the republication of these materials, as books generally do not reprint the back of the cards. By concealing the earlier personalized reading of the cards, the postcards recirculate without traces of their previous use, their former

interpretations. This erases the history of the cards as sites where competing interpretations sometimes coexisted, where tropicalization was still in process and protested, where visual representations were explicitly open to subjective rather than objective interpretation.

The contemporary picture book authors' own printed comments, however, may be viewed as a new form of handwriting, the assertion of another private inscription on the postcard archive. The authors' own "handwriting," in this instance the more indelible and authoritative form of the printed word, claims possession of the postcards as evidence of their past. Unlike the singular personal inscription of the cards by early travelers, however, the authors strive toward a more collective reclamation of the images, as is evident in the constant referral to "our past" in the publications. To authenticate the postcards as objective documents of a collective past, however, the representations could not bear traces of their previous privatization by travelers.

That the earlier caption or handwriting could disrupt the easy appropriation of these postcards into contemporary narratives of the picturesque past is evident in what appears to be the deliberate erasure of a caption on a postcard republished in *Nostalgic Nassau* (figure 17.4). The authors reprinted a version of Sands's "Two Natives" postcard, but hid its caption, overlapping it with another card. If the old caption had remained, the majority black population in the Bahamas might find it difficult to interpret such an image as evidence of the "good ole days." It might even (re)provoke local black contestation of the representation of race in postcards and resentment of the racist practices so common during the era in which they were produced. Preempting this possibility, the authors erased the old caption. Not unlike early postcard producers, who retouched or changed their captions in an attempt to make the image work for its touristic cause, this action marked an attempt to control the meaning of the cards, although now by removing a caption rather than adding one. The erasure also calls attention to the authors' self-conscious and active role in selecting and recollecting the past. Like tourists picking postcards of the Anglophone Caribbean to remember their travels, the books' producers choose particular representations to reconstruct the islands' history.

These authors not only selectively tell the history of the islands through their choice of postcards, but they attempt to steer the meaning of the postcards for other viewers by not allowing viewers the opportunity to view postcards in their historically layered complexity. Some of these organizational and contextual erasures may be attributed to the particular publica-

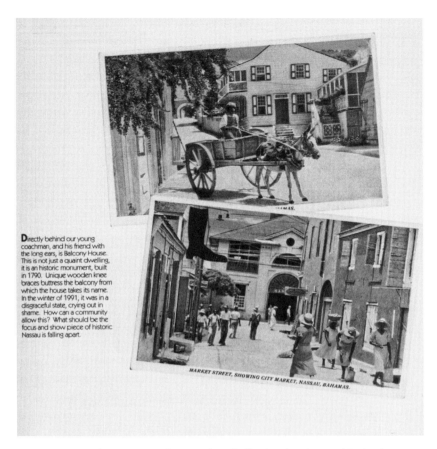

Fig. 17.4. Cropped "Two Natives" postcard, in Shelley Boyd Malone and Richard Campbell Roberts, *Nostalgic Nassau: Picture Postcards, 1900–1940* (Nassau: n.p., 1991), 16.

Within the image:

Directly behind our young coachman, and his friend with the long ears, is Balcony House. This is not just a quaint dwelling, it is an historic monument, built in 1790. Unique wooden knee braces buttress the balcony from which the house takes its name. In the winter of 1991, it was in a disgraceful state, crying out in shame. How can a community allow this? What should be the focus and show piece of historic Nassau is falling apart.

MARKET STREET, SHOWING CITY MARKET, NASSAU, BAHAMAS.

tion genre of the coffee-table picture book. Few picture books encumber their glossy pages with in-depth explanatory texts or feature the admittedly unexciting back of postcards. Indeed, Alloula's book is rare in that it is simultaneously a picture book and scholarly text—dedicated to the memory of Roland Barthes no less. (Its miscegenational form has in fact drawn the wrath of many academics.)[41] In short, any analysis of the books must take into consideration the expectations and limits of the publication form and its intended popular audience. This having been said, within a broader history of West Indian postcards, the picture books tend to ventriloquize the earlier intended meaning of the cards, precisely as they silence the contested

interpretations of these representations, which were sometimes inscribed on the postcards. In other words, while postcards of the islands have historically been sites over which, and on which, competing, ambivalent, and opposing images and interpretations of the islands battled for significatory supremacy, the content and form of these contemporary publications highlight the imperatives and narratives of early postcard producers. The questions remain: whose stories do these new narratives of the past tell? Who precisely frames the publications for public consumption, and to what end?

Revealingly, the creators of all these books and the most avid collectors of postcards and photographs in the Bahamas and Jamaica are (with few exceptions) all from the white elite classes of these societies. The newly published series of old postcards of the Bahamas, *Back Then . . . Bahamian Style*, were also reprinted from "the private albums of old Bahamian families," according to the jacket of the images. ("Old Bahamian" commonly denotes white moneyed Bahamian families in the context of the Bahamas.) Tellingly, postcards, even in more contemporary times, continue to remain out of the hands of the black population.

The racial and class backgrounds of the collectors, although not determining factors, do provide some perspective on their possible interest in and use of these colonial and touristic representations. Significantly, under colonial rule generally, and the race and class hierarchies institutionalized under this system, white elites garnered economic and political privileges on the islands, occupying one of the highest rungs on the social ladder (under British colonial elites). Members of the social group were also often the economic and social benefactors of, and supporters of, tourism and used the industry (and postcards) to cement their ties to empire and the modern world. With the transition to independence in some British colonies, during the 1960s and early 1970s (Jamaica became a nation in 1962, Barbados in 1966, and the Bahamas in 1973), the white elite still remained disproportionately influential politically and economically on many of the islands.[42]

However, in the anticolonial and nationalist movements that powered the march toward independence and in the first decades of self-governance in these Anglophone Caribbean nations, typically the long-devalued history and cultural contributions of African-Caribbean populations came to the fore both in searches for national culture and in new social histories on the region.[43] This shifting emphasis on black cultural practices and historical research often left the "white minority" on the margins of national culture and "peripheralised in historical discourse" in these societies.[44] The more recent

republication of postcards may be viewed as a subtle recentering of the history of white minorities, a shift of the historical spotlight back on the era of colonial and white political rule.

Given this social, cultural, and historical background, perhaps it is not surprising that white collectors would be attracted to images of the colonial era and the heyday of tourism and would nostalgically position these representations as "the good days." Of course, not all collectors and compilers of these books aim consciously to venerate the colonial past. Indeed, they may simply organize the books, their recollections, based on their own experiences and understandings of the past (their "private albums"), revisiting, visualizing, and even celebrating their recently neglected histories from their own perspectives. Through their published postcard collections they can re-create the social world that they, or their families before them, once inhabited. The publications may be viewed very literally as private albums, personal visual records, of the past. Joseph Abdo Sabga, the author of a postcard book on Trinidad, concedes as much when he prefaces his publication with the words: "I hope that you will find this selection to be an interesting one, bringing back fond memories, and acting as a personal album on a Journey of Memories."[45]

Typically, this private commemoration of the good old colonial days, however, is seldom presented as a select view of the history of the islands but rather as a journey of memories on which all viewers can personally embark. As such the books often posit that socially and economically society as a whole was better off during colonialism. Regardless of the various authors' motivations, when most of the publications seem to re-present history from similar (white elite) perspectives, this version of history has become reified. In this way, as Farmer points out, many of these publications engage in and authorize a kind of "romantic amnesia, for in fact 'the good ole days' weren't that good for many members of these societies."[46]

The picturesque ideal, which many postcards of the islands conjure, was created as part of and against the backdrop of the social and political repression of the majority of the population. The images presented on postcards obviously gloss over the conditions of segregation and discrimination under which much of the islands' inhabitants suffered during colonialism. The same hotel that Malone and Roberts picture, for example, and recall nostalgically with the words "thanks for the memories, dear lady," was described by black Bahamian suffragette (and Development Board critic) Doris Johnson as "the symbol of white superiority" in her recollections, *The Quiet Revo-*

lution in the Bahamas.[47] The hotel was one of the last establishments desegregated in Nassau. Thus the colonial nostalgia in which many of these books engage proffers a very select version of history that can naturalize and neutralize the violence of colonialism and tourism, presenting it to contemporary audiences as an ideal period in their past. In this process, the same images used to sell the islands to a tourist clientele a century ago have more recently been reemployed to sell this colonial past to the islands' inhabitants.

These books, which celebrate the colonial era, must be further contextualized within a wider sentiment of British colonial nostalgia that has pervaded much of the Anglophone Caribbean region (and other areas) in recent times, across race and class. As historian Barry Higman contends in his historiography of the Anglophone Caribbean, "In the English-speaking Caribbean, the not-too-distant past for which some feel a nostalgic hankering is generally represented by a world in which crime and violence were less common, food cheaper, manners more polite, and the family unit stronger. Those were the good old days."[48] Higman found that many local contributors to a *Nostalgia* column in the *Daily Gleaner* in the 1990s in Jamaica recalled the colonial era fondly, and associated the "good old days" with British colonial rule particularly. Such structures of longing exist among many classes of Jamaican society, from white Jamaicans to the island's black working-class population, including a former Universal Negro Improvement Association member. *Nostalgia* commentators described the colonial era invariably as a time when "things were plentiful," "food and everything was cheap," "everything was better run," and when "no Jamaican ever lost a single penny due to bank failure."[49] (Higman goes on to point out that as early as 1848 the Planters' Bank on the colony failed.) Higman concludes that disillusionment with contemporary socioeconomic and political predicaments in Jamaica is likely a major contributing factor in this general nostalgia for a colonial past.

Although Higman does not go into great detail about the sources of this postcolonial discontent, multiple local economic and social crises may have inspired this widespread nostalgia in Jamaica and in other Anglophone Caribbean countries. The 1990s saw the collapse of the financial sector in Jamaica with many of the island's leading banks closing their doors and the Jamaican dollar falling to all-time lows. The prospect of higher gasoline prices led to rioting in 1999. Escalating murder rates and violent crimes remain dramatic indicators of wider social discontent, disfranchisement, and desperate poverty. These high murder rates and incidents of social unrest

have, in turn, threatened Jamaica's number-one earner of foreign revenue, tourism, adding another economic blow to an already faltering economy. Any local social disturbance on the island registers high on the Richter scale of the international press, further shaking Jamaica's venerable and vulnerable tourist trade. The emphasis on societal order and touristic safety remains as high in the maintenance of the island's tourism image now as it did some hundred years ago, if not more so.

The story of Jamaica in the 1990s—increased crime, poverty, and economic uncertainty—echoes to some extent that of many other islands in the region. Although the financial and social forecast is not quite as dismal elsewhere in the Anglophone Caribbean, approximately thirty to forty years after independence, many people express disenchantment with current economic and social conditions. The increased influence of multinational corporations, international monetary boards, and developmental agencies in the region has also ushered in a new and uncertain economic future for the postcolonies. In the face of this social instability, perhaps unsurprisingly, residents from many walks of life cast a rose-colored glance at a past when (they perceive) these current social conditions did not exist.

These early twentieth-century images, which picture the touristic ideal of an ordered and orderly Caribbean society that was safe for travelers, are likely so popular in recent times because they offer a vision of a disciplined society on the islands at a moment when crime and violence (manifested even in riots on some islands) seem to reflect anything but social order. Indeed, postcards enable and encourage the perpetual consumption of the past, especially when contemporary circumstances are too "looming" or "alienating."[50] The souvenir's "function is to envelop the present within the past. Souvenirs are magical objects because of this transformation."[51] Philip Sherlock's introductory remarks to the postcard book, *Jamaica: The Way We Were*, suggest that the postcards serve this function of temporal escape in the contemporary Anglophone Caribbean: "Each postcard flies us back into years we never knew. . . . We experience the nostalgia of generations and Jamaica—The Way We Were becomes Aladdin's Cave."[52] In this way the image world of the Caribbean created on postcards does not function so differently from how it did for tourists decades ago, in that the postcards provide a visual escape to a seemingly ideal premodern location and past time removed from the current pressures or predicaments of contemporary society.

Even more than functioning as objects of the past, contemporary re-

appraisals of the postcards are about refashioning futures. The postcards recirculate to inspire "magically" the transformation of postcolonial society into this ideal. These publications narrate these postcards of an orderly Caribbean society as "our history" in order to make them parts of the inhabitable dream of the future for these Caribbean societies. This suggestion seems substantiated in Sherlock's closing remarks: "Imagination takes wing and we set off into a future, hoping that some day what we imagine will become actuality."⁵³ By positioning the disciplinary societal ideal as the history of the islands, as the once real state and condition of the islands in the past, the authors suggest that such an orderly society is an obtainable reality or possibility for contemporary society in the near future.

A letter to the *Daily Gleaner* from a Jamaican resident, Dawn McDowell, cited in Higman's analysis of nostalgia, makes this hypothesis about the connections between the touristic images of Jamaica in the past and hopes for a contemporary return to this ideal in the future more intelligible. Higman paraphrases McDowell's recollection at length:

> *"Not so long ago Jamaica was a beautiful place, and Jamaicans were a compassionate people."* The island's future, she said, "looked extremely promising on Independence Day in 1962. Even though I was not around, by hearsay and fact, I can state categorically that this was true. Books on Jamaican history tell of that era." When talking to her grandmother about "the good ole days," the growth of crime was a constant topic, linked to materialism and global changes in technology. *If only people would do good, she believed, Jamaicans could "regain our reputation as being the little island paradise that we once were. . . . knowing that we have a history to be proud of."*⁵⁴

McDowell defers to the recent past, "not so long go," in what turns out to be an indictment of the present and a prayer for the future. She also refers to Jamaica's former status as an island paradise, citing this as a historical fact. Even though McDowell first uses the words "our reputation" as being the little island paradise (suggesting how Jamaica was known, as opposed to how it was), she quickly asserted that the reputation as paradise was indeed real. The statement emphasizes the complex ways that touristic images of "beautiful Jamaica" as an orderly paradise at this moment in time are reinstated as historical fact and not connected to the construction of the island's tourism image.

McDowell's reflections on the island's paradisiacal past, however, ultimately end in a commentary and prescription for contemporary Jamaican

society. She expresses faith that if people could "do good" this "beautiful place" would once again return. Her view of "not so long ago" bears direct relation to contemporary society and her belief that the paradisiacal ideal of the island is an obtainable reality and goal for contemporary Jamaica.

In light of the history of the image world of tourism and its effects on the creation of an orderly and safe space for tourists, it is significant that McDowell asserts that if only local residents "could do good," that if only they behaved in certain ways, paradise would return to the island. In other words, while on some Anglophone Caribbean islands inhabitants have long been encouraged to behave in certain ways for tourists or were removed if they disrupted the desired picturesque order of the tourist landscape, here the writer uses the touristic ideal of the past to reissue a call for good and orderly behavior on behalf of the island's population in the present. Her comment may also be constructively related to Yates's commentary about an "orderly and diligent Barbadian society." These contemporary recuperations of an orderly Caribbean past confirm that the postcards that once were used to project a disciplined and safe image of the islands for tourists are more recently related to a contemporary desire for an orderly and safe society for the islands' residents.[55]

The picturesque and orderly ideal of the Anglophone Caribbean past represented in these books may be compared to what Mike Wallace refers to as "Mickey Mouse history,"[56] the re-creation of the past as clean, wholesome, and a world without conflict, as typified in Disneyland's utopian re-creation of Main Street.[57] Presentations of the Anglophone Caribbean through postcards create a similar deferment to the past as an ideal period. However, instead of physically creating an improved version of the past in the present, they rely on the use of past representations (images that were ideal representations of the islands at the threshold of the twentieth century) in the present to reconfigure historical memory about the islands. Unlike Mickey Mouse history, which, Wallace argues, inspires a certain passivity, "invites acquiescence to what is," and promotes "a way of not seeing and—perhaps—a way of not acting,"[58] the picturesque representations of the past in the context of the Anglophone Caribbean encourage viewers to envision the past and inspire action, a certain type of behavior needed to transform the islands into their orderly representational counterpart.

This use of a paradisiacal past to inspire a sense of a shared history, "a history to be proud of," according to McDowell, and to urge fellow citizens to "do good," recalls Homi Bhabha's descriptions of the pedagogic and

performative function of narratives of nation.[59] Although McDowell's remarks and the contemporary postcard books are not produced by the state per se (even though they use images originally sanctioned by the colonial state), they all aim to foster a sense of a collective nation partly based on the notion of a shared paradisiacal past, "our history," or "the way we were." Bhabha points out that often the idea of nation is performed or mobilized through these appeals to a shared origin, past, or through representations of the landscape "as the inscape of national identity."[60] Such narratives serve a pedagogic function, inspiring national affiliation and civic forms of behavior, that is, "doing good." In other words, contemporary recollections (visual and otherwise) of a picturesque past aim to narrate an idea of the postcolonial nation as a place that was once (and can be once again) an orderly society, to spur public sentiment, and (re)create the well-ordered and disciplined society visualized in early touristic representations.

NARRATING THE BLACK PAST: POSTCARDS AND
"THE MAKING OF HISTORY IN THE FINAL INSTANCE"
While such socioeconomic considerations may shed light on the contemporary currency of these representations, of even greater interest here are the deeper epistemological consequences of this postcard nostalgia on history and popular memory, repercussions even more pronounced in the use of postcards in "history in the final instance": scholarly historical accounts. Continuing the tradition of coopting the postcard into multiple and even opposing narratives, in addition to their enlistment in the script of colonial nostalgia and the recovery of the history of "white minorities," the postcards have also become central sites in the project of postcolonial reconstructions of subaltern histories. More specifically, historians interested in retelling, rewriting, and reconstituting the social history of the islands' black (and to a lesser extent Indian) populations have also turned to photographs and tourism-oriented postcards in their publications. Faced with the difficult task of excavating the black past in the absence of many material artifacts or local written narratives, scholars have placed a heavy burden on photographs, using the images as proof of the historical significance of black subjects, indeed, of their history as historical subjects. In order to fill in the gaps, the silences, and erasures in written archives on the region, Caribbean scholars drew from the same representational pool of colonial representations as the postcard book creators.

While many Caribbean scholars interested in narrating a history "from

below" carefully and critically sifted through textual colonial archives, some of the same scholars employed visual sources as transparent reflections of the past of the islands' black histories, perhaps strategically so. This practice is widespread across the pages and even on the covers of many history books. It is evident, for example, in an invaluable social history of the Bahamas (one that has been central to my own research on the black population in the archipelago): Michael Craton and Gail Saunders's two-part history *Islanders in the Stream*.[61] Although Craton and Saunders call their readers' attention to the biases of colonial and travelers' descriptions of the islands' black population, when discussing the "pictures, adopted and augmented by postcard makers such as the Detroit Publishing Company," they praise "the unbiased eye of the camera" for its ability to "add to—and sometimes correct—written descriptions."[62] They cite Jacob Coonley, one of the photographers who created many of his photographs and postcards to promote the islands as winter tourism resorts since the 1880s, as an example of unbiased reportage. Craton and Saunders interpret Coonley's and other photographers' images of "dusty, ragged, barefoot and always smiling ordinary people" as rare records of the harsh conditions in which blacks lived on the islands. They suggest that such representations of poverty provide a truthful account of black life, precisely in contrast to touristic representations. They do not take into consideration that images of black destitution—of barefooted, barely civilized natives—were central spokes in the revolving and recurring visual mechanics of tropicalization.[63] In their efforts to readdress the racial imbalances in historical narratives, they counted on photographs to provide a countervailing window into black life at the start of the twentieth century.

In addition, Craton and Saunders employ the visual language so prevalent in tourism, particularly ways of seeing the landscape through the lens of the picturesque, in their historical reconstruction of the black past in the Bahamas. In a section subtitled "The Life and Culture of Bahamian Blacks after Slavery" they refer to "the daily passage of market women up and down Market Street" as "one of the picturesque Nassau sights," reintroducing in the context of a historical account the descriptive language often found in travel literature and touristic images.[64] Picturesqueness is thus framed not as part of the process of tropicalization—the making of the island like a tropical picture or the presentation of the market woman as picturesque—but as a quality the landscape and its people possessed in the past. In this reuse the history of photography in the production of place and disciplining of

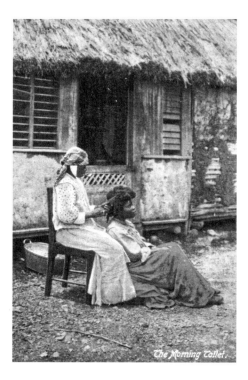

Fig. 17.5. H. G. Johnston [James Johnston], "The Morning Toilet," 1907–14, divided-back postcard, 5.5 × 3.5 inches.

people is erased. The contrived touristic image reappears, wearing the invisible mask of history, as the past as it was, not the past as it was produced.

Recent social histories have not only framed colonial and touristic images as transparent reflections of the past but have positioned them as archetypical representations of black Caribbean society. In *Cultural Power, Resistance, and Pluralism*, an effort to construct the cultural history of colonial Guyana, for instance, Brian Moore uses postcards and photographs (some of which are from Jamaica) to illustrate what he frequently describes in his captions as the "typical" customs of different racial and ethnic groups.[65] Continuing the history of captioning, recaptioning, and decaptioning (hiding captions), Moore replaces earlier captions with new ones. A photograph by James Johnston, which circulated widely on postcards with the caption "The Morning Toilet" (figure 17.5), for instance, reappears in the chapter on Afro-Creole Folk Culture next to the label "Creole Woman plaiting hair in yard."[66] The new caption transforms Johnston's photograph from a spectacle of black cleanliness for tourists to an objective illustration of blacks engaged in their daily routines. The reproduced image appears cropped into

an odd-sized L shape, which erases many traces of the figures' immediate humble surroundings and wider geographic environment. Deemphasizing the particularities of location likely more easily facilitated its appropriation as a representation of another country, Guyana, and its evidentiary value as "Afro-Creole" types. Additionally, a photograph of Johnston, the Scottish-born photographer of "The Morning Toilet," appears in the text on colonial Guyana next to the words "typical dress of the white elite males."[67] Moore's book evinces another attempt to enlist postcards into new historical narratives. The cropping, relabeling, and geographic reattribution all re-present the once "touristic" postcards in a new guise: as representative representations of the past. This newest historical recuperation of postcards and touristic photographs dramatically transforms them from objects that many black critics denounced as precisely not representative and indicative of the black population into typical representations of the black race. Such attempts to recuperate the images, to wrangle the postcards into the service of social history narratives, point to the inherent difficulties, even conundrums, of using colonial photographs to narrate black histories. Can postcards, the very representations that denied historicity to the black population, ever unproblematically yield "black history"? Can black histories ever be built on fragile postcard infrastructures?

Notes

Krista A. Thompson, "'I Am Rendered Speechless by Your Idea of Beauty': The Picturesque in History and Art in the Postcolony," in *An Eye for the Tropics: Tourism, Photography, and Framing the Caribbean Picturesque*; 252–75, 326–28. Durham: Duke University Press, 2006.

1 The National Festival Song Competition is an annual contest coinciding with Independence celebrations.
2 Philip Sherlock, *Jamaica: The Way We Were* (Kingston: Jamrite Publications, 1990); StudioArt, *Photographs 1850–1940* (Kingston: StudioArt, 1997); David Boxer, *Duperly* (Kingston: National Gallery of Jamaica, 2001).
3 "Photo Jamaica," *Caribbean Beat* (1998), 26–27.
4 Shelley Boyd Malone and Richard Campbell Roberts, *Nostalgic Nassau: Picture Postcards, 1900–1940* (Nassau: A. C. Graphics, 1991); John Gilmore, *Glimpses of Our Past: A Social History of the Caribbean in Postcards* (Kingston: Ian Randle, 1995); Ann Yates, *Bygone Barbados* (St. Michael, Barbados: Black Bird Studio, 1998); Valeria Moseley Moss and Ronald Lightbourn, *Reminiscing: Memories of Old Nassau* (Nassau: R. G. Lightbourn, 1999); Joseph Abdo Sabga, *A Journey*

of *Memories: A Memorable Tour of Trinidad and Tobago Illustrated with Picture Postcards* (Trinidad: J. A. Sabga, 2000); Ronald G. Lightbourn, *Reminiscing II: Photographs of Old Nassau* (Nassau: R. G. Lightbourn, 2005).

5 Gabrielle Hezekiah, "On the Outside Looking In?," *Fuse* 22(1) (1998): 30.

6 The phrase "other histories of photography" comes from a book by Christopher Pinney and Nicolas Peterson, *Photography's Other Histories* (Durham: Duke University Press, 2003). See also Stephen Sprague, "Yoruba Photography: How the Yoruba See Themselves," *African Arts* 12 (1978): 52–59; Clare Bell, Okwui Enwezor, Olu Oguibe, and Octavio Zaya, *In/sight: African Photographers, 1940 to the Present* (New York: Guggenheim Museum, 1996); Arjun Appadurai, "The Colonial Backdrop," *Afterimage* 24(5) (1997): 4–7; Christopher Pinney, *Camera Indica: The Social Life of Indian Photographs* (Chicago, University of Chicago Press, 1997); Heike Behrend, "'Feeling Global': The Likoni Ferry Photographers in Mobasa, Kenya," *African Arts* 33(3) (2000): 70–77; Isolde Brielmaier, "'Picture Taking' and the Production of Urban Identities on the Kenyan Coast, 1940–1980," Ph.D. diss., Columbia University, 2003.

7 See Timothy Mitchell, *Colonizing Egypt* (Cambridge: Cambridge University Press, 1988); Lucy R. Lippard and Suzanne Benally, *Partial Recall* (New York: New Press, 1992); Deborah Poole, *Vision, Race, and Modernity: A Visual Economy of the Andean Image World* (Princeton, NJ: Princeton University Press, 1997).

8 Malek Alloula, *The Colonial Harem* (Minneapolis: University of Minnesota Press, 1986), 4.

9 Howard Woody, "Delivering Views: Distant Culture in Early Postcards," in *Delivering Views: Distant Cultures in Early Postcards*, ed. Christraud M. Geary and Virginia-Lee Webb (Washington: Smithsonian Institution Press, 1998), 13. The "golden era" denotes the height of the craze in postcard collecting in the United States and Western Europe, particularly Britain.

10 In 1904 the office urged, "It is added that a great effort is being made nowadays to restore prosperity to the West Indies by making the islands better known as holiday resorts. Quite an attractive series of pictorial postcards would doubtless tend to the end in view" (*Daily Gleaner*, April 15, 1904). The "attractive" pictorial postcard was thus recruited to play a role in the restoration of prosperity to the West Indies.

11 Companies specializing in transportation, such as the United Fruit Company; Elder, Dempster and Company (owners of the Imperial Direct Line); the Hamburg American Line; the Royal Mail Steam Packet Company; and Cunard Steamship Line, to name just a few, created postcard lines on Jamaica. The Cunard Steamship Line, the Florida East Railway Line, and Munson Lines published cards of the Bahamas. Local photographers, pharmaceutical companies, and mercantile elites, who owned businesses in the ports, also produced and distributed their photographs as pictorial postcards. For example, the City Pharmacy in Nassau published postcards. In Barbados several postcard pho-

tographers, Mr. Gibson and W. L. Johnson, worked for pharmacies located on Broad Street (near where passenger ships docked). Thanks to Kevin Farmer (personal interview, May 15, 2001, Bridgetown, Barbados) for this information on photographers in Barbados.

American and British postcard companies, without direct local business interests in tourism, also sent representatives to the region. The American Detroit Publishing Company and the British postcard companies Raphael Tuck and Sons and Valentine and Sons also dispatched photographers to the British West Indies.

In the case of Jamaica, several photographers originally hailed from outside of the islands: James Johnston (from Scotland), the Duperly family (originally from France but with several generations of printers and photographers in Jamaica), H. H. Cousins (from England), and H. A. Richards (a publisher from Hungary). In the Bahamas Jacob Coonley, W. H. Illingworth, and William Henry Jackson were all photographers from the United States who created postcards of the islands.

12 *Daily Gleaner*, January 27, 1905; *Daily Gleaner*, January 2, 1904.

13 Glory Robertson, "Some Early Jamaican Postcards, Their Photographers, and Publishers," *Jamaica Journal* 18(1) (1985): 13.

14 Especially important ports included New York, Miami, Palm Beach, Boston, Philadelphia, Baltimore, Liverpool, Glasgow, Southampton, and London.

15 Farmer interview.

16 Anne Maxwell notes that at the start of the twentieth century many sitting rooms in British households contained these photographic albums into which travelers would chronicle their journeys and then publicly display their collection of views. Victorian collectors did not simply amass photographic objects but, following the taxonomies and hierarchies of scientist and botanist, often arranged these postcards and photographs into series or sets (Anne Maxwell, *Colonial Photography and Exhibitions: Representations of the "Native" and the Making of European Identities* [London: Leicester University Press, 1999], 11). In this process a single card often formed a new dialogue with its immediate photographic neighbors.

17 Susan Stewart, *On Longing: Narratives of the Miniature, the Gigantic, the Souvenir, the Collection* (Durham: Duke University Press, 1993), 138.

18 The "Barbarian" postcard resides in the postcard collection at the Barbados Museum and Historical Society.

19 *Nassau Guardian*, September 16, 1908.

20 *Daily Gleaner*, January 31, 1905.

21 *Nassau Guardian*, June 29, 1911.

22 As John Gilmore calculates, "The usual cost of a picture postcard in the Caribbean was probably the same as it was in Britain in the early years of the twentieth century: 'Penny plain, or two pence coloured'—two cents or four cents. It might cost only [a] halfpenny to send a postcard locally, or a penny to send

it anywhere else in the world (1 or 2 cents), but for a labourer who was lucky to get 24 cents for a day's work, the cost of a card and mailing it would have seemed a lot of money" (Gilmore, *Glimpses of Our Past*, viii). According to ads in Jamaica "12 Selected varieties" of postcards could be "sent postfree for ten-pence" (*Daily Gleaner*, January 13, 1905).

23 Antonia Williams, *West Indian Journal*, University of West Indies Library, Kingston, Jamaica (1908–1909).

24 Daisy Forbes, personal interview, December 15, 2000, Nassau, Bahamas.

25 *Daily Gleaner*, January 18, 1915.

26 *The Tribune* (Nassau, Bahamas), January 30, 1956.

27 Michel-Rolph Trouillot, *Silencing the Past: Power and the Production of History* (Boston: Beacon Press, 1995), 26.

28 Alloula, *The Colonial Harem*, 5.

29 Sherlock, *Jamaica: The Way We Were*.

30 Malone and Roberts, *Nostalgic Nassau*, 1.

31 Yates, *Bygone Barbados*, ix.

32 Yates, *Bygone Barbados*, ix.

33 Basil Smith, *The Bahamas in Black and White: A Pictorial Review of the Golden Age of Tourism in the Bahamas* (Nassau: Consellors, 2000), 9–10.

34 Yates, *Bygone Barbados*, ix; emphasis added.

35 Malone and Roberts, *Nostalgic Nassau*, 46.

36 Malone and Roberts, *Nostalgic Nassau*, 27.

37 Malone and Roberts, *Nostalgic Nassau*, 1.

38 Malone and Roberts, *Nostalgic Nassau*, 1.

39 David Boxer's groundbreaking research in *Duperly*, for example, promises to transform the field of research into photography and the photographic archives.

40 Stewart, *On Longing*, 138.

41 For critiques of Alloula, see Annie Coombes and Steve Edwards, "Review of *From Site to Sight, Anthropology, Photography, and the Power of Imagery*," *Art History* 12 (1989): 510–16; Rey Chow, *Writing Diaspora* (Bloomington: Indiana University Press, 1993).

42 Howard Johnson and Karl S. Watson, *The White Minority in the Caribbean* (Kingston: Ian Randle, 1998), x.

43 Historian John Aarons reiterates that "a central tenet of the cultural policy pursued by all governments since independence has been the necessity of re-dressing 'the historical imbalance' caused by this period of colonial rule. This involved bringing the 'African experience' to the forefront of contemporary life by a variety of measures" (John Aarons, "The Cultural Policy of the Jamaica Government since Independence," *Jamaica Historical Review* 20 [1998]: 38). See also Deborah Thomas, *Modern Blackness: Nationalism, Globalization, and the Politics of Culture in Jamaica* (Durham: Duke University Press, 2004).

44 Johnson and Watson, *The White Minority in the Caribbean*, 1.

45 Sabga, *A Journey of Memories*, xii.

46 Farmer interview.

47 Doris Johnson, *The Quiet Revolution in the Bahamas* (Nassau: Family Islands Press, 1972), 10.

48 Barry Higman, *Historiography of the British West Indies* (London: Macmillan, 1999), 150.

49 Higman, *Historiography of the British West Indies*, 115.

50 Stewart, *On Longing*, 139.

51 Stewart, *On Longing*, 151.

52 Sherlock, *Jamaica: The Way We Were*, 6.

53 Sherlock, *Jamaica: The Way We Were*, 6.

54 Higman, *Historiography of the British West Indies*, 151; emphasis added.

55 It may be possible to interpret the actual process of collection by some residents as a response to the perceived disorder of contemporary postcolonial societies. In organizing the "chaos" of their collections (using representations that were precisely about the ordered tourist landscape), the owners of these materials can create an ideal order. This process allows them to structure, shape, and control the past in ways that they cannot control the present, the seeming disorder of postcolonial society. For more on the act of collecting postcards see Naomi Schor, "*Cartes postales*: Representing Paris 1900," *Critical Inquiry* 18(2) (1992): 197.

56 Mike Wallace, *Mickey Mouse History and Other Essays on American Memory* (Philadelphia: Temple University Press, 1996).

57 Although the postcard books are very different forms of cultural representation from Disney's amusement parks, both seem invested in convincing contemporary audiences that the turn of the century was an ideal period in their respective countries' histories and create a nostalgia for this era. Wallace finds, for instance, that Disney's Main Street presents late nineteenth-century America as "one of the greatest optimistic periods of the world, where we thought progress was great and we all knew where we were going. [Main street] . . . reflect[s] this prosperity, that enthusiasm" (John Hench, Disney designer, quoted in Wallace, *Mickey Mouse History*, 137). Main Street not only represents an ideal period of economic prosperity, but as a physical space it signifies an environment that was clean, tidy, orderly, and without crime, in striking similarity to nostalgic reconceptions of the Anglophone Caribbean past.

58 Wallace, *Mickey Mouse History*, 149. Wallace argues that Disney, by presenting history as a pleasantly nostalgic memory "diminishes our capacity to make sense of our world through understanding how it came to be. Without a sense of the matrix of constraints and possibilities they have inherited viewers also lose a sense of themselves as agents in the present" (*Mickey Mouse History*, 149).

59 Homi K. Bhabha, ed., *Nation and Narration* (London: Routledge, 1990), 297.

60 Bhabha, ed., *Nation and Narration*, 295.

61 Michael Craton and Gail Saunders, *Islanders in the Stream: A History of the Bahamian People*, vol. 1 (Athens: University of Georgia Press, 1992), Michael

Craton and Gail Saunders, *Islanders in the Stream: A History of the Bahamian People*, vol. 2 (Athens: University of Georgia Press, 1998).

62 Craton and Saunders, *Islanders in the Stream*, vol. 2, 213.

63 John Gilmore argues that poverty in the context of Caribbean postcards was likely seen as picturesque (see Gilmore, *Glimpses of Our Past*, ix).

64 Craton and Saunders, *Islanders in the Stream*, vol. 2, 106.

65 Brian Moore, *Cultural Power, Resistance, and Pluralism: Colonial Guyana, 1838–1900* (Montreal: McGill-Queen's University Press, 1995). See photographs, for example, on pages 25, 166, and 206.

66 Moore, *Cultural Power, Resistance, and Pluralism*, 96.

67 Moore, *Cultural Power, Resistance, and Pluralism*, 25.

Fanon, Algeria, and the Cinema:

The Politics of Identification

Robert Stam

Frantz Fanon, the West Indian–born, French-educated writer who practiced psychotherapy and revolution in North Africa, is best known as the eloquent critic of colonial oppression and as the astute diagnostician of the twinned pathologies of whiteness and blackness. Recent years have seen a resurgence of interest in his work, with important writing by Edward Said, Homi Bhabha, Benita Parry, Diana Fuss, Anne McClintock, Henry Louis Gates, Neil Lazarus, Kristin Ross, Ella Shohat, and Christopher Miller. A kind of posthumous wrestling over Fanon's legacy has generated lively debates about the gendered politics of the veil, the validity of Fanon's "therapeutic" theory of violence, and the relative merits of the psychoanalytically oriented *Black Skin, White Masks* versus the revolutionary socialism of *The Wretched of the Earth*. In a postnationalist moment, queer and feminist readings have focused on Fanon's blind spots concerning forms of oppression rooted not in nation and empire but in gender and sexuality. What, contemporary analysts are asking, now seems archaic and retrograde in Fanon, and what anticipatory and prescient? After pointing to the broad contemporary relevance of Fanon's theories, I would like to explore the multifaceted relationship between Fanon and the cinema, as a prelude to the analysis of a film based directly on his life and work: Isaac Julien's *Black Skin, White Masks*.

In a postnationalist era, we have become more aware that Fanon was hardly infallible: he sometimes romanticized violence, idealized the peasantry, knew little about Arabic or Islamic culture, and had severe blind spots concerning gender and sexuality. Yet a contemporary rereading of Fanon also reveals his extraordinary prescience as an important precursor for a number of subsequent intellectual movements; in his lapidary phrases we find the germ of many subsequent theoretical developments. His anti-

colonialist decentering of Europe in *The Wretched of the Earth*[1] can now be seen to have both provoked and foreshadowed Jacques Derrida's claim that European culture has been "dislocated," forced to stop casting itself as the "exclusive culture of reference."[2] Fanon, along with allied figures like Aimé Césaire and Amilcar Cabral, reversed the currents of intellectual exchange: the Third World was generating that auratic phenomenon called "theory." What Fanon called "social therapy," similarly, can now be seen to have anticipated the "antipsychiatry" of such figures as David Cooper, R. D. Laing, and Felix Guattari. How can Sigmund Freud's "talking cure" facilitate a transition to "ordinary unhappiness," Fanon asks, when social oppression itself generates "*extra*ordinary unhappiness"? How can psychoanalysis help the analysand adjust when colonialism provokes unending maladjustment? How can patients feel at home in their environment when colonialism turns the colonized into strangers in their own land? How can psychoanalysis cure mental distress when colonialism itself triggers veritable epidemics of mental distress? Isn't psychoanalysis, in such a context, a matter (to recycle Brecht's analogy) of rescuing the drowning rather than repairing the broken dam?

Although Fanon never spoke of Orientalist discourse, similarly, his critiques of colonialist imagery provide proleptic examples of anti-Orientalist critique à la Edward Said. When Fanon argued that the colonizer "cannot speak of the colonized without having recourse to the bestiary," he called attention to the "animalizing trope," the discursive figure by which the colonizing imaginary rendered the colonized as beastlike and animalic. Within colonial binarism, Fanon writes in *The Wretched of the Earth*, "the settler makes history; his life is an epoch, an Odyssey," while against him "torpid creatures, wasted by fevers, obsessed by ancestral customs, form an almost inorganic background for the innovating dynamism of colonial mercantilism."[3] Here Fanon anticipates Johannes Fabian's critique of classical anthropology's projection of the colonized as "allochronic," as living in another time, mired in an incapacitating "tradition" seen as modernity's antithesis. For Fanon, in contrast, the colonizer and the colonized are contemporaneous and coeval. Rejecting the "progressive," Eurocentric paradigm of linear progress, he insists in *The Wretched of the Earth* that "we do not want to catch up with anyone." It was in this same spirit that Fanon criticized psychoanalyst Octave Mannoni, who argued in his *Prospero and Caliban: The Psychology of Colonization* that colonized peoples suffered from a "dependency complex" that induced them to identify with the fatherlike colonizer.[4]

For Fanon, in contrast, the colonized did not necessarily identify with the colonizing Prospero, but rather with the rebellious Caliban. (Fanon's fellow Martinican and mentor, Aimé Césaire, pursued this same identificatory logic in his version of Shakespeare's *Tempest*, where Caliban becomes Caliban X, the militant who denounces Prospero for teaching him to jabber his language well enough to follow orders but not enough to study science.)

Fanon can also be seen as an advance practitioner of cultural studies. Although he was clearly never part of an explicit cultural studies project, Fanon already in the 1950s took all of cultural life as legitimate objects of study, analyzing a wide array of phenomena—the veil, dance, trance, language, radio, film—as sites of social and cultural contestation. Although he didn't use the talismanic phrase *cultural studies*, he certainly practiced what now goes by that name. Indeed, his practice casts suspicion on the conventional Anglo-diffusionist genealogical narrative that cultural studies began in England and then spread elsewhere. In a different perspective, when James Baldwin spoke of film reception, when Roland Barthes spoke of the mythologies of toys and detergents, when Leslie Fiedler anatomized popular cultural myths, when Henri Lefebvre analyzed the politics of everyday life, when C. L. R. James analyzed cricket, and when Fanon spoke of the differentiated spectatorship of Tarzan, all in the 1950s and 1960s, they were doing cultural studies *avant la lettre*.

Although Fanon has often been caricatured as a racial hard-liner, he in fact anticipated the antiessentialist critique of race. "Lumping all Negroes together under the designation of 'Negro people,'" Fanon writes in *Toward the African Revolution*, "is to deprive them of any possibility of individual expression." In 1939, he asserts, no West Indian "proclaimed himself to be a Negro," it was only the white man who "obliged him to assert his color."[5] In Fanon's relational view in *Black Skin, White Masks*, the black man is obliged not only to be black, but "he must be black *in relation to* the white man."[6] The black man, as Fanon put it, is "comparison." Nor was colonialism essentially a racial matter; colonialism, he argued, was only *accidentally* white. (In confirmation of Fanon's point, we can cite the case of Ireland, the first British colony, which was subjected to the same processes of otherization that other, later, epidermically darker colonies also suffered.) For Fanon, racialized perception was inflected even by language; "the black," he wrote in *Black Skin, White Masks*, "will be the proportionately whiter in direct relation to his mastery of the French language."[7] Fanon thus saw race as languaged, situated, constructed. "When the West Indian goes to France," he

wrote, "his phenotype undergoes a mutation."[8] As someone who became aware of his own blackness only in France, and who was regarded by some Algerians as culturally European (i.e., white), Fanon could not *but* have a lively sense of the conjunctural, constructed nature not only of racial categorizations but also of communitarian self-definition. Yet for Fanon the fact that race was on some level "constructed" did not mean that antiracism was not worth fighting for. In the era of the "posts," we know that social identity is constructed, but the more relevant question is by whom and by what social forces is it constructed, and to what ends. Fanon's was a mobilizing, rather than a quiescent, sense of construction, one that embraced fluidity but without abandoning the struggle for such constructs as black solidarity, the Algerian nation, and Third World unity.

Fanon can also be seen as the precursor of what is variously called dependency theory and systems theory. Fanon's claim in *The Wretched of the Earth* that "European opulence is "literally scandalous" because it "comes directly from the soil and the subsoil of the underdeveloped world," anticipated in stereographic, almost aphoristic, form the arguments of later theorists such as Andre Gunder Frank, James Petras, and Fernando Henrique Cardoso (for Latin America), Walter Rodney (for Africa), and Manning Marable (for Afro-America).[9] Fanon's remark that "objectivity always works against the native," similarly, provides a historically precocious example of the media critique that became so pervasive during the 1960s and 1970s. Speaking more generally, Fanon's key anticolonial concepts reverberated outward in many directions, impacting on feminism (which "gendered" and reinvoiced Fanon's three-stage theory of disalienation), situationism (which denounced the metaphorical colonization of everyday life), and sociological radicalism (which saw French peasants as "the wretched of the earth").

It is sometimes thought that the revolutionary Fanon of *The Wretched of the Earth* has become passé, and that only the psychoanalytic Fanon of *Black Skin, White Masks* merits contemporary attention. But the more important point is the complementarity of the two projects, the inherent relationality between the sociology of the former and the psychology of the latter. And although Fanon argued in *Black Skin, White Masks* that only a psychoanalytic interpretation could reveal the "affective anomalies" that generate black pathologies, Fanon in fact was a practicing *psychiatrist* with little practical experience of psychoanalysis. And although Fanon occasionally cited Lacan, he was not a Lacanian. As David Macey points out in his biography, Fanon departs from the basic tenets of Lacanian psychoanlysis by stressing the need

to strengthen the ego, whereas Lacan saw such an emphasis as the capital sin of American "ego-psychology."[10] Fanon also doubted the universality of the Oedipus complex, claiming that it was not to be found in the French West Indies. (Stuart Hall, in the Isaac Julien film, casts doubt on Fanon's doubt.) At the same time, Fanon himself did anticipate a discourse very much inflected by psychoanalysis, to wit, postcolonial discourse. Yet, here too he was more postcolonial in a political than in a theoretical sense, especially in his trenchant critique of nationalism in the chapter titled "Pitfalls of National Consciousness" in *The Wretched of the Earth*.

The juxtaposition of the two words *Fanon* and *cinema* triggers a veritable torrent of associations. We might think of Fanon's prose—visceral, kinesthetic, sharply imaged, hard hitting, vulcanic, incendiary, with impact on the very nerves of the reader—as *itself* cinematic. Or we might explore the cinematic "afterlife" of Fanon's work, the myriad films that were influenced by or quote Fanon, including even Mario van Peebles's *Panther*, which features a full-screen shot of the cover of *The Wretched of the Earth*. Long before *Panther*, however, the Argentinian film *La Hora de los Hornos* (Hour of the Furnaces, 1968) not only quoted Fanon's adage that "Every Spectator Is a Coward or a Traitor," but also orchestrated a constellation of Fanonian themes—the psychic stigmata of colonialism, the therapeutic value of anticolonial violence, and the urgent necessity of a new culture and a new human being. One iconoclastic sequence titled "Models" invokes Fanon's final exhortation in *The Wretched of the Earth*: "So, comrades, let us not pay tribute to Europe by creating states, institutions and societies in which draw their inspiration from her. Humanity is waiting for something other than such an invitation which would be almost an obscure caricature."[11] As the commentary derides Europe's "racist humanism," the image track parades the most highly prized artifacts of European high culture: the Parthenon, "Dejeuner sur l'Herbe," Roman frescoes, portraits of Byron and Voltaire. In an attack on the cultural hierarchies of the spectator, the most cherished monuments of Western culture are equated through lap-dissolves with the commercialized fetishes of consumer society. Classical portraiture, abstract painting, and Crest toothpaste are leveled as merely diverse brands of imperial export.

The couplet *Fanon* and *cinema* also elicits the memory of some very influential Third Worldist cinema manifestos, most notably Solanas-Getino's "Towards a Third Cinema" and Glauber Rocha's "An Esthetic of Hunger," both of which resonate with Fanonian overtones.[12] Both stress anticolonial violence, literal/political in the case of Solanas-Getino and metaphoric/aes-

thetic in the case of Rocha. "Only through the dialectic of violence," Rocha wrote, "will we reach lyricism."[13] Indeed, Fanon's aura hovers over the entire initial phase of Third Worldist cinema, over films like Rocha's *Barravento* (1962), Carlos Diegues's *Ganga Zumba* (1963), and many other films of the 1960s and 1970s.

Here I will examine just two films deeply indebted to Fanon: Pontecorvo's *The Battle of Algiers* and Sembene's *Xala*—before moving on to Julien's *Frantz Fanon: Black Skin, White Mask*.

The Pontecorvo film, one of the many Third Worldist films portraying independence struggles, although directed by an Italian (in collaboration with the Algerians), is thoroughly imbued with a Fanonian spirit. An early European commercial feature treating anticolonial wars of liberation, the film reenacts the Algerian war for independence from France, a war that raged from 1954 to 1962, costing France 20,000 lives and Algeria significantly more (with estimates ranging from 300,000 to 1.5 million). Indeed, in an age when Arab, Muslim, and Algerian have become virtual synonyms for terrorist violence, it is important to recall that the violence in the Algerian situation had for at least a century been overwhelmingly perpetrated by the French. The French writer Victor Hugo, in *Choses Vues*, reports on an October 16, 1852, conversation with a French general in Algeria who told him that "it was not rare, during the French attacks, to see soldiers throwing Algerian children out of the window onto the waiting bayonets of their fellow soldiers. They would rip off the earrings of the women, along with the ears, and cut off their hands and fingers to get their rings."[14] A century later, during the Algerian war of independence, violence continued to be disproportionately French; their actions included air strikes on civilians, terror bombs in the casbah, collective punishments, and *ratonnades* (rat hunts) in which racist Europeans took revenge on any Arab they happened to meet. At times, the killing of a single French soldier would lead to destruction of an entire village. Indeed, the French "pacification" campaign resulted in the destruction of eight thousand villages. It is this disproportionate and asymmetrical violence that is forgotten when critics speak as if Fanon were the partisan of violence for its own sake. By focusing only on the reactive terrrorism of the colonized, the violence of other forms of terrorism—colonialist terrorism, state terrorism, the vigilante terrorism of the ratonnades—is rendered innocent and invisible.[15] As Ben M'Hidi puts it in the film: "Give us your planes and tanks, and we will no longer plant bombs in cafés." French intervention in Algeria was marked by horrendous massa-

cres, such as that of May 8, 1945, which resulted in 103 French dead and at least 15,000 Algerian dead (according to French official accounts) or 45,000 dead (according to Algerian accounts). Nor was French violence compensated for by civilizational benefits for the Algerians. Already in 1847, not very long after the French takeover of Algeria, Alexis de Tocqueville complained, in his *Rapport sur l'Algerie*, that "we French have rendered Muslim society much more miserable, more chaotic, more ignorant and barbarous than it was when we first encountered it."[16] Despite myths of "integration," colonialism was inherently racist. For the 1948 election, each European vote was equal to eight Algerian votes under the double electoral college, a measure designed to thwart a nationalist electoral victory. And at the moment of independence, despite the French claims of a *mission civilisatrice*, Algerians were overwhelmingly nonliterate.

A number of recent incidents and a spate of publications have brought these issues, now published in English as *The Battle of the Casbah*, to the fore.[17] In his recently published memoir, a French "Special Services" agent who served in Algeria, General Paul Aussaresses, speaks proudly of having "committed, clandestinely and in the interest of his country, actions condemned by ordinary morality, which were often illegal and therefore kept secret, such as stealing, assassinating, vandalizing, and terrorizing. I learned to break locks, kill without leaving a trace, to lie, to be indifferent to my own suffering and to that of others. . . . And all that for France."[18] In his chillingly nonchalant account, Aussaresses defends summary executions and torture in all its forms, including electric shock and near-drowning, shown in *The Battle of Algiers*. He speaks of being personally involved in the planning of a bomb plant in the casbah (much along the lines of the bombing portrayed in the Pontecorvo film), but which would have involved burning down most of the casbah by setting spilled fuel on fire. The projected death toll was seventy thousand. Aussaresses speaks as well of personally hanging the prototype of the film's Ben M'Hidi "in a manner which would suggest suicide."[19] (At the end of the book, he speaks with pride of having worked at Fort Benning and Fort Bragg for the American special services to be engaged in Vietnam.)[20] Some French intellectuals compared the impact of Aussaresses's revelations to that of Marcel Ophüls's documentary *The Sorrow and the Pity* (1969), which prompted the French to confront the similarly sordid history of Vichy collaboration.

Nor was French violence against Algerians limited to Algeria; it also took place within France itself. On October 17, 1961, the same year that

The Wretched of the Earth was first published in French, another battle took place, known as the "battle of Paris." On that day, after a peaceful Algerian protest march, the Parisian police fired machine guns into the crowd, literally clubbed Algerians to death, and threw many Algerian bodies into the Seine. A document published soon after the massacre by a tiny group of progressive policemen spoke of the bodies of the victims floating to the surface daily and bearing "traces of blows and strangulation." Six thousand Algerians were taken to a sports stadium, where many died in police custody. The official police-led coverup had it that Algerians had opened fire, that the police had to restore "law and order," and that only two people had died. Careful reconstructions of the events have established that the death toll was actually over two hundred people, with hundreds missing. The presiding police chief was none other than Maurice Papon who, according to some reports, had several dozen Algerians clubbed to death in front of his eyes in the courtyard of the police prefecture.[21] Papon was the same man accused of organizing deportations of Jews under Vichy, when he was police chief in Bourdeaux, and who had also served in the French colonial administration in the 1950s. The events have received renewed attention of late, and on October 17, 2000, a commemorative plaque was installed in Paris. Yet Papon has recently been released from prison, and his crimes against Algerians are rarely mentioned in press accounts. But the French election of May 2002, with Jean-Marie Le Pen becoming a serious candidate for president of the Republic, was also "haunted" by the war in Algeria, provoking a veritable "return of the repressed." Although its long-term origins trace back to Vichy and beyond, the movement led by Le Pen emerged in the early 1960s in the wake of what was seen as a humiliating defeat of France by Algeria. For Le Penism, the figure of the Maghrebian Arab simultaneously embodies the former colonized, the victor over France, and the immigrant "enemy." With Le Pen, the link to Algeria is very direct and personal. Le Pen was in Algeria from January to March 1957 — the period portrayed in *The Battle of Algiers* — as a lieutenant in a regiment of parachutists linked to the Massu Division. In fact, Le Pen arrived on January 7, 1957, at the height of the "battle of Algiers," just when General Massu was given full police powers by the General Governor Robert Lacoste. As part of the "antiterrorist" campaign, Le Pen was accused of various crimes. Although he admitted (in an interview in *Combat* in 1962) that he "tortured because [he] had to," Le Pen later fought off charges that he tortured and killed the Algerian Ahmed Moulay, in front of his wife, her four-month-old daughter, and their twelve-year-old son, on

March 2, 1957. Moulay was submitted to water torture (forced to drink liters of soapy water) and to electric shock. Moulay's wife, who had witnessed everything, was subsequently informed by French police that her husband had been the victim of a "settling of accounts" among Algerians. But Moulay's son, Mohammed Cherif Moulay, kept a bitter souvenir of the episode, the sheaf of a knife on which was written: JM Le Pen, ler Rep, which he subsequently donated to the Museum of the Revolution in Algiers.[22]

Banned in France and threatened by the partisans of Algérie Française, *The Battle of Algiers* offers a marked contrast with the timidity of 1960s French cinema in treating the war in Algeria. Apart from Godard's *Le Petit Soldat* (1962), which took a decidedly ambivalent stance toward the question of torture in Algeria, and apart from the brief, usually coded references to Algeria in films such as *Cléo de 5 à 7* (1962), *Adieu Phillipine* (1962), and *Muriel* (1965), most French fiction films simply ignored the Algerian war.[23] (Only a few documentaries like *Chronique d'un été* and *Le Joli Mai* managed to briefly bring the war center stage.) *The Battle of Algiers* also offers a marked contrast to the French and American films set in North Africa, where Arab culture and topography form a passive backdrop for the heroic exploits of European heroes and heroines. Whether French (*Pépé le Moko*, 1936) or American (*Morocco*, 1930; *Casablanca*, 1942), the films exploit North Africa mainly as an exotic setting for Western love dramas, a tropical decor dotted with palm trees and lazily traversed by camels. The linguistic politics of most European features set in North Africa featured Arabic only as a dull background murmur, while the "real" language was the English of Gary Cooper or the French of Jean Gabin. In *The Battle of Algiers*, in contrast, the Algerian characters, although bilingual, generally speak in Arabic with English subtitles; they are granted linguistic dignity. Instead of being shadowy background figures, picturesquely backward at best and hostile and menacing at worst, they are foregrounded. Neither exotic enigmas nor imitation Frenchmen, they exist as people with agency.

Recent publications have revealed the astonishing extent to which *The Battle of Algiers* adheres to the actual historical events. In many cases, the names of the characters and their prototypes are the same: Ben M'Hidi and Ali-la-Pointe actually existed. Elsewhere the prototypes existed but their names are changed. Yacef Saadi, the Algerian leader of the "battle of Algiers" and author of a book of memoirs about the independence struggle (*Souvenirs de la bataille d'Alger*), plays himself in the film, but under the name "Djafar."[24] Indeed, it was Yacef Saadi who first sought out Pontecorvo about

the possibility of doing the film. The French police actually did place their bombs in the Rue de Thebes, the only street in the casbah wide enough for their getaway car. The terrorist bombs were actually placed in the sites depicted: a milk bar, a cafeteria, and an Air France office. The prototype of Colonel Mathieu, the head of the parachutists, was actually named General Jacques Massu. The parachutists formed an elite unit, with their own rituals and songs, and their "romantic aura" was reinforced during the war by photo spreads in *Paris Match* and *France Soir*. Kristin Ross links the first appearance of Colonel Mathieu, in *The Battle of Algiers*, to this publicity image of Massu and the parachutists, represented as "the mythical figure of the warrior, possessed of a cold, steely, faraway gaze, a distinctively rugged camouflage uniform, sunglasses, sunburn, and a special manner of walking."[25] It was Massu who presided over the strike depicted in *The Battle of Algiers*, and who ran a powerful death and torture apparatus that "disappeared" three thousand suspects. In June 2000, a former Algerian independence fighter, Louisette Ighilahrin, accused Massu of visiting the scene where she was tortured and raped by Massu's 10th Division.[26]

But the crucial innovation of *The Battle of Algiers* did not have to do with factual accuracy: rather, it was to deploy the identificatory mechanisms of the cinema on behalf of the colonized, presenting the Algerian struggle as an inspirational exemplum for other colonized peoples. Interestingly, the issue of identification is at the heart of the work both of Fanon and of the cinema itself. For Fanon, the struggle between competing identifications and projections exists at the very core of the colonial encounter. The revolution, for Fanon, mobilizes popular identification; it exorcises the colonizing power that has occupied and settled even the intimate spaces of the colonized mind. Nation and psyche exist in a relation of homology. National revolution promotes a massive transfer of allegiance away from the metropole as introjected ideal ego. Even Fanon's celebrated "three phases" turn on the issue of identification. In the first phase (colonized assimilation), the colonized identify with the paternalistic colonizing power; in the second phase (nativist authenticity), they identify with an idealized myth of origin as a kind of Ur-mother or Ur-father; in the third phase (revolutionary syncretism), they identify with a collective future shaped by popular desire.

As Diana Fuss points out in an essay on Fanon included in *Identification Papers*, Fanon worked at the point of convergence of anti-imperial politics and psychoanalytic theory, finding a link between the two in the concept of identification.[27] The notion of identification, which "names not only the

history of the subject but the subject in history," provided Fanon with a "vocabulary and an intellectual framework in which to treat not only the psychological disorders produced in individuals by the violence of colonial domination but also the neurotic structure of colonialism itself."[28] For Fanon, identification was at once a psychological, cultural, historical, and political issue. The issue of identification also has a cinematic dimension, however, one closely linked to debates in film theory, which also speaks of identification and projection, of spectatorial positioning and suture and point of view and alignment as basic mechanisms constituting the cinematic subject. Fanon himself, interestingly, also delved into the issue of cinematic spectatorship. He saw racist films, for example, as a "release for collective aggressions." In *Black Skin, White Masks*, Fanon uses the example of Tarzan to point to a certain instability within cinematic identification: "Attend showings of a Tarzan film in the Antilles and in Europe. In the Antilles, the young negro identifies himself de facto with Tarzan against the Negroes. This is much more difficult for him in a European theatre, for the rest of the audience, which is white, automatically identifies him with the savages on the screen."[29]

Fanon's example points to the shifting, situational nature of colonized spectatorship: the colonial context of reception alters the processes of identification. The awareness of the possible negative projections of other spectators triggers an anxious withdrawal from the film's programmed pleasures. The conventional self-denying identification with the white hero's gaze, the vicarious acting out of a European selfhood, is short-circuited through the awareness of a "screened" or "allegorized" colonial gaze within the movie theater itself. While feminist film theory has spoken of the to-be-looked-at-ness (Laura Mulvey) of female screen performance,[30] Fanon calls attention to the to-be-looked-at-ness of spectators themselves, who become slaves, as Fanon puts it, of their own appearance: "Look, a Negro! . . . I am being dissected under white eyes, the only real eyes. I am fixed."[31]

Identification formed part of the very process of production of *The Battle of Algiers*. Production accounts tell us that the Algerian extras identified so much with the struggle, staged for the cameras just a few years after the events themselves, that they actually wept as they performed their grief over the destruction of the casbah.[32] More important, the film sees the events through a Fanonian anticolonialist prism, a result not only of Algerian collaboration in the filming but also of Pontecorvo's and Solinas's passionate reading of Fanon. Indeed, sequence after sequence provides audiovisual

glosses on key passages from *The Wretched of the Earth*, beginning with the film's dualistic conceptualization of a socially riven urban space. The iterative pans linking the native medina and the French city contrast the settlers' brightly lit town, in Fanon's words, "a well-fed town, an easygoing town; its belly . . . full of good things," with the native town as a "place of ill fame, peopled by men of evil repute."[33] The dividing line between these two worlds, for the film as for Fanon, is formed by barbed wire and barracks and police stations, where "it is the policeman and the soldier who are the official, instituted go-betweens, the spokesman of the settler and his rule of oppression." The contrasting treatments provoke sympathy for the Algerians. While the French are in uniform, the Algerians wear everyday civilian dress. For the Algerians, the casbah is home; for the French, it is a frontier outpost. The iconography of barbed wire and checkpoints reminds us of other occupations, eliciting our sympathy for a struggle against a foreign occupier. While never caricaturing the French, the film exposes the crushing logic of colonialism and fosters our complicity with the Algerians. It practices, in other words, a cinematic politics of identification. It is through Algerian eyes, for example, that we witness a condemned rebel's walk to his execution. It is from within the casbah that we see and hear the French troops and helicopters. Counter to the paradigm of the frontier Western, this time it is the colonized who are encircled and menaced and with whom we are made to empathize. It is with them that we are made to feel at home.

The circular flashback structure of *The Battle of Algiers* begins and ends with scenes involving the tortured Algerian who shows the way to Ali-la-Pointe's hideout. Indeed, the film is punctuated by excruciatingly painful scenes of torture. Here too Pontecorvo adheres to the historical record by calling attention to a French practice that was denounced at the time not only by Algerians but also by French leftists like Francis Jeanson, Henri Alleg, and Jean-Paul Sartre. French anticolonialist Henri Alleg spoke in *La Question* (Interrogation, 1958) of being tortured by the French paratroopers.[34] The French generals themselves, meanwhile, did not deny that they tortured; they simply argued that it was necessary. Thus the prototype for "Colonel Mathieu," General Massu, published in 1971 his self-exculpatory memoir *La vraie bataille d'Alger* (The Real Battle of Algiers), where he explicitly challenged the contestatory tone of the Pontecorvo film.[35] A recently published book by the anticolonialist Jules Roy, with the Zolaesque title *J'Accuse le General Massu* (I Accuse General Massu),[36] answers Massu's defense of torture. Roy mocks Massu's euphemisms—which

render torture as "forceful interrogation"—by saying: "Torture for you is so sweet: just a tightening of the sexual organs in a vice, or an electric current along the throat with bare wires, or on the breasts . . . no big deal, nothing serious."[37] Yet the issue of torture came up again in May 2001 when a group of French intellectuals called for an official inquiry into torture during the Algerian War.

The Pontecorvo film, following along the lines of Fanon, sees torture as an integral part of colonialism. As Fanon wrote in "Algeria Face to Face with the French Torturers": "Torture is inherent in the whole colonialist configuration . . . the colonialist system, in order to be logical, must be prepared to claim torture as one of its important elements."[38] Colonel Mathieu, in the film, tells the journalists more or less the same thing: "If you believe in a French Algeria, you must accept the means of defending French Algeria."

At times, it is as if Fanon had written the script for *The Battle of Algiers*. One sequence, in which three Algerian women masquerade as Europeans in order to pass the French checkpoints and plant bombs in the European sector, seems to illustrate a passage from "Algeria Unveiled" (in *A Dying Colonialism*), where Fanon, in one of the few passages where he actively empathizes with women of color (although still seeing them through a masculinist grid), speaks of the challenges facing the Algerian woman who crosses into the European city:

> The Algerian woman . . . must overcome a multiplicity of inner resistances, of subjectively organized fears, of emotions. She must at the same time confront the essentially hostile world of the occupied and the mobilized, vigilant, and efficient police forces. Each time she ventures into the European city, the Algerian woman must achieve a victory over herself, over her childish fears. She must consider the image of the occupier lodged somewhere in her mind and in her body, remodel it, initiate the essential work of eroding it, make it inessential, remove something of the shame that is attached to it, devalidate it.[39]

The sequence from *The Battle of Algiers* shows three Algerian women preparing their masquerade before a mirror. The mood is tentative, almost trembling. The lighting highlights the women's faces as they remove their veils, cut and dye their hair, and apply makeup to look more European. They look at themselves as they put on an enemy identity, ready to perform their national task. Whereas in other sequences Algerian women use the veil to mask acts of violence, here they use European dress for the same purpose.

One woman, Hassiba, first seen in traditional Arab dress, her face covered by a veil, might in a Western context be received initially as a sign of the exotic, yet soon she becomes an agent in a national transformation where masquerading as the colonizer plays a crucial role. As the sequence progresses, we become increasingly close to the three women, although we become close to them, paradoxically, as they perform "Europeanness." At the same time, we are made aware of the absurdity of a system in which people warrant respect only if they look and act like Europeans. The film thus demystifies the French colonialist myth of assimilation, the idea that a select coterie of well-behaved subalterns could be "integrated" into French society in a gesture of progress and emancipation. Algerians can assimilate, the film suggests, but only at the price of shedding everything characteristically Algerian about them—their hair, their clothes, their religion, their language.

A number of Algerian women have written about their experiences as urban guerrillas. Malika Ighhilhariz, a twenty-year-old lycéene during the historical battle of Algiers, has written about how she would get broad smiles from the French guards at the checkpoints: "People would see me getting out of the car just like a Frenchwoman. I would go into a block of flats and put on my veil and my face veil, come out veiled and go down into the Casbah. I would leave what I had to leave and pick up whatever—messages, weapons—had to be got out of the Casbah, and then I would pull off the same trick. In the entrance to a block of flats, I took off the veil, put on my lipstick and my sunglasses, came out and got back into my beautiful car."[40] In a related passage from *A Dying Colonialism*, Fanon writes: "It must be borne in mind that the committed Algerian woman learns both her role as a 'woman in the street' and her revolutionary mission instinctively. It is without apprenticeship, without briefing, without fuss, that she goes out into the street with three grenades in her handbag or the activity report of an area in her bodice."[41]

While we can lament the masculinist overtones of Fanon's instinctiveness, the *Battle of Algiers* sequence (which leaves moot the question of instinct) is particularly subversive in controverting traditional patterns of cinematic identification. Many critics, impressed with the filmmaker's "honesty" in showing National Liberation Front (FLN) terrorist acts against civilians, lauded this sequence for its "objectivity." But that the film shows such acts is ultimately less significant than *how* it shows them; the signified of the diegesis (terrorist actions) is less important than the mode of address and the positioning of the spectator. The film makes us want the women to com-

plete their task, if not out of conscious political sympathy then through the specific protocols of cinematic identification: scale (close-up shots individualize the women), off-screen sound (the sexist comments of the French soldiers are heard as if from the women's aural perspective), and especially point-of-view editing. By the time the women plant the bombs, spectatorial identification is so complete that it is not derailed even by close shots of the bombers' potential victims. At the same time, the film does not hide the terrible injustice of terrorism; it is encapsulated in the absolute innocence of a child eating ice cream. The eyeline matches between close shots of the bomber and of her intended victims both engender and disturb identification; for although the patrons of the café she attacks are humanized by close-ups, the film has already prepared the spectator to feel at home within the bomber's perspective, to sense the reasons for such a mission. Historical contextualization and formal mechanisms have short-circuited, or at least made us reflect on, our often simplistic attitudes toward anticolonial violence, an issue very much linked to the events of September 11, 2001.[42]

Pontecorvo thus hijacks the apparatus of objectivity and the formulaic techniques of mass media reportage (hand-held cameras, zooms, long lenses) to express political views usually anathema to the dominant media. For the First World mass media, terrorism means only freelance or infrastate violence, violence without army uniforms, never state terrorism or government-sanctioned aerial bombardments. But *The Battle of Algiers* presents anticolonialist terror as a response to colonialist violence: in Fanon's words, "the violence of the colonial regime and the counterviolence of the native balance each other and respond to each other in an extraordinary reciprocal homogeneity."[43] For Fanon, the term *violence* refers to both forms of violence. The colonialist, who is accustomed to a monopoly on the means of violence and who never tires of saying that "they" only understand the "language of force," is surprised when force is answered with force, fire with fire. At the same time, *The Battle of Algiers*, in its portrayal of neatly sequenced tit-for-tat violence, is on one level overly generous to the French, since the French were the practitioners not only of high-tech violence (planes, helicopters, tanks), but also the administrators of systematic, quasi-industrialized torture. An oppressed people, Fanon tells us in *A Dying Colonialism*, "is obliged to practice fair play, even while its adversary ventures, with a clear conscience, into the uninhibited exploration of new means of terror."[44]

At the checkpoints, the French soldiers treat the Algerians with discrimi-

natory scorn and suspicion, while they greet the Europeans, including the Algerian women masquerading as Europeans, with amiable "bonjours." The soldiers' sexism, meanwhile, leads them to misperceive the three women bombers as French and flirtatious when in fact they are Algerian and revolutionary. The sequence almost literally stages the passage from "Algeria Unveiled," in which Fanon describes the Algerian woman's confrontation with the colonial police: "The soldiers, the French patrols, smile to her as she passes, compliments on her looks are heard here and there, but no one suspects that her suitcases contain the automatic pistol which will presently mow down four or five members of one of the patrols."[45]

The Battle of Algiers thus underscores the racial and sexual taboos of desire within colonial segregation. As Algerians, the women are the objects of an overt military as well as a covert sexual gaze; they openly become objects of desire for the soldiers only when they masquerade as French. They use their knowledge of European codes to trick the Europeans, putting their own "looks" and the soldiers' "lookings" (and failure to see) to revolutionary purpose. (Masquerade also serves the Algerian male fighters who dress as Algerian women to better hide their weapons.) Within the psychodynamics of oppression the oppressed (the slave, the black, the woman) know the mind of the oppressors better than the oppressors know the mind of the oppressed. In *The Battle of Algiers*, they deploy this cognitive asymmetry to their own advantage, consciously manipulating ethnic, national, and gender stereotypes to support their struggle.

At the same time, it would be a mistake to idealize the sexual politics of *The Battle of Algiers* or of Fanon himself. Historically, Algerian women performed heroic service: they worked as nurses and combatants with the FLN in the *maquis*, they hid terrorists from paratroopers in their homes, they suffered torture at the hands of French soldiers (Djamila being the most famous case), and they shouted "Free Algeria" during Charles de Gaulle's visit in 1958. The film shows some of these activities, but the women largely carry out the orders of the male revolutionaries. They certainly appear heroic, but only insofar as they perform their service for the Nation. In his writing, Fanon seems to confound a conjunctural situation—the revolution's need for women guerrillas—with a permanent condition of liberation. The film does not ultimately address the two-fronted nature of women's struggle within a nationalist but still patriarchal revolution; it elides the gender, class, and religious tensions that fractured the revolutionary process, failing to realize that nationalism revolutions are from the outset constituted in

gender. (Mohammed Horbi, an Algerian interviewee in Isaac Julien's *Black Skin, White Masks*, a participant in the independence movement, points out that the more progressive Algerian revolutionaries saw Fanon's essay on the veil as a "rationalization for Islamic patriarchal conservatism.")

For Fanon, the liberation of the Algerian nation and the liberation of women went hand in hand: "The destruction of colonization is the birth of the new woman."[46] The final shots of *The Battle of Algiers* encapsulate precisely the same idea. They feature a dancing Algerian woman waving the Algerian flag and taunting the French troops, superimposed on the title "July 2, 1962: the Algerian Nation is born"; a woman "carries" the allegory of the "birth" of the nation. Yet the film does not bring up the annoying contradictions that plagued the revolution both before and after victory. The nationalist representation of courage and unity relies on the image of the revolutionary woman, precisely because her figure might otherwise evoke a weak link, the fact of a fissured revolution in which unity vis-à-vis the colonizer does not preclude contradictions among the colonized. In 1991 Pontecorvo returned to Algeria to examine some of these contradictions in *Gillo Pontecorvo Returns to Algiers*, a film about the evolution of Algeria in the twenty-five years elapsed since the release of the film, focusing on topics such as Islamic fundamentalism, the subordinate status of women, the veil, and so forth (the documentary was made before the civil war in Algeria had taken a toll of over fifty thousand dead). And in the mid-1990s, an Algerian feminist film, Djamila Sahraowi's *La Moitié du Ciel d'Allah* (Half of God's Sky), interviews many of the actual women militants who hid weapons under their Islamic garb. They relate their youthful enthusiasm for the revolution, along with their subsequent disenchantment as the revolution became ever more patriarchal and oppressive, asking for endless sacrifice with precious few rewards.

The revolutionary leader Ben M'Hidi, in *The Battle of Algiers*, at one point tells Ali-la-Pointe that "beginning the revolution is difficult, carrying it out is *more* difficut, and then the *real* problems begin." If *The Battle of Algiers* portrays the independence struggle, another film throroughly informed by Fanonian ideas, Sembene's satirical film *Xala*, focuses on the struggles that come *after* independence. The Sembene film draws on a very different strain within Fanon's writing: his mordant critique of the indigenous post-independence bourgeoisie. The film revolves around a fable of impotence, in which the protagonist's *xala*, a divinely sanctioned curse of impotence, comes to symbolize the neocolonial servitude of the black African elite.

The protagonist, El Hadji, is a polygamous Senegalese businessman who becomes afflicted with the xala on the occasion of taking his third wife. In search of a cure, he visits various medicine men, who fail to cure him. At the same time, he suffers reverses in business, is accused of embezzlement, and is ejected from the Chamber of Commerce. In the end, he discovers that his xala resulted from a curse sent by a Dakar beggar whose land El Hadji had expropriated. He finally recovers from his malady by submitting to the beggar's demands that he strip and be spat upon; the film ends with a freeze-frame of his spittle-covered body.

In the world of *Xala*, the patriarchal structures of colonialism have given way to indigenous African class and gender oppression, precluding the utopia of liberation promised by nationalist rhetoric. Impotence thus betokens postindependence patriarchy as failed revolution. Like *The Battle of Algiers*, *Xala* can be seen as an audiovisual gloss on Fanonian concepts. It is interesting, in this context, that at various points Fanon himself showed interest in the subject of impotence, for example, in the discussion in *The Wretched of the Earth* of the case of the Algerian man rendered impotent by the rape of his wife by a Frenchman. (Fanon's masculinist stress is on the husband as victim of impotence and humiliation rather than on the wife as the victim of rape.) Furthermore, the draft of an unpublished paper by Jacques Azoulay, François Sanchez, and Fanon was to be a study of male impotence in the Maghrebian cultural context, within the native "knowledge system." The authors point out that North African men beset by impotence, like El Hadji in *Xala*, tended to bypass Western-trained doctors in favor of *marabouts* and *talebs* like those in the Sembene film, since they attributed the impotence to magical causes.[47]

Fanon's portrait of the national middle class as "underdeveloped" and "greedy," with "practically no economic power . . . not engaged in production, nor in invention, nor building, nor labor," perfectly suits El Hadji and his commercial activities. For Fanon, the energies of the national bourgeoisie are completely "canalized into activities of the intermediary type,"[48] again a perfect description of El Hadji's merchandizing of secondary products such as Evian water and yogurt. The businessmen of the Chamber of Commerce, with their briefcases full of French bribe money, fit Fanon's description of "a greedy little caste . . . a get-rich-quick middle class . . . not the replica of Europe but its caricature." Completely identified with racist European values, this black elite avoids tourism in Spain because "there are too many blacks." Nationalism, for this new elite, means, as Fanon puts it,

"quite simply the transfer into native hands of those unfair advantages which are a legacy of the colonial period." It is no accident that El Hadji finances his third polygamous marriage with money expropriated from peasants, precisely the class that Fanon lauded (with only partial accuracy) as the truly revolutionary class. As "the people stagnate in unbearable poverty"— emblematized by the beggars waiting on the sidewalk outside El Hadji's place of business—they "slowly awaken to the unutterable treason of their leaders." While the elite constantly calls to mind its heroic sacrifices in the name of the people, the people "show themselves incapable of appreciating the long way they have come . . . [they] do not manage, in spite of public holidays and flags . . . to convince themselves that anything has really changed in their lives."

Fanon's critique of the pitfalls of nationalism anticipated, and concretely influenced, subsequent Algerian (and North African) cinema. While accepting the basic anticolonialist thrust of Third Worldist discourse, postindependence films have interrogated the limits and tensions within the Third World nation, especially in terms of the fissures having to do with race, gender, sexuality, and even religion. Within this evolution from Third Worldist to post–Third Worldist discourse, Algerian cinema increasingly pays attention to the fissures in the nation, fissures that have recently turned into veritable chasms, and to a civil war that has taken over fifty thousand lives. After the first "heroic" phase of independent Algerian cinema, which stressed the glories of the revolutionary struggle, for example, in *Wind from the Aures* (1965) and *Chronicle of the Years of Embers* (1975), Algerian cinema turned its attention toward social problems internal to Algeria, whether the status of women (*Wind from the South*, 1975; *Leila and the Others*, 1978), male sexuality (*Omar Gatlato*, 1977), or agrarian reform (*Noua*, 1977).

But some 1990s films offer an even more pronounced critique of the Algerian national revolution. Youcef, the protagonist in Mohamed Chouikh's *Youcef, Or the Legend of the Seventh Sleeper* (1994), escapes from an asylum— one is reminded again of Fanon's psychiatric ward—into what he believes to be Algeria in 1960, a world where the FLN is heroically battling French armies. A surreal time gap between Youcef's subjective perception and present-day Algeria becomes a satirical trampoline for exposing the minimal progress in the life of Algerian people since independence. Yesterday's heroes, Youcef soon learns, are today's oppressors, ready to sacrifice anyone who opposes their regime, including their old FLN comrades. Insanity no longer resides in an individual but in a social system. Other films call

attention to gender-based oppressions. Tunisian director Moufida Tlatli's *Silences of the Palace* offers a gendered and class critique of Tunisia, where the hope for social transformation after independence has yet to be completely realized. The protagonist, the lower-class singer Alya, whose revolutionary lover had assured her, back during the climactic moment of anti-French struggle, that not knowing her father's identity would not matter in the new Tunisian society, is disappointed when he refuses, years later, to marry her. The film that began with her singing the famous Umm Kulthum song "Amal Hayati" (The Hope of My Life) ends with her decision to keep her baby. Instead of the symbolic birth of a nation that concludes the *The Battle of Algiers*—"The Algerian nation is born"—*Silences of the Palace* narrativizes literal birth, thereby giving voice to women's struggle against colonialism from within as well as from without.

To my knowledge, the film *Frantz Fanon: Black Skin, White Masks*, directed by Isaac Julien and produced by Mark Nash, is the only film dedicated exclusively to the subject of Frantz Fanon. The Julien film is a product of the age of the "posts": poststructuralism, postmodernism, and, most relevant to Fanon, postcolonialism.[49] With postcolonialism, the Manichean opposition of oppressor and oppressed, and the binaristic dualism of First World/Third World give way to a more nuanced spectrum of subtle differentiations, in a new global regime where First World and Third World (the latter now redubbed the "South"). Over time, the "three worlds" theory of the 1960s has given way to more subtly differentiated analyses of the global political topography. The nation-state, once the primary unit of analysis, has given way to analytical categories both smaller and larger than the nation. A paranoid and gendered discourse of penetration and violation has given way to a sense of resistance within intimacy. With globalization, models of Manichean oppression have given way to images of interdependency. Notions of ontologically referential identity have made way for identity seen as an endlessly recombinant play of constructed differences. Once rigid boundaries now are presented as more porous; imagery of barbed-wire frontiers à la *The Battle of Algiers* has given way to metaphors of fluidity and crossing. The segregated space of the Algérie Française of the Pontecorvo film has become the miscegenated space of contemporary France and the miscegenated aesthetics—at once North African, French, and Afro-American, of *beur* cinema, the films made by Maghrebians in France.[50] The brutal borderlines of colonial Algeria have been replaced by the more subtle borderlines separating the urban metropolises of France from the *banlieu*. Colonial metaphors of

irreconcilable dualism give way to tropes drawing on the diverse modalities of mixedness: religious (syncretism), linguistic (creolization), botanical (hybridity), racial (*metissage*). Totalizing narratives of colonial domination have mutated slowly into an awareness of a modicum of reciprocity. Instead of binary oppositions, we find mutual shaping and indigenization within a Bakhtinian "in-between."

In this new epoch, both "Fanon" and "Algeria," historically shaped utterances, also mutate, changed by the new context. And just as we now know more about the savagery of French repression during the war in Algeria, we are also less likely to idealize the Algerian revolution in the wake of a civil war that has taken the lives of over 150,000 Algerians, a war rooted, in some ways, in fractures already present during the war for independence. In his *Une Vie Debout: Memoires Politiques*, Mohammed Harbi, one of the Algerians interviewed in the Julien film, has called attention to the deadly internecine battles between various factions in the independence movement, to the ethnic tensions between Arabs and Berbers, and to the murder of tens of thousands of *harkis*, Algerian collaborators with the French.[51] Far from being a universally popular uprising, the independence movement was dominated by a small cadre of middle-class urban leaders. Thus we find a symmetrical repression of history; on the French side, of torture and colonial massacres, and on the Algerian side, of violent factional splits and the massacres of the harkis. As Macey puts it, "the post-colonial Fanon is in many ways an inverted image of the revolutionary Fanon of the 1960s." The Third Worldist Fanon, for Macey, "was an apocalyptic creature; the post-colonial Fanon worries about identity politics, and often about his own sexual identity, but he is no longer angry."[52] In this moment of the eclipse of revolutionary nationalist metanarratives, Julien obviously has an altered conception of Fanon's emancipatory project. Which is not to say that Julien does not understand and appreciate Fanon's project. Indeed, Fanon and Julien can be seen as sharing certain features: (1) both are writers/artists: one with pen, the other with a camera (and also, occasionally, a pen); (2) both deal with taboo topics; they probe deep wounds, if only to suture them better; (3) both work against the grain of inherited genres and discourses: psychoanalysis/the art film; and (4) both meld theory with activism. Indeed, just as Fanon perceived the Eurocentric limits both of psychoanalysis and of Marxism, we might say that Isaac Julien interrogated the Eurocentrism of a certain avant-garde.

Just as Fanon's work emerges from the charged situation of colonialism,

Julien's work comes out of the wave of black uprisings against police brutality in the 1970s and 1980s. If Fanon embodied the theory and practice of Third Worldism, Julien's film embodies the theory and practice of post-colonial post–Third Worldism. It acknowledges, in other words, that we are living in a very different historical/theoretical moment from that of the *The Battle of Algiers*. Indeed, the frequent clips from the Pontecorvo film are meant to remind us of the passions of that other moment. But given the altered discursive context, the Julien film offers a fairly "cool" and "post" take on Fanon's incendiary prose. The film conveys both identification with and distance from Fanon, while deploying a carefully calibrated self-reflexive and ironic distance from Third Worldist rhetoric. The film lacks the nationalist passion characteristic of Fanon's historical moment, when tricontinental revolution was assumed to be lying in wait just around the next bend of the dialectic, when the Third World Left and the First World Left were thought to be walking arm in arm toward a preordained victory celebration. It is this discursive shift that makes a 1960s militant film like *Hour of the Furnaces*, despite its versatility and brilliance, now seem somewhat dogmatic, puritanical, masculinist, and Manichean.

A founder of Sankofa, one of the black British film collectives of the 1980s, Julien has directed a number of politically and aesthetically interventionist films. It is not easy to sum up the semantic riches of his films. Even the generic label of "documentary" is misleading, since Julien's "documentaries" often include highly staged sequences set within stylized decors rooted in his background in the visual arts. At the same time, it is possible to posit some salient traits shared by the films. First, Julien's films constitute an ongoing and multileveled reflection on the role of Afro-diasporic artists/intellectuals and of black cultural forms: Langston Hughes and the Harlem Renaissance in *Looking for Langston*, pirate radio in *Young Soul Rebels*, Fanon in *Black Skin, White Masks*. Apart from providing an hospitable filmic environment for intellectuals such as Paul Gilroy, Stuart Hall, Patricia Williams, Tricia Rose, and Robyn Kelly, the films unembarrassedly engage with film theoretical discourse and with cultural studies. A film like *Territories*, for example, superimposes a theoretical analysis over visual depictions of the Notting Hill Carnival; slow motion renders the process of thought as it plays over and around the arrested media image.

Julien's films also show constant concern with the critique of racism, homophobia, sexism. But that is to put the issue negatively. To put it positively, his films promote an open-ended reflection on multiple axes of dif-

ference having to do with nation/race/gender/sexuality/ and even generation and ideology (as in *Passion for Remembrance*), axes that mutually inflect and complicate each other within an overdetermined intersectionality, which are not reducible to each other, which confound any simplistic notions of essential identity. His films promote what might be called an audio-visual-textual dance of positionalities, within which race is gendered, class is sexualized, and so forth. A corollary of this open-ended dance is a pushing-the-envelope audacity, a constant flirtation with "incorrect" images, for example, the choice of a gay Langston Hughes to "represent" the African American community, or the disturbing sadomasochistic image of a black man being erotically whipped by a white man in *The Attendant*.

Third, Julien's films display a strong and variegated diasporic consciousness of blacks as cosmopolitan, international people. The films promote a kind of chronotopic superimposition. They rarely have single geographical locations, and even when they do, other locations are made to impinge on them through "alien" images and sound. Here we might think of the presence of Martinique, France, Algeria, and Tunisia in *Black Skin, White Masks*, or of the link between black British and African American musical culture in *Young Soul Rebels*. Related to this diasporic consciousness is a search for utopian spaces—the clubs in *Looking for Langston*, the disco scene in *Young Soul Rebels*—spaces typified by gender blurring, transracial intimacy, artistic freedom, and "gay relativity," spaces where black and gay culture do not have to be checked in at the door like winter overcoats. Often the diasporic consciousness is realized through the creative deployment of Afro-diasporic music: jazz and blues in *Looking for Langston*, disco in *Young Soul Rebels*, rap in *Darker Side of Black*. Even *Black Skin, White Masks*'s portrayal of Fanon's attempt to turn the psychiatric ward at Blida into a normal, humanized, hopeful space pays tribute to this utopian desire to transmogrify and redeem from alienation the negativities of everyday existence.

All of Julien's films display a clear option for stylization and reflexivity—in formal terms, a refusal of illusionism, a preference for reflexivity and flamboyant (and low-budget) theatricality. Julien's is a challenging cinema, characterized by a high multitrack density of information. Both image and sound are haunted by other texts. His films feature innovative ways of weaving archival footage with fiction films with staged scenes and interviews in a kind of audiovisual layering. The films also demonstrate a highly creative attitude toward the audiovisual archive, seen in the ways that archival footage is used to re-create, in a telescoped, almost minimalist fashion, the Harlem

Renaissance (in *Looking for Langston*) or Algérie Française (in *Black Skin, White Masks*). In the latter film, Julien turns the very lack of moving image materials depicting the historical Fanon into a trampoline for extraordinary creativity. Julien's films offer a palimpsestic aesthetic, one that goes against the grain of conventional expectations not only for the fiction feature but also for the documentary film. In Julien's work, interviews are never merely interviews; too much is happening in the shot or on the sound track. Think, for example, of the ways that Patricia Williams's commentaries are superimposed on footage of the "Rush Limbaugh Show" in *Oh That Rush!* in such a way as to highlight the contradictions between the two. She is mobilized, made to move around, hover over, and surround Limbaugh in the manner of an intellectual guerrilla sniper. The frame itself seems unable to contain such explosively agonistic figures. Williams's subtle brilliance makes Limbaugh look tawdry, defensive, mean-spirited; her intellectually vibrant persona gives the lie to Limbaugh's racist diatribes.

In sum, Julien's films challenge thematic as well as formal taboos; they fairly revel in unorthodoxy. They rub against the grain of at least two traditions: first, that of a "high modernist" avant-garde interested only in a festival of negations of dominant cinema, that is, the negation of narrative, of fetishism, of identification, of pleasure. This tradition betrays a certain Anglo-puritanism, an ingrained suspicion of fiction, beauty, and pleasure. Julien's films, in contrast, display an unabashed fondness for beauty, pleasure, rhythm, expressed in antipuritanical films that avoid the dead-end anhedonia of a certain avant-garde. But Julien's films also go against the grain of another tradition, that of a certain strand of politically radical film. In *Black Skin, White Masks* we sense a committed filmmaker but not a preachy one. The films do not deliver predigested a priori truths; the approach is dialogic rather than authoritarian. The films are multivoiced. Identification operates, but not in the conventional manner. It does not take place through idealized figures, through positive images, or through point-of-view editing or the usual protocols of subjectification. The identification is not with heroes or heroines, but with a conflictual community of aspiration, a polyvocal community that shares issues and questions rather than fixed or definitive answers.

Black Skin, White Masks does not cultivate the "aura" of its protagonist. It avoids the hackneyed, sycophantic formulas of "great man" documentaries: the ritual visit to the ancestral home, the shots of the actual desk where the artist worked; the reverential homages; the lachrymose reminiscences

of prestigious friends; the knowing voice-over asserting irrefragable truths. More precisely, the film avoids three pitfalls typical of its genre of intellectual biography: (1) hagiography, that is, a blind adoration that would make Fanon a perfectly admirable man and an infallible prophet; (2) facile critique, that is, a patronizing censure of Fanon's "mistakes" as seen from the supercilious standpoint of an unforgiving present; (3) ventriloquism, that is, an approach that would turn Fanon into another version of Julien, which would present a contingent and personal reading of Fanon as if it represented a real ontological essence. Instead, the film dialogues with Fanon. It sees and critiques his blind spots, but it also sees Fanon's questions as burningly relevant to the present. It finds Fanon's contradictions themselves interesting and productive.

Just as Fanon mixed genres and discourses in his book, mingling psychoanalysis, sociology, poetry, literary criticism, and so forth, Julien mixes genres in his film, including archival footage; interviews with Fanon's family (brother, son), fellow psychiatrists (Azoulay), and scholars (Françoise Vergès, Stuart Hall); quoted fiction films; stylized fantasy sequences; and soliloquies by the actor (Colin Salmon) playing Fanon. The film also places Fanon within a long historical context, moving from Martinique as one of the "old colonies" that predated the French Revolution, through references to Victor Schoelcher and the abolition of slavery in 1848, through to the turn-of-the-century heights of French imperialism. Despite the title, the film does not limit itself to Fanon's 1952 text. It speaks of Fanon's democratizing practices in the asylum at Blida, of his relation to the Algerian revolution, while drawing on materials from *The Wretched of the Earth* such as the case studies of colonial neurosis and psychosis related to the torture of Algerians. We learn about the sweeping changes and reforms Fanon made in a hospital where degradation, humiliation, and forced drugging had been the norm. Forced to retrofit psychoanalysis in light of the needs of the colonized, Fanon saw the psychiatric hospital itself as pathogenic, since it sealed off patients from the emotional sustenance of their ordinary relational lifeworlds. Fanon hoped, consequently, to transform the ward under his jurisdiction into a relatively nonhierarchical space of interactive conviviality. In this sense a kind of isomorphism links Fanon's attempt (together with his Algerian Jewish confrere Azoulay) to create a microrevolution in the psychiatric ward in Blida-Joinville, on the one hand, with the macrostruggle of the FLN to revolutionize the Third World nation, on the other.

Within this task, Julien cites his own intertext, specifically, *The Battle of*

Algiers. He especially privileges the torture sequences, scenes perfectly relevant to Fanon as the psychoanalyst who had to deal with both the torturers (the French) and the tortured (the Algerians). The film also cites *The Battle of Algiers* in ways that are almost subliminal. A trilled flute, taken from the sound track but detached from the image track, is deployed as a kind of minimalist leitmotif, a form of punctuation, an acoustic synechdoche for the situated, vibrating tension of the colonial agon.

Here, I focus on three specific aspects of *Black Skin, White Masks*: its deployment of the gaze, of space/time, and of voice. The Fanonian analysis of the gaze, as is well known, inserts itself within an intertextual tradition that goes back at least as far as Hegel's anatomy of the master/slave dialectic, through Alexandre Kojève's reexamination of that dialectic in his *Introduction à la lecture de Hegel* (1947), through Sartre's existential unpacking of *le regard* (especially in *Anti-Semite and Jew*), and Lacan's neo-Freudian analysis of the gaze and the "mirror stage."[53] In *The Wretched of the Earth*, Fanon casts colonialism itself as a clash of gazes: "I have to meet the white man's eyes." The colonist trains on the colonized a look of desire, of appropriation, of surveillance. He overlooks, surveys, and oversees, without being looked at, surveyed, or overseen. "The look that the native turns on the settler town," meanwhile, "is a look of lust . . . to sleep in the settler's bed, with his wife if possible."[54] And the colonialist's greatest crime was to make the colonized look at themselves through colonizing eyes; the very act of self-regard was mediated by superimposed alien looks and discourses. It is consequently no accident that the Julien film proliferates in images of disturbed specularity, in René Magritte–like images of mirrored shards, images reminiscent of other films, such as Alfred Hitchcock's *The Wrong Man*, where the fragmented mirror image literalizes psychic splitting to evoke a crisis in identity.

In his influential "Orphée Noir" essay that introduced Leopold Senghor's *Anthologie de la nouvelle poésie nègre et malgache de langue française* (1948), Sartre described the project of "negritude" as a turning back of the gaze, by which the French, who had objectified Africans, were now obliged to see themselves as others saw them. In "ocularphobic" language that recalls the returned glance by which the camera/character turns its gaze on the surprised spectator, Sartre tries to make his French readers feel the historic, poetic justice of this process by which the distanced, sheltered colonial voyeur is abruptly *vu*: "I want you to feel, as I, the sensation of being seen. For the white man has enjoyed for three thousand years the privilege of seeing without being seen. . . . Today, these black men have fixed their gaze upon

us and our gaze is thrown back into our eyes . . . by this steady and corrosive gaze, we are picked to the bone."[55]

In the wake of both Sartre and Fanon, Julien's film thematizes the racialized, sexualized look. It provides audiovisual object lessons illustrating Fanon's analysis, but it also expands and interrogates that analysis. Like that other filmic allegory of voyeurism, Hitchcock's *Rear Window*, the Julien film proliferates in words having to do with looking: "see," "regard," "the desiring gaze," "field of vision," "scopophilia," "voyeurism," the "look that fractures," the "sexualized nature of the look." Indeed, one can see the film as a theorized orchestration of looks and glances, captured and analyzed in all their permutations: the actor Fanon's direct look at the camera/spectator; de Gaulle's paternal look at Algeria as he parades through Maghrebian streets (edited in such a way that veiled women shield themselves from his regard, thus evoking the theme of "Algeria Unveiled"); the dumb, uncomprehending look of French soldiers on Algerian women, their misinterpretation of the hermeneutics of the veil; the arrogant, imperial look of French helicopters surveying Algerian crowds; the look of the sympathetic woman observer (cited from *The Battle of Algiers*) who cries as she witnesses torture and empathizes with the victim.

A particularly complex sequence features "Fanon" as psychoanalyst listening (*j'écoute*) both to the tortured and to the torturers, who tell their mutually implicating stories about fathers, mothers, children, and soldiers. Historically, Fanon would in the daytime treat French soldiers suffering the traumatic effects of having tortured Algerians, while at night he treated the victims of torture, often in a revolving-door situation, where the victims were returned to health only to be delivered up once again into the maws of the French interrogation system. The sequence offers a suggestive combinatory of looks: the French soldier looks at Fanon, while Fanon looks elsewhere; Fanon looks at the soldier, while the soldier looks away. A rare reciprocal and homosocial look, interestingly, passes between Fanon and the Algerian fighter, in a mutual homosocial gaze of shared militancy that evokes Fanon's call in *Black Skin, White Masks* for a utopian world of mutual recognitions. The most disturbed look is Fanon's look at two men kissing; the gaze is returned when one of the men (played by Kobena Mercer, another theorist of the racialized, sexualized gaze) looks back at Fanon, after which Fanon looks away as if unable to sustain a homosexual gaze. We sense a kind of homoerotic panic, the anxiety provoked by a willed *dis*identification. Fanon denied, the film reminds us, the existence of homosexuality

in Martinique; his claim that "there is no homosexuality here" ironically echoes the racist's "there is no racism here." Here the look is disrupted, named, disturbed, critiqued.

The film also points out the limitations of Fanon's view of heterosexuality. As Fanon scholar Françoise Vergès points out in the film, Fanon practices a double standard. For him as a man, the choice of a white French wife is an expression of his own inalienable freedom; it in no way compromises his integrity. But in the case of Mayotte Capécia, the black woman author of the novel *Je suis martiniquaise*, her choice of a white man as love object is a betrayal, a symptom of Europhile alienation, a desperate grasping for the magic "touch of whiteness." In short, Fanon practices asymmetrical pathologization; he scapegoats black women for doing exactly what he has done, that is, choosing a lighter-skinned partner. The shallow analysis confirms Fanon's own admission, an echo perhaps of Freud's befuddled "What do women want!" of lack of knowledge about the black woman. "As for the black woman," Fanon tells us, "I know nothing about her." Here we find again a kind of willed cognitive blocking, a gendered *dis*identification.

Black Skin, White Masks also stages the kind of diasporic space/time lived by the biographical Fanon. The very scene of the film constitutes a dispersed anachronistic chronotope. The film's "home" location is the psychiatric ward in Blida-Joinville, where Fanon went in 1953, even though the film is largely based on a book published earlier, in 1952. The film's story evokes Martinique, France, Algeria, Tunisia. Yet other spaces enter the film through radio broadcasts alluding to the black struggle in the United States as a way of generalizing meanings beyond the originary space in which they were articulated. We find this palimpsestic space/time in the sequence in which Fanon encounters the French mother and her frightened child: "Look a negro! I'm frightened!" The sequence alternates the image of Fanon confronting the woman and child, all three dressed in period clothing, with images of present-day European metropolises and their immigrants: Arabs, West Indians, South Asians, and other manifestations of postcolonial karma. The sequence thus shuttles between past and present in such a way as to underscore the scene's *contemporary* relevance and overtones.

Julien's film brings out a salient feature of Fanonian *écriture*: its subtle orchestrations of voice, its ironic pseudo-identification with the alien voice. In his essays, Fanon sometimes impersonates the voice of his oppressor. Fanon's writing is thus double-voiced in the Bakhtinian sense; it mimics the voice of oppression while investing it with a contrary ideological orien-

tation. In the film, the actor impersonating Fanon says, "there's no racism here; you're just as civilized as we are"—racist statements that pretend to be the opposite. Here racist discourse is projected or ventriloquized in a kind of discursive masquerade. It is this sly vocal mimicry that makes it possible for a dishonest polemicist like Dinesh d'Souza to misquote Fanon—even when he quotes him verbatim in *The End of Racism*. Although the words are the same, the double-voiced signifying is lost. But in the film we sense the attitude behind the words; the double-voicedness is restored through performance, through the grain of the voice and the barely suppressed anger with which the actor articulates the phrases, as well as through facial expression, intonation, and mise-en-scène. "Fanon" cites the racist, but against the dialogizing backdrop of another ideological orientation.

Black Skin, White Masks is framed, interestingly, by statements that imply a critique of all dogmatism. The film begins with untranslated Arabic (the man obsessively asserts, "I didn't kill anyone"), a usage which brings up the debate about Fanon's knowledge of Arabic and the implications of this knowledge (or lack of it) for Fanon's right to speak for the Algerians. But then Julien has his "Fanon" say: "I do not come with timeless truths." And the film ends with final words that refuse any "final word." Fanon looks directly at the camera and says: "Oh my body, make of me one who asks questions." (The corporeal genesis of the interrogation itself implies a transcendence of the mind/body binarism.) That Fanon makes the body the asker of questions is especially appropriate to the work of a filmmaker who has taught us new ways to look at and conceptualize the black body.

Like any open work, *Black Skin, White Masks* leaves us with our own questions. What is gained, and what lost, by choosing to read Fanon back to front, as it were, by privileging the psychoanalytic critique of early Fanon over the revolutionary socialist of *The Wretched of the Earth*? Is there a danger of psychologizing Fanon? Of turning him into a posty pomo-poco academic? And what is lost in the hypersexualization of the issues? What, one wonders, about forms of colonialism or racism that have little to do with the sexualized gaze, for example, the colonial appropriation of native land, or the devastating electronic machinations of international financial agencies like the International Monetary Fund? What about forms of oppression that operate by *refusing* to look, by refusing to take notice? What about the look that ignores, that renders invisible? Isn't there a danger of reducing complex historical and cultural issues to a racialized psychodrama, whose mysteries are penetrable only by a psychoanalytic master-discourse? Could

it be that the goal of the colonized is not to win a reciprocal gaze, but to put the colonialist out of the picture altogether? Or does achieving the reciprocal gaze depend on first achieving independence? Might aural metaphors of voice be more productive than visual metaphors of gaze? And what else is lost in this privileging of the category of the gaze? Is there a danger that in emphasizing Fanon's blind spots we forget how much he helped us *see*? Or that we lose sight, as it were, of our *own* blind spots? Has the film missed an opportunity by not at least hinting at Fanon's relevance for contemporary *activism* in the age of the "posts," against globalization, for example? But that one ends up asking such questions is very much in the dialogical spirit of the film itself; the film makes us as spectators, alongside Fanon and Julien, the "askers of questions."

Notes

Robert Stam, "Fanon, Algeria, and the Cinema: The Politics of Identification," in *Multiculturalism, Postcoloniality, and Transnational Media*, ed. E. Shohat and R. Stam, 18–43. New Brunswick, NJ: Rutgers University Press, 2003. Reprinted with permission of the publisher.

1 Frantz Fanon, *The Wretched of the Earth*, trans. Constance Farrington (1961; New York: Grove Press, 1963).
2 Jacques Derrida, "Structure, Sign and Play in the Discourse of the Human Sciences," in *The Structuralist Controversy*, ed. Richard Macksey and Eugenio Donato (Baltimore: Johns Hopkins University Press, 1970), 247–72.
3 Fanon, *The Wretched of the Earth*, 51.
4 Octave Mannoni, *Prospero and Caliban: The Psychology of Colonization* (New York: Praeger, 1956).
5 Frantz Fanon, *Toward the African Revolution*, trans. Haakon Chevalier (New York: Grove Press, 1969), 20–21.
6 Frantz Fanon, *Black Skin, White Masks*, trans. Charles Lam Markmann (New York: Grove Press, 1967), 110.
7 Fanon, *Black Skin, White Masks*, 18.
8 Fanon, *Black Skin, White Masks*, 19.
9 Fanon, *The Wretched of the Earth*, 96.
10 David Macey, *Frantz Fanon: A Biography* (New York: Picador, 2001), 323.
11 Fanon, *The Wretched of the Earth*, 315.
12 Fernando Solanas and Octavio Getino, "Towards a Third Cinema: Notes and Experiences for the Development of a Cinema of Liberation in the Third World," in *New Latin American Cinema, Volume One: Theory, Practices, and Transcontinental Articulations*, ed. Michael T. Martin (Detroit: Wayne Univer-

sity Press, 1997), 33–58; Glauber Rocha, "An Esthetic of Hunger," in *New Latin American Cinema, Volume One: Theory, Practices, and Transcontinental Articulations*, ed. Michael T. Martin (Detroit: Wayne University Press, 1997), 59–61.

13 Quoted in Jose Carlos Avelar, *A Ponte Clandestina: Teorias de Cinema na America Latin* (São Paulo: Edusp/Edotora 34, 1995), 101.

14 Cited by Ignacio Ramonet, "Cinq Siècles de Colonialisme," *Manière de Voir* 58 (July–August 2001): 7.

15 Robert Young in his book *Postcolonialism: An Historical Introduction* (Oxford: Blackwell, 2001), misses this fundamental distinction in his emphasis on Fanon's "espousal of the virtues and necessities of violence" and of the "hyperventilating violence [which] always formed part of the original policy of the FLN campaign and equally of the French response," an out-of-sequence formulation that has the FLN initiating the violence and the French "responding."

16 Quoted in Benjamin Stora, *Histoire de l'Algérie Coloniale (1830–1954)* (Paris: La Découverte, 1991), 28.

17 Paul Aussaresses, *The Battle of the Casbah: Terrorism and Counter-Terrorism in Algeria, 1955–1957* (New York: Enigma, 2002).

18 Paul Aussaresses, *Services Spéciaux Algérie 1955–1957* (Paris: Perrin, 2001), 15.

19 Aussaresses, *Services Spéciaux Algérie*, 16.

20 Aussaresses, *Services Spéciaux Algérie*, 196.

21 Pierre Vidal-Nacquet, *Memoire, tome II, La Trouble et la Memoire 1955–1998* (Paris: Seuil, 1998), 150, cited in Kristin Ross, *May '68 and Its Afterlives* (Chicago: University of Chicago Press, 2002), 44. The fullest account of October 17, 1961, is found in Jean-Luc Einaudi, *La Bataille de Paris: 17 Octobre 1961* (Paris: Seuil, 1991).

22 See *Le Monde*, May 3, 2000.

23 For a comparison between French cinema's treatment of the Algerian war and American cinema's treatment of the war in Vietnam, see Benjamin Stora, *Imaginaires du Guerres: Algérie-Vietnam, en France et aux États-Unis* (Paris: La Découverte, 1997).

24 Yacef Saadi, *Souvenirs de la bataille d'Alger, décembre 1956–septembre 1957* (Paris: R. Julliard, 1962).

25 Ross, *May '68 and Its Afterlives*, 36.

26 See *Le Monde*, October 28, 2002.

27 Diana Fuss, "Interior Colonies: Frantz Fanon and the Politics of Identification," in *Identification Papers: Readings on Psychoanalysis, Sexuality and Culture* (New York: Routledge), 141–72.

28 Diana Fuss, "Interior Colonies: Frantz Fanon and the Politics of Identification," *Diacritics* 24 (2/3), Critical Crossings (Summer–Autumn 1994), 19–42, 20.

29 Fanon, *Black Skin, White Masks*, 152–53.

30 Laura Mulvey, *Visual and Other Pleasures* (Bloomington: Indiana University Press, 1989).

31 Fanon, *Black Skin, White Masks*, 116.

32 For a detailed account of the production of *The Battle of Algiers*, see Irene Big-
 nardi's biography of Pontecorvo, *Memorie Estorte a uno Smemorato* [Memories
 Extorted from an Amnesiac] (Milan: Feltrinelli, 1999). The material on *The
 Battle of Algiers* is summed up in Irene Bignardi, "The Making of *The Battle of
 Algiers*," *Cineaste* 25(2) (2000).

33 Fanon, *The Wretched of the Earth*, 89.

34 Henri Alleg, *La Question* (Paris: Editions de Minuit, 1961). See also Alexis Ber-
 chadsky, *Relire "La Question"* (Paris: Larousse, 1994).

35 Jacques Massu, *La vraie bataille d'Alger* (Paris: Plon, 1971).

36 Jules Roy, *J'accuse le General Massu* (Paris: Seuil, 2001).

37 Roy, *J'accuse le General Massu*, 54.

38 Fanon, *Toward the African Revolution*, 65, 69.

39 Frantz Fanon, *A Dying Colonialism*, trans. Haakon Chevalier (New York: Grove
 Press, 1967), 52.

40 Interview, cited in Djamila Smrane, *Les Femmes Algériennes dans la Guerre*, in
 Macey, *Frantz Fanon*, 404. These revolutionary women also appear and recount
 their experiences in the Algerian feminist film *Women Hold up Half the Sky of
 Allah*.

41 Fanon, *A Dying Colonialism*, 50.

42 The relationality of these issues in both space and time became vividly clear
 to me the week of September 11, 2001, a week that I happened to be teaching
 Fanon's *The Wretched of the Earth* in conjunction with *The Battle of Algiers*. One
 student explained that he didn't have his copy of *The Wretched of the Earth* be-
 cause he had left it a few days before in the World Trade Center. I asked my
 students to compare the horrendous violence done at the World Trade Cen-
 ter to the violence done by the three women with the bombs in the *The Battle
 of Algiers*. Was it the same kind of violence? Together, we made the following
 points. While both incidents constituted terrorism which took innocent lives,
 there were also clear distinctions. In the case of Algeria, a violent means was
 used for a worthy end—the independence of Algeria and the end of colonial-
 ism. In the case of Osama Bin Laden, both the means (mass murder) and the
 ends (punishing the "infidel" according to codes that are arguably not even part
 of the religion being invoked) were completely reprehensible. In the Algerian
 case, the terrorism was clearly in reprisal for specific acts of French state terror
 (colonial domination, the bombing of the casbah) within the same national
 space; in the World Trade Center case, the terrorism could only be seen as a
 "reprisal" in a much more circuitous and inferential sense, and in any case the
 violence was not exercised against those responsible for what was claimed to
 be the initial offense. And while the WTC terrorists made no demands—for ex-
 ample, release of prisoners—the Algerian demands were quite clear: national
 independence.

43 Fanon, *The Wretched of the Earth*, 88.

44 Fanon, *A Dying Colonialism*, 24.

45 Fanon, *A Dying Colonialism*, 52.

46 See Frantz Fanon, *Sociologie d'une Revolution* (Paris: Maspero, 1959), 83; trans. Haakon Chevalier, *Studies in a Dying Colonialism* (Harmondsworth: Penguin, 1970).

47 See Macey, *Frantz Fanon*, 237–38.

48 Fanon, *The Wretched of the Earth*, 148, 149.

49 For more on the notion of post–Third Worldism, see Ella Shohat and Robert Stam, *Unthinking Eurocentrism: Multiculturalism and the Media* (London: Routledge, 1994).

50 Peter Bloom, "*Beur* Cinema and the Politics of Location: French Immigration Politics and the Naming of a Film Movement," in *Multiculturalism, Postcoloniality, and Transnational Media*, ed. E. Shohat and R. Stam (New Brunswick, NJ: Rutgers University Press, 2003), 44–62.

51 Mohammed Harbi, *Une Vie Debout: Memoires Politiques Tome 1: 1945–1962* (Paris: La Découverte, 1990).

52 Macey, *Frantz Fanon*, 28.

53 Alexandre Kojève, *Introduction à la lecture de Hegel: leçons sur la 'Phénoménologie de l'esprit professées de 1933 à 1939 à l'Ecole des Hautes-Études* (Paris: Gallimard, 1947); Jean-Paul Sartre, *Anti-Semite and Jew* (New York: Schocken Books, 1948).

54 Fanon, *The Wretched of the Earth*, 159.

55 Jean-Paul Sartre, *Black Orpheus*, trans. S. W. Allen, quoted in Martin Jay, *Downcast Eyes* (Berkeley: University of California Press, 1993), 294.

Regarding and Reconstituting Europe

Creole Europe:

The Reflection of a Reflection

Christopher Pinney

There is a delicate empiricism which so intimately involves itself with the object that it becomes true theory.

—Johann Wolfgang von Goethe, cited in Walter Benjamin,
"A Short History of Photography"

There is no *false* sensation.

—E. M. Cioran, *The Trouble with Being Born*

In the introduction to his first book, *Place, Taste and Tradition*, Bernard Smith noted that Johann Joachim Winckelmann wrote up the results of his explorations in the ruins of Pompeii and Herculaneum in the same year that "Wolfe captured Quebec and Clive consolidated the gains of the battle of Plassey."[1] Smith then suggested that "the relation[ship] between the commercial policy that led to imperialist expansion and the archaeological investigations that led to Classicism" remained to be investigated. Almost sixty years later we might conclude that this connection still remains unexplored.

With the passing of the Rococo, which Smith described as its last "original art style," European art modeled itself on others, in the form of the past, or the exotic. "In European colonies settled during the nineteenth century," Smith concludes, "art was *the reflection of a reflection.*"[2] One way of comprehending this *reflection of a reflection* is in terms of the refracted nature of colonial enunciation. We have come to accept this enunciation as split by a process of hybridization, partialization, or creolization, but have not yet fully come to accept, I think, that this colonial enunciation is a double splitting of an originary Europe *that is itself already creolized or hybridized.*

Just why it has been so difficult to concede the hybridized nature of

Europe is the subject of what follows. I shall argue that the fiction of an originary Europe has been most easily deliverable linguistically and discursively. The privileging of a particular ideational Platonic model of culture, rigorously enforcing the division between humans and nonhumans and valorizing human agency has rendered it almost impossible to recover and interpret the traces of those material flows and practices which are the evidence of a quite different Europe than the one that usually prevails. Writing about the history of what he terms "creole designs" within New Zealand, Nicholas Thomas has concluded that "In no other settler culture have indigenous art forms been mobilized so consistently."[3] This chapter explores a much earlier, but parallel, concern with what might be termed "xeno-figure" in Europe.

Ian McLean has recently argued that the painter John Glover's Tasmanian arcadias are not as secure as they might at first appear. Redemption falters in his paintings, McLean suggests, because of "Aboriginal ghosts in the landscape." "In most of the [Tasmanian] landscapes," McLean writes, "there stirs the *unhomely* (uncanny)—Glover is unable to forget the Aboriginal presence which shadows his paradise." McLean refers here not only to those images which depict Aboriginals as inhabitants of the land, suggesting that this "haunting is at its most palpable in the melancholy solitude of the wooded ranges that frame his scenes like a looming amphitheatre that watches over him with all the sublime terror of an absolute unbounded other."[4]

My aim in this chapter is to reveal the parallel, uncanny, presence of exotic objects within a materially creolized Europe. Just as the ghostly presences within Glover's paintings suggested a land that could never be "fully" settled, so the shadowy presence of xeno-figure reveals a Europe that was always a reflection of other times and places, never a self-present unity awaiting its replicatory colonial enunciation.

Material World History

What options does the history of our relationship with objects that have passed across cultures bequeath us—objects such as those we can see in the frontispiece to the 1703 English edition of Philippus Baldaeus's 1672 account of the "Traffick and Commerce" between the Portuguese and the Dutch, and the inhabitants of Malabar and Coromandel (figure 19.1)?

The route to a material world history lies broadly in the direction mapped by *Asia in the Making of Europe*, to invoke the title of a monumental work

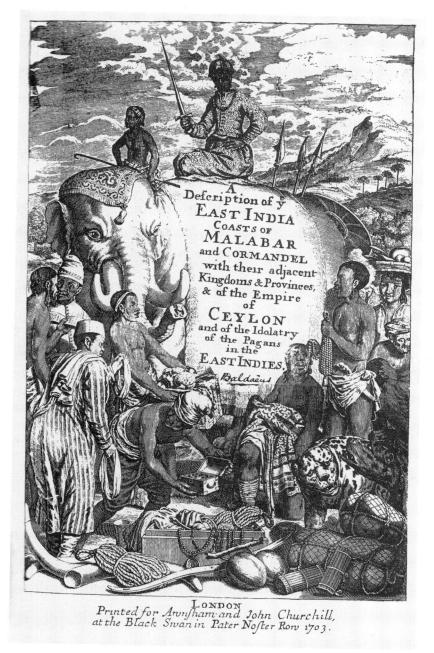

A
Description of ỹ
EAST INDIA
COASTS OF
MALABAR
and CORMANDEL
with their adjacent
Kingdoms & Provinces,
& of the Empire
of
CEYLON
and of the Idolatry
of the Pagans
in the
EAST INDIES.

Baldæus

LONDON
Printed for *Awnsham* and *John Churchill*,
at the *Black Swan* in *Pater Noster Row* 1703.

Fig. 19.1. Frontispiece to Philippus Baldaeus, *A Description of the East India Coasts of Malabar and Cormandel with their adjacent Kingdoms and Provinces and of the Empire of Ceylon and of the Idolatry of the pagans in the East Indies* (1703).

by Donald Lach,[5] and the nature of *The East in the West* to recall the title of Jack Goody's book.[6] However, materiality (conceived as a kind of figurality) cannot be grasped simply through the empirical occurrence and recurrence of particular objects, styles, and influences (e.g., how often elephants appear in early modern European paintings, or the wider economic or conventionally sociological impact that particular cultural interactions may have had). Rather, I am much more concerned with the unquantifiable and more profound textural change in European lifeworlds effected by this cultural flow.

Spiridione Roma's mural *The East Offering its Riches to Britannia*, painted in 1778, was a central feature in the East India House in London. Recent critical thinking encourages us to see such riches as signs on the verge of a recontextualization by the appropriating culture. By contrast I am interested in what those riches brought with them and the ways in which Britannia was "materially" reconfigured by this transaction. The argument developed here is not that "we" entangle objects but that objects entangle us. And the way to explore this is through attending to the transactional network that Roma depicts, rather than the false abstraction of culture (e.g., the East, *or* Britannia).

I am interested in what Jean-François Lyotard would term the figural qualities of this phenomenon. It was the desire for new tastes, new tactilities, and new spectral vibrancies which created the modern world. As Wolfgang Schivelbusch noted, "once habituated to the spices of India, Europe was ready to do anything to gratify its craving" and the European encounter with the Americas was an accidental by-product of the European lust for pepper.[7] The interesting point is why we keep forgetting this banal and fundamental truth.

An Archaeological Report (Anywhere in Europe, the Year 2003)

A spade thrust into the soil cracks against some unknown object. Churning the earth, a bright blue and white fragment is revealed. Rubbed clean of its accreted dirt, the fragment sparkles through its crackled patina. Underneath lies the unmistakable tracery of the willow pattern: a fragment of a zig-zag bridge, a willow tree, or an ornate pagoda stare at the excavator who instinctively recognizes this ubiquitous deposit—so familiar, and so strange—in the sediment of Europe.

A linguistic history of conversion is easy to establish for this object (linguistic, that is, in Lyotard's sense of striving for linguistic-philosophical

closure): the willow pattern was an adaptation of the sort of conventional river scene to be found on Chinese export porcelain of the eighteenth century and is first produced by the Caughley porcelain factory in Shropshire around 1780.

Soon after this numerous other factories produced a plethora of other exotic landscapes with buildings. John Rogers and Sons, for instance, issued a plate in the late eighteenth century based on the acquatint "Remains of an Ancient Building near Firoz Shah's Cotilla, Delhi" from Thomas Daniell's *Oriental Scenery*. The Ottoman Empire also featured widely.

The Caughley factory's output is one relic of a convulsive frenzy of *chinoiserie* that gripped much of Europe in the mid-eighteenth century. An infatuation with Japanese and Chinese decorative styles became intimately fused with Rococo and transformed the interior decoration of many elite, and not so elite, European homes. Key moments in the development of Europe's desire to constitute itself through this xeno-figure are 1688, the date of publication of Stalker and Palmer's *Treatise of Japanning and Varnishing* (describing techniques which would allow Europe to literally "resurface" itself) and the Amsterdam artist Peter Schenck's publication in 1702 of *Picturae Sinicae*, a folio of twelve plates of Chinese landscapes. Shortly after this the Nuremberg artist Paul Decker designed and produced porcelain and lacquer in this emergent "Chinese" style.

In the case of the willow pattern this hybridized creole form spread rapidly from Caughley, was mass-produced by other factories in Shropshire, and then throughout England and Europe, achieving such a saturation of the market that the whole of the literal ground of Europe came to be impregnated with a hundred million fragments of this embodied cultural translation.

Figure/Discourse

However, it is not this sort of history that interests me primarily. Much more challenging, and much more productive, is a material, "figural" history of this encounter and the everyday material creolization of Europe of which it is a part. Here the problem of conversion appears not simply in the form of a movement from one zone of cultural value to another, but also in how we might understand the complex "network" of which it is a part, and the field of effects around the object that respects its own alterity in the flesh of the world.

A productive problem arises from the doubled alterity of, say, the willow pattern fragment itself; first as a translated xenotrace or xeno-figure, originating—in some sense—in China; but also from its alterity as a figural object resistant to any easy capture by a discourse of reason. We need to resist what Thomas Docherty perceptively locates as the "consistent inability to accept the alterity of the world as alterity" and the desire "to see it (instead) as a comprehensible sign, a sign whose evidential value and truthful meaning is located less in the (self-evidential) object itself and more in the linguistic subject of consciousness."[8] In other words we need to resist the "premature translation of things into signs" and the triumph of semiology over corporeality.

The term *xeno-figure* appropriates some aspect of Lyotard's use of "figure" as a field of affective intensity. Escaping some of the demands of meaning as signification, "figure" stands in a relation of "radical exteriority to discourse."[9] Contrasting "figure" with "discourse" which strives for "linguistic-philosophical closure" and which is "limited to what can be *read*, identified, and given meaning within a closed linguistic system,"[10] Lyotard evokes through "figure" a realm not of decodable meanings, but a zone where "intensities are felt."[11] Paraphrasing Lyotard I want to explore whether there is "always something happening in [figure] that incandesces the embers of society."[12]

A linguistic history of the willow pattern's conversion would stress its assimilation—its capture by (and readability within) a European cultural frame—such that the singularity (the figural resistance) of the willow pattern's materiality would be dissolved into the discursive "solution" of its new domain. And yet—as you will soon discover if you pick up a fragment (in the spirit of a delicate empiricism)—the object retains its distinctiveness. Although leaching from the soil may have started to invade the crackles in the glaze, producing a partialized patina (not only porcelain, not only English soil, but some new third zone of difference), the fragment retains its hard edges, its figural ability to crack against your spade, to signal its presence as an ineradicable particle in a cultural/chemical "suspension" that still resists the dissolution of the discursive cultural/chemical "solution."

The European adoption of chinoiserie resulted in an economically important industry which took as its sign a "Chinese look." Just as the sediment of Europe is impregnated with traces of the domestic manifestation of this craze, parts of Europe's public landscape also bear testimony to this. One such trace is the Chinese-style pagoda built in the 1760s in the

botanical gardens at Kew. Public creole styles in turn fed into domestic material culture. For instance, the pagoda appeared in a design on plate-printed linen and cotton, manufactured in 1766 by John Collins of Woolmers, Hertfordshire,[13] copied from illustrations in William Chamber's 1763 book on Kew.

Perhaps the household which used this cloth also had hanging on its walls Joseph Dufour's *Views of India* panoramic wallpaper, and perhaps its mealtimes were similar to those described in William King's early eighteenth-century poem *The Art of Cookery*:

> Make your transparent sweet-meats truly nice,
> With Indian sugar and Arabian spice:
> And let your various creams encircled be
> With swelling fruit just ravished from the tree.
> Let plates and dishes be from China brought,
> With liveley paint and earth transparent wrought.[14]

The South Asia historian Joanne Punzo Waghorne has written about what she terms the "ontology of ornamentation." Describing the relationship between the material culture of Indian divine kings and Euro-American domestic furnishing (which often appropriated elements of divine regalia), Waghorne notes that "in the greater empire, decoration was given the ardor, the passion, frequently reserved for divine matters."[15] A similar point was made by Mihaly Csikszentmihalyi and Eugene Rochberg-Halton in their classic *The Meaning of Things* in which they noted Henry Adams's observation that French Gothic cathedrals were the "medieval equivalents of the large electric turbines of his times."[16] Domestic decoration and industrial technology are inseparable from cosmologies. The greatest cathedrals in Victorian Britain (which according to the young John Ruskin were its railways stations) frequently adopted an architectural style that directly referenced its own fantastical vision of Chinese and Islamic architecture.

London's Paddington railway station, one of Isambard Kingdom Brunel's greatest structures, owes much of its design to Matthew Digby Wyatt (1820–77). He was responsible for what John Sweetman has described as the "wrought-iron tracery of enigmatically Saracenic-looking type,"[17] some of which seems to have been inspired by the Indian "bent leaf" or paisley design with which Wyatt would have been familiar through his work on the Eastern exhibits in the 1851 Great Exhibition and his subsequent work as a surveyor for the East India Company.

One might choose to see a parallelism in the idea that these motifs are "mere decoration" and a discursive stress on the recontextualizing power of Victorian London to culturally refigure this Saracenic tracery. Both positions would grant the bent leaf a second-order significance as a mere reflection of some other more important determinant (i.e., the engineering structure of the station, or the wider context of "English" culture which is deemed to have appropriated and translated this sign).

But Mark Wigley's reading of Gottfried Semper and his claim that "architecture begins with ornament," and more precisely with the texture, sensuous play, and the "folds, twists, and turns of an often discontinuous ornamental surface," helps us start to liberate the bent leaf from its subaltern position.[18]

The power of Renaissance Italian cities was sometimes performed through the display of Oriental carpets draped over the parapets of buildings (as is recorded in Carlo Crivelli's 1486 painting *The Annunciation with St Emidius*).[19] Perhaps it was a similar "dressing" of the railway terminal that contributed to its recognition as what Csikszentmihalyi and Rochberg-Halton call a "giant store-house of power [reflecting] the goals of the age."[20]

The modern equivalent of the Kew pagoda, or Paddington Station, might be the Quantas 747 covered from its nose (almost) to its tail in a pastiche of post–Papunya Aboriginal central desert designs by the Balaranji cooperative. The domestic parallel would be the collection of artifacts which the art historian and activist Vivienne Johnson scathingly collated in her "House of Aboriginality" and whose longer history in an Australian context[21] has been so perceptively analyzed by the painter Gordon Bennett, who has elaborately transposed different cultural and historical styles between different events and topoi in what he describes as "psychotopographical map[s]."[22] In paintings such as *Home Decor (Algebra) Daddy's Little Girl* (1998),[23] Bennett explores Cook's mythic foundational moment of perception through a juxtaposition with Margaret Preston's neo-Aboriginal aesthetic, Piet Mondrian, and the different forms and textures they mobilized. A key theme in Bennett's work is the resistant identities of material style which are dramatized by the startling nature of his transpositions. Material style is resistant in the sense that it is never simply "form" whose only function is to cleanly deliver a detachable "content"; it is never fully assimilable to a discursive narrative.

In this sense, Bennett's critical position appropriates the assumptions of high modernists that style was agentive and transformative. Bennett's

particular target was Mondrian's quest to utopically harmonize a contrasting verticality and horizontality.[24] This concern with style (of a look and its transformative power) finds a more politicized parallel in recent declarations by First Nation peoples. Thus the Inter-Apache Summit — a consortium of Apache tribes — in 1995 issued a demand that it should have exclusive control over all Apache "cultural property" in which category it included "all images, texts, ceremonies, music, songs, stories, symbols, beliefs, customs, ideas and other physical and spiritual objects and concepts."[25]

The perplexed liberal anthropological response noted that such a broad definition of cultural property would encompass "ethnographic fieldnotes, feature films (e.g. John Ford's *Fort Apache*), historical works, and any other medium in which Apache cultural practices appear, whether presented literally or as imaginative, expressionistic, or parodic embellishments of concepts with which Apache identify."[26] This anthropological response has then frequently gone on to decry the impediments which such a stipulation would place in the way of the free flow of knowledge and hence the efficient functioning of liberal democracies. What these declarations also say about person/things and their agency has, however, been ignored.

"So You Got the Brain but Have You Got the Touch?"

The linguistic conversion of chintz, that quintessentially English textile patterning, is on the face of it even more straightforward than that of the willow pattern. "An old English house without a chintz room," wrote Maciver Percival in 1923, "is rather like *Hamlet* with the Prince of Denmark omitted." Percival then went on to figurally position chintz within a repertoire of looks, textures, and grains: chintz "bring[s] at once to mind visions of colour bright and gay, yet soft and subdued withal, of dark gleaming mahogany, honey-coloured oak, walnut of mysterious grain, reflecting in the polished surfaces the tints and hangings, of sunlit parlours scented with rose and lavender in quiet country parsonages and picturesque manor houses — in a word, all the surroundings of a typical country house."[27]

Chintz had first entered Britain in 1631 when permission to import it was granted to the East India Company. Chintz is a corruption from *chint*, the Hindi/Urdu word for a spotted cloth; Pepys, purchasing an East Indian calico to line his wife's study in 1663, uses the term "chint."[28] So intense was European enthusiasm for chintz (especially for the brilliance and fastness of its colors, a spectral vibrancy faciliated by indigo and madder red)

that various governments were threatened by the economic crises that the trade precipitated. In 1686 the French banned its importation, and in 1700 an Act of Parliament in England prohibited the importation of all decorated stuffs from the East Indies, Persia, and China to Britain. However, a loophole which permitted importation for re-export meant that the ban was ineffective.

John Irwin and Katherine Brett have exhaustively documented the circularity of chintz production, demonstrating that it represented Indian artisans' interpretations of the design commissions given to them by the East India Company which through a process of partialization threw up a new hybrid product that was attractively exotic to European consumers.[29] In this respect it was rather like the Venetian trade beads exported to African in the sixteenth century and now re-exported to the West as a sign of an African authenticity.

There already exists an extensive (and extremely useful) literature on chinoiserie and chintz. It is not, however, concerned with these as embodied practice, or figure—as part of an everyday corporeal aesthetics (what elsewhere I've neologized as "corpothetics").[30] Rather, existing accounts approach these genres in their purely "readerly" aspect (as something which like Lyotard's discourse "can be *read*, identified, and given meaning within a closed linguistic system")[31] and the conventional patterns of intention and effect of art historical analysis. Any understanding of these as embodiments of a doubled alterity needs to locate such material artifacts in a realm of figural affect and place the "skins" of these objects in the flesh of the world.

Wavy Meaning: Or What Is Desire?

Annie Le Brun has argued that the importance of the surrealists lay in their taking seriously the Marquis de Sade's proposal that the key question was not "what is man?" but instead, "what is desire?" In so doing, she argues, existence was recognized as a question of interplay, or processses and networks, rather than essences and ontologies.[32] We might see in this a partial solution to Bruno Latour's question as to whether anthropology will be forever condemned to inhabit territories rather than explore networks. Desire implies flows.

For a specific example we might turn to Roland Barthes's brilliant and strangely ignored reading of Bataille's *Story of the Eye*.[33] This pornographic narrative was first published in 1928 and, as Barthes explores, elaborates a

fluid transubstantiation between a common network of objects constellated by a saucer of milk, a human eye, a skinned bull's testicle, and the moon. Barthes's insight is to recognize this object narrative as something different from the familiar eighteenth-century tales about which Jonathan Lamb has written so brilliantly.[34] These stories, with titles such as *The History of My Pipe, Memoirs of an Armchair*, are, Barthes writes, about objects "passed from hand to hand."[35] Narratives of the social lives of things, they reaffirm the agency of those humans between whom they pass.

The Story of the Eye by contrast is a true object-tale in which the narrative itself is a mere mise-en-scène for the appearance of various avatars (or declensions) of the central eye/testicle/moon object. The "vibrations" of this object (though perhaps, following Michel Serres and Latour we should say "quasi-object") create a new "wavy meaning," a new indeterminate object agency, as it passes "down the path of a particular imagination that distorts but never drops it": its *sound* remains the same.[36]

"Small Mistakes Concerning the Disenchantment of the World"

Emergent sensory/figural histories concerned with wavy meaning might facilitate a new understanding of the "aesthetic" precipitation of cultural and colonial history (I mean here aesthetic in its original sense of *aisthitikos*, "perceptive by feeling," and as inseparable from bodies). This new form of history might relocate vision not as the single modality of modernity, but as part of a unified sensorium in which a recarnalized eye was but one element (note chintz's incarnation as a "texture").

This new form of history would have as one of its pressing goals the desire (by, as Latour says, "making anthropology symmetrical"),[37] to undo those European subject/object distinctions which have insisted on the triumph of discourse over figure as part of its strategy to degrade the agency of objects. Current histories articulate parallel trajectories that differ only in details. Hence Lyotard stressed Judaism's and Hellenism's strategic disparagement of a figural Eastern "irrationalism." William Pietz and Peter Stallybrass propose a similar but much later differentiation via the trope of the fetish from the sixteenth century onward.[38] The demonization of the West African fetish provided the means for Europe to define itself through its absolute person/thing and subject/object distinctions.

Sigmund Freud emphasized Judaism's invocation of a God one could not see (and hence, as Lyotard argues, the "victory of intellectuality over

sensuality"). Martin Heidegger described the rise of the "world as picture" in which man increasingly constructed the world as an object given over to man's mastery and measuring. Jay's concept of "Cartesian perspectivalism,"[39] deploying a cold vision to enforce a distance between subject and object, echoes this very closely. Finally, Michel Foucault's epistemic trajectory from Renaissance analogy to the classical and modern triumph of man maps out the same history of disenchantment.

However, as Latour notes, there have been some "small mistakes concerning the disenchantment of the world."[40] If we combine Lyotard's concern with the ineradicable presence of figure—the persistence of the sensuous in the face of abstraction—with Latour's brilliant insight that we have never been modern, we can recast most of these histories as records of a tenacious aspiration for the autonomy of the self which was always incompletely realized.

Foucauldian approaches in particular have produced a consensus that xeno-figure has always been controlled by museological structures of knowledge and display—abstracted in a space beyond touch—rather than part of an everyday tactility and sensuousness. In understanding the volatility of figure, however, Alphonse Daudet's late nineteenth-century *Tartarin of Tarascon* may well be a better guide than Foucault. Whereas Foucault frequently assumes the triumph of discursive practices and linguistic-philosophical closure, Daudet addresses the anxieties that objects provoke and the fragility of our attempts to constrain and imprison them:

> You are to picture [Daudet tells us], a capacious apartment adorned with firearms and steel blades from top to bottom: all the weapons of all the countries in the wide world—carbines, rifles, blunderbusses, Corsican, Catalan, and dagger knives, Malay kreses, revolvers with spring-bayonets, Carib and flint arrows, knuckle-dusters, life-preservers, Hottentot clubs, Mexican lassoes. . . . Upon the whole fell a fierce sunlight, which made the blades and the brass butt-plate of the muskets gleam as if all the more to set your flesh creeping. Still, the beholder was soothed a little by the tame air of order and tidiness reigning over the arsenal. Everything was in place, brushed, dusted, labelled, as in a museum; from point to point the eye descried some obliging little card reading:—
> POISONED ARROWS! DO NOT TOUCH!
> Or,
> LOADED! TAKE CARE PLEASE!

If it had not been for these cautions I never should have dared venture in.[41]

This is a model not of the enduring capture and suppression of objects, but rather of their fleeting habitation within fragile discursive categories from which they seem ready, at any moment, to escape, like a bullet, or an arrow, prefiguring Benjamin's observation that "it hit the spectator like a bullet, it happened to him, thus acquiring a tactile quality."[42]

If for Foucault the horror of the European tradition lies in the triumph of "the absolute eye that cadaverizes," Daudet marks the limits—the failure—of this cadaverization, and in stressing the tactile, bullet-like quality of the objects of European knowledge transposes its power so that they acquire the power to cadaverize *us*. The museum of "them," far from being "our" means of surveillance and control, becomes "their" threat over "us."

The Sheen of the Object: Or, Slippery Eyes

We can see a similar Latourian tension—produced by discourse's inability to fully convert figure—at work in Barthes's discussion of Dutch still-life painting in his essay "The World as Object," which takes as its central problem the question of why so much effort might have been invested in the painting of (what Barthes describes as) "these meaningless surfaces."[43] On the one hand there is evidence of a routine "possessive individualism"—the concatenation of objects signifies "man's space; in it he measures himself and determines his humanity."[44] But this museum (and here I read Barthes against his own grain) also betrays man's anxieties about the object-world and its ability to ensnare him with its "secondary vibrations of appearance." To avoid entrapment and the collapse of fragile subject/object polarities, objects have to be coated with a *sheen* in order to "lubricate man's gaze." "Oysters, lemon pulp, heavy goblets full of dark wine, long clay pipes, gleaming chestnuts, pottery, tarnished metal cups . . . grape seeds" (to recall Barthes's catalog) are given (what he terms) an "easy surface" to avoid any leakage into man's identity. Sheen operates as the inverse of stickiness—the quality which for Jean-Paul Sartre was so repulsive because it heralded the dissolution of linguistically inculcated self/other identities. Whereas stickiness dissolves or blurs bodies, sheen helps maintain the fiction of separation within an engine where the similitude of moving parts always threatens a potential seizure through self-identity.

Le Corbusier was motivated by a similar fear of entanglement by objects. Noting that he (Le Corbusier) appropriated much of Adolf Loos's earlier paranoia about ornament, Wigley suggests that whiteness was praised because it permitted the fiction of a self detached from the world around it (and hence "civilized"). The problem with decoration was that "the body of the building and the body of the observer disappear into [its] sensuous excess." This is Maurice Merleau-Ponty's chiasmatic imbrication of subject and object in perception, but *negatively coded*. As Wigley continues, "to look at decoration is to be absorbed by it. Vision itself is swallowed by the sensuous surface."[45]

From this perspective, Le Corbusier's declamation on behalf of ripolin sounds exactly the same as those missionary directives to heathens to free themselves from the nonmodern attachment to fetishes. The missionaries' fear of the fetish as a person-thing is mirrored in Le Corbusier's anxiety about not being "master of your own house":

> Imagine the results of the Law of Ripolin. Every citizen is required to replace his hangings, his damasks, his wallpapers, his stencils, with a plain coat of white ripolin. *His home* is made clean. There are no more dirty, dark corners. *Everything* is shown as it is. Then comes inner cleanness, for the course adopted leads to a refusal to allow anything which is not correct, authorised, intended, desired, thoughtout: no action before thought. When you are surrounded with shadows and dark corners you are at home only as far as the hazy edges of the darkness your eyes penetrate. You are not master in your own house. One you have put ripolin on your walls you will be *master of your own house*.[46]

Note the directionality of transformation proposed in the Law of Ripolin: it is not that the ideal citizen/subject will happen to use ripolin; rather, he or she will come to be constituted by it—as its aftereffect. Ripolin will create the subject just as previously damasks and wallpapers have created the premodern anticitizen.

Entangling Objects

The model of aesthetics that I am attempting to challenge is surely now revealed as an epiphenomenon of that passing moment of reason's self-delusion (and here I draw on Heidegger, Theodor Adorno, Lyotard, and Latour). A rational cogito at the center of a world as picture strove to rele-

gate the aesthetic to a mere superstructural reflection of some deeper infrastructural self-willed linguistic reality. With the disintegration of the historical fiction of Western reason the aesthetic returns to its primary place ("impressing itself upon man"). Increasingly what we think we have created presses down upon us and creates us. Our cities, our technology, its textures and patterns, forces us to its will: we live out its life convincing ourselves that it is simply some minor affective irreality.

"Do not knock," Adorno labels his discussion of what he calls the "implacable . . . demands of objects" in *Minima Moralia*. "What does it mean for the subject," he asks, "that there are no more casement windows to open, but only sliding frames to shove, no gentle latches but turnable handles, no forecourt, no doorstep before the street, no wall around the garden? . . . The new human type cannot be properly understood without an awareness of what he is continuously exposed to from the world of things about him, even in his most secret innervations."[47] Technology, Adorno argues, subjects men "to the implacable, as it were ahistorical demands of objects."[48] This claim for "ahistorical demands" will doubtless be greeted by many with amazement for it contradicts in some fundamental sense our investment in human/object distinctions: we think we know that objects can't have demands—it is human agency which attributes imaginative demands to them. Similarly, it has become part of academic doxa that (to quote Nicholas Thomas) "as socially and culturally salient entities, objects change in defiance of their material stability. The category to which a thing belongs, the emotion and judgement it prompts, and the narrative it recalls, are all historically refigured."[49] Within a striving for linguistic-philosophical closure this can only be true, although as Latour argues, science itself invokes "quasi-objects" (like the vacuum) which are "inert bodies incapable of will, but capable of showing."[50] However, discourse is only one possible world or domain, and in the domain of figure—I am arguing—objects assert "implacable demands." For Adorno these were "as it were" ahistorical and the subjunctive caution is surely crucial to the acceptability of this claim. Objects' demands are not ahistorical in any direct sense: clearly this would be absurd. But *subjunctively* (as relating to a contingent, hypothetical, or prospective event) objects' demands are "as it were" ahistorical. Or so I hope to convince you.

Arjun Appadurai's stress on the "social life" of objects[51] and Thomas's investigation of objects' promiscuity (for all their insight) might be seen—with the benefit of Latourian hindsight—as the outcome of a particular obsession

with the figure of man, with a man-besotted vision of reality (I should note, however, that in an article Thomas revises his earlier position in favor of a view of artifacts as "technologies that created context anew," an argument that resonates with the one expounded here.)[52] Although in Appadurai's case an attempt was made to endow objects with quasi-human characteristics by conceding them a "life" and multiple careers, ultimately culture's potency is reinscribed through its ability to infinitely recode objects. The discovery—thanks to Latour—that we were never "modern" after all has set "nonhumans" free from being, as he says in *Pandora's Hope*, "clothed in the drab uniform of objects,"[53] objects whose fate in the Appadurai and early Thomas accounts was always to live out the social life of men, or to become entangled in the webs of culture, whose ability to refigure the object simultaneously inscribed culture's ability to translate things into signs and the object's powerlessness as an artifactual trace.

Latour's suggestion that culture (and cultures) are simply an epiphenomenon of the sign of man created by the bracketing off of Nature (and that consequently *cultures do not exist*) clearly poses a dramatic challenge to conventional cultural histories and anthropologies.

Frequently the Latourian problem of what to do with the "nonhuman" is resolved by the granting of personhood to objects: paintings are granted faces[54] and late industrial technology revealed to be a complex form of animism.[55] Another (and to my mind more satisfactory) strategy involves a mutual dissolution of human/nonhuman distinctions through the emergence of a new space of mutual interaction (I propose we call it "transhuman corpography") and an exploration of the space of contact in which these different sorts of objects (or transhuman corporealities) interact, where Merleau-Ponty suggested "things arouse in me a carnal formula of their presence."[56]

Devilish Indian Diamonds

I have suggested that within the domain of discourse, objects cannot have "ahistorical" demands. If we read Adorno with a desire for linguistic-philosophical closure we must necessarily disagree with him for our entire linguistic-philosophical repertoire has been configured by the denial of such a possibility.

If we switch domains, to the figural, and recognize Adorno's subjunctive framing of his claim, it starts to become useful. Although it may well be true

that discourse has internalized a view of humans as subjects forged through the *demonization* of "other" cultural practices such as fetishism,[57] the literary and figural productions of a putatively disenchanted Europe strip away the foundations of this subject/object distinction through their imaginative exploration of a complex transhuman corpography.

Fiction makes its own world, and a world in which the intentionality of objects does not need to be established, only their capacity to "show." I mean "worlds" in the sense that Nelson Goodman proposes of domains which are structured by internal "rightnesses of fit"[58] that are relative to any one world, rather than transcendental claims to a master truth. In the light of this the fact that fiction's subjunctive "world" might be contradicted by—and indeed, be incompatible with—reason's "world" is hardly surprising. Fiction's world of figure creates a medium in which the carnal presences objects are able to produce are addressed in their own terms, rather than living under the shadow of an impossible rationalism. Like Thomas De Quincey's opium, which induced dreams in which the East became an immediate and threatening presence, the figural is a kind of drug that grants us access to domains beyond the narrowly linguistic-philosophical and that lets us live inside the corporeality of objects. Alethea Hayter suggested that De Quincey's experience of being "stared at, hooted at, grinned at, chattered at, by monkeys, by paroquets, by cockatoos" and being trapped for centuries in secret rooms within pagodas was as though "he had got into a Chinoiserie panel by Huet or Pillement."[59] Or, phrased differently, De Quincey was able to experience the subjunctively ahistorical demand of the panel through the drug/dream/writing.

A cosmology with animate objects has a powerful sublimated Latourian presence in the popular fiction of modernity. Indeed, in the new nineteenth-century detective genre we can trace a preoccupation with the identities and boundaries of persons and things in an emergent semiotics and phenomenology of empire. In Edgar Allan Poe we can see an anxiety about the power of objects within a corpography. *The Murders in the Rue Morgue* and *The Oval Portrait* systematically explore the permeability of human/animal and human/artifact divides.

The exotic was a privileged state of liminality and anxiety and it is no surprise that it is exotic objects that frequently explore the person-thing or quasi-object in eighteenth- and nineteenth-century literature.

The anxious agency accorded to transcultural artifacts finds one of its fullest literary articulations in Wilkie Collins's 1868 "sensation novel" *The Moon-*

stone where the troubling presence of an exotic object is expressive of an agency that exceeds the classificatory abilities of colonial structures. "Here was our quiet English house suddenly invaded by a devilish Indian Diamond—bringing after it a conspiracy of living rogues."[60] The moonstone is of course a diamond looted from Tipu Sultan's palace after the storming of Seringapatam in 1799 and its agency is repeatedly testified to: "When you looked down into the stone, you looked into a yellow deep that drew your eyes into it, so that you saw nothing else. It seemed unfathomable; this jewel, that you could hold between your fingers and thumb, seemed unfathomable as the heavens themselves. We set it in the sun, and then shut the light out of the room, and it shone awfully out of the depths of its own brightness, with a moony gleam, in the dark."[61] We might also connect the moonstone to David Batchelor's account of the role of gems as exemplary of an Eastern "color" (for instance, in Aldous Huxley's *Heaven and Hell* where sapphire and lapis lazuli "seemed to possess an interior light")[62] which was disruptive of a dominant "chromophobia." Batchelor's brilliant insight is that color "looks at you": chromophobia expresses a discursive desire to render the world as (subfusc) picture, an object distinct from the viewing subject. Figural color—returning the gaze—recorporealizes, recarnalizes this axis, and causes the world to presence itself again as part of a corpography.

The agency of Collins's stone is mirrored by an earlier objectification of Tipu Sultan himself. A common theme of paintings produced immediately after Tipu's death concerns his thingness and his darkness, his location within a liminal corpography. Commenting on Arthur William Devis's "Major General David Baird Discovering the Body of Tipu Sultan," Mildred Archer notes that "the tiny figures crouch below the archway engulfed by a black and yawning emptiness"[63] and Tipu's body is checked to ascertain that it is completely devoid of life.

Jean-Pierre Naugrette has suggested that the agency of the moonstone is replicated by the way in which the Indian theme "gradually pervade[s] (and even pervert[s]) the English narratives of Betteredge, Miss Clarke" and so on.[64] The whole narrative is framed—through its prologue and epilogue—by Indian experiences, and the putatively humdrum Victorian England that lies in the center of the text is determined by this Indian frame.

Twenty-six years later, in the Sherlock Holmes case of *The Speckled Band*, another animate Indian object is wreaking havoc on the sleepy interior of England. This should not surprise us, for the story is part of the reminis-

cences of Dr. John Watson, late of the Indian army (a brief biography of whom Arthur Conan Doyle considerately provides at the start of *A Study in Scarlet*). It is also salutary to recall that Holmes himself was a member of the Anthropological Institute and, as he tells us in *The Cardboard Box*, had recently written a short anthropological monograph on the outer morphology of the ear.

In *The Speckled Band* Watson and Holmes are woken early by the arrival of a terrified Helen Stonor, whose stepfather is "the last survivor of one of the oldest Saxon families in England"—the Roylotts of west Surrey. After a medical career in Calcutta, her stepfather—Grimesby Roylott—had returned to England a "morose and disappointed man" whose heriditary mania had been "intensified by his long residence in the tropics."[65]

In rural Surrey, Roylott's only friends were groups of wandering gypsies whom he would permit to camp on his land and would "accept in return the hospitality of their tents, wandering away sometimes for weeks on end."[66] His only companions were a baboon and a cheetah who were "feared by the villagers almost as much as their master" and whose occasional presence in the Roylott mansion forced his two stepdaughters to lock the doors to their bedrooms at night (note how this Surrey village has assumed all the characteristics of a colonial Indian village).

Helen Stonor's visit to see Holmes was precipitated by the recent murder of her sister who, dying in Helen's arms, "her face blanched with terror," had exclaimed, "it was the band! The speckled band!"[67] Key to Holmes's understanding that Grimesby Roylott was intent on killing his two stepdaughters (whose impending marriages would have depleted his diminishing resources) was the fact that shortly before she died the sister had been troubled by the "smell of the strong Indian cigars" which Grimesby smoked, thus indicating that there was some sort of passageway between his room and that of the sisters. This turned out to be a ventilation shaft and it was this that permitted the ingress and egress of a trained Indian swamp adder, which was in a final twist of fate to end up killing Grimesby Roylott himself, whose body is found at the conclusion of the story wearing "strange headgear" that is the speckled band, or adder coiled around his head.

If this transhuman corpography works on the unconscious, it is at a phenomenological level of bodily reaction that we might expect its effects. Exactly this point is made in *The Moonstone* when, having explained the anxiety that the "devilish Indian diamond" had brought to a "quiet English house," and the improbability of this in "an age of progress," Gabriel Bet-

teredge explains that "whenever you get a sudden alarm of the sort that I had now, nine times out of ten the place you feel it is in your stomach."[68] Betteredge seems to be agreeing with Latour that we never were modern.

If detective and ghost stories (and the genre significantly known as sensation novels) were concerned primarily to invoke a negative physical thrill, aesthetic style produced more positive effects, but the phenomenological history of the reception of these genres has yet to be written. What already exists in fragmentary form are semiological accounts of aesthetic styles, for example, which cryptologically (to use Dan Sperber's term) decode images and pattern, but have nothing to say about xeno-figure.

"Bangalore Brings the Uncanny"

If Pietz and Stallybrass are correct, and early European cultural encounters in West Africa with what becomes coded as "fetishism" are a foundational episode in the fragile definition of a Europe as *unlike* West African because it had person-thing distinctions, one could point to later moments of cultural encounter in which one can see this fragile construction decaying. Take for instance nineteenth- and twentieth-century Orientalist concerns with the position of Indian objects within a transhuman corpography and the complementary fixation with persons' abilities to become objects. Perhaps the most celebrated instance is Kim's journey through the entrance-hall turnstile of the Lahore "Aijab-Gher" (*ajab*, "strange, peculiar")—the Lahore wonder-house, or museum—into a space of encounter with (in the lama's case "open-mouthed") wonder which inscribes a paradigmatic conjunction of object and agency. Parallel accounts of ascetic renouncers' practices (such as the inscription on a photograph in London's Royal Anthropological Institute Photographic Collection, "bystanders said the yogi had been in a trance for a week") explore the suspension of the conventional signs of being "human."

Almost any travel account or memoir of India might be mined for an exploration of person/animal and person/thing dichotomies that construct India as a laboratory where the person might be experimentally put under erasure. "Bangalore Brings the Uncanny" is a chapter heading in Mark Channing's *Indian Mosaic*. Having spent two years soldiering in India, Channing is disappointed by its routine rationality until he transfers to Bangalore. Initially the cool air of the Mysore plateau makes him sleep soundly until

one night when he awakes suddenly with the sensation that somebody is in the room:

> Dimly seen and tired-looking, he was bending over me, and appeared to be smiling, for I could see a gleam of teeth. But his hands were crossed upon his breast, and that made the smile look uncanny. ("Keep clear of the uncanny!"). My heart began to thump. There was no light in the room; the night was moonless; and yet I could see him!
> A second later I realized something that made my skin prickle: half of this man's body was *outside* the mosquito curtains, and half of it was *inside* them.[69]

Bodies that glow in the dark, that have cyborg abilities to move through barriers (Channing's scene recalls *Terminator II*), and the thousands of levitating *sadhus*, gyrating ropes, and other person-things that populate (note this term) a plethora of popular Orientalist texts, participate in the elaboration of a new theoretical terrain which attempts to escape what Latour terms the "despair and self-punishment" of a disenchanted world.

The Object Creates Its Own Context

The classicist Mary Beard has documented that images of the Rosetta Stone are one of the consistent best-sellers in the range of postcards offered for sale by the British Museum, along with images of the portico by day and by night. The latter Beard explains with reference to the fact that in visitor surveys an overwhelming number of respondents when asked what they expect to find in the British Museum reply, "everything": postcards of the portico might thus be seen as the lid to the box that contains all possible knowledge.

The Rosetta Stone is very popular indeed: the British Museum Gift Catalogue advertises a reduced-size resin copy with wall hook ("gift boxed"), a luxurious silk scarf ("dry clean only"), and a Rosetta Stone umbrella ("practical and stylish"). This popularity Beard attributes to its embodiment of the putative *decipherability* of the past, and of the object in general. The stone with its parallel inscribed texts stands in a compressed way for the textualization of the visual (the stone's hieroglyphs were given a Greek translation), but also more abstractly for the possible decoding of materiality in general since the stone is an object that is also its own label. As Beard writes: "Language and writing is seen to take precedence over the artefact."[70]

The Rosetta Stone emerges as the totem of "discourse"—the fantasy triumph of a linguistic-philosophical closure—and in conclusion I want to juxtapose this apparent meta-conversional text, the supreme translational artifact of modernity, with a parallel though very different object: the sherd of Amenartas in Rider Haggard's *She*.

The parallels and differences are strangely precise. The three languages of the Rosetta Stone find a parallel in the sherd of Amenartas in the three keys that are required to unlock the casket which contains it. The keys (a comparatively modern one, an exceedingly ancient one, and "the third entirely unlike anything of the sort that we had ever seen before") are then deployed in a set of movements that as they open different elements of the casket simultaneously strip away language to the irreducible core of the object.

The appearance of this remarkable object—the sherd of Amenartas—is presaged by the disturbance of the ordinary object-world and its secure uses and classifications: "So occupied was I with my own thoughts that I regret to state that I put a piece of bacon into Leo's tea in mistake for a lump of sugar. Job, too, to whom the contagion of excitement had, of course, spread, managed to break the handle off my Sevres china teacup, the identical one, I believe, that Marat had used just before he was stabbed to death."[71] Space does not permit me to give a detailed reading of the remarkable appearance of this object, but suffice it to say that one of its consequences is the eruption of one of the most significantly material texts in popular fiction, producing a dramatic pictorialization of the narrative through its reproduction of the different texts (and their translations) which are inscribed in the text.

The entire trajectory of *She* is, however, quite different from that of the Rosetta Stone. Whereas the latter was used in the cause of semiological closure (for after about 1820—largely with the benefit of the clues from the stone—scholars were able to decipher hieroglyphics), the casket containing the sherd of Amenartas is a veritable Pandora's box unleashing the full narrative and figural complexity of the following three hundred or so pages of the novel.

The agentive centrality of the casket and its contents reminds me forcefully of the anthropologist Marilyn Strathern's account of Melanesian artefacts which are deemed to be capable of creating their "own context." Strathern suggests that many Melanesian societies may see images as compressed performances requiring little or no additional contextual information: "the very act of presentation [constitutes] the only act that [is] relevant"[72] and

talk is resisted because of the inevitable distortion that such a reframing or translation from figure to discourse will entail.

One powerful consequence of the dominance of a model of modernity as disenchantment configured by subject/object distinctions has been the attempt to discursively capture the corporeal and artifactual. Euro-America's desire to convert figure into discourse has resulted in the material realm being forced into a subjugated periphery, always seemingly fully determined by more significant and more powerfully metropolitan epistemic discourses which material culture is only ever permitted to exemplify or illustrate. Xeno-figure has, as I have suggested, been characterized by a double alterity by virtue of its nonmetropolitanness and also because of its figural alterity. I have suggested that it is surely no coincidence that exotic subjects play the supreme role of person/thing in eighteenth- and nineteenth-century literature and that transhuman corpographies are so frequently given a colonial backdrop. The task now is to develop new languages which challenge this conversional meta-narrative and articulate pathways that will allow objects and material practices to manifest their own primary role as instantiations of significance (what Edward Said has termed their "sensuous particularity"), rather than being subjugated as the expression of some higher order of meaning whose primary form is located elsewhere.

To conclude: creole designs emerged strongly in New Zealand from the 1880s onward and were given a decisive impetus with the publication of Augustus Hamilton's *Maori Art* in 1896.[73] Here I have tried to suggest that a parallel creolism characterizes much European design from the mid-seventeenth century onward. It is in this sense, to recall Bernard Smith, that colonial art is a "a reflection of a reflection."

But in addition to seeking to establish the enduring presence of a creole materiality, I have also attempted to explore a framework through which this materiality might be addressed on its own terms, rather than as a mere shadow of a linguistically envisaged form of culture whose "immateriality" is more important.

Key to the displacement of this model of culture, I have suggested, is Latour's notion of the network and Barthes's model of wavy meaning. The notion of "settlement" implies a stasis and the consolidation of this problematic notion of culture. Much as McKim Marriott urged the replacement of the "solidarities" of European sociology (at least in the context of the understanding of India) with the "fluidarities" of Indian cultural realities,[74]

so the time now seems ripe to unsettle settled ideas of the relation of culture and materiality through the exploration of the pathways of fluid, wavy meaning that I have attempted to delineate in this chapter.

Notes

Christopher Pinney, "Creole Europe: The Reflection of a Reflection," *Journal of New Zealand Literature* 20 (2003): 125–61. Reprinted with permission of the publisher.

1 Bernard Smith, *Place, Taste and Tradition: A Study of Australian Art since 1788* (Sydney: Ure Smith, 1945), 16.

2 Smith, *Place, Taste and Tradition*, 16; emphasis added.

3 Nicholas Thomas, *Possessions: Indigenous Art/Colonial Culture* (London: Thames and Hudson, 1999), 106.

4 Ian McLean, *White Aborigines: Identity Politics in Australian Art* (Cambridge: Cambridge University Press, 1998), 44.

5 Donald Lach, *Asia in the Making of Europe* (Chicago: University of Chicago Press, 1970).

6 Jack Goody, *The East in the West* (Cambridge: Cambridge University Press, 1996).

7 Wolfgang Schivelbusch, *Tastes of Paradise: A Social History of Spices, Stimulants, and Intoxicants* (1980; New York: Vintage, 1992).

8 Thomas Docherty, *Alterities: Criticism, History, Representation* (Oxford: Clarendon Press, 1996), 157.

9 David Carroll, *Paraesthetics: Foucault, Lyotyard, Derrida* (London: Methuen, 1987), 30.

10 Carroll, *Paraesthetics*, 30.

11 Carroll, *Paraesthetics*, 31.

12 Carroll, *Paraesthetics*, 28.

13 Ray Desmond, *Kew: The History of the Royal Botanic Garden* (London: Harvill Press, 1995), 111.

14 William King, "The Art of Cookery" (excerpt), in *The Penguin Book of Eighteenth-Century English Verse*, ed. Dennis Davidson (Harmondsworth: Penguin, 1973), 168.

15 Joanne Punzo Waghorne, *The Raja's Magic Clothes: Re-Visioning Kingship and Divinity in England's India* (University Park: Pennsylvania State University Press, 1994), 251.

16 Mihaly Csikszentmihalyi and Eugene Rochberg-Halton, *The Meaning of Things: Domestic Symbols and the Self* (Cambridge: University of Cambridge Press, 1981), 35.

17 John Sweetman, *The Oriental Obsession: Islamic Inspiration in British and American Art and Architecture 1500–1920* (Cambridge: Cambridge University Press, 1988), 171.

18 Mark Wigley, *White Walls, Designer Dresses: The Fashioning of Modern Architecture* (Cambridge, MA: MIT Press, 2001), 11.

19 See Lisa Jardine, *Worldly Goods: A New History of the Renaissance* (London: Macmillan, 1996), 5–10.

20 Csikszentmihalyi and Rochberg-Halton, *The Meaning of Things*, 35.

21 Vivienne Johnson, *Copyrites: Aboriginal Art in the Age of Reproductive Technologies* (Sydney: National Indigenous Arts Advocacy Association and Macquarie University, 1996).

22 Gordon Bennett, "Australian Icons: Notes on Perception," in *Double Vision: Art Histories and Colonial Histories in the Pacific*, ed. Nicholas Thomas and Diane Losche (Cambridge: Cambridge University Press, 1999).

23 Gavin Jantjes and Elizabeth MacGregor, *History and Memory in the Art of Gordon Bennett* (Birmingham and Oslo: Ikon Gallery and Henie-Onstad Kunstcenter, 1999), 37.

24 Jantjes and MacGregor, *History and Memory*, 19.

25 Michael F. Brown, "Can Culture Be Copyrighted?," *Current Anthropology* 39(2) (1998): 194.

26 Brown, "Can Culture Be Copyrighted?," 194.

27 Maciver Percival, *The Chintz Book* (London: William Heinemann, 1923), 1.

28 Percival, *Chintz Book*, 19.

29 John Irwin and Katherine B. Brett, *Origins of Chintz* (London: HMSO, 1970).

30 Christopher Pinney, "Piercing the Skin of the Idol," in *Beyond Aesthetics: Art and the Technologies of Enchantment*, ed. Christopher Pinney and Nicholas Thomas (Oxford: Berg, 2001), 151–79.

31 Carroll, *Paraesthetics*, 30.

32 Annie Le Brun, "Desire—a Surrealist 'Invention,'" in *Surrealism: Desire Unbound*, ed. Jennifer Mundy (London: Tate, 2001).

33 Roland Barthes, "The Metaphor of the Eye," printed as an appendix to Georges Bataille, *Story of the Eye* (1963; Harmondsworth: Penguin, 1982).

34 Jonathan Lamb, "Modern Metamorphoses and Disgraceful Tales," *Critical Inquiry* 28(1) (2001): 133–66.

35 Barthes, "The Metaphor of the Eye," 119.

36 Barthes, "The Metaphor of the Eye," 119.

37 Bruno Latour, *We Have Never Been Modern*, trans. Catherine Porter (London: Prentice Hall, 1993), 91 ff.

38 William Pietz, "The Problem of the Fetish, 1," RES: *Anthropology and Aesthetics* 9 (Spring 1985): 5–17; Peter Stallybrass, "Marx's Coat," in *Border Fetishisms: Material Objects in Unstable Spaces*, ed. Patricia Spyer (New York: Routledge, 1998).

39 Martin Jay, "Scopic Regimes of Modernity," in *Vision and Visuality*, ed. Hal Foster (Seattle: Dia Press, 1988).

40 Latour, *We Have Never Been Modern*, 114.

41 Alphonse Daudet, *Tartarin of Tarascon* (London: J. M. Dent, 1910), 1.

42 Walter Benjamin, "The Work of Art in the Age of Mechanical Reproduction," in *Illuminations*, trans. Harry Zohn (London: Fontana Press, 1992), 231.

43 Roland Barthes, "The World as Object," in *Barthes: Selected Writings*, ed. Susan Sontag (1953; London: Fontana/Collins, 1983), 62.

44 Barthes, "The World as Object," 64.

45 Wigley, *White Walls*, 7.

46 Quoted in David Batchelor, *Chromophobia* (London: Reaktion, 2000), 46.

47 Theodor W. Adorno, *Minima Moralia: Reflections from Damaged Life*, trans. E. F. N. Jephcott (1951; London: Verso, 1978), 40.

48 Adorno, *Minima Moralia*, 19.

49 Nicholas Thomas, *Entangled Objects: Exchange, Material Culture, and Colonialism in the Pacific* (Cambridge, MA: Harvard University Press, 1991), 125.

50 Latour, *We Have Never Been Modern*, 23.

51 Arjun Appadurai, *The Social Life of Things* (Cambridge: Cambridge University Press, 1986).

52 Nicholas Thomas, "The Case of the Misplaced Ponchos: Speculations Concerning the History of Cloth in Polynesia," *Journal of Material Culture* 4(1) (1999): 5–20.

53 Bruno Latour, *Pandora's Hope: Essays on the Reality of Science Studies* (Cambridge, MA: Harvard University Press, 1999).

54 Michael Fried, *Absorption and Theatricality: Painting and Beholder in the Age of Diderot* (Berkeley: University of California Press, 1980); David Freedberg, *The Power of Images* (Chicago: University of Chicago Press, 1989); W. J. T. Mitchell, "What Do Pictures Really Want?," *October* 77 (1996): 71–82.

55 Alfred Gell, *Art and Agency: An Anthropological Theory* (Oxford: Clarendon Press, 1998).

56 Quoted in David MacDougall, *Transcultural Cinema* (Princeton, NJ: Princeton University Press, 1998), 53.

57 William Pietz, "The Problem of the Fetish, 1," *Res* 9 (Spring 1985): 5–17; Peter Stallybrass, "Marx's Coat," in *Border Fetishisms: Material Objects in Unstable Spaces*, ed. Patricia Spyer (New York: Routledge, 1998).

58 Nelson Goodman, *Ways of Worldmaking* (Indianapolis: Hackett, 1978), 3–5.

59 Alethea Hayter, *Opium and the Romantic Imagination* (London: Faber, 1968), 88.

60 Wilkie Collins, *The Moonstone*, ed. Sandra Kemp (1868; Harmondsworth: Penguin, 1998), 46.

61 Collins, *The Moonstone*, 70.

62 Batchelor, *Chromophobia*, 74.

63 Mildred Archer, *India and British Portraiture 1770–1825* (London: Sotheby Parke Bernet, 1979), 266.

64 Jean-Pierre Naugrette, *The Moonstone by William Collins* (Paris: Didier Erudition, 1995), 17.

65 Arthur Conan Doyle, "The Speckled Band," in *The Adventures of Sherlock Holmes* (1893; Harmondsworth: Penguin, 1994), 177.

66 Conan Doyle, "The Speckled Band," 178.

67 Conan Doyle, "The Speckled Band," 180–81.

68 Collins, *The Moonstone*, 46.

69 Mark Channing, *Indian Mosaic* (London: Harrap, 1936), 95.

70 Mary Beard, "Souvenirs of Culture: Deciphering (in) the Museum," *Art History* 15(4) (1992): 521.

71 H. Rider Haggard, *She, a History of Adventure* (1886; London: Longmans, Green, 1918), 23.

72 Marilyn Strathern, "Artefacts of History: Events and the Interpretation of Images," in *Culture and History in the Pacific*, ed. Jukka Siikala (Helsinki: Finnish Anthropological Society 1990), 36.

73 Augustus Hamilton, *Maori Art* (Wellington: New Zealand Institute, 1896).

74 McKim Marriott, "Constructing an Indian Ethnosociology," in *India through Hindu Categories*, ed. McKim Marriott (New Delhi: Sage, 1990), 3.

Picasso, Africa, and the
Schemata of Difference

Simon Gikandi

Sometime in the mid-1950s the Guyanese artist Aubrey Williams, a lead-
ing member of Afro-modernism and black abstractionism, was introduced
to Pablo Picasso by Albert Camus during a visit to Paris. Given Williams's
association with various factions of Cubism and his attempt to emulate its
style to capture the hybrid cultures of his native Guyana, the meeting with
the great artist was supposed to be a highlight of his career, perhaps a cata-
lyst for new directions in the troubled relation between artists of African
descent and the international avant-garde. But as it turned out, the meeting
between Williams and Picasso, far from being an ephiphanic encounter, was
to be remembered as anticlimactic:

> There was nothing special about meeting Picasso. It was a meeting like
> many others, except that meeting Picasso was a big disappointment. It
> was a disappointment for stupid little things: I didn't like how he looked;
> I didn't like how he behaved. I never thought I would not like people like
> that. But the total of the whole thing is that *I did not like Picasso*. He was
> just an ordinary past-middle-aged man. I remember the first comment
> he made when we met. He said that I had a very fine African head and
> he would like me to pose for him. I felt terrible. In spite of the fact that I
> was introduced to him as an artist, he did not think of me as another art-
> ist. He thought of me only as something he could use for his own work.[1]

Williams's disappointment may have arisen from a sense of heightened
expectation about the master, or even the hurt that came from not being
recognized as a fellow artist, but what stands out in this description of the
encounter is that what Picasso found most enchanting about the Guyanese
painter was a "fine African head," he valued as a model for art. Williams was

disappointed that he was appealing to Picasso merely as an object or subject of art, not as an artist, not as a body, not even as a human subject. And yet, it is possible that this disappointment arose because Williams had assumed, as many historians of art have assumed over a century of modernism, that because Picasso was the most important figure in primitivism, the movement in art when the Other, often black or brown, became a catalyst for modern art, that he must have had some respect for the cultures and bodies that had made modernism possible. How else could one make other cultures and subjects the sources of art, the agents of the major breakthroughs we have come to associate with modernism, unless one also valued the people who produced it? We now know, of course, that the relationship between Picasso and his African sources was much more complicated than Williams might have assumed. Indeed, the fascination with the "fine African head" did not simply reflect the insensitivity of an artist past middle age; on the contrary, Picasso's relationship to Africa, or his investment in a certain idea of Africa, which is evident from his early career to his high Cubist period, was a meticulous attempt to separate the African's art from his or her body, to abstract, as it were, those elements of the art form that would serve his purpose at crucial moments in his struggle with established conventions of Western art. This is the gist of the argument I want to present in this chapter.

Much has been written on Picasso and primitivism but little on his specific engagement with Africa. Indeed, a major part of the argument I present here demands a separation of primitivism, as a now canonized idea in the history of modernism, from African cultures and bodies. Picasso loved the idea of the primitive and tribal, but his relationship with the cultures and peoples of Africa and Oceania was more ambiguous. We are told, by André Malraux, among others, that Picasso was irritated by "the influences that the Negroes had on me" even as he eloquently discussed the magical influence of those African objects discovered at the Old Trocadéro on that fateful day in 1906.[2] In most of his reflections on the "Negro" influence he seemed careful to make distinctions between the effect or affect of African objects and cultures. When he talked about the "Negro," he was talking about the object rather than the person.[3] The fact that Picasso had an intimate relationship with African objects is not in doubt; but there is little evidence of an interest in Africans as human beings and producers of culture beyond his general interest and involvement in anticolonial and other radical movements. Indeed, as Williams discovered in that encounter in Paris in the 1950s, Picasso seemed to be meticulous in his separation of objects of art from bodies, and

it is my contention that it was in this division of bodies from artistic models that the African could be cleansed of its danger and thus be allowed into what Rasheed Araeen has aptly called "the citadel of modernism."[4]

It is now claimed that in order for modernism to claim its monumentality, that is, its enshrinement in the very institutions of Western culture and museum culture that it had set out to defy and deconstruct, it had to shed the contaminants of the Other as part of what D. A. Miller calls, in a different context, its "routine maintenance."[5] In fact, the debates that have come to define modernism, the custodial commentaries on its monumentality, tend to see it as the triumph of endogamy over exogamy, of internal forces over external ones.[6] It is remarkable that except in those instances when the topic at hand is primitivism, the canonical narrative of modernism has little to say about African sources.[7] Now, this absence can be explained in one of two ways: one could argue, for instance, that the institutions of commentary have been so eager to secure the purity of modernism that they have become mechanisms of surveillance against the danger that engendered it in the first place. Africa is first acknowledged as a significant episode in the history of modernism, and then it is quickly dispatched to the space of primitivism, a place where it poses no danger to the purity of modern art. However, there is a second, even more interesting explanation, namely, that the practitioners of modernism had themselves started the process of containment, that they needed the primitive in order to carry out their representational revolution, but that once this task had been accomplished, the Other needed to be evacuated from the scene of the modern so that it could enter the institutions of high art. How else can we explain the paradox that runs throughout the history of modernism, the fact that almost without exception the Other is considered to be part of the narrative of modern art yet not central enough to be considered constitutive? To put it more specifically, why is it possible to argue simultaneously that the discovery of African and Oceanic art enabled the moment of modernism yet claim that these works did not have a fundamental influence in the shaping of modernism? From Daniel-Henry Kahnweiler's dismissal of the "Negro influence" in the rise of Cubism to Pierre Daix's famous claim that "there is no 'Negro' in the *Les Demoiselles d'Avignon*," one of the greatest puzzles of modern art is whether Africa has to be considered a categorical imperative in the theory and practice of modern artists or just a passing fad in the ideology of modernism.[8] My discussion will proceed in a circuitous way, but it will focus, from different directions, on both Picasso's entanglement with Africa and

the critics' and art historians' entanglement with this entanglement. My goal is to show how understanding it—the entanglement, that is—is crucial to our rethinking of the aesthetic of modernism and the schemata—and stigmata—of difference that both maintains and haunts it.

I

Let us start with a basic question: is there an Africa in Picasso's oeuvre? And if so, what form does it take? Is it the Africa of bodies or art forms, of material culture or abstracted ideals? At first sight this might appear to be a banal question, especially when we recall the countless debates surrounding the influence of Africa as the mark of Picasso's modernist breakthrough and, inevitably, the centrality of primitivism in his aesthetic practices. But this old question needs to be posed because with few exceptions, the major studies of the African influence in Picasso, whether for or against it, are explorations of the influence of certain African art objects on Picasso's work, or generalized explorations of how African art objects, discovered at the Old Trocadèro, triggered the "terror" that made modernism possible. The terms of reference in these studies tend to acknowledge the African influence and to dispose of it in the same breath, either by confining "Africanisms" to the realm of psychological fear or artistic structure. What these approaches seem to do, even in their detailed and meticulous study of "Africanisms" in Picasso, is also to minimize what I am calling the constitutive role of Africa in the making of modernism. In 1948 Kahnweiler would, in a single bold gesture, testify to the modernists heavy interest in Negro Art and still proceed to "dispute the validity of the thesis of a direct influence of African art on Picasso and Braque."[9] In 1984, William Rubin would provide perhaps one of the most detailed explorations of the influence of primitive art on Picasso's major works and still conclude that tribal sculpture did not have a constitutive role in the shaping of his art.[10] From the moment Picasso began to be canonized as the most important painter of the modern period in the 1940s, the institutions of interpretation have been anxious to minimize or dismiss any direct and determinative correlation between his works and the tribal objects that surrounded him as he undertook the project of making art modern. Where the influences of the tribal seem self-evident, they are redefined as "convergences" (by Kahnweiler), "affinities" (by Rubin), or "connotations" (by Yve-Alain Bois).[11]

My interest here is to probe the reasons for this anxiety of influence. What

threat does the acknowledgment of correlativity between the modern and its Others pose? What is the basis of the hauntology that has come to define the moment of modernism and Western high culture in general?[12] Elsewhere I have argued that one of the unifying characteristics of the aesthetic ideology that has emerged in Europe since the eighteenth century is its concern with Others as the enabling conditions of beauty, taste, and judgment and, simultaneously, with the counterpoints or opposites of these conditions. If art has come to function as the defining point of cultural achievement and civilization, it is only because it functions within economies of desires and ideals—of purity and a chaste culture—clearly distinct from the danger and defilement represented by the Other and in need of defense from the barbarism that necessitates taste.[13] Modernism presents an immediate challenge to this thesis because its overall economy, especially its adulation of primitivism, would seem to posit the Other not as a threat that must be contained but as the source of new energies. In 1919, T. S. Eliot declared that one could no longer understand culture without knowing "something about the medicine-man and his works": "As it is certain that some study of primitive man furthers our understanding of civilized man, so it is certain that primitive man and poetry help our understanding of civilized art and poetry."[14] What is easy to miss in declarations such as this one is that the primitive was a conduit to understanding "civilized" man, art, and poetry, not an endpoint in itself; there was no incentive to understand the Other unless it would lead to an understanding of Western civilization either in its "childhood" or moments of crisis. Thus, Eliot wanted his readers to comprehend something about the medicine-man so that they could recognize the sensibility of the poet, "the most able of men to learn from the savage."[15] Savagery and the artistic sensibility would intimately be connected in the aesthetic of modernism; however, it did not follow that the moderns were willing to give up civilization to become one with the savage. Indeed, the relation between the modern and the savage was defined by a dialectic of love and loathing, identity and difference. So it is with Picasso and Africa. Even in his "Negro" period, Picasso seemed to prefer the African art object to the "uncultured" African body. Nevertheless, this preference for the art object over the body was something that Picasso arrived at in the process of working through his aesthetic ideology at certain crucial phases of his career, beginning with his troubled relation to academic art during his youth, his subsequent flirtation with "soft" modernism, and culminating in the Cubism that marked the revolution in modern art. His oscillation be-

tween the African body and artwork appears to be the symptom of a deep and continuous engagement with the continent, the mythologies surrounding it, the fantasies it generated, and ultimately the threat it posed to the idea of civilization that the modernists both wanted to deconstruct and yet secure as the insignia of white, European, cultural achievement.

Under these circumstances, it is best to begin a rethinking of Picasso and the haunting of Africa by comparing his figuration of the continent in the years before his "Negro period" (1906–8) and the irruption of modernism. It is useful to recall here that in the early years of his career, Picasso was preoccupied with what Marilyn McCully has called "classicizing subjects and forms"; he was primarily attracted to the art forms of what he construed to be classical cultures, mostly Iberian and Egyptian.[16] It is important to note at the outset that he did not consider "Negro Africa" to be part of this classical heritage or classicizing impulse. The absence of Africa from Picasso's classicism suggests an early awareness, on the artist's part, that the value of "Negro Africa" as a model or source of art lay elsewhere; it could not be relegated to antiquity nor could it be considered modern; rather, it occupied a middle space temporally located both in the childhood of mankind and yet very much part of the living world. This understanding of Africa was determined—and explained—by Picasso's Andalusian background much more than his French sojourn. Indeed, as Natasha Staller has shown, Picasso's engagement with the myth of Africa predates his 1904 move to Paris or his 1907 discovery of African art objects at the Old Trócadero.[17]

My concern here, then, is the meaning of Africa in Picasso's preprimitivism period, especially the often forgotten fact that he was the product of an Andalusia whose identity had historically been defined against an African cartography, disconnected from the "dark" continent by the Strait of Gibraltar but connected to it by history. This ambiguous connection led to "a series of complex and ambivalent racial, religious, and sexual stereotypes, and [to] the Malagueno myth of Africa, including the belief that the defeat of Africa made one modern."[18] Staller informs us that the defeat of the Moors entered Andalusian consciousness as an epochal moment: "the Middle Ages ended on 18 August 1487"; it was understood "in terms of apocalyptic rupture— a rupture explicitly understood in terms of modernity."[19] The myth that Picasso inherited from this history was one in which Africa was posited as the unmodern antithesis of the new Malaga: to become modern was to break away from Africa. Modernity, rather than classicism, defined what Picasso inherited—and resisted—as tradition. Where does resistance fit into

this narrative? Since Picasso had to reject tradition in order to become an artist, or at least to break away from the artistic traditions associated with his father, he needed, paradoxically, to discover and valorize a counterpoint to the modernity of Andalusia by inventing his own version of the unmodern. He could seek this unmodern, first, in the classical tradition. But it also seems, as scholars of his early works have noted, that a mastery of classical models of painting, especially those concerning the human form, would not enable a rupture in Western systems of representation; after all, one of the uncanny moves of modernity was to embrace the classical itself as the source of its civilizational authority.[20] In this sense, it was significant that the Malagueno myth of the modern was predicated not on a break from antiquity, but from the Middle Ages, clearly associated with the Arabic, Moorish, and hence African influences.

Aware, then, that the classical alone could not be valorized as the alternative to the modern, Picasso's work in the early years turned to the painting of the body in order to appropriate its classical form but also to mark his difference from the inherited tradition. What stands out in his transitional works from 1906, such as the *Two Nudes*, is what Margaret Werth has aptly described as a historical and formal liminality.[21] Werth argues that the *Two Nudes* is liminal "in that it situates itself between formal investigation and the archaic of primitive; between materialization and dematerialization of the body; between figuration and disfiguration; and between masculine and feminine."[22] But I think this liminality is also the reflection of a deep anxiety about tradition. On one hand, Picasso wanted to figure the body in the classical style, on the other hand, he wanted his representation to be in excess of the conventions he had inherited; this excess is marked by his drawing of the human form out of proportion and, more significantly, by his conversion of the face to a mask. As the *Portrait of Gertrude Stein*, also painted in 1906, was to illustrate, Picasso would turn to masking when he felt he had failed to capture the human face even after numerous sittings.[23]

But if Picasso's goal was to break away from inherited conventions—and the distortion of classical forms in the early works seems to enforce this view—then there was an even more radical way in which he could achieve the task of disfiguration, that is, by turning to Africa. We know, for example, that the artist inscribed his youthful rebellion by claiming a Moorish identity. We also know that his adolescent drawings are populated by Moorish figures and subjects, representing the danger of what I have called the "unmodern." These drawings represent juvenile fantasies about the Moor-

ish Other. In the late 1890s, however, Picasso embarked on some academic paintings of the African body (see figure 20.1).24 These paintings are important for two reasons. First, they represent the first and only time that Picasso was interested in the corporeal form of the African. After that, as I will show later, Picasso's interest in things African, even during his so-called Negro period, was limited solely to art objects which came to stand in for Africa itself. Second, in his academic paintings, Picasso perceived Africans in a twofold relation: the African nude represented the body in its "natural" state, one which was, nevertheless, out of proportion with the "ideal" in long-established European notions about ways of representing the human form in art. (These paintings reflected stereotypical notions of the black's excessive sexuality; indeed, what made the black body, in the form of the models Picasso was painting, compelling was its unusual distortion.) In order to defy convention—in the *Two Nudes*, for example—Picasso could draw the white body by drawing it out of proportion. Now, it seemed, the black body represented the corporal form out of order, even in nature, and hence already in defiance of the laws of proportion and symmetry. In these early paintings, the African's body, in its disproportional form and primitive sexuality, would allow Picasso to kill two birds with one stone, both classicism (which favored idealized bodies) and modern culture (which was coy about male sexuality). Consequently, in this early phase of his career, Picasso adopted African forms as a way of thinking through the limitations of the forms of representation favored by the art academy, namely, a sense of order, proportionality, and idealization. The African body formed the embodiment of disorder.25

There is, of course, great irony in this narrative of Picasso's early relationship with the African: he was obsessed with African imageries and bodies before he ever laid his eyes on any real Africans; when he first visited Paris in the year of the Universal Exhibition of 1900 and encountered colonial Africans on display, blacks seemed, in Staller's apt phrase, to slip off his "mental map."26 What banished Africans and Moors from Picasso's consciousness? Where did they go? And why and how did they reappear in 1906? Behind these questions lies the larger problem of the repressed in representation, for, to twist the words of Fredric Jameson, it is precisely at the moment that the object of analysis (reality, history, or even Africa) is repressed, or its influence is denied, that "by a wondrous dialectical transfer the historical 'object' [Africa for my purposes] itself becomes inscribed in the very form."27 But a probing of Picasso's political unconscious must be prefaced

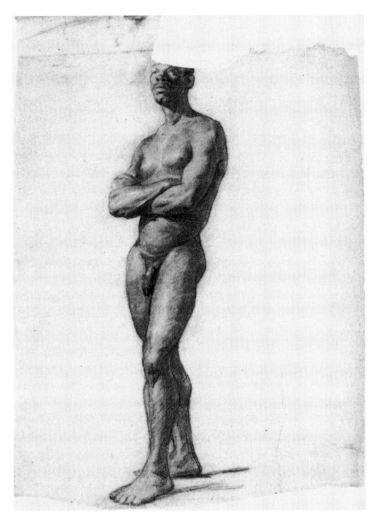

Fig. 20.1. Pablo Picasso, *Academy Study of a Black Man*, 1895–97. Charcoal and conte crayon on paper, 59.5 × 48.8 cm. © 2012 Estate of Pablo Picasso/Artists Rights Society (ARS), New York.

by two additional factors. The first one is basic, namely, that irrespective of the form they would take in Picasso's work, from the phantasm in the juvenile sketches to the abstractness of high Cubism, African objects were what he was later to call "intercessors," instruments for mediating the kinds of forces, often unspoken and unlicensed, which he needed in order to break through the edifice of modernity.[28] Apparently, Africa was most useful to Picasso when it was confined to the unconscious—there but not there— mediating other needs and desires, while not serving as a primary faction in itself. From this perspective, it would seem that when he was encountering real Africans in Paris at the beginning of the twentieth century, they had nothing useful to perform in his artistic project in their embodied form.[29]

The second factor to consider when probing Picasso's political unconscious recalls what happened during his sojourn in Gósol in the summer of 1906. Here I am interested not so much in what has been referred to as Picasso's "regression to ethnic and primitive roots," or even in his turn to female figures as the intercessors of the primitive, but in his valorization of this distortion and dissymmetry as part of his method and signature.[30] If the paintings at Gósol have one thing in common, it is their intertextual and contrapuntal relation to previous works which they acknowledge as part of their schema and yet displace in terms of form and meaning. Picasso's primary goal in the "blue period" (of which the stay at Gósol is exemplary) was the artistic deformation of the European canon of painting. This goal could best be achieved through the distortion of the white female form, a subject or figure whose ideality represented the classicism he was fighting against. This point is easily made through a comparison of Picasso's *The Harem* and Ingres's *Turkish Bath* and of his *Reclining Nude* and Goya's *The Naked Maja*. What we see in these repaintings of significant works in the European canon is a reinstallation of established conventions of painting, a distillation of formalized artistic subjects, and a transmutation of genres.[31] But what does this repainting of European works have to do with Africa? If we were to read *The Harem* in itself, as an isolated object of reflection, or even in relation to Ingres's *Turkish Bath*, perhaps nothing, for there is little in the painting that points to Africa or the "Orient" as the primary referent. Treated as autonomous objects what we have in front of us is one painting (*Turkish Bath*) functioning as the intertext of another (*The Harem*). And yet from its title and implicit motif, Picasso's *Harem* does seem to echo the odalisque, and this has led commentators to read it in explicitly Orientalist terms.[32] Picasso encouraged this kind of reading by describing the quality of

the picture as that of "L'humanité féminin, la femme d'Afrique."[33] Still, one wonders whether this kind of strong Orientalist reading is supported by the painting itself. One could argue that Picasso has modernized the odalisque and thus distorted its terms of reference and this may well have been his intention; nevertheless, compared to the modernist Orientalism of, let's say Matisse, the "Eastern" referent is weak and displaced.[34] It could be said that in comparison to Matisse, Africanisms or Orientalisms would be notable in Picasso's painting simply because they were absent where they should have been present, or rather, absent where we are encouraged to look for them. However, Africa was not entirely absent from Picasso's "mental map" in the Gósol period—it had just become confined to his artistic unconscious, where it would reemerge forcefully in *Les Demoiselles d'Avignon* (figure 20.2) in ways that are still being contested.

African art objects are, of course, part of the thick description of *Les Demoiselles d'Avignon* and also its enigma. According to Malraux, Picasso was unwavering in his view that *Les Demoiselles d'Avignon* came to him unconsciously during the visit to the Old Trocadéro and that it came to him not because of the enchantment of the forms of the African art he encountered—he doesn't seem to have paid much attention to these—but because what he recognized in this art was a force, or spirit, that was hard to describe or objectify. In other words, he was attracted by what he considered to be the unconscious and inexpressible. The discovery of African art was unique for Picasso because "for the first time the discovery of an art was not the discovery of a style. African art was discovered, not *an* African style."[35] In this context, the contrast Picasso was to make between himself and Braque was revealing. For Picasso, African objects were agents of exorcism (magical wards to be used against the economy of symbolic form); for Braque, African art was valued because of its form:

> That's also what separated me from Braque. He loved the Negro pieces, but as I told you: because they were good sculptures. He was never at all afraid of them. Exorcism didn't interest him. Because he wasn't affected by what I called "the whole of it," or life, or—I don't know—the earth?— everything that surrounds us, everything that is not us—he didn't find all of that hostile. And imagine—not even foreign to him! He was always at home. . . . Even now. . . . He doesn't understand these things at all: he's not superstitious!

Then, there was another matter. Braque reflects when he works on

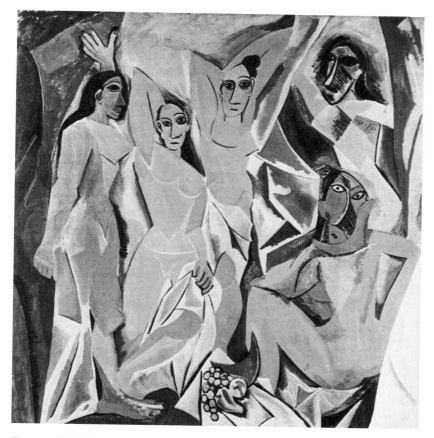

Fig. 20.2. Pablo Picasso, *Les Demoiselles D'Avignon*, 1907. Oil on canvas, 244 × 234 cm.
© 2012 Estate of Pablo Picasso/Artists Rights Society (ARS), New York.

his paintings. Personally, when I want to prepare for a painting, I need things, people. He's lucky: he never knew what curiosity was. People stupidly mistake it for indiscretion. It's a disease. Also a passion, because it has its advantages. He doesn't know a thing about life; he never felt like doing everything with everything.[36]

Now, one of the reasons reading Africanisms in Picasso has continuously generated conflicts of interpretation is because many attempts to read his "Negro period"—and even Cubist phase—as both inside and outside European cultural history are imprisoned by what Jameson has aptly called the ideology of modernism, which "imposes its conceptual limitations on our

aesthetic thinking and our taste and judgment, and in its own way projects an utterly distorted model of [literary or art] history."[37] The struggle for a pure Picasso, one uncontaminated by Africa, is ultimately a struggle to secure the aesthetic ideology of high modernism, especially the privileging of form as the mark of its breakthrough. It is not accidental, then, that many discussions of the influence of Africa in the making of Picasso's major works tend to revolve around the absence of a formal influence, or a style. And yet in their concern with substantive formal influence, these discussions start with a logic that is bound to fail because form is not what Africa had given Picasso. Indeed, one could argue that what made the African fetish attractive was that it would lead one away from forms of representation modeled on observable experience or reality. After all, as David Simpson has argued, what makes fetishism dangerous "in all perception and representation" is that "reality itself is open to construction."[38] My contention is that it is precisely the doubleness of the fetish—as a figure that is located at the heart of culture and ritual and yet seems to appear to us only in its perceptual nature, against reality—that explains Picasso's enigmatic relationship to the African figures he discovered at the beginning of the twentieth century. This doubleness is worth closer consideration because it haunts some of the most influential attempts at both connecting Picasso to and disconnecting him from the primitive.

II

In "Picasso," an essay written for the catalogue for the Museum of Modern Art's (MOMA) controversial exhibition *Primitivism in 20th Century Art*, William Rubin provided students of modern art with one of the most meticulous and detailed examinations of Picasso's engagement with tribal arts and more specifically African objects. Employing a combination of historical documentation and a systematic comparison of some of Picasso's major works and African art objects, Rubin establishes the centrality of the artist's turn to primitivism and his empathy for the artworks of the Other as one of the turning points in the emergence of modernism. He shows, convincingly, that Picasso's turn to the primitive had provided a way around artistic conventions that "had degenerated into a rhetorical and sentimental art": "By embracing primitivism in 1906, Picasso short-circuited the continuity of these inherited conventions, and his year-long exploration of increasingly remote and alien aesthetic correlatives permitted him to redis-

cover pictorial authenticity for himself."[39] In Rubin's account, the discovery of the tribal was an important bridge between the "soft modernism" that had characterized Picasso's art before 1906 and the "hard modernism" of his Cubist period.

But underneath his acknowledgment of the affinity between the tribal and the modern, Rubin's project is also underwritten by a troubling surreptitious intention: the need to minimize the role of the Other in the emergence of modernism as a style and, in particular, the significance of Africa as an artistic model, even when acknowledging their overall affect. In other words, the majestic reconstructive effort in Rubin's essay was driven by the desire to acknowledge the role of Africa as the source of certain powerful unconscious forces while at the same time minimizing the significance of the continent as the source of emulous art forms, rather than simple spiritual objects. Thus in his reading of Africanisms in *Les Demoiselles d'Avignon*, Rubin sees the African masks on the *demoiselles* as instruments for accentuating the themes of sexuality and death rather than as models. His primary thesis is that the invocation of African figures and women (both subjects of love and loathing in Picasso's psychic economy and behavior) enabled the "cohabitation of Eros and Thanatos."[40] More specifically, Rubin argues, the African faces would "finally conjure something that transcends our sense of civilized experience, something ominous and monstrous such as Conrad's Kurtz discovered in the heart of darkness."[41] Rubin acknowledged that Picasso's turn to the tribal was prompted by the absence of a "Western precedent" for mask-like heads and other forms of representing the human body in distortion, but he was insistent that the precedence of primitivism lay not in the models it provided but in its psychological connotations; the word *African*, for example, evoked "something more fetishistic, magical, and above all, potentially malefic."[42]

From this interpretation we can discern two immediate issues, which lie at the heart of the schemata of difference in modernism. The first one is how the psychologizing of the relationship between the artist and his primitive art forms depended on, or ended in, the sublimation of the perceptual in the conceptual. Building on Picasso's own claim that the tribal objects in his studio were "more witnesses than models," Rubin makes a crucial distinction between the kind of intertextuality that characterized Picasso's relationship to the works of other European artists such as Cézanne and tribal sculpture. In this scenario, tribal sculpture could function as a point of departure for Picasso, but its significance as an artistic source—a model—was

militated by the fact that Picasso "metamorphosized" his objects of reference: "Picasso was impressed by aspects of its conceptual structure, principles that he could abstract from their sources and use to his own end."[43] It would appear that Rubin's goal here is to confer the power of psychological affect on Africa while at the same time denying it a formal influence in the making of modernism. But perhaps more important is the distinction he draws between Picasso's intertextual relation to tribal as opposed to European art. Why is it that Picasso's intertextual relation to Gauguin or Cézanne was considered constitutive (hence conceptual) while his relationship to African objects was perceptual, a mere starting point to something more profound than its degree zero?

We can clarify the issue at hand here by recalling that Picasso was one of the most intertextual of modern artists. Indeed, the moments in his career that have come to be considered epiphanic, such as the sojourn to Gósol, are marked by powerful repaintings of the works of other artists. It is in his distortion of the works of his precursors that Picasso established his difference and thus his modernism. When we consider Picasso's relation to, let's say Ingres or Goya during his Gósol sojourn, Gauguin during the "blue period," or Cézanne during the Cubist phase, we are left in no doubt about the centrality of intertextuality in his project. It can easily be said that his paintings are, to borrow Jonathan Culler's words, "intelligible only in terms of a prior body of discourse—other projects and thoughts, which it implicitly or explicitly takes up, prolongs, cites, refutes, transforms."[44]

Nevertheless, in his study of the intertextual relation between the European modern and the African or Oceanic primitive, Rubin's categorical claim is that Picasso transformed the tribal masks in *Les Demoiselles d'Avignon* so radically that nothing on the canvas resembled "any African or Oceanic mask Picasso could have seen in Paris in 1907 in the studios of his friends or at the Trocadèro museum."[45] What makes this claim puzzling, however, is that it is not clear that a reading of Picasso's transformation of the masked figures from African or Oceanic traditions was radically different from the transformation that the works of other European artists underwent in his hands. Indeed, the transformation of figures and forms so that they could retain only a minimal relation to their artistic precursors was one of the hallmarks of the method that we now call abstraction. And as the structuralists used to argue in the 1960s and 1970s, one of the signatures of a strong, as opposed to a weak, intertextuality was the extent of the deviation from the

original model. Strong intertextuality is evident when the "borrowed" textual unit is "abstracted from its context and inserted as if in a new textual syntagm as a paradigmatic element."[46]

A second problem in Rubin's psychological reading of Picasso's Africanism is the emphasis he places on the subliminal and subconscious or unconscious. It is, of course, true that in foregrounding the perceptual dimension of the African connection, Rubin follows a long tradition (one encouraged by Picasso himself) in which the encounter with the primitive is defined by fear and repulsion and is hence connected to the forces that modern civilization repressed. This is, of course, the familiar narrative of primitivism in modernism. But to argue that the primitive art object appealed to the modernists because of its association with repressed psychological forces, and that those forces were the triggers for the revolutionary works of modernism, should not necessarily lead to a de facto negation of the more formal, conscious, conceptual influences tribal art had on Picasso and his contemporaries. The problem with Rubin's valorization of the psychological impact of the primitive on Picasso's artistic consciousness is that it is built on the rather dubious presupposition that subconscious or unconscious influences negate formal ones; hence his expenditure of much energy trying to show that the objects that were supposed to have influenced Picasso's revision of *Les Demoiselles d'Avignon*—Dan masks, for example—were not accessible to the artist at a particular phase in his career.

Rubin's theoretical stratagem—the claim that African art objects had entered Picasso's subconscious but never rose to the level of formal models—reflects, perhaps more boldly than that of others, a significant feature of the conundrum of modernism in its relation to the Others that it considered part of its schema. Simply put, if we deny the Other as a model for new forms of art, how do we explain the resemblances between Picasso and African masks that he was not supposed to have seen? It is in response to this question that Rubin developed his influential—and quite controversial—theory of affinities:

> The resemblances between the heads in the *Demoiselles* and the masks that have been compared to them in art-historical studies are thus all fortuitous—reflections of affinities between arts that communicate through conceptual signs, rather than through pictorial conventions directly derived from seeing. Yet the fact that so many more such affinities may be found between Picasso's art and that of the tribal peoples than is the case

with the work of other pioneer modernists reflects, on Picasso's part, a profound identity of spirit with the tribal peoples as well as a generalized assimilation of the principles and character of their art.[47]

Here Rubin's argument depends on a fundamental distinction between influence and affinity. In influence (Ingres, Gauguin, or Cézanne on Picasso, for example) the relationship between the work of art and its model takes place on the conceptual level in terms of observed formal conventions. In affinity, the influence is perceptual, almost unconscious, functioning on "an invented projection of an internal, psychological state."[48] Rubin would simply not allow for "tribal" influences on the formal, artistic level so central to the identity of modernism. It was only through the unconscious that the Other would be allowed into a now canonized modernism. An unconscious influence would not be allowed to enter the surface where form is discernible. Thus, to describe or posit an influence as unconscious is to simultaneously acknowledge its constitutive presence in the making of the object under discussion but also to deny it visibility. Apprehended in its absence and read solely in terms of its perceptual, sensual influence, the African Other would be contained and then evacuated from the edifice of high modernism.

But what are we to do with those instances where Picasso visibly modeled his works on African objects and where the relationship between the two was quite formal, as in the case of the *Guitar* and a Grebo mask? Rubin documents many instances of what appear to be conceptual African influences in Picasso's work, especially in 1907 and 1908, including *Woman's Head* and a Fang sculpture, but not even his own evidence was enough to convince him that these works constituted real models, sources of formal borrowings, rather than launching pads toward a Cubism detached from its influences. Clearly, Rubin was not willing to concede African art forms the distinctive status of art; they remained—had to remain—artifacts (ritual objects) with the capacity for psychological influence, but not sources of a formalized aesthetic. In a curious way, this confinement of African works of art to artifacts or ritual objects seems to ignore the fact that in his own relationship with African objects, Picasso tended to prefer those works which seemed to fit his *aesthetic* interests and sensibilities rather than simple affect. Indeed, if Picasso seemed to value African art objects over bodies, and quite often to privilege the former over the latter, as I argued at the beginning of this chapter, it was because he was, in a very strict aesthetic sense, self-

conscious and selective about the objects he found worthy of incorporation in his art. In short, Picasso had a clear idea about which objects, among his vast African collection, could be considered worthy of formal emulation and which could be consigned to the spectatorship of ritual.

It is now common to argue that Picasso was attracted to African art because of its capacity to generate terror or that he sought those subjects who would serve as what Bois calls "models for anatomical forms."[49] And yet the Africanist elements in Picasso's paintings only appear deforming to the extent that they call previous conventions of painting into question, not merely because they duplicate the syphilitics that he had encountered in French hospitals. In this sense it is striking that while he had in front of him some of the most deformed and terrifying figures in the African pantheon, real fetishes as it were, Picasso chose as models those masks that seemed to be closer to a familiar European grammar about form and symmetry even when they challenged some established notions of representation. Consequently, Picasso's version of tribal art is one cleansed of the terror he seemed to have experienced in his first encounter with it, streamlined in such a way that they are no longer images of the deformity we are eager to ascribe to African ritual objects. Once we recognize that Picasso modeled some of his works on African objects but also departed from them significantly, once we reject the model or no model option, we can shift the significance of his relationship with Others elsewhere.

III

Now one of the major criticisms leveled against the notion of affinity, the reigning paradigm in the study of modernism and primitivism, has centered on the implication that the tribal and the modern were bound together by what James Clifford called "a deeper or more natural relationship than mere resemblance or juxtaposition."[50] Clifford's major difficulty with affinity as "an allegory of kinship" is that in its universalizing claims it excludes the stories and experiences of the Others that modernism seeks to reappropriate in its own image, that scholars of modernism are primarily interested in tribal art for its "informing principles" or its "elemental expressive modes."[51] True enough. But it is important to underline the point that if the proponents of affinity seem to have no difficulties mounting an exhibition built on allegories of kinship, it is precisely because the aesthetic ideology of modernism was itself driven by the same impulse, the desire to en-

counter the Other in its ugliness and terror and then purify it so that it could enter the modern art world as part of its symmetrical economy. The major difference between modern artists and their posthumous patrons is simply that the former were also interested in "conceptual displacement" while the latter were invested solely in "morphological coincidence."[52] What makes Picasso such a central figure in the history of modernism's relationship to its Others was his ability to make the primitive central to the aesthetic ideology of modern art while also transforming tribal art objects in such a way that they were no longer recognizable as models. This is how *Les Demoiselles d'Avignon* has come to be read, in Hal Forster's majestic phrase, as both the primal scene of primitivism—"one in which its structure of narcissism and aggressivity is revealed"—and also the site of disavowal of the very difference it considers a condition of possibility.[53]

So where exactly is Africa in Picasso's schemata? This question returns us to the problem that opened my discussion, namely, the strict separation of African peoples and art objects in the artist's notion of the primitive. However, a set of more complicated questions needs to be posed: how could Picasso turn to Africa for its magic and art and yet avoid being entangled in its endangered cultures or the problems of its colonized peoples? How do we reconcile the terror and danger he felt when he first encountered African objects at the ethnographic museum with the symmetrical relationship he established between the tribal artwork and abstract modernism so that the two seem almost to have been made for one another? The complaint that curators of modernism and primitivism seem to avoid tribal artworks that seem impure and asymmetrical in relation to the structures of Picasso's art is a familiar one, but I have been arguing that the failure of such curatorial endeavors as the 1984 MOMA exhibition does not simply arise from a yearning to rescue modern works from the aesthetic influence of the primitive, or even from the institutional necessity to wink at, yet displace, tribal works from their context. A larger problem concerns the imprisonment of curators and historians in the logic of coherence and symmetry favored by the practitioners of modern art. In the end, this logic ignores two major problems which need to be at the center of any discussion of the relationship between modern painters and their African sources, especially when we are discussing those crucial years between 1895 and 1922 when modernism emerged: the question of African definition and authority of sources.

The question of definition was raised most poignantly by Robert Farris Thompson in 1988: "what are the indigenous *African* definitions of the

impact of African art forms on the artists of the cities of Europe (like Fang masks in Paris) at the beginning of this century?"[54] Berating the arrogance of Western art historians who never once consider that "the African priests and traditional leaders might have something of intellectual substance to contribute to this most important argument," Thompson concludes that "the final definition of the impact of African and Oceania upon modern art remains incomplete until we take large photographs of the Africanizing works of Picasso, Braque, *et al* to traditional Africa . . . and listen to indigenous comments and critical reaction."[55] We still do not have "indigenous" commentaries on works of modernism. In the few instances where indigenous artists have been given access to the institutions of commentary, they have been denied the authority of criticism.[56] Even the works of African art historians produced in the most prestigious institutions in the West are not heard across the temporal and cartographic divide that separates the study of expressive and other cultural forms between the modern and everything before or after it.

But what lessons could we learn from African art historians that would be useful to modernism, to the relation between Picasso and Africa? For one, we could learn that Picasso has had a significant, though perhaps surreptitious, influence on the field of African art studies. Otherwise how can one explain the almost unquestioning assumption that the mask is the primary medium of traditional African visual expression? On the other side of the debate, however, a shift in contexts of reading—from seeing Africa from Picasso's perspective to seeing the modern artist's from the Other's angle of vision—can yield even more useful results. Consider the fact that in a large measure, the literature on Picasso and his African sources assumes that the mask in Africa was part of a unified and intelligible tradition and that its value lay in its ritualized form and function. Yet the most detailed studies of African masks, their cultural contexts, and the views of their producers, recognize the intersection between the ritual fields in which they are produced (and out of which they perhaps cannot be understood) and the centrality of the meaning of the mask in motion.[57] Indeed, contemporary African writers and artists who have deployed the mask in their works recognize the significance of movement in determining the form of the mask and its interpretation.[58]

A final enigma must be confronted if we are to rethink the role of the Other in the making of modern art outside the ideology of modernism: how do we transcend the established doxa that it was through the acquisition of

the "mythical method" or "mystical mentality" inherent in primitivism that, to paraphrase T. S. Eliot, art was made possible for the modern world?[59] What is the source of this idea, the unquestioned notion that the art of the primitive emerged from a mystical, preconscious mentality and found its ideal form in myth? Why, indeed, did the idea of the African fetish dominate Picasso's understanding of the African primitive in that initial encounter at the Trocadéro in 1906? We are, of course, familiar with the ethnographers of the primitive mentality and the mythical method, most notably Lucien Lévy-Bruhl and Sir James Frazer, and countless studies have been devoted to the influence of their ethnography on the ideology of modernism; but we have not often paid enough attention to the ethnographers' sources. As a matter of fact, we seem to take it for granted that the ethnographers of modernism conducted fieldwork among the primitives and that their powerful ideas on the cultures and myths of the other came from native sources. The real story, however, is different. The primary sources behind the idea of the African primitive were not the academic ethnographers but a group of what I will call the surrogate native informants: European adventurers such as Leo Frobenius, Emily Torday, and Mary Kingsley; missionary ethnographers such as Robert Nassau, John Roscoe, and G. T. Basden; and colonial administrative officers such as R. S. Rattray in Ashanti and Amaury Talbot in southeastern Nigeria. These were the first Europeans to write about African cultures and to make art central to understanding the primitive mentality. They also produced their most important work in the foundational years of modernism.

Briefly, there are three reasons these surrogate informants are central to any rethinking of modernism and its ideas of the primitive. First, while academic ethnographers were generally critical of the colonial enterprise, most often its methods rather than objectives, the surrogate informants conceived their work in the field as crucial to colonial governmentality and as a practical contribution to the theoretical work of the intellectuals of modernism. They assumed that the work of ethnographers at major European universities needed the authority of observations made firsthand in the theater of colonialism. Indeed, surrogate informants cultivated close relations with the leading ethnographers of primitive cultures. Thus, John Roscoe, who wrote the first ethnography of the Baganda, was a protégé of Frazer at Cambridge, and Rattray, who wrote on the Ashanti, was a collaborator of C. G. Seligman at Oxford. As agents in the field of colonialism, the informants

premised their authority on their contact with those Africans who, in John Roscoe's words, were "uninfluenced by foreign ideas."[60] Second, the surrogate informants were the first, in those crucial years between 1905 and 1922, to promulgate the notion that the mentality of the primitive was mystical and mythical, outside modern forms of rationality, and under the hold of fetishism. One could not understand the native mind or indeed any aspect of native religion and social organization without understanding the role of the fetish, the explanatory code that connected everything. Third, as is evident from the sheer amount of cross-reference, the surrogate informants existed in a cohesive field of discourse, and thus reinforced the idea of a core set of beliefs that were uniform across Africa.

As part of a generational project, adventurers, colonial officers, and missionaries referred to each other's work and used the parallels they saw in their respective fields of operation to reinforce the power of their ideas, to provide the thick description that made their evidence unassailable. This is why even when artists such as Picasso questioned colonial practices, they seemed to reproduce the colonialist model of African societies; they questioned the practice but not the theory of colonialism. This structure—the questioning of the practice and the acceptance of the theory—tends to be reproduced when we don't interrogate the idea of Africa in modern art, when, for example, we forget the brutality that accompanied the arrival of the African art object to the West, the amount of African bodies that had to be destroyed so that the objects would arrive safely at the art museum.[61]

Finally, three challenges remain to be addressed in greater detail. The first one is how to restore the intimate relationship between the brutality of late colonialism and the emergence of the ideology of modernism, and the second is to consider more closely the role the surrogate informants played in making Africa accessible to modernism. The third one is how to displace Picasso—as the representative custodian of high modernism in art—from the ritualized place that he occupies in the modern museum.[62] It is my contention that we cannot undertake the work of displacement and deritualization without changing the language of commentary, the allegory of affinity, the contexts for reading and—eventually—our understanding of perspective and spectatorship. What were to happen, for example, if one were to exhibit *Les Demoiselles d'Avignon* next to Faith Ringgold's quilt, *Picasso's Studio* (figure 20.3), instead of traditional Pende Mbuya masks? Or if we examined *Woman's Head* not in relation to an indigenous Fang mask but next to *Mina*

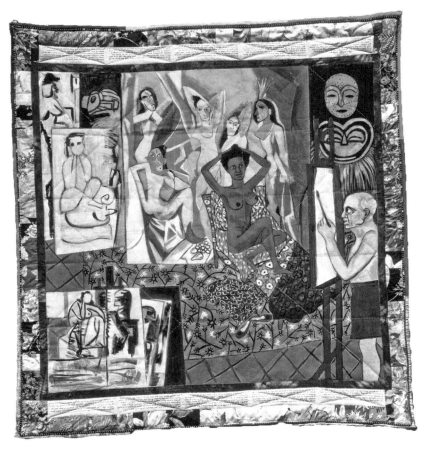

Fig. 20.3. Faith Ringgold, *The French Collection*, Part I, #7, *Picasso's Studio*, 1991. Acrylic on canvas with fabric borders, 73 × 68 inches. Wooster Museum of Art © Faith Ringgold 1991.

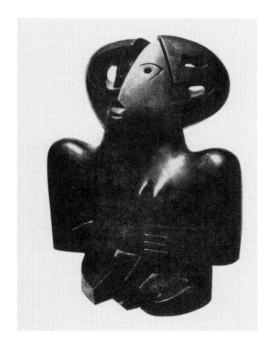

Fig. 20.4. Leandro Mbomio Nsue, *Mina ya Nnom*, 1970s, Equatorial Africa. Leandro Mbomio Nsue's grandfather and father were Fang sculptors.

ya Nnom (figure 20.4), a bronze sculpture by Leandro Mbomio Nsue, the contemporary Equatorial Guinean artist, a modern representation of the Fang perspective on form?

Notes

Simon Gikandi, "Picasso, Africa, and the Schemata of Difference," *Modernism/modernity* 10(3) (2003): 455–80. © 2003 The Johns Hopkins University Press. Reprinted with permission of The Johns Hopkins University Press.

1 Rasheed Araeen, "Conversation with Aubrey Williams," *Third Text* 2 (1987–88): 32.

2 André Malraux, *Picasso's Mask* (New York: Da Capo Press, 1994), 10.

3 Writing to Kahnweiler in August 11, 1912, about some masks he had bought, Picasso didn't hesitate to describe them as (stand-ins for) Africans: "We bought some blacks [*des négres*] at Marseilles and I bought a very good mask and a woman with big tits and a young black." Quoted in Natasha Staller, *A Sum of Destructions: Picasso's Cultures and the Creation of Cubism* (New Haven, CT: Yale University Press, 2001), 318.

4 Rasheed Araeen, *The Other Story: Afro-Asian Artists in Post-War Britain* (London: Hayward Gallery, 1989), 16–50.

5 See D. A. Miller, *The Novel and the Police* (Berkeley: University of California Press, 1988), xii. Here Miller is discussing how "modern social organization" has made even scandal "a systematic, function of its routine self-maintenance." For my purposes one can substitute difference or primitivism in modernism for scandal.

6 See for example the debates in Francis Frascina, *Pollock and After: The Critical Debate*, 2nd ed. (New York: Routledge, 2000), especially the argument between T. J. Clark and Michael Fried, 71–112.

7 My assumption here is that while the literature on black bodies and modernism has grown in recent years, as has that on race and modernism, most of it takes the African American, not the African, to be the representative black subject. See, for example, Michael North, *The Dialectic of Modernism: Race, Language, and Twentieth-Century Literature* (New York: Oxford University Press, 1994) and the essays collected in Heather Hathaway, Josef JaYab, and Jeffrey Melnick, *Race and the Modern Artist* (New York: Oxford University Press, 2003).

8 Kahnweiler's comments were made in 1948 at the height of Picasso's canonization; Daix was writing in the 1970s; both are quoted in Yve-Alain Bois, *Painting as Model* (Cambridge, MA: MIT Press, 1990), 69.

9 Henry Kahnweiler, "Negro Art and Cubism," originally published in *Présence Africaine*, collected in *Primitivism and Twentieth-Century Art*, ed. Jack Flam and Miriam Deutch (Berkeley: University of California Press, 2003), 284.

10 See William Rubin, "Picasso," in *"Primitivism" in 20th Century Art*, vol. 1 (New York: Museum of Modern Art, 1984), 260.

11 See, respectively, Kahnweiler "Negro Art," 285; Rubin, "Introduction" to *Primitivism*, 17; and Bois, *Painting as Model*, 73.

12 I pursue these questions in greater detail in Simon Gikandi, *Slavery and the Culture of Taste* (Princeton, NJ: Princeton University Press, 2011), from which this discussion is excerpted. Discussing the way the "ghostly" makes its way into the movement of European history, Jacques Derrida observes that "Haunting would mark the very existence of Europe. It would open the space and the relation to self of what is called by this name, at least since the Middle Ages." See Jacques Derrida, *Specters of Marx: The State of Debt, the Work of Mourning, and the New International*, trans. Peggy Kamuf (New York: Routledge, 1994), 4.

13 I develop this argument in Simon Gikandi, "Race and the Idea of the Aesthetic," *Michigan Quarterly Review* 40(2) (2001): 318–50. For the interplay of social ideals and ideas of pollution, see Mary Douglas, *Purity and Danger* (New York: Routledge, 1966), 1–6.

14 T. S. Eliot, "War-Paint and Feathers," originally published in the *Athenaeum* in October 17, 1919, collected in *Primitivism and Twentieth-Century Art*, 122.

15 Eliot, "War-Paint and Feathers," 122.

16 See "Chronology," in *Picasso: The Early Years 1892–1906*, ed. Marilyn McCully (Washington, DC: National Gallery of Art, 1997), 48.

17 Staller, *Sum of Destructions*, 269–301.

18 Staller, *Sum of Destructions*, 269.

19 Staller, *Sum of Destructions*, 271.

20 For this argument I have relied on Staller, *Sum of Destructions*, and the essays collected in McCully, *Picasso: The Early Years*.

21 Margaret Werth, "Representing the Body in 1906," in *Picasso: The Early Years*, ed. Marilyn McCully (Washington, DC: National Gallery of Art, 1997), 277–88.

22 Werth, "Representing the Body in 1906," 277.

23 After eighty sittings, Picasso gave up "seeing" Gertrude Stein and turned to the mask as an alternative way of viewing. The significance of this turn from the human model to the mask is discussed by North, *The Dialectic of Modernism*, 59–76. For a feminist reading of the *Portrait of Gertrude Stein*, see Tamar Darb, "'To Kill the Nineteenth Century': Sex and Spectatorship with Gertrude and Pablo," in *Picasso's* Les Demoiselles d'Avignon, ed. Christopher Green (Cambridge: Cambridge University Press, 2001), 55–76.

24 These works are discussed in detail by Staller, *Sum of Destructions*, 296–301.

25 But in discussing notions of disorder, we need to keep Mary Douglas's dictum in mind: "Reflections on dirt involves reflection on the relation of order to disorder, being to non-being, form to formlessness, life to death." See *Purity and Danger*, 6.

26 Staller, *Sum of Destructions*, 303.

27 Fredric Jameson, *The Political Unconscious: Narrative as a Socially Symbolic Act* (Ithaca, NY: Cornell University Press, 1981), 280.

28 Malraux, *Picasso's Mask*, 11.

29 This is not to deny Picasso's interest in radical anticolonial politics, merely to raise the possibility that radical anticolonialism might have needed the valorization of the primitive as part of its maintenance, a point that was to become more apparent with the rise of surrealism. For Picasso and French colonialism in Africa, see Patricia Leighten, "Colonialism, L'art nègre, and *Les Demoiselles d'Avignon*," in *Picasso's* Les Demoiselles d'Avignon, ed. Christopher Green (Cambridge: Cambridge University Press, 2001), 77–103.

30 The quoted phrase comes from Robert Rosenblum, "Picasso in Gósol: The Calm Before the Storm," in *Picasso: The Early Years*, ed. Marilyn McCully (Washington, DC: National Gallery of Art, 1997), 268.

31 My discussion here is indebted to Rosenblum's "Picasso in Gósol," 262–67.

32 As does Staller, *Sum of Destructions*, 314.

33 Quoted in Staller, *Sum of Destructions*, 316.

34 It would be interesting to compare Picasso's *Harem* with some of Matisse's Orientalist paintings. For the latter, see Roger Benjamin, *Orientalist Aesthet-*

ics: Art, Colonialism, and French North Africa 1880–1930 (Berkeley: University of California Press, 2003), especially chapter 7, 59–90.

35 Malraux, *Picasso's Mask*, 171.

36 Malraux, *Picasso's Mask*, 11, 13.

37 Fredric Jameson, "Beyond the Cave," in *Ideologies of Theory: Essays 1971–1986* (Minneapolis: University of Minnesota Press, 1988), 117

38 David Simpson, *Fetishism and Imagination: Dickens, Melville, Conrad* (Baltimore: Johns Hopkins University Press, 1982), 11.

39 Rubin, "Picasso," 241.

40 Rubin, "Picasso," 253.

41 Rubin, "Picasso," 254.

42 Rubin, "Picasso," 259.

43 Rubin, "Picasso," 260–62.

44 Jonathan Culler, *The Pursuit of Signs* (Ithaca, NY: Cornell University Press, 1981), 102.

45 Rubin, "Picasso," 262.

46 Laurent Jenny, "The Strategy of Form," in *French Literary Theory Today*, ed. Tzvetan Todorov, trans. R. Carter (Cambridge: Cambridge University Press, 1982), 40.

47 Rubin, "Picasso," 265.

48 Rubin, "Picasso," 265.

49 Bois, *Painting as Model*, 72.

50 James Clifford, *The Predicament of Culture: Twentieth-Century Ethnography, Literature, and Art* (Cambridge, MA: Harvard University Press, 1988), 190.

51 Clifford, *The Predicament of Culture*, 190, 193, 195.

52 Hal Forster, *Recodings: Art, Spectacle, Cultural Politics* (Port Townsend, WA: Bay Press, 1985), 184.

53 Forster, *Recodings*, 182.

54 Robert Farris Thompson, "Fang Mask," in *Perspectives: Angles on African Art*, James Baldwin et al. (New York: Center for African Art, 1987), 190.

55 Thompson, "Fang Mask," 190.

56 The most notorious instance of this exclusion concerns the Baule artist Lela Kouakou, who was invited to participate in a forum on African art but was allowed to comment only on works from his ethnic region because he was deemed incapable of providing "objective" aesthetic judgments, that is, those not bound by his "traditional criteria." See Susan Vogel, "Introduction," in *Perspectives: Angles on African Art*, 11. For a subtle discussion of this criterion of inclusion and exclusion, see Kwame Anthony Appiah, *In My Father's House: Africa in the Philosophy of Culture* (New York: Oxford University Press, 1992), 137–39.

57 The literature on African masks is too extensive to cite here, but see Z. S. Strother, *Inventing Masks: Agency and History in the Art of the Central Pende* (Chicago: University of Chicago Press, 1998), especially chapter 6, 39–54.

58 Dramatic deployments of the mask in motion can be found in Chinua Achebe, *Arrow of God* (London: Heinemann, 1964) and Wole Soyinka, *The Road* (Oxford: Oxford University Press, 1965).

59 See David Richards, *Masks of Difference: Cultural Representations in Literature, Anthropology and Art* (Cambridge: Cambridge University Press, 1995), 204.

60 John Roscoe, *The Baganda: An Account of Their Native Customs and Beliefs* (London: Macmillan, 1911), ix. For Rattray, see his *Religion and Art in Ashanti* (London: Oxford University Press, 1927).

61 What, for example, is the structural relationship between the destruction of the kingdom of Benin by a British expeditionary force in 1897 and the availability of Benin sculpture to the British Museum? Should it surprise us that the rooted sculpture is now housed in a modern wing of the British Museum, paid for by a family that made its fortunes in the confectionaries of empire, and named after Henry Moore, a leading modernist and connoisseur of African art? For the Benin expedition, see Annie E. Coombes, *Reinventing Africa: Museums, Material Culture and Popular Imagination* (New Haven, CT: Yale University Press, 1994), 7–28.

62 I had suggested a similar act of deritualization, albeit too briefly, for T. S. Eliot in Simon Gikandi, *Maps of Englishness: Writing Identity in the Culture of Colonialism* (New York: Columbia University Press, 1996), chapter 5, 157–89.

Double Dutch and

the Culture Game

Olu Oguibe

For those who come to it from backgrounds outside Europe (the "ethnics," "postcolonials," "minorities," all those who have ancestry, connections, or affiliations "elsewhere"), the arena of mainstream cultural practice in the West, at least in the visual arts, is a doubly predictable space—first, because it is a game space and you have to know the rules of the game, and second, because unlike any other game, such aspirants have a limited chance of success because it is predetermined they should fail. Though they may know the rules—and most who have the patience to understudy it do, bitterly so— the game is nevertheless inherently stacked against them because their presence, and worse still their success, causes a fault through an outwardly solid wall of history that ought to bar them as serious contenders. Of course, the understanding is that they belong in a different space, should create work of a particular flavor, deal with a certain set of themes, exhibit in particular venues in particular locations outside the mainstream, or be prepared to offer work of a particular nature to earn momentary mainstream acknowledgment, after which they are quietly returned to obscurity.

Predetermined spaces leave few options because the rules are set, and players in such spaces must engage them on the set terms, avoid or ignore them as viable spaces of practice, or seek ways to circumvent or subvert those terms with all the ramifications. With regard to artists in the Western metropolis whose backgrounds are "elsewhere," the rules of engagement are a straitjacket of history and expectations, which often leaves them with rather stark options: to take a fall with as much grace as the doomed can muster, or to self-exoticize and humor the establishment for a chance at that brief nod, or else fail the hard way. It would be inaccurate to imply that no such Outsiders have met with mainstream success, at least momen-

tarily, and one can easily produce the short list for contemporary art, from the Pakistani Iqbal Geoffrey in Britain in the 1960s to a smattering of young British artists who, at the turn of the century, have gained considerably visibility: Steve McQueen, Chris Ofili, Isaac Julien, and Yinka Shonibare, among others. These successes notwithstanding, since they are exceptions rather than the rule, the inevitable question remains: what does it take to break the code of this culture game and the cycle of predetermined obscurity and failure to which such artists are otherwise condemned? How do artists engage or circumvent the disabling rules of the game so as to prevail with integrity and a sense of self-fulfillment? What is the price of the ticket?

One might find answers in the success of painter and installation artist Yinka Shonibare, who made steady progress in the late 1990s in his contest for visibility within the mainstream British art world and who at the turn of the century continues to consolidate his place within that space. Shonibare first came to attention in the mid-1990s by devoting himself to a thorough understanding of the language of the metropolis, or, perhaps more accurately, the devices and strategies of its culture game, and especially the peculiar rules of the game with regard to the place and destiny of the postcolonial outsider. Paying rigorous attention to the critical debates of the day, especially postmodernism and its minority discourses, Shonibare understood that to break into the culture game he had but few cards, few choices, few avenues, or few guises, all of which inevitably required him to submit to a test of difference, and to pass that test.

In the heady days of the Margaret Thatcher years, when conservative nationalism held sway over British politics and culture and all counter-reason was consigned to the marginal corridors of protest politics, Tory minister Enoch Powell spoke of a certain test of difference: the cricket test, whose purpose was to prove the questionable loyalty of postcolonials to the British nation, and in essence the irrefutable difference that disqualified them from claims to Queen and country, by proffering evidence that their sporting loyalties lay not with Britain but elsewhere in the former colonies whence they came. On any given day, Powell maintained, the average West Indian (as British citizens from the Caribbean and their descendants are still known in England) would side with the West Indies cricket team against that of England. This was proof that they were irremediably different, and in a culture that dwelled on difference in loyalties, ideologies, language, class, and color of skin rather than the commonalities of history, the market, and football, this difference was sufficient to dislodge such groups from the grace and

glory of empire. In Powell's Britain, this difference in loyalties foreclosed the postcolonials from any form of belonging in the British nation.

However, as Shonibare would find, difference, or at least the guise of difference, does not always fit Powell's narrow definition, nor does it always have so definite a consequence as the venerable lord proposed. It does not always amount to worse neighborhood services for certain polities and groups, or their exclusion from British society, or worse still, expatriation from the kingdom. A culture that dwells on difference also distinguishes between forms and categories of difference because it operates on an economy of difference. It demarcates between what one might call tolerable difference and intolerable difference, between benign and profitable difference, as it were, and dangerous Otherness. For such a culture, difference is tolerable when it satiates the society's appetite for amusement and entertainment, or even more especially when it serves that eternally crucial purpose of propping and sustaining the society's illusions of superiority and greatness. On the other hand, difference that confronts the society's narcissism with cynicism, or challenges its claims to primacy and grandeur, or threatens to deface or dislodge its symbols of uniqueness and perpetual relevance, the society will make every effort to expurgate, radically and surgically, from its body politic. In other words, difference that merely services the civic and pleasure industries, difference that provides labor for the utility systems and for cleaning city offices, sidewalks, and buses on the public transit system, difference that appears to lend clarity to the futile logic of the center and its "elsewhere," even difference that by its presence lends credibility to the society's claims of equity and tolerance and offers proof, if it was needed, that the empire has room and heart enough for difference, that there is a speck of black in the Union Jack after all, that the metropolis is, to use the parlance of the day, multicultural. Such difference is granted a place of indispensability in the translucent cartography of a culture of difference.

This requisite difference can also serve as fertile ground for the sharp, Outsider imagination intent on taking a chance and charting its course through the labyrinths, barricades, and minefields of the culture game. Over several centuries, generations of England's Outsiders have understood this, and understood it far better than the native himself, for, as James Baldwin pointed out about America, the other culture of difference—those who are displaced and threatened with effacement but who nevertheless are tolerated on the strength of the same arguments that are employed to displace them— understand best the illogic behind their condition. Because they are required

to prove themselves otherwise worthy of the generosity of acceptance, and must endlessly be on their guard because of the treacherous nature of their condition, and must devote energy and time to unravel the curious psychology of their detractors in order to unravel the intriguing complexities of their common destiny with this detractor, they have the onus of sensitivity, criticality, and self-reflexivity because the burden of the cross is always upon them.

Only those who must engage in a constant battle to exist commit themselves to strategizing for their existence, and thus must dwell on, and in time understand, the ground rules of that engagement. In contrast, those who are privileged to take being and existence for granted have no need to understand either themselves or those others who are deprived such privilege. Because the Western metropolis has less need to question structures and patterns of existence that have served it so well, the burden of understanding does not fall on it, but on those who are served less well, which is why England's Outsiders excel in understanding the variegations of difference and its layers of ramifications, and especially in the knowledge that even the quarantine of difference to which they are condemned sometimes offers those who are intent on escaping it the very key for their escape. The door may be narrow and fraught with risks, for to defy or subvert the illogic of difference, often the Outsider must begin by exaggerating this difference. Often he must accept that difference exists, even where or when it does not, and that this difference exists in the exact form that the host culture perceives it; in other words, he must play to the gallery of difference and take a fall. He must bear his cross in full light if he must be relieved of it, and may slip out only under the darkness of his own nakedness. Because the path is narrow and the ground treacherous, few are able ever to succeed at this game without becoming, in the end, nothing but that which they set out to escape, which is what they are meant to be in the first place and to remain ever after. The Outsider who must insert himself in the guarded spaces of the Western metropolis must do so only by playing the card of tolerable difference in the hope that it serves as a guise for his intentions and schemes rather than as the straitjacket that perpetually defines his being. Such is the price of the ticket.

While this conditionality is commonplace knowledge among outsider citizens of what remains of the Empire (as Britain still prefers to think of itself), Shonibare, though born in London of African parents, was nevertheless raised in Lagos, Nigeria, within a culture and among a people whose

pride and self-confidence border on arrogance and whose understanding of citizenship and belonging run diametrical to that of the British. Later in life, this self-assuredness has served him well as he negotiates his place in contemporary British culture.

One may dwell a little on the significance of Shonibare's upbringing in Lagos, one of the world's liveliest metropolitan cities. In the 1970s, Lagos was the capital city of one of the wealthiest nations in the Third World, which, though it had just emerged from a bitter, thirty-month civil war, nevertheless commanded respect in the community of nations, thanks to its newfound oil wealth and its determination to turn this wealth into political mettle. Because the theater of Nigeria's civil war was far away in eastern Nigeria, Lagos was spared the ravages of war and moved quickly to recuperate from the momentary instability that was its only loss in the war. With the cessation of the civil war, the nation's military leaders regained the reins of power, and the highly entrepreneurial former rebels in the east surged back into the city, which then threw its doors open to the world with the promise of stability, money, sophistication, and the charm of the new. Academics from all corners of the Third World, from India and Indonesia to Brazil and Guyana poured into the country, and so did construction engineers from Germany and oil experts from France and America, investors and merchants from Syria and Lebanon, immigrant workers in their millions from across the entire West African region, as well as diaspora Africans keen to witness the rise of the miracle nation where a young army officer still in his thirties had crushed a rebellion and appeared determined to build Africa's greatest modern nation and restore the glory of his race. Lagos played host to leading artists and performers from around the globe, including country-and-western stars from America, the most prominent African American performers of the day, and an emerging crop of new pop headliners from different parts of the African continent. The movie theaters were flooded with Indian Bollywood romances and Asian and American kung fu action flicks, and every child knew his Jimmy Cliff lyrics and Bruce Lee kicks. Elsewhere around the country, a burgeoning popular culture was taking shape around a shared spirit of supreme confidence and optimism. The laid-back high-life music style that headlined in the 1960s yielded momentarily to a new form of guitar-and-lyrics–driven funk and rock music before reinventing itself in an equally hard-driven, rock-influenced new high life as bands proliferated from city to city and the youth reveled in their new freedom.

There was every reason to believe that a scheme was in place to transform

Lagos into the capital city of the black world. New museums and cultural complexes went up, vast constructions that ran on a seemingly depthless oil purse appeared all over the city, vehicle assemblies around the country trucked in throngs of automobiles to claim the new highways. As if to prove its determination to turn it into a global city, Lagos hosted the first World Festival of Black Arts and Culture in 1977, which attracted thousands of Africans and Africans in the diaspora from hundreds of nations, including a political and cultural delegation from the United States led by the American ambassador to the United Nations, Andrew Young. As Nigeria's young military leaders put it, money was "no object" and exuberance was the order of the day.

Even so, Lagos was more than a mere, young Third World metropolis aspiring to world-city status. It was a city with a rich and complex history. The site of numerous political intrigues and face-offs between the natives and colonial authorities in the nineteenth century, and one of the richest benefactors from trade with Europe, including the slave trade, the city still had a centuries-old monarchy and numerous solidly established colonial institutions, from a whole island named for Queen Victoria to colonial grammar schools, government-reserved areas, gentlemen's social clubs, and cricket and polo courts that sat in the middle of the bustling city like oases of tranquility. Politicians and expatriate oil executives milled around with street performers and hawkers of "Indian" charms, Yoruba and English mingled with every other West African tongue, bulletproof limousines shared the streets with tricycle rickshaws, Elton John and Dolly Parton records were as ubiquitous as those of Fela Kuti and Bongos Ikwue, and Amitabh Bachchan and Bruce Lee were folk heroes among teenagers.

This was the city of Shonibare's youth, as of celebrated British writer Ben Okri, and a youth who grows up in this environment with access to popular culture from all over the world and a highly globalized consciousness without a sense of marginal self or questionable identity obviously develops a psyche quite different from the scheming and understated marginal postcolonial unconscious that Britain fashioned in its Outsider citizens. Moving from Lagos to London, therefore, was like moving from a free territory to a colony under cultural mandate, a city of pretenses where people know their places and live out their destinies under the powerful, ever watchful panopticon of the state.

Shonibare returned to London as a teenager, and upon return had to relearn the rules of belonging because he was no longer the black British boy

who left; he was now the aristocratic youth from Lagos come back to reclaim his citizenship in a country where neither his aristocratic ancestry nor his birthright to citizenship translated to the privilege of acceptance. He spent his years in the British art academy resisting and defying the perpetual demand for difference, struggling to refuse and refute the orthodoxies of his supposed peculiarity. Rather than produce art that represented or signified an "elsewhere," as he was required to, an art that would separate him from the rest of his contemporaries and lend credulity to distracting fictions of difference, he instead produced art that spoke to his affinities with the rest. In the early stages of his professional career in the late 1980s he might have moved too quickly to seek his place alongside his peers, to make his claim on nation and station. He failed.

No matter. Still possessed of that far more metropolitan consciousness that Lagos imbued him with, Shonibare produced early work as a professional artist in England that transcended the minuscule, navel-gazing preoccupation with the immediate that was the predilection of his peers. He made work that was not simply in line with the period obsessions, but spoke to issues and concerns beyond the miniature territory of en vogue British and contemporary European art, work that dealt with nuclear disasters in Eastern Europe, minority experiences in America, issues in the Third World, all of which was in character with his upbringing in that metropolitan "elsewhere." However, the formal idiom of his work was no different from that of his contemporaries, and in the culture game of the Western metropolis, this was not a winning strategy, as many other, highly talented British artists of like background have discovered. Three decades earlier, another young artist with origins in the colonies, the painter Frank Bowling, had dwelled on the same preoccupations and themes with the mind to exercise the same creative liberty to speak to all that speaks back to him as an artist, unfettered by constraints of period obsessions or institutional and cultural expectations, again perhaps too quickly. Eventually he came to the same realization that to aspire beyond those creative territories earmarked for the metropolis's Others without careful strategizing was to be dealt a losing hand in the culture game.

Raised in British Guiana, Bowling studied in the same graduating class as David Hockney at the Royal College of Art in London, where, he is convinced, he was deliberately passed up for the gold medal in 1962 (which went to Hockney) and was awarded the silver medal instead. Like the young Shonibare, Bowling in the 1960s had interests that also extended beyond the

largely mundane preoccupations of his peers—Hockney's obsessions with Cliff Richard, for instance, or Ron Kitaj's formal experiments. Instead, his focus was on the great, historic events taking place in the colonies, the same events that inspired young radical intellectuals such as Frantz Fanon. Bowling was more interested in representing the collapse of empire, the epochal confrontations between the French and the Algerians, the emergence of modern nations in Africa and Asia, the events in the Congo and the death of Patrice Lumumba, the revolutions in Latin America—although at the same time he was eager to marry these large and global concerns with the same formal experiments his peers were engaged in. As Bowling has stated, although his subject matter was Lumumba rather than Marilyn Monroe, and although some of his work was inspired by Chuck Berry and Little Richard rather than Cliff Richard, it was nevertheless important to him that his work be understood and recognized as pop art, just like Kitaj's or Hockney's or Andy Warhol's in America. However, since Bowling was the Outsider of his generation of British artists, the art establishment saw his work lacking in clarity because it did not sufficiently emphasize his difference, thematically and formally. Safer and more exotic subjects such as Caribbean carnival scenes might have worked better in his favor, for then that would be different as well as tolerable. That his postcolonial, more globalized consciousness led to Lumumba and the Congo was fine, but to make pop art like the rest or new expressionist work like Kitaj's, or color-field paintings as he did later in New York, was to attempt to obliterate the distance between him and the rest, and so a new category was created for his work—"expressionist figuration"—into which he was quarantined alongside a spent Francis Bacon and a handful of fellow Outsiders. Bowling lost the culture game and was eventually terminated as a contender in British contemporary art.

A generation after Bowling, another crop of young outsiders tried to break through the barricades of the British art establishment, among them Yoko Ono, David Medalla, and Rasheed Araeen. Ono was a pioneer of performance and sound art, Medalla was a pioneer of conceptual art, and Araeen, trained as an engineer, began with minimalism before venturing into performance art and situations in the early 1970s. Again, these artists tried to circumvent or prevail over the establishment by defying the rules of engagement and refusing to play the card of difference. Because their strategy was no different from Bowling's, and their formal idioms were avant-garde without signifying the distance of difference or acknowledging difference as conditionality, they too received only a nod from the art

establishment before they were evacuated into the margins. It was not until recently that revisionist histories have tried to recuperate and acknowledge their contributions to contemporary art.

Shonibare's challenge, therefore, was to devise a strategy by which he could break the code of this historical relationship, and by so doing break the cycle of consignment to the margins. He had to find a way to pass the test of difference by engaging and outwitting it rather than confronting or defying it, and at the same time hope to break through the ranks and into the sacred space of acknowledgment without condemning himself to irremediable self-immolation and caricature. This he did in 1994 with a group of paintings called *Double Dutch*. In the paintings Shonibare used stretched everyday fabric for his support, having bought the particular line of fabric from Brixton Market in south London. The paintings were presented as an installation, wall-bound against a pink background, and as individual pieces would eventually migrate to other formations and installations, such as *Deep Blue* in 1997. But the formal postmodern devices, the use of installation, or the conceptual status of the color pink as an empty signifier mattered not at all, whereas the loud "tropical" design of the support meant everything. A considerable amount of literature has been generated around Shonibare's choice of fabric for *Double Dutch* and the fact that the wax-print fabric on which the paintings are made is customarily machine-spun in Indonesia or other locations in the Far East, then patented and marketed by firms in England and the Netherlands, but is nevertheless historically identified as African because it is widely used across postcolonial Africa, especially in the former British colonies of West, East, and South Africa, where it is part of everyday apparel. And so for good reason, because the fabrics and *Double Dutch* attracted instant attention, especially in England as galleries, museums, and curators embraced work and medium as direct references to Shonibare's "African identity." Finally, the artist had endorsed the fiction of his own Otherness, and in choosing an "African" signifier and idiom for his work, in coding his work with what appeared to be a transparent ethnicity, he had retracted his claim to a place at the center of the Western metropolis and restored the distance between himself as the Outsider and those who rightly belong in the center. Or so it seemed.

Shonibare's *Double Dutch*, understated and misunderstood as it is, must nevertheless stand as one of the most important works of cultural contestation in the late twentieth century because, far more than any other work in contemporary British art, it succeeded in outwitting and subverting the

desires and machinations of the culture of difference that is at the heart of the global contemporary art machine. Formally, *Double Dutch* is a pleasant and lively work, not at all extraordinary in this sense and lacking in any engaging iconography that can be gleaned from the surface of the support. Yet this formal ordinariness aside, rarely is a work so carefully assembled, every aspect so thoroughly worked out, every element of signification so meticulously articulated, every ramification so clearly calculated and anticipated. As mentioned, Shonibare found his "idiom of difference," the wax-print fabric, in Brixton, south London, which is known for its diverse demography but even more so as the capital of black Britain. Although numerous other black communities exist in London and such other British cities as Birmingham and Manchester, Brixton bears the added exoticism of a transposed tropical bazaar with its bold storefronts and hand-painted signs, its stocks of so-called ethnic foods and culinary accessories, its syncopations and cacophonies that remind the stranger of the complexities and allures of Babel, its costumes and apparels, its myriad skin hues and class complexities. Obviously Brixton registers the existence and presence of communities and sensibilities far more complex and alive than the black-and-white chiaroscuro of mainstream narratives, yet on the surface Brixton is the cliché of Otherness: reducible, classifiable, transparent, *différence* par excellence. Where better, then, to locate the marker of Shonibare's peculiarity than in this cardboard capital of difference? And how better to do so than to find this "African" fabric no other place but within the heart of metropolitan England itself, conceived, manufactured, marketed, and consumed without stepping across the border to any exotic ancestral homeland elsewhere? With his choice of the wax-print fabric Shonibare subtly but clearly pointed to the fact that the connection between this piece of British textile mercantilism and the Otherness that is ascribed to him is tenuous indeed. The signifier that would denote and inscribe his Otherness is, after all, entirely British and has little or nothing to do with Africa or Elsewhere.

Shonibare's choice of title for the work itself clearly indicated that he was engaged in a game, one he was confident he could win because he understood its intricacies and pitfalls. Again, in this regard, one may not find a more aptly, more carefully titled work in all of contemporary art. So far most critics have pointed only to the possibility that Shonibare's title, *Double Dutch*, must refer to the fact that a brand of the wax-print fabrics used in the paintings is known as Dutch wax. However, Shonibare's title resonates with several, more significant meanings. In recent times the term

has come to stand for the high-profile revival of a children's game of rope-skipping originally found among African diaspora populations. The game double Dutch was taken to the New World from Africa and long remained a neighborhood or front-porch pastime. Today it features in international competitions. The rope-skipper stands between two people with a rope between them, sometimes two ropes, and as they repeatedly flip the rope above the skipper's head and down again with lightning speed, she skips from one foot to the other to allow the rope to pass underneath to complete an arc without getting caught by it. This is repeated several dozen times a minute, each arc completed in a split second while the player skips repeatedly between loops of the rope.

Rope-skipping is a gymnastic game in which nimbleness and agility of body, sight, and mind are requisite. The rope-skipper must not only be visually alert to the point where this becomes instinctive, her mind and body must also work with the lightning speed and rhythm of the rope if she must avoid a terrible fall. Often the rope-skipper faces only in the direction of one of the flippers, from whom she must read her cues, and only with the most acutely honed instincts can she contend with the flipper behind, whom she cannot see. Unlike most other games where players are matched, the rope-skipper, or double Dutch player, is caught in the middle of things, between the flippers as between the ropes, between the brisk circle of the arc, between standing, jumping, and, if not careful or agile, having a bad fall. She is like a chess player who faces two opponents at once, or better still, like the lone individual who must contend with the cyclical turns of history and the establishment in a culture of difference. She must know how to skip without stumbling.

Less known to most people today, double Dutch also refers to a largely extinct language game much like pig latin, which was popular among boys at different periods and in different parts of the world throughout the twentieth century. In this language game, players applied a set of code combinations to encrypt their speech. In many cases the code involved the replacement of certain elements of syntax—all consonants in a word, for instance—with a whole word or prefix, such that the original words became not only incomprehensible to the noninitiate but almost unpronounceable also. In order to speak intelligibly in this idiolect, double Dutch speakers had to be agile, mentally and verbally, to be able to insert the right letters in all the right places with sufficient speed to form speech. They had to know, almost encyclopedically, where the requisite consonants or vowels occurred

in the spelling of each word as they spoke, making this adolescent's pastime one of the most challenging language and mind games possible. Like rope-skipping, linguistic double Dutch was also a performative art, perhaps more cultic and rarefied, in which players had to be smooth with their elocution, carry themselves with the exclusive airs of a high-minded cult, and have flawless command of the diction of their esoteric circle.

As a metaphor, therefore, Shonibare's title was a sleight of hand, referring as it does to cultural acrobatics in which the players are masters of the game. In choosing his title, Shonibare indicated his readiness to engage the culture game of the Western metropolis and to bring to it the necessary mental and performative sophistication. He would proffer a fiction of difference, like the devil's hand in a card game, and he would play with the nimble fingers and mind of a master card player, yet ultimately his winning card would not be from his sheaf of cards but from his opponent's. *Double Dutch*.

In the history of contemporary British culture, Shonibare is unique because, though he is not alone among Britain's Outsider citizens in submitting to the test of difference, he is nevertheless one of only a few artists who have engaged and passed this test by consciously offering a critical paradox of difference. Among his contemporaries a few other artists come to mind in the past two decades or so who have also played the difference card, but did so by not only offering difference but also insisting on the "fact" of such difference. Earlier we made mention of Chris Ofili, another British painter of African descent, who has gained even greater visibility than Shonibare within the British mainstream. In the mid-1990s Ofili quickly rose to fame by making dot paintings prodded on balls of elephant dung. Ofili's dot paintings, different as they were from his powerful early paintings, were largely inspired by exposure to contemporary Australian Aboriginal paintings, especially after the latter were shown in an exhibition of contemporary Aboriginal art called *Aratjara* at London's Royal Festival Hall. His use of elephant dung was also directly inspired by the work of American conceptual artist David Hammons, who had used elephant dung in his own work several years earlier, especially in his 1978 piece, *Elephant Dung Sculpture*. However, as part of his narrative of difference, Ofili attributed his source of inspiration to a brief trip to Zimbabwe, where, according to the legend, he witnessed elephant dung in use. In truth there are no traditions of use of elephant dung in Zimbabwe, but by making this fictitious, exotic connection to Africa, Ofili succeeded in establishing the distancing difference he needed to gain a safe place in contemporary British art.

The less careful reader might find Ofili's game of difference to be analogous to Shonibare's. Clearly both artists had outwitted the art establishment by playing to its exoticist desires. Both had employed false signifiers in the form of elements found within Europe itself, although Ofili further convinces his viewers by flying in his dung "from Africa." However, when more careful attention is paid to each artist's narratives of his practice, a significant distinction appears between the two. On one hand, Shonibare makes every effort to remind the viewer that the so-called African fabric he introduced to his work with *Double Dutch* is not, in fact, African at all, but a pretend marker of exotic distance that was conceived and manufactured outside Africa. As he has pointed out in *Yinka Shonibare: Dressing Down*, "African fabric, exotica if you like, is a colonial construction. To the Western eye this excessive patterning (Difference) carries with it codes of African nationalism . . . a kind of modern African exoticism."[1] On the other hand, Ofili makes a point of insisting on the authenticity of his trope, the elephant dung, by repetitively tying it to Africa, the land of animals where the people are believed to venerate animal dung, as the director of the Brooklyn Museum in New York argued in Ofili's defense[2] in 1999 after the painter's work came under attack for profanity and bad taste. Might there be an element of irony or critique in elephant dung placed under paintings in the gallery space? The potential certainly exists, but Ofili undermines any such potential by insistently associating Africa with the dung, which is to say, with wildlife, savage practices (the veneration of dung), and abjection to the point where his own complicit exoticism becomes apparent. Born and raised in England with little or no experience of Africa, Ofili is sufficiently detached to share in the conventional, European fantasies of the continent. In his references one finds an easy willingness to participate in and perpetuate those fantasies. While Shonibare's trope of difference is not only transparently fictitious but also critical of the demand for difference, Ofili's insists on its authenticity in an exercise of self-exoticization that merely reinforces that demand. Ofili lends credence to the fiction of his Otherness even as he believes himself to outwit the establishment on that account. His iteration of the narrative of difference becomes evidence of willful self-immolation, which is the price of his ticket through the gates of the mainstream.

One might argue then that Shonibare's approach to the conditionalities of the mainstream cultural space was one of active engagement through an idiom that bore an element of critique, one of positive subterfuge where the intentions are so apparent as to produce an effective ridicule of those con-

ditionalities and the culture of difference. In contrast Ofili's approach, with its repetitive narrative and its underlying insecurities, can only be described as acquiescent in spite of itself because it does submit to the demand for difference without an element of irony or critique. As Cuban curator Gerardo Mosquera has aptly observed, "Self-exoticism reveals . . . the passivity of the artist as complacent at all cost."[3] Complacency here implies compliance with the rules of the game, and not with the intent to subvert, expose, critique, or instruct, but with the sole intent to earn notice.

To find a close parallel to Shonibare's masterful subterfuge in *Double Dutch*, one might look elsewhere, to another era and another culture where difference was required of the Outsider citizen as a condition for acceptance. In 1927, the young Duke Ellington received a contract to perform with his band at the celebrated, whites-only revue in Harlem, New York: the Cotton Club. To sell the band, his manager, Irving Mills, billed Ellington's music as a new form of exotic revelry called jungle music. Under the guise of this label, however, Ellington, who, by the way, disapproved of the label, was determined to prove to America that not only was the music far from primitive or savage, he as its purveyor was in fact America's most sophisticated and innovative composer of his time. It was while headlining his music at the Cotton Club as jungle music that Ellington composed his first master opus, *Black and Tan Fantasy*, a complex blues odyssey in which he paid tribute not to the all-white Cotton Club, where people of color could play yet could not be served or entertained, but instead to Harlem's mixed-race dance clubs known as Black and Tan, where all the complexity of America could come together and manifest without forced distance or emphasis on difference. Ellington, so-called king of jungle music according to the Cotton Club, nevertheless concluded his composition with a quotation from Frédéric Chopin's *Funeral March*, which was to prove prophetic with regard to the fate of America at the end of the 1920s. In composition after composition, Ellington paid tribute to the complexity of America and in turn critiqued the jaundice of hierarchizing categories of the races. He strived to prove that his music was America's music, the chronicle and tablature of America's experience and history, and not the music of "others" straight out of the jungle. Like Shonibare's "African fabric" nearly a century later, jungle music was his trope of difference, but with that trope he would consistently and articulately critique the culture of difference.

Having broken the code of the culture game, Shonibare subsequently transformed his fabric into a signature, a product identity, again manifesting

his sophisticated understanding of the devices of success in the metropolitan culture industry. This signature he has freely applied to the interpretation of a broad gamut of themes, from his fascination for the figure of the style-conscious, smart, and conniving outsider of Victorian society, the dandy, which in itself is significant, to reinterpretations of classics of Victorian art, literature, and taste. Having earned the liberty to circulate and contemplate within the spaces of the mainstream, which is indeed unique liberty, Shonibare quickly moved on from the preoccupation with difference, a theme that, in fact, never had priority in his work, and has since ranged from visual essays on science fiction and space travel to contemplations of communal memory and in-between. To get to the depth of his subsequent work requires another essay. However, it was *Double Dutch*, the Outsider's token of difference, which made everything possible. In *Double Dutch*, his most important work to date, Yinka Shonibare broke through the displacing barricades of metropolitan exclusionism and became able to claim his place as a citizen by simply saying, "I am."

Notes

Olu Oguibe, "*Double Dutch* and the Culture Game," in *The Culture Game*, 33–44. Minneapolis: University of Minnesota Press, 2004. © 2004 by the Regents of the University of Minnesota. Reprinted with permission of the publisher.

1 Quoted in Susan M. Pearce and Okwui Enwezor, *Yinka Shonibare: Dressing Down*, exhibit catalog (Birmingham: Ikon Gallery, 1998).

2 Christopher B. Steiner, "Art/Anthropology/Museums: Revulsions and Revolutions," in *Exotic No More: Anthropology on the Front Lines*, ed. Jeremy MacClancy (Chicago: University of Chicago Press, 2002), 399–417, quote on 413.

3 Gerardo Mosquera, "From Latin American Art to Art from Latin America," in *Resisting Categories: Latin American and/or Latino?*, ed. Mari Carmen Ramirez, Tomas Ybarra-Frausto, Hector Olea, and Melina Kervandijan (New Haven, CT: Yale University Press, 2012), 1117–22.

A Parting Glance:

Empire and Visuality

Martin Jay

For all the controversy about the causes, varieties, and effects of empire, there is no doubt that it involves an asymmetrical relation of power in which one group dominates, administers, and fitfully pacifies another, often far larger in numbers. Whether the goal of that domination is permanent exploitation or paternalist development, whether its territory is contiguous or dispersed, whether its basis is informal or formal political control, imperialism involves a potent combination of direct coercion and indirect hegemonic acquiescence. To establish and maintain its domination, the imperial power has many means at its disposal, military, political, economic, and cultural. Without the last of these, it is clear that both the self-justification for imperialism and the submission to it, grudging or otherwise, would be impossible. No imperial equilibrium, however tenuous, can be established without some version of the "voluntary servitude" whose workings have been pondered since at least Étienne de la Boétie's celebrated sixteenth-century treatise on political obedience.[1]

What makes any analysis of the unequal power relations entailed by an imperialist relationship difficult is that the players in the game are rarely divisible into perpetrator and victim, oppressor and oppressed—or, for those defending its motives, protector and beneficiary—with clear-cut identities on each side. Michel Foucault's well-known argument that power never radiates out from a single source but is a dynamic exchange that often operates in a capillary rather than hierarchical manner is especially pertinent for the historically variable phenomena grouped under the rubric of imperialism. The old Chinese notion of a *comprador*, a native intermediary for a foreign agent, to take one salient example, has been widely adopted to designate those elites from within the colonized population who collaborate for what-

ever reasons, noble or ignoble, with the colonizers. Many remained under the spell of the magician Prospero, to use the famous metaphor developed by Octave Mannoni, but, as Frantz Fanon insisted, there were many others who found inspiration in the untamed Caliban.[2] Of course, there have been countless examples of citizens of imperial powers who defied the dominant ideology and actively sought to subvert their country's control over another.

On an even more basic level, the seemingly integrated identity of the colonizing civilization may itself be an imaginary construct, whereas the reality is riven by internal fissures and tensions. Perhaps the most telling example is that of "Europe" itself, whose expansion outward following the age of discovery often seemed, from the point of view of those into whose territory it intruded, as a monolithic force, bringing Christianity and modern technology, accepting "the white man's burden," and carrying out his so-called civilizing mission. But what Christopher Pinney calls the always already creolized status of "Europe" itself meant that a unified, hegemonic culture, that of the imperial power, never really existed in the first place (see chapter 19). The discursive construct "Europe" may have been far more fragile and provisional than it seemed from the vantage point of those who were colonized by it. However successfully the colonial enterprise functioned to forge the colonizers' identities, they were always haunted by the fractures they could never fully overcome. Rather than speaking of Euro-centrism, it may well be better to speak of "Euro-eccentrism," in which the simple opposition of center and periphery was always already in flux, even before extensive culture contact with the colonized.

In fact, as Rodolphe Gasché has recently reminded us in a study of the philosophical concept of "Europe," it has never been a settled region, either discursively or figurally, with firm boundaries and essential characteristics, but instead has been and remains more of what he calls an "infinite task."[3] As he points out, the name was not self-selected but taken from the Greeks, who originally thought of themselves between Asia to the east and Europe to the west. It was thus from the beginning the name given to an "other," never a fully self-assigned proper name designating a fixed entity. To this day, Gasché writes, "it is nearly impossible to find any consensus about what the proper name *Europe* refers to. That which carries this name is a rather checkered thing—from the indeterminate region in the West, where the sun sets, to the historical narratives that, at each particular moment of European history, have determined what was understood as Europe, to the contemporary uncertainty displayed by the discussions of what belongs geographi-

cally and culturally to Europe."[4] If one contemplates the tensions between the circum-Mediterranean culture before the rise of Islam and the more northern orientation of Christendom after that rise, or the divisions between Latin or Greek Christianity and then Catholicism or Protestantism, or the differences between the powers that engaged in overseas trade and conquest and those that were land-locked, it becomes clear that "Europe" was always a contested reality (a point that can be made a fortiori for labels like "the West," "the Occident" or "the First World"). As the current debates over Turkey's bid to join the European Union clearly show, it remains so.

To be sure, there were many attempts to cement the fractures within the European identity and create a more or less essential and coherent alternative. Here invidious comparisons with those alien civilizations deemed non-European were often functional in that quest, as demonstrated by the role of so-called barbarians stigmatized by the Greeks because they spoke what sounded like gibberish (the Greek word βάρβαρος [*bárbaros*] is onomatopoeic for nonsense). When Christianity became the dominant religion, alternative faiths often served the same purpose, especially if they were backed up by military might, as was the case, of course, with Islam. Alleged internal enemies of the hegemonic culture were no less frequently stigmatized in the service of forging unity, and it is no surprise that historians have come to see the struggle to subdue them as laboratories for later colonialist adventures abroad. The Jews in Germany, often stigmatized as an "inner Orient," or the Irish in Great Britain, stubborn residues of an unassimilated Celtic fringe, were two classic examples.[5] The forging of a European identity seems always to have been dependent on contrasts with external or internal "others," a dynamic that remains potent, alas, to this very day.

For all its pretensions to universalism, at least on the level of values, Europe was, of course, always internally fractured into smaller units: dynastic states, nation-states, and contiguous empires like the Habsburg, Russian, or Ottoman (which we have to remember had an extensive presence in the Balkans until the late nineteenth century). Individual states, by and large, were responsible for imperialist ventures, even if at times they followed the lead of private commercial interests, such as the East India Company. But they, too, were not always unified entities and culturally integrated before they set off to impose themselves on the lands they conquered. Spain, after all, was united only when Aragon and Castile were joined together by a dynastic marriage in 1492, the year in which European imperialism coincidentally discovered a new hemisphere to explore, exploit, and "civilize." The

Reconquista was still fresh in mind and the expulsion of the Jews only promulgated in that same year. Abjection of the cultural and religious other was, in fact, never fully successful in Spain, as the persistence of Moriscos and Marranos testifies. Great Britain, historians also tell us, did not really forge a common united kingdom from its English, Welsh, Scottish, and never fully absorbed Irish components until the age of discovery and initial colonization was well under way.[6] Rather than European nation-states, confidently homogeneous, going out to subdue the world, their fragile and fractured identities were often sutured in the process of contact with the lands they sought to control, and then only imperfectly.

As similar instability of identity complicates any attempt to make coherent sense of resistance to imperialism on the part of the peoples it sought to subdue. For culture can play as crucial a role in the challenge to imperial domination as it does in its perpetuation. As the Italian Marxist Antonio Gramsci famously argued, creating a cultural counterhegemony is a necessary strategy of subalterns in their struggle to escape subordination. Building alliances among groups with overlapping but not equivalent values, interests, and goals is not merely a function of rational compromise or even a consensus about the general will. It involves a variety of means, affective as well as cognitive, to forge a common movement of resistance. Even when outright violence is employed to drive out the imperial power, it draws on the justifications and motivations that culture can provide to undermine as well as manufacture consent.

What makes the construction of cultural resistance to imperial control an especially daunting task—first as a political project, then as a retrospective historical subject—is the even more hybridized nature of any culture that has been subjected for any length of time to that control. The neat opposition between an allegedly autochthonous, authentic, native culture and what is imposed from the outside does not survive scrutiny for long. That is, imperialism inevitably introduces alien practices, ideas, and values into the cultures it dominates, which cannot be simply rejected like a virus in a body struggling to regain its health. Retroactive purification is a vain quest.[7] Of course, those cultures were themselves by no means homogeneous before the intervention from the outside or rarely able to heal their prior fissures (as, for example, demonstrated by the tribal, linguistic, and religious tensions surviving the colonial creation of artificial modern states in Africa or the Anglophone-Francophone division in Canada).

At times, however, values and practices that initially seemed alien could

be productively redirected to challenge the hegemony of the imperial intruder. Whether one construes the result of hybridization as a "civilizing" improvement or a pollution of innocence, a compromise with the devil or a resource for resistance, the new mixture had a dynamic all its own. In fact, the residues often remain potent in the era of postcolonial recovery from direct imperial rule, when no return to the status quo ante, real or imagined, was possible. Indeed, they are often no less evident in the cultures of former imperial rulers in the aftermath of their withdrawal, in the now familiar pattern of "the empire striking back" (which can mean a lot more than merely bestowing on the former colonizers the parting gift of a more diverse culinary landscape). Indeed, the process of reverse influence starts much earlier than the end of imperial rule, as the metropole takes much more than raw materials or cheap labor from its colonial possessions. The "infinite task" of creating a stable, coherent identity—whether for a continent or the nation-states comprising it or a colonial and colonized culture—is rendered even more unrealizable by the cross-fertilization of cultures.

The primary arena in which the struggle between cultural hegemony and counterhegemony is waged is, of course, discursive, involving a mix of theological, scientific, and political theoretical arguments on all sides of the question. In addition, as the essays in this volume eloquently demonstrate, a critical role is also often played by visual practices, experiences, and technologies. From mapping new territories and representing sovereign power to the photographic and cinematic presentation of imperial relations, from the most popular mass culture to the most esoteric avant-garde art, the role of visuality in creating, sustaining, justifying, and undermining imperial power is impossible to deny.

But what precisely that role might have been differs from case to case. If the discursive realm of "Europe" was always contested territory, so was its "scopic regime," which was anything but homogeneously united.[8] The dominant visual culture, which can be called "Cartesian perspectivalism," was always challenged by alternative regimes, such as the baroque "madness of vision" and Dutch "art of describing."[9] From the perspective of so-called traditional societies assaulted in the name of modernization, modernity may appear to be a uniform package; understood from within, it has always been a highly contested range of often incompatible alternatives, including competing visual cultures.

Moreover, as students of the relationship between words and images have long recognized, there is no easy passage from one to the other. Although

in some cases, what the critic Ronald Paulsen called "emblematic images" are more or less translatable into words, in other cases, images are mute and unreadable.[10] The distinctions drawn by Foucault between "the sayable" and the "seeable," Jean-François Lyotard between "discursivity" and "figurality," or Jacques Lacan between the "scopic" and "vocative" drive all register the potential tension between visuality and textuality.[11] Irreducibility does not, however, mean incommensurability. As Sumathi Ramaswamy rightly argues in her essay in this volume (chapter 15), "pictorial history challenges us to dwell on the overlapping zone between the sayable and the seeable so as to shuttle back and forth between the two."

In certain instances, what we might call the imperial gaze basically reinforced and duplicated an already elaborated discursive code, giving credence to the ideological naturalization of artificial relationships of unequal power. Here images were largely emblematic in their function, illustrating arguments and implementing practices promoted primarily in discursive terms. Racial ideologies of innate superiority and inferiority could, for example be visually illustrated by "evidence" from photographs or ethnographic films, and restaged in panoramas, world exhibitions, or museum displays. The mass advertising of commodities, so David Ciarlo's analysis of the German case shows (see chapter 7), could function more insidiously than official government propaganda to naturalize and justify colonial rule over "inferior" races. Maps, as Terry Smith (chapter 10) argues in the case of European penetration of Australia, could impose a visual regime based on calibration, disembodiment, and symbolization that obliterated the vivid imagery and embodied viewpoints of the Aboriginals, preparing the way for the actual violence that abetted their near obliteration in reality.

Sometimes the visual objects that reinforce the dominant discursive paradigm seem innocuous at first glance. Even the seemingly harmless botanical illustrations produced by naturalists accompanying Spanish explorers analyzed by Daniela Bleichmar (chapter 2) aided the domestication of exotic nature in the service of the Western scientific worldview. "Immutable mobiles," to borrow the term from Bruno Latour that informs James Hevia's study of Western reactions to the Boxer Rebellion, supported an image of the "uncivilized" Chinese justifying their suppression (chapter 11). As Krista Thompson shows in her analysis of Jamaican postcards (chapter 17), we assume at our peril that the camera has a neutral, documentary, purely indexical relationship to what is recorded by its automatic apparatus. Well-intentioned campaigns to bring modern health care to colonial subjects,

Eric A. Stein also makes clear in his analysis of hygiene cinema in 1930s Java (chapter 12), could disseminate images of backwardness that indirectly justified delaying self-rule well into an indefinite future.

Likewise, the Orientalist devaluation of non-Western cultures and religions, of which Edward Said's controversial classic treatment has made us all so aware, can be discerned in visual representations of the "decadent, exotic, erotically alluring" East. Popular ethnographic spectacles at expositions, as Roger Benjamin's research reveals (chapter 4), were informed by the work of Orientalist painters who acted as the "visual 'research and development' wing of the whole colonial movement." Not even formalist modernists like Pablo Picasso, so Simon Gikandi persuasively argues (chapter 20), could entirely escape the colonial assumptions of a primitive mentality based on fetishism and mythic naiveté, however much they may have sought to valorize the art that it produced.[12]

As a result of the mutual reinforcement of discursive ideologies and figural practices, it might be tempting to speak of a distinct imperial or colonial scopic regime in which relative coherence obtained. Whether it would be an extension of the one that prevailed in the metropole or had unique characteristics produced by the unique hybridization of native and foreign influences would vary from case to case. In other instances, however, discursive and visual interactions across the fault lines of the imperialist experience may not have been so perfectly in tune. Svetlana Alpers's influential study of the "art of describing" recognized that the maps and illustrations done by Dutch explorers were far more sober, unbiased, and straightforward than their discursive counterparts: "the Dutch record of their short-lived colony in Brazil is an extraordinary case in point. It is the pictorial, not the verbal records of the Dutch in Brazil that are memorable. . . . Such an interest in description must be set against the fabulous accounts of the New World that were still in vogue."[13] We may also discover by closely examining material objects or visual phenomena that rather than a straightforward exercise of exploitation or victimization in which the metropole—in most but not all cases European—imposed its power and ideology on the colonized culture, a more hybridized and impure relationship was explicit from the beginning. There was, we often realize by looking at the visual evidence, rarely (if ever) a simple domination of one culture, passive and pliant, by another more active one, behaving as if it were a unified, coherent subject able to impose itself on a supine object.

Several of the entries in this volume reveal how the instability of visual

representation of life in the colonies or the invention of new visual practices could tacitly unsettle the official story told in discursive form. Tensions between showing and telling could thwart the naturalization of colonial hegemony. For example, the attempt by Spanish evangelizers in Mexico to enlist native artists in the propagation of the faith to the illiterate masses, explored by Serge Gruzinski (chapter 1), came up against the persistence of indigenous traditions that undermined any simple translation of the gospels into visual terms. When the cinema came to colonial Nigeria, Brian Larkin argues (chapter 13), the result was not an imposition of a standardizing Western technology but a new hybrid in which Hausa traditions transformed movie theaters into local spaces where transgressive behavior was shielded. In the case of the use of Indian yellow, the pigment made from cow urine whose rise and fall is charted by Jordanna Bailkin (chapter 3), the opposite trajectory was followed: when a color used to depict native flesh became controversial following the disclosure of its tainted origins, the colonial power prudently discontinued it. Here, ironically, the British desire to govern without ruffling feathers trumped the visual desire to depict natives as realistically as possible. Visual practices were changed to avoid anything that might undermine colonial power. A less successful effort to control the unpredictable effects of material things—once again Latour's inspiration can be seen—is revealed in Natasha Eaton's exploration of the animistic circulation of prints and other commodities in colonial India (chapter 6), helping transfigure networks of power into labyrinths of uncertainty and ambivalence.

A comparable unsettling effect could result from the reciprocal impact of imperial interactions on the colonizing culture itself. Nicholas Thomas calls the exotic objects that returned to the metropole uncategorizable "curiosities," outside of any aesthetic or economic context, and therefore unassimilable to dominant ideologies or scopic regimes (chapter 5). Among such curiosities, Benjamin Schmidt shows (chapter 9), are the remarkable maps that Dutch cartographers produced for global consumption after the heyday of their own empire during the golden age, maps that "promoted a freshly decontextualized, vertiginously decentered world." Christopher Pinney adds that exotic material objects, often of transcultural origin, work to introduce the power of the uncanny and the fetish into the seemingly disenchanted cultures of post-Enlightenment Europe (chapter 16). The energies coursing through the networks entangling metropole and colony, in fact, flow in both directions from the beginning. The circulation of such objects

undermines the assumption of a rational, postsuperstitious West bringing science and reason to the "primitive" world of superstition and animism. In his subtle study of photographic practices in Africa and India, Pinney reveals a fascination with the surface and materiality of the image that "creatively deform the geometrical spatializations of colonial worlds."

Likewise, Ricardo Padrón shows that early Hispanic maps were not fully in accord with the dominant modern spatial regime of geometric, isotropic, homogenizing abstraction, often substituting the meandering itinerary of explorers for the rational grid of Cartesian perspectivalist space (chapter 8). With regard to the much later struggle to mobilize nationalist sentiment in India, Sumathi Ramaswamy demonstrates that the dry, rational carto-graphic traditions brought from the West were invested with an emotion-ally laden iconography that drew on the mythical body of "Mother India" and the real bodies of patriots martyred in her cause (chapter 15). A no less radical refunctioning occurred in the narrative of European imperial-ism revealed in the architecture, photography, and painting examined by Zeynep Çelip from the Ottoman Empire and the Maghreb (chapter 14). Orientalist discourse ironically could become a source of decolonizing im-pulses when it is "spoken back"—and perhaps mirrored back as well—to the colonizers. The disruptive potential in discursive mimicry, explored by Homi Bhabha, was often realized as well in visual interactions between im-perial powers and those they sought to control.[14] As Robert Stam allows us to appreciate (chapter 18), Frantz Fanon, for all his blind spots, dislocated and detemporalized fixed spatial and chronological relationships between colonizer and colonized, a process that only accelerated with the arrival of postcolonial attempts to deal with the residues of imperial rule. As films like Gillo Pontecorvo's *Battle of Algiers* and Isaac Julien's *Frantz Fanon: Black Skin, White Mask* demonstrate, "totalizing narratives of colonial domina-tion have mutated slowly into an awareness of a modicum of reciprocity. Instead of binary oppositions, we find mutual shaping and indigenization within a Bakhtinian 'in-between.'" In a still later entirely postcolonial cli-mate, such as that inhabited by the gifted Nigerian-born British artist Yinka Shonibare, the game of scrambling the codes—playing "double Dutch" in the title of one his works borrowed by Olu Oguibe (chapter 21)—becomes so intricate and sophisticated that it manages to combine genuine critique with commercial success.

In conclusion, what can we say about the issues raised by the rich and varied essays included in this volume? First, it is clear that no simple gener-

alization about the "imperial eye" or "colonial gaze" will do justice to the plethora of different examples we have of the visual cultures in different periods and empires. No one scopic regime incorporates all the disparate cases discussed in the volume, let alone the many more regrettably excluded because of space considerations. The visual dimension of empire is as complex and ambivalent as the discursive, drawing on a welter of different practices, technologies, and material objects, to both maintain domination and challenge it. Many of these may seem trivial or marginal, but they turn out to reveal dimensions of the imperial project and its development that are otherwise overlooked. As a result, it would be imprudent to postulate a master method that future students of the visual dimensions of imperialism might apply indiscriminately to the specific cases they investigate. Perhaps the only wise rule of thumb is to practice a visual hermeneutics of suspicion, in which all of the expectations brought to the table are themselves called into question.

Second, although there is often a congruence between discursive and visual evidence, in many other cases there are tensions between them that defy any reduction of one to the other. These often change over time and ought not to be understood as frozen in any one moment, merely replicating themselves until an epochal shift—such as emancipation from colonial rule—occurs. Nor should they be understood as ending with such transformations, as many residues persist after the end of formal rule.

Third, the mimetic dynamic in imperialism involves a visual hall of mirrors that often means claims of originality or authenticity are impossible to maintain. If, as we have argued, the major players in the drama of imperialism were always already internally contested, then we have to attend to the complexities of what is imitated and by whom, rather than reduce the relationship to a simple dyad. Finally, when all is said and done—or shown and done—we cannot ignore the most fundamental characteristic of imperialism in all of its guises: that it involves asymmetrical power relations, a mixture of violence and soft coercion, and often employs visual means to achieve its ends. The spectacle of imperialism is always a screen behind which a far less attractive process unfolds. Although resistance to that process also can draw on visual practices, it too is never predominantly an affair of the eye or the gaze. That much must be conceded. But without attending to the role visual culture does play, no history of imperialism can ever claim to be complete. Nor, so these essays also make clear, can a history of Western visuality afford to look past the defining role played by the dialectics of recognition

and misrecognition, gaze and countergaze, visibility and invisibility that at once undergirded and undermined the imperialist project.

Notes

1 Étienne de la Boétie, *The Politics of Obedience: The Discourse of Voluntary Servitude*, trans. Harry Kurz (Auburn, AL: Ludwig von Mises Institute, 2008). For a more recent consideration of the same theme, see Michael Rosen, *On Voluntary Servitude: False Consciousness and the Theory of Ideology* (Cambridge, MA: Harvard University Press, 1996).

2 Octave Mannoni, *Prospero and Caliban: The Psychology of Colonization* (New York: Praeger, 1956). Frantz Fanon's critique of Mannoni's argument is discussed in Robert Stam, "Fanon, Algeria, and The Cinema: The Politics of Identification," chapter 18 in this volume.

3 Rodolphe Gasché, *Europe, or the Infinite Task: A Study of a Philosophical Concept* (Stanford, CA: Stanford University Press, 2009).

4 Gasché, *Europe, or the Infinite Task*, 12.

5 See, for example, Susanne Zantop, *Colonial Fantasies: Conquest, Family and Nation in Pre-Colonial Germany: 1770–1870* (Durham: Duke University Press, 1997); Clare Carroll and Patricia King, eds., *Ireland and Postcolonial Theory* (Notre Dame, IN: Notre Dame University Press, 2003); Eóin Flannery, *Ireland and Postcolonial Studies: Theory, Discourse, Utopia* (New York: Palgrave Macmillan, 2009).

6 Linda Colley, *Britons: Forging the Nation, 1707–1937* (New Haven, CT: Yale University Press, 1992). It was, of course, in relation to not only empire but also foreign enemies, such as Spain and France, that a common British identity was forged.

7 James Clifford, *The Predicament of Culture: Twentieth-Century Ethnography, Literature, and Art* (Cambridge, MA: Harvard University Press, 1988).

8 The phrase "scopic regime" was coined by the French film theorist Christian Metz. It has been expanded to embrace more extensive visual and discursive cultures. See Martin Jay, "Scopic Regimes of Modernity," in *Force Fields: Between Intellectual History and Cultural Critique* (New York: Routledge, 1992) and Martin Jay, "Scopic Regimes Revisited," in *Essays from the Edge: Parerga and Paralipomena* (Charlottesville: University of Virginia Press, 2011).

9 Christine Buci-Glucksmann, *La Raison baroque: De Baudelaire à Benjamin* (Paris: Galile, 1984) and *La folie du voir* (Paris: Galilée, 1986); Svetlana Alpers, *The Art of Describing: Dutch Art in the Seventeenth Century* (Chicago: University of Chicago Press, 1983).

10 Ronald Paulsen, *Emblem and Expression: Meaning in English Art of the Eighteenth Century* (Cambridge, MA: Harvard University Press, 1975). He calls those that are not emblematic "expressive."

11 For suggestive explorations of this tension, see the essays in Stephen Melville and Bill Readings, eds., *Vision and Textuality* (Durham: Duke University Press, 1995). For a discussion of these distinctions in the work of Foucault, Lyotard, and Lacan, see the relevant chapters in Martin Jay, *Downcast Eyes: The Denigration of Vision in Twentieth-Century French Thought* (Berkeley: University of California Press, 1993).

12 The vexed relationship between images in general and fetishism, a term that has a great deal of anthropological and psychological baggage, is explored in W. J. T. Mitchell, *What Do Pictures Want? The Lives and Loves of Images* (Chicago: University of Chicago Press, 2006).

13 Alpers, *The Art of Describing*, 163.

14 Homi Bhabha, "Of Mimicry and Man: The Ambivalence of Colonial Discourse," in *The Location of Culture* (London: Routledge, 1994). Although his focus is on discourse, he draws on visual metaphors to make his point: "I want to turn to this process by which the look of surveillance returns as the displacing gaze of the disciplined, where the observer becomes the observed and 'partial' representation rearticulates; the whole notion of identity and alienates it from essence" (127). Other theorists, such as the anthropologist Michael Taussig, have also developed analyses of colonizer/colonized relations based on mimesis. See his *Mimesis and Alterity* (New York: Routledge, 1993). For a critical overview of the literature, see Graham Huggan, "(Post)Colonialism, Anthropology, and the Magic of Mimesis," *Cultural Critique* 38 (Winter 1997–98): 91–106.

About the Editors

MARTIN JAY is Sidney Hellman Ehrman Professor of History at the University of California, Berkeley. Among his works are *The Dialectical Imagination* (1973 and 1996), *Marxism and Totality* (1984), *Adorno* (1984), *Permanent Exiles* (1985), *Fin-de-siècle Socialism* (1989), *Force Fields* (1993), *Downcast Eyes* (1993), *Cultural Semantics* (1998), *Refractions of Violence* (2003), *Songs of Experience* (2004), *The Virtues of Mendacity: On Lying in Politics* (2010), and *Essays from the Edge* (2011). His research interests are in modern European intellectual history, critical theory, and visual culture.

SUMATHI RAMASWAMY is Professor of History at Duke University. Her research over the past few years has been in the areas of visual studies, the history of cartography and empire, and gender. She is the author of *The Goddess and the Nation: Mapping Mother India* (Duke University Press, 2010), *The Lost Land of Lemuria: Fabulous Geographies, Catastrophic Histories* (2004), and *Passions of the Tongue: Language Devotion in Tamil India, 1891–1970* (1997). Her edited volumes include *Barefoot across the Nation: Maqbool Fida Husain and the Idea of India* (2010), and *Beyond Appearances? Visual Practices and Ideologies in Modern India* (2003). She is currently working on a book titled *Terrestrial Lessons: Conquest of the World as Globe*. She is co-founder of a transnational digital network for popular South Asian visual culture called Tasveer Ghar (House of Pictures) (http://www.tasveerghar.net).

About the Authors

JORDANNA BAILKIN is Professor of History and Women's Studies and Costigan Professor of European History at the University of Washington. She is the author of *The Culture of Property: The Crisis of Liberalism in Modern Britain* (2004), and *The Afterlife of Empire* (2012). She has also published widely on visual culture, colonialism and law, and the effects of decolonization in Britain. She is now working on the visual and cultural history of decolonization.

ROGER BENJAMIN is an Australian art historian who trained at the University of Melbourne and Bryn Mawr College. He has written widely on French modernist art, the history of French Orientalist painting, and contemporary Aboriginal art. His early publications include Matisse's "Notes of a Painter" (1985), and "Matisse in Morocco: a Colonizing Esthetic?" (1990), an early postcolonial critique of modernist art. In 1995 he co-curated a major Matisse retrospective for Australia (Queensland Art Gallery). His exhibition catalog Orientalism: Delacroix to Klee (1997), an influential survey that brings international Orientalism into the 1930s, is still in print. A decade of research culminated in Orientalist Aesthetics: Art, Colonialism and French North Africa, 1880–1930 (2003), from which his chapter in this volume is drawn. Benjamin received the prestigious Robert Motherwell Book Award for Orientalist Aesthetics in 2004. His Renoir and Algeria (2003) was organized for the Clark Art Institute before traveling to Dallas and Paris. His books on contemporary Australian art include Juan Davila (with Guy Brett, 2006) and Icons of the Desert: Early Aboriginal Painting from Papunya (2009). Benjamin has held teaching posts at the University of Melbourne, the Australian National University, and University of Sydney, where he was Director of the Power Institute from 2003 to 2007. Currently Professor of Art History at Sydney, Benjamin received a 2012 fellowship at the Clark Art Institute for research on Kandinsky's and Münter's Tunisian trip in a Mediterranean studies context.

DANIELA BLEICHMAR is Assistant Professor of Art History and History at the University of Southern California. She is the author of Visible Empire: Botanical Expeditions and Visual Culture in the Hispanic Enlightenment (2012) and a coeditor of Collecting across Cultures: Material Exchanges in the Early Modern Atlantic World (2011) and Science in the Spanish and Portuguese Empires, 1500–1800 (2008).

ZEYNEP ÇELIK is Distinguished Professor of Architecture at the New Jersey Institute of Technology. Her publications include The Remaking of Istanbul: Portrait of an Ottoman City in the Nineteenth Century (1986; winner of the Institute of Turkish Studies Book Award, 1987), Displaying the Orient: Architecture of Islam at Nineteenth Century World's Fairs (1992), Streets: Critical Perspectives on Public Space (1993, coeditor), Urban Forms and Colonial Confrontations: Algiers under French Rule (1997), Empire, Architecture, and the City: French-Ottoman Encounters, 1830–1914 (2008; winner of the Society of Architectural Historians Spiro Kostof Book Award, 2010), Walls of Algiers: Narratives of the City through Text and Image (2009, coeditor), and Scramble for the Past: A Story of Archaeology in Ottoman Empire, 1753–1914 (2011, coeditor), as well as articles on cross-cultural topics. She served as the editor of the Journal of the Society of Architectural Historians (2000–2003). She co-curated Walls of Algiers, an exhibition at the Getty Research Institute, Los Angeles (May–October 2009) and Scramble for the Past: A Story of Archaeology in Ottoman Empire, 1753–1914, an exhibition at Salt, Istanbul (November 2011–March 2012). She is now working on a new book project, titled Empires and Antiquities: Appropriating the Past. She has been the recipient of numerous fellowships, including a John Simon Guggenheim

Memorial Foundation Fellowship (2004), American Council of Learned Societies Fellowship (1992, 2004, and 2011), and National Endowment for the Humanities Fellowship (2012).

DAVID CIARLO is currently an Assistant Professor of Modern European History at the University of Colorado, Boulder, specializing in visual history, the history of empire, and the history of advertising and consumer culture. He received his doctorate from the University of Wisconsin, Madison, and taught at the Massachusetts Institute of Technology and the University of Cincinnati before finding his way to Colorado. His first book, *Advertising Empire: Race and Visual Culture in Imperial Germany* (2011), offers a visual history of colonialism and commercial culture through the delineations of figures of Africans in German advertising in the late nineteenth and early twentieth centuries and explores in detail how emerging forces of consumer-oriented mass culture reforged figures of Africans into widely circulated racist stereotypes.

NATASHA EATON teaches eighteenth- and nineteenth-century British art and the visual culture of South Asia at University College, London. *Mimesis across Empires: Artworks and Networks in India, 1765–1860* was published in 2013 by Duke University Press. She is also finishing a book titled *Color and Empire: Art, Enchanted Technology and Waste in South Asia, 1760 to the Present.* She has recently been awarded a prestigious Philip Leverhulme Trust Prize for a project on the contested and contingent status of museums in India, circa 1850 to the present.

SIMON GIKANDI is Robert Schirmer Professor of English at Princeton University and editor of the *PMLA*, the official journal of the Modern Languages Association of America. He is the author of many books and articles, including *Writing in Limbo: Modernism and Caribbean Literature* (1992), *Maps of Englishness: Writing Identity in the Culture of Colonialism* (1996), and *Ngugi wa Thiong'o* (2000), which was a Choice Outstanding Academic Publication for 2004. He is the coeditor of *The Cambridge History of African and Caribbean Literature* and the editor of the *Routledge Encyclopedia of African Literature.* His latest book, *Slavery and the Culture of Taste*, was published in 2011.

SERGE GRUZINSKI is with the École de Hautes Études en Sciences Sociales in Paris and author of several works, among them *Images at War: Mexico from Columbia to Blade Runner (1492–2019)* (Duke University Press, 2001) and *Painting the Conquest: The Mexican Indians and the European Renaissance* (1992). His most recent monograph is titled *What Time Is It There? America and Islam at the Dawn of Modern Times* (2010).

JAMES L. HEVIA is Professor of International History and Director of the Undergraduate Program in International Studies at the University of Chicago. His research interests have centered on European imperialism in Asia from the eighteenth century onward and the technologies of knowledge that were part of all colonial projects. His book-length studies include *Cherishing Men from Afar: Qing Guest*

Ritual and the Macartney Embassy of 1793 (Duke University Press, 1995), *English Lessons: The Pedagogy of Imperialism in Nineteenth Century China* (Duke University Press, 2003), and *The Imperial Security State: British Colonial Knowledge and Empire-Building in Asia* (2012). In each of these works, he demonstrates the critical role of visual media as a tool of empire. In his treatment of photography, he has argued that because of its claim to an unmediated access to reality, photographs came to dominate the visual field of imagery of Asia. As such, the photograph could be used to document the so-called problem of Asia (stagnation, barbarism) and provide rationales and justifications for a variety of European interventions into East and South Asia.

BRIAN LARKIN'S first book, *Signal and Noise: Infrastructure, Media and Urban Culture in Nigeria* (Duke University Press, 2008), examines the materiality of media technologies and their role in the formation of colonial and postcolonial urban experience in Nigeria. He has written a series of articles on practices of circulation paying particular attention to the material effects of infrastructures and how they delimit where and how circulation occurs. His current project examines the rise of new religious movements in Nigeria and the formative role media play in encoding religious practice. Larkin teaches anthropology at Barnard College, Columbia University. He sits on the board of the Society for Cultural Anthropology and is a member of the editorial collective of *Social Text*. He has published in such journals as *Public Culture, Politique Africaine, Social Text*, and *Africa*.

OLU OGUIBE is Professor of Art, Art History, and African American Studies at the University of Connecticut and has published extensively on issues in contemporary art and culture. His books include *Uzo Egonu: An African Artist in the West* (1995) and *God's Transistor Radio* (2004, 2011).

RICARDO PADRÓN is Associate Professor of Spanish at the University of Virginia. His research emphasizes the unfolding spatial and geographical imagination of the early modern Hispanic world. His first book, *The Spacious Word: Cartography, Literature, and Empire in Early Modern Spain* (2004) tracks the spatialities of early modern Spanish imperialism across cartography, historiography, and epic poetry. It argues that despite the well-known innovations of Renaissance cartography, a spatial imaginary characteristic of the Middle Ages continued to be prominent in the cartographic literature of early modern expansionism. His contribution to this volume, encapsulates his book's central argument. Padrón's current research addresses the construction of transpacific space. Other projects have taken Padrón into the fields of early modern lyric poetry, masculinity studies, and the mapping of imaginary worlds. His work has been supported by grants from the National Endowment for the Humanities and the American Council of Learned Societies.

CHRISTOPHER PINNEY is Professor of Anthropology and Visual Culture at University College, London. He has held visiting positions at the University of Chicago and Jawaharlal Nehru University, and from 2007 to 2009 was Visiting Crowe

Professor in Art History at Northwestern University. In spring 2012 he was a Getty visiting professor at Boğaziçi University, Istanbul. His research has a strong geographic focus in central India: initial ethnographic research was concerned with village-resident factory workers. Subsequently he researched popular photographic practices and the consumption of Hindu chromolithographs in the same area. His publications combine contemporary ethnography with the historical archaeology of particular media (see *Camera Indica* [1997] and *Photos of the Gods* [2004]). *The Coming of Photography in India*, based on the Panizzi Lectures, was published in 2008 and *Photography and Anthropology* in 2011. He is currently interested in cultural spaces, which conventional social theory has tended to neglect: "more than local and less than global," and spaces of cultural flow that elude the West. In addition to ongoing projects with an Indian focus (e.g., a forthcoming book, *Lessons from Hell*, on popular images of punishment), he is also working on the visual dimensions of cultural encounters from 1492 to the present.

BENJAMIN SCHMIDT is Professor of History at the University of Washington, Seattle, where he specializes in early modern European cultural and visual history and the history of early modern expansion and globalism. His books include *Innocence Abroad: The Dutch Imagination and the New World, 1570–1670* (2001), which won the Renaissance Society of America's Gordan Prize and the Holland Society's Hendricks Prize; *Making Knowledge in Early Modern Europe: Practices, Objects, and Texts, 1400–1800* (2008; with P. Smith); *Going Dutch: The Dutch Presence in America, 1609–2009* (2008; with J. Goodfriend and A. Stott); and *The Discovery of Guiana by Sir Walter Raleigh* (2007). His forthcoming book, *Inventing Exoticism*, explores Europe's engagement with the world in the period around 1700, paying particular attention to the role of pictures and the material arts.

TERRY SMITH is Andrew W. Mellon Professor of Contemporary Art History and Theory in the Department of the History of Art and Architecture at the University of Pittsburgh, and Distinguished Visiting Professor, National Institute for Experimental Arts, College of Fine Arts, University of New South Wales. He was the 2010 winner of the Mather Award for art criticism conferred by the College Art Association (United States), and was named Australia Council Visual Arts Laureate in 2010. His research interests include the history of visuality, modern and contemporary art of the world, and the question of contemporaneity. He is the author of *Making the Modern: Industry, Art and Design in America* (1993; inaugural Georgia O'Keeffe Museum Book Prize 2009); *Transformations in Australian Art*, volume 1, *The Nineteenth Century: Landscape, Colony and Nation*, and volume 2, *The Twentieth Century: Modernism and Aboriginality* (2002); *The Architecture of Aftermath* (2006); *What Is Contemporary Art?* (2009); and *Contemporary Art: World Currents* (2011).

ROBERT STAM is University Professor at New York University. He is the author or coauthor of more than fifteen books, including *François Truffaut and Friends: Modernism, Sexuality, and the Art of Adaptation* (2006); *Literature through Film: Realism, Magic and the Art of Adaptation* (2005); *Film Theory: An Introduction* (2000); *Tropi-*

cal Multiculturalism: A Comparative History of Race in Brazilian Cinema and Culture (Duke University Press, 1997); *Subversive Pleasures: Bakhtin, Cultural Criticism, and Film* (1989); and with Ella Shohat, *Unthinking Eurocentrism* (1994), *Multiculturalism, Postcoloniality and Transnational Media* (2003), and *Flagging Patriotism: Crises of Narcissism and Anti-Americanism* (2007). Their coauthored book *Race in Translation: Culture Wars in the Postcolonial Atlantic*, a comparative study of the race and postcolnonial debates in France, Brazil, and the United States, was released in 2012. He has lived and taught in France and North Africa.

ERIC A. STEIN completed his doctorate in Anthropology and History at the University of Michigan in 2005 and teaches interdisciplinary studies at the Evergreen State College. His work draws on ethnography, archives, memory, and film to examine how the political conditions of colonialism, nationalism, and anticommunism gave rise to particular models of population engineering in twentieth-century Indonesia. His recent publications include "Hygiene and Decolonization: The Rockefeller Foundation and Indonesian Nationalism," in *Science and Public Health in Asia* (2011) and "Sanitary Makeshifts and the Perpetuation of Health Stratification in Indonesia," in *Anthropology and Public Health* (2009). His current research considers medicalized birthing as a site for the making and unmaking of American citizenship and identity for recent immigrants and refugees in the United States.

NICHOLAS THOMAS visited the Pacific Islands first in 1984 to research his doctoral thesis on the Marquesas Islands. He later worked in Fiji and New Zealand and has written widely on art, voyages, colonial encounters, and contemporary culture in the Pacific. He is author, coauthor, or editor of more than thirty books, including *Entangled Objects* (1991), *Oceanic Art* (1995), and *Discoveries: The Voyages of Captain Cook* (2003). Collaborations with Pacific artists include *Hiapo: Past and Present in Niuean Barkcloth* (with John Pule, 2005) and *Rauru: Tene Waitere, Maori Carving, Colonial History* (with Mark Adams, Lyonel Grant and James Schuster, 2009). These works have addressed transformations of material culture and the entanglement of European and indigenous projects since the eighteenth century in Oceania. *Islanders: The Pacific in the Age of Empire* (2010) was awarded the Wolfson History Prize. Thomas's exhibitions have included *Skin Deep: A History of Tattooing* for the National Maritime Museum, London, and *Cook's Sites* for the Museum of Sydney, as well as *Kauage: Artist of Papua New Guinea* and several other shows at the Museum of Archaeology and Anthropology in Cambridge, where he has been Director since 2006; he is also Professor of Historical Anthropology, and a Fellow of Trinity College, Cambridge.

KRISTA A. THOMPSON is Associate Professor in the Department of Art History at Northwestern University. She is author of *An Eye for the Tropics: Tourism, Photography, and Framing the Caribbean Picturesque* (Duke University Press, 2006), an examination of the colonial imaging of the Anglophone Caribbean in photographs and its effects on landscape, history, race, governmentality, and contemporary art practice. She has published in *American Art*, *Art Bulletin*, *Art Journal*, *Representa-*

tions, *Drama Review*, and *Small Axe*. She has curated and co-organized exhibitions internationally and coedited special journal issues on "New World Slavery and the Matter of the Visual" and "Caribbean Locales/Global ArtWorlds." Thompson is currently working on *The Visual Economy of Light in African Diasporic Practice* (forthcoming, Duke University Press) on the intersections among black vernacular forms of photography, performance practices, and contemporary art in the Caribbean and the United States.

Africa (*continued*)

German advertisements and images of, 195–203; hygiene films in colonies of, 318, 323, 342n26; Indian cinema in, 360–61, 463, 598–99; Indian parallels in photography with, 461–66; indigenous architecture in, 405–11; indigenous class and oppression in, 520–32; as modernism catalyst, 567–69; Nigerian cinema in, 346–68; photography in, 458, 462–66; Picasso's interest in, 387–88, 566–89. *See also* North Africa

Africanism: antimodernity and, 358–61; of Parisian avant-garde, 131–32

Afterimage (Appadurai), 460

After the Iftar (Hamdi), 399

agency houses, print sales from, 176–77, 185n53, 188n81

agency theory of history, 40n8; photography and, 305–9; theories of race and color and, 94–96; transcultural artifacts and, 555–58

"The Age of the World Picture" (Heidegger), 455–56

Agfa photographic materials, advertisements for, 195–97, 201

Agg, James, 180n6

Agnani, Sunil, 13, 21n56

agriculture: in Algerian cinema, 521; in colonial expositions, 111–12, 130–32; in Palace of Algerian Attractions, 114–23

Aïssouas sect, 125

Alba, Duke of, 251

Alberti's Window, 55

"aleatory contracts," in colonial Calcutta, 176–77, 188n76

Algeria: in film, 508–32; French panoramic displays depicting, 112–23; images of women in, 482, 515–17, 529–32; modern revolution in, 521–32; postcolonial cinema in, 520–32; postcolonial images of, 383; violence of French colonization in, 508–20

"Algeria Face to Face with the French Torturers" (Fanon), 515

Algerian Diorama, 113

Algerian Quarter (Paris), 113

Algerian War, 409

Algiers: The Casbah (Renoir), 130

Alhambra Palace, French Orientalist depictions of, 124

Ali, Karam, 164

Ali-la-Pointe, 511, 514, 519

Alleg, Henri, 514

Allen, Arthur B., 102–3

Alloula, Malek, 20n42, 474, 482, 487

Allyn, David, 352

Alpers, Svetlana, 456–57, 615

alterity, of figures in creole Europe, 544–47, 561–62

"Amal Hayati" (The Hope of My Life) (song), 522

Amar Bharat Atma (Immortal Soul of India) (Ketkar), 434

amateur artists, paintings in Algerian panorama by, 114–23

Ambler, Charles, 359

Amboina scandal, 248, 251

Amboyna (Dryden), 246–49, 251, 262, 263n1

America (Montanus), 252

American aesthetic: departure from European images and, 65; development of, 73–83

American jazz music: emphasis on difference in, 607–8; French interest in, 131

Americas. *See* Latin America; North America

Amerique (van Kessel), 256–58, 265nn13–14

Amoenitates exoticae, in Dutch images, 260–62

Amsterdam hortus, 254

Anatomy Study of a Black Man (Picasso), 573–74

Ancestor Figures, in Aboriginal paintings, 273–75

Andalusia, Picasso's roots in, 571–78

Andalusia in the Time of the Moors (*L'Andalousie aux temps des Maures*) (Dinet), 126, 132

Andalusian images: in colonial Mexico, 47–49; by French Orientalists, 124–32

Andanças e viajes (Tafur), 222

Anderson, Benedict, 31, 33, 142, 251; on meaning of death, 415; on national geography, 426

Anderson, George William, 145–46

Anderson, Lizzie, 478

anglophone scholarship, Spanish scientific exploration ignored in, 65–73

animism: colonial consumption and, 161–64; in English prints, 160–61

Anmatyerra/Aranda language group, 273–75

The Annunciation with St. Emidius (Crivelli), 546

Anotaciones (Herrera), 220–21

Anthologie de la Nouvelle Poesie Negre et Malgashe de Language Francaise (Senghor), 528

anthropological research: allochronicity of, 504; cultural property issues and, 547; European representation of artifacts in, 145–52

anthropomorphism: in Indian cartography, 424–29; in Mexican colonial images, 53–55

anti-Christian movement, Boxer Rebellion as, 286–92, 296–300

antimodernity, in Islam, 358–61

Anti-Semite and Jew (Sartre), 528

antivisualism, in colonial/postcolonial studies, 5–9

Appadurai, Arjun, 26–27, 162, 362–63, 460, 553–54

Arab Festival (Renoir), 129–30

Araeen, Rasheed, 601–2

Aragonian images, 47–49

Aratjara (Aboriginal exhibit), 605

archeology of Europe, 542–43

Archer, Mildred, 556

architecture: African indigenous architecture, 405–11; of British railway stations, 545–47; of cathedrals, Chinese-Islamic influences in, 525; in colonial Calcutta, 180n6; in Kano, Nigeria, 349–51; of Mexican colonial monasteries, 51–55; photography of, 289–90; in stereography, 298–300; vernacularist idiom in, 383

archives: of Caribbean photography, 485; as fetish, in colonial Calcutta, 160–61; photographic archives, 300–304, 459–60; as tool of empire, 304–9

aristocratic patronage, of Dutch geography and natural history, 256

Around the World in Eighty Days (Verne), 120

Arrival of a Train at the Station (film), 339n10

art: Aboriginal mapping as, 272–75; in colonial Calcutta, 165–71; colonial expositions and aesthetics of, 114–23; criticism of Orientalism in, 397–411; empire and, 4; Jamaican colonial representation in, 474; in postcolonial Britain, 594–608; as reflection of reflection, 539

Arte de navegar (Medina), 233–34

art education, theories of race and color and, 95–96

art history, empire and, 9–11

artifacts: Aboriginal artifacts, 546–47; as curiosities, 152–56; European representations of, 145–52

The Battle of Algiers (film), 385–86,
523–32; historical accuracy of, 508–16;
Julien's filmic references to, 527–32;
role of women in, 516–20; segregated
space in, 520–27, 617; September 11,
2001, attacks and, 517, 534n42
"battle of Paris" (1961), 510
The Battle of the Casbah, 509
Battle of the Pyramids (1799), French
panorama of, 116–17
Baudrillard, Jean, 162
Baxandall, Michael, 55
Bayly, Christopher, 422
bazaar art, 424–25
Beard, Mary, 559–62
Beato, Felice, 452
Beeckman, Andries, 254
Beethoven in the Palace (Abdülmecid),
397–98
"before-and-after" hygiene films, 326–31
Beherend, Heike, 463
Beidelman, T. O., 372n53
Bénédite, Léonce, 112, 113–14, 123,
129–30
Bengal, India: Indian yellow pigment
production in, 96–98; indigo distur-
bances in, 98–99
Bengal Education Department, 97
Bengali folk artists, 439–41
Bengal Inventory Series, 188n81
Bengal Wills Series, 188n81
Benin, colonial destruction of, 593n61
Benjamin, Roger, 7–8, 13, 30–31, 111–32,
384, 615
Benjamin, Walter, 6, 26, 348–49, 380,
451, 456
Bennett, Gordon, 272, 546–47
Bennett, Tony, 112, 118, 122, 133n16, 305
Benozzo Gozzoli chapel, 52
Bernheim, Gaston, 128–30, 136n69
Bernheim, Josse, 129
Berry, Chuck, 601

Beta (film), 451
Bey, Halil, 398, 412n8
Bhabha, Homi, 15n9, 28, 162–63, 380,
450, 493–94, 503, 617, 620n14
Bhagat Singh, print images of, 416,
435–44, 444n1
Bharat Mata: Indian cartography and
images of, 424–29; patriotic Indian
prints of, 429–41. See also Mother
India
biblical iconography, truth of, 143–45
big man imagery, in Indian patriotic
prints, 427, 447n39
Bismarck, Otto von, 378
Black and Tan Fantasy (Ellington), 607
Black & White (illustrated weekly), 301
black history, postcards as tool in ac-
counts of, 494–97
black musicians, stylized paintings of,
105n7
Black Skin, White Masks (Fanon), 8–9,
503, 505–6, 513–14. See also Frantz
Fanon: Black Skin, White Masks (film)
Black Town (Calcutta), 164–65
Blaeu, Joan, 247, 253, 264n10
Blake, William, 4, 277
Bleichmar, Daniela, 29–30, 64–84, 614
Blue Nude (Souvenir of Biskra) (Matisse),
131
body marking, Aboriginal mapping as,
271–75
Boétie, Étienne de la, 609
Boeto (Javanese puppet figure), 336
Bois, Yve-Alain, 569, 583
bolero, French Orientalist images of, 125
Bonnard, Pierre, 129
Bontekoe, Willem, 253
books, printing and engraving and,
49–51
"books of wonders," Dutch production
of, 253
Borges, Jorge Luis, 33, 159, 171, 216

Bosch, Hieronymus, 48

Bose, Khudiram, 438

Bose, Subhash Chandra "Netaji," 430, 437

botanical illustrations: decontextualization of nature in, 74–75; evolution of American style in, 73–83; Spanish expeditions' focus on, 66–73, 614

Boulanger, Gustave, 398

Boupacha, Djamila, 413n26

Bourdieu, Pierre, 162, 459, 462–63

Bourne, Samuel, 35–36, 452–55, 458

Bowling, Frank, 600–608

Boxer Uprising (China), photographic images of, 285–309, 614

Boydell, John, 160–61, 183n37

Bradley, William, 268–70

Braque, Georges, 569, 576–77

Brazil: Dutch colonization in, 248, 250; Dutch maps and images of, 253–54, 259–62

Breckenridge, Carol, 26–27, 305

Brett, Katherine, 548

Breughel, Pieter, 48

British Colonial Film Unit, 318

British Museum, 147

British painting: Indian yellow pigment in, 91–104; theories of race and color and, 92–96

Brixton market (Great Britain), 602–8

Brown, E. Ethelred, 471, 480–81

Brown, John, 184n39

Brunel, Isambard Kingdom, 545

Bruyn, Cornelis de, 253

Bryson, Norman, 150, 456

Buci-Glucksmann, Christine, 457

Buckley, Liam, 13, 21n59

Buck-Morss, Susan, 11, 381–82, 456

Buffet, Paul, 118

burial poles, Aboriginal mapping on, 272–75

Burke, Timothy, 359

Burney, Fanny, 153

Burty, Philippe, 122

Busbecq, Ogier, 253

Bygone Barbados (postcard book) (Yates), 473, 482–83

Caballero, Pablo, 72

Caballero y Góngora (Viceroy), 72–73, 81

Cabral, Amilcar, 503

Cadava, Eduardo, 459

cadmium yellow, 97

Calcutta, India: collapse of European economy in, 174–80; imprinting of death and luxury in, 164–71; lotteries and aesthetic monopolies in, 171–80; print consumption in colonial era and, 159–80

Caldas, Francisco José de, 69

Calderón, Pedro, 219

calibration, in mapmaking, 267–68

Calzado, José, 72

Cambodia, in French Orientalist exhibits, 121, 128

Camoin, Charles, 128

Camper, Peter, 93–96

Camus, Albert, 566

Canada, Anglophone-Francophone division in, 612

canvases, in colonial Mexico, 47–48

The Cardboard Box (Doyle), 557

Cardoso, Fernando Henrique, 506

Caribbean: "civilized savagery" images in postcards of, 474–81; colonial cartography of, 215–21; French panoramic representation of, 118; historical narrative in postcards of, 482–97; photography of, 472–74; postcard images of, 384–85; Spanish colonization in, 215

Carpentier, Alejo, 457

Cartesian perspectivalism: in objects, 550–51; in photography, 456–58, 463; visuality of empire and, 613–19

cinema (*continued*)

and, 362–66; hygiene cinema in colonial Java, 315–38; hygiene films as colonial theaters of proof, 322–38; Indian film, 360–61, 451–52; market space compared with, 356–61; modernity and, 348–49; moral aura of cinematic space, 353–55; music videos in Jamaica, 471–74; Nigerian Hausa youths' embrace of, 361–62; in North Africa, 519–32; politics in Nigeria and, 368n1; postcolonial North Africa in, 385–86, 411; representation of colonized people in, 512; spatial arrangement in Kano of, 349–51; trans-local space in Nigerian cinema, 355–61

Cinematic Prophylaxis (Ostherr), 316–17

Cinéorama (Paris), 120, 122

Cioran, E. M., 539

circular paintings. *See* panoramas

Cité Musulmane el Omrane (Tunisia), 406

Citrin, Laura, 327–31

"civilized savagery" images, West Indies postcards, 474–81

"civilizing mission" of colonization: advertising as reflection of, 193, 197–98; aestheticization of Australian landscape and, 275–78; Boxer Rebellion and, 287–90, 296–300; ideology of, 610–19; in Javanese hygiene films, 325–31

Civil War (U.S.), photography of, 458

classicism, Picasso's view of, 561–69

class structure: Caribbean postcard representations of, 478–81, 488–97; in postcolonial indigenous society, 520–32

Cléo de 5 à 7 (film), 511

Clifford, James, 583

climate, colonial culture and role of, 168–71

Clive, Robert (Lord), 165, 168

clothing: as anticolonial symbol, 378–82, 389n4, 602–8; in Indian popular photography, 461–66; racial characteristics of, 105n13; response to Orientalism in paintings with, 397–99

Clüver, Philipp (Cluverius), 252

cobalt yellow, 97

Cockatoo Trainer (*Montreur de cacatoès*) (Silbert), 128

The Coffee Corner (Hamdi), 399

Colegio Mayor de Nuestra Señora del Rosario, 68–69

collections: colonial expansion and proliferation of, 147–52; Dutch paintings of, 256

collective social laughter, generative powers of, 336–37

Colley, Linda, 142

Collins, John, 545

Collins, Wilkie, 555–58

Colnaghi & Co., 275–76

Colón, Fernando, 229–30

colonial economies: advertising as reflection of, 190–97; aestheticization of Australian landscape and, 276–78; in British India, 172–80; cinema-market link and, 357–61; consumption of culture and, 161–64; cultures of paint and government and, 102–4; India yellow pigment as symbol of, 92–104; in rural Banyuamas (Java), 331; touristic representation in postcards of, 482–97

colonialization, Fanon's discussion of, 504–5

colonial pavilions: French panoramas and dioramas in, 111–23; in Marseille National Exhibition, 126–32

Colonial Society of French Artists (Coloniale), 123, 128–29, 132, 136n69

colonial studies: in Africa, 379–82; mapping, claiming, reclaiming, and, 33–37; mass-printed imperium and,

creole nationalism, Anderson's discussion of, 142

criollos, as natural history collaborators, 69–73

Critical Terms for Art History (Nelson and Shiff), 11

Crivelli, Carlo, 546

Crockaert, Peter, 48

Cruelty to Animals Act, 100

Crusades, French Orientalists' depiction of, 124–25

Csikszentmihalyi, Mihaly, 545–47

Cubism, 566–71, 582–83

Cuéllar, Juan de, 75

Cuernavaca, religious plays performed in, 60

culik (Javanese bogeyman), 332

Cultural Power, Resistance, and Pluralism (Moore), 496–97

cultural studies: Fanon's legacy in, 505–8; in Julien's films, 524–25

culture: modernism and, 570–78; of objects, 552–54; in postcolonial Great Britain, 594–608; resistance to empire and, 612–19

Culture and Imperialism (Said), 6

Curing Their Ills (Vaughan), 318

curiosities: artifacts as, 152–56, 616; in Dutch geographic and natural history images, 260–62

Curious George (children's book series), 155

curses: Hausa culture and power of, 364–65, 372n52; in *Xala* (film), 519–32

Dadi, Iftikar, 381

Daguerre, Louis, 134n27

Dahane, Kamal, 383, 411

Daily Gleaner (Jamaican newspaper), 490, 492, 498n10

Daix, Pierre, 568–69

d'Alési, Hugo, 120

D'Amboinsche rareteitkamer (The Amboinese Curiosity Cabinet), 254

dance, French Orientalist representations of, 125

Daniell, Thomas, 143, 176, 543

Daniell, William, 143, 176

Danjaje, Abdulkadir, 366

Dapper, Olfert, 252

Darker Side of Black (film), 525

Daudet, Alphonse, 550–51

David, Gérard, 48

Dayal, Prabhu, 437

Debvrata, 438

Decennial of French Art, 114

Decker, Paul, 543

decolonization, visuality and, 3–14

decontextualization: of artifacts, 145–52; in botanical illustrations, 74–75; of Caribbean postcards, 485–86; in Dutch geographic and natural history images, 259–62

Deep Blue (Shonibare), 602

Deferre, Gaston, 127

Dekkers, Johann (Juan de Tecto), 48

Delacroix, Eugène, 383, 399, 408–11, 413n22

de Laet, Johannes, 259

"Del rigor en la ciencia" (Borges), 216

demonization of objects, 554–58

De Natur (Dutch science journal), 119

Denys the Carthusian, 51

dependency theory, Fanon and, 506

depth, in photography, 451–58

De Quincey, Thomas, 555

Der Adelich Hofmeister (Schwart), 452

Derrida, Jacques, 387–88, 504, 590n12

derroteros, 233, 244n58

de Sade, Marquis, 548

Descripción y cosmografía de España (Colón), 229–30

desire, creole Europe and role of, 548–49

d'Estienne, Henry, 118

Hughes, Langston, 450, 524–25

Hugo, Victor, 508

human action: in colonial engravings, 149–52; in photography, 282–86

human figure: colonial power representation in advertising using, 198–99; in Indian cartography, 424–41, 445n25; in Mexican colonial images, 53–55; photographs of, 288; in stereography, 298–300

humanism, European mapmaking and, 215

human studies (*scènes de moeurs*), 122

Humboldt, Alexander von, 72

Hume, David, 155, 422

Humphry, Ozias, 165, 168–71, 176, 184n37, 185n50

Hunter, John, 268–70, 277, 278n1

Husain, Maqbool Fida, 439

Huxley, Aldous, 556

hybridity, 15n9; in cultural consumption, 162–64; of imperial hegemony, 613–19; in reconstituted Europe, 539–40

Hydrick, John L., 319–31, 333, 337–38, 342n20

hygiene cinema: archives in Indonesia of, 338, 340n14; in colonial Java, 315–38, 615

hygiene technicians (*mantri hygiëne*), in colonial Java, 315–16, 319–21, 332–37

Hynes, Nancy, 379

I Am Curious (Yellow) (film), 155

Iberian Peninsula: art in Mexico from, 47; cartography of, 215–16

iconographic style: in American botanical illustrations, 75–83; in engravings, 142

Iconologia (Ripa), 258, 265n14

Identification Papers (Fanon), 512–13

identity: colonization and integration of, 610–19; Fanon's politics of identification and, 502–32; instability in Europe of, 611–19; in Julien's films, 526–32

ideology, advertising as illustration of, 197–98

Ighilahariz, Louisette, 512

Ikwue, Bongos, 599

Illustrated London News, 302–4

illustrated newspapers, photographs of Boxer Uprising in, 300–304

image-making: in advertising, 190–93; cartography as, 226–35; disciplinary confinement of, 3–14; in Dutch Republic, 250–58; European empires and, 2, 25–39; from Flanders, 47–49; hatred of empire images and, 11–14; by Indians, colonial teaching of, 49–51; nature reflected in, 64–84; photography as, 282–309; in Spanish natural history expeditions, 66–73; text and, 292–96, 306–9; visuality of empire and, 611–19

Images: A Reader, 10–11

Images at War: Mexico from Columbus to Blade Runner, 1942-2019 (Gruzinski), 28–31

image workers: in Africa, 379–82; mapping of British India and, 383

Imagined Communities (Anderson), 33

immutable mobiles (Latour), 294–96

Imperial Eyes: Travel Writing and Transculturation (Pratt), 8

Imperial High School of Galatasaray, 402

Imperial Library (Turkey), 402–4

Imperial Maritime College (Turkey), 402–4

The Importance of Java as Seen from the Air (de Vries), 455

Impressionism, French colonial panoramas and influence of, 122

nabob, colonial characterizations of, 166

Nagda, India, photographic studios in, 459–66

Nahuatl Catechism, 48–49

The Naked Maja (Goya), 575

Napperby Station, 274

narrative, Caribbean postcard as tool of, 482–97

"Narrative of a Photographic Trip to Kashmir (Cashmere) and Adjacent Districts" (Bourne), 453–54

Narto, Pak, 336–37

Nash, Mark, 522

Nassau, Robert, 586

Nassau Guardian, 478

National Army Museum archives, 308–9

National Colonial Exposition at Nogent-sur-Marne (1907), 111–12, 130–32

National Colonial Exposition of Marseille (1906), 111–12, 123, 126–32, 136n69

National Exposition of Colonial Agriculture, 130–32

National Festival Song Competition (Jamaica), 471

National Gandhi Museum, 433–34

national identity, advertising and, 189–93

nationalism: in contemporary Great Britain, 595–96; Dutch Republic and role of, 251–58; in English prints, 160–61; Fanon's critique of, 520–32; in Julien's films, 524–25; patriotic Indian prints of, 429–41; in postcolonial Indian cartography, 429; in *Xala* (film), 520–32

National Liberation Front (FLN), 516–17, 521

national picture, India cartography and, 441–44

nation-states: cartography as tool of, 238; colonial panoramas and representation of, 122–23; Dutch Republic as, 250–58; historic narratives of, 493–94, 500n43; myth of unification and, 611–12; photography as tool of, 290–96; postcolonial Indian cartography and embodiment of, 426–29; "three worlds" theory and, 522

native artists: botanical illustrations produced by, 70–73; Christian images produced by, 55–60, 616; colonial circumscription of, 49–51; iconographic style in botanical illustrations by, 75–83; Indian cartography and, 424–29

natural history: Dutch illustrations of, 248–49, 252, 254–62; illustrations from, 64–84, 144; Spanish expeditions and illustrations of, 65–73

nature, in colonial painting, 64–84

Naugrette, Jean-Pierre, 556

nautical charts: colonial expansion and, 224; evolution of, 231–33, 235–38, 242n36

"negritude," role of the gaze in, 528

Negro Art, modernist interest in, 569–78

Negro Woman (*Négresse*) (Manet), 129

Nehru, Jawaharlal, 429, 441; in nationalist prints, 430–44

Nelson, Robert S., 11

neoglyphs (Mexican), Christian influences on, 63n49

Nesbit, Edith, 95, 102

Nesl-i Ahîr (The First Generation) (Ziya), 396

Netherlands: "decennium mirabilius" of, 254–56; Habsburg Empire and, 251; production of geography in, 249–50. *See also* Dutch Republic; Holland

Netherlands East Indies: hygiene cam-

paigns in, 320–31; Japanese occupation of, 321

Netherlands Indies People's Council, 320

A New, Authentic, and Complete History of Voyages round the World (Anderson), 146

New Galicia, cartography of, 223–24

New Gourna (Egypt), indigenous architecture in, 407

New Netherlands, 248, 250

New Order regime (Indonesia), 338

New Spain, maps of, 223–24

newspapers: cultural impact of, 142; illustrated newspapers, 301–4

New Zealand artifacts, 540, 561–62; European representations of, 147–48

Nézière, Joseph de la, 128

Nietzsche, Friedrich, 159

Nieuhof, Johan, 252, 259, 266n16

Nigeria: cinema in, 38–39, 346–68, 616; culture and politics of, 597–600; political use of cinema in, 368n1

Nineteenth-Century Visual Culture Reader (Mitchell), 10–11

Nochlin, Linda, 6–7

Noiré, Maxime, 120, 134n36

non-Western peoples, European representations of, 145–52

Nooms, Reinier "Seaman," 254

North Africa: architecture in, 405–11; film in, 385–86; Ottoman culture in, 382–83; Western and Eurocentric films produced in, 511; *Xala* (film) and culture of, 520–32

North America, Dutch colonization in, 248, 250, 252

Northern images, influence on Spanish art of, 47–51

nostalgia for colonization, in Caribbean postcards, 483–97, 501n57

Nostalgic Nassau (postcard book)

(Malone and Roberts), 473, 482–84, 486

Notebook on Cities and Clothes (Wenders), 142

"Notes of a Painter" (Matisse), 131

"Notes on the Surface of the Image" (Pinney), 384

Notting Hill Carnival, 524

Noua (film), 521

Nsue, Leandro Mbomio, 589

Nylandt, Petrus, 260–62

objects: animism of, 161–64; artifacts engravings and meaning of, 147–52; in British India, social life of, 91–92; colonial reconstitution of Europe through, 386–87; context of, 559–62; in creole Europe, 542–62; as curiosities, 152–56; demonization of, 554–58; in Dutch geographic and natural history images, 258–62; in Dutch still-life painting, 551–52; entanglement of, 552–54; figural history and, 549–51; hermeneutics of, 348–49; from India, Orientalist perspective on, 558–59; in Mexican colonial images, 54–55; narratives of, 548–49; photographs as, 294–96; Picasso's affinity for, 570–78; secular fetishism and, 177–80

objets trouvés in colonial Calcutta, 169

obliteration, in mapmaking, 267–68

Oceanic art, Other in, 568–69

Oceanic artifacts, in European engravings, 141–56

October (journal), 10–11

odalisque figure: Orientalist obsession with, 396, 398–401; Picasso's modernization of, 575–78

Oedipus complex, Fanon's critique of, 507

Oetterman, Stephan, 116, 118

Official Palace of Algeria, 113

oficiales pintores principiantes (young native painters), Spanish botanical illustrations produced by, 73

Ofili, Chris, 388, 605–8

Ogawa Kazuma, 288

Ogilby, John, 247–48, 252, 256

Oguibe, Olu, 388, 450, 452, 466–67, 594–608, 617

Oh That Rush! (film), 526

oil paintings, purchase in colonial Calcutta of, 175–80, 187n73

O'Keefe, Cornelius Francis (Captain), 287–88, 309, 310n10

Okri, Ben, 599

Olds, Oliver, 92–96

Ono, Yoko, 601–2

On Pictures and the Words That Fail Them (Elkins), 442–44

"On the Way to Market" (postcard), 479–80

Opera minora (Denys the Carthusian), 51

Ophüls, Marcel, 509

optical technology: empire framed in, 35–36, 42n35; photographic consistency and, 294–96

optics of colonial rule: advertising as reflection of, 193; power representations in advertising, 198–203

oral teaching, fresco images as basis for, 53

orbis terrarum, in medieval mapping, 212–13

Orientalism: in advertising, 192–93; in British architecture, 545–47; China's "Oriental despotism," 291–92; in colonial Calcutta, 165–71; colonial India in context of, 421–22; colonial pavilions as representation of, 111–12; in easel painting exhibitions, 123–32; Fanon's legacy and, 504; in films of North Africa, 384–85; in French panoramas, 113–23; in German package design, 193–94; in hygiene films, 317–

18; Indian objects from perspective of, 558–62; mass consumption in colonial Calcutta and, 163–64; Picasso's painting in context of, 575–78; postcolonial response to, 395–411; subalternity in, 382–83; visuality of empire and, 615

Orientalism (Said), 6–8, 263n5, 397

"Orientalism: The Near East in French Painting 1800–1880" (Nochlin), 7

Orientalist Aesthetics: Art, Colonialism, and French North Africa, 1880–1930 (Benjamin), 30–31

Oriental Scenery (Daniell), 543

"Orphée Noir" (Sartre), 528

Ortiz, Joan, 59

Ostherr, Kirsten, 316–17

O'Sullivan, Timothy, 452

Other: artifacts collections as representation of, 147–52; European empire and confrontation with, 11, 15n8, 19n37, 380–82; fetishization of, 163–64; hygiene films and construct of, 318, 342n26; mapmaking and obliteration of, 267–68; modernism and, 568–78, 579, 583–89; photographic racialization of, 296–300; in Picasso's paintings, 579–83; in postcolonial British culture, 594–608; primitivism and catalyst of, 567; reconstitution of, in postcolonial Europe, 386–88

Ottoman Empire: in European artifacts, 542–43; French North Africa and, 382–83; impact on Europe of, 611–12; response to Orientalism from, 396–411, 617

Oud en Nieuw Oost-Indiën (Old and New East Indies) (Valentijn), 253

Ouled-Naïl figures, French Orientalist depictions of, 115, 125–26

The Oval Portrait (Poe), 555

Oviedo, Gonzalo Fernández de, 222

Oxford English Dictionary, 237

Oxford ochre, 96–97

photoengraving, in German advertisements, 195–96

photography: aesthetic critique of, 284; archives, reproduction, and dissemination of, 300–304; in Boxer-era china, 283–309; depth and, 451–58; as documentation, 287–90; empire and role of, 35–39, 42n35, 614–15; enhancement of reality in, 461–66; historical narrative using, 482–97; in Jamaica, 471–74; Ottoman Turkey, postcolonial images of, 401–11; in postcards, 384–85; as power symbol, 290–92; realist backdrop of, 458–60; subaltern backdrop of, 460–61; as tool of empire, 286–92; vernacular modernism in postcolonial images, 450–66; Victorian collections of, 499n16; as virtual tour, 296–300. *See also* postcards

Photos and Phantasms (exhibition), 472–73

Picasso, Pablo: African influences on, 11, 387–88, 566–89; artifacts in work of, 141; modernism in work of, 583–89; "Negro period" of, 569–78; North African images of, 383; Orientalism and, 126, 408–11, 413n26; in Paris, 131; visuality of empire and art of, 615

"Picasso" (Rubin), 578–83

Picasso's Studio (Ringgold), 587–88

Pichon, M., 292

"pictorial turn" in human sciences, 12–14

picturesque ideal: in Caribbean postcards, 489–97; colonization and, 268, 385; in postcolonial history and art, 471–97; poverty images in, 501n63

"Pierre Loti" (hikmet), 395–96

Pietersie, Jan, 389n9

Pietz, William, 549, 558

pigment: colonial vs. domestic modes of production of, 98–101; domestic production of, 96–97; racial politics of, 92–96

Pinney, Christopher, 4, 27, 37, 40n11; corpothetic concept of, 446n32, 468n27; on creolized Europe, 381, 384, 386–88, 539–62, 610, 616–17; on Indian printmaking, 425, 431, 435, 440; on postcolonial photography and vernacular modernism, 450–66

pinturas (Mexican artifacts), territorial representations in, 226

pirate radio, film about, 524

Piso, Willem, 254, 259

Place, Taste and Tradition (Smith), 539

plague prevention, hygiene films for, 326–31

planisphere (plane chart), development of, 233–36

"plastic ethnology," panoramas as, 120–21

Poe, Edgar Allan, 555

Poerwokerto Demonstration Unit (Java), 320–31

politics: cartography and, 214–15; engravings and prints depicting, 144–45; Fanon's politics of identification, 503–32; Indian patriotic prints as tool for, 440–41; Indian yellow pigment phenomenon and, 102–4; Spanish natural history expeditions as tool of, 66

Pollock, Jackson, 151

Polo, Marco, 221–23, 227–28, 243n44

polycentrism, colonial reconstitution of Europe and, 389n9

Pontecorvo, Gillo, 385, 508–21, 617

Poole, Deborah, 25–26, 39n5

portolan charts, 231–33, 242n37, 244n51

portolano (navigational description), 231, 234

Portrait of Gertrude Stein (Picasso), 572, 591n23

Portuguese colonial expansion: in Brazil, 248; cartography and, 215, 231,

Richards, Thomas, 305
Rider Haggard H., 560
Ringgold, Faith, 587–88
Ripa, Cesare, 259, 265n14
ripolin sounds, 552
Rizo, Salvador, 71, 73, 79, 81
A Road Lined with Poplars (Bourn), 455
Robert Havell & Sons, 275–76
Roberts, Richard, 483–84, 486–87, 489
Rocha, Glauber, 507–8
Rochberg-Halton, Eugene, 545–47
Rochegrosse, Georges, 128
Rockefeller Foundation: hookworm prevention campaign, 315; International Health Division projects, 319–20; Javanese projects of, 318–20
Rococo art style, 539
Rodney, Walter, 506
Rogers, Naomi, 343n37
Rojas, Fernando de, 218
Roma, Spiridione, 524
rope-skipping game, in postcolonial culture, 604–8
Roscoe, John, 586–87
Rose, Tricia, 524
Rosetta Stone, 559–62
Ross, Kristin, 503, 512
Rothko, Mark, 151
Roy, Jules, 514
Royal Anthropological Institute Photographic Collection, 558
Royal Asiatic Society, 147
Royal Botanical Expedition to the New Kingdom of Granada, 29–30, 64–84
Royal Geographic Society, Jamaican photography exhibition by, 472
Royal Society for the Prevention of Cruelty to Animals, 100
Royal Society of Arts, 97
Rubin, William, 569, 578–83
Rüger coca firm, 197, 206n20
Ruiz, Hipólito, 65
Rumpf, Georg (Rumphius), 254

Rushdie, Salman, 382
Ruskin, John, 141, 545
Rustichello da Pisa, 221–23
Ryland and Bryer print dealers, 167, 183n5

Saad, Yacef, 511–12
Sabga, Joseph Abdo, 489
Sabon Gari ("New Town"), Kano, Nigeria: cultural space of, 351–56; market in, 357–61; rioting and violence in, 370n33
sacred message boards, Aboriginal mapping on, 272–75
Sagar Studio, 461
Sahraowi, Djamila, 519
Said, Edward, 263n5, 381, 397, 503–4, 561; on imperial visuality, 3, 5–11, 615
Saint Isidore of Seville, 212–13
St. Gregory's Mass, images in Mexico of, 57–59
St. John's-in-the-Swamps, 180n6
St. Teresa of Avila, 219
Salim and Sarinah (film), 330
Salle des Beaux-Arts, 133n19
Salmon, Colin, 527
Salon d'Autonne, Gaugin retrospective at, 130
salonnets (little salons), Orientalist painting in, 112, 123–32
Salt, Henry, 143–44
Sanchez, François, 520
Sand, Jordan, 289
sand paintings, Aboriginal production of, 273–75
San José de los Indios chapel, 48
Sankofa (black British film collective), 524
Santa Cruz de Tlatelolco, 49
Sanusi, Emir, 363–64, 366
Saracen influences in British architecture, 545–47
Sartre, Jean-Paul, 8–9, 514, 528, 551–52

Saunders, Gail, 495–96
scale: in cartography, 224; colonial power representation in advertising using, 198–99
Scarry, Elaine, 441
Schama, Simon, 382
Schenck, Peter, 543
Schivelbusch, Wolfgang, 542
Schmidt, Benjamin, 34–35, 246–62, 616
Schoelcher, Victor, 527
School of Fine Arts (Istanbul), 398, 412n7
School of Salamanca, 48
Schouw-toneel der aertsche schepselen (Theater of the World's Creatures) (Nylandt), 260–62
Schowart, Anton Wilhelm, 452
science: advertising claims based on, 196–97; cartography and, 214–21, 224–26; colonial assumptions of native ignorance concerning, 321; eighteenth-century painting and, 64–84; Spanish natural history expeditions and, 65–73; theories of race and, 93–96; Turkish educational emphasis on, 402
scopic regimes, 2, 11, 14n1, 613–19, 619n8
Scramble for Africa (Shonibare), 377–82
sculptures: in colonial Mexico, 47–49; in French colonial exhibitions, 115
sea atlases, 253
Sebbar, Leila, 411
Sedgwick, Eve, 430
seeing: domination and control and, 8–9; European empire and role of, 3–14
Select Views in India (Hodges), 143–44
Seligman, C. G., 586–87
Seller, John, 247–48
Sembene, Ousmane, 508–32
Semper, Gottfried, 546
Sen, Surya, 438
Senghor, Leopold, 528

sensation novels, 555–58
September 11, 2001, attacks, 517, 534n42
Serres, Michel, 549
severed head images, in patriotic Indian prints, 434–41
"Sévillanaises" (dance troupes), 125
sexuality: in Algerian cinema, 521; colonial segregation and, 518–21; Fanon's politics of identification and, 503, 528–32; in Julien's films, 524–25, 529–32; in Nigerian cinema space, 361–62; Orientalist fantasies about, 396; in Picasso's African paintings, 573–78. *See also* homosexuality
shadow puppet (*wayang kulit*) (Java), 37–38, 315, 334–37, 344n57
Shaheed Bhagat Singh (print), 416–17
Shaheed Smrity (Memory of Martyrs) (print), 438
Shakespeare's Gallery (print series), 168
Sharma, Lakshminarayan Khubhiram, 432, 434, 439
Sharma, Narottam Narayan, 434, 439
Shaw, Irénée, 474
She (Haggard), 560–61
Sherlock, Philip, 491–92
Shiff, Richard, 11
Shinoku Pekin kojo shashincho (Photographs of the Palace Buildings in Peking), 288–89
Shohat, Ella, 21n50, 380, 389n9, 503
Shonibare, Yinka, 3, 377–82, 388, 388n1, 389n2, 389n4, 596–600, 602–8
Shree Vasudeo Picture Co., 433
Siegel, James, 334–35
Silbert, José, 128
Silences of the Palace, 521–22
silhouettes, in German advertising, 200–203, 206n29
Silvestre, Armand, 123–24
Simmel, Georg, 352
Simpson, David, 578
Siraj ud-daula, 164

Sir Special of Ila-Orangun studio, 466
sketch-maps, 224–26
Sketch of Sydney Cove, 269–71, 278n1
skin color: medical theories concerning, 106n15; theories of race and, 93–96
slave imagery: in American advertising, 201–2; in German advertising, 199–203, 206n22
slavery: in colonial Java, 331–37; colonization and role of, 382; Dutch trade in, 250
Smith, Adam, 155, 166, 300
Smith, Arthur (Reverend), 289–90
Smith, Basil, 482
Smith, Bernard, 17n17, 539
Smith, Dave, 474
Smith, Terry, 34–35, 267–78, 614
social space, of cinema theaters, 347
social status, in stereographic images, 298–300
"social therapy," Fanon's concept of, 504
Society of French Orientalist Painters, 111–14, 118–19; easel exhibitions by, 123–32
Soemedi (Doctor), 328, 330
Somali Coast, French panoramic representation of, 118
"Some of China's Trouble-makers—Boxer Prisoners at Tientsin" (stereographic image), 298
Sontag, Susan, 35, 452, 470n66
The Sorrow and the Pity (film), 509
The Soul of India (Chandra Pal), 423
Souvenirs de la Bataille d'Alger, 511
Spain: cartographic production in, 216–21, 240n8; *espacio* concept in, 217–21, 229–35, 237–38; Flemish influences in art of, 47–49; travel texts from early modern era, 221–35; unification of, 611–12
Spanish colonial expansion: cartography and, 215; Dutch colonies and, 251–58; emergent and dominant space in car-

tography of, 215–21; gridded maps of, 223–35; natural history expeditions and, 65–73, 87n10, 614
spatiality: artifacts' occupation of, in colonial engraving, 151–52; in cinema, colonialism, and, 346–68; colonial cartography and, 33–37, 211–38; in colonial Mexico, visible and invisible space, 55–60; emergent and dominant space in colonial cartography, 215–21; in gridded cartography, 222–35; in Julien's *Black Skin, White Masks*, 528; of markets, 356–61; moral aura of cinematic space, 353–55; in Sabon Gari enclave (Nigeria), 351–56; Spanish philological concepts of, 217–19, 241n30; translocal space in Nigerian cinema, 355–61; in Western culture, 594–95
The Speckled Band (Doyle), 556–58
spectacle-image: in colonial Mexico, 60–61; of European expositions, 111–32, 615; Fanon's colonized spectatorship and, 513
Sperber, Dan, 558
Spivak, Gayatri Chakravorty, 2, 9–11, 15n8, 386, 411
Sprague, Stephen, 463–66, 470n66
Stafford, Barbara, 5
Stagl, Justin, 453
Staller, Natasha, 571, 573
Stallybrass, Peter, 549, 558
Stam, Robert, 8–9, 21n50, 380, 385–86, 389n9, 503–32, 617
Stein, Eric, 37–38, 315–38, 615
Stenhouse, John, 107n23
stereography, 283; of China, 296–300, 312n42; technology of, 296–97, 312n41
Stewart, Susan, 477
still life genre: artifacts engravings' similarity to, 150–52; in Dutch painting, 254; objects in, 551–52

Van Gogh, Vincent, 122
Van Kessel, Jan, 256–58, 265nn13–14
Van Lonkhuijzen (Doctor), 320
Van Meurs, Jacob, 248
Van Peebles, Mario, 507
Van Reede tot Drakestein, Hendrik, 254
Van Rheede, Hendrik Adriaan, 76
Varenius, Bernardus, 252
Varthema, Ludovico, 222
Vaughan, Megan, 318, 323
Velasco, Juan Lópes de, 223
Vergès, Françoise, 527, 530
vernacular modernism, in postcolonial photography, 450–66
Verne, Jules, 120
Vespucci, Juan, 235
Vichy collaboration, 509–10
Vida (Theresa of Avila), 219
Vida de Christo (Fonseca), 225–26
Vida del escudero Marcos de Obregón (Espinel), 221
video, aesthetic hierarchies and, 141–42
View into Ootacummund (Bourne), 458
Views (Lycett), 275
Views of India (Dufours), 545
Villaluenga, Juan José de, 72–73
Villers, Gaston de, 129
Vingboons atlas, 256
violence: Algerian images of, 508–20; Fanon's "therapeutic theory" of, 503, 533n15; in Nigeria, 370n33
Virgin de los Remedios, 48
Virgin of Forgiveness (Pereyns), 58
Virgin of the Antigua, 47
Virgin of Tlayacapan, 58
visible space, in Mexican colonial monastic images, 55–60
Visitors' Inquiry Association, 294–96
visual culture: advertising and, 189–93; Australian colonization and, 268–78; cinema as, 359–61; colonial/postcolonial studies and, 2–14, 384; coloniza-

tion of, 9–11; economics of, 25–26; engravings in, 142; global critique of, 12–14; Hausa moral space in cinema and, 362–66; health propaganda films and, 317; Nigerian cinema and, 346–68; patriotic Indian prints and, 434–41; postcards as, 384–85; postcolonial photography and vernacular modernism, 450–66; stereography and, 297–300; theories of race and color and, 94–96
"Visual Culture Questionnaire," 10–11
visuality: in advertising, 202–3; Australian colonization and Aboriginal vision, 267–78; empire and, 1–14, 609–19. *See also* pictorial practices; *specific visual issues, e.g.,* image-making
"visual turn," in Indian studies, 96
Vitoria, Francisco de, 48
Vitruvius Britannicus, 160–61
voice, in Julien's *Black Skin, White Masks*, 528
volume, in European botanical illustrations, 75
Von Guérard, Eugene, 276–77
"Voyages" (Hargers), 253
voyeurism, filmic allegory of, 529
Vuillard, Édouard, 129
Vyas, Vijay, 461–62

Waghorne, Joanne Punzo, 545
Wagram, Prince Alexandre de, 129–30
Wales, William, 144
Wallace, Mike, 493, 501nn57–58
walls of images: architecture of Mexican colonial monasteries and, 51–55; paintings in Algerian panorama, 114–23
Walpiri peoples, 274
Warhol, Andy, 601
Warlugulong, 35, 272–75
War of Independence (Java), 321